Africa in Flor

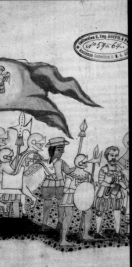
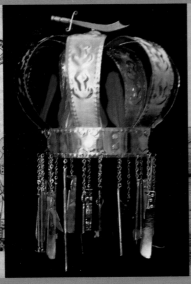
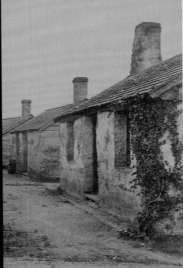

UNIVERSITY PRESS OF FLORIDA

Florida A&M University, Tallahassee
Florida Atlantic University, Boca Raton
Florida Gulf Coast University, Ft. Myers
Florida International University, Miami
Florida State University, Tallahassee
New College of Florida, Sarasota
University of Central Florida, Orlando
University of Florida, Gainesville
University of North Florida, Jacksonville
University of South Florida, Tampa
University of West Florida, Pensacola

University Press of Florida

Gainesville · Tallahassee · Tampa · Boca Raton · Pensacola · Orlando · Miami · Jacksonville · Ft. Myers · Sarasota

Africa in Florida

Five Hundred Years of African Presence in the Sunshine State

Edited by Amanda B. Carlson and Robin Poynor

Foreword by Michael Gannon

A Florida Quincentennial Book

Publication of this book has been aided by a grant from the Wyeth Foundation for American Art Publication Fund of the College Art Association.

Adrian Castro's poem "Cross the Water" from *Wise Fish: Tales in 6/8 Time* (copyright 2005) is reprinted with the permission of Coffee House Press, www.coffeehousepress.com. Excerpts from Gordon Bleach's artist statements and notes reprinted with permission from Gayle Zachmann. Chapter 14 by Andrew Warnes is a shortened and updated version of an article that originally appeared as "Guantánamo, Eatonville, Accompong: Barbecue and the Diaspora in the Writings of Zora Neale Hurston," *Journal of American Studies* 40, no. 1 (2006): 367–89. It is reprinted by kind permission of Cambridge University Press.

19 18 17 16 15 14 6 5 4 3 2 1

Library of Congress Cataloging-in-Publication Data
Africa in Florida : five hundred years of African presence in the Sunshine State / edited by Amanda B. Carlson and Robin Poynor ; foreword by Michael Gannon.
p. cm.
Includes bibliographical references and index.
ISBN 978-0-8130-4457-6 (alk. paper)
1. Africans—Florida—History. 2. African Americans—Florida—Social conditions.
3. African Americans—Florida—History. 4. Florida—History. I. Carlson, Amanda.
II. Poynor, Robin, 1942– III. Gannon, Michael, 1927–
E185.93.F5A34 2014
305.896'0730759—dc23
2013015081

The University Press of Florida is the scholarly publishing agency for the State University System of Florida, comprising Florida A&M University, Florida Atlantic University, Florida Gulf Coast University, Florida International University, Florida State University, New College of Florida, University of Central Florida, University of Florida, University of North Florida, University of South Florida, and University of West Florida.

University Press of Florida
15 Northwest 15th Street
Gainesville, FL 32611-2079
http://www.upf.com

In honor of the five hundredth anniversary of African presence in Florida, we pay tribute to the many individuals who crossed the water.

[Their] story will sing forever deep, across water, beyond geography, into the lushness of history. . . .

Adrian Castro, "Cross the Water"

Contents

PART I. INTRODUCING AFRICA IN FLORIDA

PART II. SEEKING FREEDOM IN AND OUT OF FLORIDA: SLAVES AND MAROONS

PART III. FORGING NEW IDENTITIES: AFRICAN AMERICAN CULTURE IN FLORIDA

PART IV. CONNECTING ACROSS THE CARIBBEAN

Illustrations

Foreword

For six months when I was a high-schooler in St. Augustine I delivered the morning *Florida Times-Union* on a bicycle. My route was West St. Augustine, where numerous African Americans made their home. As was the custom, before I set out I folded each day's paper into a triangular form that could easily be thrown onto porches and stoops. On Saturdays we paperboys had to ring each subscriber's doorbell and collect that week's payment. And that is how, at 791 West King Street, I met Ms. Zora Neale Hurston. It would not be until three decades later, however, when the Department of Anthropology at the University of Florida rescued Ms. Hurston from undeserved obscurity, that I learned *who she was*.

Similarly, where Florida's black populations as a whole were concerned, it would not be until the archaeological excavations of Charles Fairbanks, Teresa Singleton, and Kathleen Deagan, followed by the documentary research of historians Jane Landers, Maxine D. Jones, Larry E. Rivers, and Daniel L. Schafer, that I leaned *who the black people were*.

Now, on the quincentenary of the first diaspora of free Africans to La Florida, we have the present volume, which carries us beyond archaeology and history to a multidisciplinary reflection on the African experience, past and present. Here in one binding is the opportunity to observe black life through the lenses of geography, ethnography, language, religion, literature, art, music, dance, and food. Here, too, we can follow African American engagements with other diasporas: Hispanic, French, Anglo-Saxon, Cuban, Seminole, Haitian, Bahamian, and contemporary African.

It is gratifying to find in these pages a consistent effort on the part of the authors to move past generalities to a search for specifics—a kind of fractal geometry, if you will, that throws light on every recess and interstice.

Michael Gannon
Distinguished Service Professor Emeritus of History
University of Florida

Acknowledgments

Books are the work of many hands. And our thoughts go first to the generations of Africans and their descendants whose hands have built, shaped, and transformed Florida over the past five hundred years. We also applaud—or rather, put our hands together for—the many scholars whose efforts shed light on this subject. However, our loudest "shout out" goes to this volume's contributing authors, who are scattered in far-flung places. We thank you deeply for sharing your research, demonstrating collegiality, and most importantly, showing patience.

We especially thank three individuals in the publishing world. John Byram, our first editor at the University Press of Florida, now director of the University of New Mexico Press, met with us and encouraged us to proceed with the idea for the book. His work was followed by the work of Amy Gorelick, who guided us in the development of the book. Finally Meredith Babb, director of the University Press of Florida, took over the project as part of a group of related projects. This book has been enriched by each of them.

This project was made possible with the generous financial support from the University of South Florida's Stuart Golding Chair in African Art, the University of Hartford (Vincent B. Coffin grant and Richard J. Cardin award), the University of Florida (the Center for African Studies Research Affiliate Program, the Gatorade Fund, and the Department of Sponsored Research), and the Wyeth Foundation for American Art. This project was also developed with the support of academic organizations such as the African Studies Association, the Arts Council of the African Studies Association, the Association for the Study of the Worldwide Diaspora, and the College Art Association, which sponsored numerous conferences, symposia, and panels through which our contributing authors were able to explore early versions of their topics before scholarly audiences, providing feedback and new ways of thinking and looking.

As scholars dedicated to the history and cultures of Africa who have also spent large portions of our lives in Florida, this topic felt personal. We are grateful for the opportunity to collaborate, indebted to each other's contributions,

and equally amused by our relationship. We both studied with Roy Sieber at Indiana University. Like bookends, Robin was one of Sieber's first students and Amanda was one of his last. We both taught seminars on the topic of Africa in Florida. Amanda's was at the beginning of the project while at the University of South Florida, and Robin's was at the end of the project at the University of Florida. In each case, we were inspired by the input and receptivity of our students, who demonstrated interest not only in the arts and cultures of Africa but also in the ways in which those cultures can be witnessed in the contemporary world around them.

We recognize the generous support by our department chairs and deans who provided research time. We value staff that helped in many ways. Numerous people assisted with illustrative material, manipulating cameras and scanners and reworking images to meet publication standards or proofing portions of manuscripts. Among those we specifically name, at the risk of leaving someone out, are Ann Baird, Tom Caswell, Craig Cornell, James Cusick, Scott Horsley, Christopher Richards, Maria Trujillo, and Susan Warner.

We also acknowledge those individuals, publishers, museums, and other institutions that granted us the right to use images and words. Many of our colleagues provided field photographs.

We are most grateful for the sacrifices and support of our family members, who dealt with the disruptions, the absences, and the long hours we spent working on this project. Amanda wishes to acknowledge and thank her family members for their generous love and support: her husband, Craig Cornell, her mother, Marian Carlson, her brother, Dan Carlson, her uncle, David Schneider, and her five-year-old twins, Ethan and Emma Cornell. Robin thanks his wife, Donna Hardymon Poynor, and his son and daughter-in-law, Christopher Hardymon Poynor and Sara Shunkwiler. Without the support of our spouses, children, and friends, this would not have been possible. One morning, Amanda's four-year-old son woke up and asked, "Mom, is your book done?" It is a pleasure to tell Ethan, "Yes, it is."

And we dedicate this book to Ethan, Emma, Owen, and DJ along with other children who may someday read this book . . . listen to the past so that you may understand the present and direct the future.

Introducing Africa in Florida

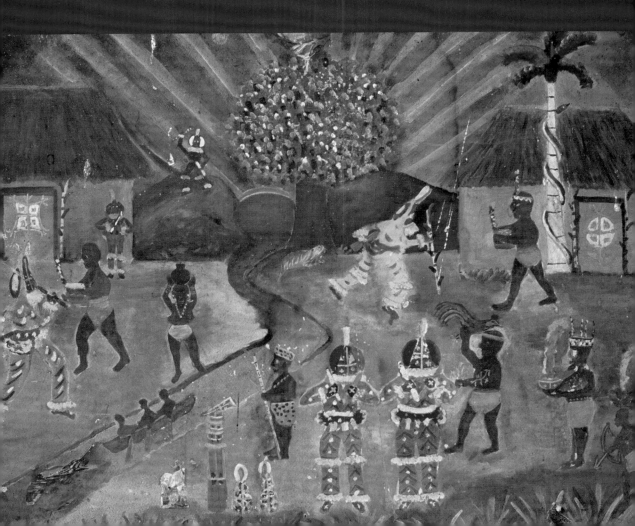

1

Mapping Africa in Florida

Into the Lushness of History

Amanda B. Carlson with Robin Poynor

On April 2, 1513, the first Africans arrive in Florida near contemporary Melbourne Beach. These two men, Juan Garrido and Juan González (Ponce) de León,[1] are free African men from Spain who accompanied Juan Ponce de León onto the shores of what would become La Florida (fig. 1.1). While this historical moment is typically written about as a voyage of exploration signaling the beginning of the European colonization of North America, we choose to write about it as the beginning of an African presence in Florida. In a sense, we are enacting what Elliot Skinner refers to as a "paradigm of Africanity," which "shifts the focus away from Europe and comes to grips with the experience of African peoples."[2] In honor of the five hundredth anniversary of the documented African presence in Florida (2013),[3] this volume celebrates the ways in which Africans and people of African descent have shaped the history and culture of Florida. These communities include African Americans, Maroons, Seminoles, Haitians, Bahamians, Cubans, Yoruba Americans, and immigrants from numerous contemporary countries in Africa.

This project began with a student-curated exhibition, "Behind the Mask: Africa in Tampa,"[4] in which Amanda B. Carlson asked her students at the University of South Florida (Tampa 2001) to expand their concept of "Africa" by exploring the trajectories of African culture that infuse the cultural landscape of Tampa (fig. 1.2). This pedagogical tool was meant to help students conceptualize African culture as something that is not fixed, distant, or exotic but rather as something that has great relevance to their own history and community. The exhibition included voices, faces, and objects relevant to African, African American, and African Caribbean communities in addition to representations of Africa in popular culture in juxtaposition with African masks, which are so frequently displayed in Western museums. The results of that exciting project left the editors of this book with a simple question: What happens when we go

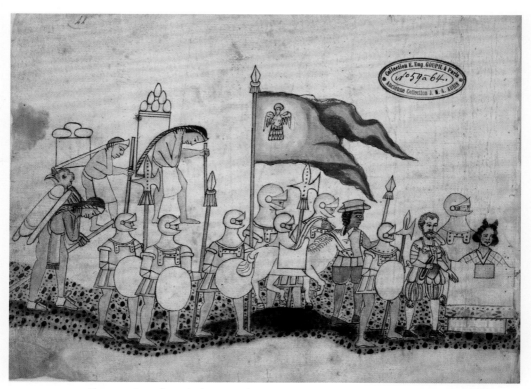

Figure 1.1. Page from *Codex Azcatitlan*, ink on paper, sixteenth century. 21 × 28 centimeters. An image from the *Codex Azcatitlan* is believed to show Juan Garrido, a free African conquistador, the fifth figure from the right, in the company of Hernando Cortés and his troops in Mexico. Garrido had earlier accompanied Ponce de León on the initial voyage to Florida in 1513. Courtesy of Bibliothèque Nationale, Paris.

looking for Africa in the rest of Florida? As Africanist art historians, our naïveté about Florida studies did not prepare us for the enormity of the subject, but it did enable us to look at this material with a fresh perspective.

According to geologists, Africa and Florida were once connected but parted ways 190 million years ago,[5] which explains why Florida's climate and geography are similar to that of many parts of Africa. While it is unlikely that these landmasses will ever reconnect, they are indeed rejoined through history. When combing through Florida history for African influences, one is confronted by a veritable tsunami of examples, with multiple waves moving across the state and altering the landscape. Few people realize the extent to which Africa has influenced the state of Florida and the importance of those influences for understanding state, national, global, and even personal histories. For instance, the first free and enslaved Africans to reach the land that would become the United States entered through the gateway known as La Florida. The First Spanish Period begins with the founding of St. Augustine—the first permanent European colony not only in Florida but in all of North America.

Amanda B. Carlson with Robin Poynor

At the time of its founding, Africans constituted 12 percent of its population. Black people constituted more than 50 percent of the population of Florida during certain time spans in the nineteenth century.[6] The most recent census estimates that black people (not including people who identify with more than one race) make up 16.5 percent of the population.[7] Along with facts and figures, this volume captures the dynamic movement of people, ideas, and objects that draw Africa and Florida closer together.

In addition to looking at the individuals who make up the diaspora, this volume also utilizes "diaspora" as a concept for exploring how Africans move throughout the world, how and where they exist, and ultimately how we come to understand these places. For instance, how do Floridians identify with Africa? How is Africa recalled, imagined, and brought into being? How does Florida shape the multiple African diasporas that move through it in addition to being shaped by them? Why and how do people identify with Africa? What do these diverse communities share? If we were to define "Africa" from the point

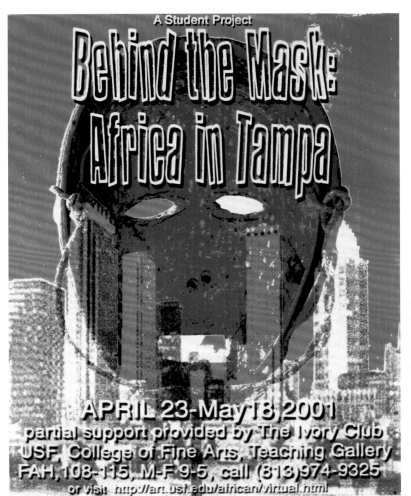

Figure 1.2. "Behind the Mask: Africa in Tampa" exhibition poster by Brandon Dunlap. Silkscreen, 2001. Students at the University of South Florida juxtaposed African masks with elements of "Africa" that they discovered in Tampa outside of the museum. Photo by Susan Warner.

of view of Floridians, could this shift our perspective on what "Africa" means and where it lies? While addressing these questions, *Africa in Florida* becomes an unexpected place to explore and examine anew the complexity of American history in which racial, ethnic, and national identities are called forth, negotiated, and celebrated.

In a sense, America begins and ends with Florida. Florida is the first point of contact for the colonial legacy, which would eventually lead to the formation of the United States. Florida also contains the southernmost (or, last) point in the United States today (Key West). In this book about Florida, the story of where America both begins and ends is tied together by the trace of Africa.

Afro-Floridian Frameworks

An Afro-Floridian identity does not exist in the same way as African American, Afro-Caribbean, or Afro-Cuban identities, all of which coexist in Florida. It is possible that some people could use all three of these terms of identity interchangeably depending upon the situation. While institutions exist that support these accepted categories, the same is not true for the term "Afro-Floridian," which is difficult to invoke in anything but an academic activity such as this. While the term "Afro-Floridian" is negligible as a term of self-identity, it is helpful in reminding us that Africa is an animating concept in the understanding of Florida. Even when Africa in Florida goes unspoken, it is present. Sagrario Cruz-Carretero asked a similar question about invoking the category "Afro-Mexican." Paraphrasing the words of a musician, she writes, "The African presence in Mexico is like sugar in coffee: it cannot be seen but it improves the flavor."[8] While the same could be said of Florida, the experience of Africa manifests itself differently than in Mexico. To try a different culinary metaphor for Florida: when looking at a recipe the ingredient list is obvious, but when you experience the food some ingredients may be very palpable and others go unnoticed. While the historical facts demonstrate that Africa is one of the main ingredients in Florida, what individuals do with the ingredient determines whether Africa is obvious or indiscernible. One can look at Florida history and trace African origins and presence, but in the experiences of individuals "Africa" becomes blended with many other identities in a stew often seasoned with complicated conversations about race.

In the past, people of color have moved to and from this region in response to governments and institutions that sought to oppress and enslave them. In this way, Florida has been a symbol of both oppression and freedom. Today, the state of Florida struggles to come to terms with its black past and present. Recent political and legal battles reflect the diverse reactions of contemporary Floridians to racial injustices inflicted during the eras of slavery and Jim Crow. For instance, in response to the racial violence in 1923 that resulted in the

Amanda B. Carlson with Robin Poynor

destruction of Rosewood, a town primarily occupied by African Americans, Florida lawmakers awarded compensation to the survivors and descendants of Rosewood seventy-one years later (in 1994) because the state had failed to defend the community, to document the event, or to take any action against the offenders. However, the same conviction to make amends for Florida's racist past is far more muddled with regard to the official state song, "Old Folks at Home," which offers a nostalgic nod to the times of slavery with offensive lyrics that refer to "darkies" and mimics the dialects of black slaves (fig. 1.3). Written in 1851 by Stephen Foster (adopted as the state song in 1935), the first verse begins:

> Way down upon de Swanee ribber,
> Far, far away,
> Dere's wha my heart is turning ebber
> Dere's wha de old folks stay.
>
> All up and down de whole creation
> Sadly I roam,
> Still longing for de old plantation
> And for de old folks at home.

This romantic representation of plantation life remains controversial. Florida legislators have twice tried and failed to remove it as the official state song. The debate rolls on about whether altering the lyrics is better than replacing the song altogether. State representative Dennis Baxley (R-Ocala), a descendant of a Confederate soldier, said, "The roots of Florida are deep and Southern," adding: "It just seems in this age of multiculturalism we can celebrate everyone's culture but mine."[9] In this moment of continuing racial tension, it is useful to (re)visit the history of black presence in Florida, which unfolds over five hundred years, in a new light that expands upon the standard view of the African experience in the United States, which is too frequently built around the narrative of the "deep south." There are many reasons why people may not want to sing about "de old plantation" as a tribute to Florida history. In fact, there is much more to sing about.

Florida has been connected to global networks for many centuries, and the experience of black people in Florida is not the same as in other parts of the "south." In that sense, looking outward into the vast Atlantic—coined the "Black Atlantic" by Paul Gilroy[10]—can be a more useful framework for understanding the African diaspora in Florida. But this only speaks to part of the history and also overlooks what is happening to the West (in Mexico, for example). Moreover, when Juan Garrido and Juan González (Ponce) de León set foot upon North America in 1513, present-day concepts of Florida, Africa, and the Black Atlantic (as we understand them today) did not exist.

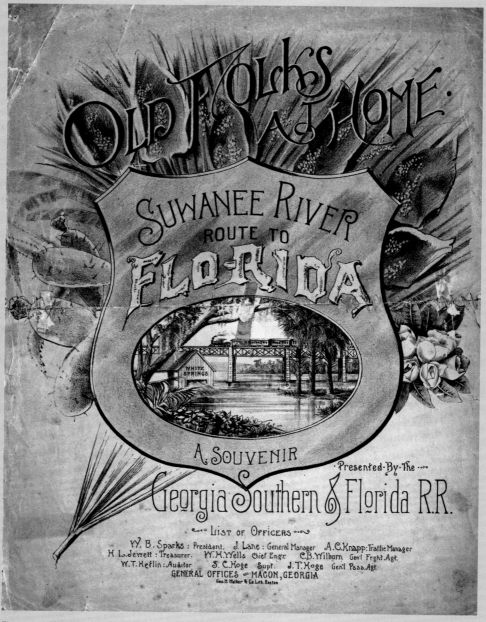

Figure 1.3. Sheet music cover, Stephen Collins Foster's "Old Folks at Home: Suwanee River Route to Florida" [189-?]. Stemming from the nineteenth-century tradition of minstrel shows, this nostalgic song idealized the rural South. A state anthem has also been adopted in lieu of replacing this controversial song. However, "Old Folks at Home" continues to be Florida's official state song (with revised lyrics). Stephen Foster was never a resident of Florida. Tampa Florida Sheet Music Collection, Special Collections Department, Tampa Library, University of South Florida.

The contemporary concept of Africa and African identities grew gradually out of experiences related to the transatlantic slave trade (beginning in the sixteenth century) and European colonization of the African continent (beginning in the nineteenth century). In this sense, Florida's history unfolds amid the emerging concepts of "Africa" and the "Black Atlantic" that transformed over time.[11] Thus, the complexity of Florida history as well as African history causes well-established models for discussing the African diaspora to appear as traces, here one moment and gone the next. In this "Bermuda Triangle,"[12] where familiar frameworks for understanding the African diaspora mysteriously disappear, we need to look closely at the circumstances of Florida to understand the ways in which traditional diaspora narratives are reinforced or revised.

A state—in this case, Florida—is perhaps an unexpected (or rarely used) framing device for discussing the broader concept of the African diaspora, which is typically addressed through more expansive regions such as Latin America, the Caribbean, or the United States. Early studies of diaspora began amid anthropological debates that revolved around two models of diaspora culture. While one model traces retentions of African culture in the diaspora (via the work of anthropologist Melville J. Herskovits), the other characterizes the diasporic experience in terms of discrimination and resistance (via the work of sociologist E. Franklin Frazier).[13] While most of the essays in this volume are embedded within the legacy of this intellectual debate, the discourse has taken other interesting turns. Scholarship in the twenty-first century recognizes that "Africa" and "diaspora" are in conversation and are constantly in the making. More than a decade ago, Tiffany Ruby Patterson and Robin D. G. Kelley, in their essay "Unfinished Migrations: Reflections on the African Diaspora and the Making of the Modern World," reflected upon the concept of diaspora at a time when diaspora studies were blossoming. They wrote that "shifting the discussion from an African-centered approach to questions of black consciousness to the globality of the diaspora-in-the making allows for a rethinking of how we view Africa and the world."[14] Patterson and Kelley describe this academic position as moving "beyond diaspora."

With diaspora studies now in full bloom, there are only a few academic texts that have broken the mold of diaspora as "merely a logical manifestation of dispersion,"[15] and more research needs to address the processes of calling diasporas into being. As explained by Colin Palmer, "In many respects, diasporas are not actual but imaginary and symbolic communities and political constructs; it is we who often call them into being."[16] What we learned from the breadth of research that fits within our framework—Africa in Florida—is that there is a vast spectrum of relationships with Africa. The framework for this book attempts to reevaluate the concept of diaspora in light of the multiple ways in which Africa becomes manifest in Florida.

While the concept of diaspora applies to many of the case studies in this volume, not all are diasporic, such as Africa as a theming device within the tourist industry. And not all practitioners of African culture are African, such as Greek American Iyanifa Vassa, whose religious devotion to the Yoruba orişa has inspired an elaborate spiritual retreat in Central Florida. And not all Africans are black, such as Gordon Bleach (a white Rhodesian artist from the country that is now Zimbabwe), whose work about Africa and Florida was informed by dialogues about race on both continents. Therefore, in this volume we examine the relevance of Africa for understanding a broad range of histories and experiences. And, we encourage a critical evaluation of the concept of "Florida" as a cultural and geographical entity in light of its encounters with Africa. In search of a language with which to make sense of these interactions, we suggest that a new vision of cultural geography is necessary in order to look beyond established categories of knowledge that separate the histories of Africans, Europeans, Native Americans, and their descendants.

Ira Berlin's concept of "Atlantic Creoles" and Avtar Brah's concept of "diaspora space" offer nuanced perspectives based on the fact that geographic borders and cultural borders no longer align (if they ever did). While Africa has always been connected to the wider world, the transatlantic slave trade constituted one of the largest forced migrations in world history, having a profound and lasting impact upon both Africa and the New World. Berlin focuses on how individuals responded to an expanding Atlantic world, while Brah directs her attention to the space that these individuals inhabit.

In the seminal essay "From Creole to African: Atlantic Creoles and the Origins of African-American Society in Mainland North America" (1996), Ira Berlin writes,

> Black life in mainland North America originated not in Africa or America but in the netherworld between the continents. Along the periphery of the Atlantic—first in Africa, then in Europe, and finally in the Americas—African-American society was a product of the momentous meeting of Africans and Europeans and of their equally fateful encounter with the peoples of the Americas. Although the countenances of these new people of the Atlantic—Atlantic creoles—might bear the features of Africa, Europe, or the Americas in whole or in part, their beginnings, strictly speaking, were in none of those places. Instead, by their experiences and sometimes by their persons, they had become part of the three worlds that came together along the Atlantic littoral. Familiar with the commerce of the Atlantic, fluent in its new languages, and intimate with its trade and cultures, they were cosmopolitan in the fullest sense.[17]

Berlin argues that Atlantic creoles were a culture that was later absorbed by the bifurcation of race that accompanied the plantation system and that became

categorized as "African" or "African-American." However, Atlantic creoles did not "disappear" from Florida as they may have elsewhere in North America. In fact, it is useful to carry this concept beyond the colonial period up to contemporary times. Not only did Atlantic creoles contribute to the making of Florida, but Florida continues to be inhabited by creoles, who are knowledgeable agents in numerous spaces.

In *Cartographies of Diaspora* (1996), Avtar Brah conceptualizes diaspora as an "interpretive frame"; and, by conceiving the term in this way she cordons off space. She asserts that "diaspora space as a conceptual category is 'inhabited,' not only by those who have migrated and their descendants, but equally by those who are constructed and represented as indigenous. In other words, the concept of diaspora space (as opposed to that of diaspora) includes the entanglement, the intertwining of the genealogies of dispersion with those of 'staying put.'"[18] Writing at the same time as Berlin, she focuses on creole spaces over simply creole individuals or communities. Moreover, her argument implies that the construction and reconstruction of space and identities are important for understanding our past and future. Likewise, Florida is a diaspora space inhabited in part by Atlantic creoles who navigate physical, political, social, and cultural spaces that are not contained by borders, which are more idea than reality.

Building upon the ideas of Berlin and Brah, which allow for an analysis of both individuals and space, our book also addresses how these individuals and spaces have been represented and interpreted via text and image. We also recognize that some diaspora narratives are built upon preexisting colonial (and postcolonial) narratives about space and place that can be overcome with new ways of seeing Africa and the diaspora.

Visualizing Africa and Diaspora

In the twenty-first century, cultural historians are gradually becoming more aware of how geographic boundaries have complicated our understanding of cultures. Along with transformation in the ways in which we think about maps, significant changes are occurring with regard to how we think about space and place. Where geography enters into discussions of social theory, debates about space-relations (physical space, mental space, and social space) have been discussed in terms of Western and non-Western understandings of space and place.[19] However, the distinction between Western and non-Western becomes rather blurry (and not so useful) in the case of Africa in Florida.

Africa in Florida maps a complex space along with the individuals who inhabit it. At what point do people identify with Africa, and how? What could these diverse communities share? What filters do we need to place over the map of Florida in order to see Africa? If we were to create a map where Africa

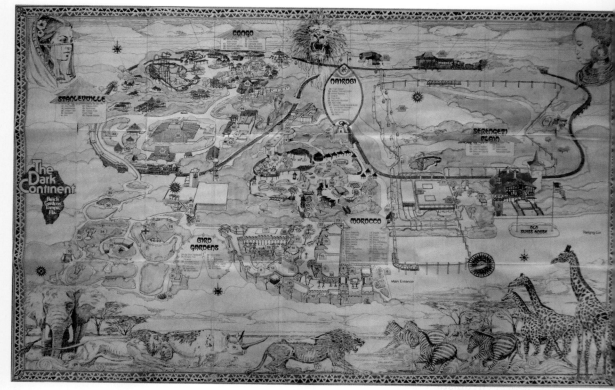

Figure 1.4. Visitor's map for Busch Gardens: The Dark Continent. Printed brochure, 1980s (?). This map is intended to guide visitors to attractions (Stanleyville and Congo sections of the park shown here). The veiled woman is a reference to Morocco (another section of the park). Apparently drawn by hand, this diagram evokes colonial maps of Africa, which often included decorative borders (vignettes) along with decorative images (cartouches) that depicted exotic images of Africans, wild animals, and African-inspired patterns and artifacts. From the P. K. Yonge Library of Florida History, Department of Special and Area Studies Collections, George A. Smathers Libraries, University of Florida.

was *in* Florida, should we do more than simply reshuffle pieces of the same puzzle? With these questions in mind, we are looking for frameworks that promote a nuanced understanding of this new type of space—"new" in the sense that we are re-imaging cultural and geographic borders that fluctuate based upon who is mapping the terrain and what it comes to represent. Just as maps reveal and veil certain types of information, so too does this book.

Perhaps it is not surprising that two art historians would attempt to rework diaspora narratives in light of the power of images, maps, and other representations of spatial knowledge. While our comfort with images and visuality may have no direct relevance to many of the chapters in this volume, it does present an approach that ties them together and offers new ways of framing questions within various disciplines.

Amanda B. Carlson with Robin Poynor

In the latter part of the twentieth century, academic approaches to cartography that relied entirely on a scientific approach were transformed by the discipline of "critical cartography," which embraces both the semiotic power of maps and their functional capacity. Moreover, maps are "graphic representations that facilitate a *spatial understanding* of things, concepts, conditions, processes, or events in the human world."[20] Maps not only record a reality; they can shape future events. The power of maps is illustrated clearly by the fact that Africa as a territory was claimed on maps by European powers long before these places were actually colonized. Maps of amusement parks operate in much the same way, literally creating a "new land." Dozens of African-themed tourist attractions in Florida (see chapter 23) produce elaborate maps worthy of an in-depth analysis, such as in figure 1.4. These maps have a practical function—helping tourists find food, toilets, and roller coasters—but more importantly, they use geography as a narrative device to extend the experience of the amusement park and to define the constructed "African" space. Whether we create maps to visualize our political desires or our imaginations, maps are about far more than geography.

Describing space with language is equally complex. The models currently used to talk about the African diaspora are often based upon geographic "markers," a type of code that we use to discuss a broad range of cultural and historical circumstances. For example, we can identify the "location" of the "deep south" on a map even though we know that it is a concept and not an actual destination. By describing these concepts in terms of a "geographic location," we are utilizing spatialized knowledge to mask the subjectivity of these terms in much the same way that we are conditioned to think about maps as objective, scientific, and truthful.

Altering an existing map (consisting of image, text, and/or object) can have a powerful effect. By essentially renaming a vast ocean (the Atlantic), Gilroy captured a powerful intellectual moment, marking a substantial shift in the way we think about the world. It was as if he took a map of the world, pulled out a pen, and with the addition of one word (Black) transformed cultural history. Just as maps can define territory as much as describe it, terms such as "deep south," "Black Atlantic," and "Africa" are conceptualized with regard to a specific type of spatialized knowledge rooted in or responding to imperialist histories. Replacing Ponce de León with Juan Garrido in the quincentennial celebration narrative is a similar textual change meant to subvert a dominant Eurocentric perspective within American history. The intention is not only to change the way in which we think about Florida history but also to question our assumptions about where Africa exists.

As geographic entities on a map, Africa and Florida may initially seem distant and distinct, but the ways in which we call them into being are similar. To look closely at the circumstances of Florida and the representations that

describe and define them, we need to rethink the spatial configuration of our cultural and historic narratives and visualize a new geography—one that accommodates overlapping diasporas, the encounters between Africa and the diasporas, an awareness of the places where these encounters take place, and individual experiences of the local and the global.

A Road Map to Africa in Florida

Africa in Florida is an interdisciplinary book that utilizes a broad scope of research to convey the depth of African influences in Florida, capturing powerful stories about diasporas—both actual and perceived. The authors were selected from an open call for essays. While both editors and several authors are art historians, other contributors work in anthropology, history, literary studies, performance studies, and religious studies. We intentionally selected a broad range of scholars who are at different stages in their careers in yet another attempt to diversify the research. Of the many excellent submissions, we found considerable overlap on certain subjects. As editors, who are Africanist art historians and not specialists in Florida studies, we were quick to see gaps in the topics that we saw as pertinent for conceptualizing Africa in Florida. Thus, our own research on visual and material culture in Florida expanded as the project developed.

The first part, "Introducing Africa in Florida," begins with four distinct narrative styles—academic, poetic, conversational, and visual—to underscore our premise that it takes many different voices to reveal the richness of African influences in Florida. In "An Overview of Florida's Black Past," historian Nathaniel Millett presents an essential history for understanding the essays that follow. His vivid account of the progression from conquest to colony to state underscores the significance of Africans and their descendants not only to Florida history but also to American and world history. Millett is the first of many diverse academic voices in this volume that are supplemented by the work of artists, whose no less scholarly contributions add a meaningful layer to this conversation. For example, in the next chapter, history is put to verse by Adrian Castro in the poem "Cross the Water," prompting us to reflect upon the global dimensions of African culture and providing an eloquent "jumping off" point for this volume.

Castro is a prominent Floridian poet who writes from Miami and whose work explores the migration of Africans across the Atlantic and the role of water as both bridge and boundary. Castro's contribution to this conversation about Africa in Florida is deeply informed by his own ancestral history and the fact that he is a babaláwo, a priest within the Afro-Cuban religious tradition based on the Yoruba concept of orișa (deities). However, "Cross the Water" (2001) is not about the Yoruba world; it is a poem about the ritual

associations and masquerades of the leopard society, a male ritual association that originated in the Cross River region in southeastern Nigeria and southwestern Cameroon (among the Éjághám, Èfik, and Èfût), where the association is known as Ékpè and Mgbè (or Ngbè). Due to the transatlantic slave trade this tradition traveled to Cuba, where it is known as Abakuá. While Castro does not directly recall Florida in this poem, he explains the poem's connection to Florida in the interview that follows. Florida is the missing link in a triangle that connects Africa and the Caribbean. This link becomes more clearly visible in chapter 16, in which Ivor Miller brings the story of the leopard society further into Florida. Nonetheless, Castro captures the essence of the complex history, which is relevant to black experience in Florida, with words that inspire us to think about African connections and influences.

Similar to the leopard society rituals that the poem describes, "Cross the Water" engages with the idea of space as an "interpretive frame" and describes movement in both the physical and the spiritual realms. Thus, it is not only scholars such as Avtar Brah who conceptualize "diaspora space." There are also practitioners within a diaspora who add to this conversation about space, which involves the act of describing space (mapping). In a sense, Castro's poem is the verbal equivalent of the painted mystical maps of the Cuban Abakuá (see fig. 1.5), which depict an African landscape (recognizable as the Cross River region) that implies a spiritual connection to an ancestral past rather than an actual homeland that one could return to. Kenneth Routon writes, "[it] is not merely a visual reminder of the society's mythic-historical origins. It also informs what may be called a magical cartography, which simultaneously 'maps' and 'charges' the society's 'geography of sacred memory.'"[21] Similarly, Castro invokes these lands—Uságare (Cameroon), Calabar (Nigeria), Regla (Cuba)—and urges us with rhythmic language to move beyond geography and to recognize how places can be connected in the spiritual realm. African concepts of mapping (especially in relation to cosmology) need to be part of any discussion about critical cartography as it relates to the African diaspora. Castro is emblematic of scores of creative thinkers with ties to Africa who are visualizing how Africa exists in the world and how individuals come to understand it and experience it.

The artwork of Gordon Bleach (1953–99; b. Rhodesia/Zimbabwe) provides an equally complex examination of the relationship between Africa (his former home) and Florida (his home in the last chapter of his life). Utilizing the tools of photography, digital technology, and theory, the artist explored these places that are not connected physically but rather historically and/or conceptually. Chapter 4, "Gordon Bleach: A Portfolio," includes selected works by the artist and excerpts from his artist's statements. These are accompanied by Amanda B. Carlson's brief essay, "Gordon Bleach: Home Can Always Be Arranged," explaining how this body of work engages with the language and

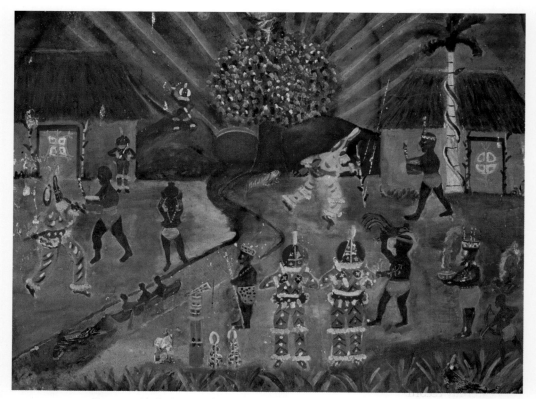

Figure 1.5. Abakuá mystical map. Untitled. Acrylic paint on wood. This painting, kept in the Miami home of an Abakuá member, depicts a mythic Calabar scene. For initiated Abakuá members it depicts "sacred space." The female figure with a jar on her head represents Sikán, the "mother" of Abakuá. The central leopard-skinned figure holding a staff represents the Iyámba lodge leader. The figure at right holding a jar with burning incense is Nasakó, the medicine man and prophet. The Íreme body-masks ensure that order and justice prevail. Photo by Ivor Miller.

history of cartography to present places such as Africa and Florida not as fixed entities but rather defined in relationship to individuals.

Bleach was an intellectual who was deeply engaged in conversations about cartography and space/place relationships, which are closely aligned to one of the objectives of this book: to understand diaspora narratives in light of the power of images, maps, and other representations of spatial knowledge. As an artist, Bleach was keenly aware of the power of images and the act of viewing. In the *eMotive Vision Series*, Bleach explores various types of vision through concepts revolving around the phrases "double vision" and "mote in your eye." In an artist statement he explains, "A mote is a speck of opaque matter (dust). . . . Mote carries ethical freight, too, in the biblical injunction to remove impairments (beam, rock) from one's own eyes before demanding mote removal from others."[22] In order to visualize Africa and Florida together, Bleach

Amanda B. Carlson with Robin Poynor

embraces the fact that visual evidence can either diminish or strengthen our ability to understand the world around us.

Armed with the conceptual tools provided by theorists, historians, poets, and artists, we are prepared to journey through the remainder of the book. The essays that follow are organized into four sections that emphasize the key intersections of Africa and Florida: "Seeking Freedom in and out of Florida: Slaves and Maroons," "Forging New Identities: African American Culture in Florida," "Connecting across the Caribbean," and "(Re)making Africa in Florida." The organization is essentially chronological, beginning with how Africans were introduced to the American continent, both as free and enslaved persons, followed by how their presence in Florida was achieved and ending with the ways that Africa is being re-created and imagined in contemporary Florida.

"Seeking Freedom in and out of Florida: Slaves and Maroons" includes six chapters that provide insightful accounts of how people of color dealt with dire challenges during the era of slavery over nearly three centuries. Jane Lander's chapter, "African Ethnic Groups in Colonial Florida," draws upon substantial documentation, resulting from the fact that Florida was once a Spanish colony where priests and administrators paid attention to the ethnicities of Africans living among them. As priests baptized, taught, married, and buried Africans, they carefully recorded the *nación* or *casta* of the individual. Therefore, we can determine the specific ethnicity of Africans in Florida and the factors leading to the "Africanization" of Florida, where language, religious, social, and cultural systems were more readily maintained than in other areas of the antebellum South.[23] In Florida, Congo peoples from Central Africa (with a historical relationship to Spain/Portugal and Catholicism) represent the largest ethnic group present during the period of slavery. Other ethnic groups included Mandinga, Carabalí, Igbo, Coromante, Susu, Wolof, Peul, Gangá, Bara, Besi, Dudrian, Mondongo, Bambara, Limba, Moyo, and Pati, among others. By tracing the ways in which ethnicity in Florida was recorded by Spaniards and invoked by Africans, we can assume that ethnicity was considered a valuable form of identification by both groups. This offers another reminder that Africans were not stripped of their identities and culture, as was sometimes reported in earlier accounts of slavery.

While detailed accounts of individuals from various ethnic groups result in a more nuanced understanding of the population, this does not ensure that social and cultural retentions can easily be attributed to a specific ethnic group (usually they cannot). However, in "African Influence on Seminole Beadwork," art historian Thomas Larose provides compelling evidence that the transmission of African skills and knowledge can be traced to specific African ethnic groups (Kongo and Yoruba) who influenced the development of Seminole beadwork in the late eighteenth and early nineteenth centuries. His research

presents powerful evidence of how Black Seminoles wore Yoruba-influenced Seminole beadwork that included the introduction of beaded embroidery along with a new selection and arrangement of colors. Along with these visual elements of design, the function of objects transformed as well. Seminole bandoleer bags went from being a utilitarian pouch to being a container for power objects as is common within Yoruba ritual traditions. The implications of this research suggest a complex picture of merging cultures among Africans and Native Americans as evidenced through remnants of material culture.

In "Black Towns of the Seminole Indians: Florida's Maroon Communities," anthropologist Rosalyn Howard argues that communities that are often referred to as "Black Seminoles" actually constitute maroon communities, which reflect the agency of individuals to resist slavery and other forms of degradation. Free and self-emancipated blacks lived independently from Anglo settlements, thus allowing for the re-creation of certain social and cultural practices. Howard draws important correlations between the maroon communities of Florida and better-known maroon communities in other parts of the Americas. What is unique about those in Florida is the way they aligned themselves with Native American settlements. In an overview of these Black towns and their relationship to the adjacent Seminole communities, Howard concludes that the Black Seminoles did not become culturally "Indian." She argues that they were really maroon communities that were attached to Seminole towns; the residents lived separately and for the most part did not adhere to Indian culture. Both communities benefited from the close proximity and the sharing of ideas and resources (as evidenced in the previous chapter). At times this involved forms of cohabitation and mixing, although the communities still remained separate. During the American settlement of Florida in the nineteenth century these unique alliances were uprooted. While some Black Seminoles were taken by American forces and situated in Texas, others fled to the Bahamas. Throughout history, people were constantly moving in and out of Florida via diverse networks and under varied circumstances.

Due to an emphasis on the Atlantic world, migrations to the West are sometimes overlooked. In 1763 the British took over Florida for a twenty-year period, which caused many blacks to flee to other parts of the Spanish empire in Mexico and the Caribbean. Individuals and entire communities crossed borders in search of more favorable living circumstances. The essay by anthropologist Sagrario Cruz-Carretero, "From Florida to Veracruz: The Foundation of San Carlos Chacalacas," explores a group of free blacks from northern Florida who migrated to Veracruz, Mexico. The author focuses on how this eighteenth-century community consisted of a diverse population (free blacks, Native Americans, and Spanish) and how they navigated this new place, which involved new models for racial and ethnic identification. In Mexico, where African and/or black identities largely go unspoken, it is important to recognize

the contributions of these communities to the cultural history of Mexico. For example, Cruz notes that Antonio López de Santa Anna, who served as president of Mexico, descended from the Florida immigrants of San Carlos.

While the San Carlos Chacalacas community never realized its desire to return to Florida, other communities did return. For example, Africans who moved to Cuba after the Treaty of Versailles (1783), in some instances, reclaimed their land in Florida when Spain regained control of the territory. The Black Seminoles from Florida who migrated to the Bahamas, as mentioned in Rosalyn Howard's essay, in some instances returned to Florida as well. Many interesting stories emerge from these migrations in which individuals attempted to optimize political alliances in the midst of competing political forces. For instance, a number of the Black Seminoles who had left for Nacimiento, Mexico, returned to Texas, where they were recruited as scouts by their former enemies, the United States Army. The next chapter illustrates just how porous borders and alliances could be.

"Slave Refuge and Gateway: David B. Mitchell and the Paradox of the Florida Frontier," by historian Andrew K. Frank, demonstrates that Florida was not only a sanctuary and asylum to which fugitive Africans could run but also a port through which newly arrived African slaves could be channeled into the region to the north. David B. Mitchell was a former governor of Georgia and federal Indian agent who was involved in a scheme to smuggle 110 newly arrived Africans from Spanish Florida into the United States. Mitchell used his extensive knowledge of the law and the border between Georgia and Florida (which was controlled by the Creek and Seminole Indians) to evade the laws prohibiting the importation of African slaves. Mitchell and the major participants in the case were cleared of criminal wrongdoing, but the Africans were ultimately enslaved in the lower South. Thus, the Florida-Georgia border became both a legal and illegal port for Africans and African Americans, either entering or fleeing slavery.

Anna Kingsley is an African woman who moved in and out of Florida under much different circumstances than the Africans described in the Mitchell case. She was an African woman from what is present-day Senegal. Although she was initially enslaved, she married the slave trader Zephaniah Kingsley. In "The Kingsley Community: Beyond the Plantation," anthropologist Antoinette Jackson discusses an extended community formed first by Zephaniah and Anna Kingsley and then by their descendants. She discusses the Kingsley Plantation (1813–39) on Fort George Island (near Jacksonville) as a space that reveals the realities of the antebellum South, which was sometimes inhabited by individuals with multiracial and multinational identities. The Kingsley family is perhaps the best example of Ira Berlin's concept of "Atlantic creoles," because they not only moved across international boundaries but also used their knowledge of international systems to improve their well-being. During the

American period they migrated with their family, which included creole children, to Haiti in order to avoid the American policies on race and slavery. Anna Kingsley later returned to Florida to reclaim her property. In this essay, Jackson traces the descendants of this powerful family and addresses the impact they have had on Florida even to the present day.

While African American heritage in Florida is tied to the histories of slavery mentioned above, diverse and varied identities and cultures evolved over a period of time spanning territory, colony, and state. The section "Forging New Identities: African American Culture in Florida" consists of five essays that deal with how African Americans have responded not only to African influences but also to European and Caribbean influences.

In "Florida's African Connections in the Nineteenth Century," historians Edgar Canter Brown and Larry Rivers paint a picture of nineteenth-century Florida so rich in details that readers will experience the syncopated rhythms of Africa and Florida that reach a crescendo during the nineteenth century. At this time most people would have known someone who was from Africa, and the general population was not ignorant of or impartial to Africa, as some may assume. Instead, there were a significant number of encounters ranging from the "Back to Africa" movement, missionary work, a fascination with the explorer Henry Morton Stanley, and an interest in the wars and colonial ambitions in Africa. While reminding us of the numerous contributions that Africans made to Florida in terms of food cultivation, herding, music, dance, architecture, and funerary traditions, the authors also recount the lives of specific individuals whose origins, interests, or travels constituted substantial links between these two places. The authors discuss notable Africans who contributed to the history of Florida, including Anna Kingsley from Senegal (planter, businesswoman, slave owner), Juan Bautista "Big Prince" Witten from Guinea (military officer), Sitiki from West Africa (notable minister), and Thomas Tucker from Sierra Leone (lawyer, educator, first president of Florida A&M University). Floridians also traveled to Africa for a number of reasons. Inspired by the "Back to Africa" movement, some black Floridians emigrated to Liberia. Floridians also went to Africa for missionary work, including Lulu Fleming, who was born a slave and eventually earned an MD and served as a medical missionary in Congo. Considering that by midcentury almost half of the territories' population had ties to Africa, it is not surprising that Floridians of all races nurtured an interest in the continent.

As mentioned in the previous chapter, cemeteries in Florida are known to have been influenced by African funerary traditions. Cemeteries are built environments that utilize spatial conventions and visual markers, which give meaning to community rituals and mark the transition of life to death. Rural communities in Florida have designed spaces and embellished surfaces with shells in order to connect with their forebears while also leaving their mark

for generations yet to come. "Signs, Symbols, and Shells: African American Cemeteries in Florida," by art historian Kara Ann Morrow, addresses African American funerary practices in rural Florida that reflect the purposeful retention of African elements as well as the adaptation of Euro-American funerary traditions. Morrow also considers how white communities in the Southeast have been influenced by African American traditions. Since numerous communities creatively adorn and transform burial grounds with shells, we cannot assume that the use of African funerary traditions is proof of a community's desire to recognize an African past or even to recognize the tradition as "African." Tracing shell use in cemeteries, Morrow underscores the cross-cultural appropriations where symbols take on multiple meanings and their origins are not always known to the individuals who adopt them.

In "Mother Laura Adorkor Kofi: The Female Marcus Garvey," historian Vibert White provides a vivid glimpse into the racial politics of 1920s Florida through the life of Laura Adorkor Kofi, a Ghanaian woman whose leadership and ideas constitute major contributions to black religious theology, black nationalism, and African suffrage. In a decade characterized by black unity and love, this story reveals the depth of the fissures within Florida's black communities, who were fighting for racial justice in "the fog of war."

Kofi attracted large followings in Florida and elsewhere because she provided a vision of Africa and a global dimension to black unity that was missing in the black nationalist movement, which had previously been led by African American and Caribbean men. She found herself in a complex web of power and politics and ultimately at odds with Marcus Garvey and the Universal Negro Improvement Association (UNIA), who had previously welcomed her contributions to the movement. With frictions reaching a boiling point in Miami, the UNIA directed the assassin's bullet that ended Kofi's life. Kofi's legacy lives on in the church and missionary movement that she founded. The Missionary African Universal Church has offered scores of African Americans Christian-based teachings infused with African ideas along with a clearly articulated political and social agenda. Kofi's story reminds us that there is not a singular African diaspora. Rather, there are numerous diasporas that form alliances and divisions in response to issues of race, power, and politics.

Andrew Warnes, a literary scholar, offers a critique of Zora Neale Hurston and her representations of barbecue in "Jerked Pig and Roast Hog: Barbecuing the Diaspora in the Writings of Zora Neale Hurston." Hurston's multiple versions of a barbecue scene provide evidence of her attempt to "Africanize" the history of barbeque. Although it stems from native Caribbean origins, Hurston uses barbeque as a literary device to draw connections between various diasporas that come into contact in Florida, as depicted in the 1937 novel *Their Eyes Were Watching God*. Analyzing southern cookbooks, Warnes concludes the widespread rewriting of the story of barbecue was influenced by the

genocide of native Caribbean cultures and the development of slavery. Warnes observes that Hurston's silence on the Indian contribution testifies to a view of the African diaspora in which blood purity is paramount. He suggests she tries to give "biological coherence" to the diaspora in "Africanizing" the foods, thus sidelining the hybridity so central to the concept of diaspora. Warnes asserts that the food in question is indeed evidence of the African diaspora in Florida but that it also evidences the Native American contribution. It points to the importance of interracial hybridity, so important in Africa's flowering throughout the Americas.

Hurston remains an icon in Florida, where there is both a museum and at least two festivals dedicated to the author who is most readily associated with the Harlem Renaissance. While Hurston's depictions of barbeque gloss over the Caribbean, Hurston focused much of her work on individuals living out African traditions in the Caribbean and the South. "Ade Rossman's *Zora Neale Hurston Series*: Living Africa under the Florida Sun" presents eight paintings, produced in 2007–2008 by Trinidadian Floridian artist Ade Rossman, which chronicle Hurston's life. The series, which was commissioned by the St. Lucie County Cultural Affairs Office in Fort Pierce, attests to the importance of Hurston in Florida. Rossman's representation of Hurston is not only visually compelling but also reveals what Hurston symbolizes to Floridians today and to the artist himself. In the brief essay that follows, Robin Poynor describes how Rossman's own history influenced this project. Rossman, who came to Florida via New York, was introduced to Africa through new lenses while moving through vibrant black communities that exist in both places. The artist presents Hurston as a monumental presence who becomes the "voice of the diaspora." In an interview with Poynor, the artist explained that through Hurston he recognized his personal connection to Africa and acknowledged how his family "lived Africa" in many ways.

The relationship between Florida's "southern roots" in northern Florida and its "Latin American/Caribbean roots" in southern Florida has been described as schizophrenic—the two parts are miles apart—both physically and culturally. In South Florida, large migrations of Cubans to Key West and Tampa (1868–1924) and to Miami (1959) were met with Haitians (1970) and Nicaraguans (1980s), among others, which added to the already present ethnic tensions in the state. Subsequently, South Florida's strong connection to the Caribbean has allowed for a mixing of racial, political, and social discourses, which are most pronounced in terms of its diverse religious practices. While Miami is often referred to as a Caribbean or Latin American city, its connections to Africa are deep and broad with large communities of Afro-Caribbean, African Americans, and more recently African people. The next section, "Connecting across the Caribbean," consists of three essays that deal with Afro-Caribbean religions in Miami: African-Christian syncretism in Lucumi, re-creations of

Abakuá ritual as folkloric celebration, and Pentecostal churches. This section demonstrates how religious practices adapt to and transform Florida, while still in dialogue with practitioners in the Caribbean and in Africa.

"Abakuá Communities in Florida: Members of the Cuban Brotherhood in Exile," by cultural historian Ivor Miller, follows a circuitous cultural migration from Africa to the Americas. Miller has written extensively about the male ritual association that originated in southwestern Cameroon and southeastern Nigeria. Its many variants in Africa go by different names (Ékpè, Ngbè, Mgbè), but for convenience's sake it is often referred to as the leopard society. Due to the transatlantic slave trade, the leopard society first appeared in Cuba (in Regla, Havana) in the 1830s, where it was reestablished as a mutual-aid society for men based on religion (Abakuá). While Miller has written extensively about the "Ékpè–Abakuá continuum," this essay moves his research further into North America. In the essay he argues that although Cuban Abakuá members have lived in Florida since the late nineteenth century as part of the larger community of Cuban exiles, Abakuá religion and its corresponding rituals were never established outside of Cuba. Thus, in Florida its history and traditions are honored, but religious ritual is not practiced. The leopard society exists in Florida in the memories of initiated Abakuá members as a reminder of Cuba, sometimes as symbols of blackness, and an identity that is tied to Africa. Performances of its masquerade and musical traditions are re-created in public celebrations, and visual artists in Miami and Key West draw heavily from the iconography associated with Abakuá material culture. This topic leads to more questions about what diaspora communities can or cannot take with them and confronts the desire of scholars to look for "authentic" religious experience while missing the bigger picture.

"Crowning the Orisha: A Lucumi Art in South Florida," by theologian Joseph Murphy, examines the metalwork "tool crowns" that adorn home altars for the Yoruba orisha in Miami. Identifying both commercial and fine art production of crowns, Murphy explains that the 1980 Mariel refugees and the 1986 reopening of visits to Cuba caused a renaissance of Lucumi arts in South Florida because it contributed to the importation of religious knowledge.

Murphy's research demonstrates how influences move in many directions. Orisa worship has origins in West Africa, was brought to Cuba as a result of the transatlantic slave trade, and was imported to Miami by exiles from the Cuban Revolution in 1959. Today, artistic offerings such as "tool crowns" are produced in South Florida and sent to other parts of the Americas as well as back to Yorubaland in West Africa. Murphy presents a complex analysis of crown symbolism and use, which blend and juxtapose multiple elements from contrasting cultural antecedents. While Murphy explains how Yoruba concepts and forms relate to crowns made in Miami, "African" aesthetics arrive within creole tradition that are built upon centuries of contact between Africa and Cuba, thus

raising more questions about how practitioners and scholars call Africa into being.

Terry Rey, a scholar of religious studies, examines the influence of Caribbean Pentecostalism on religious practice in South Florida in "The Spirit(s) of African Religion in Miami." While Afro-Cuban forms of religion are blossoming in Miami, Haitian immigrants in South Florida have not found it easy to practice Vodou, which involves the worship of African spirits. Rey describes how Pentecostal churches in Little Haiti reject African spirits but embrace the African concept of "soul force." Rey explains that "in Miami Haitian immigrants find that it is perfectly feasible to abandon the *spirits*, while forever tapping into the *spirit*, of African religion." The author follows this trend through various Pentecostal communities in Miami and points to the irony that Africa is embraced but not recalled or acknowledged. Returning to the culinary metaphor, this Afro-Floridian recipe may substitute some of the ingredients (replacing the spirits), but the African flavor remains. This is a firm reminder that African influences manifest in many ways, which is illustrated even more clearly in the next group of essays.

The final section, "(Re)Making Africa in Florida," includes five chapters that examine how the idea of Africa resonates within contemporary Florida as it is invoked in religious practices, sculpted in New Age sanctuaries, embraced by recent African immigrants, and reproduced for the tourist industry. In each case individuals are attempting to (re)make Africa in Florida through the replication of natural and built environments as well as the re-creation of performed rituals.

The first three essays deal with spiritual sites dedicated to the practice of Yoruba religion in rural, north-central Florida. The first essay is about the Ifalola compound as a built environment that is based upon Yoruba concepts of space. "Carver Baba Onabamiero Ogunleye and the Sacred Space of the Ifalola Compound," by art historian Robin Poynor and anthropologist Ade Ofunniyin, focuses on a self-taught artist and oriṣa worshiper and the sacred environment in Archer, which the artist has filled with his own sculptural forms. Sculptures and shrines serve to create linkages both physically and conceptually with the ancestors, the oriṣa, and fellow believers both in the United States and in the Nigerian homeland of the religion. This is a space in which "Yoruba Americans" (African Americans who have converted to Yoruba oriṣa veneration and who try to live a Yoruba lifestyle) can acknowledge their African roots and participate in an African-based religious experience, which is the subject of the next chapter.

Continuing the discussion about the Ifalola compound, Ade Ofunniyin describes the initiations of three African American women into the priesthood of the Yoruba religion at this same site in "Three *Iyawos*: A Transatlantic Òriṣà Initiation." Ofunniyin writes from the position of an insider, participant, and

practitioner. He describes the close ties that Yoruba Americans in the United States have with Yoruba in the Nigerian homeland. For instance, Chief Elé bùìbọn came to Florida from Nigeria to oversee the initiations described in this chapter. These ties are also maintained through pilgrimages to Nigeria. However, bringing religious specialists to perform rituals provides a sense of authenticity that serves to renew and refresh the Yoruba religious experience in Florida. While Ogunleye and others try to create an "authentic African experience" at the Ifalola compound, the next chapter describes Yoruba religious practice in another part of Central Florida that is fully accepting of ideas of changes that might occur as Yoruba religion adjusts to a new time and a new place.

Oluwo Philip Neimark (a babaláwo of Jewish descent) and his wife, Iyanifa Vassa (of Greek American descent), converted to the way of the orişa some thirty years ago. In the process they founded the Ifa Foundation of North America with the intention of providing for the spiritual and intellectual training of those who seek to follow the orişa. They also created a spiritual retreat, Ola Olu, in Central Florida, not too far from Disney (a different type of retreat). In "The Sacred Space of Ola Olu: A Neo-Yoruba Site near Crescent City, Florida," art historian Robin Poynor addresses visual forms connected with the Ifa Foundation, focusing on the rural orişa gardens created by Iyanifa Vassa. While the gardens are unique, they serve much as the collection of shrines once did in Yoruba family compounds in Africa, collectively representing the powers of the universe as manifested in the pantheon of orişa or Yoruba gods. The creation of the gardens, each dedicated to a specific energy, demonstrates the eclectic nature of the Ifa Foundation, which is firmly rooted in Yoruba theology while also embracing adaptations.

The two sacred sites discussed above (Ifalola and Ola Olu) exist in the same region of Florida and serve similar purposes. They also both incorporate objects from Africa, include built shrines and places of worship, bear Yoruba names, are involved in global networks, and are organized based on Yoruba concepts of space. And, in both cases, the founders were originally introduced to the religion through Cuban orişa practice, which they ultimately rejected. However, Ifafola is focused on an "authentic" tradition that depends upon using objects that have been consecrated in Nigeria or by Nigerians. In this community, traveling to Africa is also very important. At Ola Olu the practitioners prefer to get objects from Africa that they can consecrate in Florida, where they freely revise religious practices and ideas. And, they do not feel the need to visit Africa themselves. Worship of the orişa is thriving in Florida, but its connection to Africa varies widely.

In Florida, as in other parts of the United States, African rituals are also being performed by African immigrants in close-knit communities where masquerades and cultural dances are extremely popular. In "Igbo Masquerades in

the Sunshine State," art historian Amanda B. Carlson discusses Igbo organizations in Orlando, Miami, and Tampa and the masquerades that they have brought to Florida, which appear at parties, community events, and New Yam Festivals. This study adds a new chapter to the history of political and social organizations among the Igbo, both in Nigeria and the diaspora, and to the study of African masquerades in general. These performances constitute a new type of "diasporic masquerade" that has barely been addressed in scholarly research. The Igbo masquerades of Florida demonstrate how Igbo culture has remained dynamic and changing while still maintaining strong ties to the idea of a "homeland" in addition to developing a broad network in the diaspora. More attention to these "new African diasporas" will enrich our understanding of diaspora narratives with regard to an ongoing dialogue with Africa.

In order to reflect upon the scope of African experience in Florida, it is important to remember that Igbo peoples came to Florida long before this more recent wave of prosperous professionals. Numerous enslaved Africans, among them Igbo, came to Florida under much different circumstances. When considered together, it is a reminder of the sharp contrasts that appear in Florida history with regard to how Africans experienced "Florida" in addition to how Floridians have experienced "Africa." The next chapter is intended to highlight the extremes to which the idea of Africa has been represented and experienced.

"African Attractions: Florida Tourism Gone Wild," by Amanda B. Carlson, traces the history of tourist attractions with African themes that mix elements of botanical and zoological gardens with amusement park thrills. Carlson traces the progression of the "Africa theme" in Florida's tourism industry—prominently portrayed for well over sixty years—revealing shifting attitudes in complex narratives about Africa, nature, and global perspectives. Along with a discussion of hyperreality, this chapter also provides hyperlinks. For attractions that remain open, this chapter offers scannable QR Codes (Quick Response Codes) that allow the reader to easily go to the venue's website, which will reflect the current state of the attraction. Attractions continually change, especially in large amusement parks that want to attract repeat visitors with the lure of new rides and experiences. While these links are intended to allow the reader to reference these places, which are constantly in a state of change, it also signals another realm where Africa and Florida co-exist—the Internet. Within this historical sketch, the author considers why the African theme has been so popular and why it appears readily in Florida. What does this say about Florida's perception of Africa and popular perceptions of Florida?

While Carlson's essay is focused on representations of Africa in the twentieth and twenty-first centuries, it is crucial to remember that the individuals who have shaped Florida history have not been spared representations of Africa—both positive and negative—that are tied to complex systems of power.

Each of the chapters in this book recounts how Florida has been in constant dialogue with Africa, Africans, and images of Africa for the past five hundred years. If the idea of Africa is constantly in the making as individuals create and interpret Africa, these essays ultimately lead us to ask, How will we maneuver in a complex world where Africa can be found in the most unexpected places?

A Final Thought about Where America Ends

To the south, Florida dribbles into the Atlantic, reaching out to the Caribbean via a line of small islands known as the Florida Keys. Key West is the southernmost city in the continental United States, closer to Cuba (ninety miles away) than to Miami. Because of its location, it has been a beacon for Caribbean immigrants who have moved into and out of this region for centuries. Key West hosts a large population of people of African descent—African Americans, Afro-Bahamians, Afro-Cubans, and the Oyotunji/Yoruba Americans. Aside from Key West's many connections to African culture, its "loose" association with the United States recalls the porous nature of Florida's borders throughout history. Moreover, Florida's most southern citizens emit a creative spirit that encourages us to envision space "beyond geography" where local, regional, and global histories are encountered in new ways.

When the U.S. Border Patrol set up a checkpoint in 1982 in front of the Last Chance Saloon (Florida City, northern Keys), it created concern among locals. Rumors of a permanent immigration checkpoint triggered fear within the tourism industry that access to Key West would be complicated, threatening the livelihood of many Key West residents. From the perspective of concerned citizens in Key West, if the U.S. government was going to treat Florida City as a "border" to the United States, the implication is that everything to the south, including Key West, is a foreign country. As a form of protest, "Key West Mayor Dennis Wardlow seceded from the Union, declared war, surrendered, and demanded foreign aid. A unique battle was fought with stale Cuban bread; and, after one shot was fired, the Conch Republic was born on April 23, 1982. What resulted was a form of social and political activism grounded in serious issues rolled out in a humorous performative style that has been sustained over the course of thirty years. During the intervening years the U.S. never reacted to the secession, thereby establishing sovereignty for the Conch Republic under International Law Governing 'adverse possession between sovereign nations.'"[24]

For more than thirty years, the Conch Republic has playfully performed all of the trappings of an independent nation-state, which has resulted in bolstering tourism, the island's main source of revenue. While the Conch Republic appears to have emerged as a tourist attraction with the annual celebration of its independence, its origins are situated in political performance and activism

Secession near: Key Westers still asleep

**KATHY McCARTHY
and KAREN PAYNE**
Miami News Reporters

Last-minute talk of Key West's seceding from the United States and engaging the mother nation in all-out war was foiled by the fact that almost everyone in Margaritaville was still sleeping as the all-out declaration approached.

Tom Brown, the bartender at Sloppy Joe's, was mopping up his watering hole before heading over to Old Mallory Square for the noon secession of the continental United States' southernmost city, now renamed the Conch Republic.

"It sounds like fun," Brown said, "you ought to come down."

While Key Westers slept late — as usual — outsiders from as far away as San Diego tried to get in on the act.

"Everybody's going bananas," said City Commissioner Joe Balbontin, who has been named Defense Minister of Conch Republic. "We're getting calls from all over. The switchboard at City Hall has lit up like a clam bake. People think it's great."

Mayor Dennis Wardlow, named Prime Minister of Conch Republic, planned to hoist the new flag at noontime, and then immediately ask for a billion dollars in foreign aid from the U.S.A.

"A billion dollars to make up for the economic loss," huffed defense minister Balbontin.

Wardlow said his cabinet ministers — formerly

Flag of the Conch Republic

city council members — will debate a declaration of war against the United States.

"After they lift the roadblock, we'll surrender and then ask for foreign aid," Prime Minister Wardlow said.

Balbontin said "a tremendous amount" of people have volunteered for the Conch Militia, which could be under siege if the U.S. decides to contest the secession.

Please see KEY WEST, 11A

Flash! A late report direct from the border

ON THE CONCH REPUBLIC BORDER — Preparations for entering the sovereign nation of the Conch Republic began here today at the Last Chance Saloon.

It has changed its name to the Road Blocked Inn, and the guard post makes the federal roadblock look amateurish.

Signs have gone up, green card visas are for sale, bar habitues wearing Nazi helmets and carrying machetes and clubs stood at the roadside puzzling tourists and getting icy glares from the real roadblock across U.S. 1.

"This thing can work both ways," said bar owner Dale (Skeeter) Dryer. "If Key West is going to be treated like a foreign nation, we're willing to get into the damn act."

Signs lined the road outside the bar near the intersection of U.S. 1 and Card Sound Road. They say things like "Watch out for slow-moving refugees," "You are now entering North Haiti" and "Roadblock kits for sale."

It's all a gag, of course, but there's an underlying feeling of rage. As the noon secession neared, conchs continued to mobilize.

— John Keasler

Figure 1.6. Newspaper clipping (*Miami News*, April 23, 1982; flag originally in b/w, color added for effect) and Conch Republic passport. The *Miami News* announced Key West's threat to secede from the United States in 1982. The resulting Conch Republic began to issue passports for its citizens and diplomats, marking their legitimacy as an independent state. The Conch Republic flag now bears the apt slogan *We Seceded Where Others Failed*. Used with permission from the Conch Republic.

that draws attention to Key West's and, by association, Florida's tenuous relationship with mainland North America. The Conch Republic's continued relevance, beyond tourism, is based upon the fact that the contentious nature of borders (which define physical, political, and social spaces) is a defining feature of contemporary life. And in the wake of the recent Arab spring and the Occupy Movements, the Conch Republic's slogan has new meaning—"a people unafraid to stand up to government gone mad with power."

Since 1993 the Conch Republic has been issuing its own passports, and Conch Republic officials have reportedly used their Conch Republic Diplomatic Passport (fig. 1.6) to traverse legitimate international borders.[25] These transgressive acts were meant to validate the Conch Republic, but it also called into question the significance of borders. In the pre-9/11 era, these humorous tactics included formal interactions within state and federal government as well as with international diplomats. But no one was amused by this well-intentioned play in the weeks after September 11, 2001, when the FBI discovered that a "Mohamed Atta" had once applied for a Conch Republic passport. The events that occurred in 2001 dramatically changed how we think about borders and how we think about Florida, which was where some of the preparation and plans for 9/11 were carried out. There is no evidence that the owner of

that Conch Republic passport, which was purchased by someone in New York City years earlier, was associated with Mohamed Atta, the terrorist, although it was discovered that "the" Mohamed Atta did party in Key West while living in Florida and preparing for the attacks. While there is no concrete linkage, this tale provides cause for concern in this new era, which has been defined by the regulation of borders—which remain more idea than reality.

Like Key West, Florida has been a highly contested space. With ocean frontage on three sides, the borders of Florida appear somewhat "natural," making it easy to forget that the territory within its borders has been shaped by maneuvers fueled by power and agency that continue to this day. Florida has also held a powerful place in the popular imagination with regard to nineteenth-century romantic notions about "untouched" nature and the wild fantasy worlds of the twentieth century (cemented by Disney's Imagineers). In fact, the confluence of objects, ideas, and people engaged in the experience of Africa in Florida, which is not nearly exhausted by this one volume, is powerful if not overwhelming. It certainly requires a new way of looking, such as Gordon Bleach's concept of "double vision." And, if these new ways of seeing are to strengthen our understanding—as opposed to just making us "cross-eyed"—we need to embrace a new sense of cultural geography dependent upon looking beyond established categories of knowledge that separate the histories of Africans, Europeans, and Native Americans. The stories in this volume expand upon the standard view of the African experience in the United States, which is too frequently built around the narrative of the "deep south" and slavery, offering a far more multidimensional view of American history. Moreover, freeing Africa from a geographic location or even a distinct cultural tradition allows for a more meaningful discussion about Africa. Hence, we argue that Africa (as either a place or an idea) is entangled in many complex relationships whereby individuals in Florida situate themselves within a larger space in relation to the local, national, and transnational. The contributors to this book have walked along varied paths in order to explore a peninsula with porous borders—more at one with the world than a contained and separate entity. As we recognize the five hundredth anniversary of African presence in Florida, we honor all of the individuals who crossed the water. "[Their] story will sing forever deep, across water, beyond geography, into the lushness of history."[26]

Notes

Authors' note: The title for this chapter refers to Adrian Castro's poem "Cross the Water" (2001) in chapter 3. We were so inspired by the phrase "into the lushness of history" that this chapter begins and ends with these words.

1. While Juan González (Ponce) de León is believed to have been African, this has not been confirmed and is a subject for debate.

2. Hine and McLeod, *Crossing Boundaries,* xx.

3. The official state-sponsored celebration of this anniversary is called "Viva Florida 500," which was intended to celebrate Spanish heritage in Florida. The need to acknowledge the contributions of other ethnic groups has been articulated during the planning phase, but it remains to be seen how these political issues will manifest during the actual events.

4. Students who participated in this project include Jena Briggs, Mariela Genco, Laura Herrmann, Jocelyn Shoup Ghaznavi, Jan Hyatt-Zimmerman, Meredith Johnson, Susan Kelliher, Charlotte Lewis, Eric Laura, Janice McCaskill, Isabel Parra, Christina Spell, and Demetra Alexandrou Tsetsekas.

5. Dusheck, "Africa-America Split."

6. Landers, *Black Society in Spanish Florida*, 161.

7. U.S. Department of Commerce, U.S. Census Bureau, http://quickfacts.census.gov/qfd/states/12000.html (accessed August 12, 2012).

8. Cruz-Carretero, *The African Presence in México*, 50.

9. Ave, "Famous or Infamous?"

10. See Gilroy, *The Black Atlantic*.

11. See, for example, Mudimbe's *Invention of Africa* and *The Idea of Africa*.

12. In the second half of the twentieth century, the Bermuda Triangle (which touches Florida) captured the attention of scientists, the media, and the public due to the frequent and mysterious (and exaggerated) disappearance of ships and aircraft, which promoted a bizarre range of natural and supernatural explanations.

13. See Yelvington, "The Anthropology of Afro-Latin America and the Caribbean," for information on the development of anthropological approaches to the African diaspora.

14. Patterson and Kelley, "Unfinished Migrations," 26.

15. Ibid., 11.

16. Palmer, "Defining and Studying the Modern African Diaspora," 29.

17. Berlin, "From Creole to African," 254.

18. Brah, *Cartographies of Diaspora*, 208.

19. Spatial theory and cultural geography have been heavily influenced by the seminal works of Edward Soja (*Postmodern Geographies*) and Henri Lefebvre (*The Production of Space*). The distinction between Western and non-Western space is embedded in much of the scholarship on space-relations. See, for example, Kort, "Sacred/Profane," and Fu-Fiau, *Tying the Spiritual Knot*.

20. D. Woodward and Lewis, *Cartography*, 1.

21. Routon, "Unimaginable Homelands," 387.

22. Unpublished artist statement, courtesy of Gayle Zachmann.

23. Slave records in French territories have also been useful for documenting African ethnic identities, as demonstrated by Gwendolyn Midlo Hall's Louisiana; see http://www.ibiblio.org/laslave/introduction.php.

24. Website information (accessed March 30, 2012), http://www.conchrepublic.com/republic_position.htm.

25. Secretary General of the Conch Republic, Peter Anderson. www.conchrepublic.com.

26. Castro, "Cross the Water." See the entire poem in chapter 3 of this volume.

2

An Overview of Florida's Black Past

Nathaniel Millett

Florida's black past officially began shortly after Easter in 1513 when Juan Ponce de León's expedition from Puerto Rico landed near modern-day Cape Canaveral. Included in Ponce's expedition were two free Africans named Juan Garrido (see fig. 1.1) and Juan González (Ponce) de León.[1] Ponce's expedition to Florida was brief and unsuccessful, but the Spanish would return to Florida time and again, and every subsequent expedition or effort at settlement would include Africans or their descendants. Blacks would play a vital role in Florida's economy, culture, politics, and defenses during the First Spanish Period (1565–1763), the British Period (1763–84), the Second Spanish Period (1784–1821), and after American annexation in a process that continues today.

It is impossible to disentangle the history of blacks in Florida from the colony and state's broader history.[2] And like the broader history of the colony and state, Florida's black past defies easy generalization and is virtually unrecognizable to those who have been conditioned to think of American history as the linear story of westward expansion by Anglos that began at Jamestown or Plymouth and inevitably ended on the golden coast of the Pacific. As a Spanish (and briefly British) colonial possession, Florida was equally part of the southeastern borderlands, circum-Caribbean, and Atlantic world that was populated and influenced by various European and creole whites, Indians, and blacks from across Africa and the diaspora.[3] Colonial Florida was shaped by intense geopolitical pressures that emerged from the intersection of forces that were both long- and short-term as well as local, regional, and global, all of which the diverse populace had to contend with while attempting to create a viable society. Because of these factors, Florida's blacks played an unusually elevated and influential role within the colony's society when compared to many contemporary parts of the African diaspora and with Anglo America in particular.

The fortunes of Florida's blacks changed radically with the American acquisition of the colony and the rise of the plantation complex in Middle Florida. Much of the territory that became a state in 1845 quickly became an intimate part of the Old South as it was careening toward the Civil War. While Florida's black population exploded during this period, it was almost entirely as slaves who—while forming their own dynamic culture and contributing immeasurably to Florida's development—could only imagine the elevated status that had once been enjoyed by their colonial brethren. As was the case across the South, the Civil War and Reconstruction presented Florida's blacks with equal measures of hope and disappointment as the ultimate prize of freedom was largely tempered by the cruel ascent of Jim Crow. As Florida became a solid part of the New South, blacks were relegated to the status of second-class citizens who suffered legal and economic inequality in both rural and urban areas. Sadly, while Florida's population, landscape, and economy changed from that of a sleepy and sweltering state dominated by agriculture and dribs and drabs of tourism to one of the most populated, visited, modern, cosmopolitan, and economically prosperous states in the union, the status of its blacks remained largely unchanged. However, Florida would become a central battleground during the struggle over civil rights in what began the gradual march toward equality for African Americans. Built on this foundation, the modern black population of Florida is truly global in its makeup and outlook; plays a vital role in the state's economy, society, and culture; and, as was the case during the colonial period, represents an unusual variation of the African diaspora that is the consequence of the historical and contemporary realities of life in Florida for people of African descent.

Origins

The history of the earliest Afro-Floridians is rooted in the rise of the Atlantic world and late medieval Iberia's growing interaction with Africa.[4] Iberia's connections to Africa were multidimensional and included the centuries-long reconquest of the peninsula from the North African Moors as well as growing economic and diplomatic ties with numerous sub-Saharan African kingdoms. Just as Iberians, and the Portuguese in particular, could increasingly be found in fortified trading posts on the coasts of West Africa (in a process that was integral to the rise of the Atlantic slave trade and plantation complex), Africans and Afro-Iberians could be found in Spanish and Portuguese cities prior to the voyage of Columbus.[5] Not all, but many of these people were slaves who lived in the bustling port cities of the Spanish kingdoms and Portugal and had created a flourishing Afro-Iberian culture. Slavery was legal in the Iberian Peninsula and across the Mediterranean; however, enslavement was

far from limited to Africans, and it lacked the racial component that emerged with the rise of the Atlantic slave complex. Because of the numerous legal avenues toward freedom that were contained in Spanish slave law, which was codified in the thirteenth century, Iberia had a growing free black population. These people, who were usually born in Iberia, were among the first "Atlantic Creoles."[6] They were Christians who lived and worked in the cities as members of various Afro-Iberian communities and served as important human links between Europe and Africa.

Prior to 1492, both at home and abroad, the Iberian Peninsula was increasingly interconnected with Africa and Africans, which makes it unsurprising that both free and enslaved blacks were involved in Spanish missions of exploration to and conquest of the Americas. During the first generation or so of Spanish colonization, the vast majority of these blacks (whether slave or free) had lived in Spain prior to their arrival in the New World. Across the Americas, they performed jobs that ranged from the menial, dangerous, or disgusting to that of conquistadore (fig. 1.1). However, as the sixteenth century wore on and Spain's Atlantic empire began to take shape on top of a foundation of Aztec and Incan riches and the labor of millions of Indians, the enslavement of Africans, largely in imitation of Portuguese Brazil, became increasingly common.[7] This was the context of Juan Garrido's and Juan González (Ponce) de León's 1513 voyage to Florida as well as the broader Afro-Floridian experience for much of the Spanish colonial period.

For the next fifty years, the Spanish would send a series of ill-fated missions of exploration and settlement to Florida and the Southeast, which included blacks such as Juan Garrido and Juan González Ponce de León. Most prominent among these missions were Ponce's 1521 return voyage, which cost him his life at the tip of a Calusa's arrow; Lucas Vázquez de Ayllón's disastrous attempt to establish a permanent base in modern-day Georgia in 1526, which contained the first contingent of black slaves to arrive in North America; Cabeza de Vaca's mission to the Gulf Coast that began in 1528 and ended when a handful of survivors returned to the Spanish in 1536, among whom was an African slave named Estevan whose ability to learn Indian languages made him vital in efforts at communication with Indians; and Hernando de Soto's highly destructive march across the Southeast between 1539 and 1543, which was witnessed by numerous free and enslaved Africans.[8] Florida would not receive its first permanent Spanish settlement until the 1565 founding of St. Augustine. This was prompted by the encroachment of French Protestants in the area, by which point the region's Indians had begun to suffer dramatic population decline and the first signs of deep strains as a result of disease, violence, enslavement, and dislocation that had been wrought by the Spanish expeditions. Free and enslaved blacks were intimate witnesses and participants

in this process who brought their own cultural assumptions and chauvinisms while appearing to the Indians to be an indistinguishable feature of Spanish expansion and aggression.

For the next hundred years, the Spanish presence in Florida was largely limited to St. Augustine as a small number of Spaniards and an even smaller number of black slaves from Spain, Africa, and, increasingly, the Caribbean struggled to create a viable economy on the northern frontier of Spain's vast Atlantic empire. Records are scant from this period, but it is clear that life was difficult for the black and white colonists who struggled to build a city and carve farms and ranches from the harsh environment while living in fear of disease, hunger, Indian raids, and attacks by rival empires and pirates. However, combined with a number of legal and cultural advantages that were universally enjoyed by Spanish slaves, these circumstances would have allowed for various freedoms, as well as an elevated status for early Spanish Florida's slaves that would have been the envy of many slaves elsewhere in the Atlantic world. This was a precedent that would continue for the next 150 years as Spanish Florida failed to attract a large white population or develop a viable economy and instead remained a struggling outpost at the edge of empire that required a tremendous amount of interracial cooperation.

Imperial Rivalries

The 1670 founding of the English colony of Carolina was a watershed event in the history of the Southeast and Florida. Prior to this point, Spanish Florida had faced competition from imperial and Indian rivals, but the founding of Carolina (which was soon followed by a growing French presence along the Gulf Coast and in the lower Mississippi valley) transformed the region into a highly contested borderland in which two extreme and starkly contrasting versions of the English and Spanish Atlantic empires vied for control, with blacks serving as major actors. From Carolina's inception, its founders, many of whom were Barbadians who harbored deeply conservative attitudes toward race and a deep disdain for the Spanish empire, were committed to the expansion of African slavery, but initially they had to rely on an extensive Indian slave trade that deeply disrupted Native American societies in the Southeast.[9] By the dawn of the eighteenth century, rice had begun to immerge as a profitable staple crop that would be farmed in the narrow coastal strip known as the Lowcountry in South Carolina (and, after 1750, Georgia), which led to an explosion in the slave population of the Southeast.[10]

The Southeast soon became the scene of endless frontier warfare that was the product of imperial rivalries and the Indian slave trade. Blacks factored prominently into these geopolitical machinations as soldiers, captives, casualties, and traumatized witnesses. However, most importantly, blacks from

Anglo America began to flee to Spanish Florida in a process that would define the region for the next century and a half. In 1733, nearly forty years after the first Carolinian slaves had arrived in St. Augustine, Philip V granted freedom to all fugitive slaves who accepted Catholicism and worked for four years as public or state servants without compensation to be paid to their British masters. In 1740, the period of labor was dropped and fugitive slaves merely had to promise to become Catholic. Black fugitives, whether Catholic or not, were a sorely needed boost to Spanish Florida's anemic population, which had hit a rock bottom of less than a thousand Spaniards in 1713 at the conclusion of Queen Anne's War, and provided an invaluable source of labor and defense.[11] The former slaves had a much better life under the Spanish and played a vital role in the colony's society as they joined a growing free and enslaved black population. They were free to raise their families, marry whom they chose, earn a livelihood, and move freely among both blacks and whites. Word of the official and unofficial sanctuary to be found in Spanish Florida spread like wildfire through the slave quarters to the north in a process that Anglo settlers felt deeply undermined racial order and threatened their security. This was the root cause of the Stono Rebellion of 1739, which was the largest slave revolt in colonial America.[12]

As the eighteenth century wore on, two starkly different yet intimately intertwined and mutually reinforcing realities had emerged for blacks on either side of the Georgia-Florida border. To the north, the reality was one of brutal enslavement in the rice or indigo plantations in a highly oppressive and deeply racialized society. In Florida, blacks certainly did not enjoy full equality with their white neighbors, but even the enslaved and certainly the free lived in a fluid world of elevated status, extralegal rights, freedom of movement, economic opportunity, family rights, and military service.[13] The catch was that the colony continued to struggle along as the underfunded and undermanned periphery of Spain's empire in which life was difficult. The story of the free Black town of Gracia Real de Santa Teresa de Mose (Fort Mose for short), which was established in 1738 just outside St. Augustine, illustrates this reality[14] (fig. 2.1). Francisco Menéndez, a Mandinga, who was the leader of the black militia, was placed in charge of the settlement, which consisted largely of African and African American refugees from Carolina. The initial population probably totaled around one hundred men, women, and children. A number of the community's members had valuable skills, and the rest quickly took advantage of the fertile soil and abundance of game and fish in the area. A friar was assigned to the community and set about instructing and baptizing the population. Fort Mose served as a very public beacon of freedom across the Southeast that compared starkly with the status of slaves who were laboring on plantations to the north. It was also a powerful and symbolic military deterrent to Anglo aggression, as its male population was armed and trained

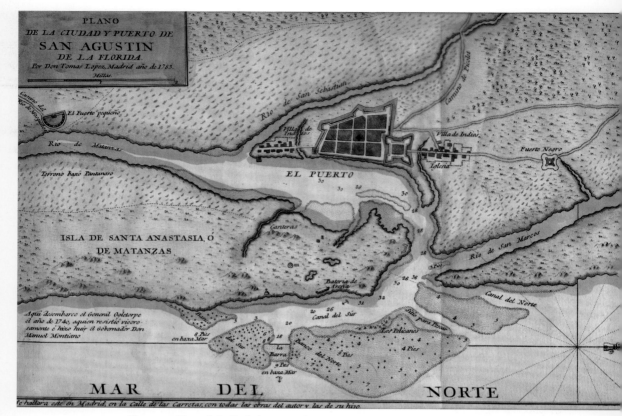

Figure 2.1. *Plano de la Ciudad y Puerto de San Agustin de la Florida* by Tomas Lopez. North America's first free Black town, Gracia Real de Santa Teresa de Mose (Fort Mose) was established in 1738 just north of St. Augustine. Although Oglethorpe destroyed the fort in 1740, it was reestablished in 1756. This 1763 map refers to it as *Fuerte Negro*. From the P. K. Yonge Library of Florida History, Department of Special and Area Studies Collections, George A. Smathers Libraries, University of Florida.

into a highly effective fighting force at a time when every Atlantic empire was reluctantly taking gradual steps to create organized black militias.[15] In 1739 Mose's militia was vital in repelling a British assault on St. Augustine, but at the cost of the town's destruction. Fort Mose was rebuilt in 1752 and continued to thrive until the 1763 transfer of Florida to the British, at which point its inhabitants moved to Cuba, as did many blacks living in Florida.

During the eighteenth century, the ethno-genesis of the Seminole Indians occurred in Florida as these Indians became a distinct people and their numbers and prosperity soared under the leadership of chiefs such as Cowkeeper, Payne, Micanopy, and Bowlegs.[16] The Seminoles of Florida, as well as other Indians of the Southeast, would become deeply entangled with blacks in a complicated series of relationships that greatly shaped the region's dynamics.[17] Many fugitive slaves decided to settle among the Seminoles, while others were "slaves" of the Seminoles who were acquired through purchase, theft, and

as rewards for service. However, life as a Seminole "slave" varied only marginally from life as an ally or associate. Both groups lived in autonomous villages with their own resources and were free to marry as they chose and raise their families as they saw fit. Periodically, if ever, the blacks were expected to deliver a token tribute of produce or livestock. Both groups of blacks intermarried with the Seminoles and attained positions of great importance, often as interpreters or advisers, and wielded a tremendous amount of influence within the broader community. The Seminoles and their black allies formed a truly Afro-Indian society that was a key ingredient in Spanish Florida, becoming a fully tripartite society in which Europeans, blacks, and Native Americans coexisted in a manner that was increasingly unimaginable in Anglo America, where the plantation complex was fully maturing and attitudes about race were hardening.[18]

British Florida

In 1763, as the result of the treaty that ended the Seven Years' War, Florida was transferred to Great Britain, and it looked as if this delicate world would soon come to an end. The colony was divided into two separate provinces of East and West Florida, which quickly developed a thriving plantation economy that was based on the model of the Lowcountry.[19] The result was a steady stream of planters and their slaves that rapidly transformed the physical and social landscape of Florida. Initially slaves were put to work in the difficult process of clearing the land. As time passed, slaves began to work on the cultivation of rice, cotton, sugar, naval stores, and the colony's most profitable crop, indigo. Plantations were particularly successful along the St. Marys and St. Johns Rivers in East Florida. West Florida never had as many slaves and specialized in the production of fur and timber. British Florida's creole and African slaves created a distinct culture and drove the colony's economy, but they lived in an oppressive and brutal slave regime that was virtually indistinguishable from that of the Lowcountry. However, slaves from Florida and further to the north continued to find sanctuary in the colony's vast interior as maroons (independent escaped slaves) or with the Seminole Indians.

The greatest number of slaves to flee their masters on both sides of the border did so during the tremendous upheaval caused by the American Revolution in Florida and the rest of the South.[20] Both Floridas remained loyal to Britain and became havens for refugee Loyalists and their slaves during and immediately after the Revolution. The population of East Florida swelled during the closing stages of the war before thousands of Loyalist slave owners, their slaves, and numerous blacks who had won their freedom by fighting against the Americans were evacuated. The evacuations following the 1784 Treaty of Paris, which returned Florida to Spain, were often confused and haphazard

with the majority of people heading to the Caribbean. Of the 11,285 slaves officially taken to British Florida, only 4,745 were accounted for after the evacuations.[21] The combination of the chaos and brutality of the American Revolution in the South, the evacuations, increased slave flight, and the participation of the Seminoles meant that the Floridas were in a shambles at the time of their return to Spain.

The Second Spanish Period

Upon the return of the provinces in 1784, the Spanish decided to keep the Floridas organized as the British had done. During the Second Spanish Period, West Florida was ruled by a military governor who oversaw a small multiracial population that included many slaves who were imported from across the circum-Caribbean and Africa.[22] West Florida traded with the Indians and developed a handful of farms, but it was always reliant on its close ties with Cuba and the rest of the Caribbean. The black population was overwhelmingly urban and enjoyed tremendous freedom of movement and elevated status. East Florida quickly became ethnically and racially diverse as settlers, workers, slaves, and Native Americans of nearly every description poured into the colony.[23] East Florida was more prosperous than West Florida, with a growing economy, and the population of St. Augustine was complemented by a moderately prosperous plantation economy, but it was equally dependent on its relationship with the Caribbean. Slaves and free people of color were vital to both the rural and urban economy of East Florida and reached their greatest numbers under Spanish rule during this period, forming the fullest and most dynamic Afro-Floridian community to date. Likewise, fugitive slaves continued to flee into the Floridas, but in 1790, at the urging of Thomas Jefferson, the Spanish ended the policy of official sanctuary. The most likely place to find sanctuary now was in the vast Seminole interior or with maroons.

The threat of racial disorder posed by the example of the Spanish Floridas combined with greed for land made the colonies tempting targets for American expansion at a time when the young United States was grappling with the subject of slavery and race as the institution expanded into the territory of the Louisiana Purchase.[24] In 1810 a large portion of West Florida was violently detached by American forces and proclaimed the "Republic of West Florida," and in 1812 the "Patriot Invasion" of East Florida began, which soon overlapped with the Creek War and War of 1812.[25] In each of these highly destructive and disruptive wars, East and West Florida relied on official and unofficial units of black soldiers for their defense, which, along with the elevated status of blacks within its society more generally, further antagonized Anglo Americans, who were steadfast in their belief that Florida had the potential to incite

a Haitian-style revolution. Nowhere was this more evident than in the story of the "Negro Fort."[26] The Negro Fort was North America's largest ever maroon community that formed at Prospect Bluff on the Apalachicola River on the border of East and West Florida between 1814 and 1816. The Negro Fort was the result of the War of 1812 and the actions of Colonel Edward Nicolls of the British Royal Marines, who had been instructed to recruit and train American slaves, as well as anti-American Indians, in order to launch raids across the Deep South. From his base at Pensacola and then, after Andrew Jackson's invasion of the city in November 1814, from a sturdy and imposing British-built fort at Prospect Bluff, Nicolls recruited and trained hundreds of slaves from East and West Florida, the Deep South, and Indian country. Nicolls was a radical antislavery advocate who instilled in his recruits a belief that they were fully human, equal to whites, and could overcome their artificially imposed condition before granting them the status of full British subjects and leaving them in charge of the heavily armed fort in May 1815. The maroon community continued to see itself as an all-black polity of British subjects and quickly formed a government, militia, thriving economy, trade links, and culture that, collectively, sought to move its inhabitants as far away from their prior condition of enslavement as possible. This was terrifying to white Americans and many southern Indians, who, in a massive joint military operation, destroyed the Negro Fort in July 1816, but not before the vast majority of the community's inhabitants had fled to a series of Seminole or maroon towns.

Over the course of the next year, cross-border tensions continued to mount as the Negro Fort's survivors reorganized themselves and, along with their Seminole allies, launched a series of raids against the encroaching American plantation complex. The result of this endemic violence was the First Seminole War (1817–18), in which the remnants of the Negro Fort, who were steadfast in their belief that they were British subjects, their Seminole allies, who believed they were formal allies of Great Britain, British advisers, and various black and Indian allies fought the American armed forces who were determined to end the centuries-long challenge to racial order that Florida posed to the Anglo plantation complex permanently.[27] The Americans were successful in defeating the black and Indian forces whose tattered remnants were pushed further south along the coast of Florida. In 1821 a large maroon community on the Manatee River known as Angola (near present-day Bradenton), which was populated by hundreds of blacks, including refugees from the Negro Fort, was destroyed by an American-sanctioned expedition of Creek Indians. Many of the survivors had to sail to the Bahamas and there established a series of free communities of which the largest was Nicholls Town, where they cultivated their rights as British subjects[28] (see Howard, chapter 7). It was also in 1821 that Spain handed the Floridas over to the United States. After one hundred

and fifty years Spain realized that it could no longer keep the Anglos at bay, and a haven of relative racial equality was now seriously undermined, but not entirely gone.

Antebellum Florida and the Civil War

In a cruel twist of fate, Andrew Jackson, the man whose repeated invasions of Spanish Florida played a decisive role in the American acquisition of the colonies, was appointed as territorial Florida's first governor. The next year Jackson handed over the reins of power to William DuVal, and Florida's legislature opened in the new capital of Tallahassee. Land was certainly cheap and plentiful in the territory, but Florida presented a number of obstacles that slowed and then shaped settlement. The swampy and sandy terrain, in which temperatures routinely soared to well over one hundred degrees, was a challenge, as was unreliable transportation. More importantly, Florida was home to at least twelve thousand blacks[29] and many Seminole Indians, all of whom were still deeply hostile to the United States. Many of Florida's blacks were slaves of masters who remained in Florida after the transfer, but many more were free and lived independently or with the Seminole Indians. Early territorial Florida continued to provide an unofficial yet deeply defensive sanctuary for former slaves and an intimidating prospect for potential slave owners.

The lure of available land was ultimately too much to resist, and Middle Florida (present-day Jackson, Gadsden, Leon, and Madison Counties) soon began to develop a thriving plantation complex in the swath of land between the Apalachicola and Suwannee Rivers.[30] Thousands of white settlers from the upper South poured into the region along with their families and extended kin networks. These migrants were committed to the expansion of plantation slavery and soon began the large-scale importation of slaves through the notorious and frequently heart-wrenching internal slave trade.[31] On units that ranged from small farms to large plantations, white masters oversaw black labor in the creation of a profitable cotton belt. Because of the insecurities and pressures that arose from the frontier conditions of Florida, its difficult environment, and the fear of slave resistance and Seminole Indians, Middle Florida passed a series of especially harsh slave codes and developed a culture that was deeply conservative, patriarchal, and violent.[32] In essence, Middle Florida became a microcosm of the more extreme tendencies of the antebellum cotton kingdom. This contrasted starkly with the situation in East and West Florida, where Spanish traditions persisted and free and enslaved blacks continued to enjoy degrees of elevated status. The experiences of Zephaniah Kingsley and his wife, Anna Madgigine Jai Kingsley, demonstrate the extent to which race relations were more fluid and dynamic outside of Middle Florida[33] (see chapter 10). Zephaniah Kingsley was a wealthy merchant, slave trader,

and planter who moved to Spanish East Florida in 1803 and soon became one of the province's leading citizens and plantation owners. Among his human property was his future wife, Anna, who was a native of Senegal. Anna would eventually be freed, and the two would wed and raise a free mixed-race family together at Fort George Island. Anna became a slave owner and successful planter in her own right. In 1835, troubled by the ascent of increasingly racist American laws and norms, Zephaniah moved most of his family and slaves (who became indentured servants) to Haiti, where he was joined by Anna three years later. Zephaniah died while traveling to New York in 1843, and soon afterward Anna was forced to return to Florida to protect her vast property in the courts against claims that her interracial marriage had no standing in American law. Eventually she was successful and ultimately lived out the rest of her years near modern-day Jacksonville until her death in 1870. The Kingsleys' relationship, family, and mobility and her career were only possible in East Florida, and this world was quickly vanishing.[34]

In 1823 the Seminoles reluctantly signed the Treaty of Moultrie Creek, which ceded the majority of their land in north-central Florida to the United States. They were moved into a reservation that dominated much of central and southern Florida. Blacks continued to play a major role in Seminole society as well as escape from their masters in East and Middle Florida, joining the Indians or autonomous maroons. As the result of the encroaching slave frontier and efforts to remove them to the West, the Seminoles and thousands of their black allies began a series of raids in 1835 that soon escalated into the Second Seminole War.[35] This brutal and highly destructive guerilla war laid waste to large sections of Middle Florida's plantation complex. By the time it ended in 1842, it had become America's longest and costliest "Indian" war. Much of the leadership, such as Abraham (fig. 2.2), had lived at the Negro Fort as young men, as had many of the soldiers, and the interests that they were protecting were black. The purpose of the war was to avoid removal and to protect the last vestiges of Florida as a sanctuary from the harsh and rigid realities of life dominated by the Anglo plantation complex.

With the defeat of the Seminoles and their black allies, the granting of statehood in 1845, and elevating prices of cotton, Florida's plantations and slave population expanded rapidly to the point where much of the state resembled the rest of the Deep South on the eve of the Civil War, but on a smaller scale and located squarely within a challenging physical environment. At the outbreak of the Civil War, Florida had the smallest total population of any state in the Confederacy at 140,000 inhabitants, of which 63,000 were black and enslaved.[36] The push for secession was led by the slave interests of Middle Florida, while West and, particularly, East Florida had sizable populations of Unionists. The Civil War was hard on white and black Floridians. The state's economy was severely disrupted, and an exceptionally high percentage of

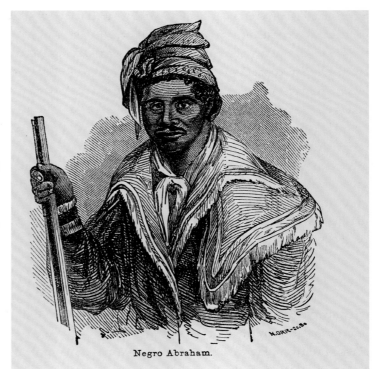

Figure 2.2. Abraham, a Black Seminole leader in the Second Seminole War, had lived at the Negro Fort near Apalachicola as a young man. Closely associated with the Seminole chief Micanopy, Abraham's town of Pilaklikaha was burned by Brigadier General Abraham Eustis. From the P. K. Yonge Library of Florida History, Department of Special and Area Studies Collections, George A. Smathers Libraries, University of Florida.

Negro Abraham.

its militarily able men spent the war fighting elsewhere in the South, which meant that the pressures on those left behind (slaves especially) were intense, and suffering was widespread. By 1862 the Union had conquered large portions of East and West Florida from where it launched raids into Middle Florida. The violence was compounded by slave flight and small pockets of intra-Floridian civil war as local Unionists and secessionists clashed. While thousands of slaves were able to flee their masters or were captured by the Union army (most famously, hundreds served in the Twenty-first, Thirty-third, and Thirty-fourth Regiments of the U.S. Colored Infantry), the vast majority of the state's slaves were relatively untouched by the war. This was because Middle Florida had gone to great lengths to insulate itself from the fighting. The Civil War ended for Florida on April 26, 1865, as Union soldiers fanned out across the state to inform the slaves that they were free, exactly three hundred years after the founding of St. Augustine.

At the end of the Civil War, Florida's landscape and economy were in tatters and its civilian government had collapsed. The central issues facing Florida were the status of the recently freed slaves, rebuilding its economy, and readmission to the Union.[37] Initially the Union government encouraged freed slaves to work on their former masters' plantations for a contracted wage that was overseen by the Freedmen's Bureau in the first step that would lead to

a century of sharecropping. Empowered by the Thirteenth, Fourteenth, and Fifteenth Amendments to the Constitution and, in principle, protected by the Union army, the Freedmen's Bureau, organizations such as the African Methodist Episcopal Church, as well as Republican and black elected officials, black Floridians enjoyed many newfound freedoms. However, an inefficient and deeply divided civilian government and Republican Party, waning northern public opinion, and the ascent of the Democrats at local and state level conspired against recently free blacks. More darkly, the rise of official and unofficial efforts to turn back the clock and erase the legal, political, and social gains won by blacks by angry whites and groups such as the Ku Klux Klan meant that a terrifying curtain of white supremacy was closing in on Florida that left blacks as marginalized second-class citizens who lived primarily in rural poverty.

The Rise of Jim Crow

In January 1877 Reconstruction officially ended in Florida. Contrary to the impression given by the appearance of northern millionaires and the first stirrings of tourism, Florida spent decades as a poor and underdeveloped rural state that existed in isolation from the rest of the South. Ruled by the Democratic Party, which was committed to segregation, the state's economy, infrastructure, schools, and services were lacking. This was especially the case for blacks, who were disenfranchised and the poorest section of society. By the turn of the century the last of Florida's black public officials had been squeezed out of office, leaving the black population with virtually no political voice. During the era of Jim Crow, black Floridians lived in constant fear of violence, and with good cause. Florida was home to a number of anti-black explosions in violence, such as 1923's horrifying Rosewood Massacre, and between 1882 and 1930 Florida had the highest per capita rate of lynching in the South.[38] The vanished dream of rights and equality, violence, segregation, and grinding poverty took a toll on black Floridians. However, these struggles were borne through community, kin, culture, and faith as well as resistance. In particular, black Floridians began slowly to organize themselves through mutual-aid lodges, churches, and civic organizations while the NAACP (which would soon be led by James Weldon Johnson, a native Floridian) engaged Florida with the national movement for racial equality. On January 1, 1919, black Floridians began openly to call on each other to pay their poll taxes and register to vote in what has been described as the "first statewide civil rights movement in U.S. history."[39] A. Philip Randolph, who founded the Brotherhood of Sleeping Car Porters in 1925 and became a national force in the labor movement and early civil rights movement, was a black Floridian who emerged from this early tradition of protest (fig. 2.3).

Figure 2.3. A. Philip Randolph, born in Crescent City, helped organize the Brotherhood of Sleeping Car Porters. He directed the August 28, 1963, March on Washington, D.C. Courtesy of State Archives of Florida, *Florida Memory*.

With the dawn of the Progressive Era, which gave way to the Roaring Twenties, Florida underwent major demographic, social, cultural, and economic changes. Advances in mass transportation and the introduction of the automobile made the state more accessible to the rest of the country. Many people moved to Florida in a trend that stimulated the housing industry and led to the growth of Florida's cities. Tourism built on its nineteenth-century foundation and became vital to Florida's economy and image. Agriculture expanded and diversified, with the cultivation of citrus fruits serving as a lucrative cash crop. In keeping with Progressive Era principles, Florida's government expanded education, services, and infrastructure. During this period of dynamic change and growth, blacks found a handful of new opportunities and occasional prosperity in the country or cities while modest black middle and professional classes (many of whom were educated at one of Florida's historically black colleges, such as Bethune-Cookman College, Edward Waters College, or Florida Agricultural and Mechanical College) expanded to a degree. However, even with the arrival of tens of thousands of northern migrants and the increased attention paid to Florida by the rest of the nation, which had the potential to take the edge off of the more excessive and public aspects of Jim Crow racism, Florida continued to be a deeply segregated society in which blacks were largely left on the outside looking in.

The Great Depression struck Florida harder than most parts of the nation and dealt a severe blow to the state's black population. Many of the New Deal agencies failed to treat black poverty, education, and health care as seriously as that of whites. One New Deal agency that played an important role in black life

and culture was the Federal Writers' Project, which recorded the memories of former slaves and employed a wave of historians and anthropologists to study Florida's black past. Zora Neale Hurston was black Florida's most famous and important beneficiary of the Federal Writers' Project. Florida, like the rest of the nation, was snapped out of the Great Depression by entry into World War II, which began a period of great change for the state and its black population. Florida's economy was jump-started by the construction or expansion of nearly two hundred military bases, infrastructure projects, and hugely increased industrial production. More than fifty-one thousand black Floridians served in the armed forces. This represented 10 percent of the state's entire black population, likewise, an equal percentage of Florida's entire contribution of soldiers to the war effort.[40] Even though the armed forces were still segregated, many blacks from Florida served with distinction or gave their lives while, back home, their friends and relatives played an integral role in the state's wartime economy that oftentimes required them to move to one of Florida's booming cities. The domestic front was also the scene of increased agitation for civil rights at a time when the persistence of Jim Crow seemed more cruel than usual. More specifically, the NAACP supported a series of court cases that supported black workers and challenged the state's exclusionary political process while traditional grassroots organizations and tactics expanded. By the end of the war, Jim Crow was showing its first substantial cracks in Florida.

The Civil Rights Movement

The explosion of postwar prosperity was particularly strong and transformative for Florida and served as the backdrop for the state and nation's civil rights movement. Building on decades of growing protest and organization, while taking its immediate cue from the 1954 Supreme Court decision in *Brown vs. Board of Education of Topeka,* Florida became a key battleground in the fight for legal, economic, and social equality for blacks. The NAACP and black Florida's considerable protest infrastructure of church groups, civic organizations, and mutual-aid lodges swelled in size as they were joined or aided by both blacks and whites from across the street and across the nation, who combined grassroots protest tactics with highly effective legal challenges to Jim Crow.[41] As was the case across the South, Florida's civil rights leaders recognized the importance of enfranchisement and, eventually, the election of black officials. By the early 1960s the number of registered black voters had begun to soar, and for the next twenty years its upward trajectory continued. In 1968, Joe Lang Kershaw became the first black Floridian elected to the state's legislature since Reconstruction, and in 1992 Carrie Meek, Corrine Brown, and Alcee Hastings were the first blacks to represent Florida in the House of Representatives.

In between these two landmarks, hundreds of blacks held elected and appointed positions in local, state, and national government, usually as Democrats. In 1964 Florida was thrust into the limelight of the national civil rights movement when Martin Luther King Jr. and the Southern Christian Leadership Conference selected St. Augustine—the North American city where slavery had first appeared—as a target city for desegregation. As King's special attention suggests, white Floridians were no different than their counterparts from across the South in resisting the end of Jim Crow even in the face of the Civil Rights Act of 1964 and the Voting Rights Act of 1965. The sad fact of the matter is that large-scale white resistance and the sheer power of history meant that, despite the huge political and legal advances made by blacks during this period, full integration and economic, social, and educational equality were still to be achieved.

Modern Florida

Despite the death of thousands of black Floridians in the Vietnam War, the death of Martin Luther King Jr., and the general economic and political malaise that had set in by the 1970s, blacks in Florida continued to build on the achievements of the civil rights era and strive for greater economic and political equality in a process that continues today. One of the most remarkable features of contemporary black Florida is the diversity of its origins. Prior to the 1960s the vast majority of black Floridians would have been descended from slaves that made their way to Middle Florida between 1821 and 1861 or, to a much smaller degree, from the slave and free black population that remained in East Florida after the departure of the Spanish. These blacks had deep roots in Florida and shared a common history of slavery, Civil War, Reconstruction, Jim Crow, and civil rights. They were overwhelmingly Protestant and defined by close-knit communities that had developed a culture that was southern, Floridian, and African. Beginning at the turn of the twentieth century with an influx of Bahamian immigrants, but exploding from the 1960s onward, Florida has witnessed the growth of the nation's most diverse and global black population. Many of the thousands of Cubans who have fled to Florida in various waves since 1959 were of African descent. They have been joined by tens of thousands of Haitian immigrants since the 1980s and many thousands of immigrants of African descent from Jamaica, Puerto Rico, and the Dominican Republic and elsewhere in the Caribbean. Many of Florida's immigrants from South American countries such as Brazil, Venezuela, and Colombia are of African descent, and the state, like much of the nation, has seen the arrival of many sub-Saharan African immigrants. Easily forgotten are black migrants from across the United States who have moved to Florida for sun, fun, oppor-

tunity, or retirement. Collectively, modern black Florida is a remarkable cross section of the African diaspora.

As has been the case for nearly half a millennium, modern black Floridians contribute immeasurably to the state's culture, society, and economy. Equally in keeping with Florida's history, its black population, while having much in common with African Americans from across the nation, is a distinct offshoot of the African diaspora. This is the result of Florida's location, climate, economy, and history, which means that the state is strongly influenced by the South, the nation, the Caribbean, Latin America, and the globe. Today—as was the case across hundreds of years of its history—Florida's blacks come from different corners of the globe, speak with different accents, belong to different faiths, and both retain and share distinct cultures while collectively shaping the character and fortunes of Florida.

Notes

1. Landers, *Black Society in Spanish Florida*, 11–12.

2. Gannon, *New History of Florida*, is an excellent collection of scholarly essays that cover most aspects of Florida's history from pre-contact to the present day. Gannon, *Florida: A Short History*, is the best single-volume treatment of Florida's past, while Tebeau, *A History of Florida*, and Douglas, *Florida: The Long Frontier*, are useful but older overviews that do not pay much attention to the experiences of blacks in Florida. The essays in Colburn and Landers, *The African American Heritage of Florida*, amount to the best single treatment of black life in Florida over the course of five hundred years, while Jones and McCarthy, *African Americans in Florida*, is a solid overview.

3. For recent overviews of the state of Atlantic history see Bailyn, *Atlantic History*, and Greene and Morgan, *Atlantic History*, and for the borderlands see Adelman and Aron, "From Borderlands to Borders." Two excellent and relevant edited collections that examine shifting identity and power are Canny and Pagden, *Colonial Identity in the Atlantic World*, and Daniels and Kennedy, *Negotiated Empires*. Hoffman, *Florida's Frontiers*, and Weber, *The Spanish Frontier*, are two masterful synthetic works that examine Florida's colonial past. Meinig, *The Shaping of America*, 172–93, 280–83, and 332–38, describes the geography of the region.

4. See Thornton, *Africa and Africans*, chaps. 1–4.

5. See Northrup, *Africa's Discovery of Europe*, chap. 1; Saunders, *A Social History of Black Slaves and Freedmen*; and Sweet, "The Iberian Roots of American Racist Thought."

6. The concept of the "Atlantic Creole" is the subject of Berlin, *Many Thousands Gone*.

7. Curtin, *The Rise and Fall of the Plantation Complex*, chaps. 4 and 5; and Klein, *African Slavery in Latin America and the Caribbean*, chaps. 1–3.

8. See Landers, *Black Society in Spanish Florida*, 12–15, and Weber, *The Spanish Frontier*, chap. 2, for the broader context of these missions.

9. Gallay, *The Indian Slave Trade*, is the newest and best account of the Indian slave trade in Carolina.

10. See Berlin, *Many Thousands Gone*, chap. 6; Edilson, *Plantation Enterprise in Colonial South Carolina*; Littlefield, *Rice and Slaves*; and Morgan, *Slave Counterpoint*, chaps. 1–4. By 1740 there were 39,000 slaves, of which two-thirds were from Africa. By 1800 there were 146,150 slaves in South Carolina. Morgan, *Slave Counterpoint*, 61.

11. Arnade, "Raids, Sieges, and International Wars," 108.

12. Wood, *Black Majority*, chap. 12. Mark Smith's *Stono* is an excellent combination of secondary and primary material on the Stono Rebellion. John Thornton has argued persuasively that many of the rebels were Kongolese and had been exposed to Iberian Portuguese Catholicism, which made the appeal of life in Spanish Florida unusually strong. Thornton, "African Dimensions of the Stono Rebellion." What is beyond a doubt is that the rebels were heading to Florida, making the events along the Stono River less of a slave rebellion, because they did not aim to destroy the institution in a violent confrontation; it was rather a calculated effort to escape slavery. Freedom was the rebels' goal, but it was freedom in Spanish Florida that they sought.

13. Classic works that compare Anglo and Spanish slavery include Tannenbaum, *Slave and Citizen;* Klein, *Slavery in the Americas*; and Degler, *Neither Black nor White*.

14. Deagan and MacMahon, *Fort Mose,* and Landers, "Gracia Real de Santa Teresa de Mose."

15. Voelz, *Slave and Soldier,* is an exhaustive treatment of slave soldiers in nearly every society in the Western Hemisphere. Brown and Morgan, *Arming Slaves,* is an excellent new volume that deals with the arming of slaves in numerous societies over recorded history.

16. See Covington, *The Seminoles of Florida*; Cline, *Notes on Colonial Indians and Communities in Florida*; J. L. Wright, *Creeks and Seminoles*; Sturtevant, "Creek into Seminole"; and Weisman, *Like Beads on a String.*

17. See Brooks, *Confounding the Color Line;* Bateman, "Africans and Indians"; Braund, "The Creek Indians, Blacks, and Slavery"; Carew, "United We Stand!"; Forbes, *Black Africans and Native Americans;* L. Foster, *Negro-Indian Relationships in the Southeast*; Kenny, "Exploring the Dynamics of Indian-Black Contact"; Littlefield, *Africans and Creeks*; Littlefield, *Africans and Seminoles*; Miles, *Ties That Bind*; Perdue, *Slavery and the Evolution of Cherokee Society*; Wright, *The Only Land They Knew*; and Wright, *Creeks and Seminoles*.

18. For example see W. Jordan, *White Over Black*, chaps. 8–15.

19. Mowat, *East Florida as a British Province*; Fabel, "British Rule in the Floridas"; Gold, *Borderland Empires in Transition*; Hoffman, *Florida's Frontiers*, chap. 9; and Schafer, *St. Augustine's British Years,* are among the few works that address British Florida. Berlin, *Many Thousands Gone*, chap. 6; Schafer, "Yellow Silk Ferret Tied around Their Wrists"; and the collected essays in Landers, *Colonial Plantations and Economy in Florida,* examine the largely understudied topic of slavery in British Florida.

20. The American Revolution in Florida is the subject of Proctor, *Eighteenth-Century Florida*; Wright, *Florida in the American Revolution*; and Starr, *Tories, Dons and Rebels*. Florida's experience during the American Revolution was much more like that described in O'Shaughnessy, *An Empire Divided.*

21. Riordan, "Seminole," 251. While a proportion of the nearly seven thousand slaves unaccounted for would have found freedom in the forests of Florida or among the area's Native American population, the vast majority's absence would have been due to death, having been sold into slavery, clerical errors, or other factors arising from the confusion of the time.

22. Coker and Ingles, *The Spanish Censuses of Pensacola*; Holmes, "West Florida, 1779–1821"; McAlister, "Pensacola during the Second Spanish Period"; and McGovern, *Colonial Pensacola.*

23. Coker and Parker, "The Second Spanish Period."

24. See Kastor, *The Nation's Crucible,* and Rothman, *Slave Country.*

25. For the Republic of West Florida see Bice, *The Original Lone Star Republic,* and Cox, *The West Florida Controversy*. Cusick, *The Other War of 1812,* is an excellent recent study of the Patriot War. An older but interesting account of the Patriot Invasion is Patrick, *Florida*

Fiasco. Stagg, *Borderlines in Borderlands,* is a good new work on this period and region. For the Creek War, or Red Stick War as it is often called, see Dowd, *A Spirited Resistance*, chap. 8, and Saunt, *A New Order of Things*, chap. 11.

26. See Millett, "Defining Freedom."

27. For the First Seminole War see Covington, *The Seminoles of Florida*; Missall and Missall, *Seminole Wars*; and Remini, *Andrew Jackson and His Indian Wars*, chap. 9.

28. For Angola see Canter Brown, "Tales of Angola"; and R. Howard, *Black Seminoles in the Bahamas,* for refugees that settled in the Bahamas.

29. Rivers, *Slavery in Florida*, 8.

30. Baptist, *Creating an Old South,* and Rivers, *Slavery in Florida,* are two excellent studies of slavery in antebellum Florida.

31. The essays in Johnson, *The Chattel Principle,* skillfully detail various aspects of the internal slave trade.

32. Rivers, *Slavery in Florida*, 9.

33. See Schafer, *Anna Madgigine Jai Kingsley.*

34. See chap. 10 in this volume for a treatment of Kingsley's descendants.

35. See Mahon, *History of the Second Seminole War,* and Missall and Missall, *The Seminole Wars.*

36. Canter Brown, "The Civil War, 1861–1865." For the Civil War in Florida more generally see Johns, *Florida during the Civil War;* Nulty, *Confederate Florida*; and Taylor, *Rebel Storehouse.*

37. See Richardson, *The Negro in the Reconstruction of Florida,* and Shofner, *Nor Is It Over Yet.*

38. P. Ortiz, "Florida and the Modern Civil Rights Movement," 224.

39. Ibid., 230.

40. Mormino, "World War II," 334–35.

41. See Button, *Blacks and Social Change*; Colburn, *Racial Change and Community Crisis*; Rymer, *American Beach*; and Winsboro, *Old South, New South, or Down South?*

3

Cross the Water

Adrian Castro

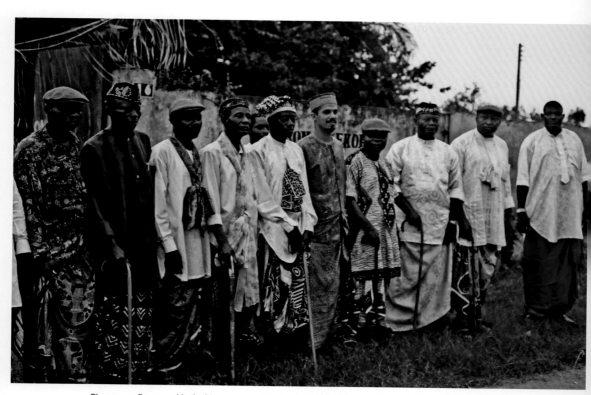

Figure 3.1. Poet and babaláwo Adrian Castro (*center*) with members of a leopard society lodge (Efe Ekpe Asibong Ekondo) in Calabar, Nigeria, 2001. Photo by Amanda B. Carlson.

What it was what she saw spotted
 prancing
 able to pounce
 among the lushness
 cascading trails trenching newly
 crossed water
in those days
 far before oyibo traded palm oil for salt
 gunpowder for slaves
before Asibong Ekondó erected ebony totem over red earth at Obutong
its friction echoed a guttural speech
 Neneké
In those days Neneké
spotted majestic motion
paws with rings of raffia
& neck with rings of raffia
tail ringing a sonorous call like
 nkaniká
 enticing fish to come & play
bell which oriented dispersed ones
 across water

When Ékpè dances at Uságare
she ripples across the bank
above Cross River
meandering like veins on young paws
 weaning
When Ékpè dances in Calabar
twigs of Akoko in hand
still above water
the right & left arm & leg crisscross
 alternating forward
 the shoulders inching forward
masked
 wide-eyed
 with staff sensing its way like whiskers
 hiding in deep ambush
 never divulging where her children sleep—
 while her children dress in secret cloth
 while the growl becomes visual
 while bonkó nshemiyá, the kushiyeremá
 the echo of goatskin on skin
 the growl becomes visual

Ékpè dances in Calabar
her children dressed in ukara cloth tied secretly
 (indigo dye written with abstract paws)

They arrive in hollowed trunk
drapped in palm fronds to signal sacred
The Ekóngo topped with brim hat
 pours libation of gin
 on the stone river bank
 while the growl becomes visual
 though they say across the water
Ékpè cannot cross water

Ékpè dances in Regla tambien
writing the body magic
 (nsibidi they say
if you can read gesture)
like Mokóngo used to
topped with brim hat
 drinking hot drink
a blade of raffia circling his neck
 gold tooth glistening—

The story will sing forever deep
 across water
 beyond geography
 into the lushness of history—
 Ngbe!

CALABAR-MIAMI, 2001

A Conversation about "Cross the Water"

Preliminary remarks by Amanda B. Carlson:

Adrian and I began this conversation in 2001 in Calabar, Nigeria, when I introduced him to members of the leopard society (Ékpè or Mgbè) and their masquerades that "speak" through gestures, movements, and symbols (fig. 3.1). Speech and silence offer limitless metaphors for describing the spiritual power of the leopard society, which is based upon a body of esoteric knowledge associated with graphic and performed scripts known as *nsibidi* (the reason I was in Nigeria). Much like *nsibidi* and leopard society rituals, Adrian's poetry "speaks" on many levels that can be appreciated by a general audience but also reveals deeper meanings for the multilingual or "initiated" reader.

"Cross the Water" is a poem that eloquently articulates many of the broader themes of this book with regard to ritual, movement, migration, history, and geography. The poem is about the leopard society, which exists in "two lands," so to speak. Literally, its lodges are active in the Cross River region in Nigeria and Cameroon as well as in Cuba (Abakuá), as a result of the transatlantic slave trade. Spiritually, it extends from the visible to the less visible worlds. Nigerians and Cubans continue to perform similar masquerades, which represent the mother of the leopard spirit—known as Ebonkó in Nigeria and Íreme in Cuba (fig. 3.2). Castro does not directly mention Florida in this particular poem, but in the interview below he states that Florida is "an implied connection, almost like the missing link of a triangle." In other words, Florida is part of the larger story that sits in silence.

Leopard society rituals cannot be practiced in Florida, yet its presence is visible to the public. In Florida, Cuban Abakuá initiates engage in cultural performances, and visual artists portray the Abakuá and its masquerades in a myriad of diverse styles (see Miller, chapter 16). For example, Leandro Soto has focused on the image of the Íreme masquerades in motion in numerous artworks. In figure 3.3, Soto captures the movement of the masquerade which he paints on an Indian silk saree, a sign of Soto's interest in multicultural references. This is perhaps why the artist was drawn to the imagery of Íreme in the first place, because of its historical and geographic reach.

Íreme is symbolic of more than cultural transference across space and time; it is also a symbol of the ability to travel in the spiritual realm. The image of Cuban Íreme masquerades performing within an African landscape (recognizably the Cross River region) is an iconic image that appears in paintings, as murals on Cuban lodges, and even as a tattoo (in a rare case). A Cuban Abakuá member kept a painted version of this image in his home in Miami (see fig.

1.5). Looking toward Cuba and Africa from Miami, these representations of ancestral connections become even more complex. It is from this place that Adrian Castro speaks.

CARLSON: Adrian, you are a man who wears many hats. What are they, and how do they relate?

CASTRO: I am a babaláwo, I am a writer, a poet, as well as an herbalist and acupuncturist, although most of my time is spent as babaláwo, writer, and herbalist.

CARLSON: Can you describe your work as a babaláwo?

CASTRO: Well, babaláwo are priests of the traditional Yoruba religion based on orishas (deities). Babaláwo are priests of Ifa, the codified system of verses and literature of the Yoruba of which a large portion of Yoruba society, culture, beliefs are formulated on. Ifa informs the essence of Yoruba culture, and babaláwo are experts in Ifa, in that literary corpus. It is not a book per se, but an oral tradition that existed in the olden days and even until now, although a lot of information about the subject has been published in books or on the internet. Some people keep information related to Ifa on their Blackberries, iPhones, and iPads; but the primary form of communication is still oral and disseminated from hand to hand to hand. So, babaláwo are theoretically experts in Ifa. I say "theoretically" because not all babaláwo are experts in Ifa. It takes, as you would imagine, many, many, many years of dedication and profound study to become versed in Ifa because it is so broad and extensive.

CARLSON: How long have you been a babaláwo?

CASTRO: Thirteen years.

CARLSON: Your poem "Cross the Water" is like a map. Can you explain where it takes us?

CASTRO: Well, the geography is a mental one, and it is a geography of memory. It begins in one place and literally travels across the water, across primarily the Atlantic Ocean, because it was the site and the theater for the transatlantic slave trade. "Cross the Water," the poem, starts with the idea of Ékpè in Cuba, where is it called Abakuá and where members believe that the fundamental spirit (of the leopard) cannot cross water. But it did cross water when it came from Nigeria to Cuba. Considering there are probably thousands of Abakuá here in Miami, I don't understand why it does not get done here, but, I don't know, maybe it is the will of the ancestors. So that is where the poem starts. It comes from this idea about what can and cannot cross water.

CARLSON: In this poem you combine personal observations and historical reflections. What is happening in "Cross the Water"? What is it about?

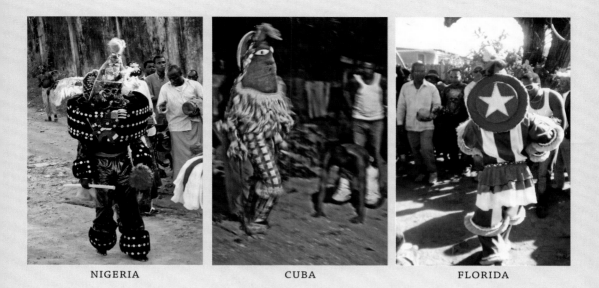

NIGERIA CUBA FLORIDA

Figure 3.2. Leopard society masquerades in Nigeria (Ebonkó), Cuba (Íreme), and Florida (Íreme). Leopard Societies in Africa have a many different types of masquerade, but the masquerade associated with the mother of the Leopard spirit is the only masquerade character that is performed in Cuban Abakuá tradition. Similarities in the costume, the dance style, and the music on both sides of the Atlantic are easily recognizable but not identical. *Left*: Ebonko masquerade, Calabar, Nigeria, 2009. Photo by Jordan Fenton. *Center*: Íreme masquerade in Havana, Cuba, 2000. Photo by Amanda B. Carlson. *Right*: Íreme in Miami, Florida, 2009. Courtesy of Angel Guerrero.

Figure 3.3. Leandro Soto, *Abacuá Saree I* (detail of figure 16.11), 2007. Indian ink on silk saree. Leandro Soto, who has worked in Florida, has produced a series of artworks that depict the Abakuá masquerades (Íreme) from Cuba with an emphasis on motion. Courtesy of the artist.

CASTRO: I am describing these to and fro contradictions that seem to be a common feature of the diaspora. There are many contradictions about the leopard society: It can't cross water, oh but it did. This is a secret society, but it's not. This is a society of brave gentlemen, of righteous men, but it's not.

And then it's about secret language, *nsibidi,* which, as you know, can be understood at different levels. This poem is also about secret language. It's about understanding something on different levels. If you know something about Ékpè, you, Amanda, will read this poem, will understand it on one level, because you have been there. You have smelled the smell; you have been to an Ékpè lodge; you have seen Ékpè. Someone who has never been to Calabar and knows very little about Ékpè will read it differently, even if they have a book on West African culture right next to them. This is what *nsibidi* is about; *nsibidi* looks like hieroglyphs to somebody who doesn't know what they are reading. So it's about secret knowledge, about secret language. This is a characteristic of all my poems.

CARLSON: The way in which you weave Ejagham, Spanish, and English words together reminds me of a secret language. Very few people would have access to all three.

In the poem you don't mention Florida. What does this poem have to do with Florida besides the fact you wrote it from Miami? Are there any relevant connections?

CASTRO: It's an implied connection, almost like the missing link of a triangle. It's like the hypotenuse is missing in our right-angle triangle. You have Africa and Cuba, and the hypotenuse, being Florida, is missing. But it's not missing, because there are so many Abakuá members in the United States and in Florida specifically. Yet it's not established in the religious sense.

CARLSON: Throughout out all of your poetry there is an underlying theme of transmigration that speaks to life in Florida, to your own family history, or even your own movement between the Caribbean, Florida, and Africa. Is it fair to say that this poem is about those themes and is part of a larger exploration of those spaces?

CASTRO: This poem is from my second book, *Wise Fish,* which is precisely about that. Why are fish wise? Well, they are wise because they have witnessed these transmigrations and since they have witnessed the transatlantic slave trade and the whole process of the African diaspora from Africa to the Caribbean, from the Caribbean to Florida. The whole process has taken place primarily by water. And how many people have actually perished in those waters? Fish have seen this, they have witnessed it. Thus, they are wise.

CARLSON: Can you give me a brief summary of your three books?

CASTRO: Well the three books are almost a trilogy. *Cantos to Blood and Honey* (1997) is about transmigration, emigration. It is about the clash of cultures and what happens when all of these people mix together, specifically about

Latinos coming into the U.S. This book has sixteen cantos, and each of those cantos is dedicated to one of the orishas that are commonly worshipped in this diaspora. *Wise Fish* (2005) takes place mostly in the Caribbean. Many of the poems have to do with leaving Africa and coming to the Caribbean. Here are a lot of poems about the Caribbean itself, and a lot of poems dealing with "Now we are in the Caribbean, what do we do now?" If *Cantos* takes place in the United States, *Wise Fish* takes place in the Caribbean, and then *Handling Destiny* (2009) goes back to Africa.

In *Handling Destiny* there are sixteen poems. Each one is dedicated to the sixteen major *odu-ifa* of the Ifa literary corpus. The first 16 *odu* called *agba odu* or 16 *meji* is where all the other 240 spring from, so there are 16 of them and there is a poem to each of the *mejis*. So in the first book was a poem of each orisha, and in this one there is a poem to each *meji*, because it is the *meji* that gave birth to the orishas. *Meji* means "two."

CARLSON: When you perform "Cross the Water," when you invoke the words, you imbue it with a certain power and energy that is not present on the printed page. Would you prefer that this poem be read or performed?

CASTRO: It could be both; again it's a different way of understanding it. If you listen to it several times, it's one way, especially if you're listening to it from me, because I pronounce it *mmmbe*. It's part of the rhythm. It's because the rhythm is not only a sound; for me rhythm is also the rhythm of the thought of the mind, how the thought happens.

I have an interesting anecdote about reading this poem. In fall 2009 I went to Seattle to teach a workshop. I was there for a week, and I did a reading as well with Chris Abani. He's a very good friend of mine; he's Igbo. He's not Ékpè, but his family comes from an area that has something similar, they call it by a slightly different name. So, in honor of us reading together and in honor of him, I read this poem. And as I started to read the poem, I started calling Ékpè like they do in Calabar when doing a libation. Wouldn't you know the power went out in the building—the theater went black! People thought it was on purpose! The sound guy later told me that everything went dead—everything! And they were recording the evening, and that part was not recorded.

CARLSON: That goes to show you the power of those calls.

CASTRO: There you go. So it is necessary to read it out loud at times. But, people can also read it and reread it. They will understand it on a different level from someone who hears it.

CARLSON: How many times have you been to Africa, and why do you go?

CASTRO: Five times, mostly for cultural enrichment, cultural education, and spiritual knowledge and education. I don't go for tourism.

CARLSON: So it helps develop your professional skills as a poet and as a babaláwo?

CASTRO: Yes, all of it, because to me, it's just one thing.

CARLSON: How have your experiences in Africa informed your poetry?

CASTRO: To a large degree. That's what *Handling Destiny* is about. A lot of those poems take place in Nigeria or come from that experience.

CARLSON: They are based on your experiences of that place?

CASTRO: In Nigeria, right. I don't think I could have written "Cross the Water" without having gone to Calabar, I don't think I could have possibly written that.

CARLSON: It seems to me that this is part of a complex exploration of your experience as a babaláwo and a poet that engages with conversations with other poets, religious specialists, practitioners. Your poetry seems to be involved with multiple conversations, even in historical conversations. Elsewhere, you have explained that you write in a rhythmic Afro-Caribbean tradition pioneered by Nicolás Guillén and Luis Palos Matos. How so?

CASTRO: Guillén was Cuban, and Matos was Puerto Rican. They were the first poets to write with an Afro style and with an Afro topic in poetry in the Caribbean in the 1930s and 1940s. Guillén went all the way to the late 1970s and early 1980s; he was the poster boy for the revolution in Cuba. Matos died in the early 1960s, already in Puerto Rico. But they were the first to be doing this. One of Matos's poem starts "tum tum de pasa y griferias, Y otros parajeros tum tumes, Bo chin che de negreria . . ." A lot of rhythm . . . a lot of that is untranslatable because there are a lot of Puerto Ricanisms.

CARLSON: What are the ingredients that inform and inspire *Wise Fish*? Is it that same Afro-Caribbean tradition?

CASTRO: I give a shout-out to Guillén and Matos because those are the people who pioneered that style of writing in the Caribbean.

CARLSON: You are writing at a different time than Guillén and Matos. How do you think your work is different from theirs?

CASTRO: Primarily, because I lived it and they didn't. Guillén and Matos were not orishas people—Matos was an upper-class white Puerto Rican, but he was interested in and sympathetic toward these things and captured the feeling of it. Nicolás Guillén was black, poor, but was a staunch communist and atheist. So the main difference is that I live this culture and religion. All that I write about is part of my being. I live it every day. As soon as I hang up with you I'm calling Nigeria. I'm calling Baba Oshitola. I have to have a long conversation with him. This morning I greeted Ifa, I cast Ifa for my upcoming trip, I marked *ebo,* so I have to do *ebo*—an elaborate ceremony. I have to go buy a goat, several pigeons. That's how I live, these people never did that. That is the main difference.

4

Gordon Bleach

A Portfolio

Gordon Bleach

Figure 4.1. Artist Gordon Bleach: born 1953 (Zimbabwe/Rhodesia), died 1999 (Gainesville, Florida). Photo by Barbara Jo Revelle. Courtesy of Gayle Zachmann.

In the *Mote Series* [*eMotive Vision Series*], medical photographs of the artist's left and right retinas are transformed into a cartographic landscape across which fragments of archival evidence are digitally layered. The voyeuristic corpus addresses various "exotic" terrains, all historically exposed to view through exploration and/or tourism: Zimbabwe and Florida.

Spurred by William Bartram's travel descriptions of Florida, the poet Samuel Taylor Coleridge amalgamated four exotic sites, including amongst them Florida's freshwater springs, for his fictional Xanadu in "Kubla Khan." Overlaid on the blue water colors of the retinas are an idyllic postcard view of Florida vegetation and, surfacing below, an image of Fort Mose, mislabeled "Maze." This was the first-ever African American fort, located near St. Augustine, Florida, since sunk into the river estuary. *Mote* puns here on the fort's moat and on the misreading of its name—memory losses, necessary resurrections. These forgettings are a part of Florida's history to be flushed out, a spectral past to percolate to the surface.

Gordon Bleach

NASA's rover shown up as a speck-like mote gleaming on Mars, beaming highlights from the red planet of energy and war. Questionable exploration rights are encoded in the word rover, which refers in one of its incarnations to piracy (perhaps to NASA's surprise). The voyeuristic spectacle of the mission is foregrounded through CNN image-feed, as is the analogy between the electro-visual processing of rover signals and the brain's processing of information from retina via the blind spot. The news flash from Mars and the red-eye from camera-flashed retinas, or from animals caught in car headlights, are brought into uneasy conjunction.

Gordon Bleach

Figure 4.2. Gordon Bleach, from the *eMotive Vision Series* (*left to right*): *Xanadu, Florida; rover, Mars; gomo Zimbabwe I; sinkhole, Rosewood.* Computer-generated digital prints, 1997. Courtesy of Gayle Zachmann.

In the Shona language, a gomo ("gaw-maw") is a mountain and a Zimbabwe is a walled city. After independence in 1980, Zimbabwe references both the nation's name and a specific historical site: Great Zimbabwe. Poised on gomos, this indigenous construction dates from ca. 12 AD and was the center for a large city-state. Through various fantastic fictions, the ruined site became a lure for European gold seekers and colonists in the late nineteenth century; intruders who charted maps such as the one reproduced. Retinal veins now stand in for economic and cultural flows in and out of Africa; hence the smelting area as mote and the Great Zimbabwe image on the $50 banknote over the upper blind spot.

Gordon Bleach

Figure 4.3.
Gordon
Bleach, from
the *eMotive
Vision Series*:
link, Saint
(*left*) and
*Status Sport,
Oil Resis-
tant* (*right*).
Computer-
generated
digital prints,
1997. Cour-
tesy of Gayle
Zachmann.

A 1762 map of Saint Augustine, the oldest continuously settled town in North America, shows a line of four segregated towns: two Indian, separated by the main Fort, and, at the top of this line, the "negroe fort"—actually Fort Mose, shown in "Xanadu, Florida." Green hues suggest both the estuarine water and, when taken together with the veins and flat backdrop, give a sense of a (cultural) petri dish experiment. Also imaged (from around 1890—founding of Miami, and coinciden- tally, of Rhodesia) are Lake Okeechobee and the Everglades (natural purity) over the right retina and the Miami River (decay, deception) as mote below the left. The Miami River— squat, squalid, and barely noticeable—is a vital conduit for legal and other traffic to Cuba, Haiti, the Gulf, and back into the USA.

Gordon Bleach

Daga ("darga") is a rust-red clay soil in Zim- babwe, and here its color grounds freedom- fighter boot print patterns. These are taken from an identification card used during the civil war in the 1970s by Rhodesian Security forces. The barefoot image is a bizarre feature of the card. Boot titles include "MARS" and "Status Sport Oil Resistant." The delicate vision (of past and future) at the bottom is of Great Zimbabwe, taken with the artist's toy camera in 1994; a wartime image of a trap covered with branches lies at the top. Camouflage and civil war: unearthed and unearthly histories with unaccountable costs.

Gordon Bleach

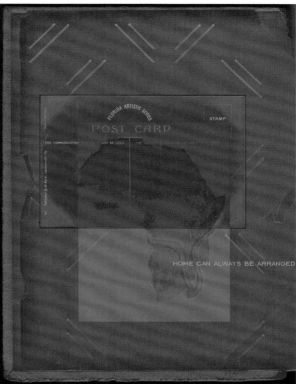

The gHostcards are constructed on the backdrop of an old Florida postcard and an album page in which the card was found, tracing negotiations of home from "Umtali, Southern Rhodesia" via its renaming as "Mutare, Zimbabwe," to "Gainesville, Florida." The remarks to the Italian architect Aldo Rossi invoke the question of European building on the foreign ground of Florida—particularly germane to Rossi, as he has done exactly that. The questions concern the rights to build, and quote spurious artifacts from ⁵CRYPT as part of the dialogue concerning this artist's "settling" in Florida.

Gordon Bleach

Figure 4.4. Gordon Bleach, from the *gHostcard Series*: *gHostcard Rossi Arches* (*left*) and *Home can always be arranged* (*right*). Computer-generated digital prints, 1998–99. Courtesy of Gayle Zachmann.

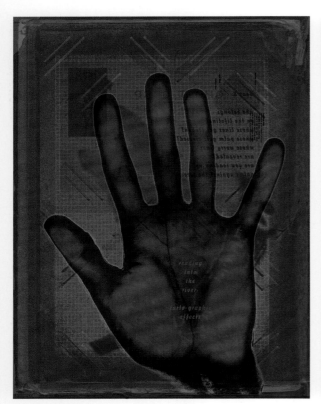

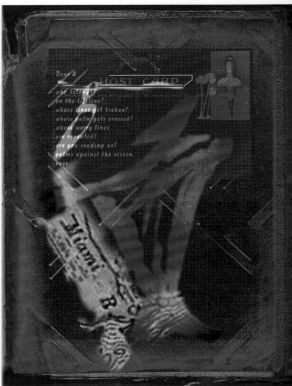

Figure 4.5. Gordon Bleach, from the *gHostcard Series*: Untitled. Computer-generated digital print, 1998–99. Courtesy of Gayle Zachmann.

The gHostcards pun on "Coast Guard" as well as "postcard" and draw too from Jacques Derrida's philosophical postings to Socrates, Freud, and others in *The Post Card*. The gHostcards are a personal inquiry into ways to divine the meaning of place in a time of itinerancy; of forced migration and widespread inequality. The gHostcards shown here are based on the Miami River area. Here, the river is treated in various ways: its shape is analyzed by a cyber-palmist on the WWWeb [World Wide Web]; the cards are inserted into album pages that pose questions as to alien/native status (UFOs, Haitians, manatees, etc.).

Gordon Bleach

Gordon Bleach

Home Can Always Be Arranged

Amanda B. Carlson

While teaching at University of Florida, Gordon Bleach (1953–99; b. Rhodesia/ Zimbabwe) created a rich and complex body of artistic work, including a significant number of prints that reference southern Africa (his former home) and Florida (his home from 1996 to 1999).[1] Meaning within these artworks is as layered as the digital editing and photographic techniques used to create them. The artist endlessly manipulated and reused layers of images and text in constant dialogue with theorists, artists, the art-historical canon, the photographic process, and with each other.[2] Bleach's unique perspective as a white African living in Florida—where Africa was constantly invoked in ways that both included and excluded him—led to a complex exploration of how individuals define themselves within spaces/places. This work presents a personal, bodily, and sensory experience of location that maps the circuitous relationships between Africa and Florida.

Bleach was at the forefront of thinking about digital processes within visual art at a time when digital imaging technologies were just becoming more readily available. His intellect along with his training as an artist, art historian, and mathematician enabled him to grasp the enormous potential of new technologies for exploring larger theoretical questions (grounded in postcolonialism and poststructuralism) that hinged on the relationship between word and image. His scholarship and artwork focus on the role of visual representation within colonial/imperialist histories and their legacies. Bleach embraced concepts associated with poststructuralism that destabilized meaning and emphasized the role of self-perception in the process of interpreting meaning (which for Bleach existed within the tension between text and photographic image). New digital technologies allowed Bleach to layer references to himself (or, the self) in details that can be obvious or hidden in a political act of interrogating an archive and asserting his own power over meaning.

Bleach likens Florida to Africa as a place of exotic appeal similarly marked by a history of black bodies in search of freedom. Africa and Florida are both places that were once populated by colonies with populations of settlers, that have been represented through romantic notions of nature, and that were connected via the transatlantic slave trade. In addition, each place has become a fetish for postcolonial fantasy whereby Africa and Florida continue to be imagined as sites of adventure and conquest. The artist explained,

> I have come to speculate on how contemporary southern Africa mirrors, with two-way distortions, certain configurations in Florida. . . . Southern Africa is inconceivable without an awareness of History writ large: Namibia, Botswana, South Africa have each walked uneasily to post- and/or neo-colonial statehood. One might claim that their late-breaking newness put them behind the times (of European independences) and ahead of the rules (more postcolonial than the USA, where Native American governance of the nation is not even a horizon of possibility).[3]

Drawing upon the comparison between nineteenth-century Florida (a symbol of freedom and oppression in America) and twentieth-century Africa (a symbol of freedom and oppression with reference to colonialism),[4] Bleach complicates our understanding of both places. A small sample of his work from the *eMotive Vision Series* (figs. 4.2 and 4.3) and the *gHostcard Series* (figs. 4.4 and 4.5) illustrates how the artist engages with Africa and Florida in relationship to landscapes, the body, the archive, and cartography.[5]

The title of the *eMotive Vision Series* is based on the expression "mote in your eye," which refers to a speck or obstruction that can create a weakness or a blind spot as well as a reflection of light.[6] In this series, each digital print includes a doubled image of the artist's retina—the part of the eye (technically, its blind spot) that captures information through light and transmits it to the brain. The artist explained, "oriented vertically with the left below and right above, the pairing carries Latin connotations from sinister to dexter and a sense of the past rising to the future. In the figure-eight overlap, there is a sense of stereo targeting or crossed eyes; of a turn taken in a spotlit arena."[7] The doubled retina (or "seeing double") could refer to disruption of clear sight or the doubling of its strength. It suggests both. As a metaphor strewn with linguistic allusions, it refers to the transmission and disruption of information in the eye and the camera just as it alludes to ideological visions and blind spots.

In each image the eye glows in a state of colorful illumination with wiry veins traversing the surface like rivers on a map with traces of images that suggest places stained by imperialist histories (in Florida and Zimbabwe, and even on Mars) motivated (or mote-ivated) by greed for power and wealth. For example, in *Xanadu, Florida* (fig. 4.2 far left, also known as *Blue Mote*), Bleach

combines the image of his doubled retina saturated in blue with the words "Xanadu, Florida, and mote" and a map of Fort Mose—the earliest settlement of free blacks in the United States.[8] Bleach appropriates a map (ca. 1752) in which Fort Mose is mislabeled "Fort Maze," a historical inaccuracy that promotes confusion.[9] Mazes, which can be linked to mathematical theory, are visual or experiential challenges that require us to find routes or pathways. In a sense, Bleach is creating a maze of references to the past in which Fort Mose is juxtaposed with "Xanadu," highlighting the tension between history and fantasy. "Xanadu" is a place of fantasy that is linked to Florida history. Bleach is referencing Samuel Taylor Coleridge's poem "Kubla Khan; or, A Vision in a Dream: A Fragment," which was published in 1816. While the poet is describing the palace of a Chinese emperor in "Xanadu," some scholars believe the description to be inspired in part by William Bartram's eighteenth-century travel accounts of north-central Florida.[10] The well-known section of Coleridge's poem reads:

In Xanadu did Kubla Khan
A stately pleasure-dome decree:
Where Alph, the sacred river, ran
Through caverns measureless to man
Down to a sunless sea.

Bartram, an eighteenth-century naturalist, described Florida as a "primitive" paradise that evoked a return to simpler times. Florida is frequently imagined as an exotic retreat from civilization or everyday life; and, the same is true of Africa. While Bartram's image of Florida as an Eden has continued into the present, it is quite the opposite of the image of the "dark continent" that developed in the nineteenth century whereby Africa is imagined as dangerous and savage. Nonetheless, both places suffered from similar discomforts associated with impenetrable vegetation amid sweltering heat, humidity, and mosquitoes. The positive gloss on Florida's tropical wilderness obviously benefited from the fact that the peninsula was physically attached to North America, which was bathed in a frontier mentality that idealized nature in the spirit of manifest destiny. Similar environments in Africa were described far less favorably. These negative perceptions carry on today, even though history tells us about the many accomplishments of cultures and civilizations on the African continent in the past and present.

In *rover, Mars* (fig. 4.2 second from left, also known as *Red Mote*), the words "MOTING, mote, Rover, Mars" are laid over glowing crimson retinas, symbolizing "the red, canal-veined planet of energy and war."[11] The Mars rover was an unmanned mission. The rover replaced the human body; or if thought of in another way, it became a technological extension of the human body in the exploration of yet another imperial space, which was being charted or mapped.

The blood-red color (along with the cartographic quality of the blood vessels) adds to the work's numerous references to the involvement of the body in the ways that we come to understand a location—or in this case, the absence or extension of the body.

A vintage postcard from Florida is the starting point for the *gHostcard Series*, which playfully incorporates the words "ghost" and "host" in the title (in reference to something that has been previously occupied by another body). The artist also plays with the term "coast guard" as a reference to protecting coastal boundaries. Unlike the glowing saturated colors of the *eMotive Vision Series*, these works were printed on Arches watercolor paper in order to resemble the matte finish of a vintage postcard but also to reference the history of Arches paper, which was used on such notable projects as Napoleon's *The Description of Egypt* (1807)—another reference by Bleach to imperialist conquest and occupation. The *gHostcard Series* also alludes to a famous text by Jacques Derrida, *The Post Card: From Socrates to Freud and Beyond* (1987), and the philosopher's concept of "arche-writing" (writing is only an account of the original meaning; it cannot be definitive in the present). Once again comingling poststructuralist theory (heavily dependent upon linguistics) and postcolonial theory (grounded in social and the political history), Bleach relies upon Derrida's proposition that the meaning is not only fleeting in linguistic representations but also in terms of the body and the perceptual.[12]

In the process of tracing his own connection to "Africa" and "Florida," Bleach creates artworks in which the meaning of place is always fleeting or transforming. In figure 4.4, the artist overlaid the words "HOME CAN ALWAYS BE ARRANGED" across a red outline of the Florida peninsula. The line that represents Florida is a mark that originates from the artist's own "life line," which he captured by scanning the bottom of his hand for a cyber "palm reading." Unlike the fingerprint, which is used to identify individuals, the life line is used to predict an individual's future. Continuously merging body and map, the artist's hand (the mark of the artist) is also equated with topography; the line becomes the Miami River (see fig. 4.5). Working at a time when new technologies such as digital photography fueled fears that "the artist's hand" would either disappear or irrevocably erase any reference to reality and truth, Bleach demonstrates the potential for both outcomes. If home can always be arranged (as the title of the artwork claims), places, much like images, are not fixed—neither are Africa and Florida. From this point of departure (origin or arche), Bleach taps into an expansive iconography that alludes to the location (or, dislocation) of the artist in relation to "home" and engages past, present, and future. Home is intangible and fleeting, but that is not to say that it does not exist.

Notes

Author's note: Thank you to Gayle Zachmann for sharing Gordon Bleach's work and for commenting on this essay. This essay also benefited from Shannen Hill's insightful feedback.

1. This body of work is an extension of the artist's Ph.D. dissertation, "Visions of Access: Africa Bound and Staged 1880–1940" (SUNY Binghamton, 2000). Although not included in the dissertation, these artworks are clearly "cut from the same fabric."

2. Bleach's loudest conversation is with Jacques Derrida, visible in the artist's choice of images (architecture, postcards, the self; all major themes in Derrida's writing). Moreover, Derrida's concepts of "the trace," "arche-writing," "spacing," in addition to his views on social and political "justice," clearly resonate within Bleach's work on Africa and Florida.

3. Quote is from an artist's statement that appeared online (in part) at "Olu Oguibe's Guest of the Week" in 1996 as "Docking Maneuvres: Florida and Southern Africa." It was then republished by Oguibe in *NKA: Journal of Contemporary African* in 2000 after the artist's death.

4. Rowe, *The Idea of Florida*, 24.

5. Bleach's other significant projects dealing with Africa-Florida comparisons include the *eratuM-Xanadu Series*, several installations, and the unfinished *Delta Series*.

6. The term "mote" has more recently described a node in a sensory system, such as the eye or a digital camera—the "tools" that the artist uses to make this artwork.

7. Gordon Bleach, unpublished artist's statement, which was prepared for the exhibition "Afromedi@rt," Museum of Ethnography, Vienna, Austria (1998). Courtesy of Gayle Zachmann.

8. The title of each work is embedded in the images in a standard form (phrase comma phrase).

9. This map belongs to the St. Augustine Historical Society and is reproduced in Deagan and MacMahon, *Fort Mose*, 34.

10. For a discussion of Bartram, Florida, and "Xanadu," see J. K. Wright, "From 'Kubla Khan' to Florida," and Ulmer et al., "Imaging Florida."

11. Bleach quoted in Oguibe, *Crossing: Time.Space.Movement*, 24.

12. Reynolds, "Derrida Arche-writing."

PART II

Seeking Freedom in and out of Florida

Slaves and Maroons

5

African Ethnic Groups in Colonial Florida

Jane Landers

It is a little-remarked fact that African history began in Florida five hundred years ago, when the free West African Juan Garrido joined Juan Ponce de León's 1513 exploratory expedition, more than a century before "20 and odd" African slaves were debarked in Jamestown. Garrido had already participated in the Spanish conquests of Hispaniola and Puerto Rico before he reached La Florida, and although his exact ethnicity is never given in Spanish records, given his early arrival in the Americas we might assume that he belonged to one of the diverse groups living near the Senegal and Gambia Rivers—the Mandingas, Wolof, Fulani, or Sereer. Garrido spent time in Lisbon and Seville before sailing to the New World and was considered *ladino*, meaning that he spoke Spanish and had converted to Christianity. Other Africans, named and unnamed, followed Garrido to Florida in subsequent Spanish expeditions, but no significant numbers of Africans settled in Florida until Cuba's captain general, Pedro Menéndez de Avilés, imported African slaves from that island to do the backbreaking work of establishing a new colony at St. Augustine.[1]

North America as a whole received only about 5 percent of the approximately twelve million Africans forced into the Atlantic slave trade, and historians who study the ethnic origins of Africans in the Americas focus, instead, on Brazil, the British Caribbean, and Cuba, which received the largest African populations.[2] Even with a greater African-born population to study, however, determining ethnic origins with any certainty is a difficult and much debated research problem. Despite the challenge, the task is worth attempting. One would not be satisfied with a history of Europeans in the New World that made no effort to distinguish among Irish, Italian, and Greek populations, for example. Recognizing that African history in the Americas deserves the same specificity, historians are now beginning the effort to identify which African ethnic groups entered the Americas when, in what numbers, and into what

geopolitical, economic, and cultural settings. This chapter explores what is currently known about the African ethnic groups that helped shape Florida and invites consideration of the cultural implications.[3]

Few enslaved Africans entered Florida during the first Spanish tenure in Florida (1565–1763), and most were either *criollos* born in other parts of the Spanish Americas or *ladinos*, like Garrido. But fortunately for scholars, Spanish administrators and clerics, unlike their counterparts in English, Dutch, and French colonies, paid attention to the ethnicity of those African-born people living among them, which they recorded as *nación* or *casta*. Priests took seriously the responsibility of instructing any newly arrived Africans in the basic precepts of Christianity, and as they catechized, baptized, married, and buried Africans in Florida they recorded their ethnicity in parish registers. A survey of 113 church marriages performed in St. Augustine during the first Spanish period which involved at least one black partner shows that Congos were the most numerous ethnic group registered, with forty-eight individuals marrying.[4] This is not surprising given that from 1580 to 1640 Spain and Portugal were one kingdom and Spain, thus, gained access to Portugal's slave-trading factories in western Central Africa.[5]

Linda Heywood and John Thornton argue that although West Africans were also swept into the Atlantic slave trade, most of the slaves shipped to the English colonies of North America and the Caribbean came from western Central Africa and were of Kongo/Angola origins. They argue that many were "Atlantic Creoles" who had at least had nominal acquaintance with Christianity and European culture.[6] When English colonists from Barbados established Charles Town in 1670, their African slaves soon learned of the Spanish Catholic colony just "ten days journey" southward and began trying to get there. English accounts state that some of their African slaves spoke Portuguese and that some of the runaways to Florida bore names such as Gran Domingo.[7] Some, thus, may have already been baptized Catholics. Others claimed to want conversion into the "True Faith." Upon deliberation, the Spanish monarch and his counselors ruled in 1693 that all slaves running from Protestant colonies should be freed and granted religious sanctuary in Catholic Florida. Word of the fugitives' reception in St. Augustine spread quickly through South Carolina, generating bitter complaints among planters and additional southward escapes by their slaves.[8]

By 1738 the numbers of runaways reaching Florida had grown to approximately one hundred, of distinct ethnic and linguistic backgrounds, and the Spanish governor decided to establish the freed Africans in a town of their own called Gracia Real de Santa Teresa de Mose, two miles north of the Spanish city of St. Augustine (see fig. 2.1). The leader of the new settlement and captain of its militia, Francisco Menéndez, was a Mandinga from the Senegambian region, but others of the Carolina refugees at Mose identified themselves

Figure 5.1. The handcrafted St. Christopher's medal discovered at Fort Mose might have been read in more than one way. St. Christopher was the patron of travelers, so the image of the saint carrying the child Jesus on his shoulders across the water could be seen as a patron for Africans who had crossed the Atlantic against their will or who had waded through Carolina and Georgia swamps to freedom in Florida. At the same time, the imagery on the reverse side could be interpreted as a variation on the Kongolese cosmogram depicting the cycle of life and the movement from the world of the living to the world of the dead. Both could express anticipation for one day crossing the watery divide separating the living and the dead to be reunited with African ancestors. Courtesy of the Florida Museum of Natural History.

as belonging to the Congo nation. Some gave added descriptors, like Pedro Graxales, sergeant of the Mose militia, who identified himself as a Congo-Solongo, a people who lived near the Congo River. Graxales was married to a slave woman of the Carabalí nation, from what is today southeastern Nigeria. The couple chose Congo godparents for their children, and Graxales also served as a godfather to other Congos at Mose, such as the former slave Tomás Chrisóstomo. Chrisóstomo married a Congo woman, Ana María Ronquillo, and on her death he married a second, María Francisca Solana, with whom he made his home at Mose.[9] These choices may have reflected a preference for endogamy, or simply the fact that Congos were most numerous in the colony.[10] In their parish registries, Florida's priests noted that some Congos had undergone previous Catholic baptisms in Africa and that even as they learned Spanish, some of them still prayed and blessed themselves in their native language of Kikongo, a Bantu language that functioned as a sort of lingua franca throughout large areas of western Central Africa.[11]

Even within a carefully practiced Catholicism one might glimpse other African cultural retentions in the material record. Archaeologists directed by Kathleen Deagan of the Florida Museum of Natural History excavated segments of rosaries at Mose, as well as a handcrafted St. Christopher's medal (fig. 5.1). The shiny, circular pendant might itself be read as a metaphor for a

Kongo cosmogram, but its surface imagery carries a fascinating dual allusion. St. Christopher—depicted, staff in hand, carrying Jesus on his shoulders over the water—was certainly an appropriate patron for Africans, some of whom would have been African Catholics, who had crossed the Atlantic against their will and escaped the dangers of swamps and patrollers on their way to Florida from Carolina.[12] The image might also be read, however, as a possible reference to the Kongolese expectation that they would someday cross the watery divide separating the living and the dead and be reunited with long-lost African ancestors.[13]

Tax records also provide insights into the ethnicity of Africans in Florida. As in other Spanish colonies, slave owners in Florida were required to register purchases and pay a tax on their slave imports. Slavers legally imported only 204 slaves into Florida from 1752 to 1763, but these slaves represented a surprising variety of ethnic nations. Like the ecclesiastical documents, these records show that persons described as Congo formed the largest single African ethnic group in Spanish Florida. Criollos ranked second, with Mandingas close behind followed by Carabalís and Gold Coast slaves (from modern-day Ghana). The Congo, Mandinga, and Carabalí nations were also heavily represented in Cuba at the same time, but the Florida tax lists also document the presence of less commonly encountered groups such as the Ibo (Igbo), Coromante, Susu, Wolof, Peul, Gangá, Bara, Besi, Dudrian, Mondongo, Bambara, Limba, Moyo, and Pati, among others.[14]

Tax officials recorded the imported slave's apparent age, stated nation, and physical appearance—including information on color, detailed scarification patterns, body, face, eye, nose, and ear shape, and any visible deformities. They assigned each slave a name and, on the basis of age, primarily, but also on physical size, declared the slave either a whole *pieza* (a Spanish term usually reserved for adult males but often assigned to robust adolescents as well), two-thirds, one-half, or one-third a *pieza*. The owner then paid the required duty—which was set at thirty-three pesos, three *reales* for one *pieza*. This may have been an incentive to introduce younger slaves (or to claim them as younger), for 123 of the 204 slaves from the tax register of 1752 were recorded as one-third *pieza*. The final act of the registration was to brand the slave with an "RF," usually on the left shoulder, as proof that the royal duty had been paid and the slave was legally registered. It is unclear who actually did the branding, but officials in Spanish Florida burned even the youngest slave listed, the five-year-old Mandinga girl whom they named Melchora. Some of the numerous children registered showed signs of abuse, such as broken noses. Ten-year-old Antonio, of the Musinbata nation, had a "very broken" nose. Nine-year-old Vizente, of the Mozindi nation, had a broken nose and had already been branded before with an "R" and a crown over the right nipple. Eighteen-year-old Thorivio, of the Mungundu nation, also already bore the "R" and crown brand over his

Figure 5.2. Bance (Bense) Island in the Sierra Leone River. Richard Oswald imported hundreds of slaves directly from his slaving factory on Bance Island in the middle of the Sierra Leone River. Although Oswald lived in England, he owned an indigo, rice, and sugar plantation located at the site of today's Ormond Beach, Florida. Courtesy of The Mariners' Museum, Newport News, VA.

right nipple.[15] David Eltis and David Richardson noted that western Central Africa always sent greater proportions of children into the trade than other regions did and that the proportion of enslaved children transported from all African provenances more than tripled from the seventeenth to the nineteenth centuries. This small sample supports that finding.[16]

Florida became even more African during the British occupation of Florida (1763–84), as incoming planter/slave traders from Carolina and Georgia imported thousands of slaves directly from Africa to work the large rice and indigo plantations they established in Florida. Sixty-six percent of the slaves on Governor James Grant's model plantation, for example, were "new Negroes." Richard Oswald imported hundreds of slaves directly from his slaving factory on Bance Island in the middle of the Sierra Leone River (fig. 5.2). Planters James Penman, Robert Bissett, and William Mackdougall formed a trading company that also shipped slaves from Africa to British Florida. Henry Laurens of Charleston and John Graham of Savannah also supplied many African slaves to Florida. One contemporary estimated that as many as one thousand African slaves were imported into Florida in 1771 alone, a peak year of the Africa/Florida trade. As a result, the labor force in British East Florida came to be predominantly black and African-born. British Florida planters generally described their slaves as being from Gambia, the Windward, Grain, Gold, and Guinea Coasts of West Africa, and from Angola. Less frequently they identified their slaves by specific "nations" such as the Sulundie or Igbo (Iboe), from what is today southeast Nigeria.[17]

Spain recovered Florida from the British in 1784 and five years later inaugurated a new free-trade policy for slaves to help stimulate the colony's economy. Perhaps uncertain of Florida's future, traders imported only small numbers of

slaves at first, and we have little information as to their origins. In 1800 Savannah merchant John Nightingale imported fifty Africans of unknown ethnicity on the brigantine *Ida* and sold most of them individually or in small groups to Spanish planters living along the St. Johns and St. Marys Rivers.[18] The Panton, Leslie & Company, which already had ships, Caribbean connections, goods, and credit, began to introduce slaves into Florida.[19] In 1802 the company's agent, William Lawrence, imported 114 African slaves, and although we cannot be certain of their origins, Lawrence, like other Florida slave traders, had contacts on the Rio Pongo and it is likely these slaves came from that region.[20] Fernando de la Maza Arredondo, head of the Havana-based company Arredondo and Son, succeeded Panton, Leslie & Company as contractor for the Florida Indian trade. In this capacity he sold the government trade goods distributed annually to the allied Indians, and this relationship may have facilitated his entry into Florida's slave trade. In 1802 Arredondo's son, Juan, managed the sale of forty-five Africans imported into Florida by Captain Nathaniel Phillip on the goleta *Betsy*. These slaves, too, probably originated from the Rio Pongo.[21]

Independent traders also saw the potential in the Florida slave trade. In 1802 Captain William Northrup imported 117 slaves from the Bahia de San Carlos, Sierra Leone, on the *James*. Later the same year, William Cook imported a cargo of thirty-nine slaves whom he had purchased in "Guinea" (the generic term denoting West Africa). Spanish officials described Cook's slaves as "being each of a distinct casta," and he may have collected them in small lots, as many independent traders did, in multiple stops along the African coast. Royal officials inspecting the slaves, as required prior to sale, had difficulty questioning the polyglot group. The public interpreter, Don Miguel Ysnardy, passed down the line of Cook's thirty-nine slaves, asking questions in several European languages, but the captives only responded to English, answering "yes" to everything, "without understanding," as if coached. African interpreters next attempted to interrogate the captives and passed down the line asking questions in their own native languages. Only seven of the thirty-nine slaves could communicate with the black interpreters; the rest spoke unknown languages. Those slaves who could communicate confirmed that they set out from the coast of Guinea in a large ship, landed at another port (probably Havana), and were then loaded onto the schooner *Cristiana,* on which they were being interviewed. After the physician examined them and declared that the slaves were healthy, Florida authorities gave Cook permission to unload and sell them.[22]

Over time, the pace and scope of African slave imports into Florida increased, and by the early nineteenth century the colony boasted some very large plantations with sizable slave populations of diverse ethnicities. The Scottish merchant and slave trader Zephaniah Kingsley moved to St. Augustine

from Charleston in 1803 with approximately sixty-four "new African negroes," some of whom he had personally brought from an unidentified port on the African coast. In 1804 Kingsley brought in another twenty-five "new" Africans via St. Thomas on his own goleta, *El Laurel,* and in 1806 he introduced three females from Havana who the interpreter testified "by their answers, all other signs and actions, and their crude manners clearly manifest that they are *bozales*" (unacculturated Africans). Kingsley's large workforce of Africans included, among others, Wolof and Susu from Senegambia, Sereer from the Rio Pongo, and Igbo from modern-day Nigeria. In 1806 Kingsley also imported sixteen slaves from Zanzibar on the East African coast. Kingsley depended upon his Wolof wife, Ana Madgigine Jai, from modern-day Senegal, to manage his multi-ethnic slaves and his multiple enterprises in Florida while he was abroad, and she did so with great success.[23]

In 1808 the U.S. congressional embargo of the slave trade took effect, and slavers who had previously sailed to Charleston or Savannah headed, instead, to Florida.[24] The Spanish government welcomed the taxes and industry that came with the slave trade and made it easy for newcomers to move into the colony and the trade. In 1810, Scottish slave trader John Fraser petitioned the Spanish government for, and received, hundreds of acres along the St. Marys River.[25] After Fraser moved to Florida, his African wife, Fenda, filled the couple's warehouses or baracoons at Bangra on the Rio Pongo with slaves purchased from native chiefs such as Mongo Barkey, chief of Bashia Branch, and Mongo Besenty, chief of Bahia, "Principal Merchants of the Rio Pongo."[26] The 370 Africans who produced the rice and cotton crops on Fraser's Greenfield and Roundabout plantations in Florida were imported from his own slave pens. Fenda and Fraser's factors on the Rio Pongo did a brisk business with Florida. In April 1810, Fraser's captain, Francisco Ferreyra, imported 126 Africans from the Rio Pongo into Florida aboard the *Aguila de San Agustin.*[27] The following July, James Cashen sailed into Fernandina with another twenty-eight slaves from the Rio Pongo, and in December another of Fraser's captains, Bartolomé Mestre, imported 140 Africans from the Rio Pongo on the *Joana.*[28] In August 1810, after a round-trip voyage of ten months, Arredondo and Son imported 174 African slaves on the frigate *Sevilla.* Despite high mortality rates on that voyage, the firm must have found the Florida slave trade lucrative, for the following year it imported 343 African slaves on the *Doña Juana.* Once again, although the company charged a medic's wages and medicines to expenses, 103 slaves, or almost a third of the shipment, died on the voyage.[29]

The slave trade to Florida was facilitated in 1811 when Joseph Hibberson and brothers Henry and Philip Robert Yonge organized the slave-trading firm of Hibberson and Yonge and on land granted by the Spanish government built a wharf and warehouse at the port of Fernandina on Amelia Island.[30] Three ships registered to Hibberson and Yonge and three registered to Henry Yonge

sailed regularly in and out of that port, along with those of Arredondo and Sons, James Cashen, Zephaniah Kingsley, John Fraser, and Daniel Hurlburt, who imported thirty-nine enslaved Africans on the *Enterprise* in March 1811, only ten of whom were adult males.[31]

Scholars such as Herman Bennett and Stephanie Smallwood have noted that Africans imported together on the same ships maintained contact with one another for years thereafter and that owners who later sold or freed slaves also referred to the ships on which they originally came from Africa.[32] This pattern is also observed in Spanish Florida through notarial records of slave sales and transfers. In 1819 Felipe (Philip Robert) Yonge sold Juan Atkinson six young slaves (ages nineteen to twenty-five), all of whom Fernando de la Maza Arredondo brought from Africa to Florida on the *Sevilla* in 1810. As children, Jane, age twenty-five, Dolly, age twenty-three, María, age nineteen, Amelia, age twenty-two, Ana, age twenty-two, and Florido, age nineteen, had shared the trauma of the Middle Passage. They had lived together at least nine years before being sold as a group, so their relationship continued under a new owner.[33]

Criminal records are another rich source of information on the ethnicity of slaves, and as they prove, Africans in Spanish Florida knew where to find others of their ethnicity and language when they needed support. On March 12, 1811, the Mandinga slave Yra/Yare ran to the nearby Amelia Island plantation of the former slave trader James Cashen, where a slave woman "of his nation" translated his terrible report that his owner, don Domingo Fernández, had just beaten his fellow slave, Yare, to death. Although Cashen's neighbor Fernández was one of the area's important planters, Cashen was required by law to launch an immediate investigation, and he interviewed slaves, the accused master, and the physician who examined the body. After swearing on the Holy Cross, the slave Bely, a native of South Carolina, testified about the tragedy, and although the slave Coffe, "a native of the African coast," was not sworn because he "professed no religion," he confirmed Bely's account. Cashen also interviewed the Mandinga Yra, using Coffe as his translator. The language they spoke was not stated, but it may have been Mande. Next, don Domingo Fernández testified that he had discovered the Africans Yare and Somer idle, and that as he marched them before him to a designated workplace, they began to converse in their own language, which may have been Mande or another lingua franca. Fernández described Yare as "enteramente bozal," meaning he could speak no European languages, but Somer could speak some English. The physician who testified in the case reported that slaves from Yare's same shipment had been sick and that some had already died and, so, after three months, Fernández was released from prison.[34]

While there may never be a definitive count, the Spanish slave ship registries and tax records clearly show that Africans were being imported into

Florida in increasing numbers until the Spanish departed in 1821. If we were to consider only legally recorded slave voyages, documents provide evidence of thirty-two voyages from Africa to Spanish Florida between 1793 and 1821, and there may have been more. In that period, sixteen ships arrived with a total of 1,575 Africans on board, with an average for the sixteen shipments of 98 slaves per ship. Using that average for the other sixteen slave shipments for which no numbers were located would bring the total introductions to 3,143 in less than twenty years.[35] From Florida, many of the Africans were then spirited across the U.S. border into the southern states that were prohibited from importing them (as I have discussed elsewhere and as discussed by Andrew K. Frank in chapter 9 of this volume), thus ensuring that African ethnic, cultural, and linguistic traditions were sustained in the South almost to the eve of the Civil War.[36]

The result of these ongoing illicit introductions of slaves direct from the African coast was that African languages and religious, social, and cultural systems were constantly renewed and did not atrophy into some more creolized form, as in other areas of the antebellum South. On Florida plantations, Africans could converse with previous arrivals and their own shipmates in their native languages, seek assistance in understanding the new society in which they found themselves, find potential partners of the same ethnicity, and preserve at least some semblance of community.[37]

As shown above, the documentary evidence for the ongoing "Africanization" of Florida is fairly extensive. Nineteenth-century newspaper advertisements for slave sales and/or runaways (fig. 5.3) also remark on African scarification patterns and language patterns of those latecomers.[38] Remnants of the creole language, Gullah, could still be heard in north Florida churches as late as the twentieth century.[39] Material evidence also points to African cultural

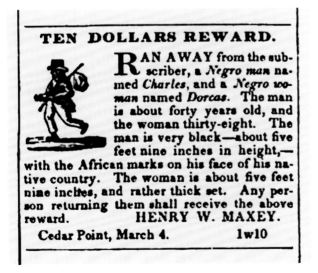

TEN DOLLARS REWARD.

RAN AWAY from the subscriber, a *Negro man* named *Charles*, and a *Negro woman* named *Dorcas*. The man is about forty years old, and the woman thirty-eight. The man is very black—about five feet nine inches in height,—with the African marks on his face of his native country. The woman is about five feet nine inches, and rather thick set. Any person returning them shall receive the above reward. HENRY W. MAXEY.

Cedar Point, March 4. 1w10

Figure 5.3. Among the many indicators of African ethnicity were scarification patterns. Newspaper advertisements, such as this 1835 example from the *Jacksonville Courier*, remark on "African marks on his face of his native country." Others might also remark on language patterns or filed teeth. From the P. K. Yonge Library of Florida History, Department of Special and Area Studies Collections, George A. Smathers Libraries, University of Florida.

Figure 5.4. Material evidence such as this African-style mahogany drum discovered in the banks of the Little Manatee River by fishermen suggests the continuance of African traditions in Florida. Collection of the Florida State Museum of Natural History.

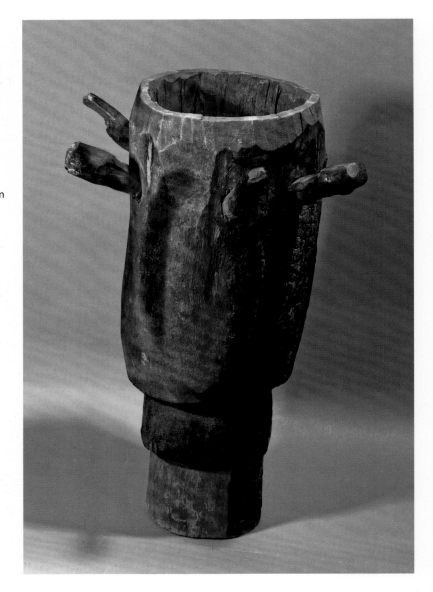

influences alive in many areas of north Florida. Slaves on Zephaniah Kingsley's nineteenth-century plantation on Fort George Island constructed their homes of a poured mix of oyster shell, sand, and lime called tabby, which has West African origins. Local fishermen found an African drum (fig. 5.4) embedded in the banks of the Little Manatee River that is now in the collections of the University of Florida's Museum of Natural History. The graves of blacks buried in the Bosque Bello cemetery in Fernandina, Amelia Island, are outlined and decorated in white conch shells and ceramic figurines of white chickens, all references to Kongo beliefs that link the afterlife with the color white and water.[40] St. Augustine's archaeologist, Carl Halbirt, excavated a nineteenth-century

home belonging to an African American resident and found white conch shells carefully placed at each brick support. A whole baby calf was interred in the floor underneath the house.[41] And yet another potential clue could be seen in the carved ivory bust of Nora Huston, a slave purchased at St. Augustine's slave market, whose elaborately braided hairdo possibly derived from West African models.[42] Given this documentary and material culture evidence, it is at least possible to theorize that less visible patterns of social and cultural retentions were also present in Florida, long after the supposed end of slavery.

Notes

1. Landers, *Black Society in Spanish Florida*. Most African American history texts still begin their narrative at 1619. See, for example, Painter, *Creating Black Americans*. For the Africans landed at Jamestown see Thornton, "The African Experience."

2. For the latest findings on the Atlantic slave trade see Eltis and Richardson, *Extending the Frontiers*. Also see the website on which they offer information on over 37,0000 slave voyages, www.slavevoyages.org.

3. On ethnicity see Lovejoy, "Ethnic Designations of the Slave Trade"; G. M. Hall, *Slavery and Ethnicities in the Americas*; and Law, "Ethnicities of Enslaved Africans in the Diaspora," 32.

4. Figures collected by, and courtesy of, Dr. Kathleen A. Deagan, Florida Museum of Natural History, Gainesville.

5. I will use the term *Kongo* to designate the African kingdom and its culture but will use Spanish orthography and *Congo* to designate an individual's "nation." On the Portuguese trade from Angola see J. C. Miller, *Way of Death,* and Thornton, *The Kingdom of Kongo*.

6. Heywood and Thornton, *Central Africans, Atlantic Creoles*.

7. Dunlop, "William Dunlop's Mission to St. Augustine in 1688," 34; the Reverend Francis LeJau wrote that Portuguese slaves in South Carolina desired communion in 1710, but local planters opposed their conversion. Klingberg, *An Appraisal of the Negro in Colonial South Carolina*.

8. Royal Decree, November 7, 1693, Santo Domingo 59-1-26, Stetson Collection, P. K. Yonge Library of Florida History University of Florida, Gainesville, Florida [hereafter cited as PKY]; Landers, *Black Society in Spanish Florida*, 24–25.

9. The Graxales children were slaves like their Carabalí mother and lived with her in St. Augustine, where their father visited them freely. How the children identified ethnically is unknown. Marriage of Pedro Graxales and María de la Concepción Hita, January 19, 1744; marriage of Tomás Chrisóstomo and Ana María Ronquillo, February 28, 1745; marriage of Tomás Chrisostomo and María Francisca Solana, December 12, 1760, Black Marriages, Cathedral Parish Records, Diocese of St. Augustine Catholic Center, Jacksonville, Florida [hereafter cited as CPR], on microfilm reel 284 C, PKY. Baptisms of the Graxales children, María, November 8, 1744; Manuela de los Angeles, January 6, 1747; Ysidora de los Angeles, December 22, 1748; Joseph Ynisario, April 4, 1755; Juana Feliciana, July 13, 1757; Pantaleona, August 1, 1758; and María de los Dolores, August 16, 1761, Black Baptisms, CPR, on microfilm reel 284 F, PKY.

10. Tomás Chrisóstomo, Nicolás de Briones, and Pedro Joseph de León of the Mose militia also identified themselves as Congos. Landers, *Black Society in Spanish Florida*, appendix 5, 261–63.

11. Elements of Kikongo are found in other creole languages, such as Gullah from South Carolina, Georgia, and Florida and Palenquero in Colombia, as well as in African-derived religious rituals in Cuba, Jamaica, and Brazil. http://en.wikipedia.org/wiki/Kongo_language (accessed 11/22/10).

12. Deagan and MacMahon, *Fort Mose*.

13. Ferguson, "'The Cross is a Magic Sign.'"

14. Landers, *Black Society in Spanish Florida*, appendix A, 269–74.

15. Ibid., 157–58.

16. Eltis and Richardson, *Extending the Frontiers*, 19–20.

17. Oswald imported 106 slaves from Bance Island in 1767 and shipments of similar size in 1771 and 1772. Schafer, "'Yellow Silk Ferret Tied Round Their Wrists'" and "'A Swamp of an Investment'?" For more on the international nature of Oswald's contacts and diverse enterprises and how they enabled him to "integrate backward" into agriculture in Florida see Hancock, *Citizens of the World*, chap. 5, and chap. 6, 203–4.

18. Sale of slaves brought in the brigantine *Ida*, October 30, 1800, Escrituras, 1799–1800, EFP microfilm reel 133, PKY. An American schooner captained by William Wyatt imported forty-six African bozales from "the Coast of Guinea" the following year. EFP, microfilm reel 55, PKY.

19. At its height, Panton, Leslie & Company owned more than 72,000 acres of land in Florida, several armed schooners as well as smaller ships, rice and indigo plantations, cattle ranches, and five trading posts. Between fifty and sixty slaves worked at the company's Concepción trading post alone, planting corn fields and food crops or herding cattle. Coker and Watson, *Indian Traders of the Southeastern Spanish Borderlands*, 34–35, 250.

20. EFP, microfilm reel 133, no. 31, PKY. Sales by William Lawrence, July 29, 1802, EFP, Briefs of Notarized Instruments, 1799–1816, PKY, 345. On the Rio Pongo see Mouser, "Trade, Coasters, and Conflict," and "Landlords-Strangers."

21. EFP, microfilm reel 133, PKY. This ship may have been the same *Betsey* that had been condemned and sold at Charleston in the summer of 1800 after the U.S. Navy schooner *Experiment* seized its cargo of eight slaves from the Rio Pongo. Canney, *Africa Squadron*, 3.

22. Panton, Leslie & Company kept sixty of those slaves, and the rest were the consignment of the Cuban merchant Fernando de la Maza y Arredondo, who had also purchased one of the *Ida* slaves. The two cargo inspections are found in Miscellaneous Civil and Criminal Proceedings, William Cook, February 1802, and William Northrup, July 20, 1802, EFP, microfilm reel 113, PKY.

23. Captain Joel Dunn requests inspection of sixteen slaves belonging to Zephaniah Kingsley, EFP, microfilm reel 114, doc 1806–1, PKY; Zephaniah Kingsley to the Governor, EFP, microfilm reel 133, May 5, 1804, PKY; Captain Henry Wright captain of the *Esther* requests, EFP reel 133, 1806, no. 5, PKY. For the definitive works on the Kingsleys see Schafer's "Shades of Freedom," "Zephaniah Kingsley's Laurel Grove Plantation," and *Anna Madgigine Jai Kingsley*.

24. Landers, *Black Society in Spanish Florida*, 237–44.

25. Fraser's executors presented claims against the United States for the considerable damages to his Greenfield plantation during the Patriot War. These were eventually settled for $157,146. Patriot War Claims of John Fraser, Manuscript Collection 31, claim no. 54, St. Augustine Historical Society.

26. Claims of John Fraser, Works Projects Administration, *Spanish Land Grants in Florida* (Tallahassee, 1940–41), 3:141–45 [hereafter cited as *SLGF*].

27. Schafer, "Shades of Freedom," 137 n. 152. Fraser's agent at Bangra, Charles Hickson, probably handled many of the sales. *SLGF*, 3:145. John Fraser to Governor Enrique White, April 28, 1810, EFP, microfilm reel 133, PKY, cited in Schafer, "Family Ties That Bind," 1–21.

When Fraser drowned in 1814, three of his daughters still lived at Bangra, but Fraser's will decreed that his five children should share equally in his sizable estate, which included 158 African-born slaves. Testamentary Proceedings of John Fraser, 1814, EFP, microfilm reel 134, PKY, and Notarized Documents, January 24, 1816, EFP, microfilm reel 55, PKY.

28. Puerto Rican officials impounded ninety-two slaves from the Rio Pongo on June 8, 1810, twelve of whom belonged to James Cashen and Gaspar Hernández, but Cashen successfully imported twenty-eight slaves to Fernandina on July 9, 1810. Cuba 419 A, Archivo General de Indias, Seville, Spain [hereafter cited as AGI]; SD 2533, AGI; Fernando de la Maza y Arredondo to Governor Enrique White, December 20, 1810, EFP, microfilm reel 133, PKY, cited in Schafer, "Family Ties That Bind," 1–21.

29. Relation of the Expenses of the Frigate *Sevilla*, August 12, 1810, and Relation of the Sale of the Cargo of the Frigate *Sevilla*, August 6, 1810, Cuba 419 A, AGI; Relation of the Expenses of the Frigate *Doña Juana*, March 20, 1811, and Relation of the Sales of the Cargo of the Frigate *Doña Juana*, March 15, 1811, Cuba 419 A, AGI.

30. *SLGF*, 3:254–56.

31. Miscellaneous Legal Instruments and Proceedings, 1784–1819, EFP, microfilm reel 115, PKY; List of ships, owners and captains, 1811–12 in Various, EFP microfilm reel 84, Bnd 298 C16, Library of Congress; Registration of the *Cirila* by Don Tadeo de Arribas, January 19, 1810, and registration of the *Don Alonso*, January 25, 1810, Cuba 419, AGI; Miscellaneous Civil and Criminal Proceedings, EFP, microfilm reel 115, PKY.

32. Bennett, *Africans in Colonial Mexico*; Smallwood, *Saltwater Slavery*.

33. Relation of the Sales of the Cargo of the Frigate, *Sevilla*, August 6, 1810, Cuba 419 A, AGI. Sale by Felipe Yonge to Juan Atkinson, May 24, 1819, Escrituras, 1784–1821, EFP, microfilm reel 168, PKY.

34. Criminal Case vs. Don Domingo Fernández, March 12, 1811, Records of Criminal Proceedings, 1785–1821, EFP, microfilm reel 126, PKY. Although the physician felt that the slaves who watched the autopsy procedure were satisfied that physical blows did not kill Yare, what they actually thought the autopsy signified is unknown. Landers, *Black Society in Spanish Florida*, 192–93.

35. Landers, *Black Society in Spanish Florida*, appendix 11, 276–77.

36. Du Bois, *The Suppression of the African Slave-Trade*, 118–23; Stafford, "Illegal Importations"; Landers, "Slavery in the Spanish Caribbean."

37. Landers, *Black Society in Spanish Florida*, 179–80, 192–95.

38. Runaway ad, *Jacksonville Courier*, April 6, 1835.

39. Personal communication of Dr. Thomas Stewart, Orangeburg, South Carolina; Turner, *Africanisms in the Gullah Dialect*.

40. Landers, *Black Society in Spanish Florida*, 170–71, 131–32; R. F. Thompson, *Flash of the Spirit*, 132–38.

41. Site visit by author and personal communication of Carl Halbirt.

42. Campbell, Kingery, and Rice, *Before Freedom Came*, cover.

6

African Influences on Seminole Beadwork

Thomas E. Larose

The presence of Africa in Florida can be documented through archaeological and physical remains, historical documents, and even oral traditions. However, one legacy of these African peoples—the transmittal of knowledge and skills to the indigenous groups occupying Florida—is difficult to prove due to a lack of documentation. However, the use of beadwork among the Seminoles does show a distinct stylistic influence from African groups that can be documented through its historic development, social usage, and formal comparisons. The "evidence" is only seen by an examination of artworks produced by these Native Americans and correlating them to similar pieces produced by African groups. This chapter examines the development of Seminole beadwork during the eighteenth and nineteenth centuries through stylistic and comparative analysis to demonstrate interactions between Africans and native Floridians, as they occupy the shared physical and conceptual realms of this land.

When Europeans first made contact with the Native Americans of Florida during the early 1500s, the group that they would call the "Seminoles" did not exist. Instead, the Mayucas, Ays, Tegesta, Tocabagos, Calusas, Timuquans, Apalachees, Apalachicolas, and Guales inhabited the territory. Although the French and Spanish would not successfully colonize the Florida peninsula until 1565, the mere presence of Europeans in the Caribbean became the doom for these peoples: European contact introduced a plethora of diseases, such as measles, typhus, tuberculosis, influenza, and smallpox, which quickly decimated the populations. By the early 1700s the majority of Florida was uninhabited.

The Spanish forced the natives who survived the initial epidemics to live around a string of missions across northern Florida, between the two main colonies of St. Augustine and Pensacola. While they ostensibly served to convert the Indians to Christianity, these missions formed a protective border

between the Spanish territory of Florida and the English and French colonies to the north and west, respectively. Housing first Jesuit and then Franciscan missionaries for the conversion of the natives to Christianity and staffed by soldiers, Spanish missions often resembled small forts. Such defensive positions were necessary, because of a continual barrage of attacks coming from both European and native sources, including the peoples that lived around them. Beginning in the 1680s and into 1702 or 1704, the British-backed Yamassees of eastern Georgia raided and finally destroyed these missions, sweeping more than a thousand Florida natives into slavery among the rice plantations of the Carolinas. The few remaining natives fled into the woods, eventually absorbed among the neighboring confederacy of Creek tribes in western Georgia, Alabama, and Mississippi.[1]

Relationships between native groups and European colonies were often contentious and filled with shifts in allegiance. In 1715 the Yamassee allied with the Creek Confederacy against British colonies in the so-called Yamassee War. Many of the Lower Creek bands, fearing retaliatory strikes, moved away from the British settlements along the coast of the Carolinas and Georgia into the now largely unpopulated regions of Florida. These new inhabitants not only served as trading partners for the Spanish but also acted as a human buffer against British encroachment from the north and from the French, who were trying to extend their control of the Mississippi River drainage into western Florida. Over the next fifty years, Hitachi speakers, ancestors of the contemporary Seminoles and Miccosukees of Florida, and Muskogee, or Creek, speakers began to repopulate northern Florida, settling in the Apalachee and Apalachicola River drainages and along the great Alachua Savannah of central Florida.[2]

As former members of the Creek Confederacy, this new group's culture, clothing, and art were at first similar to the Creeks.' However, due to the political and economic affiliations of the now geographically separate groups, they would change over the next century. In the mid-1700s the Creek Confederacy again aligned with the British, assisting Georgia colonists in raids on Spanish Florida. The new native inhabitants of Florida, in part due to their association with the Spanish, saw the political and economic advantages of distancing themselves from the Creeks.[3]

However, the status of this group was not dependent solely on their ties to the Spanish. When the groups that would coalesce into the Seminoles immigrated into Florida, the land was not as uninhabited as Spanish and other European colonists believed. Dotted throughout the northern Florida woodlands were communities of Africans and their descendants, who had escaped slavery in the Carolinas and Georgia and found refuge in Spanish Florida. Their status as fugitives, although somewhat protected in Spanish Florida, led to a lifestyle of seclusion from the European colonists, making relationships with the

Spanish nearly unrecorded. The Seminoles, however, occupying the territories between these villages and the Spanish settlements, became socially, politically, and economically enmeshed with these escaped slaves, an interrelationship that had profound influences on Seminole cultural identity.

While the new Native American inhabitants of Florida referred to themselves either as *yàtkitiscì·* (in Mikasuki) or *isticá·ti* (in Muskogee), both meaning "red person," the outside world eventually knew them as Seminoles. This term derives from the Creek word *simanó·li*, a variation of the Spanish word *cimarrón*, "wild, runaway."[4] However, just whom the Spanish and Creeks designated as a runaway is not determined. Traditionally, the origin of the term was attributed to the group's status as a breakaway entity from the Creek Confederacy. Other theories place the term's origin with the Seminoles' herding of feral cattle on the Alachua Savannah, descendants of Spanish cattle that had run away and become wild. A more intriguing possibility places the Seminoles' acquisition of their name through their close association with the black populations of Florida. In 1858, Joshua Giddings identified escaped slaves as the Creeks' *simanó·li* and the Spanish's *cimarrón*. Only through the general adoption of the term by Euro-Americans, without differentiation between red or black men, did the native populations acquire this name.[5]

Since the settling of Europeans in the Carolinas in the 1670s, chattel slavery was used in large-scale endeavors for agricultural production. Initially Native Americans were enslaved, but they were found to be ill suited to hard labor, prone to disease, and difficult to control. Large numbers of Africans were imported and forced into a life of bondage. Both native and African slaves fled south, when possible, to gain freedom. The Creek Confederacy welcomed the native fugitives, eventually reuniting them with their group if it was still intact or adopting them into another. For African slaves, the road to freedom was not as easy. Native Americans of the Southeast (Cherokee, Creek, Choctaw, and Chickasaws) all practiced various forms of slavery with systems predating European contact. However, as they developed alliances with British colonies, native groups adopted chattel slavery and held Africans in bondage to appear "civilized" to the Europeans. Bounties for escaped slaves and, later, treaties to return lost "properties" made refuge for Africans among these native groups nearly impossible.[6]

However, if an escaped slave could find his way to the Spanish-controlled lands of Florida, he or she could be free. At St. Augustine, escaped slaves often presented themselves to the Spanish authorities, who generally accepted them as free citizens. In 1693, Charles II of Spain officially granted fugitive slaves in Florida freedom on the basis of religious conversion to Catholicism and an oath to protect Spanish possessions from the British. African fugitives, classified as freemen, were employed in St. Augustine if skilled, or set up as agricultural workers on what amounted to communal plantations. To

Thomas E. Larose

accommodate the influx of escaped slaves, in 1738 the Spanish established a separate community for freed Africans, Gracia Real de Santa Teresa de Mose (Fort Mose), two miles north of St. Augustine.[7] Fort Mose was also the home to many of the native peoples seeking refuge from the British in Florida, who coalesced around St. Augustine in a macro-community.[8]

St. Augustine and vicinity were not the only areas seeing interaction between Africans and Seminoles in Florida. As more and more members of the Creek Confederacy moved into northern Florida and established communities, the Spanish saw an opportunity for lucrative trading. However, the Spanish were usually not willing to leave the sanctuary of St. Augustine for the wilderness of interior Florida. Instead, they often employed freemen of Fort Mose, particularly those who could speak a Creek dialect, as messengers and mediators.[9]

During the latter half of the 1700s, Spanish colonists rapidly expanded trade with the Seminoles. Along with deer hides and beef, Seminoles supplied the traders with agricultural products, such as corn, rice, watermelons, peaches, potatoes, and pumpkins.[10] However, the majority of this produce was not from Seminole fields but rather from those of escaped African and African American slaves and their descendants who lived in separate villages near Seminole towns. From the late 1600s through the 1700s, escaped slaves established numerous secretive farms along the unoccupied areas of the Apalachicola and Suwanee Rivers,[11] developing a maroon tradition that lasted in Florida well into the nineteenth century.[12]

These "runaways" came from a multitude of African groups—Senegalese, Asanti, Corromantee, Ibo, Egba, and Kongo. Although from diverse cultures, they shared enough cultural similarities, along with the status of escaped slaves, to settle into cohesive communities and lifestyles. Such shared traditions as matrilineal organization with hereditary chiefs, a council of elders, religious specialists, and communal living supported by agricultural production allowed them to develop a harmonious society. It also permitted the Seminoles, who shared many of these traditions, to form a communal bond with the escaped slaves.[13]

The traditional view of Seminole-black relationships is one of benevolent vassalage. African peoples were considered slaves to the Seminoles but allowed to live in comparative freedom, paying their Seminole overlords a portion of their agricultural produce, livestock, and deerskins each year in return for protection from Europeans.[14] However, such a relationship involving slavery is perhaps based more on Euro-American expectations than on actual social standings. Perhaps a more accurate view is as tenant farmers who paid a percentage of their produce to the Seminoles as tribute,[15] or with the Seminoles acting as middleman brokers for the produce of their black neighbors to the Spanish colonists. The latter interpretation coincides with the limited practice

of black and Seminole intermarriage primarily on the leadership level to cement relationships between communities.[16] Such a social practice indicates that the groups not only viewed each other as social equals but also had separate political organizations.

The social, political, and trade relations between Seminole, Spanish, and African populations in Florida were thrown into disarray when the British took possession of Florida in 1763 with the Treaty of Paris. The Spanish evacuated to Cuba, taking many freed slaves of Fort Mose with them. Others of African descent fled into the interior of Florida to live among the Seminoles.[17]

When the British gained possession of Florida, they began to import large numbers of Africans to work as slaves on new plantations. At the outbreak of the Revolutionary War in 1776, many British Loyalists of the Carolinas and Virginia moved their plantations and slaves to Florida to avoid the ravages of war and political persecution. However, when Florida was retroceded back to Spain in 1784, these British subjects made hasty departures to Bermuda. Many of the slaves in Florida at that time took advantage of the confusion to flee into the interior and seek shelter among the Seminoles.[18]

Once among the Seminoles, escaped slaves were free to live in any fashion they saw as suitable. Many undoubtedly joined existing black communities, where they continued familiar lifestyles, whether African in origin or from other enslaved societies. "Black Seminoles," as they became known, continued to identify with their African heritage, using languages, religions, and marriage customs distinctively different from those of the Seminoles. Differences in clothing preferences were noted in the early 1800s. Blacks preferred to wear pants instead of leggings, and hats or turbans instead of headbands.[19] Some blacks, however, adopted Seminole customs and dress, participating in these communities with the same rights as a native and with the same voice in community affairs.[20] Regardless of social preference, their reluctance to be seen by Euro-Americans and their degrading treatment as runaway slaves when they were leaves little record of how they conducted their lives.

Seminole culture rapidly changed and diverged from its Creek origins. Proximity to whites and blacks, along with trade and social interactions, brought numerous materials and ideas into the Seminole world. Traveling in northern Florida in the 1770s, William Bartram noted rice cultivation among Seminoles, a process learned from the formerly enslaved Africans who had escaped bondage.[21] Others noted that Seminole and African architecture, as well as dance and music, shared similarities.[22] Assimilation of external customs is a hallmark of Seminole society. Composed of distantly related groups that coalesced in northern Florida, the Seminoles are noted for their toleration and even encouragement of individualistic, nonconformist behavior.[23]

One may safely assume, then, that the escaped slaves revived some traditional customs and artistic practices of their African cultures, repressed during

Figure 6.1. Etching by John Faber after painting by William Verelst, 1734. The portrait *Tomochachi Mico and Tooanahowi of the Yamacraws* serves as an example of Creek and Cherokee attire and body markings from the mid-eighteenth century. National Anthropological Archives, Smithsonian Institution, Neg. #1129-A.

slavery, again making such practices integral to their lives. The climate of easy cohabitation between Africans and Seminoles, reinforced by trade relations, produced "neoteric societies" among both groups, with surviving patches of indigenous traditions freely mixed with external cultures.[24]

While the possibilities of this exchange are numerous, they are difficult to follow distinctly, due to a lack of documentation. For example, in his 1887 Seminole Census, Clay MacCauley noted the preference of Seminole women to decorate their dresses with pendant disks made from silver coins.[25] While this practice may be associated with the African practice of ornamentation with cowry shells, used as a form of currency throughout much of West and Central Africa prior to colonization, it is a tenuous connection. Likewise, the often gaudy appearance of Seminole men, distinctively different from that of their Creek relatives, can be linked with slave fashion ensembles replete with arm-bands, ear bobs, bracelets, and other forms of jewelry commonly associated with Africans.[26] While these intuitive connections are tantalizing, without actual proof of how the African populations in Florida dressed and ornamented themselves they can only remain as conjecture.

In an early 1734 portrait (fig. 6.1), Tomochachi, the Lower Creek chief who assisted Oglethorpe in establishing settlements in Georgia, is depicted wearing a traditional fur cape, tied at the neck. His bare chest displays elaborate tattoos that served as markers for clan affiliation, social status, and political power. Similar attire is described for the clothing of Cherokees who visited London in 1730. Southern tribes had not incorporated the use of beads into their clothing at that time, although strings of beads were reported around some Cherokees' necks.[27] These examples clearly show that, at the time of

Creek migrations, the peoples who would become Seminoles still utilized traditional clothing and decorative patterns of the Southeastern tribes and had not assimilated many external styles.

The earliest description of Seminole beadwork is in William Bartram's 1791 *Travels*. Bartram's description of the Seminole Long Warrior includes a discussion of the headband (fig. 6.2) as a "very curious diadem or band, about four inches broad, and ingeniously wrought or woven, and curiously decorated with stones, beads, wampum, porcupine quills, etc."[28] It was likely an example of the finger-woven sashes, bands, and garters becoming popular with Seminoles as they changed clothing preferences to the European-style long shirt, obtained through the deerskin trade.[29] The long shirt was preferable in Florida heat, since it was light and allowed easy movement yet blocked sun exposure and the region's multitudinous insects. Sashes cinched down the waist and were looped over the shoulder to block the neck region, while garters closed the gap between the leggings and footwear.

However, in adopting the long shirt, Seminoles lost the traditional identification value of tattoos. To compensate, beaded designs were woven into sashes and garters to display wealth and status. Brent Weisman explains this process: "In an atmosphere of wildly fluctuating partisanship, on a frontier increasingly peopled with half-breeds and cunning entrepreneurs, the grand and gaudy Seminole costume (plumes, silver gorgets and the like) immediately announced ethnic affiliation and marks of individual personality and achievement."[30]

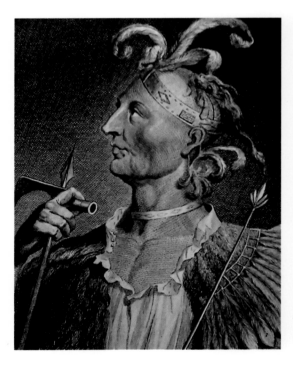

Figure 6.2. *Micco Chlucco, known as the Long Warrior*, by William Bartram. The band around Micco Chlucco's head serves as an illustration of early Seminole beadwork being developed by the end of the eighteenth century. Beineke Rare Book and Manuscript Library, Yale University.

Thomas E. Larose

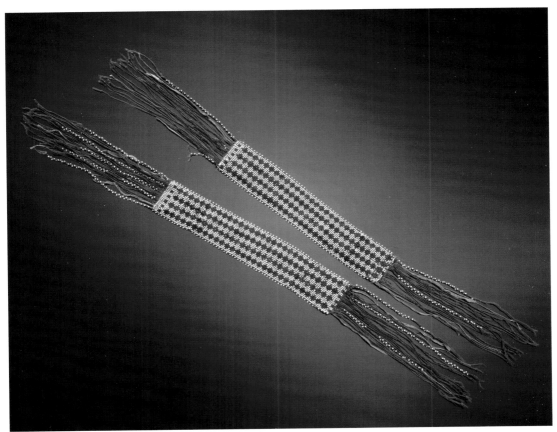

Figure 6.3. Finger-woven garter, Seminole, 1840s. White beads are used to fill in the design spaces of Seminole beadwork by the mid-1800s. Lowe Art Museum, University of Miami, 88.0052

Designs favored for finger-woven beadwork among Seminoles included chevrons, diamonds (solitary or in rows), and lightning or sawtooth patterns. The Seminoles associated these designs with family affiliation, such as an alternating diamond motif representing the Rattlesnake clan.[31] Earlier examples have patterns only outlined in beads. This style was prevalent until approximately 1825, when rows of white beads filled in the designs (fig. 6.3).[32] However, these patterns were considerably different from the traditional Southeastern tattoo designs of animals, flowers, crescents, stars, scrolls, and sun.[33]

The Seminoles' change to a nontraditional system of designs to display wealth, power, and tribal identity can perhaps be best understood by considering the escaped African slaves living among them. During the late 1700s, plantations in British Florida imported large numbers of peoples from Sierra Leone,[34] while plantation owners from the Carolinas preferred peoples from Angola and the Congo for their agricultural abilities.[35] As Seminoles were

developing a distinctive costume using finger-woven sashes, enslaved Kongos escaping from plantations in the Carolinas and British Florida, swelled the African populations of Seminole towns. Many of these escaped slaves were marked with diamond and weaving scarification patterns prevalent among the groups from present-day Angola and the Congo. As late as 1890, African-born individuals with such scarifications were still seen in Florida.[36] These designs were not only on the bodies of blacks but were also prevalent in textile designs, such as on quilts, produced by Africans in America.

Faced with the technological limitations of adding design elements to finger-woven sashes, Seminoles likely appropriated rectilinear Kongo designs used as symbols of status, power, and group identity. Symbolic associations of these patterns, representing crossroads or a cosmogram to the Kongos,[37] complemented the Seminole symbolism of the equal-sided cross as representing the four directions.[38] Not only did this solve the logistics of material use, but it also helped to give the Seminoles a distinctive identity separate from the Creeks while drawing a closer bond of identification between themselves and their African neighbors.

While bead use on finger-woven articles can be traced from the late 1700s and through the mid-1800s, embroidery with beads on commercial fabrics does not seem to have appeared among the Seminoles until approximately 1820. This change did not immediately affect sash and garter production, but by the late 1800s they had fallen out of favor and were no longer produced.[39] This change in beading techniques coincides with Spanish concession of Florida to the United States in 1821. Again, Spanish settlements and plantations of Florida were abandoned, with the majority of slaves and free blacks going to Cuba. However, some slaves escaped to the Seminoles, while some free blacks decided to stay with their properties and hope the new government would honor its promises.[40] This new body of Africans among the Seminoles, predominantly Yoruba and related groups from the Bight of Benin, were brought by the Spanish to the Caribbean and then to St. Augustine in the early 1800s.[41] Enslaved Yoruba are noted for an extensive tradition of beadwork that has left traceable influences in the Western Hemisphere, predominantly in the Caribbean and Brazil. Their beadwork tradition likely played a large role in influencing the technical and stylistic changes seen in Seminole beadwork beginning in the 1820s.

Perhaps the best evidence of this influence is seen in the evolution of the shoulder pouch, or bandoleer bag. Convention places the origin of the bandoleer bag with British shot pouches. Native Americans quickly adopted the form to hold shot, tobacco, ritual items, or other necessary materials. By the 1800s, bandoleer bags had become essential parts of Southeastern Indian dress.[42] Early examples, such as a Creek bag from 1817 (fig. 6.4), show the use of finger-woven materials with a minimal amount of beading along the edges. This

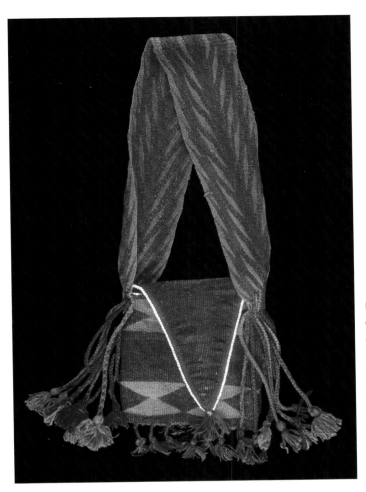

Figure 6.4. The bandoleer bag of the Creek chief Francis from around 1817. Chief Francis's bag is an example of the Creek patterns of beading on finger-woven materials. Such Creek examples are in contrast to the developing Seminole style seen in figure 6.3 and later styles as seen in figure 6.6. Used with permission of The British Museum/The Trustees of the British Museum.

decorative pattern continued throughout the majority of the Southeastern tribes, reflecting their Mississippian-period weaving heritage, even though the materials changed over time.[43]

Seminole bandoleer bags, on the other hand, discontinued the use of finger-woven materials and the diamond motif in the 1820s, replacing them with curvilinear and geometric designs representing plants and animals embroidered onto commercial wool fabrics (fig. 6.5). The origin of the Seminoles' technical ability for embroidering with beads is a mystery. One proposal states that the skill trickled down to the Seminole from the Cherokees, who were taught embroidery by Moravian missionaries in the early 1800s.[44] However, considering the distance involved for such a transaction of knowledge, the historic political divisions between the groups, and the onset of the Seminole Wars in 1816, this is hardly likely. Also, Cherokee embroidery, characterized by carefully executed geometric designs in tight rows of beads, is technically and stylistically different from Seminole embroidery.

Figure 6.5. Curvilinear patterns developed on Seminole beadwork by the mid-1800s. Illustrated by Dorothy Downs in *Art of the Florida Seminole and Miccosukee Indians* (Gainesville: University Press of Florida, 1995), figure 6.2, p. 162.

Again, African influences, particularly Yoruba, are the best sources for this change. The influx of Yoruba and related groups of escaped Africans into Seminole territory during the 1820s undoubtedly brought technical knowledge for embroidered beadworking, practiced by the Yoruba for centuries.[45] In transmission of technical skills of embroidery to Seminoles, Yoruba symbolism and ritual associations were likewise passed on, adopted and adapted into the Seminole conception of beadwork. These influences are evident in Chief Alligator's 1839 bandoleer bag (fig. 6.6). The earlier Kongo-inspired diamond motif is replaced by curvilinear serpentine patterns and lozenge-shaped designs, made out of multiple rows of contrasting beads. On the flap, lozenges are arranged and selectively filled to produce a reptilian face (presumably either the namesake alligator of the bag's owner or the rattlesnake for clan affiliation).

Similar faces (fig. 6.7) that represent spiritual intermediaries (*ìbòrí*) are typically beaded on flaps of Yoruba bags for carrying ritual paraphernalia (*àpo ìlèkè*) belonging to diviners (babaláwo) and other powerful individuals.[46] For the Yoruba, the symbolism of a serpent on a bag, similar to that of Chief Alligator, also relates to their concept of spirit intermediaries. A snake in a zigzag pattern represents for Yoruba devotees of Ṣàngó the flash of lightning through which the òrìṣà makes his presence known.[47] Interestingly, contemporary Seminoles consider the snake not only to be a clan symbol but also a messenger to Breathmaker, the creator. Howard Osceola (Seminole) explained the relationship: "We don't worship that snake. We talk to god through that snake."[48]

Thomas E. Larose

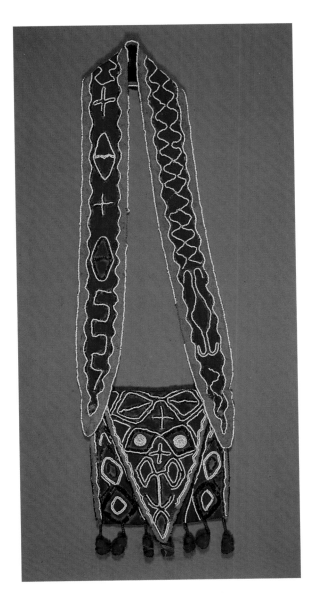

Figure 6.6. Bandoleer bag of Chief Alligator, Seminole, ca. 1839. Chief Alligator's bandoleer bag is an example of Seminole embroidered beadwork, likely derived from Yoruba influences. Photo by Dick Meier, courtesy of the Los Angeles County Museum of Natural History, #A.2135.30–4.

The stylistic change in Seminole bandoleer bags coincided not only with the introduction of Yoruba peoples into their midst but also with the onset of the Seminole Wars. This transition in materials and design is evidence of a change in the nature of the bandoleer bag among the Seminole, from a utilitarian pouch to a container for specialized power objects. Prior to Colonel Clinch's 1816 attack on Spanish Florida and the beginning of the three Seminole Wars, Seminole medicine men housed the sacred objects of each town's clans in centralized bundles. However, with the dispersal of the Seminoles south into Florida as small refugee groups, sacred bundles were divided among group leaders and shamans to give each group "Power of War" medicines.[49] Undoubtedly,

Figure 6.7. *Àpo ìlèkè*, Yoruba. This example of Yoruba embroidered beadwork, representing an *ìbòrí* (spirit figure) on a diviner's bag, shows facial characteristics similar to those in figure 6.6. Fowler Museum at UCLA, photograph by Don Cole.

special bandoleer bags were constructed to house sacred objects carried by group leaders. Decorations were added to designate the nature of these bags and enhance their powers. As Seminole leaders were captured, killed, or surrendered, these bags were confiscated and their spiritual powers dissipated. When MacCauley made his 1887 survey of Seminoles left in Florida, bandoleer bags were no longer in use, replaced by small pouches suspended from their belts.[50]

The Seminole use of ornately beaded bandoleer bags to hold power objects coincides with the Yoruba's use of specialized bags called *apo* beaded with spiritual iconography to hold religious and medicinal items (fig. 6.8). Beaded panels (*yata*), similar in style and construction to bandoleer bags, are part of the ritual regalia of Yoruba Ifa priests and devotees of the òrìṣà Ṣàngó and Òṣun.[51] Perhaps the most conclusive evidence for this specialized use of the beaded bandoleer bag by Seminoles is not their ubiquitous presence among the images of Seminole leaders but their conspicuous absence in images of "Black Seminoles." A portrait of John Horse, known to some as Gopher John (fig. 6.9), an interpreter for the Seminoles, lacks such a beaded bag. In accordance with his African heritage, he would only carry such a bag if he were a priest or diviner.

A Black Seminole priest or diviner's *yata* is possibly the origin and function of an undocumented bandoleer bag of Seminole style (fig. 6.10). On the flap is the figure of a black man wearing trousers. As late as MacCauley's 1887 report,

Seminole men still wore leggings and a breechcloth,[52] while Africans and African American men typically wore pants. The figure does not wear headgear, another essential part of Seminole costume. A red diamond shape, possibly representing the heart, is in the center of the figure's chest, with a line of red beads descending down one leg. The meaning of this bag is elusive, with modern Seminoles stating that it does not represent any of their symbolism.[53] However, the central figure is consistent with Yoruba stylization of human

Figure 6.8. *Apo ifá*, Yoruba, twentieth century. Beaded bags such as this contained Yoruba diviners' paraphernalia. Such bags seem to relate to the eventual function of bandoleer bags as containers for power objects. Samuel P. Harn Museum of Art, University of Florida, Gainesville.

Figure 6.9. Gopher John, "Black Seminole" interpreter. The representation of the Black Seminole John Horse (referred to by the American military as Gopher John) suggests that the Black Seminole who did not have the status of priest or diviner did not carry a bandoleer bag. This would be in keeping with Yoruba traditions. From the P. K. Yonge Library of Florida History, Department of Special and Area Studies Collections, George A. Smathers Libraries, University of Florida.

figures, including outlining the form with a row of contrasting beads (fig. 6.11). The figure itself may represent the owner's *ìbòrí*, or spirit intermediary. Underneath the flap, the body of the bag is decorated with radiating triangles around the outer edge. This is characteristic of Yoruba diviners' bags, which both conceal and reveal the divining tray carried inside (fig. 6.12). On the interior of the panel, four large diamonds represent the four cardinal directions invoked at the start of divination. Each is divided into four quadrants by crosses, representing the crossroads or the meeting place of spiritual and worldly forces.[54]

Included in the Seminoles' transformation from finger-woven to embroidered beadwork are a series of new motifs consisting of curvilinear scrolls, often mirrored side-by-side, as seen in an 1840s bandoleer bag belonging to Billy Bowlegs (fig. 6.13), as well as in a depiction of No-Kush-Adjo from 1858 (fig. 6.14). Some of these designs are recognizable as vegetal and animal motifs; others have no precursors in Seminole or Southeastern designs. They can be directly correlated to Yoruba beadwork designs used for spiritual symbolism on masquerades and royal regalia (fig. 6.15). For both the Seminole and the Yoruba, beaded symbols signify distinction and authority in dealing with both worldly and spiritual powers.[55]

Thomas E. Larose

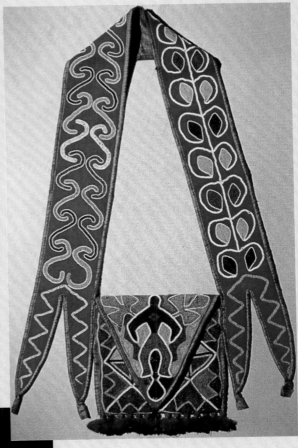

Right: Figure 6.10. Bandoleer bag, Seminole (?), ca. 1840. This Seminole-style bandoleer bag from ca. 1840 depicts a black man wearing pants. Field Museum, #258646

Below: Figure 6.11. Decorative beadwork ensemble for a Yoruba *iyalu*, or "mother drum." This set of beaded objects shows the Yoruba practice of outlining a figure in a row of beads of a contrasting color. Fowler Museum at UCLA, Photograph by Don Cole.

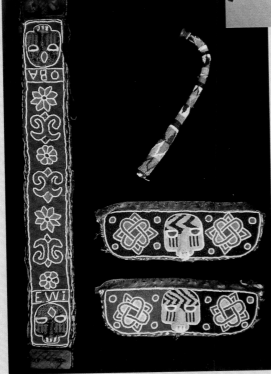

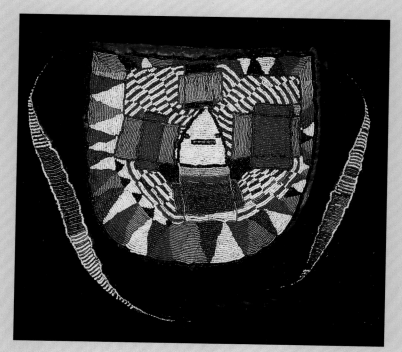

Figure 6.12. *Ápo ìlèkè*, diviner's bag, Yoruba. The Yoruba diviner's bag serves as an example of the radiating triangles of beadwork that decorate Yoruba diviners' bags. Fowler Museum at UCLA, Photograph by Don Cole.

Figure 6.13. Chief Billy Bowlegs's bandoleer bag, ca. 1840. Chief Bowlegs's bag reveals the curvilinear beaded designs similar to patterns on Yoruba ceremonial regalia. Smithsonian Museum of Natural History 1852 photo.

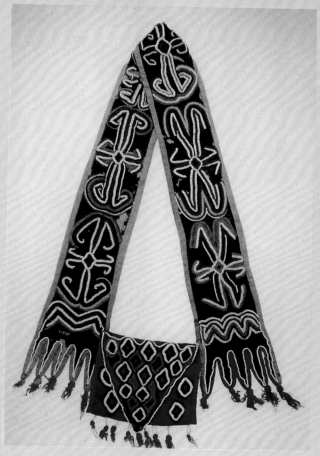

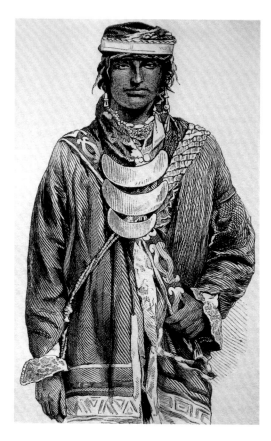

Figure 6.14. No-Kush-Adjo (brother-in-law of Billy Bowlegs). The depiction of No-Kush-Adjo provides another example of the curvilinear beaded designs on Seminole bandoleer bags. *Harpers Weekly*, June 12, 1858.

Finally, the last major influence of Yoruba aesthetics on Seminole beadwork is represented by the selection of colors and their placement. Seminole beadwork differs from its Southeastern neighbors through its preference to solidly fill in shapes with beads; other native groups preferred simple outlining.[56] Marcilene Wittmer has identified this tendency as being indicative of African influences, as evidenced by the Yoruba solid fields of beadwork.[57] To create these filled areas, the Seminoles often built concentric rows of variously colored beads, predominantly of white, red, yellow, blue, black, and green. The Seminole associated these colors with spiritual and medicinal symbolism: red and white were most commonly seen with snake and reptilian motifs, blues and black with animal and vegetal symbols.[58] While these symbolic associations of colors relate to Southeastern traditions,[59] the classification of and nomenclature for colors was apparently different from European and even native conventions. MacCauley noted that his Seminole informants classified violets, blues, and greens as an undifferentiated group and referred to them by one term, light yellow through dark orange as another, and the full range of reds as yet another.[60] While this might be an indigenous understanding of analogous colors, it is directly related to the Yoruba nomenclature for chromatics to represent spiritual connotations.

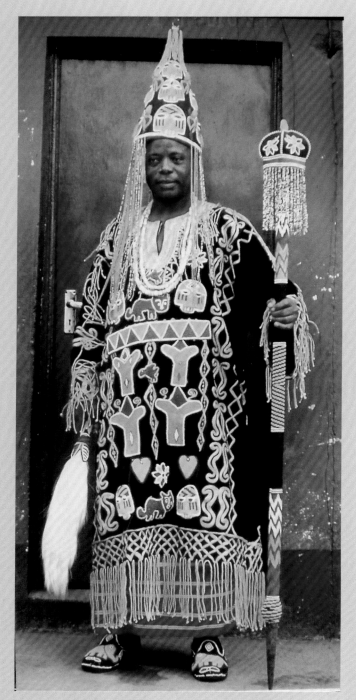

Figure 6.15. The Elepe of Efe participates in the annual royal rite. His ceremonial regalia is decorated with curvilinear beaded designs notably similar to those developed by the Seminoles during the mid-nineteenth century. Photo by Henry John Drewal, 1982.

Yorubas distinguish three main categories of chromatics: *funfun*, which includes white and gray, represents coolness and restraint; *pupa*, reds, oranges, and yellows, represents heat and activity; and *dúdú*, the cool colors of black, blues, and purples, represents moderation. Composed in certain combinations, this trio of color ranges represents the various gods and their attributes.[61] In this context, the Seminole classification of colors and use for spiritual representation is similar to the Yoruba's. Each group's conception of spiritual entities as being active, passive, or neutral allowed for the adoption of the Yoruba's stylistic associations in the production of beadwork.

Taken all together, the various formal similarities between Seminole beadwork and that of the various African groups living among them convincingly suggest that African aesthetics were a major influence on Seminole culture. Individually, each piece of evidence is perhaps tenuous and, at this point, impossible to document, but collectively they provide a strong argument. The possibility of African influences on Seminole culture, particularly given their close cohabitation in Florida, opens new avenues of investigation for post-contact Native American art, as well as the importance of African cultures in the development of the New World.

Notes

1. Mahon and Weisman, "Florida's Seminole and Miccosukee Peoples," 186.
2. Ibid., 186–87.
3. Ibid., 188–89.
4. Hudson, *The Southeastern Indians*, 467–68.
5. Giddings, *Exiles of Florida*, 3.
6. May, *African Americans and Native Americans*, 39–40.
7. Landers, "Free and Slave," 171–74.
8. Landers, "Traditions of African American Freedom and Community," 23.
9. Rivers, *Slavery in Florida*, 190.
10. Mahon and Weisman, "Florida's Seminole and Miccosukee Peoples," 189.
11. Giddings, *Exiles of Florida*, 5.
12. R. L. Hall, "African Religious Retentions in Florida," 45.
13. Britten, *A Brief History of the Seminole-Negro Indian Scouts*, 4.
14. Hudson, *The Southeastern Indians*, 465.
15. Klos, "Blacks and the Seminole Removal Debate," 130.
16. Rivers, *Slavery in Florida*, 198.
17. Landers, "Free and Slave," 171–74.
18. Ibid., 174–75.
19. Rivers, *Slavery in Florida*, 196.
20. Hudson, *The Southeastern Indians*, 465.
21. Weisman, *Unconquered Peoples*, 110.
22. Rivers, *Slavery in Florida*, 197.
23. Weisman, *Unconquered Peoples*, 121.
24. Britten, *A Brief History of the Seminole-Negro Indian Scouts*, 4.
25. MacCauley, *The Seminole Indians of Florida*, 488.

26. Rivers, *Slavery in Florida*, 170.

27. Downs, *Art of the Florida Seminole and Miccosukee Indians*, 16–17.

28. Bartram, *Travels of William Bartram*, 393.

29. Downs, *Art of the Florida Seminoles and Miccosukee Indians*, 24.

30. Weisman, *Like Beads on a String*, 41.

31. Weisman, *Unconquered Peoples*, 36.

32. Downs, *Art of the Florida Seminoles and Miccosukee Indians*, 123–28.

33. Hudson, *The Southeastern Indians*, 380.

34. Landers, "Free and Slave," 174.

35. Schafer, "Yellow Silk Ferret Tied Round Their Wrists," 75–76.

36. R. L. Hall, "African Religious Retentions in Florida," 52–53.

37. Thompson, "Kongo Influences on African-American Artistic Culture," 152–57.

38. Weisman, *Like Beads on a String*, 21.

39. Downs, *Art of the Florida Seminoles and Miccosukee Indians*, 144–46.

40. Landers, "Free and Slave," 180–81.

41. Curtin, *The Atlantic Slave Trade*, 235–64.

42. Downs, *Art of the Florida Seminoles and Miccosukee Indians*, 152.

43. Hudson, *The Southeastern Indians*, 378.

44. Downs, *Art of the Seminole and Miccosukee Indians*, 154–57.

45. Drewal and Mason, *Beads, Body, and Soul*, 34–41.

46. Ibid., 230.

47. Abiodun, Drewal, and Pemberton, *Yoruba Art and Aesthetics*, 70.

48. Downs, *Art of the Seminole and Miccosukee Indians*, 163.

49. Weisman, *Unconquered Peoples*, 96–97.

50. MacCauley, *The Seminole Indians of Florida*, 483–84.

51. Abiodun, Drewal, and Pemberton, *Yoruba Art and Aesthetics*, 78.

52. MacCauley, *The Seminole Indians of Florida*, 483–84

53. Downs, *Art of the Seminole and Miccosukee Indians*, 166–67.

54. Drewal and Mason, *Beads, Body, and Soul*, 229.

55. Ibid., 26; Downs, *Art of the Seminole and Miccosukee Indians*, 164.

56. Downs, *Art of the Seminole and Miccosukee Indians*, 166.

57. Wittmer, "African Influence on Florida Indian Patchwork," 275.

58. Downs, *Art of the Seminole and Miccosukee Indians*, 167–68.

59. Hudson, *The Southeastern Indians*, 132.

60. MacCauley, *The Seminole Indians of Florida*, 525.

61. Drewal and Mason, *Beads, Body, and Soul*, 18.

7

Black Towns of the Seminole Indians

Florida's Maroon Communities

Rosalyn Howard

Throughout the Americas, Africans demonstrated resistance to the outrage of enslavement by European colonizers. Resistance was manifest in various overt and covert forms, including poisoning their masters, setting fire to the plantations, work slowdowns, feigning illness, committing suicide, and escape.[1] Escape or running away was what led to the creation of the independent habitats known as maroon communities, where self-emancipated Africans were able to live in freedom and re-create familiar social institutions and cultural practices.

In the Spanish colonies, established during the fifteenth and sixteenth centuries, these maroon communities were called *palenques*. When the Portuguese colonized Brazil in the sixteenth century, enslaved people sought freedom in *mocambos* and *quilombos*. During the seventeenth century, the Dutch established their colonies in South America and the Caribbean; freedom seekers there—alternately called *bosnegers*, Saramaka, Aluku and Ndjuka maroons, and bush Negroes—formed maroon communities in the mountains, forests, and jungles. During that same century, the British and French also witnessed Africans seizing opportunities to gain their freedom and joining maroon communities.

The viability of these maroon communities varied, but two factors had particular salience: the degree to which they were self-sustaining and where they were located. Successful maroon communities were situated in the most inhospitable terrain available, as were Nannytown and Accompong in the formidable mountains of Jamaica; Palmares in the dense, swampy areas of Brazil; the dense hammocks and swamps of Florida; and Dismal Swamp at the border of Virginia and North Carolina.[2] Maroon communities have traditionally been acknowledged as places where enslaved peoples resided after their escape from bondage; in some instances, however, the residents also included free Africans, Native Americans, poor whites, and AWOL soldiers. This environment

of cultural and linguistic diversity formed a foundation upon which to establish cultural norms of behavior that mirrored their African societies, though morphed by extant social, geopolitical, and environmental circumstances.

Palmares, one of the best-known maroon communities, persisted in Brazil for eighty-nine years.[3] Attacked and destroyed in 1644, the community, led by Zumbi, had been the residence of Native Americans, Africans, and their mixed children.[4] Herbert Aptheker[5] cites Dismal Swamp, formerly located on the border of Virginia and North Carolina, as an example of a successful maroon community in North America.[6] The Black towns associated with the Florida Seminoles can also be considered as successful North American maroon communities in that they became sanctuaries of freedom for self-emancipated Africans.[7] Although the longevity of the North American maroon settlements did not approximate that of Palmares, they were nonetheless significant as spaces of freedom for Africans seeking respite from the harsh lives they led under chattel slavery. Maroon communities in North America are an important part of U.S. history, yet their existence has been obscured in traditional texts. Their existence demonstrates that, contrary to the patronizing depictions of slavery as "a more or less delightful, patriarchal system,"[8] enslaved people were not content with their condition and persistently sought to gain their freedom. This chapter seeks to situate the Black towns as maroon communities and to explore the relationships of their inhabitants to the Seminole Indians of Florida.

Florida as Maroon Sanctuary

Under Spain's jurisdiction, much of Florida functioned as a maroon community. It became a haven when, in the seventeenth century, enslaved Africans fled the plantations of the Carolinas, Alabama, and Georgia confident in the promise of freedom proffered by the king of Spain's 1693 royal *cedula*. Among the freedom seekers, often called fugitives or runaways, were West and Central Africans who had been seized on the continent and imported as human cargo into the port of Charleston, South Carolina, or shipped into North America from various European colonies where they had been enslaved. Creoles—the generations of persons born into slavery on the plantations—were also among the freedom seekers.

Upon arrival in Florida, the self-emancipated Africans settled as free persons with the Spaniards or with the Seminole Indians. Their freedom among the Spaniards had two caveats: they must adopt Catholicism as their religion, and they must defend the Spaniards against incursions by the British and eventually by U.S. militias and government troops. Having too few men to defend their sovereign territory placed the Spaniards in a precarious position; they welcomed the freedom seekers into their ranks as a way to thwart the

U.S. government's aggressive maneuvers designed to claim and settle Florida as their new frontier. Freedom with the Seminoles meant living in separate towns (for most) and paying a tribute—a portion of their harvest—to an allied Seminole chief. Paradoxically, both the Spaniards and Seminoles held Africans as "slaves" in Florida at the same time that they extended offers of freedom to the new arrivals. That designation as "slave" by Spaniards and Seminoles, however, held very different meanings and consequences. Unlike those enslaved by the Spaniards, freedom seekers who allied themselves with the Seminole Indians, though described as their slaves or vassals, were not treated as chattel slaves; they enjoyed lives of substantial freedom. The Seminoles' designation of "ownership" often served to protect the fugitives from former slave owners seeking to claim them as their "property."

African Alliance with the Spaniards

In 1738 the freedom seekers, many of them skilled artisans—for example, carpenters, ironsmiths, coopers, and masons—constructed the first free black settlement in North America, Gracia Real de Santa Teresa de Mose (Fort Mose), located approximately two miles north of Spanish Florida's capital St. Augustine (see fig. 2.1). There they experienced full cooperation and assistance from the Spaniards.[9] Spaniards formed several black militias, composed of both the newly arrived freed blacks and Africans presently enslaved by the Spaniards. Captain Francisco Menendez, a freedom seeker who, like most others who allied themselves with the Spaniards, had adopted a Spanish name, was a militiaman and community leader in Fort Mose.[10]

The 1763 Treaty of Paris ended the first Spanish period in Florida, and the British assumed control for the next twenty years. During the British period, Florida ceased to be a sanctuary for freedom seekers. Spaniards, along with their enslaved blacks and free black allies, fled to Havana, Cuba. Once there, many of the free blacks settled in Matanzas, on the southern coast of Cuba.[11] During the American Revolution, thousands of British Loyalists substantially inflated Florida's population. They established indigo and rice plantations with the labor of creole and "seasoned" slaves whom they had brought with them from their plantations, but they also imported large numbers of "new" Africans from their "homelands in interior Senegal, Mali, Guinea, and Sierra Leone, with additional numbers from Nigeria and Angola."[12]

British tenure in Florida, however, ended when the Treaty of Paris (Versailles) dictated the retrocession of Florida to the Spaniards. At that time, many Loyalists departed for other British colonies and attempted to resume their plantation economies in these new locales. Some of them, however, chose to remain in Florida, running their plantations with the assent of the returning Spaniards. This was certainly a complex time in Florida.

Upon Spain's regaining Florida, an insufficient population for maintaining the plantation economy established by the British caused the Spanish to open the territory to American homesteaders, who brought African enslaved laborers with them. The United States, which had only recently purchased the Louisiana Territory, was intent on adding Florida to its southern territorial holdings.

African Alliance with the Seminoles

Self-emancipated Africans and Seminole Indians shared an interest in thwarting American efforts to take over Florida. American acquisition of the territory would deprive the Seminoles of their newly acquired homelands, and it would portend a return to enslavement, or death, for the runaways. The threat of return to enslavement created a strong will to fight among these self-emancipated people; they were considered by many observers at that time to be the fiercest warriors.[13]

Some of the people who became known as the Florida Seminole Indians originated in Alabama and Georgia as members of the Muskoke polity, better known as the Creek Nation. Internecine fighting, largely about whether or not to collaborate with the Europeans, led a number of Muskoke to leave their homes and resettle in Florida during the seventeenth and eighteenth centuries. As in their former Muskoke homes, the Seminoles' new communities were composed of linguistically and culturally diverse groups of people, possibly including a few indigenous Floridians whose tenure in Florida dates to twelve thousand years ago. Although their populations were decimated from exposure to diseases, harsh working conditions, and the genocidal policies and practices initiated by European colonizers of the Americas, there may have been a few survivors from Florida's indigenous societies, such as the Timucua, Calusa, and Apalachee. The diverse group would later become known as Seminoles, a corruption of the Spanish word *cimmarone*, which means "runaway."

Like the Spaniards, the Seminoles were constantly harassed by persons who were intent on settling Florida and who had no qualms about destroying the people who were already resident when they arrived. The alliance of Spaniards, Seminoles, and Africans was a logical response to the mutual threat posed by U.S. militias, unwelcome settlers, and pattyrollers, a term used by enslaved persons to refer to the slave patrols hired to capture and return them to bondage.[14] Their joint forces presented a formidable barrier to American expansionism and posed a significant threat to the plantation economy of the United States. News of the sanctuary extant in Spanish Florida and the successful opposition mounted by allied Seminole and black warriors in Florida would likely inspire revolt if it spread widely among the enslaved populations in the United States.[15] Removal of the Seminoles, among whom some of the freedom

Rosalyn Howard

seekers had found sanctuary, became the focus of the Americans; this would, effectively, eliminate this safe haven and the threat it posed. Fomenting disaffection and antagonism—divide and conquer—was a key tactic employed to this end. Despite divisive attempts, the strong alliance of the Seminoles and the freedom seekers was clear, as evidenced by the following comments of M. M. Cohen:

> It will be difficult to form a prudent determination with respect to the maroon negroes who live among the Indians on the other side of the little mountains of Latchiona [Alachua], their number is said to be upwards of three hundred. They fear again being made slaves, under the American government; and will omit nothing to increase or keep alive mistrust among the Indians, whom they in fact govern. If it should become necessary to use force with them, it is to be feared that the Indians would take their part. It will, however, be necessary to remove from the Floridas [East and West], this group of lawless freebooters, among whom runaway negroes will always find refuge.[16]

Black Towns

Their alliance with the Seminole Indians led to freedom seekers in Florida becoming known as "Black Seminoles" (or "Negro Seminoles" in the terminology of that time).[17] They resided, primarily, in separate villages known as Black towns where they enjoyed virtual autonomy. Each community selected its leader, was associated with a specific Seminole chief, and operated within mutually agreed upon parameters.[18]

Black Seminoles were important contributors not only to their own survival but also to the Seminoles'. Their knowledge of agricultural techniques in particular was highly valuable to the Seminoles, whose most prominent subsistence activity had traditionally been hunting. The Seminole chiefs also augmented their diets with the Black Seminoles' obligatory food tribute. Black Seminoles and their towns played integral roles in Seminole society. However, serving as warriors and interpreters, adopting the Seminole style of dress, and constructing similar dwellings did not mean that Black Seminoles became totally acculturated. The fact of their physical separation in the Black towns, where they were free to practice their own cultural and spiritual traditions, was key to the maintenance of their own cultures. According to Rivers, "their cultural ways differed greatly from those of the Seminoles. The differences helped to form the maroons' unique ethnicity and defined them as a people."[19]

Similar in characteristics to the prototypical maroon communities, Black towns were frequently situated in inhospitable areas, in or near the numerous Florida swamps, and always in proximity to their allied Seminole villages.

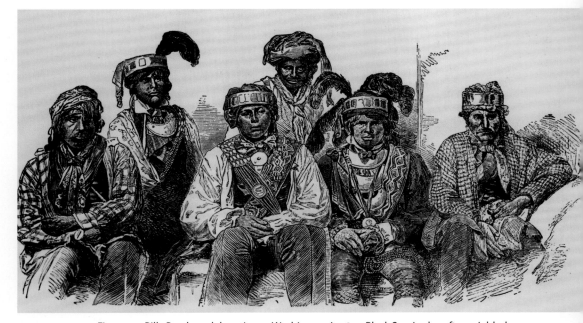

Figure 7.1. Billy Bowlegs delegation to Washington in 1853. Black Seminoles often wielded considerable influence within Seminole affairs, often serving as interpreters. Abraham (*center, standing*) is pictured with the Bowlegs delegation as published in *The Illustrated London News*, May 23, 1853. Courtesy of State Archives of Florida, *Florida Memory*.

Black towns can be viewed both as maroon communities and as structural components of the Seminole towns to which they were situated in somewhat close proximity.[20] The inhabitants were categorized as (1) free blacks; (2) blacks who had recently escaped enslavement; (3) African and creole blacks and their progeny; and (4) "captured" blacks.[21] Also, since self-emancipated Africans and their Seminole allies occasionally intermarried, Black town populations included the wives, husbands, and children from these unions. The roles the residents fulfilled varied depending upon their individual skills. According to Klos, "Only a few Black Seminoles were bilingual, and those who were became influential in Indian councils. . . . [S]ome were interpreters and advisers of importance, others were warriors and hunters or field hands . . . but even a Black of low status among the Seminoles felt it was an improvement over Anglo-American chattel slavery."[22] Abraham, July, and August, in particular, asserted a high degree of authority as leaders in their Black towns, and they were held in high regard among most Seminoles. As community leaders and valued interpreters, they frequently negotiated on behalf of the Seminoles with Europeans and Americans; Abraham (see fig. 2.2) actually traveled to Washington, D.C., in 1858 with a Seminole delegation, acting as their interpreter (fig. 7.1).

The earliest Black towns were located in the northern and central regions of Florida, particularly clustered around present-day Alachua, Hernando, Leon,

and Levy Counties.[23] In her book *Black Society in Spanish Florida,* Landers's map situates all of the known Black towns, as well as Fort Mose and Negro Fort (fig. 7.2).

Most of the available information on the Black towns of Florida is in the form of archival documents, and the records are more complete for some towns than for others. In 2000, archaeologist Terrance Weik conducted the first, and still only, excavation of one of the Black towns, Pelaklikaha, also known as Abraham's Old Town (fig. 7.3 and number 9 on the map). Pelaklikaha was settled after the 1813 destruction of Chief Micanopy's Alachua villages, and Micanopy is known to have spent much of his time there. Located ten miles east of the infamous Dade's Battlefield in Sumter County and twelve miles south of Okahumpka (Micanopy's village), it is noted for being perhaps the longest occupied of all the Black towns. Archaeological evidence and archival documentation indicate that it existed from 1813 to 1836.[24]

Abraham, "sense-bearer" or confidant to Chief Micanopy, "came as near being 'head chief of the Seminoles' as any at the outbreak of the great Seminole war."[25] He was reputed to be a highly experienced, respected, and influential "chief" in Pelaklikaha and among the Seminoles in general. General Jesup, one

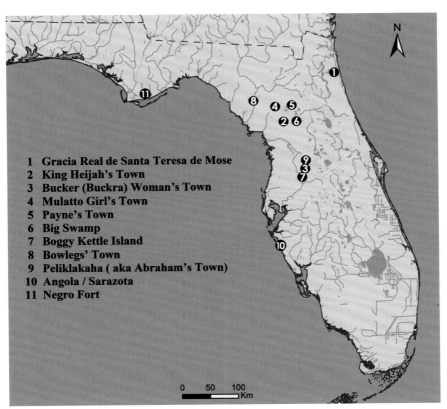

1 Gracia Real de Santa Teresa de Mose
2 King Heijah's Town
3 Bucker (Buckra) Woman's Town
4 Mulatto Girl's Town
5 Payne's Town
6 Big Swamp
7 Boggy Kettle Island
8 Bowlegs' Town
9 Peliklakaha (aka Abraham's Town)
10 Angola / Sarazota
11 Negro Fort

Figure 7.2. Florida's black forts and Black towns show that most were located in north-central Florida. Based on a map by Jane Landers. Map by Chen Yin-Hsuen.

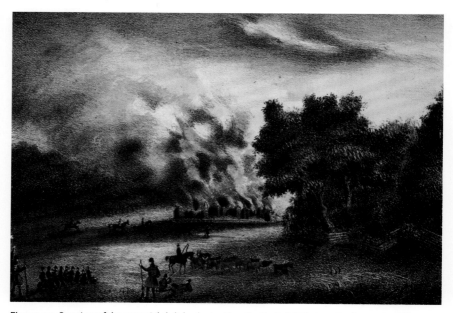

Figure 7.3. *Burning of the town Pilak-li-ka-ha by Gen. Eustis*. Pelaklikaha, also known as "Abraham's town," had served as Abraham's home and headquarters from the 1820s. General Eustis razed the village in 1836 in one of the early military skirmishes. From the Gray & James series of hand-colored lithographs on the war (1837). Library of Congress, Prints and Photographs Division, LC-USZC4–2727.

of several U.S. military leaders charged with eradicating the Seminoles from Florida, described Abraham as "the most cunning and intelligent Negro we have here; he claims to be free."[26] During a trip to Florida in 1826, U.S. Army major George McCall stated:

> On the third day we reached "*Pelahlikaha*" [*sic*]—in English, "Many Ponds." In the midst of these ponds, on a ridge of high "shell-hummock" land . . . there now flourishes one of the most prosperous Negro towns in the Indian territory. We found the Negroes in possession of large fields of the finest land, producing large crops of corn, beans, melons, pumpkins and other esculent vegetables. They are chiefly runaway slaves from Georgia, who have put themselves under the protection of Micanopy . . . to whom, for this consideration, they render a tribute of one-third of the produce of the land, and one-third of the horse, cattle and fowls they may raise. Otherwise they are free to come and go at pleasure, and in some cases are elevated to the position of equality with their masters. I saw while riding along the borders of the ponds fine rice growing; and in the village large corn-cribs well filled, while the houses were larger and more comfortable than those of the Indians themselves. The three principal men bear the distinguished names of July, August and Abram.

We found these men to be shrewd, intelligent fellows, and to the highest degree of obsequious.[27]

Other Black towns include King Heijah's Town, Mulatto Girl's Town, Bucker (Buckra) Woman's Town, Payne's Town, Big Swamp, Boggy Kettle Island, Bowlegs' Town, and Angola. Details of these towns follow.[28] (The numbers appearing next to the towns' names indicate their location on the map in figure 7.2.)

Mulatto Girl's Town (4) was located south of Alachua and was occupied from approximately 1818 until 1823.

Payne's Town (5), located in Alachua County, was an important venue for runaways. King Payne was particularly open to providing a haven for the fugitives and refused to return them when requested at various times by Anglo-Americans. It was occupied from approximately 1790 until 1813 when the residents were burned out. Anglo-American forces wreaked havoc there, destroying 386 dwellings and the large food reserves, consisting of 1,500 to 2,000 bushels of corn.[29] The survivors fled west to form a new community.

King Heijah's Town (2) was located in the area south of present-day Alachua County. It was occupied from 1818 until early 1823.[30] King Heijah (whose name variously appears in documents as Koe Hadjo, Coa Hadjo, and Alligator) was a Seminole war chief (fig. 6.6). Swanton[31] notes that this town principally consisted of Negro slaves.[32] Swanton, who was guided to the Alachua savanna by two "Indian Negroes," reported that "these people, I was told, had never been far from their native settlement, and appeared as shy and ignorant as savages." The term "savages" is undoubtedly is a reference to their allies, the Seminoles.

A Black Seminole named Cudjo was the leader in **Big Swamp (6)**, which was located near present-day Ocala and occupied until around 1840. Big Swamp was associated with Seminole chief Bowlegs (see figs. 7.1 and 6.13), whose town was destroyed by American forces in 1813.

Bucker or Buckra Woman's Town (3), affiliated with Chief Sitarkey of the Alachua Seminoles, was located near Long Swamp, east of Big Hammock (Chocachatti). It was occupied from circa 1818 to approximately 1823. Rivers notes that the town's name may have derived from an African expression for "white man," a pejorative term from the Igbo language that was used by the enslaved in reference to their masters.[33]

Boggy Kettle Island (7), located on the Withlacoochee River, was inhabited from around 1814 until the 1840s. Like Bucker (Buckra) Woman's Town, it too was affiliated with Sitarkey, chief of the Alachua Seminoles.

After the destruction of his Alachua town in 1813, Chief Billy Bowlegs moved west to the Suwannee River and established a new village, also called **Bowlegs' Town (8)**. The majority of allied blacks resided there, farming the fertile soils along the banks of the Suwannee River. Bowlegs's second town was

attacked and burned down in 1818. Many of the survivors—Seminoles, Black Seminoles, and free blacks—fled to the Tampa Bay area where they established yet another Black town, Angola.

The exact location of **Angola (10)** is currently being sought by a multidisciplinary team of scholars.[34] Historical documents indicate that this Black town is likely to have been located in the Sarasota–Tampa Bay area, positioned somewhere near the confluence of the Braden and Manatee Rivers. On old maps this area was designated as "Negro Pointe." This strategic location would have provided Angola's residents convenient access to the Gulf of Mexico, Cuba, and the Caribbean Sea, granting an effective way to receive goods from their British and Spanish allies and providing a safe harbor for oceangoing vessels.[35]

Angola is referred to in some historical accounts as Sarasoat[36] or Sarrazota.[37] The name Angola is also referenced by two Cuban fishermen, who had operated a rancho near there, on their 1824 land claim document.

Historian Canter Brown Jr. called attention to this little-known maroon settlement in his essay titled "The Sarrazota, or Runaway Negro Plantations: Tampa Bay's First Black Community, 1812–1821."[38] Black Seminoles and others—including free blacks, recently self-emancipated Africans, Black Seminoles, and Seminole Indians—resided there from 1812 to 1821. The population may have approximated seven hundred persons.[39] Most residents had arrived in Angola as remnant members of communities such as Negro Fort, Alachua, and the villages along the Suwannee River that were destroyed by Anglo-Americans with the aid of their Indian allies over the course of the First Seminole War. An 1819 report stated that "'the negroes of Sawanne fled with the Indians of Bowlegs' Town toward Chuckachatte [Chocachatti],' north of Tampa Bay and sixty or seventy miles southeast of the Suwannee villages."[40] There they established the maroon community that would become known as Angola. According to Brown,

> the black plantations at Sarasota prospered for several years and in one form or another still were in operation as late as 1821. They proved a magnet for runaway blacks. . . . Pioneer Floridian John Lee Williams wrote of the plantations as they appeared in 1833: "Oyster River at the south-east side of Tampa Bay, was explored for twenty miles. . . . A stream that enters the bay joining the entrance of the Oyster R., on the S.W. was ascended about six miles. The point between these two rivers is called Negro Pointe."[41]

When Angola was destroyed in 1821, some of its residents were killed while others were captured. According to Landers, "several hundred Coweta warriors sponsored by Georgia speculators raided the Tampa Bay and Sarasota Bay settlements and carried northward a number of Blacks, cattle, and horses."[42]

Indian Agent Jno. Crowell issued a report in 1822 listing the names of fifty-nine persons captured at Angola and delineating their status; some captives remained "on hand," others had been returned to their "owners," and the status of a few who had once again escaped was noted as "ran away." The names of two of these captives who "ran away," Scipio Bowlegs and Prince McQueen, also appear on an 1828 list of "foreign Negro slaves" taken into protective custody at Red Bays, Andros Island, Bahamas.[43] These archival documents make it apparent that the two men who escaped from captivity in Angola succeeded in their journey to freedom on Andros Island.

John Lee Williams reported that he saw the ruins of the cabins upon his visit to Angola in 1833.[44] Vanquishing this Black town, which had been the refuge for many blacks, Seminoles, and other freedom seekers since 1813, was an important victory for U.S. forces, General Andrew Jackson in particular, and their Indian allies, the Coweta.

The Black towns associated with the Seminole Indians in Florida were, by definition and example, maroon communities. These communities permitted self-emancipated Africans to enjoy lives of relative freedom as well as the latitude to practice their own cultural traditions and to incorporate new ones learned through contact with their Seminole allies. Recognition of these Black towns as maroon communities is an important step toward dispelling prevailing myths of Africans' docile acquiescence to enslavement in North America and toward illuminating the significance of the alliances created and sustained among the Spaniards, Seminoles, and freedom-seeking Africans in Florida.

Divergent Paths of the Maroons

The alliances forged in Florida between freedom-seeking Africans and Seminole Indians dissolved or were dramatically altered when the majority was forced to relocate west to Indian Territory (fig. 7.4). Upon arrival there, Black Seminoles experienced harsh treatment and threats of reenslavement from some of their former Seminole allies, as well as the Creek, Choctaw, Chickasaw, and other tribes who had preceded the Seminoles to Indian Territory. Feeling unwelcome in their new "home," some of the new arrivals fled to Mexico with Seminole leader Coacoochee (Wild Cat) (fig. 7.5) and Black Seminole leader John Horse (Juan Cavallo) (see fig. 6.9). The Mexican government permitted the freedom seekers to establish yet another maroon community. Nacimiento des los Negros is located just across the border from Texas; it is still occupied by the descendants of the first settlers who refused to follow Wild Cat and John Horse back to Indian territory when those two found Mexico unsatisfactory. After the Civil War abolished slavery in the United States, some of the Black Seminoles residing in Mexico (renamed Mascogos)[45] crossed the U.S. border and, ironically, became the warriors known as the Seminole Negro

Figure 7.4. *Sorrows of the Seminoles.* Many Seminoles were placed on ships to make the journey west to Texas and then to Oklahoma. The nineteenth-century engraving depicts the deportation of the Seminoles from Florida. Courtesy of State Archives of Florida, *Florida Memory.*

Indian Scouts, famous for battling Indians on behalf of the U.S. government (fig. 7.5). Brackettville, Texas, is home to their proud descendants, who celebrate the Scouts in an annual parade and ceremony.

Unsuccessful in their repeated efforts to remove the estimated two hundred Seminoles and their Black Seminole allies who remained concealed in the swamps of South Florida, U.S. government forces decided to cut their losses and leave them there; they were no longer considered a viable threat to the settlement of Florida. Their descendants became the present-day Seminole Tribe of Florida, Inc., and the Miccosukee Tribe of Indians of Florida. A few Seminoles and their Black Seminole allies had also fled into Florida's interior; Polk, Levy, and Hernando Counties are home to their descendants today.[46]

An estimated 200 to 250 others skillfully evaded the pattyrollers' and U.S. military's efforts to capture them; they fled Florida and landed on Andros Island, Bahamas, beginning in 1821. There they established a maroon community, Red Bays, on the unoccupied northwestern shore of Andros Island. In the 1920s the original population was forced to relocate a few miles south to Lewis

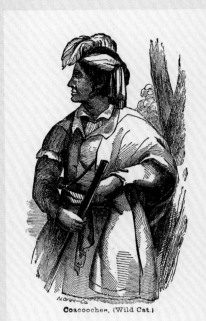

Figure 7.5. *Coacoochee or Wildcat*. Engraving by N. Orr for Joshua Giddings's *Exiles of Florida*, based on Orr's own 1848 engraving (*left*) and John Jefferson (*right*). The Black Seminole leader Coacoochee along with John Horse led some of the relocated Seminoles from Texas to Mexico, where the Mexican government permitted the freedom seekers to establish the maroon community Nacimiento des los Negros. The two found Mexico unsatisfactory and returned to Indian Territory, but some refused to follow them back to the United States. Ironically, after slavery was abolished in the United States, some Black Seminoles in Mexico recrossed the border and assisted the United States government in fighting Indians. John Jefferson, shown in his military uniform, was the grandson of John Horse. *Wildcat* engraving from the P. K. Yonge Library of Florida History, Department of Special and Area Studies Collections, George A. Smathers Libraries, University of Florida. Jefferson photograph courtesy of UTSA Libraries Special Collections.

Figure 7.6. Although a few Black Seminole descendants are still in Florida, most are scattered in Mexico, Texas, Oklahoma, and Andros Island in the Bahamas. In 2012 a number of Black Seminoles met at the National Underground Railroad Conference in St. Augustine. Fred Payne of Mexico, John Griffin of Florida and Dub Warrior of Texas pose with author Rosalyn Howard.

Coppitt[47] due to repeated incidences of death and destruction inflicted on their community by powerful hurricanes. Lewis Coppitt was renamed Red Bays circa 1960s and today it is home to approximately three hundred descendants of the original settlers who proudly declare their Black Seminole heritage. Their oral history recounts their ancestors' courageous sojourn through the swamps and keys of Florida and across the formidable Gulf Stream. There, on Andros Island, the Florida maroons finally reached their "promised island."[48]

Notes

1. Bilby, *True-Born Maroons*; Thompson, *Flight to Freedom*; Craton, "Forms of Resistance to Slavery"; Willis, "Divide and Rule."

2. Bilby, *True-Born Maroons*; Weik, "Freedom Fighters"; Hadden, *Slave Patrols*; Gottleib, *The Mother of Us All*; Porter, *Black Seminoles*; M. C. Campbell, *Maroons of Jamaica*; Aptheker, "Maroons within Present Limits"; Kent, "Palmares."

3. Kent, "Palmares."

4. Forbes, *Africans and Native Americans*, 63.

5. Aptheker, "Maroons within Present Limits."

6. See also Hadden, *Slave Patrols*.

7. Weik, "Archaeology of Maroon Societies" and "Freedom Fighters"; R. Howard, *Black Seminoles in the Bahamas*; Landers, *Black Society in Spanish Florida* and "Traditions of African American Freedom and Community"; Porter, *Black Seminoles*; Ogunleye, "Emancipated Africans."

8. Aptheker, "Maroons within Present Limits," 165.

9. Landers, *Black Society in Spanish Florida*; Deagan and MacMahon, *Fort Mose*.

10. Deagan and MacMahon, *Fort Mose*.

11. There were 145 free Africans and 86 Indians. Landers, "Free and Slave," 96–97; Deagan and MacMahon, *Fort Mose, 37*.

12. Schafer, "Yellow Silk Ferret," 85.

13. Porter, *Black Seminoles*.

14. Hadden, *Slave Patrols*; Giddings, *Exiles of Florida*.

15. Guinn, *Our Land before We Die*, 34.

16. Cohen gleaned this information from a manuscript penned in 1821 by then Indian agent J. A. Peniere to General Andrew Jackson, in Cohen, *Notices of Florida and the Campaigns*, 46.

17. These Africans and their descendants have variously been called Seminole Negroes, African Seminoles, Seminole Maroons, Exiles, Afro-Seminoles, Black Indians, Black Muscolguges, Mascosgos, Estelusti, and Self-Emancipated Africans.

18. Porter, *Black Seminoles*.

19. Rivers, *Slavery in Florida*, 196.

20. Ogunleye, "Emancipated Africans"; Mulroy, *Freedom on the Border*; Price, *Maroon Societies*; Riordan, "Seminole Genesis."

21. "Captured" is the term used to refer to blacks who were liberated from plantations on raids conducted by Black Seminoles and Seminoles in Florida. They have also been called the *Estelusti*.

22. Klos, "Blacks and the Seminole Removal Debate," 131.

23. Weisman, *Unconquered Peoples*. According to an 1832 map, these counties were located in the area designated as Alachua County.

24. Weik, "Freedom Fighters"; Landers, *Black Society in Spanish Florida*.

25. Swanton, *Early History of the Creek Indians,* 400.

26. Quoted in Giddings, *Exiles of Florida,* 138n.

27. In Herron, "Black Seminole Settlement Pattern": 40–41.

28. Mykel, "Seminole Towns."

29. Guinn, *Our Land before We Die,* 34.

30. Landers, *Black Society in Spanish Florida,* 236.

31. Swanton, *Early History of the Creek Indians.*

32. Ibid., 47.

33. Rivers, *Slavery in Florida,* 197.

34. A multidisciplinary research project titled "Looking for Angola" was launched in December 2004, initiating the search for a second Black town. Archaeological shovel testing commenced in several locations in the Sarasota region near the confluence of the Braden and Manatee Rivers in December 2004. "Looking for Angola" is being conducted by a group of scholars including an historian, historical archaeologists, a cultural anthropologist, a nautical archaeologist, and a public school educator. Baram, "Haven from Slavery"; R. Howard, "Black Seminole Diaspora" and "'Wild Indians' of Andros Island"; Canter Brown, "Tales of Angola," *Florida's Peace River Frontier,* and "The 'Sarrazota.'"

35. Brown, "The 'Sarrazota.'"

36. See Landers, *Black Society in Spanish Florida,* 236.

37. Brown, "The 'Sarrazota.'"

38. Ibid.

39. Ibid.

40. Porter, *Black Seminoles,* 25.

41. Brown, "The 'Sarrazota,'" 8.

42. Landers, *Black Society in Spanish Florida,* 237.

43. Bethell 1828 London Duplicate Despatches. In D. E. Wood, *A Guide to Selected Sources for the History of the Seminole Settlements at Red Bays, Andros 1917–1980. Appendix* 10 (Nassau: Dept. of Archives).

44. Williams, *The Territory of Florida.*

45. Mulroy, *Freedom on the Border;* Porter, *Black Seminoles.*

46. Mabel Sims and John Griffin, personal interviews.

47. "Coppitt" is Bahamian vernacular for the word "coppice," defined as a densely wooded area.

48. Howard, *Black Seminoles in the Bahamas* and "Promised Is'Land."

8

From Florida to Veracruz

The Foundation of San Carlos Chachalacas

Sagrario Cruz-Carretero

On September 3, 1763, more than six hundred people, both military and civilian, embarked from San Miguel de Pensacola in West Florida to sail to Veracruz in New Spain. Bad administration and budgetary frauds in the Pensacola Spanish government and its jurisdiction in West Florida helped to bring about the British occupation in 1763. After the commercial and military overthrow, Spaniards in Florida began to migrate to the most important Spanish Gulf-Caribbean commercial centers, taking with them a few faithful Indians, free Africans, and black slaves. In February 1765 a party of forty Yamasee Apalachino Indians and black families from the villages of Escambe and Punta Rasa, near Pensacola, settled in the present-day Mexican state of Veracruz in San Carlos (1765–1814), an "Indian town" inhabited by blacks.[1]

San Carlos Chachalacas was established in precolonial times, but almost all the original inhabitants had succumbed to disease introduced by Spaniards during the sixteenth century. The few indigenous survivors were relocated nearby. The process of repopulating San Carlos in 1765 as an "Indian town" with African descendants from Florida was a convenient policy of control by the Spanish government, which considered the Floridians as uprooted and problematic neighbors. The policy of creating new "Indian towns" also made an African descendant's identity in New Spain society vanish. After more than two centuries since the founding of San Carlos, this chapter pays tribute to all those blacks and Indians who came from Florida and became part of my country, forming a multiethnic and multiracial Mexico.

In this chapter I address the establishment of San Carlos, the circumstances of how this group left Florida, why they wanted to return to Florida, and how they ultimately remained in New Spain. The history of San Carlos speaks to a broader set of issues about how black populations in eighteenth-century

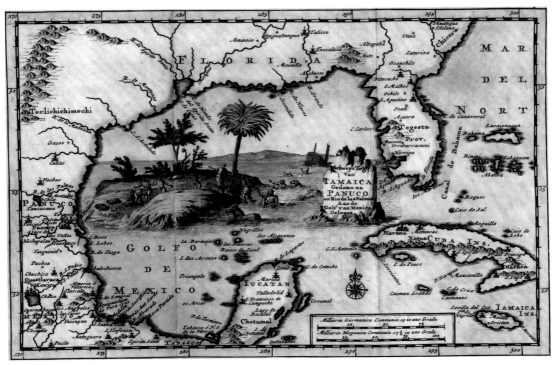

Figure 8.1. Map of the Gulf of Mexico by Pieter van der Aa. Commerce and history once tied Spanish colonies around the Gulf of Mexico and the circum-Caribbean area together. The eighteenth-century map showing the Gulf suggests how close Havana, Pensacola, and Veracruz were. Pensacola was part of a commercial web including not only British colonies but also Spanish Veracruz, French Louisiana, the Caribbean islands, and the northern coasts of South America, leading to more and more British control. From the P. K. Yonge Library of Florida History, Department of Special and Area Studies Collections, George A. Smathers Libraries, University of Florida.

Mexico worked within the colonial structure and its categories of ethnicity, race, and caste.[2]

From Florida to Veracruz

When the 1763 Treaty of Paris transferred possession of Florida from Spain to England, authorities from both nations took charge to facilitate the migration of citizens and subjects of the Spanish Crown to various destinations. Almost four thousand Spaniards went to Havana, and to Campeche and Veracruz in the Gulf of Mexico (fig. 8.1). As a result, vast portions of Spanish Florida between the Mississippi River and the Florida peninsula, including those portions now referred to as "The West Florida Parishes" of Louisiana,

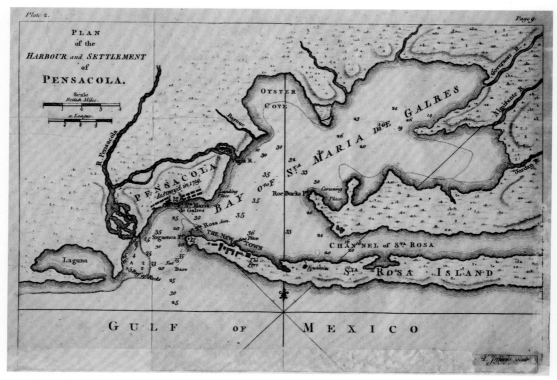

Figure 8.2. *Plan for the Harbour and Settlement of Pensacola*, by Thomas Jefferys, 1763. When the British took over the military fort and prison at Pensacola, Native Americans, Africans, and people of mixed descent were evacuated by way of the Gulf of Mexico to Veracruz. From the P. K. Yonge Library of Florida History, Department of Special and Area Studies Collections, George A. Smathers Libraries, University of Florida.

the lower portions of Mississippi and Alabama, and what is now known as "The Panhandle" in Florida, were left isolated.

Several military prisons located in this region had served as buffers to deter conflict between several groups of the Creek Nation and the Spaniards. When the British took over the military fort and prison in the villages of Escambe and Punta Rasa, Native Americans, Africans, and people of mixed descent began their voyage by way of the Gulf of Mexico (fig. 8.2). In addition to this mixed band, several Spaniards and *criollos* (Spaniards born in the Americas) released by the British from the military prison of Pensacola joined the group. Among the reasons for the emigration was the ruinous state of the military prison, but there were also conflicts among the various coexisting groups—converted and not converted Indians, the Spanish, the English, and the French.[3]

The Florida Indians who had not converted to Christianity remained behind to claim their lands. In fact, they preferred English occupation because the British did not sell them adulterated products, did not beat them, and did not try to evangelize them as the Spanish had.[4]

Converted Indians, whom the Spanish had led to conversion as early as the sixteenth century, sought Spanish protection. These Indians shared many cultural traits with the Spanish. In some ways they seemed to live the Spanish way of life, observing the Catholic faith, bearing Spanish names and surnames, and dressing in the manner of the Spanish. At the same time, however, they maintained cultural differences. Among a variety of differences, foodways, subsistence activities, architecture, settlement patterns, social organization, hunting, hunting ceremonies, fertility ceremonies, tribal chiefdom structure, and the organization of young soldiers into sodalities can be noted. When those Indians who emigrated with the Spanish settled down in New Spain, these cultural traits resulted in cultural shock.[5]

Among the more than six hundred people who embarked from San Miguel de Pensacola on September 3, 1763, were civilians, all the military troops, and the governor of Pensacola. When they arrived at Veracruz City, the great majority of the military migrants were recruited for the war against England; the remaining Spanish civilians settled in Antigua Veracruz (Old Veracruz City) and the present city of Veracruz. Another boat with hundreds sailed to Havana. Another vessel with forty black Indian families left at a later date, its destination Veracruz. Many died in the journey. Only twenty-two of the last forty families arrived safely in Veracruz. The official report did not mention the causes of death. Moreover, the Florida black Indians were victims of robbery and were thus deprived of their belongings during the voyage. A year later, the black Indians received a small compensation provided by the Spanish government; but the fugitive thieves were never captured.[6] It is interesting to note that among the persons emigrating from Florida was the Santa Anna family, ancestors of Antonio López de Santa Anna, who decades later held the powerful position of president of Mexico.[7]

After fifteen months of residing in La Antigua, Veracruz, the Florida immigrants settled in San Carlos, a new community organized for them under the direction of the viceroyalty. Toward the end of 1765, the men received documents to assert legitimate possession of their land and permits for constructing houses and other buildings. The town, located twenty-four miles from La Antigua, had a plaza, a city hall, and a church. The construction of these was a significant expense for these black Indians, whose funds had been greatly reduced.[8] While the men built the town, the women and children remained in La Antigua.[9]

Founding an "Indian Town"

San Carlos was constituted as an "Indian town" in 1765. There was a limited presence of Spaniards and indigenous population, if any, in its makeup. However, *pardos* (browns) and mulattoes did not reject the Indian town

organization but accepted it as an institutional structure that went beyond the interests of race or ethnicity.[10] The self-sufficient dynamics of Indian towns established links with the dominant Spanish system by means of paying taxes, work, property conflicts, and jurisdiction. All of these were collective problems for Indian towns.

The history of Indian towns in Mexico had been complex and dynamic, with multiple changes in political, social, economic, and spatial configurations. During the sixteenth century, the first century of Spanish colonization, changes were introduced. An elite class or group was created. New Indian towns were formed due to a demographic collapse and its consequences. The centralization of towns in the early colony consisted of a *cabecera* (capital of the county) that functioned as nominal nucleus for the region.

After the demographic collapse of the sixteenth century, towns could not continue with their regular functions, so remnant populations were merged with those of other surviving towns, and some thus lost their ethnic identity as "Indians." At this same time, a great number of African slaves were brought to work in the cattle haciendas and in the coastal zones. Africans mixed with Indians and Spaniards in such a way that by the eighteenth century the lowlands of Mexico were inhabited by a population with a majority of blacks, *pardos,* and mulattoes. This population settled down on a variety of colonial properties such as the royal towns, congregations, and cattle and agricultural haciendas. At the end of the eighteenth century most of these rural, racially diverse workers did not have permanent residences or property. Especially in the coastal zones, gangs and vagabonds were problematic for the colonial administration. Banditry was rampant, and fugitive slaves were a problem as well. The conformation of Indian towns with heterogeneous populations, predominantly *pardos* and mulattoes, guaranteed a sense of belonging for the inhabitants, but for the administration it provided some means of control over their residents and a way to extract tribute.

During the seventeenth and eighteenth centuries, the development of the colonial system gave way to a decline of these competitive centers, the fragmentation of the old Indian towns, and the incorporation of new ones with communal lands. By the end of the colonial period, the Indian towns had become "congregations" or settlements with few inhabitants. This resulted in conflicts between *cabeceras* and the small satellite settlements that had developed into new Indian towns and congregations. Although they were diminished in political importance, Indian towns continued to support the Spanish colonizers through taxes and labor force.

The church gave unity to the towns, providing the only ritual images of local saints as well as a symbolic pattern that became the axis of the community's union and identity. At the same level, *cofradías* (brotherhoods that honored a particular saint) favored the union of the old and new and provided a sense of

belonging to both. Such brotherhoods are evidence of religious syncretism in which the transformation of identity changes from the pre-Hispanic cult and to the cult of local Catholic saints.[11]

From the end of the seventeenth century and into the beginning of the eighteenth, towns were substantially compact settlements with a central church and plaza. As populations moved, new towns were created, as demonstrated by this case study. The requirements for founding a town were (1) a minimum of eighty families (although this number was not always reached); (2) provision of an adequate building for the church; and (3) providing good reasons to become independent (for example, poor communications with the *cabecera* or town hall). The territorial demarcation for the new towns was established according to traditional measures of endowment following legal dispositions avoiding conflicts with authorities and neighbors.[12]

The colonial governmental system followed a policy of repopulating the hot lowlands creating "Indian towns" inhabited by descendants of Africans, the great majority being mulattoes or *pardos*. In addition, a few Indians who were not natives from the regions, migrants whose original ethnic backgrounds had already disappeared in the sixteenth century, were relocated to such places. Also rootless groups like the black and Indian mixes (who were not accepted in the formal groups of their parents and thus had no right to inherit the land) and Ladinos (acculturated Hispanic Indians) helped to repopulate the region. The result was the dilution of the Indian phenotype and the associated cultural characteristics. Founded at the end of the seventeenth century and into the eighteenth, these new towns shared common characteristics. Among the shared traits was the function of the church as center of political and social organization and as a means for consolidation after demographic recovery. During the eighteenth century, however, the newly created towns such as San Carlos did not have the Indian background associated with the older towns.

Similar to other Indian towns, San Carlos was established by migrants, was founded with the formation of a church, and occupied isolated land where the demographic collapse of the sixteenth century had been drastic.[13] The social differences between Indians and castes that populated these new Indian towns were vague. Characteristics of the caste system made it ambiguous and heterogenic. Thus, people frequently pretended to belong to or to be members of another caste if it was convenient, especially for evading taxation.

The people who founded San Carlos were classified as members of castes, and the ethnicity of its inhabitants was doubtful and not well defined. In addition, they did not belong to any Indian towns that had previously been established in Florida. It is known that non-Indian people were classified as "Indians" when they settled down in a town or when they became members of the town hall, governors, or *caciques* (chiefs). That is to say, as the historical documents of San Carlos suggest, they established an Indian governmental

structure without being Indian.[14] What were collective motivations for constituting an "Indian town"? These motivations included the acquiring of a territorial base, the consolidation of a political structure, having means of survival through the increment of population, but mainly, making legitimate claims over land.[15]

Reproduction of the model for an "Indian town," while being populated by caste members, was something natural due to the existence of indigenous antecedents in the involved population and due to the implication of political privileges. Spanish authorities considered the promotion and foundation of Indian towns inhabited by caste members convenient. If not, they risked losing control over these segments of the population. Classification by race during the eighteenth century had already proved to be an inoperative form of control. Groups such as *cofradías*, mulatto and *pardo* militias, as well as towns of Indians proved to be the best forms of control over castes.[16] In addition, the colonial government increased the number of taxpayers, maintaining constant records of the inhabitants.

Due to the suffocating control over the inhabitants of these Indian towns, many residents left. This is precisely what seems to have happened in San Carlos, leaving it almost isolated.[17] During the eighteenth century, the constant migration and circulation of rural Indian populations and members of castes moving to urban centers and vice versa makes it impossible to establish clear social limits between caste members and Indians in the lowlands of the Gulf of Mexico.

San Carlos: Floridians in New Spain

The abrupt emigration from Florida into New Spain, difficulties in adapting to the new land, and pressures on the people of San Carlos to afford payments demanded by the church and government provoked a tense situation among its inhabitants. As a result they petitioned the Spanish king on several occasions to return to Pensacola.

A special relationship seems to have existed between the San Carlos population and Carlos III of Spain. Letters of the period indicate that the San Carlos inhabitants described themselves as "families inflamed by love to the sacred Catholic religion, and to the King." The documents also assert that the people of San Carlos were in the service of the armed militias and that they had been dedicated to hunting while in Pensacola. Because they were poor, had special privileges from the Spanish Crown, and had lost all of their goods and properties in Florida,[18] they continually demanded exemption from tax payments.

In Florida, the migrants had lived in small settlements dedicated to farming.[19] They had made canoes and rafts from tree trunks. Some were leather tanners and made chamois from skins. They had also built wood fences. Some

migrants had been *trapicheros* (small sugar and alcohol factory workers) and produced *piloncillo* (brown sugar).[20] Some women had gathered clams, an activity that was continued in San Carlos.[21]

San Carlos was surrounded by extensive forests of precious wood. Communal land had to be cultivated equally by all the inhabitants, but tracts of land were distributed to each family for housing and cultivation. However, they had poor agricultural harvests during the first years of settlement. Agricultural activity by the immigrants came into conflict with the interests of neighboring *haciendas*, their landowners, renters, and tenants. Ranchers frequently voiced disagreements with the presence of the San Carlos residents.[22]

When the Florida immigrants began to raise cattle, thus in direct competition for grasslands with the *hacienda* and ranchers, complaints by neighboring settlers grew even stronger. Landowners threatened the San Carlos people by trying to charge rent for use of grasslands. When San Carlos animals invaded *hacienda* lands, the *haciendas* threatened to confiscate the cattle. But they were not successful in the practice of cattle raising as well.

The Florida immigrants also practiced hunting wild animals and feral cattle, activities that supposedly affected the cattle of the landowners. Having always been hunters and gatherers, the San Carlos people did not easily adapt to the sedentary customs of the Spaniards.

San Carlos inhabitants had been assigned as watchmen and guards to protect the coast, which was often besieged by the English enemies. This too, however, was a bone of contention with their neighbors. Their activities as watchmen and guards gave them the right to bear arms. But they also seemed to be involved in the introduction of contraband goods. In addition to having the privilege to raise cattle and being exempt from paying taxes, the inhabitants of San Carlos had concessions to hunt, to fish, and to navigate canoes downstream in the lower part of the Chachalacas River. Nevertheless, these concessions were constantly violated by the Spanish authorities, which caused the San Carlos inhabitants to present complaints formally before Carlos III.[23]

A significant personality trait others associated with San Carlos inhabitants was what was perceived as their unmanageable personality. For example, the mayor of La Antigua (Old Veracruz) made constant requests for servants from San Carlos. Such petitions were never attended to because of the categorical refusal of the population to be servants, no matter what the consequences of their refusals.

From the beginning of their arrival to the New Spain territory, the Floridians had problems, pressures, and quarrels with neighbors stemming from their having previously been elected as "guard and protector of the Christian Indians of Pensacola." In San Carlos "the town of tributary Indians" had to abide by a set of eleven instructions. These instructions implied being alert to the defense of La Antigua (Old Veracruz) in case of invasion and the capture

of smugglers.[24] In addition, people from San Carlos were obliged to construct fortifications and wooden fences for the protection of their settlement.[25] They were also committed to watch that strangers did not enter into the town, including Spaniards, blacks, or *mestizos*. San Carlos inhabitants had orders to capture any marauding suspects within the zone, the town, the river, or the road. It was illegal to give refuge to runaway slaves or deserters, which they were to turn over to Spanish authorities in La Antigua Veracruz.

San Carlos acquired a semi-autonomous status similar to that of other free Black towns such as San Lorenzo de los Negros and Santa Maria Guadalupe de los Morenos de Amapa.[26] Strict observance of moral and good behavior was demanded of the San Carlos population. Marriage to outsiders was encouraged in order to guarantee that such newcomers remained in the town to increase its population density. Exemption of tax payment was permitted during the process of "adaptation" to the new habitat so they could contribute to their own subsistence and to the local market. A common account was set up for the profits coming from harvests of communal land. Nevertheless, the harvests were deficient, and poverty increased during the second half of the eighteenth century.[27]

In 1766 the economic and agricultural crisis was so severe that the San Carlos inhabitants wrote to the king of Spain requesting permission to return to Florida. Their resolution to return was especially emphatic when José de Gálvez recovered Florida for Spain in 1781. However, the king of Spain never authorized their return. At any rate, the poverty in which the San Carlos inhabitants lived made the trip back "home" an economic impossibility.

The first two harvests (1765–66) were insufficient to support the population. During the first year, they had to deal with bad climate and a locust plague.[28] Agricultural traditions had not been very rooted in the San Carlos migrant community. In Florida they had practiced agriculture only in the cultivation of individual family plots. As a result, once they established San Carlos, communal fields were neglected and were often invaded by animals. Although agricultural production increased in 1767, the living conditions of the people of San Carlos still were deplorable.

In spite of adversity, the San Carlos inhabitants survived and continued with their assigned functions as coastal watchmen and as a defense for the region. Several times authorities requested neighboring landowners to exercise patience and tolerance with the San Carlos "Indians," arguing that the migrants had decided to continue being faithful subjects to the king of Spain and to follow the Catholic faith. Besides, they lived in poverty and they had an important duty as protectors and watchmen of the Veracruz coast. Authorities demanded that the landowners permit free use of San Carlos communal lands, and the bishop of Puebla agreed to cover the expenses of the church to help the people of San Carlos.[29]

In 1773 the viceroy authorities were accused of concealing the occupation of San Carlos within the limits of a *mayorazgo* of La Higuera—a huge property that historically could not be divided or sold. It could only be increased by extension and inherited by primogeniture. The heir of this *mayorazgo* demanded the immediate evacuation of the settlement by arguing that a *mayorazgo* could not be sold or partitioned. It had to be preserved as a unity of land. In addition, exigencies of tax payments and obligated financial support to the church drove the population of San Carlos away. They dispersed in an irregular way toward the hinterland.

The population of San Carlos had been reduced by emigration, but disease also played a role. In 1780 a smallpox epidemic left only five surviving families within San Carlos town limits.[30] The reduction of population continued, although the number of inhabitants is vague. Dispersion and death, combined with a weakened social structure of these few remaining inhabitants, along with the litigation over lands, were used as pretext for the authorities and the church to request in 1782 the relocation of the diminished San Carlos population to two communities—Carretas and Monte Grande. These new towns offered a compact settlement pattern and facilitated the church's assistance. Otherwise, they could have continued living in San Carlos but under the precept to form a compact pattern. It had been stipulated that everyone was free to live where they pleased, but not without God, judge, religion, government, and police.[31]

The intended relocation of the San Carlos population was planned for a section of a vast neighboring land compound, the Hacienda Acazónica, property formerly held by Jesuit friars who had been expelled in 1767. The property had been confiscated and was currently under control of the General Treasurer of Royal Property. The priest of La Antigua (Old Veracruz), who presided over religious services for San Carlos, insisted on the relocation of these "Indians" from San Carlos to the town of Carretas. However, the presence of these Florida immigrants was an annoyance to those already living in Carretas, who perceived the Floridians to be undesirable neighbors. The San Carlos people alienated the renters of the land that had been left by the Jesuit friars, causing economic losses to the government.[32] Apparently the relocation never took place and San Carlos survived into the new century. In 1814, in the heat of the war of independence, royalists set fire to San Carlos.[33] Until that year, San Carlos was recognized to be inhabited predominantly by blacks that presumably joined the independent insurgents, becoming enemies of the Spanish government, and thus giving reason for the royalists to burn the town.[34] Survivors of the fire then migrated to La Antigua Veracruz, San Isidro, in the municipality of Actopan, Paso de la Palma, and Las Higueras, in the municipality of Vega de Alatorre.[35]

References to the town after the fire are vague. We know that the people

who came from Florida and inhabited San Carlos suffered in Veracruzan lands—something that seems to be a common experience for all refugees through persecution, discrimination, and intolerance. The people of San Carlos defended "living in freedom," a phrase repeated constantly in the historical documents, which denotes their indomitable spirit.[36]

The presence of these migrants from Pensacola was threatening to San Carlos's surrounding neighbors in spite of the fact that blacks and Indians never represented a high level of competition to agriculture and cattle production in the New Spain market controlled by Spaniards.

Racial Identification: A Black "Indian Town"

The racial composition of these families is not clear, because race was obscured in the historical documents. Spanish authorities reported in documents about the foundation of the town that the inhabitants of San Carlos were Yamasee, Apalachino, Talapuce, and Apizca Indian migrants from Florida and that they depended on agriculture, although they relied more on hunting, fishing, and gathering. The 1770 census indicates that the town of San Carlos was founded by forty-seven Yamasees and Apalachinos, as well as some Spanish and *criollos* (soldiers who had married Indian wives or were widowers of Indian women and who lived among the Indians).[37] Twenty *criollo* men from Florida who were married to Indians, Spaniards, and/or mulattoes were noted. In summary, by 1770, even though the population was decidedly heterogeneous in racial composition, it was classified as an Indian town.

Eleven years later, the 1781 census shows the dynamic mobility of population into towns: the population of San Carlos is referred to as being made up of forty-eight racially heterogeneous people, including Indians, *mestizos* (mixed-race people), black mixed-race people called *pardos,* and mulattoes.[38] Although its inhabitants belonged to other racial groupings and were predominantly black, San Carlos was again registered as an "Indian" community.

Pensacola had had military troops of *pardos* and mulattoes, who had been dismissed during the 1763 migration. Some of them, who probably lived temporarily in Cuba, had collaborated heroically when José de Gálvez recovered Florida from the English in 1781. They were able to recuperate their old properties in Florida. Their bravery was recognized in ceremonies. They were given military awards. They were also granted compensation for having suffered outside their land for so many years.[39] However, black, *pardo,* and mulatto militiamen who lived in San Carlos and had been part of the dismissed squadron from Pensacola in 1763 never had the opportunity to return to Florida.

In 1769, José de Gálvez, the Mexican viceroy, decided to include all blacks, mulattoes, and castes living in diverse cities and towns as taxpayers. The *matlazáhuatl* (smallpox) epidemic throughout New Spain had decreased the

population and at the same time had reduced the number of taxpayers. Indians were also among the taxpayers. Only women were exempted from the payment of taxes. In 1781, however, an exemption order was extended to caste members who enlisted in the militia regiments of San Carlos as watchmen of the Veracruz coast.[40]

The San Carlos military census of 1799 referred to fourteen *pardos*, two whites, three *mestizos,* and two children, whose race was not mentioned.[41] Notably missing in these figures are Indians within the San Carlos population at that time. What is the implication of this when San Carlos had been known as an "Indian town"? Considering the high level of Indian mortality, one possibility is that more Indians had originally populated the town but that their numbers were eventually diminished. At the same time, colonial legislation tended to oversimplify a complex social structure that at the end of the eighteenth century was characterized by diffuse racial frontiers. Being Indian had at least one meaning at that time: it implied belonging to one of the settlements known as "Indian towns," which presumably inherited political groups of natives from the years of the conquest. Were they defined with that term only for legal aims, or in opposition to Spaniards and to other groups?[42]

There were Indians that were not controlled by the authorities and that were thus excluded from census, payment of taxes, and other duties and activities associated with the social and political structure of the town. Those groups of Indians were more acculturated to the Spanish standards with diffuse legal positions, and they did not classify themselves as Indians. Functionally, they could not be classified as Indians.

Definitions of race and caste were problematic. Black mixture categories were non-operative. Frequently such categories were ambiguous and inadequate in defining the complex racial and cultural composition of the end of the eighteenth- and early-nineteenth-century colonial society. The position of an individual in this scheme corresponded to socioeconomic status and statistical appreciation more than to racial classification. *Pardos* conformed a very heterogeneous racial group and could not be classified in terms of racial origin because they were registered as taxpayers or as members of the coastal militia.

In the case of the Indians, their status was determined according to the type of social structure aggregation, for example, "Indian town." In spite of being a term for racial classification, it was the social classification of the inhabitants of New Spain conformed by undefined groups who "lived" their social condition, which was not exclusively defined by their racial ascendance. It was determined by their lack of social or institutional links. These "undefined groups" included people from all racial or ethnic groups and who had different economic positions denominated as castes. It was the first attempt of racial classification applicable to those who were neither Indian nor Spaniard. Those who did not have a socioeconomic identification were associated with people

of negative social position—such as delinquents, fugitives, maroons, vaga-
bonds, urban pariahs, and beggars. In the coastal area, where San Carlos is
located, the great majority of these people without structural-social connec-
tions belonged to the castes; that is, they were the racially mixed population
with African ancestry.

During the eighteenth century, the acquisition of a social-structural iden-
tity was the usual strategy for survival. Originally, Indian towns developed
as important political bodies with a territorial base whose origins could be
traced back to their precolonial histories. These political units were preserved
during the initial time span of colonization through institutions such as the
encomienda, a forced Indian labor system justified as necessary to carry out the
Indian conversion to Christianity and for the offering of religious instruction.
Likewise, the precolonial town called *altepetl* in Nahuatl was reestablished dur-
ing the early colonial period, and the ancient *tlahtoque,* a political structure or
chiefdom governed by an *Indio cacique* (Indian chief), continued as the power
structure system of early colonial Indian social organization. Continuity can
be seen in symbolic and ceremonial aspects, including Indian power structure
institutions, which were essential for the transition for effectively and effi-
ciently forming full-fledged colonial government.

Conclusion

Because they were members of castes, the inhabitants of these "Indian towns"
had no ethnic identity. While historical documents may clarify their identities,
the fact remains that historical texts refer exclusively to the Indian character
of the population of San Carlos, omitting entirely the town's African origins.

The invisibility of these Florida emigrants is still prevalent today in the his-
tory of San Carlos. By official decree, on November 13, 1930, the town of San
Carlos was upgraded to the category of village and changed its name to Úrsulo
Galván, after the agrarian movement leader who had been born in the town.
Historical references of the municipality mention the town as having been
founded by Spaniards and a minority of natives from Florida, but they do not
make any reference to the black presence as contributors to the local history.
Mexico has been acknowledged as an indigenous and Spanish country, but the
contribution of the third root, the African descendants, and their participa-
tion in the construction of the nation is almost ignored. San Carlos and the
African descendant population who founded the town are examples of this
omission.[43]

Notes

1. "Indian town" is a legal term for a settlement of "non-Spaniards" inhabited by Indians or African descendants in colonial times. San Carlos Chachalacas is thirty miles north of Veracruz City, in the central part of the state of Veracruz along the Gulf of Mexico. See figure 8.1.

2. Castes were socio-racial system of categorization that enabled the segregation of mixes between blacks and indigenous people, and sought to favor the hegemonic, or dominant, group made up of Spaniards and their descendants. According to the law, access to privileged posts in the church and the military was limited for castes considered to be inferior. There were even attempts to forbid members of these castes to use certain modes of dress and ornamentation with jewelry. For example, *rebozos* (shawls) and *mantones de manila* (embroidered shawls) were for the exclusive use of Spanish women. Also, bearing arms, horseback riding, and literacy were not permitted for inferior castes.

3. García de León, "Indios de la Florida," 107–9.

4. Ibid., 107–9.

5. Ibid., 110.

6. Gold, "Conflict in San Carlos," 3.

7. García de León, "Indios de la Florida," 111. Antonio López de Santana was president of Mexico eleven times from 1833 to 1855. He is remembered in Mexican history for the war with Texas in 1836 and the loss of half of the Mexican territory that bordered the United States during his government. Santana was named after his grandfather, who was a distinguished member of the Dragon regiment that fought against the British in Pensacola in 1763.

8. Gold, "Conflict in San Carlos," 5.

9. Archivo General de la Nación [hereafter AGN] Tierras, vol. 1085, exp. 2, fojas 23–24.

10. García Martínez, "Pueblos indios, pueblos de castas."

11. Ibid., 107.

12. Ibid., 108–9.

13. Ibid.

14. AGN Tierras, vol. 1085, exp. 2, fojas 1–42.

15. García Martínez, "Pueblos indios, pueblos de castas," 113.

16. Ibid., 114.

17. AGN Tierras, vol. 1085, exp. 2, fojas 1–42.

18. AGN Tierras, vol. 2780, exp. 11, fojas 169–169va.

19. García de León, "Indios de la Florida," 112.

20. AGN Tierras, vol. 1085, exp. 2, foja 3.

21. AGN Tierras, vol. 1085, exp. 2, foj 37va.

22. AGN Tierras, vol. 2780, exp. 11, foja 168va.

23. AGN Tierras, vol. 2780, exp. 11, fojas 171–171 va.

24. AGN Tierras, vol. 2780, exp. 11, foja 169va.

25. García de León, "Indios de la Florida," 115.

26. Now known as Yanga, San Lorenzo de los Negros had been founded by runaway slaves commanded by Yanga, an African leader, at the beginning of the seventeenth century in the central part of the state of Veracruz. Santa Maria Guadalupe de los Morenos de Amapa, another free Black town, was founded in the eighteenth century in the state of Oaxaca.

27. García de León, "Indios de la Florida," 115–16.

28. AGN Tierras, vol. 2780, exp. 11, foja 170.

29. AGN Tierras, vol. 2780, exp. 11, fojas 170–170va.

30. AGN Tierras, vol. 1085, exp. 2, fojas 1va–2.

31. AGN Tierras, vol. 2780, exp. 11, fojas 167–68.

32. AGN Tierras, vol. 2780, exp. 11, fojas 168va–169.

33. Anónimo, *La insurgencia en la Antigua Veracruz*, 25.

34. Ibid., 6.

35. Montemayor, *La población de Veracruz*, 28.

36. AGN Tierras, vol. 1085, exp. 2, foja 32va.

37. García de León, "Indios de la Florida," 114.

38. AGN Tierras, vol. 1085, exp. 2, fojas 28–29.

39. De Reparaz, *Yo Solo*, 254.

40. Zavala, *El servicio personal*, 61.

41. AGN Indiferente de Guerra, exp. 47B 1778–1812, foja 309va.

42. García de León, "Indios de la Florida"; Gold, "Conflicts in San Carlos."

43. After many attempts to abolish slavery in Mexico throughout nineteenth century, racial distinction was forbidden by law. Today, Afro-Mexicans towns and organizations are fighting to get legal recognition after having been omitted by history.

9

Slave Refuge and Gateway

David B. Mitchell and the Paradox of the Florida Frontier

Andrew K. Frank

In the winter of 1817, the seemingly unrestrained movement of African slaves drew attention to the porous nature of the Florida-Georgia frontier. Africans in this territory frequently aroused the anxieties of white southerners, who worried that their slaves would find freedom in Florida and forge "murderous" alliances with Spanish soldiers or Indian warriors. The events of late 1817, however, were profoundly different. David Brydie Mitchell (fig. 9.1), a former governor of Georgia and federal Indian agent, faced charges of smuggling 110 African slaves through Spanish Florida, into the Creek Indian nation where he worked, and then into Georgia and Alabama. The controversy coincided with the onset of the First Seminole War, an event largely precipitated by fugitive slaves finding refuge in and near Florida's Indian communities.[1] Although scholars have long recognized the role Florida has played in drawing fugitive slaves down from the early American South, the Mitchell Affair, as it became known, reveals that Africans also moved in the other direction. The unregulated borderlands that lay between the United States and Spanish Florida created a fluid region that enabled smugglers, slave catchers, and slaves themselves to move in all directions. The proximity of sovereign Native American communities further complicated the boundary between Georgia and Florida. The Mitchell Affair exposed how the Florida borderlands enabled the multi-direction migrations of African people and complicated every attempt to regulate slavery.[2]

The public controversy began in late 1817 when Georgia governor John Clark accused Mitchell, a well-established political opponent, of violating the federal ban on engaging in the African slave trade.[3] Clark, U.S. General Edmund Pendleton Gaines, and other influential Americans alleged that in the past year Mitchell had knowingly financed and orchestrated the smuggling of 110 African-born slaves into the United States. Mitchell arranged to transport

Figure 9.1. *Portrait of David Brydie Mitchell*, oil and canvas. Indian agent David Brydie Mitchell, previously governor of Georgia, was accused of smuggling African slaves from Florida into Creek territory and then into the United States. The Mitchell Affair exposed how the unregulated borderlands created a fluid region that allowed smugglers, slave catchers, and slaves themselves to move in all directions. Georgia Capitol Museum, Office of Secretary of State, Courtesy of Georgia Archives, Georgia Capitol Museum Collection.

the slaves from Amelia Island in Spanish East Florida across the border into the Creek nation, where they were divided among his friends and allies in and near the Creek agency in Georgia. Clark and the others charged Mitchell with flagrantly violating federal and state laws in order to take advantage of a differential in slave prices between the United States and Spanish Florida.[4] If these allegations were true, Mitchell violated the Nonimportation Act of Congress, which prohibited the importation of Africans into the United States as of January 1, 1808.[5] Mitchell, who launched a public campaign in regional and national newspapers to defend his honor and reputation, denied that he did anything illegal. He insisted that his political enemies had maliciously spread an "abominable untruth" and that the controversy had more to do with local politics than legal issues or the importation of slaves.[6]

After lengthy local and federal investigations, the Mitchell Affair came to a somewhat mixed conclusion. A grand jury in Georgia determined that

Andrew K. Frank

the Indian agent had arranged the importation of the Africans from Spanish Florida, and its members expressed their "indigna[tion] at the violation of law whose object is to preserve from shame the character of our country." Although Mitchell had committed a "flagrant violation" of the law, the grand jury regretfully decided that "all hope of justice in this case is at an end."[7] Two issues prevented the case from going to trial. First, the statute of limitations for the 1807 law had expired, and the 1818 law that replaced it was not yet in operation when the slaves entered the Creek agency. A federal case was therefore unlikely to succeed. Second, and perhaps more importantly, the evidence was unclear as to whether any of the Africans had ever set foot in Georgia and thus under the jurisdiction of a state law specifically designed to augment the federal non-importation statutes. The African slaves had passed into the hands of a Georgia citizen, to be sure, but this did not authorize the Georgia courts to hear a case about the importation of the slaves into the sovereign Creek nation or even the Alabama Territory.[8] Geographic and temporal technicalities led Savannah's district attorney, Richard Habersham, and several federal officials to drop the legal matter. Mitchell, despite widespread belief in his guilt, escaped prosecution. Upon reading the evidence, U.S. Attorney General William Wirt concluded that the "impudent rascal" was guilty.[9]

The findings of the grand jury and Mitchell's subsequent dismissal as Indian agent did little to change the collective fates of the 110 African men and women at the center of the Mitchell Affair.[10] Despite their undisputed African origins and quasi-legal importation, most of the slaves remained the property of their new owners. Only a few were apprehended and sold at auction by the state of Georgia. Investigators could not determine where the remaining slaves lived or who had them in their possession. Some seemed to have been sent into the Alabama Territory to be sold, while others remained in Indian country. The slaves with Creek masters and living in Creek country proved the hardest to track down. They were, in the overly vague words of Andrew Jackson, "carried to some point unknown."[11]

The Mitchell Affair reveals at least two important elements of the African American experience on the Florida-Georgia borderlands. First, it points to the limitations of understanding Spanish Florida solely as a refuge for Africans or treating the permeability of the North Florida border as a one-way portal for African slaves. For the 110 smuggled Africans, Spanish Florida served as a port of entry into North America and then the United States. Even as Florida was "a haven for runaway slaves from Georgia and the Carolinas," hundreds of Africans and African Americans found themselves on northern and western trajectories out of Florida and into bondage.[12] Second, the Mitchell Affair reveals the ways in which non-European sovereign powers like the Creek and Seminole Indians made the enforcement of international trade laws virtually impossible. Spain, Great Britain, and the United States all struggled to bring

these Indians into their jurisdiction, and frequently acknowledged that they could not control the actions of their own citizens when they entered the Indian terrain. In essence, the process of illegally transporting the Africans from Spanish Florida to the United States paralleled the process of laundering money. Much as counterfeiters and drug dealers use otherwise legitimate businesses to conceal the origins of their cash, Mitchell used the sovereignty of the Creeks to hide his slave contraband. By passing the slaves through the Creek agency and Creek villages, the original identities of the slaves could be obfuscated and their illegal origins could be erased. This path, and his reliance on intermarried white men and Creek Indians to conduct the transportation of the African slaves, also allowed Mitchell to act under the dominion of sovereign Indian nations and to otherwise try to avoid state and federal laws designed to prevent smuggling.

Before Mitchell became Indian agent, he learned firsthand about the uncontrolled nature of the Florida-Georgia borderlands and how the presence of Creek and Seminole Indians complicated the enforcement of law in the region. After all, one could travel from Spanish Florida directly into Creek or Seminole territory, and from there enter Georgia. As Georgia's governor from 1809 to 1813 and 1815 to 1817, Mitchell struggled to prevent slaves from running to Indian lands in Florida and elsewhere and then becoming residents of Spanish Florida. In 1810, for example, Mitchell agonized about the "Masasuca Town" in "the Spanish Dominion" of East Florida because it was an "asylum for negroes."[13] He heeded numerous requests, sometimes with some success, to use the U.S. military or embedded Indian agents to guard the frontier and otherwise arrange the return of enslaved African Americans who used Florida and Seminole towns as places of refuge. In 1812 Mitchell tried to arrange an agreement with East Florida for the reciprocal return of runaway slaves even as he warned the governor of East Florida that arming African residents would do irreparable harm to U.S.-Spanish relations. Later, in 1816, Mitchell convinced Florida's governor to apprehend two slaves who fled to Florida after they escaped from Georgia's St. Simon Island.[14] In other instances, Mitchell tried to lure slaves out of Seminole villages with lucrative rewards and ransoms. When he became Indian agent in 1817, Mitchell continued to address the problem caused by the porous nature of the Florida-Georgia frontier. He worked to convince Creeks to serve as slave catchers rather than harborers and helped arrange the return of dozens of runaways to their masters in each of the southeastern nations. Even while Mitchell valiantly fought for his legal innocence in 1820, he arranged the return of ten slaves who took refuge in St. Augustine to their master at the Creek agency.[15]

Although Spain stopped granting formal sanctuary to fugitive slaves in 1791, Mitchell and others recognized that they needed to take proactive steps to prevent slaves from exploiting the Florida-Georgia borderlands and the

sanctuary provided by alliances with or residence in Florida's Indian communities. In 1812, after some "murderous excursions" by Seminoles and fugitive slaves in Georgia, for example, Mitchell arranged to have "constant guards and patrols on the border." Without men on the ground filling the gaps in Florida's porous border, the governor feared, slaves would continue to run to Florida and then return to Georgia in order to commit acts of violence. The problem was clear, he explained: "Most of our male negroes on the sea board are restless." An unguarded border allowed them to "make many attempts to get off to [St.] Augustine, and many have succeeded."[16]

During the Patriot War (1812–13) and the Red Stick War (1813–14), Mitchell and others struggled to regulate Georgia's border with Spanish Florida. In these instances, Mitchell was not simply concerned with the financial costs of slaves fleeing into the Spanish Territory. Georgians also faced the threats of hundreds of slaves and enemy Indians who returned across the Florida border in order to make periodic raids.[17] Once again, Mitchell observed that Native Americans complicated regulations on the Florida-Georgia border. Alliances with Native Americans allowed Africans to operate without the consent of Spaniards who also worried about the mobility of African slaves. As a result, Governor Mitchell complained that the dangers of the permeable Florida frontier were exacerbated because "the blacks assisted by the Indians have become very daring."[18] The porous nature of the boundary between Spanish Florida and the state of Georgia, he explained, allowed African Americans to escape to freedom and then return to Georgia to extract retribution. A larger lesson was clear, though. The presence of sovereign Creek and Seminole Indians made the Florida-Georgia borderlands uncontrollable.[19]

Others shared Mitchell's concerns about Spanish Florida's porous frontier during the late eighteenth and early nineteenth centuries.[20] These concerns often focused on the Negro Fort in Apalachicola, but they extended to all of northern Florida in the years that preceded and followed its destruction in 1816. Many white southerners feared that their former slaves would "take up the cudgels" of the Spanish Crown and turn "our southern country [into] a state of insurrection."[21] When eighty black slaves were feared to have taken refuge in Florida in 1812, Lieutenant Colonel Thomas Smith concluded that he needed more troops to protect the Florida frontier: "The safety of our frontier I conceive requires this course. They have, I am informed, several hundred fugitive slaves from the Carolinas and Georgia at present in their Towns & unless they are checked soon they will be so strengthened by desertions from Georgia & Florida that it will be found troublesome to reduce them."[22] John McIntosh made this clear to Secretary of War James Monroe in January 1813: "St. Augustine, the whole province will be the refuge of fugitive slaves; and from thence emissaries . . . will be detached to bring about a revolt of the black population in the United States."[23]

The permeability of the Florida-Georgia frontier also troubled slaveholders on its southern side. Florida's planters, much like their counterparts in Georgia, struggled to prevent African Americans from running to freedom in Indian territory and in Georgia. In March 1781, for example, George Nowlan feared that one slave, who once belonged to a trader in Creek country, "has made the best of his way for Georgia."[24] Other black Floridians, including four of Robert Bradley's slaves, fled from Florida and headed directly to a Creek village. Bradley hoped that a twenty-shilling reward would lead Neptune, Bacchus, Apollo, and Limerick back in his possession on his Pensacola plantation. In this instance, an Indian trader and several Creeks returned the slaves and apparently shared the reward.[25] As a result, Florida planters repeatedly posted ads in Georgia's papers, calling for return of their runaway slaves.[26] These fugitive slaves recognized that Florida's permeable boundary allowed mobility in both directions.

While many Americans worried about the problems that an unregulated Florida-Georgia boundary created, others recognized that it presented a financial opportunity. In the eighteenth century, for example, traders routinely passed contraband goods like rum, guns, and cattle across the border.[27] In addition, Florida's reputation as a sanctuary for runaway slaves led opportunistic Americans and Native Americans to serve as slave catchers. They entered into Florida, captured former slaves and other black residents, and then claimed rewards upon their return. In some instances, Native Americans in Florida stole slaves from Georgia plantations, brought them home to their villages, and then ransomed them back to their owners.[28] At the same time, some maroon communities in Florida found themselves at the mercy of repeated raids by slave catchers from Georgia.[29] On several occasions, the U.S. military initiated these raids. In 1812, for example, Colonel William Miller led a group of Indian warriors and U.S. troops into Florida, and together they captured fifty-eight African Americans and "returned" them to slavery in Georgia.[30]

Before the Mitchell Affair, nearly anyone familiar with the Florida-Georgia borderlands recognized the problems that resulted from the presence of sovereign Indian communities. Nowhere was this more apparent than in trade regulations. In the late eighteenth and early nineteenth centuries, Spanish, British, and American officials struggled to control traders when they lived with and obtained permission to trade from Indians themselves. They issued licenses, passed elaborate trade regulations, and otherwise tried to limit the terms of the lucrative Indian trade. In most cases these efforts proved futile, especially when Native Americans gave permission to traders of their own. For example, when one Creek woman with a European father engaged in the Indian trade without a license in 1802–3, U.S. Secretary of War Henry Dearborn rightly worried that he did not have jurisdiction. "If Mrs [Sophia] Durant is an American Citizen," he wrote, "have her arrested and punished. . . . If she is

an Indian . . . we have no control over her."[31] A couple of decades later, Mitchell's replacement struggled with a similar issue. This time, a problem resulted when the Creeks gave permission for intermarried white men to live and trade among their wives' families. "Have white men who take with an Indian Woman a right to become traders without a licence[?]," he asked. "If they have[,] there will be no licenced traders. For this plain reason, they will all have Indian wives for the sake of being irresponsible to the laws regulating trade."[32] The lesson, for Mitchell and other American officials, was clear. When Creeks or traders protected by the Creeks defied trade regulations and other federal or state laws, little could be done if they remained in Creek country.

Other problems resulted when Native Americans asserted jurisdiction over their own villages and territory. Mitchell and other American officials could not help but notice the Creeks' and Seminoles' desire to "punish our bad people ourselves" prevented the long arm of the law from reaching deep into Indian country.[33] In 1813, while trying to obtain "satisfaction" for two murders, Mitchell recognized that "there is a distinction between a murder committed by an Indian within the limits of our settlements and one committed in the Creek Nation." One he could control; the other he could not.[34] The traditional diplomatic ties between Spain, Britain, and the United States, which allowed the extradition of criminals across national borders, did not translate easily to decentralized Indian nations. Native Americans, by virtue of the protection provided by village chiefs and various treaty stipulations, repeatedly circumvented Spanish, American, and British laws. This ability even extended to non-Indian men who married Native American women and lived in their villages. These "Indian countrymen"—as the men were called—frequently traveled between Florida, Georgia, Alabama, Creek territory, and Seminole lands. They often smuggled goods, transported slaves, and transacted official business.[35]

The path that brought the 110 Africans into the United States made it clear that Mitchell and others were acutely aware of the permeability of the Florida-Georgia frontier and of the ability of Creeks and Seminoles to circumvent American and Spanish laws. In fact, the scheme that brought the slaves from Africa to the Creek agency was not a planned affair. Even Mitchell's accusers asserted that the African slaves, who originally numbered around 160, were destined for Havana in 1817 when a French-born pirate, Luis Aury, captured the ship and took them ashore at Amelia Island. Aury, who later proclaimed himself commander in chief of a briefly "liberated" Amelia Island, established a "tyrannical pirate regime" of *men of all nations*" and "men of all colors" who terrorized nearby ships. At the end of 1817, Aury was stealing and reselling a thousand African slaves out of Spanish Florida and into the United States. Rumors persisted that his band consisted of Spaniards, "renegade Americans," and maroons from Georgia, South Carolina, Haiti, and other destinations.[36]

At this point, John Loving applied to agent Mitchell, "who I thought to be a better judge than I was[,] to know his opinion respecting it and particularly whether he would sanction their being brought through the Indian Country." At this point, Loving stated that Mitchell "told me he had been thinking of it himself and that I might bring them with propriety and safety through the Indian Country to the Agency, where he would protect me." When Loving became convinced that transporting the Africans constituted a violation of U.S. law, he "dropp'd the idea all together."[37] Mitchell apparently did not. Instead, greed and his understanding of Indian sovereignty led him to transport the slaves across the southern borderlands.

The path out of Spanish Florida took advantage of the legal sovereignty of specific individuals, the inability to Georgian authorities to oversee the Creek agency, Mitchell's legal autonomy at the Creek agency, and the shared borders between the Creeks, Seminoles, Florida, and Georgia. One could travel between any of the two locales without entering a third, complicating the ability to regulate trade between the groups. In this way, Mitchell took advantage of the peculiarities of the Florida border to hide the origins of their slave property. By passing the slaves through the Creek agency rather than directly into Georgia or Alabama, Mitchell effectively prevented investigators from being able to track down the slaves, shifted much of the burden onto Creek Indians and others protected by Creek sovereignty, and otherwise deflected his own participation in the transaction.[38]

About a dozen individuals other than Mitchell actively helped transport the 110 Africans from Spanish Florida to the Creek agency and beyond. They traveled in two groups, both of which were guided by and passed between several Indian traders and Creek Indians. Most of the individuals were trusted friends and relatives of Mitchell; many also lived under the regulations of Creek society. Four in particular—William Bowen, an Indian named Tobler, Timothy Barnard, and George Stinson—reveal the peculiar nature of the boundary that separated Spanish Florida and Georgia and the political rather than just the geographic component of it. Together, they demonstrated how Indian sovereignty complicated jurisdiction on the Florida borderlands.

William Bowen may have been the most important individual involved in the importation scheme. Bowen was a military captain who was quite familiar with the methods of smugglers and the illicit trade among the Indians. In 1817 he struggled to fulfill a military directive to suppress the illegal trade with the Indians.[39] In November 1817, Bowen led the first group of slaves out of Amelia Island and to the Creek agency.[40] Mitchell repeatedly blamed Bowen for orchestrating the smuggling scheme and asserted that Bowen had forged papers that demonstrated that the slaves were from Camden County, Georgia. Most of the investigators did not believe that Bowen acted without the consent of Mitchell. Mitchell and the investigators agreed, however, that Bowen

had manipulated the political and legal context to arrange the transportation of the Africans out of Florida. In the following months, Bowen returned to Florida as the United States waged war on the Seminoles, helped capture more than one hundred black slaves, and fought several battles alongside Creek chief William McIntosh, likely one of the recipients of the 110 smuggled African slaves. After the battles with the Seminoles, Bowen attempted to use his connections with the Creeks to have his slave property returned.[41]

In early 1818, when it became clear that an investigation into the smuggling had already begun, Bowen arranged to have the second group of Africans imported into Creek society by "an Indian by the name of Tobler."[42] Because he believed that "the risk of getting this lot through [was] considerably more than the first," Bowen called on Tobler to lead the second coffle.[43] Relying on Tobler, who was the Creek child of an Indian trader and Creek mother, served several advantages. For many years, Tobler earned the trust of European and Native American leaders by serving as an interpreter for both Georgian, Floridian, and Creek officials. He augmented his position as a trusted cultural broker by orchestrating the return of several felons who found refuge among the Indians.[44] He also helped Thomas S. Woodward retrieve several of his slaves who had escaped to Florida.[45] In addition, Tobler spoke English and knew the well-traveled and not-so-well-traveled paths in the southern backcountry. At the same time, Bowen apparently recognized that Tobler's Creek citizenship served an incalculable advantage. If he was caught, Tobler could call upon his clan and village for protection as he and other Creeks had done in the past. In 1804, for example, Tobler avoided punishment for stealing horses from Georgia frontier settlers by finding anonymity in his Creek village and by relying on the protection provided by fellow clan members. Not surprisingly, Tobler also escaped prosecution for his role in the Mitchell Affair.[46]

When Bowen arrived into Creek country he passed the slaves to an intermarried white Indian trader named Timothy Barnard, a man who lived in the "the neighborhood of the agency," had frequently worked with Mitchell, and was a relation of his by marriage.[47] Barnard housed the second group of slaves, alongside many of his own, and then apparently helped transport them out of Creek territory and into Alabama. During the ensuing investigation, Mitchell called upon Barnard, who was "well acquainted with the circumstances," to testify on his behalf.[48] Mitchell had good reason to trust Barnard. In addition to working as Mitchell's assistant at the Creek agency, Barnard and three of his Creek sons remained loyal to the United States during the Red Stick War, choosing to lead a group of Indian warriors against the Creek majority and British troops in Florida. When the war ended, Mitchell rewarded them handsomely for their military leadership and continued to call upon their services as interpreters, messengers, and sometimes as sub-agents.[49] On many instances, Barnard's sons conducted agency business inside Indian villages,

where their clan affiliations and matrilineal kinship ties made them welcome while Mitchell was an outsider.[50] As in the past, the scheme to smuggle African slaves capitalized on Barnard's and his children's ability to benefit from the legal rights that ties to a Creek family afforded.

The Mitchell Affair ended with its 110 smuggled African imports enslaved in the lower South and its major participants cleared of criminal wrongdoing. For intermarried white men and Creek Indians, the implications of the Mitchell Affair could not be clearer. Native sovereignty augmented the permeability of the Florida-Georgia borderlands by preventing Euro-American officials from enforcing their laws. George Stinson understood this better than most. Stinson, an intermarried white man who worked for the Indian agency as a blacksmith, testified to what he knew about the Africans and then watched as the investigation stayed clear of accusing Indian countrymen and Creek Indians of criminal wrongdoing.[51] When the investigation ended, Stinson put into practice what he had learned by setting up a trading house in Creek country. When he faced trial for trading without a license in 1824, he successfully defended himself by stating that as a resident of the Creek nation he did not need one. The United States simply did not have jurisdiction there.[52]

Stinson learned from the Mitchell Affair what many historians have overlooked: that the presence of sovereign native communities exacerbated the permeability of the Florida-Georgia frontier. Neither Spain nor the United States could effectively regulate a border that was physically and politically under the control of Creek and Seminole Indians. This resulted in a Janus-faced reality for African Americans. Rather than solely being an asylum for fugitive slaves to run to, the Florida-Georgia border also served as a port for the legal and illegal entry of enslaved Africans and African Americans. While African Americans tried to use the frontier to their own ends, so did many Indians and white Americans. Mitchell may have spent much of his career negotiating with his Indian neighbors and fighting to eliminate the refuge that Spanish Florida and Indian lands offered to African Americans. Even so, when the opportunity presented itself, he was not averse to capitalizing on the porous Florida-Georgia border by turning it into a gateway into American bondage.

Notes

1. Mahon, "The First Seminole War"; Saunt, *A New Order of Things*; Twyman, *The Black Seminole Legacy*.

2. Rivers, *Slavery in Florida*, 4–8, 142–43, 189–92, 197–201; Landers, *Black Society in Spanish Florida*; Mulroy, *Freedom on the Border*; Frank, "Red, Black, and Seminole"; Aron and Adelman, "From Borderlands to Borders."

3. William W. Bibb to David B. Mitchell, February 2, 1818, David B. Mitchell Papers, Newberry Library, Chicago, Illinois.

4. Slaves sold in East Florida for about half of what they cost in the rapidly expanding

cotton culture of Alabama. Edmund P. Gaines to William Rabun, January 23, 1818, in *Niles Weekly Register*, February 14, 1818.

5. William H. Crawford to Mitchell, April 3, 1818, Mitchell to Calhoun, November 11, 1819, and Mitchell to Calhoun, March 20, 1820, Mitchell Papers; *Georgia Journal*, November 2, 1819, April 27, 1821. For a discussion of the legal case see Shingleton, "David Brydie Mitchell and the African Importation Case of 1820."

6. Mitchell to Andrew Jackson, March 22, 1818, Mitchell Papers. See also Mitchell, *An Exposition*.

7. *Southern Recorder* (Milledgeville, Ga.), May 16, 1820.

8. William Bowen to Mitchell, March 23, 1818, War Department, Letters Received, National Archives, Washington D.C., Record Group 75, Microcopy 271, 3:148 [hereafter cited as WD LR].

9. Wirt to Monroe, January, 21, 1821, in *American State Papers, Miscellaneous*, 2:957–75. Although the issue was never resolved in court, many contemporaries in and out of Creek society believed the allegations to be true. See "The Case of the Africans," Antonio J. Waring Jr. Papers, Georgia Historical Society, Savannah.

10. William Moore to Clark, July 25, 1819, WD LR, 3:140–41; Calhoun to Mitchell, February 16, 1821, War Department, Letters Sent, National Archives, Record Group 75, Microcopy 15, E: 54 [hereafter cited as WD LS]; Savannah, *Daily Georgia*, April 28, 1837. Secretary of State John Quincy Adams publicly came to a similar conclusion. See Adams to Clark, March 18, 1820, in *Niles Weekly Register*, April 15, 1820; Clark to Adams, April 28, 1820, WD LR, 3:170–71.

11. Jackson to Calhoun, February 14, 1818, in Bassett, *Correspondence of Andrew Jackson*, 2:354. Most indications point to the slaves heading to the Alabama territory. See Extract of Letter from Mitchell to Governor of Georgia, in *Georgia Journal*, November 2, 1819.

12. Rivers, *Slavery in Florida*, 4.

13. Buckner Harris to Mitchell, November 11, 1810, Panton, Leslie and Company Papers, University of West Florida, Pensacola. See also Benjamin Hawkins to Mitchell, December 8, 1812, Telemon Cuyler Collection, Hargrett Library, University of Georgia; Hawkins to Mitchell, November 16, 1812, Cuyler Collection; Runaway Notice, *Georgia Argus* (Milledgeville), August 18, 1813.

14. Mitchell to Hawkins, October 8, 1810, Governors Letter Books, Georgia Department of Archives and History [herafter cited as GLB]; Mitchell to Hawkins, April 22, 1811, GLB; Hawkins to Mitchell, December 7, 1812, in Grant, *Letters of Benjamin Hawkins*, 2:625; José Coppinger to Mitchell (draft), June 20, 1816, East Florida Papers, P. K. Yonge Library, University of Florida [hereafter cited as EFP]; James Black to Mitchell, June 11, 1813, Georgia, East Florida, West Florida and Yazoo Land Sales, 1764–1850, Georgia Department of Archives and History.

15. Mitchell to Coppinger, August 7, 1820, Mitchell Papers; Runaway notice, *Milledgeville Reflector* (Georgia), April 14, 1818.

16. Mitchell to James Monroe, September 19, 1812, GLB. Complaints about Floridians (Spanish or Indian) raiding to capture slaves from southern planters continued after the Mitchell Affair. See *Carolina Gazette*, August 7, 1819.

17. Hawkins to Mitchell, September 7, 1812, in Grant, *Letters of Benjamin Hawkins*, 2:617; Mitchell to Monroe, Territorial Papers of the U.S. Senate, 1789–1873, National Archives, reel 86-A.

18. *Niles Weekly Register*, December 12, 1812. Mitchell negotiated directly with Spain for the reciprocal return of runaway slaves. See Mitchell to Coppinger, April 4, 1816, EFP.

19. Hawkins to Mitchell, August 2, 1813, in Grant, *Letters of Benjamin Hawkins*, 2:653; Archibald Clark to Mitchell, August 8, 1812, Mitchell Papers.

20. See Juan Nepomuceno de Quesada to Diego [James] Seagrove (draft), February 20, 1793, EFP; *Georgia Gazette*, March 28, 1793; T. F. Davis, "United States Troops in Spanish East Florida 1812," 106–7.

21. Porter, "Negroes and the East Florida Annexation Plot," 17–18.

22. Smith to Thomas Pinckney, July 30, 1812, in T. Frederick Davis, "United States Troops in Spanish East Florida 1812–1813, Part II," 107 and 96–116.

23. Quoted in Porter, "Negroes and the East Florida Annexation Plot," 24.

24. *Royal Georgia Gazette* (Savannah), March 8, 1781.

25. *Georgia Gazette* (Savannah), August 17, 1768.

26. *Georgia Journal*, January 1, 1817; Matthews to Quesada, March 27, 1795, EFP.

27. Nelson, "Contraband Trade under the Asiento, 1730–1739," 57; Extract of A Letter from William Bowen to Daniel Hughes, January 22, 1817, in Carter, *Territorial Papers of the United States*, 18:49–50; Richard Henderson to John Martin, December 23, 1782, in Hays, "Creek Indian Letters," 1:42–44; Henry Dearborn to Hawkins, August 18, 1807, WD LS, B: 330.

28. White, "Indian Policy of Juan Vicente Folch," Alexander McGillivray to Estevan Miro, June 24, 1789, Lockey Collection; John Hambly to John Leslie, September 28, 1788, Lockey Collection. See also Holland Braund, "The Creek Indians, Blacks and Slavery," 612–13.

29. Hall, "Maritime Maroons"; Mitchell to Coppinger, October 31, 1816; EFP.

30. *Pensacola Floridian*, September 22, 1821.

31. Dearborn to Hawkins, January 24, 1803, WD LS, A: 2–4.

32. John Crowell to Calhoun, April 6, 1824, Office of Indian Affairs, Creek Agency, Letters Received, National Archives, Record Group 75, Microcopy 234, 219: 78–79 [hereafter cited as CA LR].

33. White Lieutenant to Seagrove, June 23, 1793, in *American State Papers, Class II: Indian Affairs* 1: 401.

34. Mitchell to Hawkins, February 3, 1813, GLB.

35. Gaines to James Barbour, July 18, 1825, CA LR, 219: 1327–38; Frank, *Creeks and Southerners*.

36. *New York Spectator*, December 13, 1817; Connecticut Courant (Hartford), December 16, 1817; John Houston McIntosh to William Crawford, in *U.S. Gazette for the Country* (Philadelphia), January 8, 1818; "Amelia Island, South American Patriots, &c" *National Register* (December 20, 1817); "Late from Amelia Island," *Weekly Recorder* (October 15, 1817); *Niles Weekly Register*, November 29. 1817; Landers, *Black Society in Spanish Florida*, 245.

37. John Loving to Clark, September 27, 1819, WD LR, 668: 3:141. See also *Miguel De Castro vs Ninety-Five African Negroes*, Admiralty Court, Georgia District, Savannah, 1819–20.

38. Bowen to Mitchell March 23, 1818, WD LR, 3:148.

39. Extract of a letter from Bowen to Hughes, January 22, 1817, in Carter, *Territorial Papers of the United States*, 18:49–50.

40. William Moore, deposition, October 15, 1819, WD LR, 3:142–43.

41. Mitchell to Calhoun, July 7, 1820, WD LR, 3:559–60; William McIntosh to Mitchell, April 13, 1818, Cuyler Collection; Bowen to McIntosh, June 1, 1818, Cuyler Collection.

42. Moore, deposition, October 15, 1819, WD LR, 3:143.

43. Bowen to Mitchell, December 25, 1817, WD LR, 3:144–45.

44. A Talk from the Kings and Head Warriors of the Cowetas, Broken Arrows, Cussetas and Usachees to Governor of Georgia, May 24, 1794, Ayer Collection, Newberry Library, Chicago; Mitchell to John C. Calhoun, July 7, 1820, WD LR, 3:558.

45. T. S. Woodward, *Woodward's Reminiscences,* 153.

46. John McAllister to John Milledge, August 12, 1804, GLB.

47. Nathaniel Ashley, deposition, February 9, 1818, WD LR, 3:149–50; Mitchell to Gaines, March 30, 1817, *American State Papers, Indian Affairs,* 2:156–57.

48. Moore, deposition, October 15, 1819, WD LR, 3:142–43; Mitchell to Governor of Georgia, May 18, 1820, WD LR, 3:606.

49. Hawkins to Mitchell, August 12, 1813, Panton, Leslie, and Co. Papers; Abstract of Payments made by Mitchell, 1818, in *American State Papers, Class V: Military Affairs,* 2:108; Payroll of the general, field, and staff officers of General William McIntosh's brigade of Creek Warriors, lately in the service of the United States, January 14, 1820, in *American State Papers, Military Affairs,* 2:119.

50. Hawkins to Pinckney, September 5, 1814, in Grant, *Letters of Benjamin Hawkins,* 2:695.

51. Georgia Stinson, deposition, November 6, 1819, WD LR, 3: 707–9.

52. Moore, deposition, October 15, 1819, WD LR, 3:143; A. K. Frank "Family Ties."

10

The Kingsley Community

Beyond the Plantation

Antoinette T. Jackson

The Kingsley Plantation is located on Fort George Island in Jacksonville, Florida (figs. 10.1 and 10.2). It was originally owned by Zephaniah Kingsley (b. 1765, Bristol, England), who was both a slave owner and slave trader. He was actively involved in transporting Africans—enslaved and free—between Africa, the Caribbean, and the Americas. He fathered children with African women and sometimes established households, plantations, and businesses with them. In addition, he formed a business and spousal relationship with Anta Majigeen Ndiaye (b. 1793, present-day Senegal, West Africa), most commonly known as Anna Kingsley. The larger Kingsley community—which included enslaved African workers, free Africans, free people of color, descendants of enslaved African Americans, and descendants of plantation owners—represents a spectrum of experiences in relation to enslavement and freedom in the context of race and ethnicity in the United States and the Caribbean. I will show how the African diaspora experience is intertwined in the everyday lives of people and the places in which they interact. The Kingsley community is a story about Africans in Florida, but more importantly about the relationship between Africa, Florida, and the Caribbean.

Today, the physical space of the Kingsley Plantation has been partially restored by the state of Florida and the National Park Service. This site reveals facts about the realities of plantation life in the antebellum South. The Kingsley family and their community provide an opportunity to explore the complex space of the African diaspora experience, which reaches well beyond the plantation. This discussion privileges the portrayal of the plantation as an extended community by presenting a dynamic array of relationships formed first by Zephaniah and Anna Kingsley and then by their descendants, thus expanding fixed characterizations of Africans in plantation spaces in North

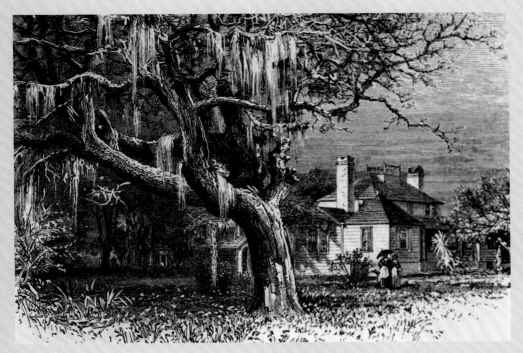

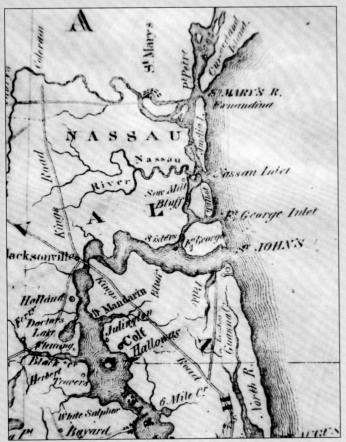

Above: Figure 10.1. Kingsley Mansion, Fort George Island. The Kingsley Plantation, depicted here in 1878, was situated on Fort George Island facing the Fort George River, the primary means of transportation. Zephaniah Kingsley and his wife, Anta Majigeen Ndiaye, built the plantation in 1814. Courtesy of State Archives of Florida, *Florida Memory*.

Left: Figure 10.2. *Map of the Territory of Florida*, by W. H. Swift, 1829 (detail). This portion of an 1829 map shows Fort George Island at the mouth of the St. Johns River. From the P. K. Yonge Library of Florida History, Department of Special and Area Studies Collections, George A. Smathers Libraries, University of Florida.

America. My analysis of this family's story brings into question the very nature of space within narratives about the African diaspora by juxtaposing historical accounts of the Kingsley family with perspectives of the contemporary descendants gleaned from ethnographic research and oral history.[1]

The Kingsley Story

Between 1802 and 1808 Zephaniah Kingsley dispersed hundreds of enslaved Africans throughout the Americas for economic gain—specifically importing Africans into Florida, Georgia, and South Carolina. A shipping document from 1802 lists Kingsley as captain of the *Superior*, which arrived in Havana with 250 Africans.[2] Taken from various locations in Africa, these individuals were sold into slavery in the Americas under the direction and discretion of Kingsley. A document filed by Kingsley as part of his confirmed Spanish Land Grant claims record lists his introduction of enslaved Africans into Florida:

> Certified and sworn that Zephaniah Kingsley introduced into the province, 64 slaves; 21 of them in the sloop "Laurel" from the port of San Tomas, 5/5/1804; 10 on 6/25 of the same year in the schooner "Laurel," alias the "Juanita," proceeding from Havana; 16 in the sloop "El Jefe," coming from Charleston, 7/15/1806; 3 in the schooner "Esther," coming from Havana, on 10/21/1806; and 10 in the schooner "Industria," coming from Georgia, 3/9/1808.[3]

Anta, later known as Anna Kingsley, is thought to be one of three *bozales* (newly imported person from Africa) whom Zephaniah purchased in Havana in 1806.[4] Zephaniah acknowledged Anna as his wife and established homes with her in East Florida (Laurel Grove and Kingsley Plantation) and later in Haiti. Although Kingsley was not unique with respect to his lifestyle of trading enslaved Africans and at the same time engaging in intimate family relations with African women, he was unique in publically espousing ideas of racial harmony, interracial marriage, and multiracial family and kinship associations in Florida.[5] Anna had four children with Zephaniah—George, Mary, Martha, and John. She and three of her children were freed by Kingsley in 1811. The fourth child was born after Anna's emancipation. Anna was both enslaved and a slave owner in that the record shows that she owned enslaved Africans.

Around 1837, Kingsley resettled in Haiti. Historian Daniel Schafer writes: "He sold most of his Florida properties and purchased several plantation tracts in the free black Republic of Haiti, where Anna Kingsley and her sons George and John Maxwell, along with other Kingsley co-wives and children and fifty slaves, settled in 1837."[6] However, both of Anna's daughters, Mary Kingsley Sammis and Martha Kingsley Baxter, married wealthy white men and chose

to remain in the Jacksonville area. Anna eventually returned to Jacksonville in 1846 to rejoin her daughters and their families.

Diaspora Narratives

Kingsley's multiracial and multinational family underscores the contradictions and tensions forged in the context of the transatlantic slave trade and enables the re-imagination of plantations to include a broader and more complex range of experiences. In an interview (New York, 1842), Kinglsey (ZK) discussed with Lydia Maria Child (LC) his relationship with Anna:

LC: Where did you become acquainted with your wife?

ZK: On the coast of Africa, ma'am. She was a new nigger, when I first saw her.

LC: What led you to become attached to her?

ZK: She was a fine, tall figure, black as jet, but very handsome. She was very capable, and could carry on all the affairs of the plantation in my absence, as well as I could myself. She was affectionate and faithful, and I could trust her. I have fixed her nicely in my Haitien colony. I wish you would go there. She would give you the best in the house. You *ought* to go, to see how happy the human race can be. It is a fine, rich valley, about thirty miles from Port Platte; heavily timbered with mahogany all round; well watered; flowers so beautiful; fruits in abundance, so delicious that you could not refrain from stopping to eat, till you could eat no more. My sons have laid out good roads, and built bridges and mills; the people are improving, and everything is prosperous. I am anxious to establish a good school there.[7]

Child's interview emphasizes the contradictions that governed Kingsley's life and is a reminder of the complexities of life from a diaspora perspective in which people were engaged in developing strategies for living in light of and in response to the transatlantic slave trade and the global expansion of Europe. This included defining and negotiating notions of family, freedom, and social place based on race.[8] The Kingsley case challenges stereotypical representations of plantations and informs the complexities of the diasporic experience for enslaved Africans and their descendants.

The Kingsley Plantation is a place that broadens static notions of plantation life through the vivid and often controversial persona of its former residents: Zephaniah and Anna Kingsley. The National Park Service currently maintains the Kingsley Plantation site, which also contains the Timucuan Ecological and Historic Preserve. Kingsley's descendants (fig. 10.3) and others interested in

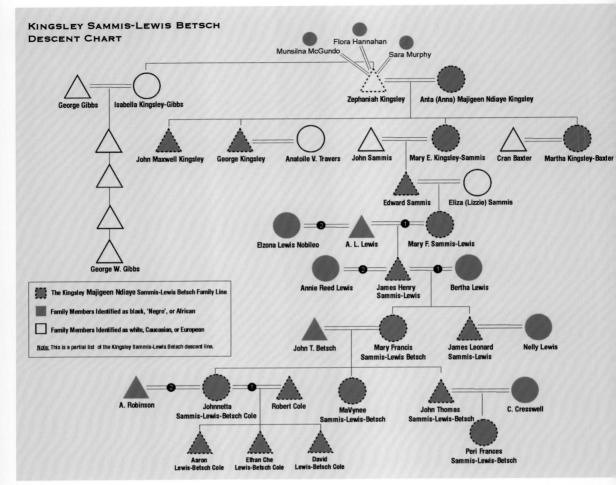

Figure 10.3. Kingsley Plantation extended community chart. By the late 1820s Zephaniah and Anna Kingsley had turned wild Fort George Island into a profitable agricultural venture and at the same time began to build not only a family but a far-reaching community. The chart indicates both black-identifying and white-identifying members of the family. Courtesy of Antoinette Jackson.

learning more about the plantation gather at the site for the Kingsley Plantation Heritage Celebration, an annual event sponsored by the National Park Service since 1998. The perspectives of these descendants shed light on how we understand the meaning of plantations in the contemporary moment, revealing a more dynamic idea of space.

The Kingsley Heritage Celebration was based on an idea presented to the National Park Service by Kingsley descendant Manuel Lebrón, who was raised in the Dominican Republic. The Heritage Celebration fosters contemporary and ongoing interpretations of the plantation site through dialogue, interactions, and perspectives shared by descendants and others. While one of the

stated goals of this event is to help the local community explore cultural traditions that show how plantation life operated in the past, the event also gives primacy to ways in which the plantation is experienced by descendants in the present and the meaning that is attached to this place. Narrative accounts offered by Kingsley descendants Peri Frances Betsch, George W. Gibbs IV, and Johnnetta Betsch Cole link the past and the present and connect the site to the broader world. Descendants of Zephaniah and Anna Kingsley provide interpretations of slavery, plantation characterizations, and the global expansion of Europe in relationship to the transatlantic slave trade.

Peri Frances Betsch is an eighth-generation African American descendant. She shared the following ideas and feelings about circumstances surrounding the initial encounter between Anna and Zephaniah:

> Sometimes it makes me laugh. . . . But I don't think it was like some . . . "I saw him across the crowded slave market, and he winked at me." That's ludicrous! I can't buy into that. And also you got to think, like I would imagine, these people looked crazy to her, like, "who are you?"
>
> . . . I imagine some redheaded white guy with a beard, wearing funny woolen clothing, and she must have been like . . . "You want me to do what?" I just can't picture it. But I really always wonder what was she thinking.[9]

Betsch is on a personal mission to find out more about her family's ancestral connection to Anna Majigeen Ndiaye. She journeyed to Senegal in 1998 in search of information about Anna's life before Florida. Fluent in French, she interviewed griots (local family and community historians) in Senegal who provided her with important information about the history of Anna's lineage based on her family name—Majigeen Ndiaye. Betsch plans to continue her quest for information about her great-grandmother's life in Africa as a personal tribute to her legacy.

George W. Gibbs IV, a Kingsley descendant who self-identifies as white, expressed his thoughts about his great-uncle's business operations in this way:

> This was pure and simple a place for Zephaniah Kingsley to bring slaves in his ships to Fort George, and they tied up here and they disembarked here at Fort George, and they began the domestication, if you will, of the African slaves he had brought to America or to Florida for the purpose of training on this site and selling them, moving on and selling those slaves. This was all about slave trading. This was not about—this was not a tobacco plantation where Zephaniah sat up here in a straw hat and corn cob pipe and watched his crops grow and harvested them every year and made money. His business was—he was in the slave trade business on this site.[10]

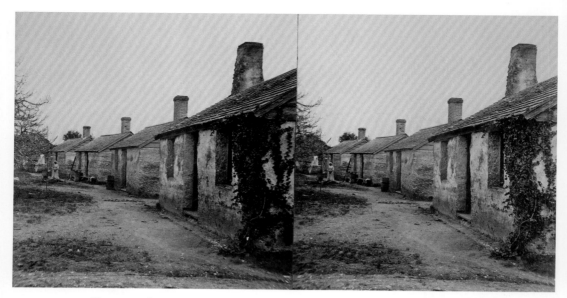

Figure 10.4. Stereopticon image of the slave quarters at the Kingsley Plantation. The thirty-two cabins were constructed of tabby, a technique associated with West Africa. The distinctive semicircular plan perhaps recalls circular villages in some parts of Africa. The two structures at the center of the arc, reserved for the black foremen, were slightly larger than the others, measuring some twenty-five by nineteen feet. From the P. K. Yonge Library of Florida History, Department of Special and Area Studies Collections, George A. Smathers Libraries, University of Florida.

Acknowledging the realities of "the family business," Dr. Johnnetta Betsch Cole captures the power of her family's legacy and the centrality of Anna Kingsley to its story. A self-identified African American woman and a seventh-generation descendant of Anna and Zephaniah Kingsley, Cole is a trained anthropologist, former president of both Spelman and Bennett Colleges, and the current director of the Smithsonian's National Museum of African Art. Presenting the keynote address at the eleventh annual Kingsley Heritage Celebration on February 21, 2009, Cole declared Anna Kingsley her *shero*, a female hero of special note because of her gender and the extraordinary obstacles she had to overcome. In the case of Anna Kingsley these obstacles included slavery, racism, sexism, and patriarchy in the 1800s. Standing on the grounds of the Kingsley Plantation, a place Cole described as difficult for her to visit, she poignantly commented on the complexity of Anna Kingsley's life. Although Kingsley was an enslaved African woman, a free woman of color, a woman of wealth, and then an owner of enslaved Africans herself, Cole encouraged the enthusiastic and attentive audience to consider making Anna their *shero* as well.[11]

These narratives about the Kingsley Plantation provide a more comprehensive means of developing a portrait of the diasporic experience of Africans in

Florida. The cultural complexities of navigating race, place, gender, and class in America in the aftermath of the transatlantic slave trade are revealed in the way a place is used, represented and interpreted.

The Plantation and Beyond

The Kingsley Plantation is not only a physical reminder of transatlantic slave trade in Florida; it is also a mediating space where descendants of the Kingsley family and others share memories about, or reconcile their own contradictory relationships with, the Kingsley Plantation and its history and heritage from just before the antebellum period to the present. Oral history and interview testimony provided by Zephaniah and Anna's African, European, and Latino descendants and descendants of enslaved and free persons of color and others also provide important perspectives for understanding the significance of this place.

The Kingsley Plantation site is located east of Jacksonville at the northern tip of Fort George Island (fig. 10.2). Control of the island alternated between the Spanish and the British before being purchased by Zephaniah Kingsley Jr. in 1817 during the second Spanish period (1784–1821). The Kingsley settlement consisted of an interesting arrangement of slave cabins (fig. 10.4) and Kingsley's own residence a short distance away, but clearly visible from the cabins.

> The Kingsley slave settlement consisted of thirty-two cabins arranged in a distinctive arc. Trees were planted in front of each house in this semicircular village, and wells reportedly were placed between every two cabins. The dwellings were well constructed with tabby. Cabins measured approximately sixteen by twenty feet or less and thus, even though their substantial mode of construction made them both fire and hurricane resistant, they were very cramped. Two slightly larger structures were located at the midpoint of the curving row of slave houses. These two-room houses, measuring close to twenty-five by nineteen feet, were reserved for the slave drivers—black foremen who supervised the daily operations of the plantation.
>
> . . . Kingsley's own residence, a building two stories tall with a wide veranda, stood about a thousand feet from the slave village. It was clearly the largest building on the plantation.[12]

Kingsley owned the plantation until 1839, when he sold it to his nephews Ralph King and Kingsley Beatty Gibbs. In 1955 the state of Florida acquired the Kingsley Plantation and in 1967 began restoring the plantation to reflect its condition during the time of Zephaniah Kingsley. What remained of the Kingsley Plantation was Zephaniah Kingsley's "big" house (fig. 10.1), Anna Kingsley's "kitchen" house, a barn, slave cabins (fig. 10.4), and approximately

720 acres of land and waterway access via the Fort George inlet. Archaeological research conducted on this property has provided additional information about life on the Kingsley Plantation.

The late Charles Fairbanks of the University of Florida received a grant from the Florida Park Service for excavations of the plantation slave cabins. These cabins provide a visually arresting reminder of the institution of slavery practiced in northeast Florida. Fairbanks's goal was to discover more about African lifeways in America through an examination of material remains.[13] At the Kingsley site, Fairbanks excavated one slave house and part of another and was able to supply the state park administration with details later used for site restoration. In summarizing his 1968 excavation findings, Fairbanks concluded that the material culture he uncovered proved that Africans supplemented their diet beyond provided rations and that in some cases enslaved Africans did have access to firearms. Also, based on ceramic pieces recovered, he hypothesized that the period of occupation as a slave site indicated a community that existed as early as 1820 through at least 1850.[14]

In November 2011 the National Park Service, along with archaeologist James Davidson, announced the discovery of six graves at Kingsley Plantation dating back to the early 1800s, a remarkable find. These graves have been identified by Davidson as most probably those of enslaved individuals from West Africa who may have lived on the plantation during the time of Zephaniah Kingsley's ownership. The discovery of the graves has provided another opportunity for the contemporary Kingsley community to participate in the interpretation and commemoration efforts at the site.

The archaeological findings of Fairbanks,[15] Walker,[16] and more recently Davidson[17] reflect the importance of the recovery and interpretation of material culture for understanding life on Kingsley Plantation. Another way to understand the Kingsley Plantation is to look at geographic sites related to the Kingsley Plantation that are not part of the plantation itself.

The story of the Kingsley community is intertwined with the history and culture of Jacksonville.[18] For example, the former home of John S. Sammis and Mary Elizabeth Kingsley-Sammis is one such site (fig. 10.5). The house still stands in the Clifton subdivision in the Arlington area of Jacksonville. It is believed that Anna Kingsley, who died in 1870, lived out her final days in this home, known by local residents as "the old Sammis house." The Sammis Family Cemetery, located in the same neighborhood, is believed to contain the graves of Anna Kingsley and her daughters, Martha and Mary, as well as those of John Sammis and other family members.

Rather than only focusing on the plantation as an institution that controlled the lives of those associated with it, these places locate the plantation as part of a more complex set of relationships and associations. Such an approach disrupts segmented and generic plantation characterizations that

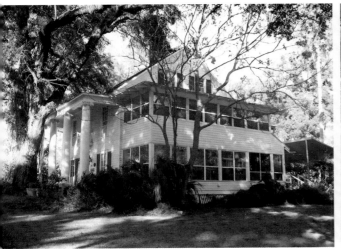

Figure 10.5. John Sammis house (*left*) and Sammis Family Cemetery (*right*). In 1830 Anna Kingsley's daughter Mary married New York merchant John Sammis. They operated a sawmill and owned a plantation on eight thousand acres in what is now Arlington, a Jacksonville neighborhood. The two-and-a-half-story Classical Revival house they built facing the St. Johns River still stands (photo by Hein Vanhee). The nearby Clifton Cemetery, also known as the Sammis Family Cemetery, is believed to contain the graves of Anna Kingsley and her daughters, Martha Kingsley Baxter and Mary Kingsley Sammis. The four graves in the front of the photograph are all Sammis graves (photo by Susan Cooksey).

depict the life and culture of African people and their descendants solely in the context of common images of plantations. While the Kingsley Plantation remains a historic site and a tourist attraction, the Kingsley Plantation community extends well beyond the physical site of the plantation. The Kingsley community includes descendants of Anna and Zephaniah Kingsley along with others associated with the plantation wherever they live and work today. This is most evident in the story of the Kingsley-Sammis-Lewis-Betsch family.

In 1884, Abraham Lincoln (A. L.) Lewis (1865–1947) (fig. 10.6) married Mary F. Sammis (1865–1923), the daughter of Edward Sammis, a Duval County justice of the peace. Mary Sammis was the granddaughter of Mary Elizabeth Kingsley-Sammis and John S. Sammis, and the great-granddaughter of Zephaniah and Anna Kingsley.

The A. L. Lewis and Mary F. Sammis union formed one of the most prominent dynasties of wealth, influence, and power in Florida's African American community. A. L. Lewis, one of the founders and later one of the presidents of the Afro-American Life Insurance Company (the Afro), became one of the richest men in Florida during the 1920s and remained so until his death in 1947. He amassed large amounts of property in Jacksonville and throughout Florida and operated many successful business ventures. Mary F. Sammis-Lewis was very active in the Jacksonville community. Among her many civic, social, and

Right: Figure 10.6. Abraham Lincoln (A. L.) Lewis. A. L. Lewis married Anna Kingsley's great-granddaughter Mary Sammis. Their union produced one of the most prominent dynasties of wealth, influence, and power in Florida's African American community. Lewis became one of the wealthiest men in Florida in the 1920s and remained so until his death in 1947. Courtesy of State Archives of Florida, *Florida Memory*.

Below: Figure 10.7. Postcard of Bethel Baptist Institutional Church. The Sammis-Lewis family played important roles in the Bethel Baptist Institutional Church. Mary F. Sammis-Lewis, the great-granddaughter of Zephaniah and Anna Kingsley, served as deaconess. Founded in 1838, it is the oldest Baptist congregation in Jacksonville. Originally an integrated congregation, most of its early congregants being black slaves, the church remained interracial until after the Civil War. When white members tried to force blacks out of the church, a court ruling determined that the blacks, having a majority, were the rightful owners of both the name of the church and the property. The present structure was built in 1904. Courtesy of State Archives of Florida, *Florida Memory*.

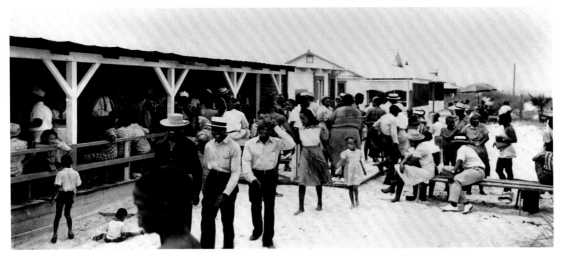

Figure 10.8. Picnic at American Beach for the Second Baptist Church, Jacksonville. In the early 1930s A. L. Lewis and six others invested in a strip of land fronting the Atlantic on Amelia Island. At that time it was one of few beaches in Florida open to blacks and thus attracted throngs of visitors. The development of American Beach made it possible for black families to enjoy vacations on the coast during Jim Crow. Courtesy of Ernestine Latson Smith.

business activities, she served on the Deaconess Board of her church, Bethel Baptist Institutional Church (fig. 10.7), for over twenty years.[19]

A. L. Lewis and his family, as well as others in the African American community, owned homes on American Beach (fig. 10.8), located on Amelia Island north of Jacksonville. Racial segregation policies enforced throughout the state of Florida during the Jim Crow era resulted in restricted or limited access to beach recreation for people labeled as "Negro" prior to 1964. In the 1920s, A. L. Lewis decided to develop a vibrant beach community for African Americans to counter such racial policies. For many years this beach resort community served as the hub of recreation and entertainment for families and civic and social organizations throughout the South. Johnnetta Cole describes her American Beach experiences in this way:

[W]hen the big Afro picnics would happen once a year, I have just gorgeous memories of my father making his own barbecue sauce and barbecuing there.

. . . It was in my view what community could really be about, that is folk caring for each other, sharing what they had, going beyond lines of biological kinship to feel a sense of shared values, and one must say also, to feel a sense of shared oppression. Because it was clear to everybody that while A. L. Lewis in his wisdom and with his wealth had made sure that that beach was available, not just for his family, not just for the Afro,

I mean people now live in Virginia, in North Carolina who remember coming to that beach. But everybody knew that we were on that beach and could not be on the other beaches.[20]

Cole's description exposes tensions associated with reconciling the reality of slavery and its legacy, segregation, in the United States. Further, Cole highlights how the conflation of race and class, which occurred in the aftermath of the transatlantic trade and in the face of legalized segregation in the United States, served to restrict descendants of enslaved Africans and descendants of plantation owners identified as non-white (or racialized as "black") to certain geographic and social environs.

While Mary and Martha remained in Florida, the Kingsley sons, George and John Maxwell Kingsley, established households in the present-day Dominican Republic, then known as Haiti. Members of the Kingsley-Lebrón family discuss details of the family narrative beyond the plantation and beyond Florida.

According to stories shared by Manuel Lebrón and his mother, Sandra, when they were interviewed at the 1998 Kingsley Heritage festival by students from the University of Florida,[21] Manuel's great-great-grandmother Maria, who lived in the Dominican Republic, was the great-great-granddaughter of Zephaniah and Anna. In other words, Maria's mother was John Maxwell Kingsley's daughter. Additionally, Sandra and Manuel indicated that they had first become acquainted with historian Daniel Schafer and his research during their visit to the Kingsley Plantation in the mid-1990s and were encouraged by his work and his determination to collect information on Anna Kingsley's family.

In a recent conversation with the author, Lebrón emphasized the fact that while he was growing up in the Dominican Republic he always heard stories about Anna. Family members always talked about a pouch with gold coins tied to her wrist. Family memories recall her house by the beach where attendants waited on her and that she always wore long flowing white gowns. The Kingsley story is an important part of the family life and lore for descendant Manuel Lebrón and his family. Lebrón, who currently lives in Europe, says that the Kingsley story is shared at all family events—they always talk about the Kingsley family.[22] Manuel, the proud descendant of Zephaniah and Anna Kingsley, continues to research his family history, and he gave the keynote address at the 2005 Kingsley Heritage Celebration.

The Kingsley community encompasses a wide array of associations and interconnections, including geographic landmarks (St. Johns River, American Beach) (fig. 10.8), material cultural remains (Clifton Cemetery, the Old Sammis House) (fig. 10.5), social institutions (the Afro-American Life Insurance Company, Bethel Baptist Institutional Church) (fig. 10.7), and specific individuals and families with varying kinship and other associations with the plantation (e.g., Clara and Eartha White) (fig. 10.9). For example, in 1886, Clara and

Figure 10.9. Clara and Eartha White. It was not only descendants of Anna and Zephaniah Kingsley involved in the broader community of the Kingsley Plantation. Clara White, daughter of slaves, and her daughter Eartha lived in what was known as Anna Kingsley's "kitchen" house and were active members of Bethel Baptist Institutional Church, where Mary F. Kingsley Sammis Lewis served as deaconess. Eartha, remembered as a philanthropist in the Jacksonville area, was the first female employee of the Afro-American Life Insurance Company and a trusted friend of A. L. Lewis. Courtesy of State Archives of Florida, *Florida Memory*.

Eartha White lived on the Kingsley Plantation in what was formerly known as Anna Kingsley's "kitchen" house. Eartha Mary Magdalene White and Clara White were also members of Bethel Baptist Institutional Church, where Mary F. Kingsley Sammis Lewis had served as deaconess. Additionally, Eartha was A. L. Lewis's trusted business adviser and friend as well as the first female employee of the Afro-American Life Insurance Company. Understanding relationships with place, both physical and social, is especially important when seeking to expand knowledge about the experiences of Africans and descendants of Africans in America.

Place plays a critical role in transition, movement, and memory within the African American community, and particularly in the sociopolitical context of the transatlantic slave trade. In the United States, the development and enforcement of legislation and ordinances, even after the institution of chattel

slavery was abolished in 1865, was a legal means of continuing to keep people (e.g., anyone identified as black) in their place within a social hierarchy defined by race. In the case of the Kingsley Plantation, the experience and reality of the transatlantic slave trade extends beyond the geographical/physical site. This study of kinship, place, and diaspora through the lens of the Kingsley Plantation exposes the reality and complexity of navigating race and place beyond the geographic confines of former antebellum plantation spaces for descendants of the Kingsley family. My research is concerned with the numerous connections that link the Kingsley Plantation and the Kingsley family with people, places, and activities throughout the Jacksonville community and beyond.

Conclusion

The massive movement of African people during the transatlantic slave trade has contemporary implications. Drawing on an African diaspora framework with respect to the transatlantic slave trade can lead to dynamic ways of collecting data as well as understanding and critically analyzing social actions. One of the most significant aspects of the African diaspora experience, the formation of community, has been documented in this chapter via the representation of the Kingsley Plantation as an extended community.

Beginning with the historical reality of Zephaniah Kingsley's life as a slave trader and slave owner, to his spousal relationship with Anna Kingsley, and extending into the present with his descendants and their negotiations with identity and social place, this profile and analysis of the Kingsley Plantation community provides a specific case of diasporic experience of Africans in North America. In this study, the Kingsley Plantation has been presented as a community with dynamic social relationships and experiences between people that extends well beyond the geographic, physical, and institutional boundaries that typically frame discussions of plantation life. The community profiled includes greater Jacksonville and the surrounding areas from Fernandina (to the north) to St. Augustine (to the south) and all other places where Kingsley descendants and others associated with the plantation live and travel.

Diaspora theorist Khachig Tölölyan refers to the transatlantic slave trade period of African diaspora formation as an "exceptional" case, especially when evaluated in relation to the Jewish experience. Specifically, he theorizes about types of diaspora formations in which loosely connected populations, when viewed in the context of their own homelands, are "turned into a diaspora" or single cultural unit with no distinguishing identities within the host country "by the gaze of that hostland."[23] However, my work attempts to represent a diversity of diasporic experiences. This approach is informed by scholars such as Brown[24] and Gilroy,[25] who aggressively challenge notions of universality

based on a common diasporic memory and propose other ways of looking at the diasporic experiences of Africans. Gilroy, for example, writes: "The history of the black Atlantic since then, continually crisscrossed by the movements of black people—not only as commodities but engaged in various struggles towards emancipation, autonomy, and citizenship—provides a means to re-examine the problems of nationality, location, identity, and historical memory."[26] In this way, the experiences of a captive African on a slave ship, an African American Pullman porter, a recreational traveler with black skin, or Zephaniah Kingsley's extended African family, for example, can be explored and analyzed from a political or sociocultural perspective as opposed to exclusively biological connecting factors.

Methodologically, ethnography has served as a useful tool for capturing the dynamic nature of the ongoing dialogue between the past and the present. The ethnographic vignettes presented represent the arrival of Africans in America, not only as cargo, chattel, and "slave" entries in ship dockets and plantation diaries and ledgers, but also as individuals, families, and communities.

Notes

1. This research is based upon an ethnographic study I completed in 2001 in conjunction with Allan F. Burns under National Park Service (NPS) Contract no. Q5038000491.
2. Eltis et al., *Trans-Atlantic Slave Trade*; Schafer, *Anna Madgigine Jai Kingsley*.
3. Spanish Land Grants (1941), 21.
4. Schafer, "Shades of Freedom."
5. Kingsley, Address to the Legislative Council.
6. Schafer, "Zephaniah Kingsley's Laurel Grove Plantation," 113.
7. Child, *Letters from New York*, 156–57.
8. Wolf, *Europe and the People without History*.
9. Interview with Peri Frances Betsch, 2001.
10. Interview with George W. Gibbs, 1998.
11. Jackson, "The Kingsley Plantation Community."
12. Vlach, *Back of the Big House*, 187–88.
13. Interview with Kathleen Deagan, July 28, 2001.
14. Fairbanks, "The Kingsley Slave Cabins."
15. Ibid.
16. K. J. Walker, "Kingsley and His Slaves."
17. Davidson, Interim Report.
18. Jackson with Burns, *Ethnohistorical Study*.
19. Phelts, *An American Beach*; interview with Marsha Dean Phelts, Amelia Island, August 25, 1997.
20. Interview with Dr. Johnnetta Cole, 2001.
21. Interview with Sandra Lebrón, 1998.
22. Personal communication with author, November 8, 2010.
23. Tölölyan, "Rethinking Diaspora(s)," 13.
24. J. N. Brown, "Black Liverpool, Black-America."
25. Gilroy, *There Ain't No Black*; Gilroy, *The Black Atlantic*.
26. Gilroy, *The Black Atlantic*, 16.

PART III

Forging New Identities

African American Culture in Florida

11

Florida's African Connections in the Nineteenth Century

Canter Brown Jr. and Larry Eugene Rivers

As the close of the nineteenth century approached for Floridians, the African Methodist Episcopal bishop of Liberia and Sierra Leone died on November 23, 1900, at his Jacksonville home. While thousands mourned the passing of Morris Marcellus Moore, the connection he represented between Africa and Florida would not have appeared unusual to those who knew him. Bishop Moore was himself a Floridian, born a slave near Quincy forty-four years earlier (fig. 11.1). And, as far as Floridians were concerned, he was not the first of their number to occupy his episcopal assignment. After all, his predecessor as bishop for Sierra Leone, too, had been a Floridian. Having entered the world near Lake City in 1848, Bishop Abram Grant had gone on to help found the church's Liberia Conference years after he had served Duval County as a county commissioner.[1]

As hinted at by the examples of Bishops Moore and Grant, Africa's presence in Florida had resounded as an influential and continuing theme in the colony, territory, and state's evolution during the nineteenth century. The connections, arguably, ranged over millennia rather than over a mere century. Florida and northwest Africa actually had constituted one land until separated hundreds of millions of years ago by the dynamics of plate tectonics. Legacies of that union remained in magnetic forces and geologic structures that continue to undergird the alluring semi-tropical surface. The legacies remained also as whispers of a distant past when, as they occasionally do, Saharan winds bore storms of captured sands across the Atlantic to leave state residents confronted by red dust and red sunsets.[2]

Underscoring their affinity, Florida and portions of Africa, as visitors to both places acclaimed, shared similar environmental conditions, flora, and fauna. One Florida-born missionary eloquently recorded her discovery of this fact soon after arrival in the Congo Free State during the century's waning

Figure 11.1. Marcellus Moore, African Methodist Episcopal bishop of Liberia and Sierra Leone. Born a slave near Quincy, Florida, Moore served as the bishop of Liberia and Sierra Leone for the African Methodist Episcopal Church. Courtesy of State Archives of Florida, *Florida Memory*.

years: "I shall be delighted to see it rain once more. The climate seems quite like that of my own beloved birth State, with that exception." The missionary added, "I think if the country is ever cleared up, as our Florida is being done, the climate will be even superior to that of Florida."[3]

As will be seen, quite a number of Floridians traveled to Africa in the nineteenth century; still, the overwhelming numbers journeyed in the opposite direction. Consider that, at the century's commencement, the Spanish colonies of East and West Florida already consisted in large part of African-born or African-descended residents, mostly slaves. Those numbers grew so that by 1814 a majority of the recognized population of East Florida—the region stretching from the Suwannee River to the Atlantic and including the peninsula—consisted of enslaved human beings of African heritage. After the United States finalized acquisition of the colonies in 1821, Florida's steady population growth brought with it increasing numbers of such persons. By 1840 almost half of the territory's residents had ties to Africa. Thirty years later a comparable level prevailed in the state. The century's end found that 43 percent still carried that African link.[4]

Significantly, native Africans maintained a continuing and sometimes prominent place within that population. In 1801, East Florida's military commander, Georges Biassou, was not African himself; still, his parents had

Canter Brown Jr. and Larry Eugene Rivers

originated on that continent, and the heritage they imparted loomed very large for him. Famed for his 1790s exploits during the Haitian revolutions, he echoed that African heritage by practicing *vodou* while observing, as Jane Landers explained, "at least a syncretic Catholicism." In a similar vein, an observer during the Haitian war years had found his "war tent . . . filled with kittens of all shades, with snakes, with dead men's bones and other African fetishes" and remembered that Biassou would appear at nighttime dance rituals "with his *boccors* [religious specialists] to proclaim in the name of God that every slave killed in battle would re-awaken in his homeland of Africa."[5]

Although Biassou could not honestly call Africa his place of birth, one of his immediate successors could do so. Juan Bautista "Big Prince" Witten had been born in the West African region of Guinea before enduring the tortuous Atlantic crossing to American slavery in South Carolina and Georgia and then courageously undertaking an ultimate flight to freedom in Florida. The highlight of his subsequent military career saw him in 1812 defeating a detachment of U.S. Marines and allied soldiers during East Florida's Patriot War.[6]

While Biassou and Witten vividly represent the substantial number of nineteenth-century Floridians of prominence with strong African ties, there are many other excellent examples. Anna Madgigine Jai Kingsley, discussed by Antoinette Jackson in the previous chapter, is one of them. At Laurel Grove, near today's Orange Park, her ideas helped to mold the modern concept of orange cultivation in groves. Later, at Fernandina and Fort George Island she built an even stronger reputation as a businesswoman, manager, and innovator.[7]

Not far south at St. Augustine, Anna Kingsley's contemporary Jack Smith aimed his life at a course far different from that of plantation magnate. Originally named Sitiki, he recorded of his early days, "I was born in an interior country of western Africa [in 1794 or 1796, and] at the age of four or five I became captive to a neighboring people" (fig. 11.2). Sold to a ship's captain, he then became a Georgia slave, a literate Connecticut farmhand, a captive of the British during the War of 1812, and, beginning in summer 1817, a Floridian. Six years afterward, his life changed again. "The first religious instruction that I received was in the year 1823 from Mr. Glen, a Methodist minister," he recalled, "and on the 26 of December, I joined the church and took the sacrament." Smith's devotion soon expressed itself in preaching. By the 1840s he pursued that calling in his own St. Augustine "meetinghouse." Officially licensed as a minister in 1867, Jack's "zeal" and "spirit" attracted the devotion of his congregants. Sitiki died "of old age" at St. Augustine on September 3, 1882. By then, he had touched the lives of thousands through his ministry, kind works, and friendship.[8]

Notably, at least a few of the era's prominent Africa-born Floridians were white, with Moses Levy likely offering the foremost illustration. He came into the world during 1782 in Morocco and was raised at the fortress seaport of

Figure 11.2. Jack Smith, originally named Sitiki. "Uncle Jack" Smith was a former slave of historian Buckingham Smith in St. Augustine. He told his own story in a handwritten document in which he stated, "I was born in an interior country of western Africa at the age of four or five. I became captive to a neighboring people." He became the first black Methodist minister in St. Augustine, where he established his own church. Courtesy of the Collection of the St. Augustine Historical Society Research Library, Manuscript Collection 112.

Mogador. By various turns he emerged as an individual of large reputation, known far and wide as a businessman, entrepreneur, Jewish utopian, and social reformer. When the United States took over Spanish La Florida in 1821, Levy quickly invested in its future and soon controlled 100,000 acres. His endeavors included a sugar plantation on the St. Johns River and the projected Jewish settlement called Pilgrimage near Micanopy in Alachua County. When Moses passed away in 1854, his son David Levy Yulee (fig. 11.3) served Florida

Canter Brown Jr. and Larry Eugene Rivers

as U.S. senator, the first person of Jewish or African descent to attain that exalted rank.[9]

It bears mention that persons of African birth continued to arrive in Florida by various means throughout the nineteenth century, certainly long after the United States banned the slave trade in 1808. Beginning with implementation of that ban, La Florida served as an open conduit for the illegal transportation of slaves to Georgia and elsewhere, with Fernandina and Pensacola in particular earning reputations for their roles in the illicit traffic. As further discussed by Andrew Frank in chapter 9, the practice persisted after the American era dawned, with smugglers taking advantage of innumerable "secluded places on the coast." Dr. Charles Parrish, for one, clearly recollected his experience as a victim of slave smuggling. Known to some as Blackhawk, Parrish reportedly touched the shores of today's Sunshine State in the mid-1830s, about the time of the Second Seminole War. An obituary told the story, if only briefly, when he died at Albany, Georgia, in 1889. "When a small boy just over from the Dark Continent," it began, "he was captured by Seminoles in Florida." Even on the Civil War's eve, the trade continued. Reports circulated, for instance, that

Figure 11.3. United States senator David Levy Yulee. Yulee's father, Moses Levy, was a white Jewish Moroccan immigrant. In 1821 Levy invested in some 100,000 acres in Florida, where he envisioned a Jewish settlement in Alachua County. When Yulee was elected senator, he was the first person of Jewish or African descent to attain that dignified position. Courtesy of State Archives of Florida, *Florida Memory*.

Virginian James Evans settled in 1859 at mostly deserted Fort Myers "for the real purpose of establishing a Depot for the reception of African Slaves."[10]

Even bloody Civil War clashes and, in the conflict's wake, slave emancipation failed to stem the Florida arrival of individuals who recently had been held in slavery. As Key West and Tampa came in the 1870s and 1880s to pull the burgeoning cigar manufacturing industry away from its Cuban roots, formerly enslaved Afro-Cubans landed by the hundreds in both communities. In 1891 a major religious publication pointed out this fact clearly. "Speaking of St. Cyprian's P. E. Church at Key West, Fla.," its report advised, "the *Churchman* says: 'This is probably the most unique congregation in the United States, as it is mostly composed of native Africans who were slaves in Cuba.'"[11]

Not all black Africans coming to Florida during the nineteenth century came restrained by the shackles of slavery, for as Thomas de Saliere Tucker's story makes evident, some came voluntarily (fig. 11.4). Born on July 21, 1844, on Sherbro Island, Sierra Leone, Tucker received his early education at the Mendi Mission school before relocating in 1856 to Oberlin, Ohio, at a religious

Figure 11.4. Thomas De Saliere Tucker. Tucker was one of the early pupils of the American Missionary Association's Mende Serra Leone Mission. He was sent to the United States to study at Oberlin College at the age of twelve. Trained as a classicist and attorney, he was eventually named first president of the Normal and Industrial College for Colored Students (formerly the State Normal College for Colored Students) at Tallahassee, which became Florida Agricultural and Mechanical University. Courtesy of State Archives of Florida, *Florida Memory.*

leader's behest. There the lad pursued his studies, eventually graduating from Oberlin College in 1865 with a B.A. degree in classics and humanities. He followed this achievement in the early 1880s by earning a law degree at New Orleans's Straight University, after which he practiced at the bar in Louisiana and at Pensacola. After Florida's legislature authorized a normal school for "Colored Teachers," Governor Edward A. Perry, also a Pensacola resident, turned to Tucker in 1887 to guide the institution's development. The lawyer and educator thereafter served as principal of what would become Florida Agricultural and Mechanical University until he resigned in 1901, moved to Jacksonville, and again took up the practice of the law.[12]

Of course, not all Floridians of African birth were well known; yet, as the century's years slipped toward its end, any number of Africa-born men and women enjoyed a degree of local renown for their origins as well as their longevity. Corporal Jaudon was one such person. Said to be "the oldest man in Florida" at his death in 1877, "Daddy Corporal" reportedly had achieved 117 years. "He belonged to the African tribe Esco Gullah," the *Jacksonville Sun* explained, "and was brought to this country when a boy." Five years later Santa Quanta at Archer claimed brief celebrity. A widely circulated sketch gave his age as 120. "Me big boy in old country; some hair on face," he reminisced about his departure from West Africa in 1778. George Bush, who died near Palatka in 1889, was "supposed to be 108 years of age." Although he was born at St. Augustine, his mother had been "an African slave imported woman." An obituary noted, "In appearance he looked more like a descendant of an African Arab than of a Congo or Guinea negro." The next year at Old Town, Stephney Mitchell followed Bush to the grave. Friends claimed him "to be 120 years old." Explained one of them, "The old man was brought from Africa."[13]

Reminders of Florida's African links repeatedly arose from the publication of such items in the state's press, but the nineteenth century preserved or introduced various forms of other African legacies across a wide spectrum of notice and experience. Take, for example, what residents called—and call—specific natural features and places. Tolagbe M. Ogunleye has speculated that at least two of Florida's waterways, the Alafia and Suwannee Rivers, carry African names. The former, she argues, means "peace, health, wealth, happiness, bliss" in Yoruba, while the latter represents "my house, my home" in Kikongo. Similarly, the Wahoo Swamp may derive its name from the Yoruba word for "to trill the voice." Other scholars similarly have posited that dozens of additional places, including communities such as Chuluota and Wauchula, can trace their names to African, rather than Native American, sources.[14]

Some Florida places retain in our memory even today a direct connection with Africans and persons of African descent. The most famous may be the Negro Fort, once located on the Apalachicola River and destroyed by the U.S.

Army in 1816. Ogunleye stresses that its inhabitants called the outpost Ashila Fort, the name deriving from the Kikongo word for "to build or construct a house for someone else." Several hundred miles to the south and east lay a maroon settlement on a point of land where the Braden River enters the Manatee, not far from Tampa Bay. That community hosted survivors of Ashila Fort, among others, until its own destruction by Creek Indian allies of Andrew Jackson in 1821. What its residents called the community has not come down to us, but Cuban fishermen residing nearby referred to it as Angola. Rosalyn Howard's excellent examination of "Black Towns of the Florida Seminoles," chapter 7 in this volume, provides further insight into other communities of a similar nature.[15]

Persons, as well as places, carried African names. To a significant extent this dynamic derived from a desire to maintain family connections over generations, ones that stretched back to African homelands. West African day names especially proved popular. Thus, Florida provided a home for any number of males named Cudjo or Cudjoe, meaning in Ashanti "child born on Monday," or Cuffy or Cuffee, meaning "child born on Friday." Not unusually, plantation record keepers adopted English names that simply were homonyms of African ones. In these cases, to site a few illustrations, Abbey might refer to Abanna, Billy to Bilah, Jack to Jaeceo, Moses to Moosa, and Sam to Samba. Even some Seminoles carried names of African origin. Chief Billy Bowlegs's mother, to cite an example, was known as the Buckra Woman, and one of her settlements was called Buckra Woman's Town. Buckra, ironically, meant "white" in its original African form as expressed in the Efik tongue.[16]

Even residential housing sometimes reflected African form and practice. Architectural historians point to the shotgun house, a structure commonly seen in Florida of the nineteenth and early twentieth centuries, as a structure with African origins. The name, they suggest, stemmed from the West African term *shogun*, which meant "God's house" in the Yoruba language. Collections of structures and neighborhoods, too, could represent African practice. When she arrived at her husband's Laurel Grove plantation at Orange Park, Anna Kingsley found, accordingly to Daniel Schafer, "a transplanted African village inhabited by black men and women from distant nations and cultures." Later at Fort George Island, she seemingly reconstructed a semicircular West African village reminiscent of scenes from her youth to serve as the plantation's slave quarters (see fig. 10.3). The tabby technique used in the construction itself—one utilized throughout Florida—originated according to some scholars in her Senegalese homeland. In the same vein, at Key West in 1860 the U.S. marshal assisted in providing temporary housing for Africans seized in the illegal slave trade and destined for return to their home continent. "When within the enclosure one may easily imagine himself to be in an African vil-

lage," a visitor related, "fourteen hundred wild Africans are grouped about, engaged in various diversions, or lazily basking in the sun."[17]

For today's Floridians such reminders of African links may come to notice only rarely, but for those captivated by the state's historic cemeteries the opposite often is true. Family, church, and public graveyards (and even funerary customs) may contain any number of examples of African practices preserved over the centuries. Occasionally, wooden grave markers fashioned from "small pine boards or shakes carved to resemble a 'head and shoulders'" survive as an example. More commonly, in historic graveyards—whether intended for white, black, or all burials—shells may be found decorating and adorning the site. According to Sherrie Stokes, these "represented the deceased person's passage to the spirit world." Said another way, they pointed to "eternal life." Africans were not alone in prizing the use of shells for this purpose, but their influence may be seen and felt in Florida's application of the custom as explored further in this volume in Kara Ann Morrow's essay "Signs, Symbols, and Shells: African American Cemeteries in Florida" (chapter 12).[18]

The list of such links and influences runs on and on. West Africans, for instance, refined Florida's cattle industry through application of grazing and herding techniques developed in their homelands over the course of millennia. A great variety of crops also made their way across the Atlantic in both directions. Items from Africa taken for granted by Floridians have included peanuts, watermelons, and some varieties of millet and rice. Methods of working these crops and other labor-related practices and techniques jumped the ocean as well. Thus, when Anna Kingsley arrived at Laurel Grove, she felt comfortable with the work environment. "This was a pattern of labor readily recognizable to Anna," her biographer shared, "whose uncles had sent slaves to labor in the millet fields of Jolof." Something as basic as seeing someone carry a load might have stirred her memories of home. The African practice of carrying bundles on the head persisted in portions of Florida well into the twentieth century[19] (fig. 11.5).

And then there was music and dance. African sounds, techniques, cadences, beats, poses, steps, and movements punctuated life in nineteenth-century Florida, permeating farms, plantations, and towns. Sometimes the airs struck fear and prompted restrictions and reprisals, particularly when insistent African drumbeats in the nighttime raised alarms and portents of slave insurrection. More often, delight resulted. As music historian Wiley Housewright observed of Swedish tourist Fredrika Bremer's experience at St. Augustine, "She was fascinated with songs and celebrations of the Negroes." A French aristocrat contributed his impressions gleaned during the 1830s in Leon County, ones that articulated the central importance of Africa-derived music and dance to those who performed it. "Draw near to a plantation, and the

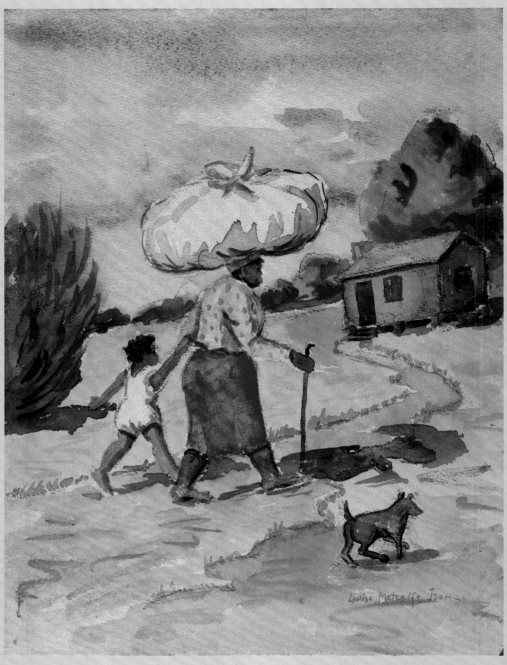

Figure 11.5. *Totin Home the Wash*, by Louise Metcalf Isom. Watercolor on paper, 11.75 × 8 inches. Africanisms in speech, food, and various customs were well represented in Florida over time. The ways people moved or carried items often reflected African origins. For example, the African practice of carrying loads on the head continued well into the twentieth century as manifested in Isom's painting. From the Florida Collection of Cici and Hyatt Brown.

noisy outbursts of laughter that you hear there will make you forget the over-seer who goes about provided with his huge whip," the comte de Castelnau recorded. "Then comes the rest days, and all the miseries of the week are for-gotten in the wildest dances and the most ridiculous capers."[20]

Who can imagine the evolution of music and dance in nineteenth- or twen-tieth-century Florida, much less the South and the nation, without African contributions? Fifes, banjos, and fiddles originating in African sources punctu-ated and enlivened daily life, while emphasis on the beat of drums pushed mu-sical experimentation forward on a course that led ultimately to rock and roll. Make no mistake about it, either. Black performers who grasped the sounds and feel of Africa outshone with their interpretations white imitators who strove through minstrel shows or other avenues to capitalize on music that was not their own. Thus, a bystander could comment on a black worker in the post-emancipation era: "He can plunk almost any string instrument and produce lively, toe-tickling harmonies from a battered mouth organ. Danc-ing comes as naturally to him as singing." On the other hand, a St. Augustine visitor could add, "The Christie imitation of Negro dancing and singing is tol-erable; but like all imitations, somewhat of a caricature." From such circum-stances and conditions, Florida emerged by 1901 as a vital center for bringing music, dance, and performance with African origins to audiences throughout the nation. By that time, the vehicle primarily was vaudeville.[21]

Africa thus touched nineteenth-century Floridians where and how they lived, died, and were buried, in what they ate and how they worked, and in the sounds that entertained, diverted, and sometimes either frightened or inspired them. Africa—whether they recognized the fact or not—served as a nexus for influence and diversion, and proof of that fact, if proof still is needed, appeared continually in the newspapers that Floridians read. The solid level of interest manifested earlier in the century persisted and even increased as the years passed and the state headed toward the twentieth century. Though the specific focus changed repeatedly, the call of Africa resounded. The subject might center on matters of substantive importance to Floridians such as the slave trade or possible answers to the fate of slaves freed from bondage. More often, it touched on the exciting, dangerous, exotic, and forbidden. Thus, as early as the 1870s, explorer Henry M. Stanley's African adventures captivated readers. Meanwhile, lurid tales of cannibalism always drew interest, as did news of the discovery of gold, diamonds, and other treasures or of "tribes of little men extending halfway across Africa." Even the merely odd or excep-tional occasionally managed to push itself forward for attention. Thus, Florid-ians carefully followed H. J. Tiffin's 1896 attempt to nurture an ostrich farm on his Merritt Island property. In the process they grew closely acquainted with the fact that ostriches "are frequently put to use [drawing carts] in Africa"

and that Tiffin's handbook for progress came in the form of Arthur Douglass's *Ostrich Farming in South Africa*.[22]

Wars and colonial ambitions naturally provided African grist for the mill of Florida journalists. Sometimes tribal conflicts provided the story, but increasingly South African turbulence drew Sunshine State attention. "Among the minor wars England is waging is the one in South Africa against the Boers," the *Fernandina Florida Mirror* explained in 1881. "[The Dutch-descended Boers] seem to be a brave people," the newspaper added, "something like our cattle rangers of the Western territories, accustomed to the expert use of arms, brave and hardy, and more than a match for the English troops sent against them." When the Boer War reignited in 1899, a special connection awaited Florida's consumers of news. Winston Churchill, then a journalist, explained in a description of June 1900 British efforts to secure Johannesburg and its suburbs. "The whole of [General Ian] Hamilton's force had marched by ten o'clock, but even before that hour the advance guard had passed through the Johannesburg suburb of Florida and picketed the hills beyond," he reported. Alluding to the Royal Botanic Gardens, in London, Churchill added, "Florida is the Kew Gardens of Johannesburg."[23]

The newspapers experienced little difficulty in singling out even more African subjects to interest Florida readers. After the American Colonization Society (ACS) founded Liberia in 1822 as a home for freed American slaves, journals dedicated prime coverage to the colony, the issues of emancipation its existence raised, and the ACS. The articles sometimes combined information on the Liberian experiment with details regarding the British colony at Sierra Leone. From early on, some Floridians supported the ACS while others expressed or hinted at a willingness to emigrate there. In line with those sentiments, the ACS organ *The African Repository* could relate in 1855 that "a gentleman in Florida, with one of his friends, offered in timber and money, a subscription of $3,000 . . . to build a ship . . . to run regularly between Liberia and the United States." Similarly, in 1833 *The Repository* had quoted a Savannah letter as reporting, "T. Smith, from Florida, says that if the passage were six months instead of six weeks, he would cheerfully undertake it; and begs me to endeavor to assist his wife and children on." Florida support for the ACS also could be seen in the residence at Tallahassee during the 1840s of former Virginia congressman Charles Fenton Mercer, a founder and longtime officer of the organization. Key West lawyer H. W. Smith's commitments during the same period proved so profound that they still were remembered with appreciation over one-quarter century later.[24]

While the focus on Liberia commanded a respectable share of Florida press attention during the 1800s, the century's final two decades saw the Congo emerge into clearer view, a circumstance that can be ascribed directly to the actions of a Floridian. His name was Henry Shelton Sanford, and, although he

hailed from Connecticut and had served as a general officer in the Union army during the Civil War, he had cast his lot when peacetime came with Florida and its development. Today, the city of Sanford stands as his memorial. In the 1880s, however, Sanford achieved acclaim or infamy, according to your point of view, through his close association with King Leopold II of Belgium in the creation of the Congo Free State and then with entrepreneurial attempts to exploit the Upper Congo region's economic potential. In doing so he proudly proclaimed to the world his attachment to his adopted state. "The Sanford Exploring Expedition was the first commercial enterprise started [in the Congo]," he explained in 1887, "and its steamers named the *Florida*, after my native state, and the *New York*, were the first commercial boats launched upon the waters of the Upper Congo."[25]

Newspapers followed Sanford's Congo activities with fascination and awe, but meanwhile Florida's residents were gleaning other perspectives on the Congo and African matters generally through an alternative medium, their churches. Actually, involvements of Florida churches in African missionary work dated back at least to the close of the century's first half, when Georgian Thomas Jefferson Bowen, well known to Floridians from his Seminole War exploits in the 1830s and his Baptist ministerial labors in the next decade, helped to pioneer Christian mission work in Yorubaland, a vast region mostly identified today with Nigeria. Bowen's labors received wide attention, including in Florida, because he proved so prolific a writer of letters and reports. Then, in 1857 he published his memoir *Central Africa: Adventures and Missionary Labors in Several Countries in the Interior of Africa, from 1849 to 1856*. Back from the "Dark Continent," the now former missionary supported himself through preaching and lectures when health permitted. As a biographer noted of the years immediately prior to his death in 1875, "From 1868 to 1874 he travelled in Texas and Florida."[26]

T. J. Bowen's name became a household word in Baptist circles throughout Florida, but his renown and influence offered merely the tip of the iceberg in terms of missionary ties between the Sunshine State and the Dark Continent. Most mainstream churches embraced missionary work during the era, including sending workers to various corners of Africa or, at least, helping to support them there. To offer just one example, Edwin T. Williams represented Presbyterians in Liberia from 1854 to 1860. Struck, as Bowen had been, by ill health, he first returned to his native Georgia to recover but soon relocated south. "He became a member of Florida Presbytery and pastor of the church in Quincy, Florida," a friend explained upon his death.[27]

At Quincy, in the months preceding his death in 1866, the Reverend Williams may have been permitted to perceive the beginnings of a dramatic change that was to remake Florida's religious, political, and social scenes and alter dramatically the state's ties to Africa. With the Civil War ended and

emancipation of persons of African birth and descent assured, Allen Jones Sr. and Dennis Wood had joined with friends at Quincy to erect a brush arbor to permit services by a new church, the African Methodist Episcopal Church. That body and its rival, the African Methodist Episcopal Zion Church, had entered Florida in 1865 and 1864, respectively, to allow former slaves their own vehicles for religious commitment and expression. Some whites had welcomed their ministers and missionaries, but others had perceived threats from this "African" innovation. Tallahassee's *Florida Sentinel*, for one, mocked this "Advance of African Civilization" in a front-page item run in January 1866. The *Tampa Florida Peninsular* ended the same year with feigned indignation at the effrontery of an AME "African Bishop." Its editor queried, "How sagacious this African Bishop?"[28]

Whatever end such negative voices intended, the African Methodist churches proved durable in their Florida ministrations, and by the mid-1870s church leaders found their denominations secure enough to begin projecting their own foreign missionary efforts. In both cases the Bahama Islands served as the initial field of interest, but Africa diverted attention before long. This evolution of perspective and interest may have been aided in the early 1880s by the arrival of AME clergyman Albert P. Miller, who had served on behalf of the American Missionary Association in Sierra Leone following his 1878 graduation from Fisk University. Back in the United States by 1881, Miller began studies at the Yale Theological Seminary, but his wife's health led to a Florida respite. Assigned to Lake City in 1882, his stay proved short lived but his influence on Florida's conference leaders likely worked a profound impact.[29]

Influence for African missions within Florida's AME Church also derived from the sentiments of the great Georgia churchman Henry McNeal Turner, later Bishop Turner. Time and again he participated in Florida conference meetings, pointing eastward to Africa and the mission that awaited there. The message resounded by the mid-1870s and through the century's end. Among those who absorbed Turner's admonitions for foreign service stood a young preacher from Columbia County named Abram Grant (fig. 11.6). A man of enormous talent and capacity, Grant by 1888 enjoyed election as an AME bishop, and by the late 1890s he had received appointment as AME supervisor for the Sierra Leone and Liberian Conferences. In that capacity he traveled in 1899 to the region, bringing national publicity to the church's African work. Grant aided his own Florida protégé, Morris Marcellus Moore, to election to the episcopate the next year and doubtlessly influenced Moore's immediate assignment to the West African conferences.[30]

For the most part Floridians belonging to the AME Church contributed to the African missions financially rather than from undertaking a personal mission. Annual conference missionary meetings and sermons encouraged collections that underwrote costs. Repeated wherever AME influence was felt, the

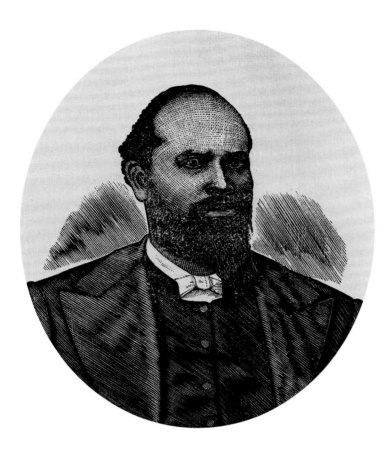

Figure 11.6. Bishop Abram Grant. Grant was born as a slave in 1848 near Lake City, Florida. After the Civil War, he gained his education in missionary and night schools and eventually attended Cookman Institute. By 1888 Grant had been elected as an AME bishop. In the late 1890s he was appointed as AME supervisor for the Sierra Leone and Liberian Conferences. In 1899 he traveled to that part of Africa, bringing national publicity to the church's African work. Courtesy of State Archives of Florida, *Florida Memory*.

efforts produced substantial results. C. T. Shaffer of the church's extension department updated the figures for the hundreds of persons who attended the 1896 session of the East Florida Conference at Jacksonville, reporting "that $20,000 had been raised during the past four years for missionary purposes; that the church [on a national level] had thirty-eight missionaries in Africa who were working to civilize Africans and teach them of Christ." One individual with Florida connections notably accepted a mission not long after Shaffer's presentation. During the 1870s Conrad A. Rideout had earned a degree of notoriety practicing law at Monticello. Finding his welcome wearing thin, he had relocated first to Arkansas and then to Washington State. The years drew him closer to his church, however, especially through Bishop Turner's influence. By century's end, attorney Rideout served in South Africa as "Advisor to the Chiefs of Lesotho and Pondoland."[31]

Interestingly, a Baptist woman rather than an AME male represented Florida most visibly and significantly in African missionary work during the late nineteenth century. Louise Cecilia Fleming had been born a slave in 1862 at Hibernia Plantation on Fleming Island in the St. Johns River near Green Cove Springs (fig. 11.7). After the Civil War she attended Jacksonville schools, taught at St. Augustine, and pursued a degree in Raleigh, North Carolina, at

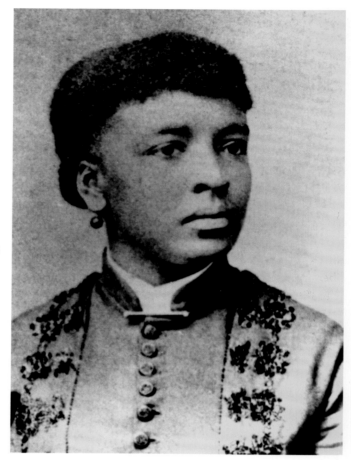

Figure 11.7. Louise Cecilia Fleming. Born into slavery near Green Cove Springs, Florida, Fleming attended Jacksonville schools and taught at St. Augustine. Pursuing a degree at Shaw University in North Carolina, she graduated as class valedictorian in 1885. The first female missionary to Africa appointed by the Woman's Baptist Foreign Missionary Society of the West, Fleming underwent some medical training and left for the Congo in 1887. On a return trip to the United States she earned her medical degree in Philadelphia in order to return to the Congo as a medical missionary. Courtesy of American Baptist Historical Society, Board of International Missions Collections biographical files.

Shaw University, where she graduated as class valedictorian in May 1885. Already she burned with desire for mission work, and she managed in 1886 appointment as the first female missionary dispatched to Africa by the Woman's Baptist Foreign Missionary Society of the West, an associated organization of the American Baptist Missionary Union. A brief sojourn for medical training preceded her voyage to the Congo in 1887. Fleming came to love Africa, but the continent took its toll on her health. Back in the United States for recuperation by 1891, she earned her medical degree while lecturing in Florida and elsewhere on her experiences. "Her portrayal of the habits, customs and manners of the people among whom she has been laboring; and in whose interest and welfare she has so nobly consecrated herself, was most touching, tender and thrilling," reported the *Jacksonville Evening Times-Union* of one presentation in 1895. "The audience was greatly moved," the item continued, "and all felt the sincerity and devotion of spirit that fills the bosom and accelerates the motive of the dear good woman who has laid her all on the altar for Christ and humanity." As a medical missionary Lulu Fleming returned to the Congo, but

her health again suffered. Following repeated trials, she returned for a final time to the United States and died at Philadelphia on June 20, 1899.[32]

African-American Missionary Baptists thus contributed to African work as did AME and AMEZ adherents, although AME endeavors predominated in a related field of activity, emigrationism. Where some Floridians earlier had expressed an interest in emigration to Africa, specifically to Liberia, the post–Civil War years brought greater curiosity and eventually real commitment. As early as 1866 future congressman Charles Purman had inquired on behalf of "a population of 5,000 freedmen" in the Jackson County region "about Liberia, its resources, climate, and the means of getting there." That early initiative went no further, but by 1872 applications from Florida were reaching American Colonization Society offices. Some individuals had departed the United States by November, and the following March it was reported that "3000 applicants from Georgia and Florida . . . are waiting for an opportunity to go to Liberia."[33]

In the years immediately thereafter, as the Reconstruction era ebbed and the return to power in Florida of white conservatives began to consolidate, the AME influence sparked renewed life in the "Back to Africa" movement. Particularly, Bishop Henry McNeal Turner preached the cause whenever opportunity was afforded. Florida ears picked up his call, including those of the state church's leading figure, Presiding Elder Charles H. Pearce. At various places Liberian Exodus Organizations formed, such as the one Allen Jones helped to found in Escambia County. "My faith is more firm than ever," Jones recorded in December 1877, "and I fully believe that thousands of our race will ere long reach their natural and peaceful home in Liberia." The ACS reportedly boasted within a matter of weeks of "applications on behalf of a quarter of a million of coloured people," individuals who were "chiefly resident in South Carolina and Florida." Among them, Jackson Countians again figured, sending two representatives to Washington "to make arrangement for the emigration of a number from Jackson County to Liberia." And, at Tampa in May the local newspaper announced that a small group had "boarded a steamer bound for Liberia." The hubbub proved, however, more sound than fury. Always voices within the church, such as that of Florida's bishop Jabez P. Campbell, protested. As was reported of his statements at a Quincy conference held in February 1878, "He took occasion to tell those who had ideas of emigrating to Liberia that any who had money enough to buy farming implements and provisions might go and thrive, but that nation did not want an importation of paupers from this country." The report added, "He thought that the Almighty had brought the Africans here to dwell in bondage awhile for some wise purpose of his own."[34]

A decade had passed before another wave of emigration fever was reached. In the meantime, conditions for African Americans in Florida had deteriorated significantly. Farmers throughout the South were locked in spirals of reduced

crop prices and burgeoning debt, while racial violence increasingly plagued the countryside and even some urban areas. Florida by the 1880s had taken the lead on a per capita basis for race-based lynchings, a reputation it maintained into the 1930s. It seems that Liberia interest centered by that time most intensely, but not exclusively, in Alachua and Marion Counties. Frank and Annie Whittier were among those who left Gainesville in 1888, for instance. Three years later the ship *Liberia* departed New York with another party that included Ocala's AME minister H. W. White. "He said he never felt safe in the South," an account observed. Disappointment at conditions found in Liberia prompted some who emigrated to return to Florida homes, but others continued to set their sights on relocation. In one example, as a Chipley item from 1895 noticed, "We learn that a good many of them signify their willingness to go [to Africa]." The century ended with the controversy continuing unabated. Bishop Abram Grant's 1899 Africa trip convinced him, for one, that emigration would not work. Instead, he stressed missionary work. "They ought to go, if at all, in the same way that others do to help develop the country and better the condition of the people," he expressed. "The best products of our schools are to be obtained for that purpose."[35]

Africa, Africa, Africa. The word echoed in Florida in most places at most times through the nineteenth century. The connections proved as constant as, at times, did those red sunsets produced by Saharan sands. Africa loomed as exotic, compelling, and even dangerous. But, it also found commonplace access to most lives. Thus, an account of a gathering of AME churchmen in 1897 would have drawn few remarks upon its details. State Normal and Industrial College for Colored Students principal Thomas D. Tucker had invited church dignitaries, including Bishop James C. Embry, Financial Secretary Morris Marcellus Moore, and church editor T. W. Henderson, to the "beautiful grounds" of the State Normal and Industrial College. Henderson especially was struck by seeing his old friend from college days. "The writer was next introduced and expressed his great pleasure in meeting in this high position his old acquaintance, President Tucker whom he remembered at Oberlin over thirty years ago." Henderson added without hesitation, "He remembered that the President was brought from Africa."[36]

Notes

1. *Washington (D.C.) Colored American*, April 1, 1899, December 1, 1900; *Topeka Plain Dealer*, April 14, 1899; C. S. Smith, *A History of the African Methodist Episcopal Church*, 221; Talbert, *The Sons of Allen*, 56–57; Rivers and Brown, *Laborers in the Vineyard of the Lord*, 190, 194–97; Brown, *Florida's Black Public Officials*, 94.

2. Arthur et al., "Florida's Global Wandering through the Geologic Eras," 11–12.

3. *Philadelphia Christian Recorder*, December 8, 1887.

4. Landers, *Black Society in Spanish Florida*, 161; Department of Commerce, Bureau of

the Census, *Negro Population, 1790–1915* (Washington, D.C.: Government Printing Office, 1918), 51. On the growth of Florida's slave population and planter economy during the territorial and statehood periods, see Rivers, *Slavery in Florida*.

5. Landers, *Black Society in Spanish Florida*, 81, 122, 132, 226.

6. Ibid.

7. See Schafer, *Anna Madgigine Jai Kingsley*.

8. See Sitiki, *Odyssey of an African Slave*.

9. See Monaco, *Moses Levy of Florida*.

10. Du Bois, *The Suppression of the African Slave-Trade to the United States*, 8, 180; *Cleveland Gazette*, July 13, 1889; Theodore Bissell to Harrison Reed, April 1, 1864, Florida Direct Tax Commission Records, Records of the Treasury Department, Internal Revenue, Record Group 59, National Archives, Washington, D.C.; Grismer, *The Story of Fort Myers*, 93–94, 275.

11. *New York Age*, May 9, 1891. See also Greenbaum, *More Than Black*.

12. Dumbaya, "Thomas de Saliere Tucker"; Rivers and Brown, "'A Monument to the Progress of the Race,'" 39–41.

13. *Savannah Morning News*, May 18, 1877; *Tallahassee Weekly Floridian*, May 22, 1877; *Fernandina Florida Mirror*, November 25, 1882; *Jacksonville Florida Times-Union*, July 17, 1889, July 20, 1890.

14. Ogunleye, "AROKO," 399; Pollitzer and Moltke-Hansen, *Gullah People*, 123–24.

15. Ogunleye, "AROKO," 400, 412; C. Brown, "Tales of Angola," 5–49.

16. Rivers, *Slavery in Florida*, 164, 197; Inscoe, "Carolina Slave Names"; Holloway, "Africanisms in African American Names," 86.

17. Vlach, "The Shotgun House" (1976); Vlach, "The Shotgun House" (1983); Vlach, *The Afro-American Tradition in Decorative Arts*; Whitney, Means, and Rudloe, *Priceless Florida*, 52; Schafer, *Anna Madgigine Jai Kingsley*, 28–29, 52–56; *New York Herald*, June 21, 1860.

18. Stokes, "Gone But Not Forgotten."

19. Gray, *History of Agriculture in the Southern United States to 1860*, 1:173, 194, 2:723; Pollitzer and Moltke-Hansen, *Gullah People*, 97; Schafer, *Anna Madgigine Jai Kingsley*, 30. See also Landers, *Black Society in Spanish Florida*, and Carney, *Black Rice*. See also J. B. Harris, *High on the Hog*.

20. Rivers, *Slavery in Florida*, 166–67; Housewright, *A History of Music and Dance in Florida*, 233; de Castlenau, "Essay on Middle Florida," 243.

21. Rivers, *Slavery in Florida*, 166–67; Housewright, *History of Music and Dance in Florida*, 254, 273; Rivers and Brown, "'The Art of Gathering a Crowd.'"

22. *Fernandina Florida Mirror*, February 7, April 10, 24, 1880, May 12, 1883, June 13, July 18, 1885; *Tallahassee Florida Sentinel*, March 8, 1866; *Jacksonville Florida Union*, March 7, 1868; *Titusville Florida Star*, June 28, 1883; *Starke Bradford County Telegraph*, February 5, 1892; *New York Times*, June 21, 1896; *Jacksonville Daily Florida Citizen*, September 1, 1896.

23. *Fernandina Florida Mirror*, February 26, 1881; *Titusville Indian River Advocate and East Coast Chronicle*, December 15, 1899; *Starke Bradford County Telegraph*, June 29, 1900; Churchill, *Ian Hamilton's March*, 262–63.

24. *Pensacola Gazette and West Florida Advertiser*, June 5, 1824; *Pensacola Gazette*, March 29, 1835; *Jacksonville Florida Republican*, February 8, 1849, June 27, 1850, February 9, 1854; *African Repository and Colonial Journal* 9 (December 1833): 316; *African Repository* 31 (January 1855): 12–13, (November 1855): 342. On Charles Fenton Mercer, see Garnett, *Biographical Sketch of Hon. Charles Fenton Mercer*; *New Orleans Weekly Louisianian*, July 30, 1871.

25. Hochschild, *King Leopold's Ghost*; Rivers, "Louise Cecilia Fleming"; *New York Times*, February 14, 1889.

26. Burlingham, *Story of Baptist Missions in Foreign Lands*; *Milledgeville (Ga.) Federal*

Union, January 11, 1853, May 12, 1857; *Milledgeville (Ga.) Southern Recorder*, March 10, 1857; *Washington (D.C.) Daily National Intelligencer*, September 16, 1857; Bowen, *Central Africa*; On Bowen generally, see Okedara, *Thomas Jefferson Bowen*.

27. Wilson, *The Presbyterian Historical Almanac*, 454–55; Rankin, "Incidents of Missions in Western Africa," 538–39.

28. Brown and Rivers, *For a Great and Grand Purpose*; Rivers and Brown, *Laborers in the Vineyard of the Lord*; *Tallahassee Florida Sentinel*, January 25, 1866; *Tampa Florida Peninsular*, December 15, 1866.

29. Brown and Rivers, *For a Great and Grand Purpose*, 72; Rivers and Brown, *Laborers in the Vineyard of the Lord*, 89; *Indianapolis Freeman*, March 8, 1890; *Philadelphia Christian Recorder*, June 29, 1882; *Jacksonville Florida Times-Union*, March 8, 1883.

30. *Philadelphia Christian Recorder*, April 13, 1876; Rivers and Brown, *Laborers in the Vineyard of the Lord*, 22, 34, 76, 102, 108, 179, 185–86, 192–93; *New York Sun*, January 12, 1899; *Washington (D.C.) Colored American*, March 25, April 1, 1899; *Cleveland Gazette*, June 3, 1899. On Henry McNeal Turner, see Angell, *Bishop Henry McNeal Turner*.

31. *Jacksonville Florida Times-Union*, February 21, 1896, February 26, 1897; *Tallahassee Weekly Floridian*, July 18, 1876; *Quitman (Ga.) Reporter*, May 2, 1877; *Savannah Morning News*, May 25, 1877; *Columbus (Ga.) Enquirer*, May 27, 1877; *New York Globe*, June 9, 1883; Page, "Conrad A. Rideout"; J. R. Campbell, *Songs of Zion*, 199.

32. Rivers, "Louise Cecilia Fleming," 122–50; *Jacksonville Evening Times-Union*, September 7, 17, 1895.

33. *Papers Relating to Foreign Affairs*, 327–28; *Tallahassee Sentinel*, January 15, 1870; *Milledgeville (Ga.) Federal Union*, May 1, 1872; *Macon (Ga.) Telegraph and Messenger*, November 19, 1872; Hazard, *Miscellaneous Essays and Letters*, 130.

34. Angell, *Bishop Henry McNeal Turner*, 119–20; Morris, *A Praise-Meeting of the Birds*, 32–33; Cruwell, *Liberian Coffee in Ceylon*, 151; *Jacksonville Weekly Sun and Press*, March 14, 1878; *Washington (D.C.) Daily Critic*, March 14, 1878; P. Ortiz, *Emancipation Betrayed*, 73; *Tampa Sunland Tribune*, May 11, 1878; *DeLand Volusia County Herald*, February 28, 1878.

35. *Indianapolis Freeman*, May 18, 1889, February 16, 1895; *New York Age*, January 11, 1890; *Starke Bradford County Telegraph*, December 5, 1890; *Columbus (Ga.) Daily Enquirer-Sun*, July 15, 1888; *New York Herald*, October 31, 1891; "Liberia and the Negroes"; "Negro Colonization"; *Pensacola Daily News*, January 26, 1895; *Jacksonville Florida Times-Union*, July 17, 1895, September 30, 1896; *Topeka Plaindealer*, April 14, 1899. On deteriorating conditions for Florida's African Americans during the 1880s and 1890s, see Ortiz, *Emancipation Betrayed*.

36. *Philadelphia Christian Recorder*, February 11, 1897.

12

Signs, Symbols, and Shells

African American Cemeteries in Florida

Kara Ann Morrow

Few aspects of modern life inspire such retrospective contemplation as the rural cemetery. Many scholars have devoted considerable efforts to deciphering the cultural riddles these rich deposits of folklore, art, and history offer. The industry, creativity, and cultural standards of rural populations are often shone off gloriously in the out-of-the-way corners of the Deep South. Tracing the origins of unique styles of cemetery decoration is of particular interest to scholars of both European American and African American cultures, who identify and comment on Africanisms—cultural elements in the New World with sources in African traditions[1]—and distinctly African aesthetics, which are topics consistently featured in almost any article or book on Africanisms in America. Handmade gravestones, personal items associated with the dead, shells, clocks, tile work, and an aesthetic appreciation of accumulation, once so popular in folk cemeteries, are still richly executed in small rural graveyards.[2] This chapter provides a glimpse of the unique monuments that grace the rural graveyards of northwest Florida's "Big Bend," the region of the Florida Panhandle north of Apalachee Bay and south of the Alabama-Georgia state line, where well-documented Africanisms, especially the application of seashells (see fig. 12.1), are easily discernible. Florida's Gulf Coast is an ideal landscape for observing the placement of shells in both African American and European American cemeteries. The very abundance of materials provides artists and mourners in the region with extraordinary opportunities for the artistic expression of cultural memory, knowledge of history passed through generations.

Even though most of the cemeteries at the heart of this study were legally, and to some degree still are socially, segregated, African American and European American graves in the southeastern United States are typically in close proximity to one another, if not in the same divided cemetery. Often

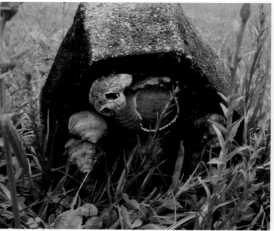

Figure 12.1. Anthropomorphic-shaped cement headstone (*left*) and footstone (*right*) with embedded shells, Jackson County, Florida. Photo by Kara Morrow.

the graves of both groups can be viewed from the same position in a cemetery, very much separated, but occupying the same landscape, a fact overlooked by researchers. Some scholarship also disregards the impact African American culture has had on European American visual culture, even though such influences are well documented in the realms of agriculture, diet and food preparation, language, yard art, architecture, textile design, metalsmithing, and music. The sheer abundance of examples and the numbers of shells on African American graves would command any viewer's attention on the roads that surround these graveyards. The proximity of African American and European American cultures in areas of the South where demographics prove the presence of both, if nothing else, suggests a mutual reinforcement of the practice of decorating graves with shells, an African tradition in Florida.

Africa in Florida's Cemeteries

Perhaps the most prominent signifier of the rural African American graveyard is the presence of distinctly shaped, often homemade grave markers, which provide a degree of permanence to the otherwise ephemeral gravesite. Usually made of cement, these headstones and footstones testify to the artistic inventiveness of a group that was not allowed to, or could not due to financial constraints, buy mass-produced stones, the hallmark of middle-class, white cemeteries of the nineteenth and twentieth centuries. Cement provided folk artists the freedom to create an array of shapes including anthropomorphic silhouettes (fig. 12.1) and tau crosses, T-shaped monuments (fig. 12.2). It also permitted a variety of symbolic and decorative objects to be inserted into the faces and backs of the markers in order to draw reference to surviving African

belief systems, especially the *dikenga da Kôngo* and the flash of spiritual presence discussed below. For example, a circular motif of shells is embedded in both the head and foot markers of rather human-shaped forms in Marianna, Florida (fig. 12.1). Nearby, marbles frame a headstone, terminating in an equal-armed cross, and ceramic tiles adorn a child's grave in Apalachicola (fig. 12.3). The presence of old, dried, bag-shaped chunks of cement around these cemeteries suggests that many such markers were made onsite and decorated at the grave in the presence of the interred deceased.

As a remembrance of a deceased ancestor, the gravesite also becomes a focal point for the spiritual interaction between the living and the dead as reflected in the *dikenga da Kôngo* sign, which stems from the African Kongo cosmological belief system.[3] The Kongo cosomogram can take a variety of forms, including a cross, a diamond, a quartered circle, and a spiral (fig. 12.4). At its essence the cosomogram provides a map of the Kongo spiritual universe, tracing the continuity of life from the living world, symbolized by the top half of the sign, to the world of the dead, encompassed by the bottom half of the cosomogram. A body of water separates these two realms, an ocean between the mountainous landscapes of the living and the dead. The cosomogram is a symbol of cyclical immortality, a never-ending movement of life force, as well as a map of the very creation of the universe. Its symmetrical, focused form indicates wholeness, health, equilibrium, and even moral balance.[4] The equal-armed cross anchoring the circle or spiral is referred to as the *Four Moments of the Sun*. The perpendicular and vertical points of the cosomogram signify the height of living, human power at the noon position and the zenith

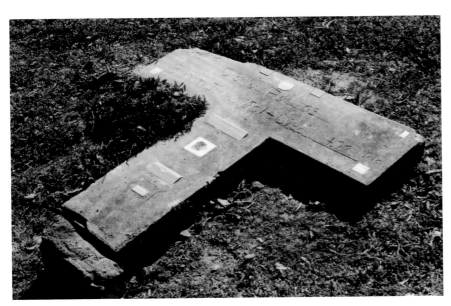

Figure 12.2. Tau cross headstone, Leon County, Florida. Photo by Kara Morrow.

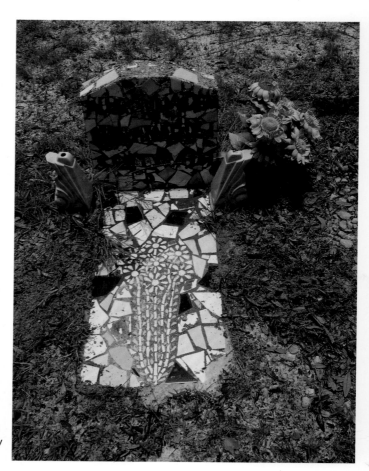

Figure 12.3.
Child's grave
with tile inlaid
headstone,
Franklin County,
Florida. Photo by
Kara Morrow.

of ancestral, otherworldly influence at the six o'clock position. As the sun rises in the right or easternmost sector, the cosomogram confers a visual metaphor of the soul's birth through the primordial ocean into the living world. The westernmost region marks the soul's movement through the waters into the spiritual world at dusk.[5] The repetitive motion of the *Four Moments of the Sun* then communicates the never-ending momentum of life, an ideal metaphor for the grave marker of a loved one. This concept is expressed graphically on headstones with the common epitaph of "Sunrise" with the indication of the birth date, and "Sunset" with the inscription of the death date of the interred in southern African American cemeteries.

Color symbolism, especially the color white, constitutes an important part of Kongo cosmographical meaning. The relevance of white and reflective surfaces such as foil and mirrors reveals the *flash of the spirit,* or the presence of a spiritual force at the grave in African cultural systems. Some Kongo philosophies propose the spiritual world is a white realm, manifested by white chalk or the pale gleam of bleached seashells.[6] The color white, which is an important

element in older African American cemeteries, has continued in importance, appearing in countless recent whitewashed markers, white gravel, and white statuary.

Similar concepts apply to the shapes of the headstones and their decorative embellishments. In African American graveyards the tau-shaped headstones reflect the bottom half of the cosomogram, an indication of the spiritual power of the deceased (fig. 12.2).[7] This large cement T-shaped headstone in Tallahassee is also decorated with inlaid bathroom tiles of various colors and shapes. The presence of tile in water-oriented spaces such as bathrooms and kitchens provides an association of tile with the watery passage between the worlds mapped by the cosomogram. Thus, the common use of embedded tiles on grave markers is an Africanism indicating the crossing of the watery boundary between the world of the living and the world of the dead.[8] The tradition of the inset tiles in older African American markers was greatly elaborated in the 1960s in the African American section of a segregated Apalachicola cemetery. The headstone and cement slab of a child were not simply differentiated with a tile set in cement like neighboring homemade headstones, but were covered with a mosaic of both representational and abstract motifs, and words (fig. 12.3). The artists' use of bathroom tiles—with their associations with water seen throughout the cemetery—on the child's grave produced an exceptional monument that draws attention to the expense of purchasing materials and time relegated to the art. Such monuments comment on the changes in financial and time-based assets at the disposal of the population. Despite the seemingly infinite artistic possibilities of the shaped and inlaid headstones, the markers are only one visual manifestation of Africanisms in these cemeteries.

In the panhandle of Florida some types of grave goods, both broken and intact, are particularly prevalent: glasses, ceramic cups, cookware such as frying pans, enameled-metal bowls and pitchers, mason jars, milk glass, depression glass, and seashells. These objects are scattered around African American cemeteries, but the exact composition of grave goods is difficult to evaluate because the articles are sometimes displaced or eventually sink into the sandy

Figure 12.4. Manifestations of the Kongo cosmogram, after Thompson and Cornet. Courtesy of Kara Morrow.

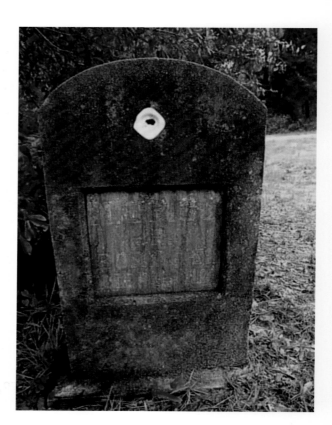

Figure 12.5. Ritually broken plate in cement headstone, Franklin County, Florida. Photo by Kara Morrow.

soil as vegetation reclaims grave mounds. Many gravesites have not survived the ravages of vandalism, neglect, and perhaps most destructive, cleanups. Well-intentioned church and community groups often organize efforts to reclaim neglected cemeteries from overgrown foliage and discarded trash, only to inadvertently remove or burn purposefully placed grave goods, plantings, and even markers. However, in most cemeteries one can observe broken pieces of shell and shards of glass, crushed and trampled into gravesites recalling documented and photographed Kongo funerary traditions.[9] On occasion, small pieces of statuary are observable on graves today. Thus, in Florida the evidence of African influences in African American cemeteries is significant; however, the specific meanings of these influences are difficult to decipher. Fortuitously, examples of relevant items such as mirrors, plates, shells, tiles, glass, and marbles remain pressed into slabs, headstones, and footstones, which maintain not only the objects but the original placement and composition of the articles.

One such example exists in Apalachicola and reflects both the *flash of the spirit* and the *dikenga da Kôngo*. A small white saucer, carefully positioned so that it creates a diamond-like form, survives in the marker's surface (fig. 12.5).[10] A small hole was carefully pecked out of the center of the little plate,

providing a physical point indicating the intersection of the axes of the *Four Moments of the Sun*. The tau cross (fig. 12.2) contains a similarly manipulated tile in the center of its composition. The spiraling line of the seashell perhaps best illustrates this repeated concept of centrality, intersection, or focal point within African American monuments in Florida's cemeteries.

Traversing the Waters: Shells in African American Cemeteries

The eloquence of the swirling form of the Kongo cosomogram is apparent in the Bakongo language (fig. 12.4). The word *zinga* can connote a spiraling form, a shell, or to live a long life.[11] As such, the form of the cosomogram, its association with water, and the spiraling shape of a seashell are intimately linked in the metaphorical system.[12] That the shell is a favorite decorative motif in Florida's African American cemeteries and is presented with great creativity and variation should come as no surprise. While crockery, marbles, and tiles provide eloquent examples of African belief systems in Florida's graveyards, the most ubiquitous medium expressing these philosophies is the seashell.

Accumulations of shells amass on the cement slabs of many African American graves. The cemetery visitor can find dozens of shells scattered across a grave or pressed into the hard, compacted dirt. Various types of shells are often present at a single grave. Reflective white oyster shells and gleaming cockleshells, originally assembled over the once grassless grave mound, are now visible under the scrubby grass. Shells are sometimes sunk into the concrete of the homemade grave marker or slab.

The face of an anthropomorphically shaped headstone in Marianna, Florida, twenty miles southwest of the Alabama-Georgia-Florida border, supports at least twelve shells, while another seven cover the marker's base where it enters the ground (fig. 12.1). An accompanying foot marker replicates the aesthetic. The set is remarkable not only due to the number of shells in the monument but also because the artist's composition survives almost intact. Each of the shells is cemented into the memorial, still maintaining its exact original placement. The shells—cockles, conchs, scallops, and tulips—are arranged in a circular pattern on the surface of the marker. The artist positioned every spiral-shaped shell so that the coiling ends of the shells face the viewer. The overall composition forms a circle, while each individual coil provides a microcosm of the whole. Even as the monument has aged and many of the shells have broken, the spiraling interiors of the objects continue the emphatic reference. The footstone repeats the aesthetic (fig. 12.1). The artist placed the shells not only high up on the markers but also at the very base of the cement, where the monuments enter the ground, drawing attention to the visual barrier between the world of the living and the realm of the dead. That point of intersection references the center of the *dikenga da Kôngo* like the tau cross

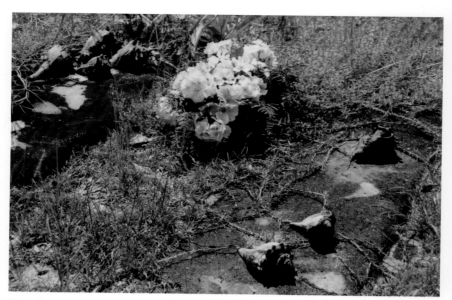

Figure 12.6. A multitude of conch shells grouped on cement slabs, Franklin County, Florida. Photo by Kara Morrow.

(fig. 12.2) and the embedded plate (fig. 12.5), both of which have prominent holes emphasizing the cosmogram's center.

Large white conchs also decorate neighboring graves throughout the same cemetery (fig. 12.6). The placement of shells, "believed to enclose the soul's immortal presence,"[13] as well as inset tiles, and the "T"-shaped markers on African American graves can be understood as cosmic maps providing directions to the deceased in his or her pilgrimage to the afterlife.[14] In this context the grave becomes a complex system of loaded symbols, an altar of sorts, mediating between the living and the ancestral dead. The grave is a spiritually charged place, a liminal zone at once powerful and dangerous. As such, the material objects left on the grave or deposited in its markers announce the grave's liminal status. In this interpretation the grave goods and shells are at once flashing white acknowledgments of spiritual presence as well as accumulated offerings, ritually sacrificed.[15] The grave is a point of reciprocal action between the living descendant and the spiritual ancestor. In the African Kongo belief the interaction of the spiritual is not an abstracted distant concept solely associated with death. Rather, the relationship of the living with the spirit world is a life-affirming reciprocity that maintains or restores balance and harmony in the living community.[16] Tellingly, African Kongo and African American religious practitioners consider dirt from the grave a powerful ritual material for achieving spiritual parity in the corporeal realm.[17]

In many Florida cemeteries broken shards of shells can be seen embedded in the hard earth just beneath the grass. In the 1970s, John Michael Vlach photographed cockleshells installed over the dirt of a grassless grave mound in South Carolina.[18] His photograph shows the grave mound over the deceased, covered with large white cockleshells set concave-side down in neat rows. The soft soil provides a foundation for the shells that allows them to maintain their positions. The shells are very closely spaced; little dirt shows through the composition. His photograph preserves the aesthetic of the covered grave just after its completion, an ephemeral composition quickly undone by the leveling effect of the sinking grave, intruding vegetation, and raking cleanup efforts. Vlach's photograph provides us with a possible reconstruction for the disrupted aesthetic in Florida's cemeteries. The covering of the grave mound in its entirety suggests the application of a barrier over the disturbed earth, above the deceased. The gleaming white shells, like the horizontal element of the cosomogram, delineate a metaphorical and literal divide, the liminal space recently traversed by the dead.

The altar-like installations in African American cemeteries that promote an interaction between the living and spiritual worlds find an interesting comparison with spirit jugs. Spirit jugs are clay vessels richly adorned with a variety of inset objects. These applied items are typically the same kinds of ritual or sacrificial goods that are placed on graves, highlighting the liminal status of the plot as well as the spiritual presence. Many of the objects have powerful metaphorical associations: jewelry, beads, screws, keys, coins, chains, mechanical gears, white dolls and statues, glass, mirrors, and especially shells.[19] Very possibly funerary objects or at least commemorative, these vessels are by process, aesthetic, and meaning solidly linked to the inserted shells of the markers and grave mounds. Vlach also identifies a vase with similar embedded objects that was probably placed on a grave as either a marker or a grave good.[20]

The inlaying of objects in spirit jugs and funerary monuments in African American cemeteries not only reflects African Kongo belief systems but is also similar to the method of grave construction in southeastern Nigeria. As such, the very process of impressing items into funerary objects and graves may be an Africanism in Florida. According to an account by P. Amaury Talbot, those graves were constructed of "a low divan made of mud, 8 to 10 feet long, 3 feet wide, and about 1½ feet high. All along the edge plates and dishes have been pressed into the mud when soft. These were first broken, as is always done with the property of the dead, but the hardening mud acts as cement to hold them together."[21] The headstones containing the small pierced saucer (fig. 12.5) and the numerous circular shells (fig. 12.1) closely replicate this process. The resulting aesthetic is not only prominent in African American graveyards

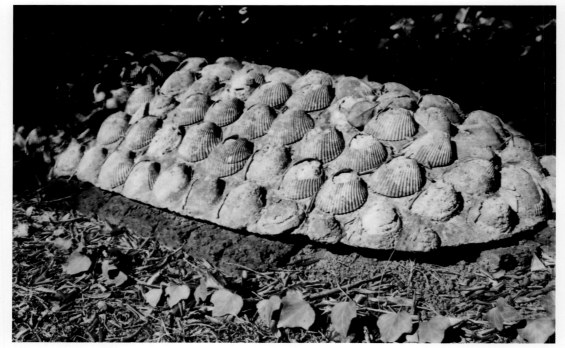

Figure 12.7. Cockleshells in cement on European American grave, Cairo, Georgia. Photo by Kara Morrow.

in Florida but is also present in at least one neighboring European American cemetery. Interestingly, nineteenth-century European American graves just north of the Leon County border are decorated through this exact process (fig. 12.7).

Analyzing the Sources: Shells in Anglo-American Cemeteries

While the practice of incorporating shells into gravesites is more pronounced in Florida's African American cemeteries (fig. 12.6), shells are also present in neighboring European American burial grounds (fig. 12.8). The visual similarities between such graveyards are readily apparent, but the significance and meaning of these decorations are obscure. The spiraling conch shell commonly appears in most burial grounds in Apalachicola. As such, these cemeteries provide ideal grounds for study. As folklorists and cultural geographers acknowledge, many European American and African American cemeteries share decorative traditions.[22] The commonalities include grassless mounded graves, the placement of figural statues and grave goods, homemade markers, the use of shells as grave decoration, and the tradition of "making do."[23] Nevertheless, aesthetic differences do exist. In the African American plots of coastal Apalachicola, a multitude of large conch shells are scattered across grassless

concrete slabs (fig. 12.6). Nearby, a grave in a European American plot provides a subtly different aesthetic, displaying a single conch before a mechanically produced monument (fig. 12.8). Rather than a great accumulation of shells, here a single large conch is more typical. The appearance of this grave, as well as the entire European American cemetery, is more formal, even predictable, than the African American graveyards discussed above due to the abundance of commercially purchased markers and machine-etched marble. However, gleaming white cockleshells and spiraling conchs are a common addition to the European American graves.

The relationship between these two practices is a point of controversy among scholars who analyze southern cemeteries.[24] Some researchers demonstrate a general unwillingness to attribute the introduction of the tradition to a repressed population, especially in communities where legal and social segregation was intended to maintain strict cultural boundaries.[25] In north Florida, where shells are abundant, the placement of shells on graves in European American cemeteries is certainly not as common as the practice in African American cemeteries. When the practice does occur in European American

Figure 12.8. Conch shell on European American grave, Franklin County, Florida. Photo by Kara Morrow.

burial grounds, shells are rarely as profuse or varied as on neighboring African American graves. The African American practice maintains an aesthetic of accumulation where myriad shells are used (fig. 12.7). Upwards of a dozen large conch shells accentuate many of these graves, commanding attention and awe even from a great distance.

Complicating our understanding of these cultural landscapes, different attitudes toward African American and Anglo-American gravesites have resulted in vastly different levels of preservation. Thus, any data suggesting that European American examples of shell grave decoration predate African American ones are significantly skewed. While often burial grounds receive the respect and maintenance merited by their roles as the resting places of ancestors and containers of a great variety of historical information, others—especially those no longer connected to municipalities, churches, or family property—are ultimately lost, or even worse, vandalized or reclaimed for farming or development. In some cases greed and disrespect have taken their toll. According to Jackson County's online index of cemetery surveys, researchers classify many African American cemeteries as "abandoned and not maintained," "all headstones gone," "cemeteries 'lost' might be plowed under," and "paved over." One particularly disturbing explanation reads, "all headstones stolen . . . later a house was torn down and the blocks under the house turned out to be headstones."[26] Often cemeteries are now so deep within the landowners' hunting grounds that access is dangerous or impossible. Still others are not surveyed, nor are they a matter of public record, and thus only local inhabitants know their locations.

The most significant problems within the scholarly argument on the origin of European American funerary shell decoration are the repeated ambiguous allusions to Anglo traditions of using shells on burials. The historiography of the scholarship is never carefully considered. The practice of associating shells with the interment of the deceased is certainly an ancient one, dating back tens of thousands of years in both Europe and Africa. It was known in the classical traditions of Greek and Roman cultures. However, as is often the case in research, citing the shells buried in Neanderthal and Paleolithic European graves does little to elucidate the specific contemporary practice in the Americas. In fact, the great paucity of information on the use of shells in modern and contemporary grave decoration in the British Isles, where so many southerners of European descent trace their ancestry, is reason to demonstrate caution when analyzing American gravesites.

Fredrick Burgess's sparsely documented but influential book illustrates this problem.[27] Burgess interprets an anonymous nineteenth-century description in *Chambers's Journal* of a London cemetery replete with shells as an example of the practice among white Londoners when the cemetery could very well have been populated my immigrants from non-Western populations. In short,

the description of God's Acre suggests African traditions or at the very least other non-Western traditions, on display in east London, not Anglo-British traditions as previously assumed. Thus, this often-repeated example does not suggest that funerary shell decoration from the British Isles influenced American gravesites, or at least in the way that scholars assume. Burgess's other conclusions, which suggest the possibility of continuity for the presence of shells in white American cemeteries with modern British traditions, are problematic as well.

Burgess compares shells excavated in ancient megalithic tombs to shells that adorn modern graves on the island of Anglesey—information frequently repeated by scholars. This remark deserves careful consideration, because he does not provide locations or photographs for these graves, like the *Chambers's Journal* description. After surveying dozens of cemeteries and scanning hundreds of graves on the island, I found almost no evidence of shell use.[28]

If the practice of using shells to decorate graves in Anglo burial grounds is difficult to trace in current sources and cemeteries, then deciphering the meaning of the aesthetic is in its own way even more problematic. The contextual meanings of shells in white southern cemeteries put forth by scholars of upland folk cemeteries are as far-reaching as the geographic sources.[29] However, none of the explanations seem appropriate to the predominantly Protestant cemeteries of the South, because they are so far removed in time, geography, and religious significance from southern traditions. Jordan explains that the ancient history of the shell motif began as part of an ancient Mediterranean Mother Goddess worship, which was linked to the cult of the Virgin Mary in southern European Christianity: "The shell, in particular the spiraled conch, was an especially appropriate symbol, since it resembled in shape the female reproductive tract. . . . To place a shell on or in the grave was to intercede with the great goddess in behalf of the deceased."[30] Jordan goes on to explain that the practice of carving shells onto sarcophagi was well known in the ancient Greek and Roman worlds and that the custom was spread to Britain by the Romans. As such, explanations of the meaning of the shell on modern European American graves remain anachronistic allusions, which seem unsatisfactory in the contemporary Christian world. When discussing practice, Jordan paraphrases and cites Burgess's references to the *Chambers's Journal* article and the Welsh tradition, acknowledging, "In the succeeding centuries, the practice survived. Some present-day Welsh graves on the island of Anglesey are decorated with shells, and conches reportedly adorned the graves of the poor in certain English cemeteries in the 1850s. English and Welsh immigrants probably introduced the practice to the southern Atlantic seaboard of the United States in colonial times." However, Jordan notes that the shell custom does not seem to be present in the colonies of New England or the eastern seaboard.[31] The conspicuous absence of the practice where immigration patterns suggest it would

be most prevalent suggests that the tradition may indeed not be traceable to the British Isles. The secondary sources bring us back around to the same untenable observations discussed above. Since the most common explanations for the presence of shells on southern European American graves—the cemeteries of England and Wales—are unlikely, perhaps we should look next door, across the shared landscape to the cemeteries where the practices are most abundant.

Conclusion

I propose that consistent access to another's visual culture makes it probable that the white communities in the Southeast were and are influenced by the easily traceable African American use of shells as cemetery decorations in those areas where African Americans make up a significant portion of the population. Stated more generally by Judith McWillie, "Today the assimilation of African aesthetic and spiritual resources in the South is a cross-cultural phenomenon that continues to mold the consciousness of African Americans and Euro-Americans, alike."[32] Such a statement supports an aesthetic intersection between a shell-covered African American grave in South Carolina photographed by Vlach and the similarly decorated European American grave just over the Florida state line (fig. 12.7). In both locations cockleshells were pressed into the grave mound over the deceased. In the white cemetery the shells were permanently established in a layer of concrete. Of course, the incorporation of the aesthetic by the European American community does not require the transfer of African American meaning.

While the aesthetic system of shell decoration seems adaptable across American cultural landscapes, the strictly Afrocentric meaning is not; however, the Kongo cosomogram, with its associations of balance, longevity, connectedness, and even immortality, does reflect a universal human concern with permanence, continuity, and remembrance. These connections seem much more relevant to the Protestant, southern cemetery's landscape than Mother Goddess worship or references to female genitalia. When inquiring among white southerners why a shell might be incorporated into a grave, one is likely to hear reflections on the unique beauty of the conch, the longevity of the form, or the rejuvenating nature of water. Christian concepts such as the soul's immortality or the promise of salvation through the purification of baptism can be easily inferred by these popular interpretations. African American responses to the relevance of shells in cemeteries are quite similar. This fact further complicates efforts at interpreting meaning in these visual systems. It suggests universality in the association of water with the soul's immortality, and the integration of African belief systems into Christian models.

At some point distinct meanings become hopelessly enmeshed and ultimately indecipherable.

As stated by Richard E. Meyer, ethnic populations proclaim "a most powerful and eloquent voice for the expression of values and world-view inherent in their self-conscious awareness of their own special identity."[33] As such, the rural African American cemetery can be seen as a complex display of visible ethnic signifiers. While this chapter recaps the well-documented Africanisms as they are seen with some individuality in north Florida cemeteries, at the heart of this endeavor is the fluid relationship of cultural identity in the modern African American church graveyard. At once these cemeteries boast the presence of "continuity and change, tradition and innovation, retention and assimilation."[34] Documented Africanisms—handmade gravestones, tile work, grave goods, shells—represent a fluid, ever changing, ever creative, distinctly African American aesthetic. These Africanisms, ubiquitous in the rural southern landscape, are very possibly influencing symbolic visual systems on European American graves in once segregated or neighboring communities. These observations suggest an even greater presence of Africa in Florida than is often granted.

Notes

1. Holloway, *Africanisms in American Culture*, ix.

2. Folk cemeteries are graveyards dominated by homemade monuments reflecting inherited traditions; they are often executed by untrained artists.

3. Large numbers of African-born individuals from the Congo River basin were enslaved and forcibly moved into the American Southeast between 1808 and 1859, providing demographic support for the presence of Kongo cultural philosophies in this region. Curtin, *The African Slave Trade*, 150; J. H. Smith, "Plantation Belt in Middle Florida," 113–16; Vass, *Bantu Speaking Heritage of the United States*, 1979.

4. The cosomogram is also referred to as Mpemba. Fu-Kiau, *Tying the Spiritual Knot*, 23; Janzen and MacGaffey, *Anthology of Kongo Religion*, 34; Blockie, *Death and the Invisible Powers*, 83–85.

5. R. F. Thompson and Cornet, *Four Moments of the Sun*; R. F. Thompson. *Face of the Gods*, 48–95; R. F. Thompson, *Flash of the Spirit*, 101–60; R. F. Thompson, Mason, and McWillie, *Another Face of the Diamond*.

6. R. F. Thompson, *Flash of the Spirit*, 132–42.

7. Morrow, "Bakongo Afterlife and Cosmological Direction," 108.

8. R. F. Thompson, *Flash of the Spirit*, 135–38; Vlach, *By the Work of Their Hands*, 143.

9. Glave, "Fetishism in Congo Land," 825–36; Weeks, *Congo Life*, 10.

10. Vlach connects the use of plates to an African practice where plates are embedded in walls over the deceased. Vlach, *Afro-American Tradition*, 143.

11. R. F. Thompson, Mason, and McWillie, *Another Face of the Diamond*, 24.

12. R. F. Thompson, *Flash of the Spirit*, 134–37.

13. Ibid., 135.

14. Ibid., 132.

15. On the importance of accumulation on altars see Rubin, "Accumulation."

16. Blockie, *Death and the Invisible Powers*, 18–19, in particular.

17. R. F. Thompson, "Flash of the Spirit," 105–7.

18. Vlach, *Afro-American Tradition*, 143.

19. Arnett and Arnett, *Souls Grown Deep*, 1:56–58. For similar objects see Vlach, *Afro-American Tradition*, 145, and R. F. Thompson and Cornet, *Four Moments of the Sun*, 161.

20. Vlach, *Afro-American Tradition*, 145.

21. Talbot, *In the Shadow of the Bush*, 94 and 215. See also Vlach, *Afro-American Tradition*, 142.

22. Jordan, "'The Roses So Red'"; Jeane, "Folk Art in Rural Southern Cemeteries"; and Jeane, "The Upland South Folk Cemetery Complex."

23. A term defined by Jeane, "The Upland South Folk Cemetery Complex," 108; Jeane, "Folk Art in Rural Southern Cemeteries," 159–74.

24. For an ambitious and thorough examination of possible origins for folk cemetery and grave decoration see T. G. Jordan, "'The Roses So Red.'"

25. Jordan, "'The Roses So Red,'" 227–58; Jeane, "Folk Art in Rural Southern Cemeteries," 159–74; and Jeane, "The Upland South Folk Cemetery Complex," 107–36.

26. "Jackson County, Florida Cemeteries and Churches," *Rootsweb*, last modified September 23, 2008. http://www.rootsweb.ancestry.com/~fljackso/CemteriesandChurches.html.

27. Burgess, *English Churchyard Memorials*, 183–84; "God's Acre," 385–87.

28. This research was made possible in part by a Faculty Development Grant from Albion College.

29. Jeane defines the Upland South folk cemetery as "a distinctive type of burial ground widely dispersed across the rural South. . . . characterized by hilltop location, scraped ground, mounded graves, east-west grave orientation, creative decorations expressing the art of 'making do.'" Jeane, "The Upland South Folk Cemetery Complex," 108. Jordan, "'The Roses So Red,'" 237–39, see especially note 13.

30. Jordan, "'The Roses So Red,'" 238.

31. Ibid., 238 n. 13.

32. R. F. Thompson, Mason, and McWillie, *Another Face of the Diamond*, 5–6.

33. Meyer, *Ethnicity and the American Cemetery*, 1.

34. Ibid., 3.

13

Mother Laura Adorkor Kofi

The Female Marcus Garvey

Vibert White Jr.

In the mid-1920s Laura Adorkor Kofi appeared on the American black nationalist scene from Gold Coast (now Ghana), West Africa, preaching a message of self-help, black pride, and African nationhood that electrified thousands of African Americans who joined her quest for black independence and sociopolitical power. The African leader formed a powerful organization that challenged black nationalist leader Marcus Garvey for supremacy for African American leadership[1] (fig. 13.1). Her movement was short lived, however. On March 28, 1928, Kofi was assassinated by members of the rival Universal Negro Improvement Association (UNIA) while lecturing to supporters in Miami. Although she was taken by an assassin's bullet at the age of thirty-five she created a unique movement that made her the female Marcus Garvey and Africa's Warrior Mother.[2]

Kofi's Rise and Fall in the UNIA

Kofi arrived in the United States during the Great Migration of the 1920s. Africans, like Europeans, were flocking to the United States in search of opportunities in the young and vibrant nation. And like black Americans who migrated from the South to the North, Africans also settled in communities like Paradise Valley (Detroit), Chicago's Southside, and New York's Harlem. In addition to this migration, scores of Caribbean and Bahamian people filtered into the Overtown district of Miami and into the Florida Keys. By the mid-1920s the nation held over 200,000 African, Bahamian, and Caribbean immigrants.[3]

In 1917 Marcus Garvey set up his self-help black nationalist UNIA organization in Harlem. Garvey created a new consciousness and attitude, especially among America's black southerners, when he observed that they were not alone in their fight against racism and that millions of blacks worldwide stood

Figure 13.1. Laura Adorkor Kofi. Kofi came to the United States from Ghana to preach a message of self-help, black pride, black independence, and sociopolitical power for people of African descent. Her eventual headquarters were in Florida.

with them.[4] Preaching a heavy dosage of black pride, independence, black business development, and pan-Africanism, Garvey built an international organization that numbered over 20 million followers and was worth millions of dollars globally. By 1920 Garvey was America's most dominant black leader, and his UNIA easily overshadowed such African American groups as the National Association for the Advancement of Colored People, the National Urban League, and the Moorish Science Temple Movement. The Caribbean apostle's message was heard in every section of the world. One of the greatest areas to adhere to Garvey's call was continental Africa; from Egypt to South Africa and from Ghana to Ethiopia, Garvey's newspaper, *The Negro World*, echoed the words of the Great Black Liberator. In fact, many African villages sent young men to port cities to listen to readers of the organ. These boys, or runners, were ordered to memorize the entire paper and to recite the articles of the

paper to community members. Thus, by 1920 UNIA had over 20 million Africans and blacks in the African diaspora as members.[5]

One of the Africans who was attracted to Garvey's message and organization was Laura Adorkor Kofi from Kumasi, Gold Coast. According to Kofi, her father—King Knesipi, a major leader of the Asante people—sent his daughter to the United States to educate and repatriate black people in the Americas to Africa. Kofi, a believer of Asante folklore and a prophecy which stated that an Asante child would unify all Asante (black) people, was self-confident and assured. When she entered the United States she was not respectful of so-called white supremacy, nor was she hampered by the laws of segregation. Her mission was for the African American. Thus it was not surprising that Kofi was attracted to Marcus Garvey's vision and organization.[6]

Kofi surfaced in New York City in 1926, where she frequently attended Garvey's Universal Negro Improvement Association meetings. Local UNIA officers took note of the assertive and attractive African woman and observed how people flocked to her as a representative of African pride, strength, and self-determinism. During this time Kofi also traveled to Detroit, Philadelphia, Chicago, and Newark, New Jersey. In these cities she was able to witness firsthand the migratory spirit of black Americans leaving southern regions of the United States only to confront northern racial bigotry, racism, unemployment, and slum living. She also met followers of a variety of black organizations such as the NAACP, the National Urban League, and the Moorish Science Temple Movement. These associations helped Kofi to understand the peculiar plight of African Americans and the various schools of thought for political change and social justice.[7]

In early 1927 the UNIA, struggling for money and membership due to Garvey's conviction for mail fraud and imprisonment in an Atlanta federal penitentiary, named the African immigrant to the post of national field representative (NFR). Her new office threw her to the forefront of the movement. As the NFR Kofi recruited over 5,000 members and raised over $10,000 for the UNIA in less than five months. In July 1927 the UNIA leadership, and specifically Garvey, were impressed and excited about this West African woman. Garvey's organ, *The Negro World*, featured excerpts of Kofi's speeches and praised her as a great leader and orator. In the same year Kofi visited Garvey before his deportation to Jamaica. During this meeting Garvey and Kofi enjoyed a conversation that aligned their views about the empowerment and liberation of black people throughout the world.[8] However, shortly after the meeting something changed; Garvey's respect for Kofi transformed into contempt and hatred.

In August 1927 rumors surfaced that Kofi was a fraud, suggesting that she was not from West Africa but from Georgia. Certain UNIA members convinced the jailed Garvey that Kofi was scheming for UNIA members' monies. Garvey

claimed that the "so-called Princess" told the membership that they could purchase passage on African ships back to their homeland. Garvey instructed his followers to bar Kofi from all organizational meetings and events.[9] An understanding of this dramatic turn reveals greater tensions within black nationalist movements in Florida (and the United States) during this era.

Kofi and Miami Divided

The rift between Garvey and Kofi is linked to the Miami division of the UNIA, which officially formed on November 14, 1920. While the UNIA leadership in Miami was in the hands of African Americans, West Indian blacks gravitated to and joined the movement in greater numbers than did native black Americans. For example, James B. Nimmo, who originated from the Bahamas, stated that arriving in Miami "was like coming into slavery."[10] Thus he joined the UNIA, which he saw as a bulwark against white racism. The number of black islanders in the UNIA mirrored the cultural differences and tensions between the two groups of Americana blacks. The foreign blacks from the islands showed a greater degree of radicalism and less inclination to accept secondhand status and treatment from white American southerners than did their continental brethren.[11]

The federal government took notice of the UNIA membership and the militant voice of foreign blacks in southern Florida. In 1921, Leon Howe, director of the Florida division of the Bureau of Investigation (the forerunner of the Federal Bureau of Investigation), wrote agency head J. Edgar Hoover that Bahamians and West Indians controlled the UNIA in Florida.[12] In response, the bureau ultimately manipulated the tension between the two black groups to create mistrust and tension between African Americans and Caribbean/Bahamian blacks.[13] They did not realize that the government had created a "greased wall" that prevented the group from ever fully achieving their goals and potential.

The divide that agents fueled polarized the two black communities in Miami, ultimately causing the two groups to view each other as being radically different, especially in the areas of social dynamics and political ideology, further escalating the suspicion and disdain they already had for each other. Black Americans were used extensively to inform the local white power elite to identify and negate the voices of aggressive and bold individuals in "Black Miami." Having the need to be included in American society, many African Americans were willing to exploit Caribbean blacks and to cut ties with them.[14]

Although the government stimulated division between the two communities and attempted to destroy the UNIA, the Garvey group continued to grow at a rapid pace. By 1921 Miami's UNIA had a membership of over two thousand people.[15] The ranks of its roll came from diverse places such as Jamaica, Haiti,

Puerto Rico, Honduras, Panama, Columbia, and Costa Rica, although it still had a few African Americans. The south Florida branch was a well-oiled machine.[16] That is, they held weekly lectures at the organization's Liberty Hall, where speakers spoke on such diverse topics as the Haitian Revolution, the Chicago Race Riot, and Jim Crow legislation.[17] At the same time, the Miami branch of the UNIA was being constantly harassed by local police, and UNIA members were threatened with job loss and bank foreclosures. Florida officials put pressure on black leaders, deporting some to the Caribbean, and fueled public concerns over potential race riots. Meanwhile, Marcus Garvey and the national branch were being squeezed by the federal government and jealous leaders such as A. Philip Randolph, W. E. B. Du Bois, and Walter White, to name a few, who worked to close down the black nationalist organization. In 1925 Garvey was arrested, sentenced, and jailed for mail fraud, which also caused a drop in membership and activities.[18] It was in the wake of this downward spiral of the UNIA that the unique voice of Laura Adorkor Kofi was sounded.

Since the inception of the UNIA, Garvey had preached the redemption and liberation of Africa. For years, however, Miami Garveyites had been lukewarm in their reception of this ideal. Although there is little evidence of branch leaders speaking against Garvey's "Back to Africa" plan, West Indian blacks, who represented the majority of the membership in the UNIA in southern Florida, were solidly middle class, educated, and business smart. Thus most of them had little reason to pack for Africa.[19] By the mid-1920s, however, because of their economic success, their assertive attitudes, and their resistance to second-class citizenship, they became targets of violent attacks by whites. Therefore, like Samuel Culmer, vice-president of the Miami division, who stated that "Africa is our only refuge," Caribbean UNIA members began to look seriously at Africa as a destination.[20]

While many now promoted the repatriation argument, few had any real idea of Africa. Garvey, now in jail and a person who never traveled to the African continent, was their only window onto Africa until Laura Kofi appeared on the scene. Kofi, a dynamic, bold, aggressive, and brilliant organizer, captured the imagination of Florida's UNIA members in the void left by Garvey. In a fearless, anti-white but religious presentation, she excited audiences with her first-person account of West Africa. She juxtaposed African culture, history, and growth with that of Europe and the United States, presenting America as a place for black oppression but Africa as the land of black liberty.[21]

Indeed, Kofi was unique. In a nation and in a period that stressed the inferiority of women and of black people, she challenged both notions. On May 19, 1927, she addressed an audience in Liberty Hall in "Colored Town," telling the audience of three hundred about the riches and great cities of the continent.[22] Kofi predated Malcolm X and Elijah Muhammad in speaking about the fertile fields of the continent and the resources it could provide for the world. Kofi

stated that the continent is the capital of the world and Africa's children are the kings and queens of the universe. Kofi's black nationalist language and her polemical stories of Africa resonated greatly with members of Florida's Caribbean and black Latino communities. Thus, everywhere Kofi spoke she attracted vast audiences that numbered in the hundreds and thousands. In cities such as Miami, Daytona Beach, Jacksonville, Tampa, St. Petersburg, New Orleans, Mobile, and Atlanta, people scrambled to hear "the African female warrior."[23]

By 1927 Kofi had become America's most sought-after black female speaker. The female warrior barnstormed through the Midwest, Northeast, and Dixie—speaking at churches, halls, and even picnics, drawing crowds and raising money. Kofi, still an open supporter of Garvey and the UNIA, was blindsided and saddened by Garvey's UNIA attack.[24] The elder leader set out to destroy Kofi's character, organization, and ability to lead. The actions taken by the UNIA were quite strange considering that Garvey had once penned in *The Negro World* that Kofi was helping to restore pride and strength in black people the world over. It appeared, however, that the greater the assault against Kofi by the UNIA, the more the underclass supported the African.[25] The gravitational pull Kofi had on the black community ultimately created a violent and dangerous atmosphere for Kofi and her supporters.[26]

In Miami, Garvey's UNIA leaders had already set out to destroy Kofi. They ordered the African Legion, the UNIA military squad, to disrupt Kofi's meetings. Following orders, they harassed Kofi's supporters, broke up Kofi's meetings, and manhandled and beat up UNIA members who were seen supporting the African woman. The activities in 1928 by Garvey's supporters surprised and concerned the West African leader. She did not want to believe that she was being targeted for assassination by the UNIA, but she did voice concern that something harmful may come to her. Indeed, the idea of physical harm by a fellow freedom fighter and race advocate was very difficult for many to believe, especially in light of the era of black pride, self-help, and black unity.[27] Considering Garvey's past in reference to threats and violence, the disjointed relationship between Garvey and Kofi was potentially dangerous.[28]

For African Americans the 1920s, the time of the Harlem Renaissance, was a period of racial self-awareness, racial pride, proactive political thought, racial solidarity, and confronting the evils of racial bigotry, racism, and discrimination in the United States. Although several of the leaders and movements held vastly different philosophies, it was not uncommon for them to forge pacts of unity for the greater good of the cause. Thus it was quite unusual for a leader of the magnitude of Marcus Garvey to go after philosophical rivals.[29] But, unfortunately for Kofi, he did. In fact, Garvey supporters had her arrested in St. Petersburg for preaching "race activism," where she was strip-searched by police for voodoo articles that African American ministers claimed she used to

control audiences. The times were very dangerous for Kofi, and her death was near. Heeding the advice of her associates, she left Miami for Jacksonville, a port city three hundred miles to the north.[30]

In Jacksonville, Kofi announced her split from the UNIA. She organized, founded, and incorporated the African Universal Church and Commercial League (AUC), which focused on the same general principles espoused by the UNIA—race solidarity, black self-determinism, and the return to the African homeland—but with a special interest in black revolutionary theology. Specifically, Kofi's mandate centered on the following objects and aims of her AUC:

> to establish universal love among the race; to promote the spirit of pride and love; to reclaim the fallen, to administer to and assist the needy; to assist development of independent Ethiopian nations and communities; to establish missionaries or agencies in the principal countries and cities of the world for the representations and protection of all Ethiopians to promote a conscientious spiritual worship among the native tribes of Africa; to establish universities, colleges and schools for the racial education and culture of the people; to conduct a world-wide commercial and industrial intercourse for the good of the people; to work for better conditions in Ethiopian communities.[31]

Now known as Mother Kofi, her creation of the AUC increased the tension among black nationalists. Members of the two groups threatened each other. Rumors surfaced that individuals on both sides were terrorized, followed, and attacked. Kofi began to argue that her own people, black religious leaders, were the ones who were lining up with the UNIA to destroy her. For instance, she stated that "preachers [were] jealous of her Bible teachings on God and Africa."[32] The African leader constantly spoke on the greatness of Africa, the wealth of its soil and people; but she also addressed the divine calling of responsible black Americans to make the continent a better place for its people. She viewed black people as being spiritually superior to whites and as having an older culture and greater civilizations than those of Europeans. She stated, "whites knew the truth of my tongue; but many of my own children are ignorant."[33] On one occasion in Alabama, observers viewed a black pastor walk out of a mass meeting that Kofi held. He stormed out in an angry manner and offered a white police officer ten dollars to stop the meeting and to arrest Laura Kofi.[34] The officer asked, "Why?" The preacher reportedly stated, "That woman is speaking against white people." The officer responded, "She is speaking the gospel truth and it is for everybody, she is speaking to you and me."[35]

Despite the harassment, Mother Kofi attracted mass audiences in Alabama, Georgia, Mississippi, and various towns and cities throughout the Sunshine State. Crowds were enormous. In Mobile, a baseball park was rented for a Kofi presentation. The audience was so large that it not only packed the venue but a

line the length of two city blocks formed as people waited to hear the leader.[36] Yet despite her popularity, she was constantly under the threat of terror—especially in southern Florida.

In Miami, the UNIA hatred of Kofi climaxed to a violent end. The final battle escalated in the UNIA and AUC fight to use Liberty Hall, a major black venue in Liberty City, for a lecture and meeting in the Miami community. The contest for the hall was so tense that Miami's Police Department padlocked the building so that neither group could use the site. In response, Kofi secured the use of Thompson's Hall, another venue in the district. Members of the local UNIA were livid that Kofi's group secured a venue for their affair. Immediately and aggressively the UNIA boldly declared that the African woman "must be stopped" by any means.[37]

On March 28, 1927, Mother Kofi, knowing that her life was in jeopardy, strangely ordered her bodyguards to sit down while she lectured. In most cases, bodyguards would have lined the venue in various standing posts. At approximately 9:00 p.m., as she was speaking about the divine power of God to liberate the blacks of America and Africa, a shot rang out from where a bodyguard would normally be standing. In seconds the woman with a dominant and passionate voice for black pride and strength fell limp with a single gunshot blast to the back of the head.[38] The hall, packed with thousands, went into pandemonium with chairs flying, people running, individuals being stomped. In the mix Kofi's supporters spotted the captain of the UNIA's African Legion, the paramilitary arm of Garvey's group. Hurt and angry, the mob of supporters grabbed the captain, Maxwell Cook, and stomped him to death. In the immediate aftermath police rounded up selected UNIA leaders for questioning, or rather for protection from mobs of Kofi supporters. Two UNIA members were indicted for first-degree murder but were ultimately found not guilty in a grand jury ruling.[39] Although Kofi was physically silenced, her movement continued through the religious and utopian communities she had established and through her philosophy.

Kofi's Legacy

The Kofi murder resulted in the formation of a cult-like following. Stories circulated about how she was shot holding a Bible as she preached about the history and future of black people and their special relationship with God. Followers began to refer to the deceased leader as the prophet, God's last messenger before the second coming of Christ.[40] In the days and weeks following Kofi's death there were a series of funeral processions from Miami to Jacksonville. For hundreds of miles thousands of people followed the motorcade that stopped at selected locations in such places as West Palm Beach where seven thousand people paid the AUC twenty-five cents each to view the body.

Finally, on August 17, 1928, over 10,000 followers witnessed Kofi's remains being placed in a specially built mausoleum in the Duval Cemetery, a formerly all-white graveyard in Jacksonville. However, while Mother Kofi lay in her final resting place, thousands of blacks, both members and non-members of the AUC, began to preach her message of self-help, black nationalism, and revolutionary theology.[41]

During her brief tenure Kofi had established communities and churches in Miami, Jacksonville, St. Petersburg, Tampa, Mobile, Jackson, Savannah, Atlanta, New York, and Detroit. The focuses and objectives of Kofi's AUCCL centered on self-determinism in religious, cultural, and social ideology. In these centers she taught a blend of African and African American Christianity that was mixed with elements of evangelical thought and African-based religious ideologies that can be seen in other African-based religions such as Cuban Santeria and Haitian Vodou. In addition, within Kofi's religious structure she had instructed her followers to speak African languages of Ga or Xhosa within the religious communities.[42]

At the heart of the AUC was centered a New Age African/African American religious tradition. The God she promoted was a black deity that was involved in the protection of and the advancement of his black children. Within this theological framework Kofi created a structure that depicted God as the father, Jesus as the son, and herself as the physical savior on earth, specifically, the prophet to the black world.[43]

Kofi, following the discourse of ancient prophets such as Moses of the Jews or Muhammad of the Muslims, proclaimed that God came to her with a law for mankind to follow and the directive that they must obey. She maintained that God visited her in dreams. In the course of several months and three major visions she finally accepted the orders of God to minister to her lost people. Similar to the story of the Virgin Mary's being a host for God's seed for the birth of a holy son, Kofi stated that "Old Man God cleansed and purged me for his program."[44] The organization's religious doctrine reads: "He fixed her; he planted His Spirit In her and all through her and made her a changed personality. She is now no more the carefree African young women or housewife but is transformed by His Holy Spirit. . . . Almighty God making Himself unto Motherhood in her. . . . Wonder of wonders that Adorka was now and henceforth to be known as 'Mother' especially for the poor, the orphans, the widows, the despised, the distressed and the downtrodden of her people and whosoever will everywhere."[45]

By 1928 Kofi had become a fixture in black American theology and race development. Membership in her church spanned several states, and churches were established in scores of cities.[46] Sensing the power of her words and the strength of her movement, Kofi had added on to the already growing and changing ministry.[47] Often preaching directly from the Bible, especially the

Old Testament, Kofi formulated an idea that if one is to be included in "Mother's Book" they must immediately join her movement. In this light, she now concluded sermons with the following statement: "Enroll your names with your Mother, children! If you don't have but one drop of black blood in you, and know you cannot pass for white, enroll your name."

In the midst of enrolling and signing their names in "Mother's Book," new members recognized Africa as black America's spiritual and physical Mecca or Jerusalem. In the 1920s most African Americans had no real attachment to the African continent. Their views of Africa came primarily from white Americans who saw Africa as a disjointed land with inferior people who lacked culture, a history, and any progressive initiative for a better society and world. Therefore, Kofi had to deal with black Americans who also saw Africa from negative white perspectives, who openly pronounced their detachment from the continent. Within the Kofi theology was an educational doctrine to deprogram African Americans of the notion that their ancestral home was a place of barbarians, savages, and people who lacked a culture, religion, and a civilization. In addressing the issue Kofi constantly preached about the great cities, universities, and kingdoms of Africa. She also stated that ships from Africa would embark for such American port cities as New Orleans and Jacksonville with goods to trade and men of power and money who would build great enterprises in the United States for their black American brothers and sisters. Kofi had created a pan-Africanist philosophy among underclass black Americans.[48]

Kofi not only used firsthand information from being an African to teach about the history of the continent, its culture, and the modern nature of its cities, but she also consulted the Bible to teach on the history and culture of black Americans and their lot in white America. She interpreted the scriptures as scrolls written for the black race; that is, according to Kofi, the book teaches on the past, present, and future state of black Americans. However, while she focused on blacks, she insisted that if whites listened to her, they too would reap rewards and benefits. It is reported that throughout her travels the black masses and scores of whites respected and accepted her teachings as being good for both races. Perhaps this is why there are no reported incidents or records of white reactionaries attacking her members or establishments.

Kofi's popularity was based primarily on her African roots. Prior to Kofi, African American people were addressed and influenced by American- and Caribbean-born leaders. Race advocates like Marcus Garvey and Noble Drew Ali spoke openly and aggressively of the roots of black Americans in the east, that is, either Africa or Asia. However, while they spoke and created brilliant organizations, they were not Africans.

Black Americans were impressed that an African woman told them about progressive African nations that wanted to connect with them in the United States. The exciting nationalist dialogue that Kofi brought pertaining to black

unity, racial dignity, and cultural acceptance from the Mother Continent to black Americans created an electric atmosphere that promoted a higher level of race consciousness than was suggested by earlier groups. Kofi's followers wanted to speak African languages, obtain an African education, eat African food, and live in an African culture. To them it was more than going to Africa; it was for the continued evolutionary growth of the African world. As one of her followers stated, "we came out overjoyed by greetings from Africa. It was the first time that we ever heard such good news and glad tidings from our people in motherland Africa."[49] The thesis of Kofi's racial theological argument rested on her own words. She stated, "Your people of Africa own and control their land; they sell their products to the western world and they buy machinery and manufactured goods."[50]

Kofi's theology grew and became clearer in reference to her ministry with each lesson. Before her murder she wrote *Sacred Teachings and Prophecies*, a treatise in which she outlined her mission, arguments, and objectives. In addition, the text presented scriptures directly geared to her teachings along with sacred hymnal music written by Mother Kofi.[51] Many of the songs were really old gospel hymns with new words. Lastly, the manuscript presented a doctrine that listed her within the framework of the Christian Holy Trinity, that is, Father, Son, Holy Spirit, and Mother Kofi—divinity on earth.[52]

While Mother Kofi created and presented a powerful concept of black religious ideology coupled with black nationalism and African suffrage, her theology grew greater after her death. A few weeks before her untimely death in 1928, Kofi foretold of a successor, a messenger sent by God who would set up her government on earth. She told her top leaders that God said her message was a wake-up call to stimulate God's people to embrace themselves as the people of God and positive representatives of Mother Africa. However, the next person would take the message and the organization much further than herself. Mother Kofi maintained that "you will know this man by his small size and loud voice." One of her followers asked, "How could someone take us to greater heights? Mother you have already established churches, industrial clubs and have taught us about our history—what is greater?" She responded, "You will know."[53]

In 1928 a "little man with a loud voice" appeared—Little or Lil Brother Eli Nyombolo from South Africa. Rev. Nyombolo, a follower of Mother Kofi from afar, immigrated to Florida to serve and help Kofi build the organization and movement that she envisioned. However, by the time of his arrival, Mother Kofi had been murdered and buried. Thus, he learned about the intimate teachings and activities of Kofi through her trusted lieutenants. After months of study and reflection, Nyombolo told members of the African Universal Church that he would complete Mother's assignment. During his tenure he created a working governmental structure for the movement while creating religious,

cultural, and educational programs that included the instruction of several African languages. In addition, while Mother Kofi had established members throughout the South, Nyombolo retraced her footsteps and emulated what she had done in Jacksonville. Between 1930 and 1970 Nyombolo created utopian black communities in Alabama, South Carolina, Georgia, and Mississippi. The greatest Kofi village, however, was Adorkaville in Jacksonville, Florida.[54]

Eli Nyombolo: Following in Kofi's Footsteps

Nyombolo, a member of the Zulu Nation in South Africa and the Xhosa people, was one of the first recorded pan-Africanists from the continent (aside from Kofi) who openly led a primarily African American group. Having a heritage of an ethnic group that held a long tradition of independence, self-determinism, and protectionism of their lands and culture, he was quite aggressive in promoting these values in southern blacks. Like Mother Kofi, who taught members of the AUC about her ethnic group in Gold Coast, Nyombolo gave lessons on the Zulu Nation and its greatest leader, Shaka Zulu, the Black Napoleon, and his epic battles against the Afrikaans and the British. In addition, he spoke about the greatness of the Xhosa people, who were known not only for their fierce wars against Europeans but also for the aggressive mode of education that depended upon using European laws to gain full acceptance in colonial Africa. Also of note, Nyombolo spoke about a new organization that was going to sweep Europeans off of the African Cape—African National Congress (ANC). He was right. In 1994 the ANC, through nonviolence, selected armed revolts, and legal means, ended the apartheid system that regulated blacks in South Africa to a restricted caste system. In 1994 ANC leader Nelson Mandela, a Xhosa-Zulu, became the nation's first black president.[55]

Nyombolo thus viewed Kofi's mission and AUC not just as a pan-Africanist movement but also as a social-religious organization that focused on revolutionary change through religion. Actually, Nyombolo combined the resistance movement of South Africa with the passion for change by African Americans in the United States. Therefore, the utopian communities that he continued from Kofi's work were training centers of black revolutionary theology, black nationalism, and self-determinism. From 1929 to 1970 Nyombolo led the AUC in several directions. It became an international group with sister churches in Gold Coast/Ghana and in South Africa; it was recognized by the ANC when Nyombolo became secretary of a human rights group. Nyombolo was also director of the Walker Business College (Jacksonville), an African American business college—the first in the United States that graduated many members of the AUC. In addition, Nyombolo founded the Afrocentric Ile-Ife Institute (Jacksonville), a religious school for elementary and high school students.

quette of black inferiority and passivity, West Indians became a threat and subsequently were a target of white racists and nativists.

19. Author unknown, *Mother's Sayings: From the Book of Her Secret Teachings and Public Ministry* (Jacksonville: AUC, 1928), 4–10.

20. Ibid., 15.

21. Nyombolo, *The African Messenger*, 2–4.

22. Bair, "Ethiopia Shall Stretch Forth Her Hands Unto God"; a Kofi follower wrote a note reviewing Mother's treatment by "her enemies." Kofi Papers.

23. "UNIA Miami Chapter Membership File." Kofi Papers.

24. Nyombolo, *The African Messenger*, 6–8.

25. The black moderate leadership class in the 1920s viewed Garvey as a disgrace and negative force in the struggle for African American equality and justice. In the aftermath of Garvey's meeting with Klan leaders, black leaders sought Garvey's deportation. Thus, they worked with the Bureau of Immigration and the Bureau of Naturalization within the Justice Department to have Garvey deported.

26. UNIA note on Laura Kofi by Miami Chapter of the UNIA. Marcus Garvey Papers. Schomburg Center for Research in Black Culture, New York Public Library.

27. Nyombolo, *Mother's Sacred Teachings,* 64; "History of Black Jacksonville," unpublished document, Jacksonville Historical Society, Carl S. Swisher, Jacksonville University, Jacksonville, Florida; Nyombolo, *Mother's Sacred Teachings,* 58.

28. Nyombolo, *The African Messenger,* 6.

29. E. B. Nyombolo, "A Self-Help Project of the Missionary African Universal Church" (published and distributed in Jacksonville, Florida for AUC members only, ca. 1940), 21.

30. Ibid., 23.

31. Ibid., 22.

32. Ibid., 21.

33. Nyombolo, *The African Messenger,* 29.

34. Harold, *Rise and Fall of Marcus Garvey*, 78–80.

35. *Miami Times*, February 21, 1985.

36. Ibid.

37. "Negro King Coming in Murder Inquiry," *New York Times*, Wednesday, May 21,1928.

38. Nyombolo, "A Self-Help Project," 3.

39. Ibid.

40. Ibid., 26.

41. Ibid., 6.

42. Ibid.

43. Ibid., 7; *The African Messenger Magazine Newspaper,* 3; Nyombolo, "Self-Help Project," 8; Kofi, "Mother's Sayings," 4–5; Nyombolo, *African Messenger*, 3; Newman, "Warrior Mother of Africa," 131–34.

44. Nyombolo, "Self-Help Project," 9.

45. Ibid.

46. "Mother's Sayings," 6–7; pan-Africanism and black unity were common themes of black nationalists between 1914 and 1985. Leaders like Du Bois, Malcolm X, John Henrik Clarke, Louis Farrakhan, and Ron Karenga engaged in discussions and conferences that sought to clarify the positions of pan-Africanists globally. Scores of international conferences were held throughout the twentieth century in such places as Paris, New York City, South Africa, and Senegal.

47. "Mother's Sayings," 4.

48. Ibid., 5.

49. Author unknown, "Sacred Teachings & Prophecies," 15 (members wrote scores of pamphlets and essays on Mother's philosophy and teachings, and not all are known or published); Newman, "Warrior Mother of Africa," 136–37; Nyombolo, *The African Messenger*, 11–12.

50. Newman, *Black Power and Black Religion*, 136.

51. Nyombolo, *The African Messenger*, 18.

52. Interview, Piko Nyombolo Horne, Jacksonville, July 19, 2005.

53. Ibid.

54. Ibid.

55. Pinko Horne, "Jacksonville Connects with South Africa," *Florida Times Union*, June 25, 2007.

56. Nyombolo, *The African Messenger*, 9.

57. Newman, "Warrior Mother of Africa," 136.

14

Barbecuing the Diaspora

Jerked Pig and Roast Hog in the Writings of Zora Neale Hurston

Andrew Warnes

Delving into the roots of barbecue—finding out who first cooked it and why—has long seemed a promising way to find out more about the historical influences that the African diaspora has exerted over national U.S. culture.[1] Barbecue, after all, is not just seen as the most American of foods. It also appears among the most African American, and the BBQ joints and shacks outside metropolitan Florida have long been places where you are likely to find black cooks carrying out serious culinary work. Indeed, almost as a counterweight against the long-standing dismissal of these skills by metropolitan arbiters of culinary excellence, African American writers have long expressed passion for the food and wonder at its producers. Ntozake Shange, Albert Murray, and Alice Walker, to name a few, express delight in barbecue; consistently, indeed, their works make the food seem—to use a term that recurs throughout Bobby Seale's cookbook, *Barbeque'n with Bobby* (1988)—"scrumptious."[2] But these writers characteristically also approach barbecue as a food that holds special significance for the African diaspora. Often, for them, barbecue feasts seem able to reunite black communities—to gather together people scattered across the United States or even the world.

This literary use of barbecue is epitomized by Alice Walker's *Color Purple* (1982), the concluding pages of which make the food central to a diasporic optimism that contrasts sharply with the novel's desolate opening. Having grown up in West Africa, Adam, offspring of Celie's earlier rape, finally meets his mother at a barbecue in the American South. The food offers a conversation opener, a point of contact the estranged family badly needs:

> Everybody make a lot of miration over Tashi. People look at her and Adam's scars like that's they business. . . . They make a fine couple. . . .
> What your people love to eat over there in Africa? us ast.

She sort of blush and say *barbecue*.
Everybody laugh and stuff her with one more piece.[3]

The conclusion to *The Color Purple* playfully extols barbecue, investing it with the power to replenish not only African bodies but also familial ties frayed by these bodies' scattering around the world. Celie's realization that she and her African relatives ate the same food long before their return to each other effectively expands the barbecue affirmations of many African American cookbooks, layering Jessica Harris's observation that in the modern United States "black folks, barbecues, and summertime are an inseparable combination" by suggesting that such inseparability could reach out to Africa itself.[4] This, however, is far from an isolated episode in African American literature. Like Ntozake Shange's discovery that in the Caribbean the "same oil barrels that we use to barbecue" become steel drums, Walker's diasporic barbecue belongs to an established tradition in which these outdoor feasts evince kinship between remote communities of African descent.[5] This tradition, indeed, sometimes suggests that we could add to the spices enlivening barbecued meat the further flavor of Africanism itself, as if the smoke rising from Mississippi BBQ shacks and Jamaican jerk stalls, having disappeared into the stratosphere, formed a canopy that could hug the diaspora itself.

Zora Neale Hurston, Alice Walker's leading literary foremother, casts a long shadow over *The Color Purple*.[6] Her influence, however, is nowhere stronger than at the novel's close. Glancing back at *Their Eyes Were Watching God* (1937), Celie's diasporic barbecue revises and revisits the hogroast Joe Starks famously calls to mark Eatonville's acquisition of street lighting. Revise, because Hurston's depiction of a hogroast dominated by the patriarch Joe Starks becomes in Walker's hands a scene of female emancipation, which realizes a womanist love more redolent of Janie Starks's eventual awakening. And revisit, because, even as she reverses the gender dynamics of Eatonville's hogroast, Walker advances Hurston's idea that such barbecues demonstrated Africa's continuing cultural influence over black American life.

This chapter begins by examining how *Their Eyes Were Watching God* and other writings substantiate Hurston's belief that hogroasts like Joe Starks's evidence Africa in Florida. I show how Hurston uses a knowing intertextuality to crowd her oeuvre with a set of key scenes—scenes that, thanks to their periodic resurfacing in altered shapes, acquire the status of a template. The Eatonville hogroast is one such template: following amendments, it appears three times in Hurston's oeuvre, surfacing in *Their Eyes Were Watching God* and *Tell My Horse* (1938) as well as *Jonah's Gourd Vine* (1934). I then argue that, because these texts describe black life in Florida, the Caribbean, and Alabama, respectively, the fact that each plays host to Hurston's barbecue template effectively associates this food with the diaspora and eventually with Africa

Figure 14.1. Eleanor Mathews, *Eatonville*, watercolor on paper, 13.75 × 18 inches. The town of Eatonville, founded in 1863 after the signing of the Emancipation Proclamation, is one of the first incorporated Black towns in the United States. Home to Zora Neale Hurston, it is the backdrop for her novel *Their Eyes Were Watching God*, in which Hurston's description of a hogroast becomes a sort of template for diasporic writing on barbeque. From the Florida Collection of Cici and Hyatt Brown.

itself. As maroon Jamaicans baste, roast, and eat hogs in a manner identical to that practiced by black Floridians—as the feast in *Jonah's Gourd Vine* is accompanied by a drum "whose body was still in Africa"—so barbecue appears, for Hurston, proof of Africa's lingering vitality even in twentieth-century Florida.[7]

I then show why this claim is problematic. For the pursuit of such authentic barbecue is always doomed to failure, and for the simple reason that the word for this food arose out of the colonial Caribbean.[8] Nothing that barbecue signifies, no matter how delicious, can be fully understood unless we understand the signifier itself, and its origins amid the atrocious circumstances of conquest. What is more, these Caribbean origins were fully apparent during Hurston's lifetime. Numerous contemporary dictionaries agreed with H. L. Mencken's *The American Language* (1919) that "*barbecue* came from a Haitian word, *barbacoa*."[9] Admittedly, barbecue's subsequent journey to its global ubiquity was anything but straightforward, and absorbed the influences of

African cuisines as well as those of Europe. Indeed, one might argue that Hurston repeatedly "Africanizes" barbecue because, in Jamaica as in black Florida, these feasts were and are so often accompanied by music and storytelling performances manifestly originating in African cultures. Yet the suspicion that Hurston dismissed the native origins of barbecue because of its association with black cultural performance in itself suggests a discomfort with the sheer mess of hybrid culture and a desire to keep hold of a definition of diaspora founded in blood. The following discussion, then, ends by raising a possibility Hurston herself could not countenance: that the prominence and power of barbecue in African American communities, as attested by leading black writers, resulted in at least some degree from contact with the indigenous peoples who long dwelled at empire's margin.

A Caribbean Eatonville

One of the most remarkable aspects of Zora Neale Hurston's remarkable career is her claim that she completed *Their Eyes Were Watching God* in only seven weeks. Upon arriving in Haiti in September 1936, and having just toured the island's famed beauty spots, Hurston delayed her ethnographic fieldwork by only this time in order to write, from beginning to end, her famous novel of Floridian love and labor. Perhaps the most compelling explanation for Hurston's impressive creative activity is that her literary imagination was fired by the surrounding Caribbean. *Their Eyes Were Watching God* certainly enfolds Janie and Tea Cake in a tropical landscape, rich with citrus, jasmine, guava, and bougainvillea, which is not just recognizably Floridian but redolent of island life. Janie and Tea Cake's later movement toward the Everglades, not to mention their arrival in a fertile "muck" also frequented by Bahamians, add to the impression that *Their Eyes Were Watching God* wants to detach Florida from the mainland United States—to drag it down and into the arms of the Caribbean archipelago.[10]

Seven weeks nonetheless remains an incredibly brief time in which to write a novel. *Their Eyes Were Watching God*'s propensity to draw on earlier writings, I would suggest, offers another reason why Hurston could finish it so quickly. As Alice Gambrell has argued, Hurston practiced this kind of self-revision throughout her career. For Gambrell, such self-revision—which, borrowing from Nathaniel McKay, she terms "versioning"—exceeded mere literary expedience.[11] It did not just allow Hurston to surround the adventures of Janie Starks with a world of black folk culture already developed elsewhere. It was also a fruitful authorial strategy that helped Hurston sustain "a constant inventiveness."[12] Citing Hurston's story of a rivalry between two Conjure herbalists—versions of which appear in "Hoodoo in America" (1931), *Mules and Men* (1935), and *Dust Tracks on a Road* (1942)—Gambrell suggests that such

intertextual links, effectively, helped to maintain the unity of a body of work circumstance had dispersed across ethnographic, literary, and journalistic genres. But nor, I would add, did such "versioning" simply unify Hurston's oeuvre. It also helped unify the diverse diasporic outposts on which this oeuvre alights. "Versioning" illustrated the diaspora: it enabled Hurston to reveal the threads that bind together the place where *Their Eyes Were Watching God* was written (Haiti) and the place where it is set (Florida).

Reading Hurston in this light can become like hunting, a case of tracking down her wandering textual templates. In the case of *Their Eyes Were Watching God,* some of these paths are easier to track than others. But the fact that Hurston wrote the novel in Haiti throws off a particularly strong scent, suggesting that *Tell My Horse*—the result of her fieldwork both on this island and in Jamaica—is a promising place to begin our intertextual search. As Robert Hemenway concludes, the notes Hurston made in Jamaica just before arriving in Haiti formed the basis for much of *Tell My Horse.* While in Jamaica, Hurston "lived quietly" among the Jamaican maroons "residing in the forbidding Saint Catherine Mountains at Accompong," biding her time, in order to form a new record of their culture. Eventually the patience of these early months paid off, and Hurston was invited to join the men of the society on what Hemenway calls a "ritualistic hunt for a wild boar."[13] Hurston's subsequent report of her experience is now a classic of food writing, and is quoted in full in the account of the origins of "jerk" cookery in Norma Benghiat's *Traditional Jamaican Cookery* (1985).[14] Of prime importance here, though, is the fact that, while the following quotation first appeared in *Tell My Horse,* Hemenway's observation that this study merely gathered notes Hurston made while in Jamaica suggests that its composition actually predated *Their Eyes Were Watching God.* Certainly, the following passage substantiates Valerie Smith's suggestion that *Tell My Horse* was "written in a hurry":[15] it has the flavor of a journal entry, busily recalling the moment when—after three days and nights without a sighting—Hurston and her fellow hunters see

the wild boar approach and pass . . . The men crept closer and Esau chanced a shot. . . . The hog made a half turn and fell. . . .

Then all of the men began to cut dry wood for a big fire. When the fire began to be lively, they . . . put the pig into the fire on his side. . . . Everything was now done in high good humor. No effort was made to save the chitterlings and hasslets, which were referred to as the "fifth quarter." . . . The meat was then seasoned with salt, pepper and spices and put over the fire to cook. It was such a big hog that it took nearly all night to finish cooking. It required two men to turn it over when necessary. While it was being cooked and giving off delicious odors, the men talked and told stories and sang songs. One told the story of Paul Bogle, the

Jamaican hero of the war of 1797 who made such a noble fight against the British . . .

Towards morning we ate our fill of jerked pork. It is more delicious than our barbecue. It is hard to imagine anything better than pork the way Maroons jerk it. . . . We came marching in singing the Karamante' songs.[16]

This was not the first "barbecue" episode Hurston had written. For her first novel, *Jonah's Gourd Vine* (1934), she developed a scene in which a white plantation owner allows his workers a night watching "Hogs roasting over the open pit of oak coals."[17] But, if *Tell My Horse*'s Jamaican hunt shares much with *Jonah's Gourd Vine*'s barbecue, its affinity with the Eatonville hogroast of *Their Eyes Were Watching God* is far more pronounced. Held to celebrate Eatonville's acquisition of street lighting, *Their Eyes Were Watching God*'s hogroast differs from *Jonah's Gourd Vine*'s as it manifests an affirmation of black civic independence. The fulfillment of Joe Starks's somewhat dogmatic ambitions, it marks the ascent of the town he considers "his" from a collection of "shame-faced houses scattered in the sand and palmetto roots" to an incorporated community plunged into the national economy (56). This text parallels *Tell My Horse* very closely:

> The women got together the sweets and the men looked after the meats. The day before the lighting, they dug a big hole in back of the store and filled it full of oak wood and burned it down to a glowing bed of coals. It took them the whole night to barbecue the three hogs. Hambo and Pearson had full charge while the others helped out with turning the meat now and then while Hambo swabbed it all over with the sauce. In between times they told stories, laughed and told more stories and sung songs. They cut all sorts of capers and whiffed the meat as it slowly came to perfection with the seasoning penetrating to the bone. The younger boys had to rig up the saw-horses with boards for the women to use as tables. Then it was after sun-up and everybody not needed went home to rest up for the feast. . . .
>
> Near the time, Joe assembled everybody in the street before the store and made a speech. . . .
>
> "Dis occasion is something for us all to remember tuh our dyin' day. De first street lamp in uh colored town. Lift yo' eyes and gaze on it." . . .
>
> As the word Amen was said, he touched the lighted match to the wick, and Mrs. Bogle's alto burst out in. (72–74)

Their Eyes Were Watching God here clearly manifests "versioning" and the coherence it could bring to Hurston's dispersed oeuvre. Like a single patch on a

patchwork quilt, this hogroast scene repeats patterns Hurston used earlier, mixes them with other patterns, and anticipates patterns later to come, creating an impression in which change and difference exist in a context of similarity. That is to say, the evident *difference* between these scenes—the contrast between preindustrial Jamaica maroon culture and the fact that the Eatonville hogroast celebrates the arrival of "modern" street lighting—highlights their close textual affinity. Both scenes, after all, share the gender separation that *The Color Purple* overhauls: in both, these all-male crowds are described by broad assertions as a single unit—"they" are said to "dig" this and to "do" that, to "cut dry wood" and to "cut all sorts of capers." And this process of self-quotation can seem concentrated in the fire: "a big fire [of] dry coals" in *Tell My Horse*, it morphs into the "glowing bed of live coals" that cooks Eatonville's hogs. Both narratives then emphasize the time taken to cook the hog: "all night" in the former, the "whole night" in the latter. In both the meat is turned by two men, identified as Hambo and Pearson in *Their Eyes Were Watching God* but nameless in *Tell My Horse*. A subsequent construction in the former—"while it was being cooked . . . the men talked and told stories and sang songs"—produces a very direct echo of the latter—"they told stories, laughed, and told more stories and sung songs." Quoting each other nearly verbatim, outlining the firing, basting, and consumption of the hog, these scenes announce a certain authorial consistency, forcing the reader to recognize that *Their Eyes Were Watching God* and *Tell My Horse* spring from the same pen.

This deliberate intertextuality, however, also raises the stakes far beyond mere authorial expedience. It announces a cultural commonality between black Jamaica and black Florida. Stepping back from a single patched scene, the reader finds that the quilt as a whole matches the outline of the diaspora itself, that Hurston, for all her interest in the culturally specific, is also identifying threads that connect locality with locality, patch with patch, and "island" with island. In the course of basting and eating the hog, the Jamaican maroons and black Floridians of *Tell My Horse* and *Their Eyes Were Watching God,* respectively, are shown to spring, not only from the same pen, but from the same cultural source: Africa. Both groups are shown by Hurston to embellish their barbecue with a range of cultural forms—song, "speechifying," and dance—that Hurston herself had helped show were often African in origin. The maroons sing a song in Jamaican Creole, a language whose useful inscrutability to English ears partly stemmed from its retention of the "common grammatical forms" from West Africa.[18] Eatonville's denizens, meanwhile, are fluent in what has since been termed *ebonics*; their enthusiastic responses to the barbecue are expressed in a language form that, as Molefi Kete Asante observes, "contains structural remnants of certain African languages."[19] Awaiting barbecue, Eatonville offers prayers, songs, and stories, enacting a black Floridian

form of worship that Hurston elsewhere described as full of "elements which were brought over from Africa and grafted onto Christianity."[20]

Consequently, African influences over the barbecue feast, although most loudly trumpeted in *Jonah's Gourd Vine* and its invocation of "Congo gods talking in Alabama," remain clearly audible in *Tell My Horse* and *Their Eyes Were Watching God*.[21] Even in the latter texts, moreover, these influences drown out *barbecue*'s messy and murky origins in the colonial Caribbean as well as the high levels of contact between black and indigenous peoples that is surely another point of commonality between north Jamaica and rural Florida.

Hurston's 1927 essay, "Cudjo's Own Story of the Last African Slaver," confirms her impulse to avoid these fascinating possibilities. Here, Hurston asserts that, in West Africa, "hogs are prepared by taking brown sage and burning off the hair, then washing the skin thoroughly. The animal is usually roasted whole very much as we barbecue. This was probably the origin of the barbecue in America. The word, however, is derived from a native name in Guiana."[22] The tension, as such, grows clear. On one hand, "versioning" presents a formal strategy that would seem able to accommodate diasporic diversity. Just as the patches of a quilt often recall one another even as each remains unique, so "versioning," far from mere textual repetition, enacts a kind of creative embroidery, enabling Hurston to create new scenes based loosely on a single template. The barbecue scenes analyzed so far thus contain within their form an implied recognition of hybridity; each is modified according to its textual and subsequently its actual environment. But this admission of external forces is then shut down by the insistence on similarity. *Tell My Horse*'s observation that the maroons' "jerked pork . . . is more delicious than our barbecue" epitomizes this phenomenon. For this phrase, superficially, celebrates diversity. It admits that barbecue results less from a monolithic African inheritance than from the complex interactions of diverse local influences. But the very close textual symmetry of *Tell My Horse* and *Their Eyes Were Watching God* then undermines this admission conclusively; for our discovery that maroons and Floridians cook hogs in exactly the same way suggests that, on the contrary, jerked pork *is* "our barbecue." Interracial complications remain felt even as Hurston, concentrating on forms of labor activity, does what she can to spirit them away. At the time, of course, Eurocentrism remained endemic, and Hurston's interest in African influences helped counteract its long-established institutional biases. Her failure to assimilate Indian influences, however, cannot be excused so easily. Ultimately, in her writings on barbecue, Hurston fell victim to what Kadiatu Kanneh calls "cultural monologism."[23] She sacrificed the rebellious plurality of anticolonial history to protect an account of barbecue's origins based on racial purity. Soon we will see that this was far from the only sacrifice that Hurston's commitment to barbecue's African roots required.

Anticolonial Barbecue

Some places seem destined to play a more important role in world history than others. Guantánamo Bay, "two spits of dry scrubland . . . on Cuba's south-eastern heel," is one such place.[24] Five centuries before gaining notoriety as a holding camp for those captured in the War on Terror, Guantánamo Bay was the scene of an encounter between Columbus's crew and the native Taíno—of a remarkable encounter, which, in its tension, its casual theft, and the fleeting disappearance of its Indian actors, seems almost to anticipate the annihilation of the Arawaks and subsequent popularization of barbacoa around the world. Columbus had to wait until his second voyage of 1494 before fully exploring Cuba, an island he still regarded as part of the Asian mainland. In April of that year, a small fleet consisting only of the *Niña*, *San Juan*, and *Cordera* set sail from Columbus's base on Hispaniola, La Isabela. Reaching Cuba's eastern extreme, the fleet followed the coastline southwestward to reach Guantánamo Bay on April 30. We do not know when Columbus and the other men first saw the smoke rising from the barbacoa. Nor do we know at what point the Taíno saw the boat, and abandoned the beach to hide in the scrubland beyond it. What we do know is that, landing in the bay, as Samuel Eliot Morison notes, Columbus's men found "a large quantity of fish, . . . and two gigantic iguanas being cooked on spits in the open, guarded by a dumb dog." The subsequent actions of Columbus's party suggest that they regarded this strange scene as natural, explicable—as though the food was indeed barbecuing itself, an offering from God rather than the property of others. Hunger lent legitimacy to the theft. Spurning the iguana, "which the Spaniards thought the most ugly and disgusting creatures they had ever seen," Columbus's crew had eaten all the barbecued fish by the time the food's cooks returned to the beach.[25] Translated by Columbus's Taíno interpreter Diego Colón, who understood their language immediately, the Arawaks thanked Columbus for sparing the iguana: as William Lemos notes, "capturing them was hard work and their meat delicious."[26]

Invisible cooks, terrified gratitude, the outrageous disapproval of the thieves: the encounter at Guantánamo Bay can seem remarkably prophetic, a grim portent of Europe's imminent colonization of the region. The disappearance of the Taíno, however, also occurs within popular food history. That is to say, it might be impossible to fashion anything so straightforward as a foodway from barbecue's complicated and colonial history; but it is also impossible to even begin to imagine such a thing without beginning before Columbus and with those Arawakan peoples who called beds *barbacoas* and practiced sophisticated forms of smoke cookery. Nonetheless, despite this, the long-standing situation in which "the Caribbean's greatest contribution to the American diet—barbecue—isn't generally recognized as Caribbean at all" continues to apply.[27]

In the historical wake of Columbus's voyages, as the geopolitical map of the world was redrawn, European travel writings generally acknowledged barbecue's native origins. Between the 1660s and 1700s, writings by William Dampier, Robert Beverley, and Edmund Hickeringill all presented barbecue as an invention of the New World, transcribing the term as *barbecu, barbacue,* and *barbacu,* respectively.[28] While these texts attribute barbecue to varying Indian nations and offer conflicting definitions of it, all nevertheless broadly substantiate the Arawakan influences that have helped shape modern notions of barbecue. All expose the etymology tracing barbecue to the French *barbe á queue* ("head to tail") for what the *Oxford English Dictionary* now says it is: an "absurd conjecture," a grotesque act of Eurocentric falsification.[29] All discredit Hurston's belief—made explicit in "Cudjo's Own Story of the Last African Slaver"—that Africa "was probably the origin of the barbecue in America." And all suggest that *Their Eyes Were Watching God*'s hogroast manifests, not Africa in Florida, but a heady mix involving the cultures of the native Caribbean.

Before we return to Hurston's Florida hogroast, let us consider further barbecue's torrid colonial history, its turbulent outward journey from Guantánamo Bay to Eatonville and elsewhere. A sign of the sheer volatility of barbecue's history—of its surprisingly consistent saturation in discourses of racial struggle—lies in the fact that the French etymology now labeled an "absurd conjecture" is only one among many past misattributions of the food. Another such misattribution emerges from the fact that, while most English dictionaries published since the seventeenth century acknowledge barbecue's native etymology, travel accounts since 1800 often took little account of such definitions. European and European American observers, sampling this thing called barbecue or watching its preparation from afar, felt free to disregard its native influences and invent new myths of origin to explain it. The Eurocentric myth of the primitivism common to other peoples in particular robbed barbecue of any cultural particularity, reduced it to an instinctual level, and encouraged these commentators to think of the food as African without worrying too much about what this etiological shift might mean.

Such a shift is, perhaps, most striking in the references post-1800 European writings make to *jerking,* the form of barbecue Hurston encountered in Jamaica. Earlier works generally acknowledge *jerk*'s native origins, supporting *The Dictionary of Jamaican English*'s attribution of the term to the "Quichua Indians" of Colombia.[30] At the turn of the nineteenth century, however, the switch has been thrown: what we might call the "Africanization" of barbecue has begun. A journal entry of 1803 by Lady Nugent, for instance, defines "jerked hog" as "the way of dressing it by the Maroons," the Jamaican fugitives Hurston later visited.[31] In the same year, R. C. Dallas's *The History of the Maroons* confirmed this new association, noting that such fugitives "are, like other negroes, fond of savoury dishes, jirked hog, and ringtail pigeons,

delicacies unknown to an European table." Dallas adds, "I know not whence the word *jirked* is derived, but it signifies cutting or scoring internally the flesh of the wild hog, which is then smoked, and otherwise prepared in a manner that gives it a very fine flavour."[32] Slippery, apparently able to detach and reattach itself to alternative folk cultures, *jerk* or barbecue here remains (to European eyes) emphatically a sign of the racial Other—an exotic food, able to remind the colonial how far he or she is from the familiarities of home.

How do we respond to this "Africanization" of barbecue, to the throwing of this etymological switch? All of the texts mentioned here belong to the European canon, and all are thus subject to the increasingly pseudoscientific appearance racial thinking acquired during the period of transatlantic slavery's most rapid expansion. Barbecue's amorphous qualities owe much to the amorphous and in many ways interchangeable identities thrust upon nonwhite peoples by a European perspective that, convinced of its own superiority, often named Indians "niggers" and labeled Africans "savage." On the other hand, however, a considerable body of evidence suggests that the "Africanization" of barbecue sketched in such subjective fashion also had some basis in fact. It is noticeable that, in the eighteenth century, the first reports of barbecue in North America are written in Virginia, Florida, and other of the slaveholding colonies that imported Africans from the Caribbean in the largest numbers. In this alternative light, the *Africana* encyclopedia's brief discussion of barbecue—its suggestion that "enslaved Africans may have learned some culinary techniques, including barbecue, from West Indians" and then carried this new knowledge to "colonial South Carolina"—seems, if anything, too tentative.[33]

Evidence that the "Africanization" of barbecue results from more than European racial ambivalence also emerges from M. G. Lewis's *Journal of a West Indian Proprietor* (1834), an account of colonial Jamaica written in the aftermath of British Emancipation. In the course of his journal, Lewis reveals himself to be something of a gustatory tourist, a man who tours the culinary delights of Jamaica's fatal shores rather as the English middle classes today tour Tuscany. Lewis also displays a tendency—equally evident in Dallas's *The History of the Maroons*, and indeed still characteristic of much gustatory tourism—to depict all the dishes he encounters as pure and authentic to their cooks and thus to dispel the possibility that the regions of his daring travels might harbor their own complex histories of interracial hybridity and fusion. Seeing the black faces of his Jamaican cooks, Lewis enlists almost all he eats into an African culinary repertoire, lumping "land and sea turtle, quails, snipes, plovers. . . . barbicued pigs, [and] pepperpots" together.[34] Lewis's unnamed cook then serves "a barbecued pig," which Lewis notes "was dressed in the true maroon fashion, being placed on a barbecue (a frame of wicker-work, through whose interstices the steam can ascend), filled with peppers and spices of the highest flavour, [and] wrapt in plantain leaves."[35]

This remarkable dish—its striking blend of ingredients, its pork and spices and plantain envelope—demands to be placed in the context of marronage. Unlike many modern barbecues, it does not just involve charcoal grilling, its apparatus instead replicating that of the native *barbacoa* ("through whose interstices the steam can ascend") so that the food slowly smokes. But such apparent native influences are complemented by the fact that the meat is then "wrapt in plantain leaves," placed inside an ingredient long associated with Africa.[36] A native letter in an African envelope, the dish consequently calls to mind interracial marronage, the encounters that occurred in Jamaica's "mountainous terrain, and rich forest cover," which afforded "ample opportunity for fugitive slaves," whether native or foreign-born.[37] The interaction between African ingredient and native method apparent in this dish certainly furnishes an apt metaphor for the emergence in the Caribbean of such new peoples as the black Caribs, in whom Africa and America likewise coalesced. And the nearest American equivalent to these Caribbean histories, of course, took place in Florida. Eight years before *Their Eyes Were Watching God*, Ralph Gabriel noted that the "word 'Seminole' means 'separatist' or 'runaway.' About 1775 the Creeks who migrated to the Florida country began to be called by this name. . . . As fugitive slaves fled to their villages, they began to show a mixture of negro blood."[38] Richard Price has since explored the legacy of this anticolonial encounter, demonstrating the "long history of close collaboration and intermarriage" between the "Seminoles and maroons" of Florida that has also resulted in the new cultural forms that Thomas Larose and Rosalyn Howard explore elsewhere in this volume.[39] Some of these Seminoles, however, also appear toward the end of *Their Eyes Were Watching God*:

> [Janie] saw a band of Seminoles passing by. The men walking in front and the laden, stolid women following them like burros. She had seen Indians several times in the 'Glades, in twos and threes, but this was a large party. . . . later another party appeared and went the same way. Then another just before sundown. This time she asked where they were all going. . . .
> "Going to high ground. Saw-grass bloom. Hurricane coming."
> Everybody was talking about it that night. But nobody was worried. The fire dance kept up till nearly dawn. The next day, more Indians moved east, unhurried but steady. Still a blue sky and fair weather. Beans running fine and prices good, so the Indians could be, *must* be, wrong. . . . Indians are dumb anyhow, always were. (228–29)

Like William Faulkner's Indians, these Seminoles exist in a fictional world of such sophisticated originality that even their obvious stereotyping can seem somehow ironic or knowing. Many of Faulkner's critics have punctured this interpretative allure, recognizing that, in "many essentials, Faulkner's Indians

conform to the main contours of 'savagism,'" in Mick Gidley's phrase.[40] By contrast, considering the above scene from *Their Eyes Were Watching God*, Erik Curren observes that "as soon as the folk community is threatened by an outside force—in this case, the power of nature—it begins to display white attitudes." They dismiss "tribal lore" and acquire a "bigotry and materialism more typical of white America than of black folk culture. After all, the Bahamians do not share these attitudes. . . . Lias the Bahamian decides to leave because he trusts the Indians' judgment."[41] For Curren, the dumbness of Hurston's Seminoles stems less from authorial stereotyping than from textual necessity; it illustrates how Florida black folk can "whiten" once the prospect of economic security appears before them. In this explanation, Seminoles are silenced not by *Their Eyes Were Watching God*'s narrator but by the "close-minded empiricism" of the novel's more money-minded black characters. But what Curren overlooks is that the Seminoles' silence precedes this misguided verdict. Many pass Janie by before one finally grants her an answer whose speech marks effectively restore authorial omniscience even as its excessively epigrammatic structure declares the debt it owes to Indian stereotypes of nobility, reticence, and ecological sensitivity. Silent Indians surface elsewhere in Hurston's oeuvre: *Mules and Men*'s introduction, for instance, tells us the "Indian resists curiosity by a stony silence."[42] This silence must not be confused with absence. Rather than making them invisible, Hurston typically renders American Indians as a presence that refuses to speak, especially when compared to the vibrant expressive cultures of the African diaspora. *Their Eyes Were Watching God* not only represents the silent introspection of the Seminoles but also contrasts it with the open contact conducted within the diaspora between black Florida and the Bahamas. The possibility of contact beyond this diaspora is not absent from the novel so much as its incompatibility becomes apparent: the Bahamian Lias is a very minor character, and the exceptional nature of his faith in "the Indians' judgment" makes such "trust" interpretable as a remnant of an interracial conversation that Hurston otherwise prohibits.

The silence of Hurston's Indians and her denial of barbecue's native influences testify to a view of the African diaspora in which blood purity remains paramount. Abolishing dialogue between Seminoles and African Americans while denying the occurrence of intermarriage between them ultimately protects the symbiosis of race and culture. That is to say, Hurston, witnessing the enormous resonance barbecue holds in diverse cultures of the diaspora, is driven by her belief in the biological coherence of this diaspora to "Africanize" the food, to source it back to the Old World's Atlantic Coast. But the problem with such a move is that, in the process of affirming an African culture long denigrated by racist thought, Hurston reasserts a biological view of culture familiar from Eurocentrism. She sidelines the hybridity so central to diaspora. Ironically, Hurston's need to maintain the biological coherence of the diaspora

sacrifices a far greater gift than barbecue: the minds of Africa's fugitive ma-roons, some of whom clearly refused to submit to race thinking, instead embracing Indians cast into an equivalent oppression, even assimilating their island cuisines. Hurston's representations of the Eatonville hogroast and the maroon *jerk* can indeed be seen as evidence of Africa in Florida and Jamaica, respectively. But only if we also recognize the native influences apparent in these foods. What barbecue reveals, finally, is the importance interracial hybridity has played in Africa's cultural flowering throughout the Americas.

Notes

1. This is a shortened and updated version of an article that originally appeared as "Guantánamo, Eatonville, Accompong: Barbecue and the Diaspora in the Writings of Zora Neale Hurston," *Journal of American Studies* 40, no. 1 (2006): 367–89. It is reprinted by kind permission of Cambridge University Press. I develop and enlarge on these ideas in *Savage Barbecue: Race, Culture, and the Invention of America's First Food* (Athens: University of Georgia Press, 2008).

2. Seale, *Barbeque'n with Bobby*, 2.

3. Walker, *The Color Purple*, 54.

4. Harris, *Iron Pots and Wooden Spoons*, 59.

5. Shange, *If I Can Cook*, 65.

6. Walker, "Zora Neale Hurston," 86.

7. Hurston, *Jonah's Gourd Vine*, 61.

8. See Alegría, "Indian America: Tainos," 346; and Keegan, "The Caribbean."

9. Mencken, *The American Language*, 112.

10. Hurston, *Their Eyes Were Watching God*, 196. All further references to this edition appear in the text.

11. Gambrell, *Women Intellectuals, Modernism and Difference*, 14.

12. Ibid., 115.

13. Hemenway, *Zora Neale Hurston*, 228–29.

14. Benghiat, *Traditional Jamaican Cookery*, 99–101.

15. V. Smith, *Wrapped in Rainbows*, 321.

16. Hurston, *Tell My Horse*, 36–37.

17. Hurston, *Jonah's Gourd Vine*, 58.

18. Curtin, *Two Jamaicas*, 26.

19. Asante, "African Elements in African-American English," 22.

20. Hurston, *Go Gator and Muddy the Water*, 96.

21. Hurston, *Jonah's Gourd Vine,* 60.

22. Hurston, "Cudjo's Own Story," 650.

23. Kanneh, *African Identities*, 121.

24. Lelyveld. "In Guantánamo," 62.

25. Morison, *Admiral of the Ocean Sea*, 120–21.

26. Lemos, "Voyages of Columbus," 709.

27. Zibart, Stevens, and Vermont, *The Unofficial Guide to Ethnic Cuisine and Dining in America*, 333.

28. See Hickeringill, *Jamaica Viewed*, 59; Dampier, *A New Voyage round the World*; and Beverley, *The History and Present State of Virginia*, 178.

29. *Oxford English Dictionary*, 1:947.

30. *Dictionary of Jamaican English*, 245.

31. Lady Nugent, *Lady Nugent's Journal*, 70.

32. Dallas, *History of the Maroons*, 90–91.

33. Myers, "Food in African American Culture," 764.

34. Lewis, *Journal of a West Indian Proprietor*, 92.

35. Ibid., 128.

36. Harris, *A Kwanzaa Keepsake*, 65.

37. Segal, *The Black Diaspora*, 131.

38. Gabriel, *The Lure of the Frontie*, 120.

39. Price, "Introduction: Maroons and their Communities," 15.

40. Gidley, "Sam Fathers's Father," 127.

41. Curren, "Should Their Eyes Have Been Watching God?" 19.

42. Hurston, *Mules and Men*, 2.

15

Ade Rossman's
Zora Neale Hurston Series

Living Africa under the Florida Sun

Robin Poynor

In response to a commission by the St. Lucie County Cultural Affairs Office in Fort Pierce, Florida, the artist Ade Rossman (fig. 15.1) created a series of paintings in 2006 depicting the life of Zora Neale Hurston (1925–60). While conducting preparatory research for the series and in investigating the life of Hurston, Rossman recognized parallels between his own life and that of the eminent scholar and author. Although he has never been to Africa, Rossman has experienced "Africa" in a number of ways during the course of his life. Born in Trinidad, he remembers his grandmother as the community "medicine woman" making treks into the wilderness to seek healing roots, barks, and leaves. In Rossman's mind at the time, she was just doing her thing, "living her life under the sun," as he puts it. Only later was he able to put his grandmother's behavior into a "more African" perspective and to realize that the things she did were essentially "African."[1]

At a young age, Rossman moved with his family to Brooklyn, which he recalls as more and more "West Indian–ized" over time. He went to a Catholic high school there, but he also discovered Yoruba religion in Brooklyn, where a babaláwo divined his Yoruba name. His marriage was consecrated by a babaláwo, and a babaláwo officiated at naming ceremonies for his children, who also received Yoruba names. His study of Yoruba culture was, he says, an attempt to discover African culture, and as he studied Yoruba religion he realized more and more that the life his grandmother lived in Trinidad and the folk practices she observed had their roots in African traditions. Her medical knowledge derived from practices similar to those he discovered in Yoruba religion.

He studied commercial art at NYC Technical College, which allowed him to better articulate his ideas visually through line drawing, perspective, and elements of design. Further study at Pratt Institute led him to experiment

Figure 15.1. The artist Ade Rossman of Ft. Pierce, Florida, was born in Trinidad. Courtesy of Ade Rossman.

with commercial design and fashion illustration. Later, while employed in California, he was commissioned to design a calendar for a Rastafarian group. Research into Rastafarianism for the project allowed him to realize his passion for research and his interest in the pan-Africanist teachings of Rastafarianism, which led him to develop further his ideas about Africa and being African.

When he settled in Fort Pierce, Rossman was confronted by the legacy of Zora Neale Hurston.[2] Fort Pierce is one of two Florida cities that pride themselves on connections with the life of the scholar-writer who played an important role in the Harlem Renaissance.[3] She spent the last years of her life in the city, writing an occasional column for *The Chronicle*, Fort Pierce's black newspaper. Hurston also supported herself to some extent as a substitute teacher at Lincoln Park Academy, located near the small house in which she lived until just before her death in 1960.[4] She was buried in an unmarked grave in the

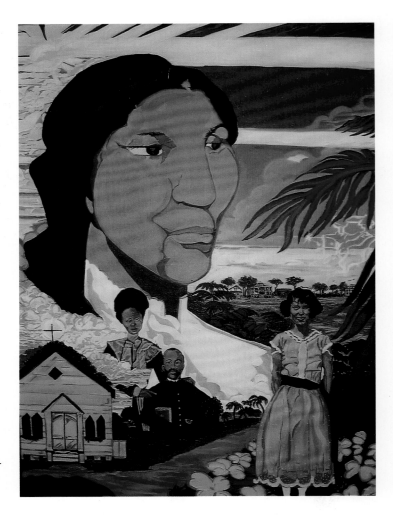

Figure 15.2. *Zora at the Cross-roads.* In this painting, Ade Rossman pictures the young Zora looking away from her father and her stepmother and their Eatonville world, thinking beyond the immediate world she had known. Courtesy of Ade Rossman.

cemetery known as the Garden of Heavenly Rest. Alice Walker, in homage to the author who had so inspired her own writing, commissioned a headstone to be made for an unmarked grave in the part of the cemetery where Hurston was said to have been buried.

Fort Pierce hosts the annual Zora Fest, where the famed author is celebrated, which inspired Rossman's own interest in Hurston. A variety of activities honor the memory of one of the city's best-known residents. A luncheon known as "Hattitudes" references her predilection for wearing fanciful hats, and birthday parties are held in her honor. Readings, enactments, and scholarly presentations celebrate not only Hurston's life and works but also celebrate being African. It was during Zora Fest that Rossman discovered Valerie Boyd's biography of Hurston, *Wrapped in Rainbows*.

Reading the book inspired Rossman, who began to recognize elements of his own life as he read about Hurston's life. In response to reading Boyd's book, he created a painting. When his reggae band was asked to play for part of the

2007 Zora Fest celebration at the Pelican Yacht Club, Rossman's wife suggested that he use the painting as a prop for the performance. Valerie Boyd happened to see it and asked who had painted it, and ultimately purchased the painting.

Boyd also introduced Rossman to the committee in charge of Zora Fest, and they commissioned him to design the poster for the 2008 event. The committee had imagined a single poster—an image of Hurston surrounded by several smaller circles, each vignette illustrating an aspect of her life. Upon looking more closely at Boyd's book, Rossman argued that a series of eight paintings would be required to represent the various stages of Hurston's life appropriately, and that is what he did. His compositions were influenced by artists such as Tom Feelings, an artist and illustrator, and John Byrne, an artist for comics. The styles in which they work seem appropriate to tell a story. Each painting is effective for telling a different portion of the story of Zora's life—her image at the center of a colorful and narrative background in which smaller images are stitched together. While Byrne no doubt made an impact on his style, Feelings likely inspired him for other reasons. Best known for his book *The Middle Passage: White Ships/Black Cargo*, Feelings addressed the African American experience. His innovative 1958 comic strip *Tommy Traveler in the World*

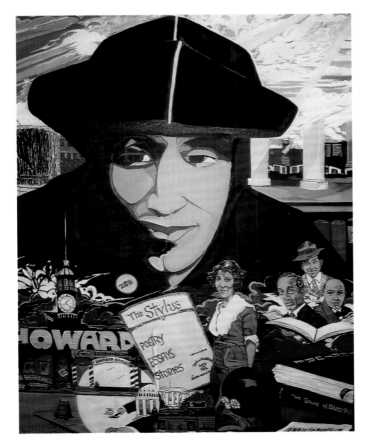

Figure 15.3. *Emergence of the New Dawn (Prelude to the Harlem Renaissance).* Here the painter imagines the writer's life in Washington at Howard University. Three powerful figures that influenced her at the time are depicted: W. E. B. Du Bois, Langston Hughes, and Alain Locke. Courtesy of Ade Rossman.

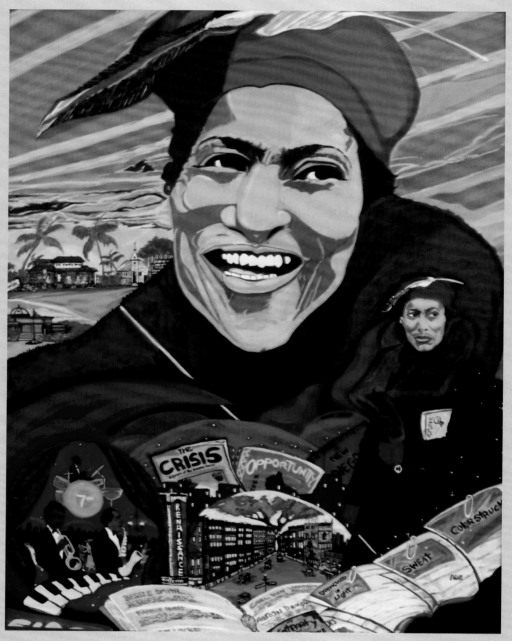

Figure 15.4. *Renaissance Woman (The Lady of the Renaissance)*. The artist tries to capture the excitement of Zora's arrival in Harlem. He includes a vignette of Eatonville behind her, suggesting that the town is now in the past. Instead it is Barnard College and Harlem that are of interest. Books that set the tone in depicting the modern Negro—*Fire*, *Crisis*, *The New Negro*, and *Opportunity*—are arrayed below her portrait, and her own book *Spunk* is clutched in her arm. Two representations of Zora, one broadly laughing and the other serious, refer to her statement, "I love myself when I'm laughing and then again when I'm looking mean and serious." Courtesy of Ade Rossman.

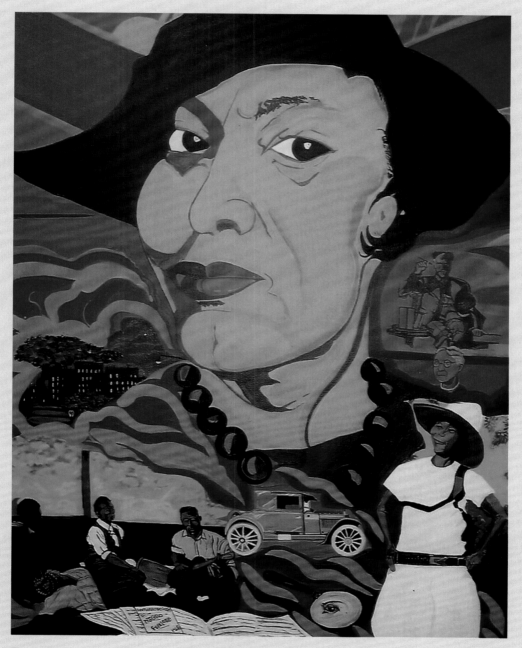

Figure 15.5. *The Lady, Her Pen and Her Magnificent Shawl.* In this painting Rossman wants to capture what he sees as Zora's flair. The imagery alludes to her first Deep South fieldwork on Negro folklore, which had been endorsed by Franz Boas. The smaller image of Zora shows her carrying a gun near the automobile she used in her research in Florida. Courtesy of Ade Rossman.

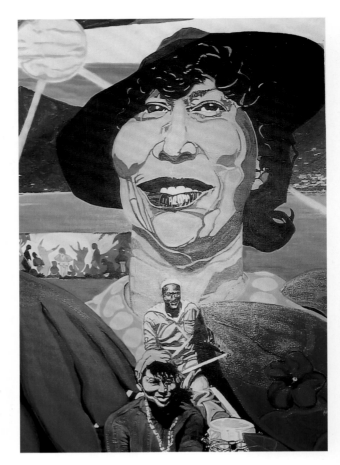

Figure 15.6. *Jump at De Sun*. Here the artist shows the anthropologist on her second folklore expedition, this time in Jamaica and Haiti. Rossman pays homage to Aaron Douglas, a Harlem Renaissance artist and friend of Zora. Showing Zora drumming in the center, the artist alludes to her time as confidante to the maroon chief. At the same time he intends it to represent drumming sessions and ceremonies in Haiti, where Zora was initiated as a Voodoo (Hoodoo) priestess. In another vignette, Zora returns with her drum, her *ilekes* (ceremonial beads), and inspiration for her book *Their Eyes Were Watching God*. Courtesy of Ade Rossman.

of Black History was released in book form in 1991. It is a young black boy's imaginary adventures as he discovers extraordinary black heroes and heroines in American history. Thus, Feelings's illustrated narratives were inspirational to Rossman as the artist thought through the stories about Zora that he garnered from Boyd's book. The original paintings from which the posters were designed are currently on display at the Zora Neale Hurston Branch Library in Fort Pierce.

Through the chronological representation of Hurston's life, Rossman realized that Hurston both lived Africa and observed Africa wherever she worked or lived. He depicts her teen life in Eatonville (fig. 15.2), her sojourn to Howard University, and her studies at Howard and Barnard College in New York (fig. 15.3). Another painting illustrates her association with the artists of the Harlem Renaissance who exposed her to contemporary ways of thinking about Africa (fig. 15.4). In this respect, Rossman suggests that individuals such as W. E. B. Du Bois, Alain Locke, and Langston Hughes "preached Africa" but that Hurston approached Africa in another way. Rather than looking afar for Africa, Hurston, under the tutelage of anthropologist Franz Boaz, returned to

Figure 15.7. *One Room with a View (The One Room Studio)*. Rossman intended in this painting to capture the peace and contemplation Zora experienced in the one-room studio she rented in 1951 to begin her career as writer and storyteller. Although she has left anthropology behind, the artist wants to suggest that the discipline has enriched her mind and provided her with the ability to observe. It was in the small room that she wrote *Of Mules and Men*. The bookshelf holds a copy of *Their Eyes Were Watching God* placed among others that inspired her. Courtesy of Ade Rossman.

Figure 15.8. *The Eve of the Prophetess (Older Zora)*. Rossman here tries to capture Zora in the later stages of her life when she lived in Fort Pierce, Florida. To the left is Lincoln Park Academy, where she served as a substitute teacher. To the right is the tiny house at 1734 School Court, where she lived simply and inconspicuously. Here she worked obsessively on *The Life of King Herod* and worked part time for the *Fort Pierce Chronicle*, writing articles such as "Hoodoo and Black Magic," based on her Caribbean research. Courtesy of Ade Rossman.

Florida and ventured into the Caribbean, where she witnessed Africa on this side of the Atlantic (fig. 15.5). She recognized African traditions and patterns in Eatonville, Florida, the all-black community where she had grown up. She recognized it as she carried out research in Haiti and the Bahamas, and she recognized it in the lives of those who worked the turpentine stills of north Florida.

By developing the series of paintings from which the posters for Zora Fest would be made, Rossman became more aware of his own path in relation to his ancestors. In his mind the idea of "the Africa that is far away" is not as important as "the Africa that is near," that which is lived by individuals like his grandmother, who had demonstrated her Africanness in Trinidad by, as Rossman expresses it, "just doing under the sun." Today, he says, "there is a reaching for Africa, for ancestry," suggesting that many are searching for roots, for connections with the motherland. His discovery of Zora Neale Hurston, Boyd's *Wrapped in Rainbows,* and further research on Hurston's life inspired him to realize that Africa is being lived in many of the places he has lived

himself—in Trinidad, in Brooklyn, in Fort Pierce, and elsewhere in Florida and the United States and in the Caribbean. From Rossman's perspective, the lived experience of just "doing what you do under the sun" is more important than a simple self-conscious awareness of Africa. Throughout Rossman's series, the artist juxtaposes vignettes and snippets from Hurston's life in which she experienced "Africa." As the theme of this volume suggests, there are many ways of experiencing Africa. Portraits of individuals—W. E. B. Du Bois, Alain Locke, and Langston Hughes—reference the academic Africa or the literary Africa championed by the Harlem Renaissance (fig. 15.3). But representations of unnamed individuals of Florida (fig. 15.5) and the Caribbean (fig. 15.6) also embody the Africa that they inherited merely by "living under the sun," suggesting that just living it is somehow different from learning it in an academic way. Scenes of Eatonville, Howard University, Harlem, Haiti, the Bahamas, and the forests of Florida where turpentine tappers worked—all give voice to Africa as lived experience and its being lived. "Africa" is a continent, but it also

Figure 15.9. *Daughters of the Talking Drum (Final Scene)*. The last painting in the series shows Zora in ceremonial garb drumming in a ceremony. The artist alludes to the times she spent in Haiti, Jamaica, and the Deep South and refers to the past, present, and future. The drum is the one she brought from Haiti. Rossman includes vignettes of her dancing with children, interviewing Cudjo, a former slave from whom she learned. Cudjo's grandchildren seated with him refer to continuity of the African past, becoming both the present and the future. In the distance, Zora performs the crow dance suggesting a phoenix-like rebirth. In the foreground is a book revealing portraits of writers Maya Angelou, Toni Morrison, Alice Walker, and Valerie Boyd, each inspired by the writer. Courtesy of Ade Rossman.

exists in the lives of people who bear witness to their ancestors who brought parts of Africa across the Atlantic to Florida within their very being.

Notes

1. I first met Ade Rossman while I was consulting with the St. Lucie County Cultural Affairs Office when he and his young daughter showed me the series of paintings he had done in preparation for the posters for Zora Fest. I later arranged to spend a day in Fort Pierce with Rossman to discuss the series of paintings and the ways in which the work and the story of Zora Neale Hurston has made an impact on his own life. All quotations in this essay are from our discussion on that day, July 9, 2010.

2. Fort Pierce and St. Lucie County have made an effort to make their connections with Hurston recognized through a number of ways. The St. Lucie County Library System, the City of Fort Pierce, the St. Lucie County School District, the St. Lucie County Board of County Commissioners, the St. Lucie County Historical Commission, the St. Lucie County Cultural Affairs Department, and the St. Lucie Historical Society have created the Zora Neale Hurston Dust Tracks Heritage Trail in honor of the writer. Colorful kiosks and trail markers provide information and include maps of Hurston's travels through Florida, especially Fort Pierce.

3. The other city boasting ties to Hurston, Eatonville, one of the first all-Black towns incorporated in the United States, is where Hurston spent her earliest years. It eventually became the setting for her best-known work, *Their Eyes Were Watching God*. Every January, Eatonville sponsors its own Hurston celebration, the Zora Neale Hurston Festival.

4. The house where Hurston lived has been proclaimed a National Historic Landmark.

Connecting across the Caribbean

16 Abakuá Communities in Florida

Members of the Cuban Brotherhood in Exile

Ivor L. Miller

The Abakuá mutual-aid society of Cuba, re-created in the 1830s from several local variants of the Ékpè leopard society of West Africa's Cross River basin, is a richly detailed example of African cultural transmission to the Americas. Since the late nineteenth century, many Abakuá members have lived in Florida as part of the larger Cuban exile community. While focusing on the Florida experience, this essay discusses Abakuá historically, since there exist structural relationships between its lodges, as well as spiritual connections among its membership that extend from West Africa to the Western Hemisphere.

Abakuá leaders who migrated from Cuba have regrouped in exile and maintained their identity as Abakuá, but due to their strict protocol they did not sponsor lodges outside of Cuba. Therefore the Abakuá communities in Florida gather for commemorative celebrations but do not perform initiations, which are performed only in their home lodges in Cuba. Due to renewed communication with African counterparts through a series of meetings in the United States, Europe, and Africa since 2001, Abakuá activities—including rumbas and commemorative social gatherings—have intensified in the first decade of the twenty-first century. Meanwhile, vibrant expressions of Abakuá practice have been produced by Cuban artists in Florida through representational paintings that depict Abakuá as integral to a Cuban national identity.

Ékpè Migrations, Abakuá Foundations

The Abakuá mutual-aid society established by Africans in Regla, Havana, in the 1830s was derived principally from the male "leopard societies" of the Cross River region of southeastern Nigeria and southwestern Cameroon. Calabar, the main port city of this region, is the homeland of three distinct communities, known as Àbàkpà (Qua-Éjághám), Èfût, and Èfìk, who call their society

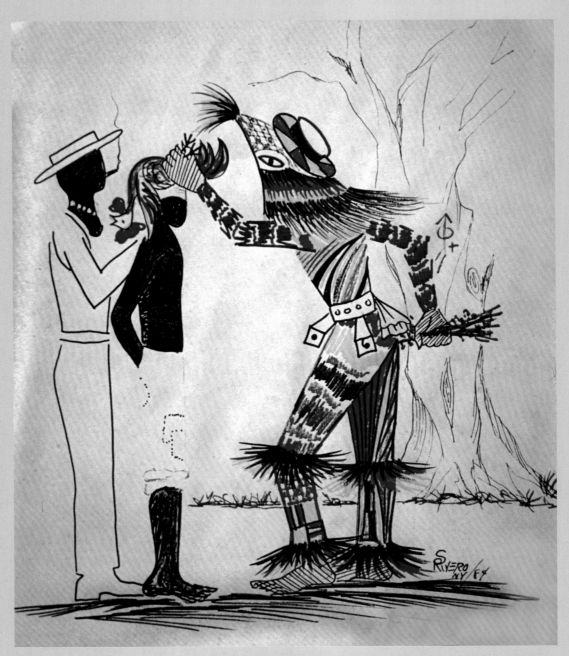

Figure 16.1. *Untitled*. By S. Rivero, New York, 1984. Paper and pen, 8.5 × 11 inches. This drawing of an Abakuá initiation in Cuba depicts an Íreme body-mask, rooster in one hand and herbs in the other, "cleansing" the neophyte while his sponsor stands behind. The tree is marked with a sign that authorizes the action. Abakuá in Florida remember Cuban initiations but do not perform them. Archives of Luis Fernández-Pelón, Miami. Photo by Ivor Miller, 1994. Used with permission.

Ékpè and Ngbè (or Mgbè), after the Èfìk and Éjághám terms for "leopard."[1] Although Cross River peoples migrated to many parts of the Western Hemisphere during the transatlantic slave trade, it was only in Cuba that they succeeded in re-creating Ékpè, as far as is currently known.

Ékpè was established in Cuba because among the thousands of Cross River people there were included knowledgeable specialists instrumental in organizing their people through the transmission of traditional knowledge. Another important element was the conducive tropical environment with mangrove estuaries similar to that of Calabar. In Calabar, Chief Bassey Efiong Bassey explains,

> If you want to plant an Ékpè in some place, there must be an Obong Ékpè [a titleholder] with authority, who is versed in the procedure. In colonial Cuba, it was possible, because some of the people who went were Obong Ékpès who were forcibly taken away. When they got there they knew exactly what to do to plant it. There is the belief that if you don't have the authority, if you don't know the procedure inside out, it will lead to death, or you will lose your senses. So people don't want to do it.

The Cuban leaders have maintained their Ékpè (i.e., Abakuá) in their homeland, but they have never authorized any member to establish a lodge outside of Cuba. The same is true for contemporary Nigerian Ékpè leaders, who to date have not authorized any lodge to be created outside of Africa.

In West Africa, as in Cuba, the societies are organized through local lodges each with a hierarchy of grades having distinct functions. Because of the obvious historic and conceptual links between Ékpè and Abakuá, I refer to both as variants of an Ékpè-Abakuá continuum that exists in the contemporary regions of Nigeria, Cameroon, and Cuba, all places where lodges are organized, although some of their members live outside these regions, including the United States.

As a diaspora practice, Abakuá maintains many facets of the Ékpè practice of West Africa from two centuries ago. Abakuá leaders transmit inherited historical information by performing it as "ritual-theater" during ceremonies. All of the roughly 150 lodges in Cuba have traditions of coded language and ritual performance that refer back to West African origins. Cuban Abakuá leaders look to the Calabar region with reverence as a historical source and a holy place. For example, Abakuá have created many maps that indicate specific places and events in the foundation of their institution in Africa (see fig. 1.5). Abakuá phrases also refer to African foundations: "Echitube akambamba, Èfìk Obuton?" asks, "How was the first lodge created in Africa?"[2] The Èfìk Obuton lodge of Cuba was named after Òbútòng, an Èfìk community in Calabar with a strong Ékpè tradition. This phrase evokes African founding principles in the

present. Even with this orthodox sentiment, Abakuá leaders acknowledge adaptive innovations in Cuba throughout their history.

Abakuá intiations are performed exclusively in Cuba. Those members who live in Florida therefore look to Cuba as a source; their activities celebrate foundational moments in Abakuá history, specifically the anniversaries of their particular lodges. This is because in Florida there are no lodges nor initiations. Throughout the Ékpè-Abakuá continuum exists a generalized protocol that new lodges may be established only with the sponsorship of a "mother" lodge, while initiations may only be conducted by specific titleholders working in concert. This protocol has led to the containment of lodges within the specific geographical regions of Nigeria, Cameroon, and Cuba. Nigerian members living in the United States have wanted to establish lodges there, but leaders in West Africa have not yet sanctioned it.[3] Cuban members in Florida also have tried to establish lodges there, but leaders in Cuba have not sanctioned it. In an exceptional case, in the late 1990s several lodge leaders from Cameroon who migrated to the United States began the process of creating a lodge in the Washington, D.C., area in order to pass their authority on to their children also living in the United States. Because this project is ongoing, it will be dealt with in a future publication.[4] The general reluctance to authorize lodges outside of Africa and Cuba is meant to protect the institution by preventing new lodges from acting autonomously outside the jurisdiction of the mother lodges. Though this strict protocol remains, modern communications (letters, telephones, websites, e-mail, and air travel) are being used to bring Ékpè and Abakuá members into greater awareness of each other. This new development is reflected in recent cultural expressions of Abakuá in Florida by Abakuá leaders, as well as by their allies working in the arts.

Abakuá Jurisprudence and Exile to Florida

Abakuá members reached Florida from Cuba after their ancestors had initially migrated from West Africa, where Ékpè was a "traditional police" under the authority of the council of chiefs of an autonomous community. Their decrees were announced publicly and their verdicts executed by specific Ékpè grades with representative body-masks (i.e., a uniform that covers the entire body to mask the identity of the bearer). In colonial Cuba, Abakuá leadership maintained the prestige of Ékpè through the autonomy of each lodge and the rigorous selection of its members. Because the primary allegiance of an Abakuá member was to his lodge and its lineage, Abakuá held jurisdiction over its members, a position that conflicted with agendas of the Spanish government. As a result, Abakuá has been demonized by various colonial and state administrations through much of its history.[5] But other narratives maintained by Abakuá leaders represent Abakuá as being "tan Cubano como moros y cristianos"

Figure 16.2. Ritual activity in a Havana Abakuá temple. Untitled. Acrylic paint on wood. At the center of the lodge altar is a Sese Eribó drum with four plumes issuing from the top. *Left to right:* a short man with white animal horn around his shoulder, rooster in one hand and herbs in the other, represents the title of Nasakó, the medicine man; the Íreme body-mask holds a short staff and a broom for "cleansing" the temple space; a man kneels with a ceramic jar on his head during the process of his receiving a title; an Abakuá leader representing the title Enríkamo holds a drum with plume to guide the Íreme's actions. Archives of Luis Fernández-Pelón, Miami. Photo by Ivor Miller, 1994.

(as Cuban as black beans and rice). These Abakuá narratives are persistent because they coincide with the widespread Cuban ideology that "A Cuban is more than mulatto, black, or white," as famously articulated by José Martí, "the apostle of Cuban Independence," in the late nineteenth century.[6] The deep ties existing between Cuban creoles that transcended race and class were sustained in many cases through membership in Abakuá, whose members by the 1860s included eligible males of any heritage, making them the first Cuban institution whose leadership reflected the ethnic diversity of the island, long before the creation of the Cuban Republic (see fig. 16.2).[7] At the onset of the Cuban Wars of Independence (1868), those suspected by colonial authorities of being rebels were sent into exile in Spanish Africa (Chafarinas Islands, Ceuta, Fernando Po [today Bioko], and other sites); among them were Abakuá. To evade possible deportation, many Abakuá members fled to Florida as part

of a larger Cuban community, creating social networks and cultural imprints that exist to the present.

Confronting Misconceptions

Misconceptions and misinformation of African-derived institutions—the rule during the slave trade and colonial period—persist into the present, and Abakuá is no exception. Being a self-organized African-derived institution un-authorized by colonial authorities, Abakuá was misconceived as a criminal organization. Later reports about Abakuá creating lodges in Florida were simply erroneous. Both errors were documented in twentieth-century literature to the extent that they became accepted as fact.

To outsiders, all African-derived traditions were "black culture," without awareness of distinctions between communities. Abakuá were commonly referred to as *ñáñigos* (*nyanyigos*), a term likely derived from the *nyanya* raffia chest piece worn on many Ékpè and Abakuá body-masks. Distinct African-derived practices were lumped together as *ñáñigo* by outsiders, but colonial authorities also associated *ñáñigos* with crime. Abakuá members have therefore since the early twentieth century rejected this term, using instead "Abakuá," a term likely derived from the Àbàkpà (Qua-Éjághám) people of Calabar. The general confusion about *ñáñigo* persists in the literature about Abakuá in Florida.

From the 1860s to the present, exiled Abakuá members have regrouped in foreign lands. Because of this, some scholars have argued that new Abakuá lodges were re-created in the Cuban diaspora, including Florida. There is little evidence for this. The collective and hierarchical nature of Ékpè in the Cross River region, a structure firmly reproduced in Cuban Abakuá, prohibited the informal foundation of new lodges.[8] Certainly, exiled Abakuá gathered to share their music, dance, and chanting, but initiations seem not to have been performed, nor were lodges created. Abanékues (initiates) who gathered in exile would not have the authority to form a lodge, nor could they perform ceremonies, since there would have been no sponsoring lodge or group of title-holders to direct the rites.[9]

Abakuá lore recounts how African ancestors designed a collective that could act only in concert. This practice underscores the profundity of the transfer of Ékpè to Cuba, since this could only have been achieved through the collective action of authorized titleholders and their supporters. Even today, Abakuá is the only African-derived institution in Cuba to maintain both a collective identity and a decision-making process affecting the entire membership.

The collective procedure required for the creation of the first Abakuá group is repeated throughout the Cuban literature.[10] This includes the payment of

fees, the consecration by a sponsoring lodge, and the presence of other lodges acting as witnesses; these are basic to the transmission of Abakuá authority.

Abakuá members have been present in Florida since the late nineteenth century, yet to date there is little evidence of Abakuá ceremonies for establishing a chapter being performed there. The earliest known reference to Abakuá in the United States was written by Raimundo Cabrera, who described the arrival of his passenger ship from Havana to Key West in 1892: "Just as the boat came close to the shore, one saw the multitude that filled the wharf and heard the special whistles that came from it, to which were answered others of the same modulation from the passengers who occupied the prow. I realized the meaning of these whistles! They are tobacco rollers from Havana who recognized and greeted one another. This greeting of *ñáñigo* origin was imported to the *yankee* city."[11] Abakuá greetings normally consist of coded handshakes and phrases, but on special occasions whistles were used. For example, a dignitary of the Havana lodge Biabanga was said to have "substituted his oral chant for the notes of the *pito* (reed flute) . . . in the *beromo* or procession."[12]

Migration

In 1886, with the foundation of the cigar-making company town of Ybor City outside Tampa, many Havana cigar workers migrated there, making it the largest Cuban settlement in the United States. Many male tobacco rollers, but certainly not all, were Abakuá members, as described by Gerardo Pazos "El Chino Mokóngo," a third-generation Abakuá of Spanish descent. From Havana, he told me about his family members who escaped persecution by migrating to Key West and Tampa in the late nineteenth century:[13]

> My grandfather Juan Pazos (1864–1951) was born in the barrio of Jesús María, the son of a Spaniard. He was obonékue [initiate] of the lodge Itá Baróko Efó [meaning "the first ceremony of Efó"].
>
> Many Cuban tobacco rollers went to Tampa, Florida, and stayed there, including my grandfather's brother, who was a member of the lodge Ekori Efó. They left during the persecution of the Abakuá by the Spaniards, and later by the Cuban government. Many left in schooners to Florida, because those captured were sent to Fernando Pó, Ceuta and Chafarinas. I knew several elder men of color sent there who told me their stories. They were very tough prisons and many Abakuá who were deported there died.
>
> My grandfather's brother lived in Tampa, and he never told me that they "planted" [initiated] in Florida. No Abakuá elder ever told me that they "planted" there.

While there are written histories of Cuban tobacco rollers in Florida, there is no history of Abakuá in Florida, precisely because there has been no Abakuá ritual activity in Florida. Likewise, many narratives of Abakuá in Spanish West African penal colonies where Cubans were imprisoned have been lost because they were not tied to the foundation of new lodges; when the colonial wars were over, the populations dispersed, often returning to Cuba. Cubans have come to Florida since the late nineteenth century to the present due to political, economic, and personal reasons. The recollections of Cuban Abakuá regarding Florida remain vivid because of that region's proximity to Cuba and the continual communications between family members.

Confusion in the Published Literature

Abakuá leaders report that even though Abakuá leaders lived in Florida, they could not conduct ceremonies, because there were no lodges there with the knowledgeable personnel and ritual objects. Nevertheless, a series of scholarly essays have claimed that Abakuá lodges existed in Florida.

For example, in 2001 Cuban scholar Enrique Sosa argued for the "certainty of the existence of *ñáñigos*" in Key West in the late nineteenth century among exiled tobacco workers.[14] Sosa uncritically cited an earlier scholar who wrote: "Imported from Cuba, Ñañigo appeared in Key West as a religious, fraternal and mutual-aid sect among blacks in the period 1880–90. The last Ñañigo street dance occurred on the island in 1923."[15] For her evidence, this scholar cited Stetson Kennedy's 1940 WPA report:

> A Nanigo [*sic*] group was organized in Key West, and enjoyed its greatest popularity between 1880 and 1890. They gave street dances from time to time, and dance-parties on New Year's. . . . In 1923 the last Nanigo street dance to be held in Key West was performed "for fun" by Cuban young people, attired in make-shift costumes.
>
> Leader of the Nanigos in Key West was a man named Ganda, a small "tough" Cuban mulatto. . . . Ganda conceived the idea of making elaborate Nanigo costumes, head-dresses, *bongós* (drums), and other equipment, teaching young Cubans in Key West the Nanigo dances, and then joining his company with a carnival of some sort. . . . He finished the costumes and other equipment, but died in 1922.[16]

While Kennedy did not give evidence for the foundation of Abakuá lodges there—he merely described costumes and recreational dances—later authors cited his work as evidence. In Havana, Gerardo Pazos "El Chino Mokóngo" explained that Kennedy's description was not that of an Abakuá rite: "It is not possible even that they left in *berómo* [procession], without *planting* [a ceremony]. It is possible that *comparsas* [carnival troupes] paraded around with

representations of Abakuá with similar costumes and rhythms, but this is not Abakuá ceremony."[17] To perform an Abakuá procession requires the authorization of lodge leaders as well as access to their ritual objects. Any expression of Abakuá in Florida would only be in remembrance of Cuban ceremonials, in themselves a remembrance of Cross River Ékpè events.

Kennedy reported to me that he spoke little Spanish at the time of research and had no proof of the society existing in Key West.[18] Instead, he gathered recollections among exiled Cubans about the society as it existed in Cuba.[19] Nevertheless, Kennedy's work inspired later scholars as well as an official Florida guidebook that appears to be based upon his work:

> From Cuba . . . the Latin-Americans of Ybor City and Tampa have imported their own customs and traditions which survive mostly in annual festivals. The Cubans found good political use for voodoo beliefs brought by slaves from Africa to the West Indies and there called *Carabali Apapa Abacua* [*voodoo* being used generically for "African spirituality"]. Prior to the Spanish-American War [Cuban Wars of Independence], Cuban nationalists joined the cult in order to hold secret revolutionary meetings, and it then received the Spanish name, *Nanigo* [an Èfìk-derived term]. In 1882, *Los Criminales de Cuba*, published in Havana by Trujillo Monaga, described Cuban Nanigo societies as fraternal orders engaged in petty politics. Initiation ceremonies were elaborate, with street dances of voodoo origin. Under the concealment of the dances, political enemies were slain [a confused reference to carnival]; in time the dance came to signify impending murder, and the societies were outlawed by the Cuban Government [could be either a reference to Abakuá, outlawed in 1875; to King's Day processions, outlawed in 1884; or to carnival processions, outlawed in 1912]. When the cigar workers migrated from Cuba to Key West and later to Tampa, societies of "notorious Nanigoes," as they were branded by Latin opposition papers, were organized in these two cities. The Nanigo in Key West eventually became a social society that staged a Christmas street dance. . . . the last of the street dances was held in 1923.[20]

Nanigo, like *voodoo*, is simply a buzzword for unassimilated black people. The claim of "societies of 'notorious *Nanigoes*'" was partially inspired by depictions of carnival dance with body-masks by Key West artist Mario Sánchez (b. 1908 in Key West) (fig. 16.3). Such depictions were misconstrued as evidence for Abakuá ritual activity, when in fact they merely represented popular dances like rumba and carnival groups. (Sánchez's work will be discussed in a later section.)

Historian Louis A. Pérez Jr.—coauthor of *Tampa Cigar Workers* and author of several histories of Cubans in the United States—reported to me: "I have

Figure 16.3. *Manungo's Backyard Rhumba, Key West, 1919*, by Mario Sánchez (b. 1908, Key West). This image depicts a Cuban-style Cuban rumba, which includes three Abakuá masquerades. Used with permission of Nance Frank, Gallery on Greene.

not come across any Abakuá references in Tampa during the late nineteenth- and early twentieth-centuries."[21] Anthropologist Susan Greenbaum wrote *More Than Black: Afro-Cubans in Tampa*, a study involving the mutual-aid and Cuban independence group the Club Martí-Maceo in Tampa. She wrote to me that during her fifteen years of research, "Nanigos were the subject of hushed and infrequent references. There could have been an active Abakuá under-ground here, but I never heard of it."[22]

Nevertheless, Cuban scholar Sosa argued for the existence of Abakuá lodges in Florida by referring to an essay by José Martí (1893) titled "Una orden secreta de africanos" (A secret order of Africans) that described exile Tomás Surí in Key West. Sosa argued that Martí referred here to the Abakuá (without mentioning them by name).[23] Martí wrote that Surí belonged to "a tremendous secret order of Africans . . . a mysterious, dangerous, terrible se-cret order," but described an order of Africans where members rejected use of a drum, wanting instead to create a school.[24] This could not have been an Abakuá lodge, however, because without the consecrated drums there can be no lodge.[25] Martí may have referred to a group akin to Masons whose members included Abakuá, but his message is ambiguous.

In turn, Sosa's erroneous essay was cited uncritically by Ishemo, who wrote: "José Martí appreciated the patriotism and the financial contribution to the war effort made by the Abakuá cigar workers in Key West, Florida. He relates his visit to a *ñáñigo famba* (a sacred room in the temple) and described it as 'a room which is decorated with the flag of the revolution.'"[26]

None of the sources cited confirm this statement. The "secret society of Africans" as described by Martí required that the holder of the "third grade" be able to read. This cannot be Abakuá; grades are not numbered, and there is no such requirement.

Most recently, a scholar wrote that "*Potencias* [Abakuá lodges] were also established in the United States in the nineteenth century by Afro-Cuban migrant workers in Florida."[27] An attempt to verify the source of the citation proved that it too was a misquote.[28]

Evoking Abakuá in Miami

Among the significant cultural achievements related to Abakuá in Miami were the publications of Lydia Cabrera (1900–1991), who did extensive research in Havana and Matanzas from the 1930s to the 1950s. Her publications are the most relevant for the history of Abakuá, as well as other African-derived institutions such as Lukumí and Palo Monte. Cabrera left Cuba in the 1960s to settle in Miami, where she published a series of volumes documenting oral narratives of the African-derived traditions of Cuba, including monumental studies of Abakuá drawn esoteric signs (1975) and language (1988), each about five hundred pages, without which the study of Abakuá would be nearly impossible.

In 1994, in Miami, I met Luis Fernández-Pelón "El Pelón," a titled Abakuá member who was recommended by my teachers in Havana (fig. 16.4). Regarding Abakuá activities in Miami, he told me: "Here in Miami there are ceiba [kapok] and palm trees, but since the most important thing—the *fundamento*—[an object with ritual authority] is in Cuba, no Abakuá group can be consecrated here. I have met with all the Abakuá who live here and we have had celebrations with my *biankomó* [drum ensemble], but no consecrations."[29] Unlike the sacred objects of other Cuban religions of African descent, those of Abakuá are thought not to have left the island.

Nevertheless, in 1998 the "birth" of the first Abakuá group in the United States was announced in Miami.[30] It was named Efí Kebúton Ekuente Mesoro, a reference to Efík Obúton, the first lodge established in Cuba in the 1830s, itself named after Òbútòng, a community in Calabar. The event took place on January 6, considered the anniversary of Abakuá's foundation in Cuba.

The would-be Miami founders sent a letter to Abakuá leaders in Havana, announcing their existence.[31] The Abakuá leaders I spoke with in Havana

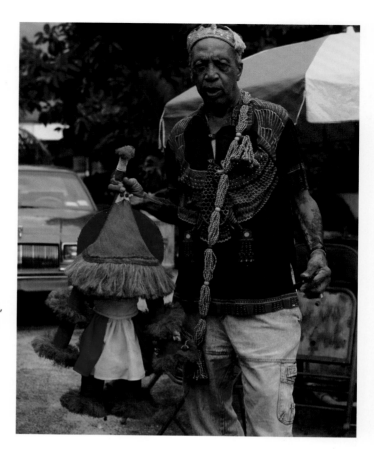

Figure 16.4. Luis Fernández-Pelón, Miami, 1994. Fernández was both a babaláwo (Ifá diviner) and an Abakuá titleholder. He wears a *collar de maso* (large necklace) for Ifá while holding an Abakuá Íreme doll. The doll has a skirt with colors of the Cuban flag. Photo by Ivor Miller.

unanimously considered it a profanation: the "birthing" of an Abakuá group without a sponsor is not valid. Additionally, they observed that many of these same Miami leaders had been previously suspended from their Cuban groups for disobedience, and hence had no authority to act.

Gerardo Pazos "El Chino Mokóngo," who was also a babaláwo (Yorùbá Ifá diviner), told me:

> It is not possible that a lodge was created in Miami, because no Cuban there has the authority or knowledge to perform the required transmissions. Whoever would create a lodge in Miami would have to come to Cuba and carry a *fundamento* [sacred object] from there. It is not the same with the Yorùbá religion [which does travel]. We cannot predict the future, but until now there is no Abakuá in Miami or anywhere in the USA who has sufficient knowledge to create a new *tierra* [lodge]. In this moment, September 27, 2001, there is no Abakuá in the USA who knows enough of the [ritual] language required to make the transmissions. Because I, Gerardo Pazos, Mokóngo of Kamaroró, do not know anyone with enough knowledge to create a lodge.

According to Cuban lore, Abakuá lodges were established in Havana and Matanzas by knowledgeable Cross River Ékpè leaders who had the authority to do so. Since Ékpè leaders could not return to Africa, they moved forward and created. But Abakuá members living outside of Cuba can return to consult with their elders to seek possible authorization to establish new lodges. "El Chino Mokóngo" continued:

> Those Abakuá who have migrated to the USA do not have the knowledge to create a Potency [lodge] there, because this process requires many men with knowledge and because these ceremonies are very profound. In addition, when a Potency is created, one must pay the *derecho* [fee] of one rooster to all the existing Potencies in order to be recognized by them. If a *juego* [lodge] is born in Havana, it must pay this fee to the other *juegos* in Havana. If it is born in Matanzas, then to the others in Matanzas. The *juego* they tried to create in Miami had no godfather [sponsor], and furthermore, it did not have the knowledgeable men to found it. It cannot exist.

"El Chino Mokóngo's" statement reflects not only his personal views but the protocol followed by all Abakuá leaders on the island.

Ifá in Cuban Miami

To appreciate the containment of Abakuá lodges to particular port cities of western Cuba—in spite of the global travels of its members as well as the desire of some to establish lodges abroad—it is instructive to note a parallel movement in the Yorùbá-centered Cuban practice of Ifá, noting that its reestablishment is a simpler process. Like Abakuá, Ifá is thought to have been established in Cuba in the first half of the nineteenth century.[32] Before the 1959 Revolution, the estimated two hundred babaláwos in Cuba all knew each other.[33] By the 1990s, leading Cuban babaláwos gave me estimates of ten thousand to describe their numbers, and neophytes were arriving from throughout the Americas, Europe, and elsewhere to receive Ifá consecrations and travel home with them.

In 1978, highly specialized Ifá ceremonies performed in Miami were geared to reproduce there the foundation of Ifá in Cuba some 150 years earlier.[34] The ceremonies were led by Nigerian babaláwo Ifayẹmi Elébùìbọn *Awise* (chief Ifá priest) of Oṣogbo, who traveled to Miami for the occasion.[35] Two of the participating Cuban babaláwo were also Abakuá leaders, Luis Fernández-Pelón, who was initiated as a babaláwo in Nigeria, and José-Miguel Gómez, both of whom are cited in this study.[36] This Ifá reestablishment ceremony was led by one babaláwo, while Abakuá consecrations involve scores of initiated men acting

in concert, in addition to the required tributes paid to the existing lodges in Cuba.

José-Miguel Gomez was an Abakuá leader who ran for the political office of councilman in Sweetwater, Florida, in 1991. Gómez was the Mokóngo of his lodge Ebión Efó from 1926 to 2003, Mokóngo being one of the four leaders of an Abakuá lodge. Gómez lived to be the eldest holder of this title in his generation.[37] He was also a babaláwo, as well as a leader of Cuban-Kongo practice: Padre Enkiza Plaza Lirio Mama Chola, Templo #12, Santo Cristo del Buen Viaje.[38] Gómez left several unpublished essays about Abakuá history in Cuba and Africa. He thus exemplified Abakuá activity in Florida: he did not create a lodge or lead ceremonies, even though he was a master; instead, he studied the Cuban past and African mythology while passing it on to fellow initiates.

Abakuá Activity in Miami, Twenty-First Century

Abakuá activities in Miami in the first decade of the twenty-first century have been ignited by recent face-to-face encounters between Abakuá members and their Nigerian and Cameroonian counterparts in the United States. These encounters began in 2001 when an Abakuá performance troupe participated in the Èfìk National Association of USA meeting in Brooklyn, New York. In 2003, two Abakuá leaders traveled to Michigan to meet the Obong (Paramount Ruler) of Calabar during another Èfìk National Association meeting. In 2004, two Abakuá musicians traveled to Calabar, Nigeria, to participate in the annual International Ékpè Festival. In 2007, an Ékpè troupe from Calabar and an Abakuá troupe performed together onstage in Paris for five concerts celebrating their common traditions. Then in 2009, those Abakuá living in the United States who went to Paris produced a CD recording that fused music and ritual phrases from both groups. Called *Ecobio Enyenison*, "Our Brothers from Africa," it also included the participation of a Cuban artist named José Orbein, whose painting appears on the jacket (fig. 16.5), and an Abakuá singer named Ángel Guerrero, both based in Miami. All of this activity has energized Abakuá communities in Miami, where Guerrero has also acted as an entrepreneur by sharing information about African Ékpè with his ritual brothers and organizing them in cultural events that have been advertised on the internet and recorded in video programs.

The first cultural event in Miami was billed as an "Abakuá fiesta" (party or feast) to ensure that it was not misinterpreted as an initiation ritual (fig. 16.6). It was held on February 8, 2009, in a private home with a large patio to accommodate the drumming, dancing, and food preparations where hundreds gathered. A second party was held on August 2, 2009, to celebrate Guerrero's birthday. After these general events for the entire community, members of particular Cuban lodges living in Miami began to celebrate the anniversary

Figure 16.5. *Ecobio Enyenison* CD cover. Painting by José Orbein for the U.S.-produced Cuban Abakuá recording by the Enyenison Enkama Project, 2009. The cover illustration depicts the African continent as sacred space with seven title-holders in profile as archetypes. Below the second "o" of Ecobio is Nasakó, the medicine man and prophet who wears a sea sponge like a hat as part of his paraphernalia.

of their lodge's foundation. On February 24, 2010, the members of the lodge Ítiá Mukandá Efó gathered with friends to celebrate the anniversary of their founding in 1947 in Havana.[39]

On January 2 and 3, 2010, in Miami, members of two Havana lodges from the same lineage, Efori Enkomon (founded 1840) and Ékue Munyanga Efó (founded 1871), celebrated a feast to adore the La Virgin de la Caridad (the Virgin of Charity), the patron saint of the Munyánga lodge and also of the Cuban nation (fig. 16.7). This saint is popularly understood as a dimension of Ochún, the Lukumí/Yorùbá goddess of fertility, who for Abakuá also represents Sikán, their Sacred Mother.[40] This date was chosen for being a weekend near January 6, known as "Abakuá day," the anniversary of the colonial-era Three King's Day processions wherein African "nation-groups" would perform their traditional dances and greet the governor general in Havana. This day was chosen

Figure 16.6. "Primer encuentro artistico de Abakuá en La Florida." The poster advertises "The first artistic gathering of Abakuá in Florida." Poster by José Orbein, Miami, 2009.

to found the Abakuá society in Cuba because they were able to use the mass celebration as a cover for their own activities. On September 14 and 15, 2010, members of the Havana lodge Amiabon (founded in 1867) gathered, apparently for their own anniversary (fig. 16.7). The most recent feast was "Abakuá day" on January 8, 2011, in Miami at a private home (fig. 16.8).

These activities have been meaningful to Abakuá on either side of the "Rum Curtain." Ángel Guerrero (2011) reported that Abakuá had little opportunity to communicate across the Gulf Stream from the 1960s to the 1980s: "Because of the rupture in communications between those who left and those who stayed, many members willing to send money to help their lodges in Cuba were impeded. Also, many Abakuá lodges performed ceremonies without knowing

Left: Figure 16.7. "Íreme Eribangando; Abakuá Day." Poster by José Orbein, Miami, January 2–3, 2010. The Íreme body-mask represented in the poster performs to "open the way" for the others in processions. The image suggests that all are welcome to follow in the procession.

Below: Figure 16.8. "Abakuá Day." Poster by José Orbein, Miami, January 8, 2011. At the upper left is a portrait of Andrés Petit, revered by most Abakuá for making it an integrated institution that reflected the makeup of Cuban society.

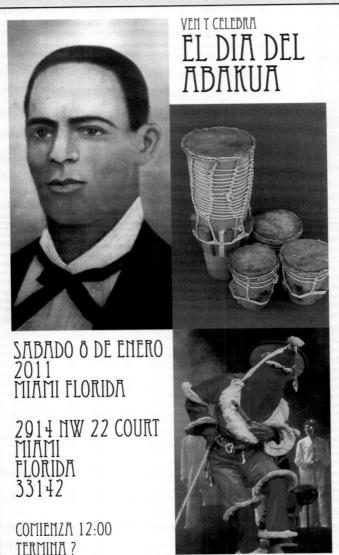

that some of their brothers in exile had passed away." In Cuba, as in West Africa, when a lodge member dies, all lodge activities are suspended until the proper rites are enacted. In the United States since the first decade of the twenty-first century, Guerrero reports:

> Now with mobile phones, faxes and internet we receive news instantly. Experience has taught me that the links between Abakuá members obliges one to see the condition of exile in a specific way. Our solidarity makes us think about how we can help our brothers so that they have a more dignified life, because in essence this is part of the oath we made upon initiation in the society Ekoria Enyene Abakuá [full name of the Abakuá]. Through all the gatherings so far here in Miami our greatest achievement has been to gather and unite all those brothers who had been divorced from their lodges in Cuba, so that now they are actively supporting their lodges. Thanks to Abasí [Supreme Being] this achievement has already benefited many lodges in Havana and Matanzas. Today we are stronger than ever, because "In Unity, Strength!"

Abakuá gatherings in Miami were inspired by the recent communication with African Ékpè members; contact with Africans confirmed that their inherited lore really did come from African masters. In other words, instead of simply assimilating into the values and systems of North America and forgetting their past, many Abakuá have opted to accept responsibility for their oaths of solidarity, thus renewing ties with their Cuban lodge members. Instead of an abstract or nostalgic relationship to African Ékpè and Cuban lodges, Abakuá in Miami are emerging as actors in an international movement within the Ékpè–Abakuá continuum of exchanging ideas, and of reassessing the values of their inherited traditions for the identity of their communities.

Depictions of Abakuá by Artists in Florida

From the late nineteenth century to the present in Cuba, there has existed an artistic tradition of using Abakuá themes in music, theater, and painting as a symbol of the Cuban nation itself. This tradition has continued among Cuban artists living in Florida today.

Mario Sánchez (1908–2005) is an early example of an artist working in Key West who documented carnivalesque popular dances in the early twentieth century. Because he depicted various styles of body-mask performance, including Abakuá Íreme and Puerto Rican Vejigantes, some scholars interpreted this as evidence for Abakuá rites occurring in Key West.[41] Sánchez was more likely exploring issues of identity and cultural performance, as did other artists mentioned in this essay. Artists have been creating images of Íreme for numerous purposes, none of which provide evidence for Abakuá ritual activity in

Florida. Instead they are examples of artists honoring their Cuban traditions, their memories of Cuban identity, and so on. The next three artists (discussed below) are not Abakuá members, yet as males from the western part of the island where Abakuá is practiced, they understand its important role in Cuban history and identity and incorporate Abakuá motifs in their work. Some have gone further to study the literature, especially that of Lydia Cabrera.

In addition to promoting Abakuá events artistically, José Orbein (b. 1951) has painted many series depicting esoteric aspects of Abakuá tradition. Living in Miami, Orbein was born and raised in the Cayo Hueso neighborhood of Havana, a barrio named in homage to the exiled Cubans living in Key West who supported the independence movement against Spain in the nineteenth century.[42] Orbein wrote: "Now living in Miami, I'm using influences of the Abakuá in my canvases. I'm a strong believer of the society who was raised admiring and respecting all the Efori Enkomon ekobios [brothers] of my neighborhood Cayo Hueso in La Habana, that includes some of my family and close friends. My ancestors came from the Calabar region in Africa; I know this because my grandmother used to keep a log of the lineage of my family dating back to enslavement."[43]

The ties of Calabar and Abakuá to Orbein's family and community have generally inspired his creative process, but his collaborations in Miami with Abakuá singer Ángel Guerrero have led to a series of Abakuá themes with specific imagery and titles based upon deep knowledge. For example, Orbein's *Obonekue Arabensuao* (fig. 16.9), painted in Miami in 2008, depicts an Obonekue neophyte undergoing initiation with the *arabensuao* mystic circle drawn on the head.[44]

Another work, *Enkiko Nasakó Murina* (2009), refers to the presence of the rooster during the initiation process (*ekiko* is "rooster" in the Èfìk language of Calabar). In southwest Cameroon, Nasakó is remembered as a prophet from the region of Ùsàghàdè where Ékpè was legendarily founded centuries ago.[45] The painting depicts five neophytes blindfolded during initiation, with a rooster, next to a sacred *ceiba* (kapok) tree with three dimensional thorns. The painting *Iyamba Quiñongo* (2010) represents the Iyamba (a lodge leader) and his signs of ritual authority. This work demonstrates that Orbein is also informed by the publications of Lydia Cabrera, in this case *Anaforuana* (1975), about the ritual signatures of the society. Whereas Iyamba is the title for a lodge leader in the Calabar region, *Kinyongo* is derived from the Èfìk phrase *ke enyong*, meaning "in the sky," which could be interpreted as "Iyamba has powers from the sky" or "Iyamba is the highest."

Orbein was also a promoter of the Abakuá feasts organized by Guerrero in Miami from 2009 to the present, through creating poster advertisements. His poster for the 2009 event presents the Abakuá phrase "Akamanyére crucoro umbarain tete ayeripondo," meaning "welcome all as a great family," while

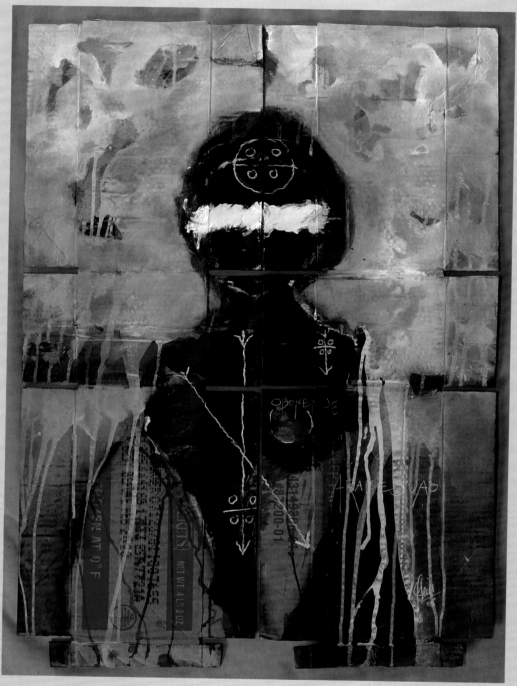

Figure 16.9. *Obonekue Arabensuao*. By José Orbein, Miami, 2008. 20 × 32 inches. Acrylic and charcoal over cardboard. The painting depicts a neophyte during an Abakuá initiation with a handkerchief across the eyes and esoteric signs drawn on the body. The arrows pointing downward indicate initiation. Used with permission.

announcing "the First artistic gathering of Abakuá in Florida" (fig. 16.6). The map identifying the location of the feast is a sign that these activities promote education about Abakuá practice as a community-wide event, instead of being a "secret, hidden" one that in the past may have aroused suspicion among non-members. The process of communicating with West African counterparts is fueling desire for a wider public understanding, so that the ongoing public performances already mentioned will be popularized as relevant to all in the transatlantic African diaspora, as well as the Cuban diaspora. The 2010 poster displays the "Íreme Eribangandó," a body-mask used to lead processions during initiation ceremonies, implying that "Abakuá is moving forward" (fig. 16.7). The use of the colors and star of the Cuban flag are another statement that Abakuá is "as Cuban as black beans and rice." Participants have reported that in Cuba, the use of a Cuban flag on an Íreme could lead to conflicts with the authorities, a reminder that Abakuá jurisprudence has acted independently from the colonial Spanish and Cuban state since its foundation. The 2011 poster celebrates the legacy of nineteenth-century Abakuá leader Andrés Petit through his portrait (fig. 16.8). In the 1850s–60s Petit lead the successful process of initiating the first white Abakuá members, thus ensuring that Abakuá would be open to all eligible males of any heritage.[46]

Painter Elio Beltrán (b. 1929) was born and raised in Regla, a small industrial town on the Bay of Havana where Abakuá was founded in the 1830s. Still a vital center for African-derived community traditions, Regla is home to scores of active Abakuá lodges. From his home in Florida, Beltrán wrote: "I grew up registering dream-like images in my mind during my childhood years. Images that many years later would emerge as oil paintings to help me to ease my pain of separation from the very dear surroundings and people that I loved in Cuba." A series of paintings reflect the impact of an Abakuá Íreme (body-mask) performance on the young artist. *Asustados Intrusos,* or "Scared Intruders" (1981), depicts "three scared kids hiding and secretly watching an Abakuá initiation in the early 1940's behind the tall grass at the edge of a cliff in the night.[47] I believe it was the Otán Efó brotherhood of the Abakuá on the outskirts of my hometown Regla.[48] I was one of the three boys overlooking the scene of the celebration on the site at the entrance to what was known then as *El callejón del Sapo*." A second painting, *Ceremonia Secreta* (1987), depicts the same event from 180 degrees (fig. 16.10). These paintings are remarkable for depicting how a hermetic club became famous among non-initiates who were awed by the communal rites.

A third painting, *Memories del Carnaval* (2010, not illustrated here), reconstructs the night scene of a Carnival celebration in an Old Havana neighborhood circa 1938–40. It shows how elements of African-derived traditions (an Abakuá mask, a batá drum, a conga drummer with the *camisa rumbera* [fluffy

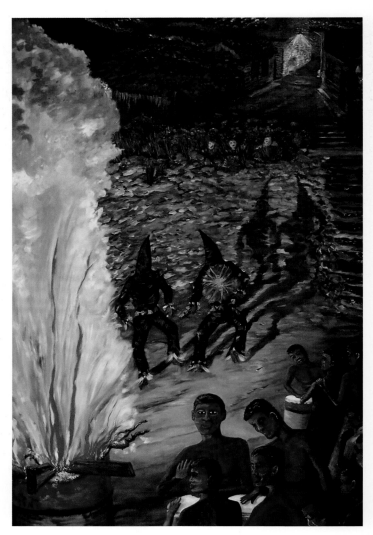

Figure 16.10. *Ceremonia Secreta* (Secret Ceremony). By Elio Beltrán, 1978. Oil on canvas, 48 × 36 inches. The painting illustrates the childhood memories of the painter who witnessed Abakuá rites in the town of Regla, near Havana. While Abakuá members play drums and Íremes dance at the bottom, three children observe through the grass above. Used with permission.

sleeves] of early rumba players) were fused in the citywide celebrations. In all of these works, one senses the profound impact of an Abakuá mask performance on the young viewer, as well as the identification of Abakuá as part of the national culture.

Beltrán's corpus recalls the reaction of Spanish poet García Lorca to an Abakuá performance during his visit to Cuba in 1929–30. About it, Lydia Cabrera wrote, "I do not forget the terror that the *íreme* instilled in Federico García Lorca, nor the delirious poetic description he made for me the day after witnessing a *plante* [ceremony]. If a Diaghilev had been born on this island, surely he would have made the diablitos [*íreme*] of the *ñáñigos* parade through the theaters of Europe."[49] While Beltrán has worked primarily from his memories and in isolation, other painters have consulted with Abakuá members during their creative process.

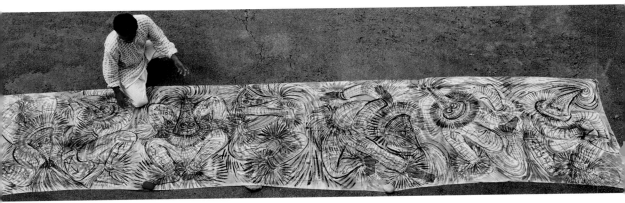

Figure 16.11. *Abacuá Saree I*. By Leandro Soto, 2007. Indian ink on silk *saree*. 21 × 4 feet. A long silk *saree* is used as a canvas to depict Abakuá masquerades in motion. A detail of the work is in figure 3.3.

A multidisciplinary visual/installation and performance artist, Leandro Soto (b. 1956) was a leading figure in Cuban art in the 1980s and among the first artists in his generation to explore Afro-Cuban themes. Based in Miami since the 1990s, Soto began to work with Abakuá imagery in the first decade of the twenty-first century after learning about the Kachina body-masks of Hopi people of the American Southwest. He created a series of video-installation-performance pieces with Abakuá imagery that presented the artist as an Abakuá mask—here a symbol of Cuba itself—who encounters a kindred tradition in North America.[50] Soto's Abakuá series generally celebrates motion through Abakuá body-masks and coded symbolism imagery (fig. 16.11; see detail in fig. 3.3). During this process, Soto conversed extensively with Ángel Guerrero, studied Lydia Cabrera's publications, and also reproduced nineteenth-century Abakuá signatures for Miller's book on Abakuá history, *The Voice of the Leopard* (2009).

Conclusions

It is remarkable that the Abakuá cultural movement has been able to expand from ritual secrecy in Havana and Matanzas onto the global stage of performance in the process of communicating meaningfully with African practitioners of Ékpè—the source tradition from which it was separated some two hundred years ago. As with other cases of oral transmission across long time and space intervals, such as the Vedic and Homeric poems, the Abakuá example combines intensive artistic discipline with a ritualized guild framework. As the present moment of history is witnessing the reconnection of the two ends of this vast diasporal arc, the impact of this encounter on the local communities of practitioners is fascinating to observe. At the same time, the public nature of the new encounter is eliciting unprecedented openness to scholarly access,

which promises to enrich the description of each of the local traditions that were heretofore so closely guarded from outside view. This chapter documents the participation of Abakuá members in Florida in this process, as well as their allies in the arts who honor and celebrate Abakuá as part of an overall Cuban national identity. Eventually, the global Ékpè-Abakuá network may develop its own organic scholarship from within, such has happened already to an extent with the Yorùbá-Lukumí tradition.

Author's Note

Thanks to Amanda B. Carlson and Robin Poynor for their support of this project as well as their fine editing. Thanks also to Norman Aberley (curator of the Key West Art and Historical Society), Nath Mayo Adediran (director of National Museums, Nigeria), Peter Appio, "Chief" (engineer) Bassey Efiong Bassey, Elio Beltrán, George Brandon, Orlando Caballero, Osvaldo Caballero, Jill Cutler, Senator Bassey Ewa-Henshaw, Luis Fernández-Pelón, Liza Gadsby, Susan Greenbaum, Ángel Guerrero, Stetson Kennedy, Chester King, Victor Manfredi, José Orbein, Louis A. Pérez, Gerardo Pazos, Leandro Soto, Robert Farris Thompson, and Brian Willson. Thanks to the J. William Fulbright Foreign Scholarship Board for a Fulbright Scholars Grant to Nigeria (2009–11) and to Professor James Epoke—the vice chancellor of the University of Calabar. Thanks to the National Museum of African Art (NMAfA), Smithsonian Institution, in Washington, D.C., for a Senior Fellowship (2011–12).

Notes

1. The leopard society has many names depending on the local language, including Nyàmkpè (in Cameroon), Bònkó (in Equatorial Guinea), Òkònkò (in Ìgbo), and Abakuá (in Cuba). Most West African communities also recognize the term Ékpè, since the Èfik influence in the region was widespread in the nineteenth century.

2. Roche y Monteagudo, *La policía y sus misterios en Cuba*, 27. All translations from Spanish to English are by the author.

3. Since the first Ékpè-Abakuá meeting in Brooklyn, New York, in 2001, I have discussed this issue with many Ékpè titleholders from the Calabar and Cameroon region now living in the United States.

4. The group who call themselves "Ékpè USA" is led by "Sisiku" E. Ojong Orok, "Sesekou" Joseph Mbu, "Sesekou" Solomon Egbe, and "Sisiku" Mbe Tazi, among others. Because of their authority as Ékpè leaders in their villages in Cameroon, they have been able to establish at least one lodge, cautiously following the protocols of this institution.

5. An 1882 publication on "The Criminals of Cuba" began a chapter on the "Nyányigos" by stating: "The police have worked hard to eradicate the nyányigos" (Trujillo, *Los criminales de Cuba*, 360). A 1901 publication on Spanish penal colonies stated: "Finally, the nyányigo was conceived of as a dangerous being, shown clearly by the mass deportations during the last period of our dominion, that accumulated a large number of nyányigos in Ceuta, in Cádiz, and in the Castle of Figueras" (Salillas, "Los ñáñigos en Ceuta," 339).

In 1925 a study of the history of Regla, the birthplace of Abakuá in Cuba, had a chapter called "Criminality and Nyanyagismo in Regla" (Duque, *Historia de Regla*, 125–27). A 1930 publication in Cuba asked rhetorically if Abakuá was related to "abominable crimes": "In Cuba, are witchcraft and nyánigism religious practices or black magic? . . . Is it true that they shelter organizations dedicated to the most abominable crimes?" (Martín, *Ecué, changó y yemayá*, 7). This contextualization of Abakuá continues into the present. In 2011 in Havana a monograph was published with the title "The Abakuá Society and the Stigma of Criminality" (Pérez-Martínez y Torres-Zayas).

6. Martí, "Mi Raza"; Martí, *Our America*, 313.

7. The Havana lodge Bakokó Efó, mentioned above, was specifically responsible for organizing the entry of European descendants into the Abakuá society (cf. I. Miller, *Voice of the Leopard*).

8. For details see I. Miller, *Voice of the Leopard*, 137–39.

9. In Calabar and nineteenth-century Cuba, *Àbànékpè* was an Ékpè term for first-level initiate. Cuban Abakuá use the variant terms *abanékue* and *obonékue*.

10. An 1881 source refers to the payment of fees to create Cuba's first lodge, a process consistent with Cross River and later Cuban practice. Rodríguez, *Reseña histórica de los ñáñigos de Cuba,* 5–6.

11. R. Cabrera, *Cartas a Govín*, 3–4. R. Cabrera was the father of the eminent Cuban folklorist Lydia Cabrera.

12. F. Ortiz, *Los instrumentos de la música afrocubana*, 5:301. Ortiz wrote that the reed "gave some notes in antiphonic form so that the multitude would respond in chorus with his chants." Ibid., 309.

13. Kennedy reported: "Nanigo came to Florida for various reasons. There were naturally some Nanigos among the Cubans who immigrated first to Key West and later to Tampa, seeking employment in the cigar factories and other industries. Others were revolutionary patriots seeking refuge from the tyranny of Spain." "Ñáñigos in Florida," 154–55.

14. "Lo que extraemos de su lectura [de Kennedy y Wells] nos lleva a la certeza de la existencia de ñáñigos [en Key West]." Sosa, "Ñáñigos en Key West, 165.

15. Wells, *Forgotten Legacy*, 48.

16. Kennedy, "Ñáñigos in Florida," 155.

17. Interviews with Gerardo "El Chino" Pazos, in Havana.

18. Telephone conversation with Stetson Kennedy, April 2002. Kennedy referred to his lack of fluency in Spanish. Describing research among a Cuban family in Tampa, he wrote: "When the cooking is over and the meal placed on the table, there is a sudden burst of very rapid and excited Spanish which I am unable to understand" ("All He's Living For," 21). In a letter to the author, Kennedy (2002) wrote: "I do not know much about *naniguismo* beyond what I have read in Dr. Fernando Ortiz's *Los Negros Brujos* . . . and my own article." In his next letter, Kennedy (2002) wrote: "I do not now recall the contents of my *nanigo* article, or whether it even implied that there might have been nanigo organizations in Florida. I suspect that it would be difficult to prove either that there had been, or had not been."

19. "Recent folklore recording expeditions conducted by the Florida Work Projects Administration of the Library of Congress located a number of people in Key West and Tampa, besides those already mentioned, who undoubtedly have an initiate's knowledge of *Nanigo*, obtained both in Cuba and locally. . . . But because of their extreme poverty, they refuse absolutely to perform without some pecuniary remuneration—which unfortunately was unavailable to the WPA expeditions" (Kennedy, "Ñáñigos in Florida," 155). If Abakuá groups did exist in Florida, they would have performed ceremonies, aspects of them public, to which WPA researchers could have gone. Lacking such groups, there was only "fragmentary mention" of a masked dancer and a bongó. I did locate testimonies of

Cubans and Spaniards who had lived in Cuba, Key West, and Tampa, conducted in Ybor City and Tampa in the late 1930s. The Federal Writers' Project Papers housed in the University of North Carolina Library at Chapel Hill contain descriptions of cigar workers born in Havana and living in Florida; none of them refer to the Abakuá.

20. *Florida: A Guide*, 133.

21. Historian Louis A. Pérez Jr., letter to the author, 2004.

22. E-mail to the author from Professor Greenbaum, 2003.

23. Sosa, "Ñáñigos en Key West," 166–67.

24. Martí, "Una orden secreta de africanos," 324; Muzio, *Andrés Quimbisa*, 71–72; Sosa, "Ñáñigos en Key West," 167; Ishemo, "From Africa to Cuba," 256. Jesús Cruz (personal communication, 2000), Ekuenyon of the Ordán Efi lodge in Matanzas told me that he had heard that Tomás Surí was Abakuá but that his lodge name was not known. After reading Sosa's essay, Cruz responded that nothing in this article proves that Abakuá conducted ceremonies in Florida, nor are such activities known about by Abakuá leadership in Cuba.

25. In spite of the errors in this essay, Sosa should be praised for his support of Abakuá culture in Cuba in the early 1980s in the form of his book (*Los Ñáñigos*), since it was an unpopular theme in the political sphere at the time.

26. Ishemo, "From Africa to Cuba," 268. Ishemo falsely cited Muzio (*Andrés Quimbisa*, 71) and Helg (*Our Rightful Share*, 87); there is no mention in either of Martí, a Fambá, or a flag. Ishemo also cited Sosa ("Ñáñigos en Key West," 167–68), who in turn cites Martí ("Una orden secreta de africanos"), but Martí made no mention of Abakuá. Martí wrote of a secret society of Cuban "Africans," who had given up the drum in order to learn to read—a non sequitur—and whose reunions took place in a "bannered hall . . . the hall whose parties were adorned with the banner of the revolution" ("*sala embanderada* . . . la sala que adorna sus fiestas con la bandera de la revolución") ("Una orden secreta de africanos," 324). Sosa imagined that Martí wrote of an Abakuá group in Key West. Ishemo's piece is riddled with the uncritical repetition of errors, and poor translations.

27. Ayorinde, "Ékpè in Cuba," 141.

28. Ayorinde quoted Brandon ("The Dead Sell Memories," 108). Brandon (2011 personal communication) confirmed that he made no such claim and that this was a misquote.

29. Luis "el Pelón" died in 1997 in Miami; his body was carried to Havana to receive Abakuá ceremonies and burial. Ceiba (Kapok, or White Silk Cotton Trees) are "venerated and revered in forests zones of Nigeria. It is a fetish tree and sacrifices for the release of people captured and detained in the world of witches and wizards ready for the kill are performed at the base of this large tree" ("Nature Trail Tree List," 3).

30. Cf. I. Miller, "Obras de fundación: La Sociedad Abakuá."

31. I was shown a copy of this letter in the office of Mr. Ángel Freyre "Chibiri," president of the Abakuá Bureau (la Organización para la Unidad Abakuá), in Regla in 2000.

32. Cf. D. H. Brown, *Santería Enthroned*, 78; Ortiz reported the founding of Yorùbá-derived Batá drums in Havana in the 1830s (*Los instrumentos de la música afrocubana*, 315–16).

33. "There are said to be about two hundred true babaláwo in Havana, and most of them have been drawn to the large cities where they can earn more money." Bascom, "Two Forms of Afro-Cuban Divination," 171.

34. The ceremony performed was the creation in Miami of the first Olofies, a ritual vessel possessed only by high-ranking babaláwo. A 1978 Miami newspaper article reporting on the event stated that the first Olofies were made by Yorùbá babaláwos in Havana more than "200 years" before. Archives of Luis Fernández-Pelón.

35. Thanks to Mr. Nath Mayo Adediran (2005 personal communication), for the cor-

rect title and spelling. For a detailed report on this process see D. H. Brown, *Santería Enthroned,* 93–95.

36. From a Miami newspaper article published in 1978, in the archives of Luis Fernández-Pelón. There I saw and videotaped a photograph of Luis Fernández and two other Cubans in Oṣogbo, Nigeria, in 1978, taken during their initiation as babaláwos there. I also saw a photograph of Ifayẹmi Elébùìbọn dedicated "To my godson José-Miguel Gómez" (Caballero, 2005 personal communication).

37. David Brown reported that Gómez was initiated into the Lukumí Ocha system in 1929 (*Santería Enthroned,* 160). This is consistent with the early Cuban tradition that eligible males should be initiated into Abakuá and Palo Mayombe *before* entering the Lukumí tradition. One interpretation of this tradition is that the "Carabalí" (from Calabar) and Central African "Kongo" people arrived to Cuba and other American regions *before* the Yoruba/Lukumí.

38. David Brown reports that Gómez was "the first Cuban-born babaláwo to have made Ifá in the United States" (*Santería Enthroned,* 325 n. 92). The Cuban-Kongo lineage called Santo Cristo del Buen Viaje was organized by Andrés Petit in the mid-1800s (cf. Cabrera, *La Regla Kimbisa del Santo Cristo del Buen Viaje*).

39. In this era in Cuba, February 24 was a national holiday—thus a day free from work—to celebrate the "El grito de Baire" (the Cry of Baire), the commencement of the final war of independence in 1895 by the Cuban rebels against Spain. Being a carnival day in the 1890s, this date was chosen to start a rebellion under the cover of a mass celebration.

40. See chapter 17 in this volume on Lucumi crowns.

41. Sánchez created "Manungo's Diablito Dancers" in the 1930s to depict Sánchez's memories of the "*ñáñigo* street dance" in 1919. Some scholars thought that this was an *Abakua* performance, but in fact the body-masks were Puerto Rican Vejigantes, not Abakuá. The work represents a street jam session with a bongo player, a trumpet player, and two body-masquerades, in the context of carnival. I. Miller, *Voice of the Leopard.*

42. Louis Pérez (2006 personal communication); Orovio, *El carnaval babanero,* 85. The name Key West is an English gloss upon the earlier Spanish name, Cayo Hueso. The Cuban communities of Cayo Hueso in Florida actively countered the Spanish regime. Le Roy y Gálvez, *A cien años del 71,* 58; Foner, *Antonio Maceo,* 120; Montejo-Arrechea, *Sociedades negras en Cuba,* 104.

43. E-mail message from José Orbein to the author, September 2007.

44. Cabrera documented a version of this term: "Biorasa: círculo que se dibuja en la cabeza del neófito para ser iniciado." *La Lengua Sagrada de los Ñañigos,* 112.

45. The BoNasakó family, meaning "the family of Nasakó," presently lives in Ngamoki within the Ekama community of Ngolo-speaking people of the Rumpi Hills in Cameroon. Thanks to Mr. Nasakó Besingi of Mundemba, as well as Mr. Kebulu Felix of Limbe and their extended families, Cameroon, the author attended BoNasakó family reunions in Ngololand in February 2011 and March 2012.

46. For details see chapter 4 of I. Miller, *Voice of the Leopard,* 103–18.

47. Chapter 2 of Beltrán's autobiography *Back to Cuba* tells this story.

48. Otán Efó was founded around 1909 in Regla. Lydia Cabrera wrote: "Otán Efor . . . of Regla. Ancient Potency." *La Lengua Sagrada de los Ñañigos,* 465.

49. Cabrera, "La Ceiba y la sociedad secreta Abakuá," 35; Cabrera, *El Monte,* 217.

50. Cf. I. Miller, "Abakuá: The Signs of Power." Soto titled these performance pieces *Efi Visiting the Desert* (after the Èfìk people of Calabar who helped create Cuban Abakuá) and *KachÍreme,* a fusion of the Hopi Katchina and the Cuban Íreme body-mask. See the artist's gallery at http://www.leandrosoto.com/kachÍreme-efi-visiting-the-desert.html.

17

Crowning the Orisha

A Lucumi Art in South Florida

Joseph M. Murphy

In the spring of 2001, I purchased an intricate miniature crown from a bo-
tanica in Washington, D.C. (fig. 17.1). The ornament, draped with chains of
tiny brass tools and capped by a golden statuette of the Virgin of Charity, is
an example of a "tool crown" made to adorn the altars of the orishas and an
important part of their veneration in the United States. I learned it was made
in Greater Miami, the center of an ongoing revival in orisha-related arts and
religion. In November 2002 I met several crown makers in Miami and Hialeah
and came to better understand the place of their art in the renaissance of Af-
rican religious traditions in South Florida.[1]

I had seen tool crowns during my first experiences with orisha religions
in New York in the 1970s, yet the Miami crown that I acquired is structurally
more elaborate and symbolically suggestive than any I had noticed before. The
flashing brass pieces, and their repetition in groups of five, lets the devotee
know immediately that this is a crown for Oshun, a beautiful orisha associated
with wealth, elegance, and glistening water. Yet what drew me to the crown
was the finial, the gilded statuette of a Catholic saint, Nuestra Señora de la
Caridad del Cobre, the Patroness of Cuba.

In the juxtaposition of the elements of the crown a magic lies: the orisha,
the Virgin, the crown, and the tools work together to reflect the cultural his-
tory of their makers and to empower their community to thrive in the brave
new world of contemporary Florida. The crown is the site for the expression
of a plural spiritual heritage in the multicultural world of South Florida. To
understand its eloquence I will examine the community that produced it, its
ceremonial context, and its historical precedents.

Orisha Devotees in Miami

The tool crowns of South Florida arose out of the nineteenth-century encounter of enslaved Yoruba with the folk piety of the Spanish colonial empire. Many thousands of Yoruba were taken to Cuba to toil on sugar plantations and in the industries that supported the exportation of the island's "white gold." In the cities of Cuba they were able to build mutual-aid societies, *cabildos africanos*, where they could effectively refashion African patterns of leadership and worship.[2] The *cabildos* were organized as chapters of Roman Catholic parishes, often under the spiritual patronage of a saint. The public life of the *cabildo* involved Mass and procession on the patron saint's feast day.[3] It is here that that the well-known association between the Catholic saints and the Yoruba orishas developed in the spiritual life of the Lucumi, as Cuban Yoruba were called.

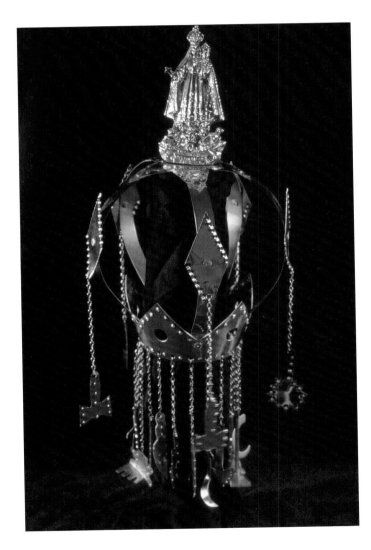

Figure 17.1. Oshun-Caridad crown, Juan Gonzalez, ca. 2001. Photo by David Hagen.

Lucumi *cabildos* crowned their own kings and queens and constructed a social hierarchy through ceremonies of enthronement. In 1851 the Swedish traveler Fredrika Bremer visited the Cabildo de Señora Santa Barbara de la nacion Lucumi Alagua in Havana. She described entering a building on a street where several *cabildos* were located: "The room was tolerably large, and might contain about one hundred persons. On the wall just opposite to us was painted a crown, and a throne with a canopy over it. There stood the seats of the king and the queen. The customary dancing was going on in front of this seat."[4] Bremer describes a drum ceremony where entranced participants received spirits recognizable as orishas venerated in Cuba and Miami today. According to some teachers of the tradition, the initiation procedures of Lucumi religion were patterned on the coronation of Yoruba kings, particularly those of the legendary Shango, lord of the palace at Oyo. "To make an *orisha* is to make a king," Cuban orisha priestess Calixta Morales told Lydia Cabrera in the 1950s. Yoruba kings were crowned with the symbolic presence of the ancestors, so Lucumi initiates are crowned with the presence of an orisha, "made" in the ceremonial work of ordination.[5] This conjunction of royalty, initiation, altar display, and ceremonial trance suggests a symbolic pattern that will inform our interpretation of the Lucumi tool crowns of the present.

The tradition of orisha veneration by enthronement was taken to Florida by exiles after the Cuban revolution of 1959. Some evidence indicates ties in the early twentieth century between a Cuban *cabildo* and an Afro-Cuban society in Tampa, but the lines of priestly succession recognized in Miami today derive from exiles of the later twentieth century.[6] The first orisha initiation in Miami was conducted around 1965 and, from humble beginnings, the tradition took root and flourished as has the exile Cuban community itself. The Miami-Dade County census of 2000 records some 650,000 people who identify themselves as Cuban, nearly 29 percent of all residents.[7] This prominence and success prompts many Floridian Cubans to say with pride that "all of Miami is now Little Havana."[8] Cuban traditions in many forms, including orisha religions, are interwoven with daily life in the region.

Three factors might be noted in understanding the growth of the tradition in South Florida: the infusion of Afro-Cuban expertise with the Mariel refugees of 1980; the resumption of visits to the island in 1986; and the successful court battle of the Church of Lukumi Babalu Aye in 1993.

Most of the exiles in the 1960s were white and affluent or middle class, while the leadership of the orisha traditions on the island was generally poorer and black.[9] Though several distinguished orisha priests and priestesses were among the first waves of exiles, the majority of Lucumi elders were left behind.[10] In 1980 the Cuban government permitted nearly 125,000 people to leave for South Florida from the port of Mariel. "Marielitos" were more

representative of the working class and even underclass of Cuban society and stirred racial and class prejudices among Cubans and non-Cubans alike in South Florida.[11] Yet the Mariel exiles were appreciated by the orisha community for bringing precious knowledge to reinvigorate Miami traditions. Among them were talented orisha priests and musicians such as Gerardo Durán, Peto Gónzalez, Gilberto Martinez, and Ezequiel Torres.

A second factor may lie in the easing of travel restrictions on Cubans living in Miami. Beginning in 1979 and then more effectively in 1986, Floridian devotees could legally visit Cuba to bring much-needed medicines and necessities to friends and relatives and return with orisha initiations unknown or unavailable in Miami. Some retrieved fundamental altar objects they had been forced to leave behind years before.[12] These exchanges have given rise to entrepreneurship in Cuba, where visitors may be provided with questionable information and initiations or directed to state-sponsored priests and priestesses of contested authority. Nevertheless, the opportunity, so long denied, to visit and learn from respected priests and priestesses in Cuba was a catalyst in the development of orisha traditions in Miami.

Finally, the protracted and ultimately victorious court battle of Hialeah's Church of Lukumi Babalu Aye (CLBA) gave the orisha community a public profile. Not all orisha priests and priestesses are supportive of this change in direction, but many have followed the CLBA's example in developing more centralized organization, the certification of clergy, and more public celebrations.[13] One result is a dramatic rise in ordinations to the orisha priesthood. In 1997 alone the CLBA ordained some five hundred priests and priestesses.[14] The affirmation of the legitimacy of the traditions by the Supreme Court and the positive publicity that attended the decision have brought new resources to the traditions and new attention to its material expression.

The confluence of prosperity in Florida, closer ties to Cuban wisdom, and American religious freedoms and sensibilities has brought about a renaissance in Lucumi arts. Speaking of the development of Lucumi religions in Miami, priest and crown maker Antonio Salas says, "So the religion, from this point on . . . it began to blossom, because it began to bloom as the flowers bloom . . . so then it was in affluence, affluence."

The successes of the South Florida Cuban community have supported an unprecedented development of material religious culture, allowing many artists to earn a livelihood by providing objects for orisha devotion. An exhibition, "At the Crossroads: Afro-Cuban Orisha Arts in Miami," curated by Nelson Mendoza, Miguel Ramos, Stephen Stuempfle, and Ezequiel Torres, profiled over twenty artists in such areas as altar making, beadwork, dress making, and metalwork.[15] While the models for nearly all the objects were derived from Cuban sources, the quality of materials and artistry are unique to the Florida

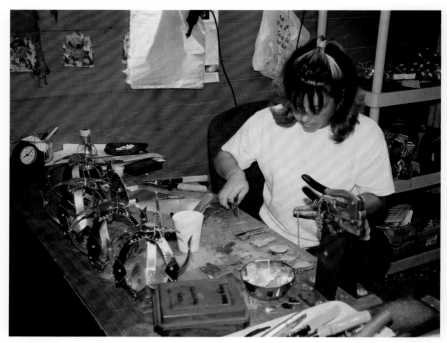

Figure 17.2. Milagros Gomez at workbench, Yemaya Products, Hialeah, Florida, 2002. Photo by Joseph M. Murphy.

community. It is here that the crown makers of the orisha traditions work and sell their creations to a growing clientele of increasingly affluent and culturally diverse devotees.

My Oshun-Caridad crown was made in a workshop in a large Hialeah botanica called Yemaya Products. Here orisha objects are fabricated for distribution to botanicas across the country. The business is presided over by the owner Alex Billamia and the crown making left to Juan Gonzalez and his assistants (fig. 17.2). When I was at the shop in November 2002, Milagros Gomez worked on several crowns for Oshun. Spread out on a large worktable were strips of cut brass snipped into bands, medallions, and miniature tools. Gomez, in her thirties, was made a priestess of the orisha at age sixteen. She took up crown making recently. She said that there is no special religious vocation to be a crown maker, but it is important to be knowledgeable about the religion in order to use the proper metals, include the appropriate tool emblems, and arrange them in their correct numbers. They are free, however, to improvise on the finial. She said that the Caridad del Cobre statuette is a popular choice, but not integral to designating Oshun. Botanica owner Billamia said it is a style "more or less Spanish" that appeals to many Cubans identifying her with Oshun.

If Yemaya Products caters to the wholesale botanica trade, Antonio Salas is the consummate artist among Miami crown makers (fig. 17.3). Salas makes

crowns only on commission and puts individual effort and creativity into each. Born in Cuba in 1930, initiated there as a priest of Shango in 1961, he left for the United States in 1963. He learned metalwork as a stove maker in Cuba and didn't turn to crown making until he came to Florida. First in his kitchen, then his garage, and now in a fully equipped workshop, Salas is the best-known metalworker among orisha practitioners in South Florida. He considers his own work the finest: "Now I am at an elevated state," he says. "There is competition, but I don't consider it as competition because within the competition there has never been anything that can come close to this. Similar, more or less, but no . . . I've done it better." He can boast of clients all over the United States, from Cuba, and even Africa.[16] Salas is a purist who says he does not innovate, but models his crowns on those given to him in a *libreta*, a notebook he received from his godfather. He shared a page of the *libreta* with me that detailed the list of miniature tools appropriate to the crown of the orisha Yemaya Achabá.

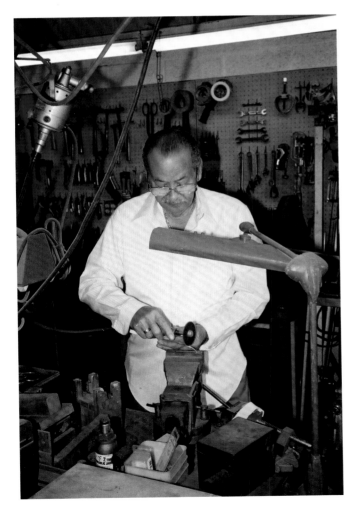

Figure 17.3. Antonio Salas in his workshop, Miami, 2002. Photo by Joseph M. Murphy.

These Cuban American artists produce objects central to the veneration of the orishas throughout the Americas and now in Yorubaland itself. Their importance for devotees lies less in their beauty and creativity and more in the ceremonial purposes they serve within the material culture of Lucumi religion.

The Ceremonial Context of the Lucumi Crown

The crowns are part of much larger altar displays that are constructed in the homes of orisha priests and priestesses. They are designed to rest on the top of lidded porcelain soup tureens, or *soperas*. Each *sopera* contains fundamental symbols of an individual orisha, most particularly stones that represent the living presence of the spirit. The *soperas* are likened to an outer vessel that contains a hidden mystery, as the human head might be seen as the container of an intangible soul.

The *soperas* are arranged in a variety of ways depending on the ceremonial occasion, the means of the devotee, and the divined wishes of the orishas themselves. They are ordinarily placed on the shelves of a cabinet, the doors

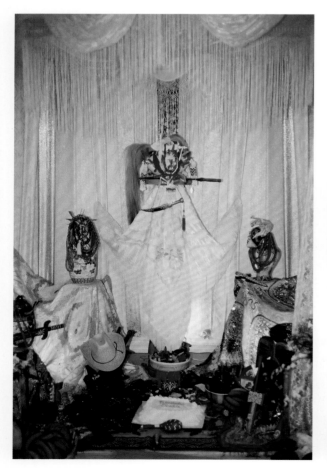

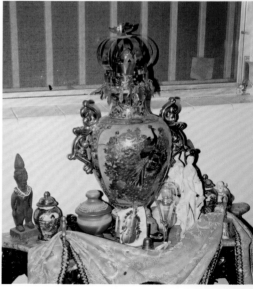

Left: Figure 17.4. *Trono* (throne) celebrating a devotee's anniversary of initiation, Miami, 2002. Photo by Joseph M. Murphy.

Below: Figure 17.5. Oshun crown on *sopera*, Miami, 2002. Photo by Joseph M. Murphy.

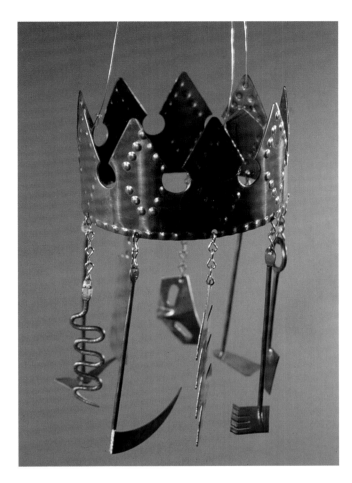

Figure 17.6. Small crown for Oya by Antonio Salas, 2002. Photo by David Hagen.

of which may be closed to forestall the curiosity of those ignorant of or even hostile to African divinities. But on certain occasions they may be displayed in the living room, set on pedestals covered in rich cloth. Some arrays take up an entire room hung with silks and brocades with ten or more *soperas* draped in luxury. These are the "thrones" (*tronos*) of the orishas, where they sit in state and accept the prostrations of devotees (fig. 17.4). It is on these occasions that the tool crowns are shown at their best, crowning the *sopera* heads of the orisha stones as they receive their community at their royal courts (fig. 17.5).

The decision to adorn the orisha altar with a crown, like so many other initiatives in Lucumi religion, is felt to rest with the will of the orisha and not the devotee. Two orishas, Oshun and Oya, are said to be "born with a crown"; that is, when these orishas are "made" or given birth to in the ceremonial work of the initiation, their fundamental stones automatically receive a crown. These "birth crowns" are usually smaller without arches and finial, and hung with only the basic number of tools appropriate to the orisha (fig. 17.6). It is only later that larger crowns are placed on the *soperas*, substituted for the smaller ones, superimposed upon them, or put on for the first time. The orisha's desire

for a larger crown is communicated to the devotee through divination or directly through mediums in trance.

The orishas speak through the patterns formed by the fall of sixteen consecrated cowrie shells in a complex oracle known as *dilogun* or "sixteen" for the basic set of variables in response. Through their patterns devotees learn details of their relationships with the orishas. These can include what are called the "roads" or specific forms of the orishas that have been "made" and, thus, the specific regalia appropriate to them. An orisha may request that in the future the devotee purchase a crown. It is usually in the resolution of a crisis in the devotee's life—an illness or other serious problem—that the promise to adorn the orisha will be kept.

An orisha may make its desire for a crown known at a drum ceremony when priests and priestesses receive the orishas in trance at the festival. Crown maker Milagros Gomez explains, "Either way, in the shells or at a party [drum ceremony] the orisha can come down and tell me 'Listen I want you to find me a really pretty crown; I want to help with certain things going on in your life and I want you to get me a crown,' Whatever the situation may be, you get him a crown."[17]

Antonio Salas says, "You buy a large crown because the orisha asks for it, not because you want it. People are in the religion out of necessity, not because they like it. It is 80 percent about illness; crowns are gifts to the religion. It is all about balance." While the orisha instigates the choice of crown for adornment, many considerations may apply. Milagros Gomez mentions the practicalities of gift exchange with the orishas:

> It depends on the size that you can afford and the size of what your *sopera* is. If my pocket can only afford a small one, the *orisha* has to understand that I can't afford a big one; so I get a small one. The plain-jane ones are the ones that the *santo* [orisha] is born with. Now if you want to go on your own and make a luxury one, after I do *ocha* [undergo ordination] I know what road she is—let's say Oshun with the drum [a road of Oshun, Ibú Aña]—I can just go order her one with a drum on top because that's her road. When you do *ocha* you really don't know the road of your orisha until the day of the reading [*itá*].[18]

All the devotees with whom I spoke assured me that the crowns are not fundamental symbols of the orishas as are the stones and other objects within the *soperas*. To be fundamental (*fundamento*) means to be, in a sense, alive—a physical presence of the orisha that requires interaction. The *soperas* contain the living recipients of the sacrifices, but the crowns only rest atop the real presence. Milagros Gomez: "If I was to feed Oshun, I'd take the crown off because the crown doesn't eat."

Yet the crowns have their own instrumentality. They are consecrated in herb-infused water called *omiero*. Their tools are indications that they can "work" for their devotees in very practical ways. They may cut a path for the devotee through a personal problem, carve a solution where none would ordinarily exist, or fight to protect the devotee.[19] And crowns become the site of exchanges in their own right as devotees often place money in the joints of the crown as offerings to the orisha.

The larger crowns thus indicate a mature relationship with the orishas, one where a *promesa* has been fulfilled, and so a more intimate relationship with the spirits. Metal crowns placed on the *soperas* reinforce the dignity and power of the orisha and its connection to lines of orisha bearers reaching back to Cuba and Africa.

Precedents of the Lucumi Crown

The constituent elements of crowns in different historical contexts make an interesting study as sites for cultural and political symbolism. One need only recall the double crown of ancient Egypt, which signaled political unification yet cultural difference between Upper and Lower kingdoms.[20] In Western Europe crowns are said to have arisen out of the Mediterranean practice of encircling the head of champions with laurel wreathes and with the elaboration of military helmets.[21] Distinctive finials might be seen in the crosses atop the helmets of Christian crusaders and crescents on those of Moors and Saracens. A crown from the tomb of Sancho IV, a thirteenth-century king of Castile, has a castle finial in reference to the kingdom's namesake.[22] The immediate stylistic prototypes for the Lucumi tool crowns of contemporary Miami are likely to derive from two sources, one European, the other African. The style of the main body of the Lucumi crown seems to be modeled on the miniature crowns made to adorn the statues of Catholic saints, especially the Virgin Mary. Hanging tools, on the other hand, appear to have as their prototype the distinctive veil of Yoruba royal crowns and the amulet chains of tools sacred to the orisha Ogun. As we will see, each has a part to play in the organization of the Lucumi crowns.

The crowning of images of saints has a long history in the Eastern churches and was a staple part of Roman Catholic worship in the sixteenth century. An official rite for crowning images of the Virgin Mary was promulgated in the nineteenth century that referenced the antiquity of the practice and the biblical justification for it, as Mary is seen to deserve "the crown of glory." The rite specifies that the crown "should be fashioned out of material of a kind that will symbolize the singular dignity of the Blessed Virgin."[23] Eighteenth- and nineteenth-century exemplars from the Spanish Americas testify to beautiful

craftsmanship in precious metals. Nearly all the representations of the Virgin in Cuban popular iconography show her crowned with variations of the distinctive arched crown now familiar to us from its Lucumi forms. The patron saint of Cuba, La Virgen de la Caridad del Cobre, wears such a crown in all her depictions (fig. 17.7).

It may be that Lucumi crown makers in colonial Cuba earned a living by making similar articles for Catholic churches and shrines. José Antonio Aponte, who was a leader of an early-nineteenth-century Havana *cabildo* dedicated to Santa Barbara and the orisha Shango, was an artisan with sculpture

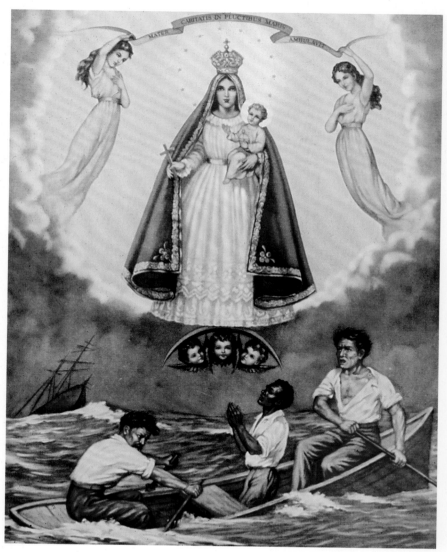

Figure 17.7. Popular chromolithograph of Nuestra Señora de la Caridad del Cobre, patron saint of Cuba.

Joseph M. Murphy

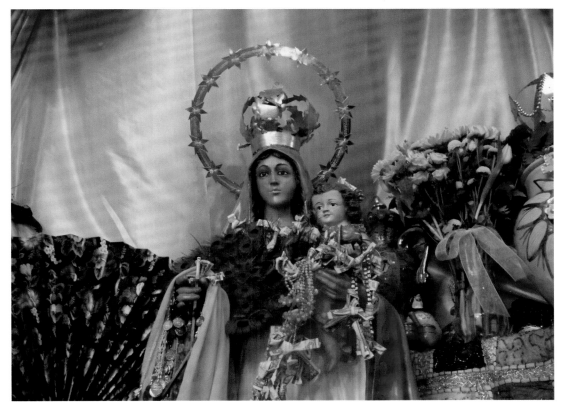

Figure 17.8. Crown on statue of La Virgen de la Caridad, Washington, D.C., 2002. Photo by Joseph M. Murphy.

commissions from local churches.[24] Contemporary crown makers in Miami also make adornments for the statues of saints in devotees' homes (fig. 17.8).

While the crowns for saints account for the likely models for the band, arches, and finials of the Lucumi crowns, the chains and tools are another matter. With no precedent in European arts, direct antecedents seem to be Yoruba regalia and religious sculpture. Hanging chains of tools are strongly reminiscent of two categories of Yoruba sacred arts: the royal *adé,* or sovereign's crown,; and the tool amulets sacred to the orisha Ogun.

The *adé* worn by Yoruba monarchs on state occasions is the primary symbol of sovereignty and a metonym for royalty itself (fig. 17.9). The basic elements of the *adé* have been well summarized by Robert Farris Thompson as a cone, from which hangs a veil of beads and which is surmounted by the figure of a bird.[25] The cone is usually embroidered with beads, often with a stylized face or faces gazing outward. The crown also contains *osù,* a mystical substance that connects the head of the wearer with the heads of all those who have previously worn the crown, the royal ancestors.[26] The head (*orí*) in Yoruba thought is both the ordinary skull and also a preexistent spiritual entity that lives in

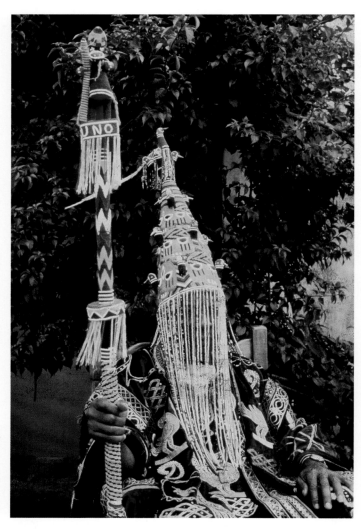

Figure 17.9. The Orangun-Ila, Yoruba sovereign. Photo by John Pemberton III.

the other world and is chosen by each person and orisha before coming to earth.[27] A distinction is often made by calling the ordinary head the "outer head," *orí odé*, and the ancestral soul the "inner head," *orí inú*.[28] The beaded face and veil of the *adé* reinforce the representation of the royal ancestors through the visible containers of crown and outer head. The face is sometimes said to be that of Oduduwa, the prototypical Yoruba king and progenitor of the sixteen traditional kingdoms. The veil (*ìbòjú*) redoubles the idea that the distinctive features of the "outer head" are not to be seen or, perhaps better, seen through, so that the ancestral presence is appreciated. Thompson summarizes, "His own face has vanished and the countenances of his ancestors have become his own at a higher level of vision. Thus the meaning of the frontal face on the beaded crown seems to be: the union of the living king with the deified royal dead."[29]

Joseph M. Murphy

Figure 17.10. Miniature tools for Ogun amulets. Drawing by Robert Mueller.

Chains of tools of the Lucumi crown are similar to the veil of the royal *adé*, but the chain and tool motifs appear to be closely associated with amulets for the orisha Ogun, the deity of iron.[30] Yoruba hunters dedicated to Ogun wear chain bracelets and necklaces from which hang miniature versions of the iron products of Ogun's forge (fig. 17.10). Kevin Carroll writes that each of these tools represent a "branch" of Ogun, a different manifestation of the deity symbolized by different iron implements: Ogun of the house by a knife; Ogun of the farm by a hoe; Ogun of the hunters by a gun; and so forth.[31] Thompson identifies miniature tools in other areas of Yoruba sacred arts. He writes: "The *amula ogun* is composed of the very miniature emblems—swords, bells for Osanyin, serpent—which were the signs Agbeke [priestess of Erinle] characterized . . . as powers of the iron god. Herbalism depends on iron."[32]

Some Yoruba crowns appear to combine metal tools and headgear. Thompson notes the use of brass crowns in Ekiti and Ijebu, one of which was said to have once carried a chain veil.[33] In 1965 he photographed the Odo Nópa crown with its hanging brass pendants (fig. 17.11). Regal headgear and metal tools are brought together in the famous Gu figure from Dahomey. Thought to be a representation of Gu, the Fon equivalent of Ogun, the sculpture is of a human form topped with an iron hat affixed with the iron products of the forge (fig. 17.12).

Finally, the stylistic connection between Yoruba metalwork and the Lucumi crown is supported by comparative orisha arts from Brazil, where elegant metal crowns are worn by *orixá* mediums in trance. Candomblé crowns feature European-styled bands—and sometimes arches and finials—with veils of fine chain (fig. 17.13).

During the weeklong cycle of ceremonies constituting ordination into Lucumi priesthood, the initiate is fitted with clothing, in designer-priest Ysamur Flores-Peña's words, "fit for a queen."[34] On the middle day of the

Left: Figure 17.11. Brass crown of the Nópa, Ijebu Yoruba. Drawing by H. J. Sutton. From R. C. Abraham, *Dictionary of Modern Yoruba* (London: University of London Press, 1958), 292.

Below: Figure 17.12. Headgear, iron statue of Gu, Benin. Drawing by Robert Mueller.

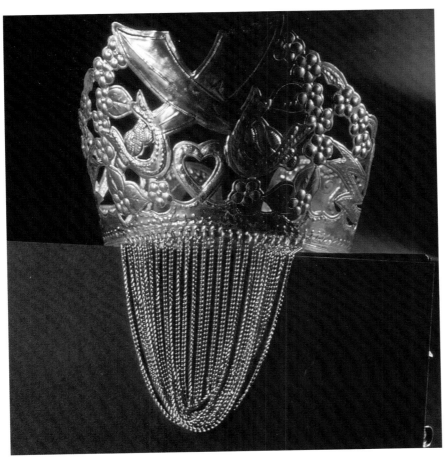

Figure 17.13. Crown for Oxum, Rio de Janeiro, 1991. Photo by Joseph M. Murphy.

initiation cycle, the novice is presented to the community, seated in state on a royal mortar throne, flanked by rich canopied drapery. As initiates are installed into the Lucumi priesthood by enthronement, their vestments reflect the regal qualities of the patron orishas. Their heads are often covered with fabric crowns to reflect the dignity of the orisha and the placement of the spirit on their heads, now vessels for the orishas (fig. 17.14). Again we see a conjunction of crown, head, and spiritual presence in Yoruba and Yoruba-derived symbology. We will return to this after looking at the Lucumi tool crowns more closely.

Elements of the Lucumi Crown

From our sketch of Spanish, Yoruba, and Brazilian precedents and parallels we can look at the Lucumi crown more closely. Yoruba and European crowns contain several of the same structural features: a circlet ringing the head,

Figure 17.14. Initiation crown for Ochún by Maria Elena Larralde, Hialeah, Florida, 2010. Photo by Joseph M. Murphy.

an enclosed extension or projection upward, and a finial in representational form. Larger Lucumi crowns vary considerably, but all are arranged into three constituent parts: the circular body, the hanging tools, and the finial. Smaller crowns have only the circlet and the minimum number of tools (fig. 17.15).

The circlet is usually a single band of metal riveted at the ends. The bottom of the band is pierced with holes for the chains, while the top is crenelated. The type of metal used and pattern of numbers in its ornamentation indicate which orisha is being crowned. Mary Ann Clark has argued that while the stones and other *fundamentos* contained within the *soperas* are the primary signifiers of the orishas, color and number are the most important "second order signifiers."[35] This is borne out by the crowns: brass or gold in patterns of

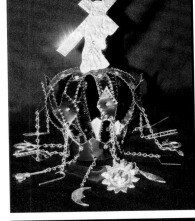
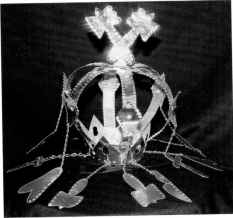
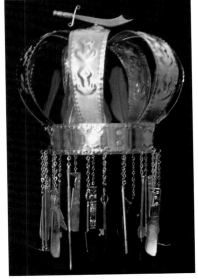

Figure 17.15. Four Lucumi tool crowns (*clockwise from top*): (a) small Ochún crown with edan; (b) Obatala crown with Christ remata by Juan Gonzalez; (c) crown for Yemaya Ogunté by Antonio Salas, photo by George Chillag, courtesy of the Historical Museum of Southern Florida; (d) crown for Chango with double axes by Juan Gonzalez. Photos by Joseph M. Murphy.

five for Oshun, copper in nines for Oya, and white metals in eights for Obatala. The arches and tools follow the same color and number symbolism, though the number of tools may be doubled, tripled, or quadrupled.

The tools of the "tool crown" are seen as implements that the orishas use to "work" for the devotee. Each presents a capacity of the orishas to build, transform, or envision a world on behalf of their children.[36] Weapons empower the orishas to fight for their devotees. Some are emblems strongly associated with the patron orisha; others are generic or characteristic of different orishas. Oshun's crowns, for example, are hung with five *edanes*, miniature pins or staffs reminiscent of her powers as the mother of brass and of earth powers.[37]

The crowns of female orishas are often accompanied in altar displays with metal bracelets (*idé*) coded in number and color with the crowned orisha. These too are protective ornaments—tools if one will—complementing the powers of the crowned head.

A curious feature of the tool collection on any given crown is the presence of tools that more clearly "belong" to an orisha other than the crown's patron. Shango's *oshé* thunder ax, for example, appears on a crown for Oshun. Antonio Salas says this has to do with stories about the orishas. Each tool refers to a particular narrative about the orisha when he or she lived on earth. These stories, *odú*, preserved in the divination systems, are learned by devotees at their foundational *itá* initiation reading and at subsequent readings throughout their lives. In many of the stories orishas appropriate the tools of their fellows, either through cooperation or by guile. There can be a sense of rivalry in the display of the tools, a rhetoric of power among the orishas. By arraying other orishas' tools below the crown, the owner may be praising and flattering the crowned orisha as the owner of *all* powers, even—and especially—those of other orishas.

The question of position brings us to our last element in the larger Lucumi crown, the finial or *remata*. The *remata* usually represents a "road" or aspect of the orisha. It communicates directly the owner's connection to the orisha and can carry personal rather than traditional associations. Antonio Salas says that he does not innovate with the *remata*, although others do. It should only represent a traditional "road" of the orisha as revealed in the *itá* reading. Thus a crown for Oshun Akuara is topped by a quail; for Oshun Ibú Kolé, a buzzard. Salas even insists on *rematas* that are opaque to patrons, but he will turn away patrons who want fanciful *rematas*.[38] Other crown makers feel free to innovate *rematas* that appeal to the personal faith of their patrons. Milagros Gomez will make a crown as people want it. Pointing to an Oshun crown with a butterfly *remata*, she says, "Oshun as butterfly means nothing, but people like it."[39]

What first attracted me to the Gonzalez-Gomez crowns were the innovative *rematas*, particularly those with Catholic themes. "No, la Virgen de la Caridad is not a road of Oshun," says Milagros Gomez, "it's just a style people like." Yet

a close look at the uses of La Caridad to represent Oshun reveals a remarkable synergy between the two divinities. Both are water-born *criollas*; both are warriors and healers; both are royalty and single mothers. La Caridad may be seen to reflect Oshun in Cuban social life and national identity. She is not a traditional road of Oshun but perhaps an innovative one.[40]

The *remata* of another Gonzalez-Gomez crown shows a similar dialectic: an Obatala crown in aluminum and patterns of eight is surmounted by a figure of Christ carrying his cross (fig. 17.15b). When one considers the well-known *odú* of Obatala silently enduring imprisonment and indignity to his royal person, the image of the Christian passion communicates Obatala's suffering very effectively. In fact, Andres E. told me that he knows a priestess of Obatala who receives just this "very beautiful road" of Obatala in ceremonial trance and mimes the tortured route to Calvary.[41]

The position of the *remata* of the Lucumi crown recalls Thompson's parallels among the Yoruba * adé* and other sacred symbols. He finds:

> The links between kingship, healing, and divination are perhaps more powerfully extended by the sharing of the bird emblem. The native doctor is often identified by the possession of a wrought iron staff surmounted by a single iron bird or a circlet of minor birds under a commanding bird at the summit. Similar staffs are also made for the cult of a riverain spirit, Eyinle, who has marvelous powers of healing. Southwest Yoruba medicine staffs often have roughly horizontal radial bars near the top of the staff a short distance underneath the senior bird at the top. These bars sometimes end with miniature iron implements (sword, arrow, machete, and so forth) associated with the "hot" iron god Ogun, together with cryptic emblems of other deities associated with heat and witchcraft. Their siting suggests control by a superior force manifest in the spirt of the bird or, alternatively, the bird as messenger.[42]

The Lucumi crown suggests a similar structure of power. As the bird on the *adé* or staff sits supreme over the royal head and the emblems of other powers, the *remata* may be seen to dominate the powers arrayed below it. The crowned orisha takes on the emblems of other orishas, whose powers are now at its command. Ochún Ibú Kolé or Yemaya Ogunté are regaled as the sovereign of all powers represented by their fellow orishas' tools in their train. Writing of crown-like structures in Yorubaland, Rowland Abiodun explains, "The highest place, the apical position of authority called *àpèré* became Orí's throne. From there, he reigns and sends the other *òrìsà* on errands."[43]

The *remata* may be connected to a larger pattern of Yoruba symbolism called by Margaret Thompson Drewal "projections from the top." She notes that not only the *adé* and orisha staffs are topped in finials but all manner of religious symbolism is characterized by emphasis on the head and projection from it.

Drewal writes that a projection from the head "hints at the vital force" (*ashé*) that the adorned head now carries.[44] As we saw with the *adé,* the crowned sovereign is now no longer simply himself or herself, but his or her head is now a vehicle for more puissant ancestral forces. So these other projections indicate the incarnation of the force of *ashé* in its various forms. The bearer of the projection is thus "possessed" by the force, signaling the manifestation of the invisible through the visible. This symbolic linkage offered by Drewal becomes the foundation for our conclusions about the Lucumi crowns of Miami.

Conclusion

The designation of the Lucumi crowns as examples of African culture in Florida raises a number of issues. The crowns of today are the result of nearly two hundred years of intercultural contact in Africa and Cuba and, more recently, the United States. They are creoles, born of the interaction of Yoruba, Spanish, Cuban, and American aesthetic values and religious meanings. It may be moot to ask whether we are looking at Yoruba crowns that have been creolized with Spanish stylistic conventions, or Spanish crowns "Yorubaized" with chains, tools, and a representation of orisha roads as a finial. The Yoruba and Spanish crowns share a number of stylistic and functional features: it is, after all, why we call them both "crowns" in English. Much of what is said of the *adé* can be said of the crowns for the Virgin. Both encircle the head and concentrate attention upon it. Both expand the magnitude of the head and contain it in the Yoruba cone or European arch. And both surmount the extension with a finial in representational form, suggesting a transcendent authority to whom the wearer is subject but also represents. Thus the Yoruba sovereign rules at the pleasure of the "Mothers" symbolized by their night bird; and the Catholic Virgin has dominion at the behest of the Christ as shown by his cross.

The chains and tools present a feature unknown to the European crown and distinctly reminiscent of the *ibòjú* veil of the *adé,* the brass chains of the Ijebu crowns, and the dangling medicines of the herbalist staffs as described by Thompson above. The Lucumi crowns reveal striking stylistic similarities to these Yoruba sacred objects in their organization of constituent parts from top to bottom: finial, cone, pendants.

It is more difficult to determine if the Yoruba meanings of these elements— as explored by Thompson, Beier, Abiodun, and others—are shared by the Miami Lucumi community. Discussion of the kind of "meaning" of interest to the researcher may be avoided by devotees for a number of reasons. Devotees are famously reticent in discussing knowledge that might be deemed hidden or esoteric. On the other hand, it may simply be that crowns are used without consideration of their abstract meanings. The "meaning" of the crowns should probably be found in their use, the ceremonial context outlined above. Here

again the question of African provenance is difficult to determine. I have found no ethnographic documentation of the placing of crowns on lidded pots at altars in Yorubaland, while in Cuba crowns are placed on the statues of *santos* in home and church shrines. That these *ere oibo* (white people's images) are sanctified by miniature crowns is suggestive of an impetus for their placement on *soperas* in Cuba.[45] On the other hand, not all orishas are crowned, and the rules governing their crowning are unlike the coronation rites for the statues of the Virgin Mary. Drewal's linkage between Yoruba aesthetics and spirituality seems to be operative in the ceremonial display of the Lucumi crown and so in the interpretation of the African meanings implicit in their use.

Drewal documents the religious importance that the Yoruba place on the human head and the attention that is drawn to it by artistic projections in a variety of forms. The placement of Lucumi crowns on the *soperas* may be seen to maintain the Yoruba analogies observed by Drewal: the crown projects from the head, which acts as a vessel containing an inner mystery. By means of the crown the inner mystery is both concealed and revealed. In the case of the Yoruba sovereigns the *adé* projects from the top of the ruler's head, concealing the outer face and the *osù* inside the cone, and revealing the inner head of Oduduwa and the royal ancestors. The crowned sovereign becomes a "generalized entity," in Thompson's phrase, and the crown a mask.[46] Beier states, "The crown thus becomes the mask that transforms him [the sovereign] into the 'brother of the gods.'"[47]

The arrangement of symbols among *adé*, head, and divinity is replicated in the initiation of novices as medium-priests. Initiates are "crowned" with their patron orishas, which are literally placed inside their heads. The head is shaved, an incision made at the top of the cranium, and the *osù* herbal preparation that embodies the orisha is rubbed into it. The initiate becomes an *adosu*, "carrier of the osù," making his or her head a receptacle for the spirit. Pierre Verger writes, "The body of the Adoshu has become the mystical container specially prepared to receive an intangible force and only a particular one. This idea is analogous to a pot containing fresh water being fit for river fish but not for sea fish."[48]

Verger's analogy between devotee and pot is quite apt, for we see the same arrangement at the Lucumi altar. The *soperas* are the vessels, the "outer heads," that contain the mysteries, the "inner heads" of the orishas, which are represented by *fundamento* stones. As the *sopera* "head" is a vessel for the orisha in ceremonial altar display, so the devotee's head is a vessel for the orisha in ceremonial trance. Though the Lucumi do not wear veiled crowns during dance ceremonies, we have noted that crowns are worn at ordination, when the orisha is "placed on the head" of the initiate. And veiled crowns are worn in Brazilian Candomblé where the connection between crown and trance is yet more explicit.

Thus the crowns present us with three linked ideas of vessels and embodiment: royalty, altar, and ceremonial trance. Through the *adé* the head of the sovereign is shown to be a container, a vehicle, for the royal ancestors. We might say that when crowned the sovereign is "possessed" by them. The novice too, through the "crowning" rites of initiation, especially the "crowning" with the *osù*, is a vessel and vehicle for the orisha. And, finally, the Lucumi crowns project from the top of the *sopera* vessels, marking the primordial inner heads of the orishas embodied through fundamental stones.

The aesthetics and spirituality of concealment and revelation expressed by the Lucumi crowns seem a direct extension of Yoruba values in South Florida today. Ulli Beier expresses this Yoruba symbology succinctly: "Thus behind each appearance there is another, subtler, more mysterious power; man can penetrate layers of symbols, to reach closer to the core of truth, but he is unable to understand or endure the final revelation of truth."[49]

The crown makers of Florida and their precursors in Cuba have restated Yoruba spirituality through blending the aesthetics of several cultural traditions. It is likely that the skills to make the metal crowns to adorn saints were in some demand in colonial Cuba and so the Catholic models were expedient to use to adorn the orishas. It is conceivable as well that the idea of adorning the *soperas* with crowns was suggested by the Catholic practice to crown images. Nevertheless the aesthetic parallelism of crown-vessel-mystery shows clear analogies with Yoruba antecedents as described by Drewal. Writing about the use of English-style crowns by contemporary Yoruba sovereigns, Drewal says: "Crowns for everyday use probably reflect European (or more specifically British) crown conventions. It may be that non-Yoruba crowns suited traditional purposes in part because of the projection."[50]

The Lucumi metal crowns, with their finials, arches, circlets, chains, and tools, both blend and juxtapose multiple cultural antecedents. In the organization of these elements they restate the movement from outer to inner, explicit to implicit, exoteric to esoteric, that lies at the heart of Yoruba spirituality. This juxtaposition and dynamism seems particularly apt in the case of the crowns with Catholic saint finials such as my Oshun-Caridad crown. The Cuban Virgin speaks of an exoteric religious identity, signaling the more esoteric presence of Oshun armed with tools of power. The Lucumi crowns reveal a community that has organized its creole heritage into a spirituality that moves from symbol to mystery.

Notes

1. I want to thank the Theology Department and the College Dean's Office of Georgetown University for their support of this project. Thanks, too, to Otto Tianga, Jeff Gonzalez, Steve Stuempfle, Cristina Geada, Milagros Gomez, and Antonio Salas for their time or timely assistance. Finally, *muchisimas gracias* to Oba Oriete Miguel "Willie" Ramos, whose generous aid is apparent in so many of the notes. Willie made possible the field research behind this paper, and I dedicate the project to him. Modupe Ilari Oba!

2. See P. A. Howard, *Changing History*. See also the seminal work by Fernando Ortiz, *Los cabildos afrocubanos*.

3. Ortiz, *Los cabildos afrocubanos*, 24.

4. Bremer, *The Homes of the New World*, 380.

5. D. H. Brown, "Garden in the Machine," 382ff.; Cabrera, *El Monte*, 24; and Ramos, "The Empire Beats On," 95–97.

6. Greenbaum, *More Than Black*, 135–36.

7. http://factfinder.census.gov/bf/_lang=en_vt_name=DEC_2000_SF1_U_QTP3_geo_id=05000US12086.html.

8. García, *Havana USA*, 86.

9. Sandoval, "Afro-Cuban Religion in Perspective," 93.

10. Miguel Ramos suggests these *olorishas* as formative members of the Miami community from that era: Celia Gónzalez, Christian Rodriquez, Josefina Beltrán, Jorge Mones, Concha Pomoa, Jorge Cortada, Viki Gómez, Abelardo Hernández, Ana Luisa Guillot, Emma Teran, Juvenal Ortega, Anibal Guerrero, and Carlos Gómez.

11. See Larzelere, *The 1980 Cuban Boatlift*; Masud-Piloto, *From Welcomed Exiles to Illegal Immigrants*; McCoy and Gonzalez, *Cuban Immigration and Immigrants in Florida*; García, *Havana USA*; and Fagen, Brody, and O'Leary, *Cubans in Exile*.

12. Sandoval, "Afro-Cuban Religion in Perspective," 93.

13. Ramos, "Ashé in Flux," 15–17.

14. Ibid., 17.

15. A small sample of the magnificent objects from the exhibit can be seen at http://www.historical-museum.org/exhibits/orisha/orisha_start.htm.

16. On my visit to his shop he showed me a large *opa osanyin* that he said had been commissioned by a Nigerian babaláwo priest for use in Africa. The model, he said, was a photograph from a book. It was interesting to think of a Nigerian religious object, made by a Cuban orisha priest in the United States, modeled on ethnographic photographs.

17. Personal communication, Milagros Gomez, July 5, 2003.

18. Ibid.

19. I'm indebted to Mei-Mei Sanford for suggesting the metaphorical uses of tools. See her work on Ogun in "Powerful Water, Living Wood."

20. Goebs, "Crowns."

21. Ibid.

22. Goodall, "Regalia."

23. These excerpts from the coronation rite are from the site of the Marian Library at the University of Dayton, the largest repository of Marian scholarship in the world. http://www.udayton.edu/mary/resources/crowning.html.

24. Palmié, *Wizards and Scientists*, 87.

25. R. F. Thompson, "The Sign of the Divine King."

26. Abiodun, "Hidden Power," 21.

27. Abiodun, "Verbal and Visual Metaphors."

28. H. J. Drewal, Pemberton, and Abiodun, *Yoruba: Nine Centuries*, 26; M. T. Drewal, "Projections from the Top in Yoruba Art," 47.

29. R. F. Thompson, "The Sign of the Divine King," 245. Ulli Beier concurs: "The function of the crown is to eliminate the individual personality of the wearer and supplant it with the divine power of the dynasty." Beier, *Yoruba Beaded Crowns*, 24.

30. To this might be added the chains that link the staffs of the *edan Ogboni*. C. O. Adepegba writes, "the two images [on the *Ogboni* staff] represent man, male and female, bound by an oath to keep what they do a secret. The chain that connects them represents the oath." Adepegba, *Yoruba Metal Sculpture*, 36.

31. Kevin Carroll cited in H. J. Drewal, "Art or Accident," 239.

32. R. F. Thompson, *Black Gods and Kings*, chapter 11/3.

33. R. F. Thompson, "The Sign of the Divine King," 238.

34. Flores-Peña, "'Fit for a Queen.'"

35. Clark, "Asho Orisha," 150.

36. The term for the tools that I have heard is the Spanish *herramienta*. Lydia Cabrera at one point refers to them as *fifuni* and seems to disparage the Spanish usage. She writes: "sus atributos, *Fifuni* en lucumí, y en el lenguaje corriente de la Santería 'las herramientas de los Santos.'" Cabrera, *Koeko Iyawó*, 11.

37. This term is rendered in a variety of ways in Lucumi orthography, such as *edani*; *odani*; *odanes*; *aldanes*. Each seems consistent with the brass *edan* of Yoruba sacred art, particularly the *edan Ogboni*. See Lawal, "À Yà Gbó, À Yà Tó." See also Adepegba, "Oshun and Brass."

38. Personal communication, November 8, 2002.

39. Ibid.

40. See Murphy, "Yéyé Cachita.

41. Personal communication, June 14, 2001.

42. R. F. Thompson, "Sign of the Divine King," 248.

43. Abiodun, *Verbal and Visual Metaphors*, 263.

44. M. T. Drewal, "Projections from the Top in Yoruba Art," 44a.

45. The provocative coinage *Ere Oibo* is taken from Cabrera's *Koeko Iyawo*, 13. I've never heard it used in Miami.

46. R. F. Thompson, "Sign of the Divine King," 232.

47. Beier, *Yoruba Beaded Crowns*, 24.

48. Verger, "Trance States in Orisha Worship," 19.

49. Beier, *Yoruba Beaded Crowns*, 26.

50. M. T. Drewal, "Projections from the Top in Yoruba Art," 91 n. 4.

18

The Spirit(s) of African Religion in Miami

Terry Rey

Soul Force in the Magic City

On any given weekend in Miami you can attend Catholic masses celebrated in Haitian Creole or in the West African Igbo language; dance at a Santería *bata* drumming ceremony; have a reading done by a Haitian Vodou priestess; or have hands laid on you at any of the city's hundreds of Caribbean or African American Pentecostal storefront churches. Miami's police force, meanwhile, receives special training on how to interpret religious symbolism and ritual paraphernalia of African derivation, while the janitorial crews at a city courthouse, affectionately known as the "Voodoo squad," regularly pick up offerings left by plaintiffs and defendants alike to influence their trials' outcomes.[1] At Florida International University, such offerings are sometimes even found in the library during exam week. As these examples illustrate, the spirit(s) of African religion is (are) indeed alive and well in "the Magic City."

"Soul Force" is Leonard Barrett's term for "that quality of life that has enabled Black people to survive the horrors of their diaspora,"[2] a force whose fuel and funnel are quintessentially religious and quintessentially African. Soul Force is thus a New World incarnation of the quest for vital force at the heart of African traditional religion, a force that the Yoruba call *ashe*. It is this *spirit* of African religion, this Soul Force, that is manifest in all forms of black religion in Miami, be it African American and Caribbean Pentecostalism, Cuban Santería, or Haitian Vodou. In the United States' southernmost city of Miami, thousands of African Americans and descendants of Africans from the Caribbean, along with a relatively small but growing West African immigrant community, have, though this enduring Soul Force, been remolding Christianity anew. In many cases, immigrants adopt new ways of fashioning Soul Force from the city's long-standing African American community, as, for

example, in the establishment of storefront churches. Toward the same end, immigrants from Cuba, Haiti, and other Caribbean islands have also brought with them the rich African-derived religious traditions of Santería, Regla de Ocha, Lucumi, Palo Monte, Shango, and Vodou. Miami's religious landscape thus features a strong African content, fertilized by two principal streams, one Afro-Caribbean and the other African American. A third, more recent stream of Soul Force, from Nigeria, is also now flowing in Miami. For Robert Hall, effectively tracing Soul Force down these streams requires "placing spirit possession and ritual ecstatic dance at the heart of the controversy over African survivals."[3] Thus, in addition to looking at the more obviously African-derived religions like Santería and Vodou, wherein the *spirits* of African religion thrive, I argue that contemporary African American and Caribbean Pentecostalism in Miami, wherein the *spirit* of African religion thrives, should also be considered to be in significant part African-derived religious expression.[4]

African *Spirits*: Vodou and Santería

Though sibling religions, Vodou and Santería have undergone markedly different transformations in Miami. Since its emergence in the seventeenth century in the slave plantation colony Saint-Domingue, which became independent Haiti in 1804, Vodou has at times been forced to negotiate its existence underground. Yet over the last forty years the religion has become increasingly open in Haiti, where the 1987 Constitution affords it "official religion" status along with Catholicism, where in 2003 President Jean-Bertrand Aristide granted legality to its baptisms and marriages, and where very public Pentecostal-style "Vodou churches" have recently been operating in Port-au-Prince.[5] However, many Haitian immigrants in South Florida who had practiced Vodou in Haiti sever their ties to the *lwas* (spirits) upon arrival, even if they remain clients of herbalists or botanicas in the United States. There are numerous reasons for such apostasy, including the onerous economics of maintaining Vodou devotions in the homeland from afar,[6] the lack of temples in South Florida, and, especially, racism and its accompanying religious bigotry, in the face of which Haitian immigrants often dissociate themselves from Vodou. Yet fortunately, there are abundant *extra-Vodou* venues in Miami where Haitian immigrants cultivate and reap Soul Force, such as in Little Haiti's one hundred churches. That is to say, in Miami Haitian immigrants find that it is perfectly feasible to abandon the *spirits*, while forever tapping into the *spirit*, of African religion.[7]

Aside from the three or four small quasi-public temples in the city, Vodou in Miami is largely home-based, with altars erected in practitioners' homes, where *oungans* and *manbos* (priests and priestesses) visit to preside over occasional ceremonies, usually either rites of passage or feasts for the *lwas* (spirits), and sometimes initiations. Since the city is built on a swamp, there

are no basements in Miami, which serve so well as temples for Vodouists in New York, where Vodou thrives in the devotion of thousands of Haitian immigrants. Still, a small minority of Haitians in Miami do practice Vodou regularly, while many others situationally consult with a *manbo* or *oungan*. As with Santería, Vodou's lifeline in Miami is the botanica, or religious goods store. Most Haitian botanicas are either run by or affiliated with *manbos* or *oungans* who offer divination services, in addition to retailing a plethora of herbs and ritual paraphernalia. The city's largest Haitian botanica, Botanica Halouba, actually has a sanctuary (*perestil*) inside. There are roughly two dozen Haitian botanicas in the city, many of which cater in part to Hispanic clients (figs. 18.1 and 18.2). Meanwhile, there are more than one hundred Cuban botanicas in Miami, which likewise offer divination and other ritual services in addition to religious goods.[8]

Quite contrary to the downward trajectory of Vodou in South Florida, the Afro-Cuban religious traditions of Lucumi (Lukumi), Regla de Ocha, Palo Monte, and Santería have, in some respects, enjoyed fuller success in Miami than in contemporary Cuba.[9] According to *Obá* Miguel "Willie" Ramos, one of Miami's most respected Lucumi orisha priests (*olorisha*) and diviners (*obá oriaté*), the first wave of Cuban exiles brought traditions that have since been lost in Cuba, thus making Miami home to some of the most original forms of Lucumi in the world. In the 1960s and 1970s and up until the Mariel Boatlift in 1980, there was something of a "Lucumi brain drain" out of Cuba: "These people set up here in the U.S., began functioning here, and these traditions, which are older than the ones being practiced in Cuba today and didn't have to go through any of the forced adaptations that the traditions in Cuba have gone through, remain here; they are lost now in Cuba."[10] Thus with good reason, Ramos has called Miami "the Mecca of the Lucumi religion."[11]

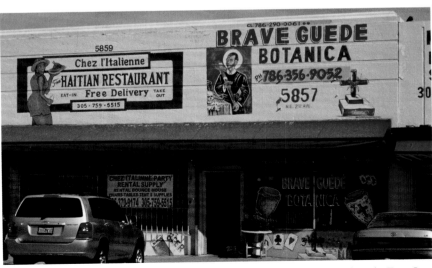

Figure 18.1. Botanica Brave Guede, a Haitian botanica in Little Haiti, Miami. Photo by Terry Rey.

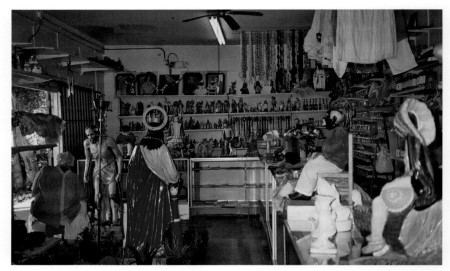

Figure 18.2. Interior of a Haitian botanica in Little Haiti. Photo by Jose Antonio Lammoglia.

No other Lucumi congregation has been more influential than the Church of the Lukumi Babalú Ayé (CLBA) in Hialeah.[12] The CLBA was founded by *Obá* Ernesto Pichardo along with three other Lucumi priests and an attorney in 1974, making it the first-ever Lucumi church in the United States.[13] They faced resistance that escalated to the legal level. Arguments made against the CLBA in local municipal hearings tellingly echoed the paternalism and racism that were a hallmark of the Euro-Christian conquest of Africa and the Americas. The chaplain of the Hialeah Police Department, for example, called Santería "foolishness" and "an abomination to the Lord" and the worship of "demons." "I would exhort you . . . not to permit this Church to exist."[14] His sanctimony aside, the chaplain was obviously oblivious to the extraordinary resilience of the orishas and their devotees that has allowed a long-persecuted faith to emerge as the veritable "world religion" that it is today.[15] At any rate, out of "concern . . . that certain religions may propose to engage in practices which are inconsistent with public morals, peace or safety," the city council approved an emergency ordinance to prohibit the ritual sacrifice of animals, based upon Florida's animal cruelty statutes. The Florida state attorney concurred that the "ritual sacrifice of animals for other than food consumption" was not "necessary" and was thus punishable under state law. Pichardo and the CLBA sued the city of Hialeah, alleging violation of their constitutional rights as embodied in the First Amendment: "Congress shall make no law respecting an establishment of religion, or the prohibition of the free exercise thereof." In 1993, U.S. Supreme Court Justice Anthony McLeod Kennedy finally handed down the historic ruling in favor of Pichardo and the CLBA, concluding that the city's ordinances had "as their object the suppression of Santeria's central element, animal sacrifice."[16] Thus the Supreme Court of the United States ruled

that the city of Hialeah's ban of the ritual sacrifice of animals was unconstitutional, thereby safeguarding the rights of all practitioners of African-derived religions (and, for that matter, of any and all religions) in America to ritually sacrifice animals.

In addition to ritual sacrifice, divination is a central feature of Santería. The most important divination ceremony, La Letra del Año (The Letter of the Year), has been taking place in Cienfuegos, Cuba, since the colonial era. In this originally clandestine ceremony, which takes place on December 31 and culminates at midnight, *babalaos* (diviners, spelled *babalao* in Cuban tradition) gather to invoke the orishas (especially Orun, or Orunmila, the spirit of divination) and ask for their insight into the coming year's events and for guidance as to how to best serve the orishas over the next twelve months. Since 2000, La Letra del Año has been simultaneously performed on New Year's Eve at a Miami horse farm called Rancho Odú Ará.[17] On December 31, 2002, among the prescriptions for devotions revealed to the *babalaos* by Orun was the demand that a series of communal drum ceremonies (*wemileres*) be held in honor of particular orishas. On one of these occasions, in April 2003, several hundred devotees gathered at Rancho Odú Ará and danced to sacred African drumbeats, while a white middle-aged Cuban American man dressed in white was possessed by Shango, the orisha of thunder and lightning, who expressed his appreciation both for the feast and the elaborate altar that had been erected there in his honor. Besides La Letra's general predictions of wars, storms, and other calamitous events destined to unfold in 2003, one *babalao* from another Santería community in South Florida claims to have been told by the orishas that the Florida Marlins would win the World Series, which, despite facing 150-to-1 odds in Las Vegas when the baseball season opened, they did in a stunning six-game-series upset over the powerful New York Yankees![18] For this, the *babalao* held a special ceremony to officially proclaim 2003 as "The Year of the Marlins."

African *Spirit*: Miami Pentecostalism

Although Soul Force in Miami is most obviously manifest in traditions like Santería and Vodou, wherein are worshipped the *spirits* of African religion, it also enjoys a healthy presence in African diasporic Christianity, especially in its Pentecostal form, wherein the *spirit* of African religion continues to thrive. Put otherwise, even though Caribbean Pentecostalism strongly demonizes African *spirits*, it centrally and ritually carries on its *spirit*, because the hallmarks of Pentecostalism—namely, speaking in tongues, spirit possession, faith healing, and even dancing—are quintessentially (though not exclusively) African forms of religious experience. Hall's insightful directive concerning "the heart" of African religious survivals in the Americas (quoted above) sheds important

light on this unitive dimension of Pentecostalism, even where its forms develop independently of one another. Because spirit possession and ritual dance (and, one should add, healing) feature centrally in Pentecostal ritual, Soul Force may be called a taproot of the Pentecostal revival. It is therefore sound to conceive of the movement as being in significant part the product of second-generation African-Christian syncretism. Please recall here that, although admittedly multi-ethnic and multi-local in its genesis, one of the key initiators of the modern Pentecostal movement was the revival at the largely African American Azusa Street Mission in Los Angeles, which was inspired in 1906 by an African American preacher named William Seymour, the son of slaves. And quite remarkably, the Azusa Street revival caught flame at around the very time when a prophet named Simon Kimbangu rose in the Congo; when Pentecostally inclined Holiness churches and Ethiopianism emerged in the West Indies; when Isaiah Shembe's healing prophecy inspired the Nazarite revival in South Africa; and when originally Nigerian Aladura churches began to sweep West Africa. Thus the twentieth century witnessed a profusion of Soul Force in Christian forms throughout Africa and the African diaspora, one that has been fueled in significant part by at least four factors: (1) African literacy and the resultant appropriation of scripture from mission churches; (2) greater African control over and creativity in the production and performance of music in ritual; (3) "traditional" African concerns with healing and embodiment being placed at the center of Christian practice; and (4) the migrations, both forced and free, of African and African-descended peoples.

In Caribbean, African American, and African forms, Pentecostalism is fast becoming Miami's most vital religious force. In the impoverished inner-city neighborhood of Little Haiti, for instance, out of over one hundred churches in a fifty-by-twelve-block section of the city, roughly forty are Pentecostal and Haitian, the majority of these of the storefront variety. In wealthier Hispanic neighborhoods like Kendall, meanwhile, large Pentecostal churches are springing up at an impressive rate. Additionally, small and often interdenominational Pentecostal healing services take place frequently in private homes, where most participants tend to be Caribbean immigrants.

Several colleagues and I recently oversaw the mapping/canvassing of roughly three-fourths of the religious gathering places in Miami-Dade County.[19] Of 859 congregations included, 296 (34 percent) were explicitly Pentecostal, with an average membership of 68 congregants. Of the 152,653 total reported members of the congregations canvassed, Pentecostals numbered 20,087 (13 percent).[20] Yet these figures do not give the entire Pentecostal picture, because, according to Waldo César, "The impact of the Pentecostal movement has influenced other Christian denominations. The continued vitality and prosperity of many Protestant and Catholic churches are due to the charismatic inheritance which originated in Pentecostalism."[21] This is certainly the case

in Miami, where many such charismatically revitalized mainstream churches, though not categorized in our study as "Pentecostal" (such as, especially, African American, Afro-Caribbean, and Hispanic Baptist churches), nonetheless are quite Pentecostal in their styles of communal worship, even as they remain quite different in their theologies and ecclesiologies. Our findings suggest that one in three Christians in the Magic City today is either explicitly Pentecostal or sometimes partakes in ceremonial rituals that may be labeled Pentecostal.[22] An increasing number of them, moreover, are Catholic.

The most significant recent development in Caribbean Catholicism is the charismatic renewal, which has brought decidedly Pentecostal forms of ritual into Catholic churches. Priests or nuns reputed to possess the charism of healing draw hundreds and sometimes thousands of Caribbean Catholics to their services in Miami, at times tripling and quadrupling normal attendance, especially among Haitian Catholics. Notably, this spiritual enthusiasm traverses the epic chasm between Haiti's socioeconomic classes, which is also evident in Miami. At Christ the King Catholic Church in the relatively upscale Miami-Dade neighborhood of Pinecrest, for instance, I have witnessed extraordinary Pentecostal enthusiasm following a mass said by a visiting Haitian priest, Father Jules Campion, who is the clerical leader of the exploding Catholic charismatic renewal in Haiti. By the service's end about twenty people were lying on the floor in various states of ecstasy, some of them speaking in tongues. In the impoverished inner-city neighborhood of Little Haiti, meanwhile, early summer feast day celebrations at Notre Dame d'Haiti Catholic Church for Our Lady of Perpetual Help, Haiti's patron saint, sometimes inspire possessions by the Holy Spirit, speaking in tongues, and faith healings among the thousands in attendance. As notes Margarita Mooney, furthermore, in Haitian Miami "Charismatic prayer meetings can occur in small groups of eight to ten people in someone's home, or among much larger groups sometimes reaching several hundred people at the weekly Charismatic prayer sessions at Notre Dame that end with Mass."[23]

Although the Protestant Pentecostal revival and the Catholic charismatic renewal emerged chiefly out of Los Angeles and Pittsburgh, respectively, much of Miami's Pentecostal and charismatic force (and thus much of its Soul Force) derives from the Caribbean and elsewhere in Latin America.[24] The swelling popularity of these movements is of course complex, but one influence is especially striking. When asked about the origins of the Haitian Catholic charismatic renewal (whose annual gathering in April in Port-au-Prince now draws over 100,000 people), one founder explained, for example, that the earliest enthusiasts were mostly middle- and upper-class women who had finally found a "legitimate" (as opposed to their notion of the "illegitimacy" of Vodou) venue in which to have the ecstatic religious experience of spirit possession! This indicates that Afro-Caribbean peoples know well that embracing the *spirit* of

African religion remains possible even when its *spirits* must be rejected or even demonized.

Notably, long before the charismatic renewal ever swept their islands, some Caribbean immigrants had already been importing a strong flavor of Soul Force into the Miami Catholic Church. In light of the near total absence of public Santería and Vodou temples in the city, Santeros and Vodouists have for several decades now made relatively free syncretic use of Catholic churches, as they always had in their homelands. This is especially true of ornate churches or ones dedicated to saints who are assimilated with popular orishas or *lwas*, where devotees sometimes render homage and offerings to the originally African spirits (although some Catholic priests and even ushers sometimes eject from their churches anyone wearing *eleke* devotional beads). Behind the Shrine of La Virgen de la Caridad del Cobre, for instance, one can often find Santeros casting yellow flowers into Biscayne Bay as gifts for Ochún (the Cuban version of Oshun), the water orisha with whom Caridad, Cuba's patron saint, is so strongly associated (see figs. 17.7 and 17.8). On Caridad's feast day of September 8, furthermore, Santería initiands dressed entirely in white can be found among the multitude of the faithful either at their patron saint's shrine or at the larger celebration now held at the American Airlines Arena, and yellow flowers and garments are in abundance, even among those who don't realize this to be Ochún's and not Caridad's color.

The Traditionalist Catholic Shrine of St. Philomena in Little Havana is likewise an attractive church to some Santeros and Vodouists. Father Timothy Hopkins, the shrine's pastor, once described for me a mass during which two Haitians gradually undressed in a pew, changed into white garments, and doused their bodies in sacramental oil. It is not uncommon, he added, to find all kinds of ritual offerings for the *lwas* and orishas within and outside of his church.[25] A Vodou priest, meanwhile, has performed a protective ritual (*pwen pwotèj*) for the shrine's main statue of its namesake to protect it from sorcerers or other individuals with "sacrilegious" intent. One could easily find many other examples of Soul Force smuggled into (or out of!) Miami's Catholic sacred spaces, like the honey candies sprinkled in the flowerbeds outside of Caridad's shrine, honey being the preferred offering of Ochún, or like the grave dirt from Catholic cemeteries required for certain amulets and charms in Palo Monte.

West African Immigrant Religion in Miami

Although the 2000 U.S. Census counts fewer than five thousand African immigrants in Miami-Dade County, mostly from Nigeria and Ghana, they undoubtedly are undercounted, with perhaps as many as half of them being missed.[26] Significantly, the census does indicate a 112 percent increase in this population

from 1990 to 2000. Such an impressive population increase readily portends the emergence in the city of both more independent African congregations and African congregations nested in longer-standing churches. As ethnic demographics shift with the influx of "new" immigrants into urban neighborhoods, preexisting Euro-American (or even Hispanic) churches are creating space for ethnic sub-congregations of more recent immigrants. The number of Nigerian immigrants in northwest Miami has become so great, for example, that the St. Vincent de Paul Catholic Parish has added a weekly Igbo-language mass to its schedule.

The Igbo parishioners at St. Vincent de Paul comprise the largest African Catholic community in Miami. According to one leading lay member, Chris Anyagaligbo, St. Vincent's Igbo community counts "about 35 families . . . but *big* African families."[27] Igbo mass at St. Vincent de Paul usually draws around one hundred congregants. It is scheduled for 2:00 in the afternoon, though punctuality is hardly the norm. Instead, congregants, many of them dressed in beautiful West African dashikis and colorful headdresses, tend to mull about in the churchyard greeting one another until, in decidedly African fashion, the conga drums call the faithful to gather, speaking to them much like the priest when he proclaims "Chukwu noyelenu" ("The Lord be with you"). Music features prominently in this mass, where young men beat conga drums to West African rhythms and the worshipful voices of about a dozen people lead the congregation in beautiful Igbo hymns, making this one of the most stirring choirs in the Catholic Archdiocese of Miami.

Whereas in Nigeria most Catholics are Igbos, most Yoruba Christians are Protestants. In general, first-generation Nigerian Protestants originally belonged to the Anglican and Baptist mission churches. But since the rise of independent African churches in the 1920s and 1930s, Nigeria's Christian landscape has been forever altered by the Aladura movement, which is composed of "churches distinguished by the practices of 'tarrying' for the Holy Spirit and speaking in tongues, as well as by a concern for effective prayer and visionary guidance, and for a more spontaneous, African style of music and worship."[28] Today counting upwards of ten million members worldwide, in less than one century Aladura has become a loosely connected global network of sometimes immense church organizations. Principal among them are Cherubim and Seraphim, founded in 1925, Church of the Lord (Aladura) and Christ Apostolic Church, both founded in 1930, and the Church of the Seven Seals of God, founded in 1979.

Christ Apostolic Church (CAC) is the thickest branch of the flourishing Aladura tree, counting more than five million members worldwide. Presently there are twenty-seven CAC churches in the United States, five of them located in Florida. Miami's CAC branch, founded in 1987, is the state's oldest, and today consists of roughly four hundred members. Although most of its

congregants are Yoruba, the church conducts its worship and praise service mainly in English because it has recently attracted a handful of Haitian and Hispanic members. Still, most of the hymns sung at CAC in Miami are in Yoruba, and most of the faithful dress in West African styles much like those who attend the Igbo mass at St. Vincent de Paul Catholic Church, just a few miles away.

Besides their profound Christian faith and splendorous African dress, these congregations (one Igbo and Catholic, the other Protestant and Yoruba) also share an affinity for lively hymns sung in African languages. But the similarities end there. At St. Vincent de Paul, for example, conga drums are played, whereas at CAC a Western drum kit and organ accompany the hymns. This reflects Aladura's strong theological self-identification as "born-again," which "is simply incompatible with certain other forms of identification—most obviously religious," including the use of traditional African drums that have long honored the orishas and the ancestors.[29] When I pointed out to one CAC member, a middle-aged Yoruba woman, that the orishas of her homeland are adored by tens of thousands of Cubans in Miami, she responded curtly that "Satan is strong, but God willing they will find the true life in Christ like we have." Fascinatingly, however, whereas Aladura explicitly breaks its ties with "the sins of the fathers" by prohibiting devotion to ancestors and the orishas, it nonetheless most strongly carries on the *spirit* of African religion in its worship service's unbridled religious ecstasy: "I find us very lukewarm today," proclaimed a woman from the pulpit during one Sunday CAC hymnal worship service in Miami early in 2004. "You should be possessed by the fire of the Holy Spirit, lifting your arms and voices to the Lord on high, and rolling around on the floor."

Conclusion

By way of conclusion I offer some reflections on the 2001 "Face of the Gods" exhibit at Miami's Florida International University Art Museum, curated by Robert Farris Thompson. Over the course of its six weeks at FIU, it became abundantly clear that for people of a variety of ethnic groups and religious persuasions this impressive collection of African and African-derived altars, being far more than a mere art exhibit, represented a rare and powerful occasion to access relatively "pure" Soul Force in public, or to directly access both the *spirit* and the *spirits* of African religion at a public venue in Miami. Besides a bowlful of money left near the Eshu altar located (appropriately!)[30] at the museum's entrance, devotees left coins and monetary notes from several countries on most of the seventeen altars. They also left rum and a whole assortment of prayer cards and other offerings. The three-gallon bottle of rum that was part of Cuban artist José Bedia's remarkable Palo Monte altar was often sipped by

the faithful, some of whom spit mouthfuls of the quintessentially Caribbean alcoholic spirits on the Kongolese cruciform at the altar's center. So inspired by the Soul Force that she felt at the exhibit, one Haitian *manbo* from North Miami sent several clients there to place offerings for the *lwas*. And on any given day people could be found at prayer somewhere in the museum, including a small group of university employees who appeared before work each day for their morning devotions. Most remarkably, the prayer card announcing a funeral mass for a Haitian woman that had been placed on the Yemaya altar later disappeared, only to be found the following week at her grave in Our Lady of Mercy Catholic Cemetery, a few miles north. Tellingly, in life she was a charismatic Catholic much possessed by the *spirit* of African religion, even as she had been alienated from Africa's *spirits*, to whom she has since returned.

Notes

1. Hiaasen, "At Courthouse, Even Chickens Need Bodyguards."
2. Barrett, *Soul Force,* 1.
3. R. L. Hall, "African Religious Retentions in Florida," 98.
4. Although not a focus of this chapter, it should be noted that the earliest expressions of Soul Force in Miami probably took the form of the Junkanoo and Goombay festivals among Bahamian immigrants who arrived in the area somewhat earlier than African American immigrants, who themselves came from northern Florida, South Carolina, and Georgia. See Dunn, *Black Miami in the Twentieth Century,* 13–19.
5. Hurbon, "Haitian Vodou in the Context of Globalization."
6. Richman, "The Protestant Ethic and the Dis-Spirit of Vodou."
7. For a fuller, more recent discussion of Haitian Vodou in Miami, see Rey and Stepick, *Crossing the Water.*
8. Lammoglia, "Botanicas." Given that there are an estimated 100,000 Santería practitioners in Miami and 100 Cuban botanicas, there are therefore roughly 1,000 practitioners for every botanica. This provides as sound a method as any to estimate the number of Haitian Vodou practioners: with 24 Haitian botanicas in the city, it is reasonable to multiply this figure by 1,000 to arrive at the total of 24,000 Vodouists in Miami. This is approximately 10 percent of Miami-Dade County's total Haitian population.
9. In addition to the large population of Cubans who practice Afro-Cuban religions in Miami, there is a small community of African Americans who also practice some variant of Yoruba-derived religion, with a few houses serving as their temples. The most significant is the Ile Orunmila Temple, which is led by Chief Adedoja E. Aluko, an African American babaláwo (diviner of the Ifá oracle) who was ordained in Ile-Ife, Nigeria.
10. Miguel "Willie" Ramos, interview with Katrin Hansing, Miami, October 4, 2001.
11. Miguel "Willie" Ramos, interview with Nathan Katz, Miami, February 9, 2005. For more insight into Lucumi religion in South Florida, see chapter 17 in this book, as well as Ramos's own impressive website, www.eleda.org.
12. "In 1999, the Church of the Lucumi closed its doors because of the annual forecast of the *orishas.*" O'Brien, *Animal Sacrifice and Religious Freedom,* 191.
13. Many priests of Afro-Cuban religious traditions, like Pichardo and Ramos, opt not to refer to their religion as Santería, since this title, which means literally "The Way of the Saints," plainly reflects European Catholic rather than traditional African forms of

devotion. "Lucumi" is their preferred designation for the religion that they practice and represent.

14. In O'Brien, *Animal Sacrifice and Religious Freedom*, 43.

15. Olupona and Rey, *Òrìsà Devotion as World Religion*.

16. United States Supreme Court, Church of the Lukumi Babalu Aye, Inc. v. City of Hialeah, 508 U.S. 520. June 11, 1993, decided.

17. According to Miami babaláwo and poet Adrian Castro, a smaller-scale ritual was being performed in Miami as early as the 1970s by a Cuban babaláwo named Pipo Pena, though primarily for private audience. Specifically, Pipo was performing the ceremony known as Letra de Casa (Letter of the House), which mainly limited its predictions and advice to members of a babaláwo's spiritual household. Adrian Castro, interview with José A. Lammoglia, Miami, November 10, 2003.

18. Babaláwo Rigoberto Zamora declared "la letra de Ifa Ellombe dice que los Marlins iban a tener una rotunda victoria. . . . Y . . . es por eso que acordamos en una Junta Extraordinaria, nombrar este ano . . . el ano de los Marlins." "La Letra del Año." Unpublished manuscript, International Union of the Yoruba Rights, Tampa Bay, Florida, 2003.

19. See Stepick, Rey, and Mahler, *Churches and Charity*.

20. The variance in these figures is explicable by the fact that in Miami, as elsewhere, individual mainstream congregations have larger memberships, such as Baptist churches (286 per) and Roman Catholic parishes (998 per). These data were compiled as part of the Pew Charitable Trusts' "Gateway Cities" project.

21. César, "From Babel to Pentecost," 23.

22. For an ethnographic and sociological analysis of a few of the West Indian Pentecostal churches in Miami, see Tsuji, Ho, and Stepick, "The Struggle for Civic Social Capital in West Indian Churches."

23. Mooney, *Faith Makes Us Live*, 79.

24. The earliest black church in Miami, the Macedonia Missionary Baptist Church, was founded by Bahamian immigrants in 1894, two years before the city was incorporated. Over the next three decades, numerous other black churches emerged; most of them were Baptist, and a few were African Methodist Episcopal. See Dunn, *Black Miami in the Twentieth Century,* 106–17. There is no evidence that any of these pioneer black churches in Miami were Pentecostal.

25. Father Timothy Hopkins, interview with Terry Rey, Miami, September 15, 2001.

26. United States Census Bureau, *United States Census 2000,* www.census.gov/cen2000.

27. Chris Anyagaligbo, interview with Terry Rey, November 30, 2003, Miami. Anyagaligbo, who originally came to the United States to study at a university in Alabama in the late 1980s, is an usher and one of the leading laypersons in Miami's Nigerian Catholic community. Masses were first said in Igbo in the Archdiocese of Miami in 1992 by Father Hyacinth Edokwe at the Parish of Our Lady of Perpetual Help. Once moved to St. Vincent de Paul, the Igbo community was soon ministered by Father Gregory Njuku, who is widely hailed as the key figure in the establishment of Nigerian Catholicism in Miami. He still visits on occasion.

28. Peel, *Religious Encounter and the Making of the Yoruba*, 314.

29. Marshall-Fratani, "Mediating the Global and Local in Nigerian Pentecostalism," 86.

30. In traditional Yoruba religion, Eshu is the orisha of the crossroads whose presence is always required to open doors between the human and spirit worlds. Eshu has taken on the name Legba in Vodou and Elegguá in Santería.

PART V

(Re)making Africa in Florida

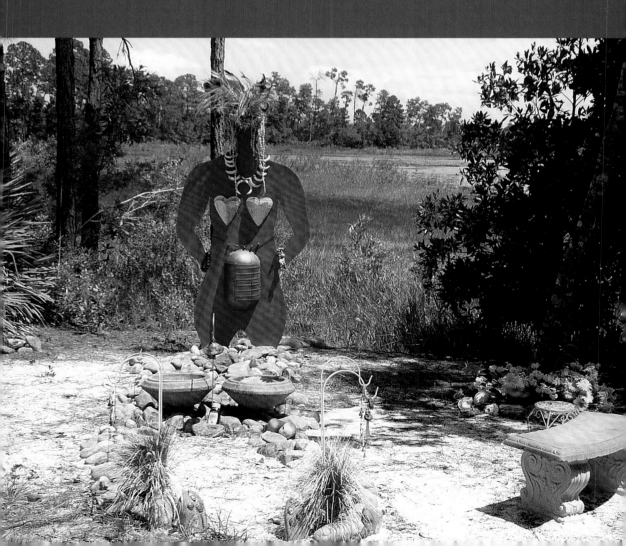

19

Carver Baba Onabamiero Ogunleye and the Sacred Space of the Ifalola Compound

Robin Poynor and Ade Ofunniyin

Baba Onabamiero Ogunleye ("Baba Ona") is an African American carver who practices Yoruba culture by worshipping Yoruba orișa, speaking the Yoruba language, and attempting to live what he considers a Yoruba lifestyle[1] (fig. 19.1). In this chapter we will explore how Onabamiero constructs and manipulates space and the environment in which he lives to assert his "African-ness" and to identify with the Yoruba culture of Nigeria.[2] He and those who share his lifestyle invoke their African ancestry as they re-create Yoruba traditions in north-central Florida in Alachua County, which contains Gainesville (a university town) along with many other small towns and rural stretches of land. By tracing the evolution of this Yoruba American artist's spiritual and creative development and by investigating the ways in which he has created an environment within Ifalola Compound (Archer, Florida), where he lives and works, we gain insight into questions of identity and difference that are important to those who practice variations on the Yoruba religion of the orișa or who are exploring their Africanness. The exploration of Africanness of self for Onabamiero is accomplished by embedding himself in an African experience, by seeking and developing ancestral ties, and by creating a community in which Africanness can be shared and experienced. This has led him to build an environment within the Ifalola Compound in which individuals and groups can acknowledge, comprehend, and practice the African experience. The process of reconfiguring spiritual space is a means of cultural identification.

Onabamiero: The Road to Alachua

Onabamiero Ogunleye was born August 21, 1953, in south-central Georgia, not terribly far from where he now lives in Alachua County, Florida. The fifth of nine children, he attended the segregated schools of Berrien County.

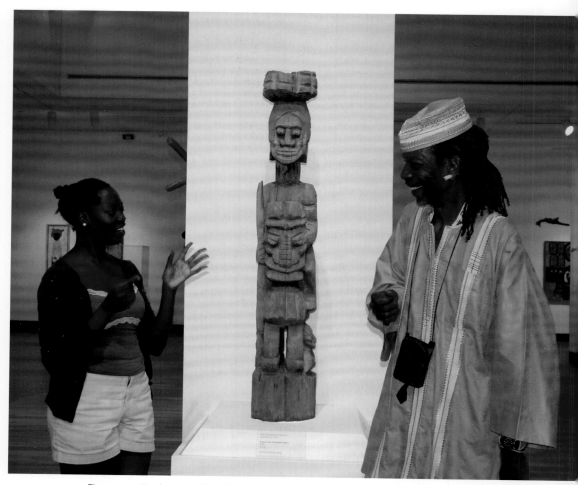

Figure 19.1. Onabamiero Ogunleye, a babaláwo and carver in north-central Florida, talks with a student next to one of his sculptures on display at the Harn Museum of Art at the University of Florida. Photo by Tami Wroath. Courtesy of the Harn Museum of Art.

A scholarship to Brewton-Parker Junior College, a Baptist institution in Mount Vernon, Georgia, allowed him to begin a business administration program. Upon his transfer to a public school, Middle Georgia College in Cochran, his worldview began to change when he realized that he did not feel comfortable in trying to understand his place in the world in the context of a white-dominated culture.[3] Deep down he knew there was something else, and he believes now that it was his ancestors beginning to "pull on" him. In exasperation he uttered the prayer, "I know there's another way." At that moment he says he decided to leave Middle Georgia College, despite the fact that the semester was near completion. He transferred to Armstrong State College in Savannah, where he first heard about African Liberation Day.[4] He joined busloads of people from Savannah to travel to Washington, D.C., to experience the event.

Robin Poynor and Ade Ofunniyin

African Liberation Day changed him totally. Among the new people he met were those dressed in African garb. In his mind, these people had experienced more and were more aware of their roots than he was. Some were Rastafarians who told him "Many are called but few are chosen" and indicated that they could teach him and lead him to a point of spirituality. Onabamiero felt his journey had begun and he decided not to return to Armstrong State. For about a year he stayed in Washington, meeting people who had been to Africa as well as African Americans who were practicing Yoruba culture. On hearing of an African-style settlement in South Carolina, he decided to go and see Oyotunji Village for himself, a step that was to transform his life even more dramatically.

Oyotunji Village in South Carolina was the invention of Walter Serge King. As a result of his commitment to black nationalism and his disillusionment with the plight of black Americans, King sought an African-based spirituality. In the 1950s he flirted with African-derived religions, including Haitian Vodou. Then he discovered Cuban Santería and traveled to Cuba for initiation into Obatala worship in 1956.[5] Returning to New York to practice the new African-based religion, he founded the Ṣango Temple in New York City in 1959 and the Yoruba Temple in Harlem in 1960. However, his disenchantment with the syncretic overtones of Catholic saints and Christian ideas in Afro-Cuban religion prompted his efforts to reform several aspects of the Yoruba experience in the United States and to purge it of its Catholic/Christian elements. In the early 1970s, the Yoruba Americans of the Yoruba Temple determined that although Yoruba religion could be practiced in an urban setting such as New York, urban architecture was not conducive to the organization of the African family[6] and the setting did not provide the "natural" environment for the cultivation of the flora and fauna needed in the sacred rituals.[7] In 1970 the group moved to South Carolina and established Oyotunji African Village. At Oyotunji, which translates "Oyo again awakes,"[8] King re-created with some accuracy an American version of the Yoruba culture of Nigeria and established himself as its *oba* (king), Oseijiman Adefunmi I.

Onabamiero Ogunleye was an early participant in the Oyotunji experiment. On his arrival there in 1974 he met his first *baba*, or godfather, Ojomo Ogunleye. In Oyotunji Onabamiero was a member of the militia and worked alongside many of the early settlers as they chopped trees to clear the land and to construct shrines, temples, and residences (fig. 19.2). Here he began to think in terms of organizing space by placing distinctive forms in relationship to each other to create a visual environment that inspires religious devotion and cultural awareness and differentiates it from non-African spaces. It was here also that he first experienced artistic creation and expression for himself. Early in his stay at Oyotunji, Onabamiero painted a wall at his godfather's compound depicting the king of the ancient Yoruba kingdom of Ife on horseback

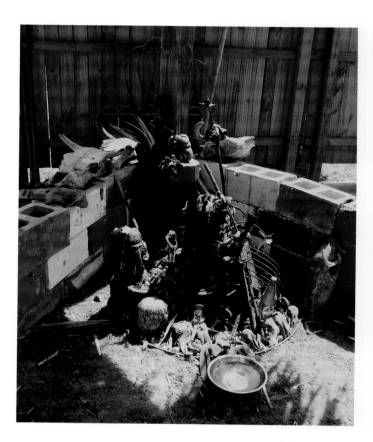

Figure 19.2. Oyotunji Village in South Carolina, shrine to the god of iron, Ogun. Onabamiero lived at Oyotunji Village near Sheldon, South Carolina, for some nine years prior to settling in Archer, Florida. Photo by Jody Berman.

and women carrying twins on their backs. The painting inspired his godfather to give him the Yoruba name "Onabamiero," meaning "Art stays with me." Onabamiero recalls how painting the picture seems to have released something from within, a realization that creating visual forms can aid in cementing internal mystical experiences.

It was at Oyotunji that he learned about how the manipulation of form, objects, and space can be used to create a powerful environment that could impact and change one's lifestyle, emphasize one's difference from the mainstream's norm, and establish a sense of belonging within an alternative lifestyle based on African concepts and lifeways. Although living in Oyotunji was demanding and challenging, he was satisfied to live and to learn at the village. For some eight years he endured the arduous life in the developing environment of Oyotunji and participated in the creation and expansion of the community.

Some participants in the Oyotunji experiment, however, were not content with the policies imposed by Adefunmi and the harsh living conditions at the African Village. A number of them began to move out into the world, taking with them ideas of living an African life in the United States and of practicing Yoruba culture. The mid-1970s marked the beginning of the dispersal of

Robin Poynor and Ade Ofunniyin

villagers from Oyotunji and the emergence of Oyotunji extensions or satellite communities across the United States—from the Carolinas to California, from Chicago to Florida and in between.

Because his godfather had decided to move on, Onabamiero went first to New York City for about two years, where he supported himself by carving. From New York he moved to Florida for about a year and a half and then moved to California—first to Los Angeles, and then to Fresno, where Ojomo Ogunleye had settled. He stayed in California for almost five years.

Oyotunji adherents who left the South Carolina community took considerable pride in spreading African beliefs and values to other parts of North America. A significant number of them moved to north-central Florida and Alachua County. Among those who went to Florida was Ona's godfather, a dancer, photographer, and musician.[9] Another Oyotunji member, Omialadora Ajamu, an artist, businesswoman, and musician, had spent nine years living in Oyotunji before arriving in Gainesville.[10] When Ajamu moved to Gainesville she opened the Third Eye Marketplace, an ethnic store and botanica that specialized in African and African-related materials. Babaloṣa Oriṣamola Awolowo, a chief and one of the principal artists and founders of Oyotunji, established himself in Archer, Florida, a small town just outside Gainesville[11] (fig. 19.3). Awolowo, now deceased, had played a major role in the creation

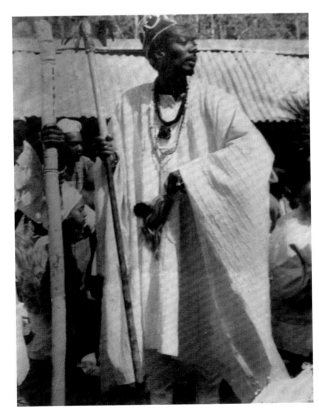

Figure 19.3. Babaloṣa Awolowo. Babaloṣa was one of the founders of Oyotunji. When he left the African Village to settle in Archer, Florida, his godson Onabamiero Ogunleye followed. Unknown photographer. Photo courtesy of Onabamiero Ogunleye.

of Oyotunji and its physical environment, and he is remembered for having taught many people the ways of the Yoruba. Moreover, the individuals mentioned above organized and worked in performing groups presenting drumming, singing, dance, and storytelling at community festivals, museums, and schools in north-central Florida.

About 1984 or 1985 Onabamiero came to Gainesville to study for the priesthood with his second godfather, Babalosa Awolowo. During the three or four years he stayed with Awolowo, he actively worked as a drummer and musician and participated in cultural and musical presentations. At the same time he apprenticed himself to learn to install ceramic tile, which he still does for a living. When Awolowo passed away in 1989, Onabamiero stayed in Florida to continue his legacy, overseeing performances and events in memory of his mentor. Eventually he purchased his own acreage outside Archer.

In an effort to connect more intentionally with Yoruba traditions, a number of Oyotunji associates made pilgrimages to the Nigerian homeland of the Yoruba. Onabamiero's first godfather, Ojomo Ogunleye, for example, went to Nigeria and lived in Owo in 1973. Ogunleye wanted to learn firsthand the ways of the Yoruba and to further identify with the culture he had adopted. For him and an increasing population of sojourners, such trips to Nigeria demonstrated an early interest in altering, refreshing, and renewing the Yoruba experience in the United States through contact with what they perceive as the source. Ogunleye's sojourn in Africa was a powerful example for Onabamiero, who made his own pilgrimage to Nigeria in 1996.

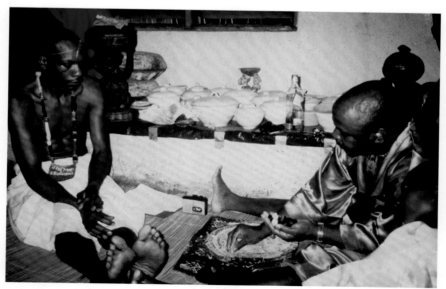

Figure 19.4. Initiation in Oṣogbo, Nigeria. Chief Ifayẹmi Elẹ́bùìbọn divines for Onabamiero during his initiation in Nigeria. They sit in front of the Obatala shrine in Elẹ́bùìbọn's compound, which is the inspiration for Onabamiero's own shrine in Florida (see figure 19.10). Photo courtesy of Onabamiero Ogunleye.

Robin Poynor and Ade Ofunniyin

Onabamiero went to Oṣogbo, Nigeria, where he lived at the compound of Chief Ifayẹmi Elébùìbọn.[12] There he was initiated into the Obatala priesthood[13] and Ifá[14] (fig. 19.4). He was given the tools of divination, including *opon ifá*, *iroke*, *opele,* and *ikin ifá*. Reflecting upon that experience, he states that although he had studied the language and had used it at Oyotunji and in ritual, "To hear the language spoken was like drinking water." The people, the town, the down-to-earth quality of the individuals he met, the marketplace—everything was inspirational to a man who had practiced the religion for over twenty years but had not yet experienced "the source." On his return to the United States, Onabamiero found it difficult to come down from "the high" of his visit, realizing he had to go back to living every day in a Western culture.

The Development of an Artist

Onabamiero Ogunleye—a renaissance man—is simultaneously community participant, activist, storyteller, drummer, diviner, and carver. He is currently a godfather to a number of individuals who have become active in the Yoruba community in Alachua County as well as further afield. If we consider the word *renaissance* in the sense of renewal or rebirth, it is also applicable to Onabamiero, who senses a need to look to the Nigerian source in order to renew and refresh the traditions of African Americans who want to experience their African heritage through participation in Yoruba American religion and culture. We will look back at his development as an artist, focusing on his role as a carver, in order to examine the way he uses sculpture to produce multiple and varied experiences within an environment in order to encourage encounters with the spiritual and the cultural.

When Onabamiero arrived at Oyotunji, someone had presented him with a copy of Robert Farris Thompson's book *Black Gods and Kings*.[15] The book was his introduction to Yoruba forms and iconography. Not long after, while Onabamiero was involved in a work detail, Oba Adefunmi called the men together and stated that he wanted each man to carve an object. None of the men had prior experience with carving, but each attempted to produce an object from wood. Inspired by the twin figures *(ere ibeji)* he saw in Thompson's book, Onabamiero decided to carve one. Using a mallet and a chisel on a piece of oak, he began to experiment. He remembers with amusement, "The first time I didn't get the stomach, the legs—it was just one big head about fifteen inches tall. But I was pretty impressed with it." Both the name Onabamiero ("art stays with me") and the interest in carving stayed with him. As he carved more, Onabamiero was able to control the elements of the sculpture. As time progressed, he was able to think the image through and to control the details. About the same time, he was advised in an *ifá* reading that his ancestors had been carvers and that they had created beautiful forms for temples and for

embellishing the palaces of kings in the Yoruba homeland. The sacred knowledge of *ifá* reaffirmed for him his destiny, not only to carve beautiful sculptures but also to define important spaces with them as his ancestors had done.

During the eight years that Onabamiero resided at Oyotunji, he helped to build the temples to the orișa and carved a number of the images there. He also placed carvings in Oyotunji's marketplace, where they sold quickly. Among the many types of Yoruba-inspired objects he produced at Oyotunji were dance wands for the god of thunder, mortars, priest's staffs, and carvings for the orișa Ọșun and Oya. His inspiration for iconography and types came from Thompson's book. He states that he attempted to replicate the examples in the book as closely as he could. Working in this manner gave him insight into Yoruba traditions.

Onabamiero states that he carves because he needs to. It is as if he is impelled by inner necessity to express himself spiritually by carving images that recall his African heritage as inspired by Yoruba religion and culture. He has experimented with a number of woods. In California he used redwood, but recently he has experimented with Florida woods such as cedar, oak, cypress, and an assortment of pines, including long needle, slash, and sand pine.

For the most part, Onabamiero is self-trained as a sculptor. However, his knowledge of his ancestral connection to woodcarving serves as a source of inspiration and gives him a sense of fulfillment in terms of familial destiny. The tools he uses include chisels, knives, hatchets, chain saws, files, and rasps, in addition to traditional Yoruba knives, hooked blades, chisels, adzes, axes, and mallets he obtained in Nigeria (fig. 19.5).

While Thompson's *Black Gods and Kings* informed the types of sculpture he produced and the iconography he used, Onabamiero's style is his own, developed from his relationship with the materials and the images that come from his mind. His style is informed by his experimentation with tools and his attention to what different woods "tell" him to do in response to their textures and forms.

He blocks out a form and then works the larger forms into smaller forms, refining and developing detail as he goes. Symmetry is vital to his work, and he uses the nose on the face as the line by which the rest of the symmetry is to be developed. He speaks of the need to have breasts, legs, arms, and other forms deriving from the relationship of the line that passes through the nose to the rest of the body. In demonstrating his technique, Onabamiero worked slowly over several weeks so we could follow the stages in which he carved. Using a piece of sand pine salvaged from clearing his own land, he began blocking out the body on the lower end, reserving the upper portion in case he decided he wanted a double figure or an object carried on the head. Using a chain saw and a hatchet, he blocked in the main shapes. The use of chisels allowed him

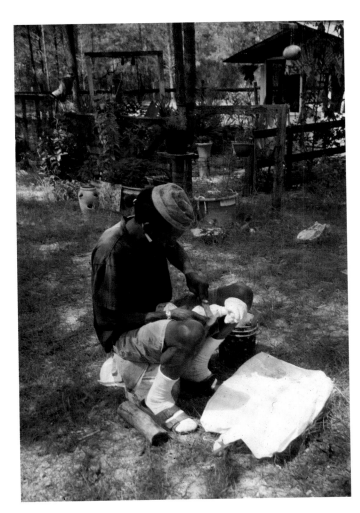

Figure 19.5. Onabamiero Ogunleye carves a figure from the soft wood of a sand pine, 2001. Photo by Robin Poynor.

to refine the forms. Eventually he used rasps and files to smooth and perfect shapes further.

Onabamiero carves for various purposes. He has sold his objects in the marketplace at Oyotunji but also at sidewalk art shows. Yoruba American adherents have commissioned figures for use in shrines. Most importantly, he has carved pieces to activate his own compound and shrines, helping to create ritualized and sacred spaces.

The Ifalola Compound: Art and Ritual Space

After Awolowo died, Onabamiero purchased his own acreage to establish his home, a temple to Obatala, various shrines, and smaller buildings and shed used on the acreage. He named his home and the altars and shrines associated with it "Ifalola," one of the names he received upon initiation into *ifá*. During

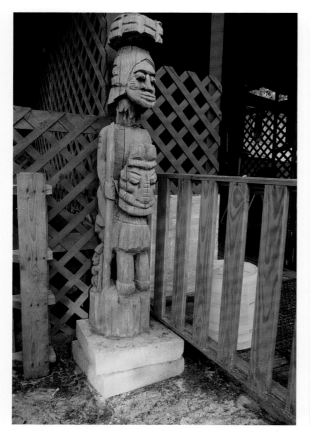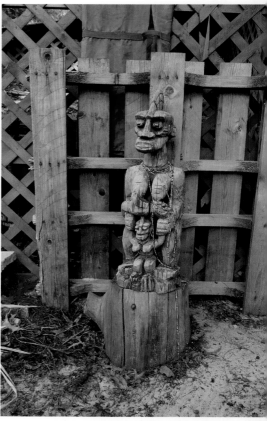

Figure 19.6. A number of sculptural forms such as this carving of an equestrian (*left*) and the mother and child (*right*) decorate the temple and grounds at Ifalola. Photos by Robin Poynor.

our first visit, we noted a significant space at the entrance, a shrine dedicated to Ògún, the Yoruba god of iron and patron of smiths and artists.[16] Although Onabamiero was dedicated to the orisa Osun from his early days and to Obatala and Orunmila as a result of his Nigerian experience, as a carver he must honor the patron orisa of artists and the god of iron, Ògún. During our first 2001 visit we saw two huge carvings representing warriors, referring to Ògún's role as warrior god, guarding the accumulation of metal tools and implements that made his shrine.

Entering into the compound, we noted other sculptural forms standing alone, not in the context of altars or shrines. Although these sculptures were not used specifically in ritual, their presence suggested to Onabamiero links to ideas of orisa and to the ancestors, and in a sense they "Africanized" the space—an equestrian figure alludes to the hot-spirited gods such as Ògún and Sango. Nearby, a carving of a mother and child references the nurturing aspects of the orisa and the role of women (fig. 19.6).

In Yoruba tradition, Ògún is said to "wear many faces," alluding to the various roles he plays as builder, defender, warrior, or preparer-of-the-way. The word "face" is also used to refer to an altar. It is acknowledged that the face of the god changes according to the function he or she fulfills, but the face as manifested in the altar will change over time as well through rearrangement and additions of objects and materials. In *Face of the Gods*, Thompson observed that the spacing of shrines within a Yoruba community is very important, as is the sense of space within a shrine, but that the space is not constant.[17] He observed, for example, that the configuration of stones in Ògún's altar at Ife is often rearranged, redefining his space.[18] The Ògún shrine at Ifalola has evolved over the decade or so we have observed it. It has been moved several times, the movements determined by divination as the compound has changed and as Onabamiero has responded to requests made by the orișa through divination. Although its composition in 2010 incorporated many of the original metal objects already in place in 2001, the placement of the forms in relation to each other was significantly different. For example, in 2004 Onabamiero constructed a large roofed gateway into the compound. One side of the construction is dedicated to Ògún (fig. 19.7). On the right side of the entryway is the shrine to Eșu, the messenger god[19] (fig. 19.8).

Other sculptures in the compound call attention to the presence of Onabamiero's temple, which houses the altar to Obatala and also serves as the consultation chamber for divination. A number of forms referencing orișa

Figure 19.7. A large roofed gateway into the compound provides space for the Ogun shrine, to the left of the gateway as one enters the space. Photo by Robin Poynor.

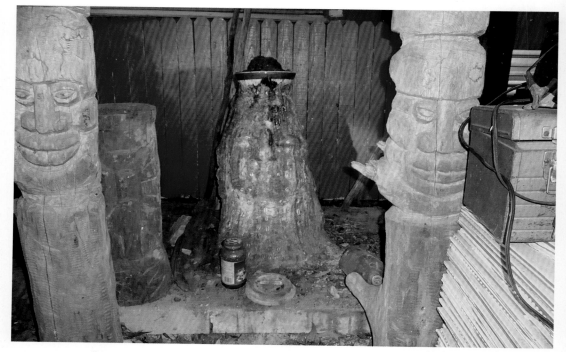

Figure 19.8. On the right side of the entryway is the shrine to Eṣu, the messenger god. Photo by Robin Poynor.

define the space as "more than ordinary." To one side of the temple, a figure carved of cypress refers to the god of water, Olokun. Figures representing a warrior and a hunter stand atop a table on the deck in front of the temple. A sculpture of Eṣu guards the entrance to the temple (fig. 19.9).

The interior of the temple, like the space outside it, further creates an environment conducive to experiencing the Yoruba mode of worship carried out within. Its arrangement references the orisa venerated within the space and is created by amassing objects from Nigeria, those sculpted by Onabamiero, and odds and ends placed as offerings or mementos to the gods. Onabamiero is intiated into the Obatala priesthood. The altar to Obatala (the god of whiteness) dominates the small space within the temple, which includes white ceramic tiles and white implements (fig. 19.10). A few green tiles in the center refer to the god of divination and the space where Onabamiero performs *ifá*. Along the altar, an assortment of objects allude to both Obatala the god and to those who worship there. The altar includes portrait photographs of Onabamiero and his children, a copy of Abraham's *Dictionary of Modern Yoruba*, a book on Obatala written by Ifayẹmi Elébùìbọn, Onabamiero's Nigerian godfather, an assortment of sculptural forms from Nigeria and elsewhere, and Onabamiero's own sculpture.

Left: Figure 19.9. A figure of Eṣu guards the entrance to the Obatala temple. Photo by Robin Poynor.

Below: Figure 19.10. The altar to Obatala dominates the small space within the temple. White ceramic tile and white implements reference the god of whiteness, Obatala. Photo by Robin Poynor.

Figure 19.11. Onabamiero's Ifá paraphernalia sit alongside the altar and include two diving trays, tappers to call the god, and a carved cup to hold the palm nuts used in divination. Photo by Robin Poynor.

But the Obatala temple is not exclusively for the veneration of the god of whiteness. Onabamiero's *ifá* paraphernalia sit alongside the altar, and it is here that he performs divination. The equipment includes two divining trays, tappers to call the god, and a carved cup to hold the palm nuts used in divination, all from Nigeria (fig. 19.11). An *ifá* bowl placed on the Obatala altar along with a complex stand to support it both come from Oṣogbo.

Outside the temple, a shrine to the *egungun* allows Onabamiero to honor his ancestors (fig. 19.12). An *egungun* costume, previously worn in performance in honor of the ancestors, serves as a backdrop to the shrine, a brass mask created by Onabamiero serving as the face. Several of Onabamiero's carvings decorate the shrine, while a number of objects refer to and recall his father— his father's chair, a photograph of his father. Plants and foods are placed on the altar as offerings to the ancestors. This shrine is an example of how the artist combines references to his African ancestors and his more immediate family, reflecting the artist's interest in merging Yoruba-ness and self.

Next to the *egungun* shrine, a shrine dedicated to Oya is set off by tall carved posts (fig. 19.13). Several small images decorate it as well. Although in Nigeria Oya is the goddess of the Niger River and the oriṣa of wind and storm, in Santería and Oyotunji traditions she is associated with death and the cemetery. Thus her shrine's position next to that of the ancestors is fitting.

Conclusion

Creating a place that is conducive to living a spiritual life and one that consciously makes reference to the Yoruba roots of Onabamiero's experience allows for the continued exploration of Yoruba-ness and of self. While the environment that has been created by Onabamiero is expressive of his sense of being Yoruba as an individual, it also reflects a connectedness to insights about place and spirituality that prompted the early Oyotunji settlers to move away from Harlem to South Carolina. Apartment dwellers in New York and other urban areas have spatial limitations and are prohibited from creating the types of open-air worship sites that dominate Ifalola and Oyotunji. Many adherents have done a sufficient job of adapting their practices to urban environments

Figure 19.12. Outside the temple, a shrine to the *egungun* allows Onabamiero to honor his ancestors. An *egungun* costume, previously worn in performance in honor of the ancestors, serves as a backdrop to the shrine, while a brass mask created by Onabamiero serves as the face. Photo by Robin Poynor.

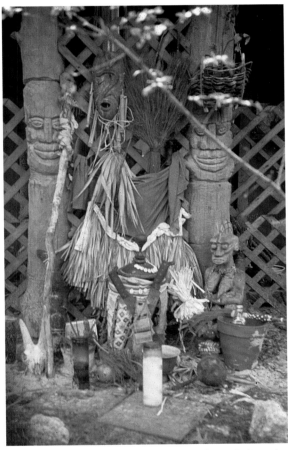

Figure 19.13. Next to the *egungun* shrine, a shrine dedicated to Oya is set off by tall carved posts. Several small figures decorate it as well. Onabamiero repositions objects in the compound over time. The post figures in the Oya shrine in this photograph, for example, were later positioned in the Eşu shrine pictured in figure 19.8. Photo by Robin Poynor.

and have not allowed spatial constraints to restrain their aesthetic and artistic use of space and objects. However, some, like those at Oyotunji and in North Florida, felt inhibited by the space available in the city. This is particularly evident in the types of space provided for the placement of objects of worship. The construction of elaborate sites in which to situate these objects is typical in Oyotunji and is replicated at Onabamiero's compound. By creating an environment in which individuals and the group can acknowledge, comprehend, and practice the Yoruba experience, Onabamiero continues a tradition that he was instrumental in establishing during his earlier experiences at Oyotunji and that he undoubtedly observed during his visit to Oşogbo, Nigeria. The woodcarvings and shrines created by Onabamiero serve to foster linkages to individuals and groups in the Yoruba homeland in Nigeria and to reinforce ideas of Africanness.

Notes

1. We will refer to Onabamiero Ogunleye by his first name to avoid confusion with one of his godfathers, Ojomo Ogunleye. Those who know him refer to him as Baba Ona. We were first aware of the artist because of performances he had been involved with and a small exhibition of his work that was organized for a university gallery.

2. The Yoruba of southwestern Nigeria and the Republic of Benin have exerted an enormous influence in the African Atlantic world, giving rise to Cuban Santería and Brazilian Candomblé. In addition, many Yoruba components are recognizable in Haitian Vodun and other African-based Caribbean religions.

3. Onabamiero has met with the authors numerous times, beginning in June 2001, to discuss his experiences with the Yoruba religion, Oyotunji, his moves to New York, to California, and eventually to Florida, his experiences in Nigeria, and the development of the altars at his Archer, Florida, home. The statements attributed to Onabamiero derive from countless interviews and discussions taking place between 2001 and 2013.

4. African Liberation Day is celebrated in Africa, the Caribbean, Europe, and North America. It was first observed "in 1958 on the occasion of the First Conference of Independent African States held in Accra, Ghana. At that time, the 15th of April was declared Africa Freedom Day, ' . . . *to symbolize the determination of the people of Africa to free themselves from foreign domination and exploitation.*' Later in 1963, upon the founding of the Organization of African Unity (OAU), 31 Heads of African states declared May 25th as African Liberation Day. This important, historic event has been observed and institutionalized in various places worldwide, every year since its inception." Press Release, African Liberation Day, May 19, 2010—1:11 pm—Posted in Africa, African-American News, Brothers Corner, Sistas Corner.

5. See Hunt, *Oyotunji African Village*; Omari, "Completing the Circle"; Clarke, *Mapping Yorùbá Networks*.

6. Hunt, *Oyotunji African Village*, 35.

7. The Ifa Foundation of Central Florida expresses similar concerns regarding the difficulty of practicing Yoruba religion in Western urban complexes. In a similar way, they moved from high-rise buildings in Chicago to rural areas. See chapter 21 in this volume.

8. Founded from Ile-Ife perhaps in the fourteenth century, Oyo became the most powerful of Yoruba kingdoms, eventually dominating and controlling all of western Yorubal- and between the seventeenth and early nineteenth centuries.

9. Public Records data for the Division of Corporations for the Florida Department of State indicate that Ojomo Ogunleye, along with Abiola Adewole, Ayoka Lanloke, Onabamiero Ogunleye, and Rafael Santa, filed for incorporation as "The African Family, Inc." located in Archer, Florida.

10. Omialadora Ajamu is the sister of one of the primary leaders of the Oyotunji movement, Chief Adenibi S. Edubi Ifamuyiwa Ajamu. The two began working for the Southern Christian Leadership Conference in the "End the Slums Movement" in Chicago and worked with Martin Luther King Jr. until his death. In the early 1960s their attention was drawn to black nationalism, the work of Queen Mother Moore at Mount Addis Ababa temple in New York, and Oba Adefunmi I and Babalosa Orisamola Awolowo. In the late 1970s, Omialadora's brother established the Ilesha Anago Africa Orisa Temple and Cultural Center in the Miami area.

11. Awolowo was buried with honors at Oyotunji, where his tomb is prominently located in the courtyard of the Ogboni House within the precincts of the palace.

12. Ifayemi Elẹ̀bùìbọn plays a major role in instructing Yoruba religious practitioners in North America and in the Caribbean. His work is addressed by Ade Ofunniyin in chapter 20 of this volume.

13. Obatala is the Yoruba orisa of wisdom and moral convictions. An alternative name is Orisa N'la, which translates as the "big orisa" or "important orisa," emphasizing the significance of this senior orisa.

14. Ifá is the Yoruba system of divination, practiced under the guidance of the orisa Orunmila.

15. R. F. Thompson, *Black Gods and Kings*. Enthusiastic lectures by Thompson about his research among both the Yoruba in Nigeria and the Kongo in the DRC and his connections of those cultures across the Atlantic have inspired many African descendants in the Caribbean and the Americas. His book *Flash of the Spirit* has been especially well received by those who want to explore or to reclaim African cultural roots.

16. Robin Poynor follows the evolution of Onabamiero's Ògún shrine and compares it to other shrines to Ògún in Florida and South Carolina in an article for a special issue of *Nova Religio*, vol. 16, no. 1 (August 2012).

17. R. F. Thompson addresses the concept of altar in *Face of the Gods*, addressing not only Yoruba altars but also other African traditions of altar making and the transatlantic forms created in the Americas.

18. Ibid., 181.

19. In Yorubaland, Ẹsu is often placed at the entrance to a compound or at the door of a house. As the god of the crossroads but also as the god of mischief, he is best kept outside. The Yoruba have traditionally said that one must "keep trouble outside."

20 Three *Iyawos*

A Transatlantic Òrìṣà Initiation

Ade Ofunniyin

On Thursday evening, August 5, 2005, three women from distinctly different backgrounds became three *iyawos*. They would remain *iyawos* for one year from the day of their initiations. The literal Yoruba translation for the word *iyawo* is "wife," "bride," "spouse," or any "married woman." However, in the context of Òrìṣà/Ifá practices the term applies to the "bride of the òrìṣà." Every person initiated into one of the "traditional" òrìṣà sects must be *iyawo*, a designation that stands regardless of gender or age. The women's initiation in this instance took place over four days and ended on the Sunday evening of the same week.[1] The initiation is the first one of this importance that Onabamiero has hosted at his compound named Ifalola in Archer, Florida. It is a telling story of the growth and potential of Ifalola and of the vision he and his wife Olapatun had for establishing the spiritual hub that their home has become. At Ifalola, a two-acre area on a seven-acre tract has been transformed into an enchanting and sacred space.[2]

This chapter examines linkages between the Yoruba American community in north-central Florida and practitioners of Yoruba religion in the city of Oṣogbo in Nigeria. In preparation for a discussion of the initiations in north Florida, directed by a priest from Nigeria, a brief explanation will address the evolution of practices of followers of the òrìṣà from Santería/Lukumi-style religion to Oyotunji-related practices to an effort to bring religious observances more in line with religious practice in the Nigerian homeland. It questions how the three women referred to as "three *iyawos*" in the title of this chapter made choices to be initiated and how those choices moved each of them to particular sets of actions or inaction, decisions or indecision. It also addresses the fundamental processes that the three women experienced during their initiations and looks at ways in which their worldviews were transformed. In the process

of initiation, the participants strengthened bonds they had already established with Africa through previous travels and through academic pursuits.

The three women came to this experience hoping for and expecting transformation. They knew that they were about to see and learn things about themselves and to gain access to another consciousness. Each felt a personal sense of being present to an unraveling of innate knowledge, an undoing of her current "self," a peeling away of the "false" self. Each came hoping to be directed to a path that leads to a clearer understanding of some of the mysteries of the òrìṣà. The hopes and expectations of these women were born out of their own life experiences and their observations of other people they knew who were involved in some form of òrìṣà practice. Each woman had witnessed some form of positive and life-changing transformation in some other person, and each imagined a similar fate for herself.

My inquiry into this very private and personal activity was privileged by the fact that I am a participant. Because I was an insider, it was necessary to suspend my academic focus as objective observer and immerse myself in the process. While I do not question the merits of scientific objectivity, it is my hope that this research demonstrates the importance of up-close, front-door scholarship. Insider scholarship enables researchers who have gained a sort of "capital" through long years of engagement and participation in closed communities to observe and provide analysis for subject areas that were formerly unapproachable. It cultivates a collaborative research environment in which the investigated community is aware of the researcher's intent, contributing to breaking down barriers that prevent up-close observations and in-depth analysis.

While much has been written about Ifá/Òrìṣà-Voodoo/Santería/Lukumi over the past three decades, much about initiations remains hidden in diaspora communities, which had constructed walls of secrecy because it was deemed necessary to keep African religious practices out of the purview of plantation owners, enslavers, and law enforcers to avoid persecution and castigation. The types of rituals performed during initiation into the priesthood are regarded as secret and sacred and are not to be observed by the uninitiated or to be revealed to the public.

African American Òrìṣà Practice and the Break with Santería/Lukumi

While most North American diaspora communities involved in Òrìṣà/Ifa traditions began their investigation into and participation in the Yoruba-derived religion through Cuban Santería/Lukumi, a break with the Cuban practices began during the 1960s when Walter King, who had converted to Santería,

refused to continue to include worship of the pantheon of Catholic saints associated at that time with Afro-Cuban practices, as discussed in the previous chapter. At Oyotunji African Village in South Carolina, he instituted a form of the Yoruba religion devoid of Catholic elements, yet he included elements from other African-based religions. All three babaláwos based in the United States who were involved in the initiations discussed in this essay began their discoveries of Yoruba culture through earlier associations with the Oyotunji African Village.

Controversies between Walter King, who assumed the name Adefunmi I, and Cuban Americans practicing Santería were many. Points of contention concerned not only the acceptance or rejection of Catholic saints and other syncretic elements but also issues concerning practices of initiation, aesthetics, and iconography. Other problems had to do with race and "ownership" of African-based practices. Santería/Lukumí priests and practitioners disassociated themselves from Adefunmi and his followers.[3] For the most part, disaffections between Cubans and African American priests have lessened over the past few decades. However, the contestations and disparities in practices, aesthetics, and iconography still point toward the compelling differences in worldview and the relationship with Yorubaland that divide and separate African American and Cuban adherents. These differences play themselves out significantly in initiation rites, ceremonies, and cultural performances. They are also apparent in the ways that *iyawos* are initiated and in the ways in which they conduct themselves during their pedagogic year.

Recasting Traditions

There is not a single way of being an initiate or of practicing indigenous African religion. In the West, the disparities between Candomblé, Òrìṣà-Vodun, and Santería/Lukumí practices and the debates about "traditions" and "authenticity" can be heard at academic conferences, viewed on the internet, and are especially prevalent in the communities of worshippers. During the course of this project I heard numerous stories from informants and friends about treatments that resulted in some form of abuse or inappropriate use of power. The three *iyawos* discussed in this chapter elected to turn to Yorubaland and to the tutelage of Chief Ifayẹmi Elébùìbọn of Osogbo for their initiations (fig. 20.1).

Chief Ifayẹmi Elébùìbọn: An African Priest for the Diaspora

Over the past three decades a substantial number of scholarly, professional and middle-class African Americans, Puerto Ricans, Jamaicans, Cubans, Brazilians, Australians, and Venezuelans have traveled to Osogbo, a thriving city in Òṣun State, Nigeria, to be initiated into Ifá or òrìṣà-worshipping sects by

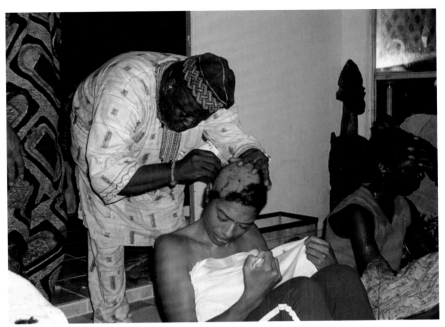

Figure 20.1. Chief Ifayẹmi Elébùìbọn, the Araba of Oṣogbo, one of the most powerful tradi-
tional titles in Yorubaland, has made a number of trips to Archer, Florida, to initiate and train
Yoruba Americans who want to experience a more authentic African-based religion. Here in
2005 he shaves the hair of one of the *iyawos* prior to her undergoing initiation in Archer. An
assisting babaláwo begins the process on a second initiate. Photo by Ade Ofunniyin.

Chief Ifayẹmi Elébùìbọn and his cadre of babaláwos (see fig. 19.4). Many of
these sojourners to Elébùìbọn's compound/temple are priests/priestesses
and/or practitioners of one of the several types of diaspora Oriṣa/Ifá worship-
ping traditions.

Elébùìbọn resides with his extended family and a group of worshippers in
an expansive compound in Oṣogbo. On the grounds there is an Ifá temple, a
cultural center and museum, and a botanica in which religious paraphernalia
and Yoruba gift items are sold. Elébùìbọn's sons, also babaláwos, work with
him during initiations and other cultural-religious services. His wives and
daughters serve in various official capacities during rituals, ceremonies, and
festivals.

Ifayẹmi Elébùìbọn is without question one of the most popular babaláwos
of this era. An international religious/cultural broker, he is the Awise (chief
Ifá priest) of Oṣogbo and in 2010 became the Araba Awo of Òṣun State. In
addition to his religious duties in Oṣogbo, he is vice-president of the Africa
International Steering Committee for the World Òrìṣà Conference and is a
central figure in the discourses, initiatives, and new directions within cultural-
religious traditions. In addition to religious activities, he is a poet and the
founder of *Artists Magazine* (1997). He has written books,[4] produced videos

and CD-ROMs, and produced and performed in a docudrama. His popular program *Ifá Olokun/Asorodayo* on Nigerian National Television, Ibadan, presents the cosmology of Yoruba belief in Ifá and situates Ifá traditions as practical for contemporary and urban societies. His textual and audiovisual materials are marketed in Nigeria and also to a large and growing population of priests/priestesses, worshippers, and neophytes throughout the diaspora. These deal primarily with Ifá narratives and òrìṣà principles and practices.

As a celebrated authority on Yoruba culture and traditions, Elébùìbọn travels throughout Africa, Europe, the Far East, the United States, and South America. He practices traditional rites such as divination, initiation, and sacrifices on four continents (Africa, Europe, North America, and South America). During his travels he frequently initiates neophytes and performs Yoruba culture. His involvement with Ifá traditions in Cuba, for example, dates back to the late 1970s, when he initiated three white Cubans as babaláwos "in ceremonies unprecedented outside the African-American pipeline, in which a group of Yoruba and Cuban-American babaláwos worked together."[5]

His primary role is as a master teacher. Elébùìbọn has established Yoruba religious and cultural hubs throughout the United States in cities and towns such as New York City, Los Angeles, San Francisco, Atlanta, Charlotte, and New Orleans. He has also established himself in smaller towns such as Hawthorne and Archer in north-central Florida. All of these centers, organized by his disciples, are used primarily as spiritual and cultural spaces in which Elébùìbọn meets with followers to perform Ifá divination and to consult with clients. From each of these communities he has selected, initiated, and trained several men and women who now work as apprentices, priests/priestesses, babaláwos, *apetebi*, and *iyanifas* to carry out his work. These people sponsor and organize lectures and talks for him around the United States, manage his itinerary, and facilitate meetings with clients. Elébùìbọn frequently travels to the United States to visit supporters and to meet and service new clients. His U.S.-based associates collaborate with him in organizing and performing rituals for individual practitioners and for local groups. While the ceremonies and rituals appear to be similar and without formality, each consultation is individual. Divination provides the space in which the priest and client are able to engage and commune with ancestors, òrìṣà, and other unseen energies.

Elébùìbọn in Florida

Elébùìbọn's earliest visits to Florida were to minister to the Santería/Lukumi community in south Florida. It was later that Ifá devotees in north Florida began their own pilgrimages to Oṣogbo and to sponsor his visits to Archer, Florida. At a naming ceremony for one of Baba Onabamiero Ogunleye's daughters, Elébùìbọn had come to officiate. While there he lectured on traditional

African culture, discussing such topics as rites of passage, ancestor veneration, destiny, and divination.

In July 1998 Chief Ifayemi visited Archer again as the guest of Ogunleye and Botanica Ifalola. This event was co-sponsored by Ifá Culture Center in Meddletonville, North Carolina, and *Mahogany Revue* Foundation, a central Florida African American newspaper. In November 2002 Elébùìbọn returned to Archer as a part of his North American circuit. Ogunleye arranged the visit to enable family members, adherents, and clients to perform specialized rituals with the more experienced babaláwo and to serve as a planning session for a more extensive visit to the area by the master teacher. On the 2002 visit he remained in the Archer area for about five days and performed Ifá consultations and rituals for twenty-two people of different ages, ethnicities, genders, and nationalities, including white and black Cubans, a Jamaican, and African Americans. Three American-based babaláwos, who had previously been initiated at Elébùìbọn's Oṣogbo compound, assisted with the rituals. Elébùìbọn returned to the Florida communities during the summer of 2005 to initiate three women and a man. Two of the women were to be initiated into the Òṣun priesthood. One woman and the man were to be initiated into the Òrìṣànla/ Obatala sect.

Seven Òrìṣà or a Single Òrìṣà?

In the Santería/Lukumi tradition, initiates receive seven òrìṣà and are instructed to care for and serve all seven. Elébùìbọn gives a single òrìṣà or the òrìṣà that guides the head of the *iyawo*, much in the same way that Adefunmi had begun to practice in Oyotunji. While Oyotunji and Oṣogbo adherents initiate to a single òrìṣà, divination may indicate after initiation that some òrìṣà may require initiates to receive more than one òrìṣà in order to balance their lives or to aid in the work that their kismet dictates they perform. It is only for this reason that both Adefunmi and Elébùìbọn would give additional òrìṣà to initiates—only at the injunctive of Ifá.[6]

Initiation: Ceremony, Ritual, and Performance

Ceremony, rituals, and performance are central to the practice of indigenous Yoruba cultural expressions. Initiations acknowledge phases of transformation and are references to hierarchy and tradition. Tales and allegories that allude to creation and the beginning of humankind, which took place in Ile-Ife according to Yoruba beliefs, are woven into the Ifá myths (*odu*) given to initiates during divination, more recently addressed in the volumes of literature on Yoruba mythology. Many of these are seemingly fantastic and epigrammatic, but they are the substance of Yoruba cosmology and theology.

Elẹ́bùìbọn is a master teacher and brings his vast knowledge of Yoruba traditions, performance, and history to his clients. He plays an active role in the understanding of initiation, ceremonies, ritual, and religious performance in a number of diaspora communities. His pedagogy reinforces and strengthens the African diaspora's interest in Yoruba culture and traditions. By placing emphasis on what he terms "traditional," Elẹ́bùìbọn aids diaspora students and clients to make connections with an African past—a past until now largely situated in slavery and void in its connection with an indigenous African-inspired ethos.

In initiations, most of the people brought to the grove or "room" to receive òrìṣà have no idea what the rites will entail. This "unknowingness" is partly due to the fact that the uninitiated are forbidden to enter the sacred space and partly because what goes on in that space is regarded as sacred and secret. The mysteries are the reserved privilege of priests and officiates who conduct the rituals. Access to this specialized knowledge distinguishes priests from mere adherents. Except for extraordinary cases, neophytes are required to pay the full cost of initiation in advance, a price usually amounting to several thousand dollars.[7] In rare cases the òrìṣà demand that a person be initiated at no cost to the initiate. Elẹ́bùìbọn allows for some payments to be made in installments. Because he is based in Nigeria, payments are usually sent to him via Western Union.

Ceremonies and rituals performed during initiation are intended to disrupt and disorient the initiate's consciousness and to reinstate the individual as a newly created being. For most of the millions of priests/priestesses in the Yoruba diaspora, this disruption usually begins with an Ifá consultation with a babaláwo or a *merindilogun* reading (sixteen cowry shells) with a priest, and the person is sometimes advised to participate in some level of initiation. Individuals are drawn to consultations for any of a number of reasons. Some seek advice about health issues; others come with concerns about finances, legal matters, relationships, and/or cultural/spiritual development. Most attendees are informed that some ritual may include an offering to an òrìṣà or that sacrifice must be performed. Such oblations may be as simple as a presentation of fruits, or it may involve the sacrifice of an animal, usually a fowl or a goat. The formulation of the necessary ingredients is determined during the consultation. The offering is usually concocted and administered by the attendant priest or babaláwo.

The Initiates

The three women initiated in the 2005 event chose to be connected to Elẹ́bùìbọn and Oṣogbo-styled rites of passage as opposed to the types of initiation normally available in the United States. They chose Elẹ́bùìbọn as officiant

primarily because of his vast experience with teaching, his writings on Yoruba traditions, and his relationships with their sponsors, all of whom were student *awos* of the babaláwo. Deference for their personal destinies and sociocultural heritage are at the core of the three *iyawos'* rationale for being initiated. For them initiation signifies a redemptive solution to an African ancestral past and a connection to progenitors situated at the forefront of the creation of all life. The three women wanted an experience that was disconnected from the Cuban Lukumi rites practiced in the United States. At the same time, they wanted what they considered a more "authentic" Yoruba investiture.

Two of the women were dedicated to Òṣun. Both had made previous pilgrimages to Oṣogbo and had visited Òṣun's grove there, had bathed in her sacred river, and had propitiated the òrìṣà in order to enhance their lives. One of the two had spent time at Elébùìbon's compound, where he had performed Ifá divination for her and had made sacrifices and offerings to various òrìṣà on her behalf. Although the third had neither been to Yorubaland nor met Elébùìbon, she was aware of him through Elébùìbon's godson, Onabamiero Ogunleye, the spiritual father of Ifalola Compound, where she had received her introduction to Yoruba culture.

All three *iyawos* are professional women affiliated with academic institutions. The transformations they sought through initiation included enhancements in both their professional and private lives. *Iyawo* Tolu works at Columbia University as a researcher for a project in which she counsels African American couples when one partner is HIV positive. At the time of her initiation, *iyawo* Wembe taught African and African American history at Benedict College in Columbia, South Carolina. She was also working toward the PhD through the University of Texas, specializing in Yoruba history. *Iyawo* Talabi teaches math at a large college in north-central Florida and would eventually like to work in a profession that promotes healing and well-being.

In addition to their interests in the healing arts, each of these women is a cultural teacher. Each has created for herself a life that personifies and displays her intent on an African presence. The clothing they wear, the ways in which they accessorize their bodies, the environments they have created for living—all express their moral and social values and speak to their focus and commitment to their own well-being and the well-being of others. These ideas are at the heart of what Ifá teaches. In addition, engagement in some form of artistic expression and/or the healing arts is a common point of interest with many of the adherents in the various communities in which I conducted my research.

Initiation for each of these women began the moment she agreed that it was time to receive òrìṣà. Because of my long-standing relationships with *iyawo* Tolu and *iyawo* Wembe, I was involved with helping each to work out logistics and helping to resolve some of the issues determining their decisions to be

initiated at the time. I had previously discussed the possibility of traveling to Oṣogbo to Elébùibọn's Compound with each. *Iyawo* Tolu and I had determined to make our journey during the summer of 2006. Elébùibọn's presence in the United States, however, seemed providential and pushed everyone's initiation agenda forward.

Preparation

Organizing the event took several interstate phone calls to the women, who were located in Florida, New York, and South Carolina, to their sponsors in Florida and North Carolina, and to Elébùibọn, who was in Los Angeles at the time. Elébùibọn carries two cell phones with him at all times, keeping him connected with family members in several different countries and with his network of student priests and clients. His phone is constantly busy as he negotiates consultations, arranges rituals, and settles payment arrangements. His travel and living arrangements are managed and paid for by those who commission his services. In the case of this initiation, the sponsors and three *iyawos* were responsible for paying his expenses and making all of the travel arrangements.

The women formed a network and divided tasks of locating and acquiring the various items they were responsible for providing. Preparations for the three involved shopping for clothing to be worn in the initiation room and clothing to be worn during the subsequent coming out ceremony. They also had to purchase white sheets and towels as well as vessels to be used to house their òrìṣà objects and to contain water. All of the items had to be new.

In addition to purchasing materials and clothing, each *iyawo* had to arrange leave time from work, make travel arrangements, and participate in a number of conference calls with Elébùibọn to determine which òrìṣà will guide each *iyawo's* head. After getting the necessary information from the women, Elébùibọn was able to ascertain details through consulting Ifá.

The women also made financial arrangements to cover expenses of traveling, cost of the actual initiation, and cost of any other services that might be required that were not covered in the initiation cost.[8] An example of this is the receipt of *ikin Ifá* by *iyawo* Wembe and *iyawo* Talabi immediately following their initiations to Òṣun and Obatala. *Iyawo* Wembe also wanted to receive Ori but decided instead to do it at another time.[9] The final cost paid by each *iyawo* for the services rendered during this initiation was approximately five thousand dollars. The money was parceled out to Elébùibọn during the several different phases of the ceremonies and was paid to him in cash. Elébùibọn was to bring the items that were unavailable locally and had to be brought from Nigeria, but the three sponsoring babaláwos were responsible for providing the animals, condiments, and several of the objects that were to be used.

In addition to the preparations by the *iyawos*, the supporting cast of babaláwos had to make preparations as well. Although it is not nearly as difficult as in urban areas, locating and procuring animals always takes special planning. Because no one had ever been initiated at this site before, the babaláwos had no real idea of the exact number of pigeons, roosters, hens, guinea fowls, goats, and snails required. The best we could do was estimate based on previous rituals. We knew about the items that the òrìsà we were working with normally requested or accepted. Between the three of us we had many of the required items. However, our approximations were inaccurate and we had to go in search of animals and items several times during the actual initiation rites. The inventory of animals and fowls needed for the rituals necessitated several trips to vendors as far as fifty miles from Archer.

There are certain rituals that Elébùìbọn refuses to perform outside of Nigeria. He asserts that the needed ingredients for these rituals are available only in Africa and in some instances are found exclusively in Nigeria. However, items that were once rare and difficult to acquire outside of Africa are becoming increasingly available through online purchases, from itinerant vendors who specialize in indigenous African products, and in specialty shops that import African products and goods. Various objects such as condiments, livestock, herbs, and food items are essential to the formulation of the sacred initiation rites. While many of the required initiation ritual condiments are items that might be suitable for general household use and many of the food items may be found in the diets of people who practice indigenous religions, others were not so easily found.

The Event

The three women traveled from their homes in New York, South Carolina, and Florida to Ifalola Compound in Archer, Florida, to be initiated. Although they had communicated with each other via the telephone, their meeting in Archer was their first face-to-face encounter.

During the initiation of the three *iyawos*, I was able to participate in and observe the processes that enabled the women to gain entrance to the gateway of self-discovery, personal transformation, and historical knowledge as Elébùìbọn divined for each of them. His assistants performed the requisite rituals.

The ritual space in which the lives of the *iyawos* were to be transformed was small, and the instruments used to perform the feat were few. The space created and engineered by Onabamiero approximates Elébùìbọn's own temple room in Oṣogbo (see figs. 19.4 and fig. 19.10). In it are kept his families' spiritual shrines, objects for ancestral spirits, Eṣu, Ifá, Òrìṣànla, Ori, and an assortment of ritual paraphernalia. Onabamiero constructed an adjacent room for

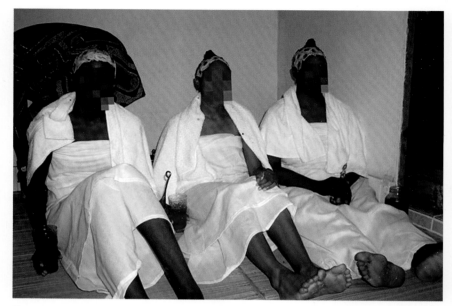

Figure 20.2. During the four-day initiation period each of the *iyawos* had to be dressed in white clothing and remain in the initiation room for instruction and rituals at Ifalola compound. Photo by Ade Ofunniyin.

the *iyawos'* initiation and expanded the space to accommodate the ritual/ceremonies (fig. 20.2). It also served as a space for the *iyawos* to sleep, meditate, and receive instructions during the four days. All of the women wore white during the two nights that they stayed in the room. They lived under ritual proscriptions as they received guidance and instruction from Elébùìbọn and his assisting babaláwos and as sacrifices were made and rituals observed.

At the end of the initiation period a coming-out festivity took place, which was a joyous period of time and a celebration that was opened up to the broader community, including both practitioners as well as interested friends. For this occasion, each *iyawo* wore new clothing symbolic of the òrìsà to whom she had been dedicated. For example, for their coming-out attire *iyawo* Tolu and *iyawo* Wembe each decided on two outfits, one yellow and the other green, colors corresponding with Òṣun's colors. Since *iyawo* Talabi's guardian òrìsà is Òriṣànla/Obatala, whose sacred colors are white, she wore white clothing for the entire affair.

Conclusion

Despite the fact that an increasing number of people choose to have their rites performed in Yorubaland or by a babaláwo or priest from "home," this choice does not come without controversy. Cuban-styled Santería/Lukumi rites dominate the òrìsà worldview in the United States.[10]

After the intense four-day event involving ritual proscription, ceremonial activities, sacrifices, divinations, and intense learning, each *iyawo* feels that the initiation event established her as the person she is intended to be and aligned her with the ancestors and the òrìṣà, giving her the mind-set to fulfill her own destiny. *Iyawo* Wembe, Wimilawe, crowned Òṣun, married Tejumola, the man that Ifá indicated she would wed. She earned a PhD in history from the University of Texas in 2009, having completed her degree requirements in three years. At the time she was pregnant. In fact, her healthy son, Akin, was born shortly before her defense, and she was nursing while she defended her dissertation. As her sponsoring babaláwo for the initiation, I attended her exams, providing support and witnessing her triumphant success in a typical graduate student and faculty adviser struggle. *Iyawo* Wembe credits the guidance and clarity that she received during counsel with her ancestors, with the òrìṣà, and with the elders that sustained her through the process. Wimilawe is now a practicing priest and provides counsel to others. Her husband, Tejumola, was initiated into Ifá at Elébùìbọn's Oṣogbo temple during the time that Elébùìbọn was installed as Araba of Oṣogbo.

Orisatolu, the eldest of the three *iyawos,* was also crowned Òṣun. Her reasons for coming to initiation were layered. According to her story, she had haunting visits from her deceased grandmother. In addition she had been experiencing some debilitating health-related issues. Her relationship with her son was not the best, and she was estranged from him, her daughter-in-law, and her grandaughter. Moreover, her mother was experiencing dire health problems. Orisatolu also credits the balance brought about by her initiation and the impact of the òrìṣà in bringing about the positive changes that have taken place in her life over the past six years. Much has shifted in Orisatolu's life. Her mother, now much healthier, lives with her in her Harlem apartment. Her relationship with her once-estranged son and granddaughter has improved dramatically, and she recently returned from a cruise with them. Other areas of her life have changed; she will soon retire from her job as a counselor at Columbia University and plans to work as an artist, using her creative talents to heal others.

While I have not been in communication with Orisatalabi, the reports I received from her godsisters tell of a life that has been enhanced greatly. She continues to teach at a local college and is pursuing another graduate degree.

As a participant observer, my interests go beyond the merely academic. Many people still have no knowledge of òrìṣà worship or any other African tradition, yet a sizable portion of the world's population has been introduced to the practice by means of personal contact, through literature, or via the internet. Information on the òrìṣà has overwhelmed cyberspace. Hundreds of videos and photographs can be viewed online and in some instances downloaded and used as instruction for practice. While information such as that

contained in this chapter may serve to create a more informed public, I suggest it can be used in other ways as well. After many years of practice, I recommend a deep study of the subject to anyone who might be earnestly interested in developing a deep understanding of òrìṣà, of ancestor reverence, or any other African religious tradition. I believe that spiritual development is a lifetime work, and deciding to investigate does not have to be brought about because of some crisis or other urgent need. One can come just to praise, honor, and serve.

Notes

1. New-age groups are emerging that perform initiation rites that deviate from conventional practices. Those performed by Chief Ifayẹmi Elébùibọn adhere to traditions practiced in the Nigerian homeland.

2. See chapter 19 in this volume for additional information about Ifalola and the Ogunleye family.

3. The controversies between Adefunmi and Cuban practitioners of Yoruba religion were later underscored by Elébùibọn, who states that while he was advising Cuban babaláwos in Miami, they warned him against going to Harlem to work with the "blacks." He found their interdiction to be not only odd but also offensive. At one point during our discussion he pointed to his arm and exclaimed, "The people that I was being warned against, look just like me" (August 2, 2005, interview with Elébùibọn).

4. Among the books Elébùibọn has written are *The Healing Powers of Sacrifice*; *Apetebii: The Wife of Orunmila*; *Adventures of Obatala 1 & 2*; *Poetry Voice of Ifá*; *Ifá, the Custodian of Destiny*; *Invisible Power of Metaphysical World: A Peep into the World of Witches*.

5. D. H. Brown, *Santería Enthroned*, 94. Elébùibọn remembers this experience as troubling and controversial.

6. For more details on Santería/Lukumi initiation customs see Matory, *Black Atlantic Religion*.

7. Santería/Lukumi initiations might cost as much as ten thousand dollars. In a few exceptional cases, priests perform initiations at no cost or for whatever amount of money the initiate can afford. In some cases, remuneration is worked out in service to the community.

8. Such additional services sometimes include rituals that come up during any one of the several readings that are performed during initiation or receiving multiple òrìṣà.

9. It is often the case that during the Ita ceremony Ifá advises that additional work must be performed and/or additional òrìṣà must be received to fortify the life of the recipient. Elébùibọn usually advises that time and long life is the favor of Ifá.

10. For more on this system, see D. H. Brown, *Santería Enthroned*.

21

The Sacred Space of Ola Olu

A Neo-Yoruba Site near Crescent City, Florida

Robin Poynor

As one drives along the narrow, sandy, two-path lane into the woodland sanctuary of the Ola Olu retreat, the dramatic form of a large metal bird with bulging eyes, its huge beak open to reveal a wavy, pointed tongue, seemingly rises on diaphanous wings from a circular trench (fig. 21.1). During ritual occasions in which the bird image is used, a fire is built in the trench, and the creature appears to emerge spectacularly from a nest of smoke and flames.

While the bird imagery seems to relate immediately in the Yoruba-conscious mind of visitors to the concept of *aje* and to ideas of women's power, its intention at the Ola Olu retreat relates instead to the almost universal concept of the Phoenix. Philip Neimark, founder of the Ifa Foundation of North and Latin America,[1] purports that all ancient philosophies expressed basic truths in metaphorical tales or myths. One of these, which Neimark sees as having enormous significance to the continued development of the Yoruba-based philosophy of Ifa, is that of the Phoenix. In many ancient mythologies, the Phoenix builds a nest to occupy and then sets it afire. As the conflagration reduces the bird and nest to ashes, a new, young Phoenix arises.

The Phoenix garden is but one area in the constructed environment in central Florida, the Orișa Gardens of the Ola Olu retreat. The gardens and retreat reflect both great respect for the original ideas of the Yoruba religion and also the possibilities of invention required for a new time and a new place. For example, the introduction of the Phoenix imagery demonstrates an eclecticism that may be seen elsewhere in the gardens. In addressing the Phoenix imagery, Neimark states that he sees the ending of an era in today's world and "the beginning of the birth of a vibrant new stage where the new values cast out the old."[2] Neimark suggests that it is "not the end but the beginning of the next evolutionary imperative." The philosophy of Ifa, he claims, was designed to recognize, adapt to, and embrace change "through the inherent flexibility

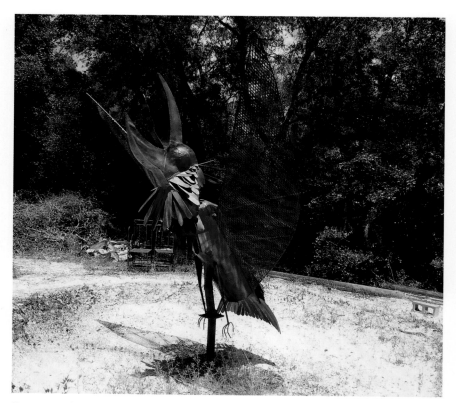

Figure 21.1. A large metal Phoenix emerges from the earth as one approaches the Ola Olu retreat in central Florida. Photo by Robin Poynor.

and adaptability of the eternal living energies it is composed of." Change is intrinsic, and "every aspect of Nature exhibits constant dynamic movement designed to achieve, or maintain, Balance."[3] The Ifa Foundation states that energy as it is conceived in Yoruba religion is timeless and universal but that it remains fluid and adaptable. The applications of these basic energies, Neimark maintains, "depend upon the time, culture, character and technology of those using them."

In a 1977 essay on the festivals in the Yoruba city of Ila-Orangun, John Pemberton noticed that,

> while the *orişa* in the diversity and individuality of their persons and attributes may be understood as providing an explanatory system and a means for coping with human suffering in one of its specific modes, it is when one considers the pantheon as a whole, as a total system, that one discerns that the total assemblage of the gods, known through their festivals and shrines, expresses in its totality a world view. And it is in the reality of this world view that Yoruba experience is given coherence and meaning and the tensions and dilemmas of life are surmounted.[4]

It is that totality, expressed in numerous shrines, which the Orisa Gardens at Ola Olu attempts to recognize. While each "garden" at Ola Olu works as a shrine or altar dedicated to a specific manifestation of an energy (aṣe) known as an orisa, the combined gardens reference aṣe in general as the combined energy of the cosmos.

This chapter addresses ideas and visual images used in the context of the Florida-based Ifa Foundation of North and Latin America, especially as they are manifested in Ola Olu. Ideas of continuity and respect for tradition work together with those ideas suggested by Neimark that have to do with change and adaptation.

The individuals and groups who use the wooded facility located near the Ocala National Forest in central Florida perceive it to be a place in which the energies of the universe as manifested in the Yoruba orisa are concentrated and amplified through the rituals that take place there. Such energies are also transferred to or embodied in spiritual tools consecrated and made available by the Ifa Foundation and incorporated into ritual events in the gardens. The natural environment, consisting of gnarled and lush vegetation, has been modified by clearing paths to connect small openings in the forest growth for altars to various orisa or energies.

Such inventiveness and change, as suggested by Neimark above, have always been a part of Yoruba religious traditions. Even the origin myths of the Yoruba imply diaspora and proliferation. Expansion and extension of Yoruba culture are inherent in the name of the place where creation took place, Ile-Ife, which loosely translates as "the place of the spreading."[5] Over the centuries, the spread of Yoruba religious concepts has not always followed the paths one might expect—from Ile-Ife to other Yoruba kingdoms, to neighboring peoples, and eventually across the Atlantic. Over time, Yoruba gods, myths, music, songs, and drumming have all traveled. Strands of Yoruba thought have diverged and merged—even into the present. Today there is a worldwide Yoruba religion with many practitioners working in the contexts of numerous variations, but the "truths" of Yoruba religion manifest themselves in many ways.

Change is inherent as well in the concept of the orisa as a group and in their number. Yoruba traditions maintain that the gods number 201 or 401 or 1701. The "one" at the end of each large number suggests that there is always the possibility of an until-now-unknown orisa making itself known to humanity. An orisa of exceptional importance in one region may not be known in another. And there is always the possibility of a new manifestation or new insights regarding the energies of the world. The continuing change, flexibility, and inventiveness inherent in Yoruba religion can be recognized as it moved over time across West African geography, modifying as it manifested itself among various Yoruba cultures, as it blended into Fon culture, as it moved across the Atlantic to become Santería or Candomblé, where it blended with

religious belief systems from other African groups, and where for a time the orișa and corresponding saints of Iberian Catholicism merged to allow the veneration of the orișa to continue. Through it all, new imagery and new iconography made the religion relevant to those who used it in new times and in new places. New environments required different materials. New plants in new landscapes allowed for experimentation.

The genealogy of the Ifa Foundation can be traced from Nigeria to Cuba to Miami by way of Santería, and from Santería to a husband-and-wife team who have attempted to understand the meaning of the way of Ifa by looking back to Nigeria through study of written resources, through the mediation of a Nigerian babaláwo,[6] and through the Ifa system itself. Over the past forty years or so, Vassa (Iyanifa Olufadeke) and Philip (Oluwo Fagbamilia) Neimark have lived and worked in Chicago, Illinois, and Bloomington, Indiana. They have been in Florida since 2001. The Neimarks state that they started their exploration of Yoruba religion "partly out of need, partly out of curiosity, and partly out of dissatisfaction with what Western spirituality seemed to offer." Dissatisfied with their ventures in Lucumi[7] because of its secrecy and their objections to racial, sexual, and gender discrimination they perceived in that tradition, they made a conscious effort to find the African roots of the religion.[8]

Through interaction with Afolabi Epega, a fifth-generation babaláwo whose grandfather had recorded numerous *odu*, Philip Neimark honed his knowledge of orișa traditions and his divination skills. Those efforts eventually resulted in the founding of the Ifa Foundation in 1982. In 1993 Neimark wrote *The Way of the Orișa* as a way to introduce the concept of Ifa to mainstream America.[9] *The Sacred Ifa Oracle*, translations of *odu* by Epega with introductory material by Neimark in 1995, has made primary material available for both practitioners and interested outsiders.[10]

Along the way the Neimarks created Ola Olu in Florida as a spiritual retreat with shrines and gardens in which many initiations have taken place. Initiation, they say, is but the smallest of steps toward working knowledgably with the energies of the universe. Once introduced to the way, participants are encouraged to take part in Ifa College, an online effort to continue instruction and interaction among practitioners of Ifa. By bringing together a large group of individuals to share, learn, and teach, the college provides training and growth for initiates. Those involved in the Ifa Foundation come from an amazing geographical range, including not only North America but also South America, the Caribbean, Eastern and Western Europe, and Asia. Although many participate only through web interaction, others visit central Florida to take part in ritual activities at Ola Olu. Iya Vassa is primarily responsible for the retreat and its activities. While her own acts of devotion to the orișa and the ancestors take place daily in her home, further meaningful interaction

with the energies that are of interest to the Neimarks finds vital expression in Ola Olu.

The concept of the central Florida retreat is not entirely new. Before arriving in Florida, the Neimarks had created such a retreat in Bloomington, Indiana, which they used for approximately eight years. One of the reasons they decided to relocate to Florida was for the warmer climate where the functions of an outdoor retreat area would be more welcoming and allow year-round use. On leaving Bloomington, key stones were chosen from each altar and crated to be taken to Florida to create the bases for altars in the new site.

The retreat is located outside a small town in central Florida. Its rural location and its isolation were considerations in selecting the site, but the ease of transportation because of its being near Orlando was also a factor. The retreat includes nine secluded acres on a small lake. The Neimarks state that it offers "the utter peace and serenity required for ceremonies and initiations." For them, such a site is preferable to those settings in basements or garages where many oriṣa initiations have taken place on this side of the Atlantic. Their viewpoint is that Ifa is a philosophy based in nature and that the energies with which they work are best "embodied and learned in a setting without televisions, car alarms, sirens or noisy neighbors."[11]

In some ways, creating such a retreat in nature is not unlike the concept of organizing the "sacred grove," a location that is so important in many West African religions. The Yoruba are known for their urban lifestyle. In the urban conglomeration they maintained a tradition of government by kings, who were in turn supported by an administrative chain of command consisting of palace officials, chiefs, and elders. The emphasis on being urban was primary among the Yoruba, but at the same time there has always been a great respect for nature, the forest, and the powers and energies of the wilderness. Yoruba healers have a special relationship with the forest, where they have traditionally harvested pharmaceutical roots, barks, and leaves. A number of oriṣa are closely associated with the wild, especially healing deities such as Osanyin and Erinlè and the hunting deity Òṣóòsì.

But the urban Yoruba make a distinction between going out into the forest to collect or to gather powers and actually living there or staying for prolonged periods of time. For centuries the Yoruba have thought of themselves as an urban people, and one does not retreat to the forest unless one is a hunter or has other reasons for entering the wilderness. In some instances, however, the forest has been brought into the Yoruba city. The two best examples of wilderness introduced into the Yoruba urban environment are *egúngún* groves in or near cities where preparation for *egúngún* events takes place, and the background forests of Yoruba palaces. The background forest of the palace at Owo, for example, at one time approached one hundred acres in size. It was

there that herbalists of the palace could collect ingredients for healing and protecting. It was large enough to allow for hunting as well.

Neimark sees Western urban conglomerations as being distinctly different from Yoruba traditions of urban complexes. The focus in the Western worldview on the role of the individual and the separation of the individual from the whole is troubling to him. He sees the idea of individual supremacy as paramount in Western civilization. In the West in recent times, a different way of thinking about nature and the forest or wilderness has developed. In a number of instances in which Yoruba religion has been adopted, participants have rejected the urban environment to relocate to rural settings. Walter King experimented with practicing Yoruba religion in New York, but he eventually felt the urban setting was too constraining. He moved to the wilds of South Carolina to establish Oyotunji in a woodland setting. The houses and temples are placed among trees, and the forest surrounds the community. In north Florida, practitioners such as Baba Onabamiero Ogunleye, discussed in chapters 19 and 20, have located themselves on secluded acreage surrounded by forest.[12]

Although the Neimarks live in a comfortable home in a suburban setting in Ormond Beach, Iya Vassa states that "in order to begin to understand, feel and restore ourselves to the proper relationship with Nature, we must once again become part of it." Like the founders of Oyotunji in South Carolina, the Neimarks felt that practicing Yoruba religion is not easily accomplished in urban centers such as Chicago, New York, Los Angeles, London, or Paris. Iya Vassa says that metropolitan areas in the West exude an "overwhelming dissonance of energy" that makes it virtually impossible to practice the religion. Neimark says, "Instead you MUST find the time to place yourself in a quiet, natural environment, an environment where the sounds of car horns, sirens, trains and planes cannot be heard."[13]

Ola Olu is conceived as a spiritual retreat and teaching center where initiations and ceremonies take place. Hidden in the woods off a limestone road, the private space allows ceremonial work to be done with freedom. The Neimarks believe that the energies of Native Americans and escaped African slaves who once lived in the area make it an especially energized space, a "spiritual vortex." The rustic teaching house stands on stilts overlooking the small lake and gardens. Teaching can take place beneath the house, and initiates can rest there between activities. The upstairs portion is a comfortable, home-like space where initiates sleep and study.

The Orișa Gardens are located throughout the property, and openings in the forest cover are dedicated to a variety of "energies" as the Neimarks refer to the orișa. They include Èṣù, șigidi, Aje, Ela, Osanyin, the ibeji, Șango, the ancestors, Nana Buuken, Oya, Oṣun, Yamonja, ori, Ogún, Òṣóòsì, Oke, Orișa Oko, Orunmila, and Obatala. While the gardens are not at all like anything one

would see in a Yoruba city in Nigeria, in some ways the layout of the Oriṣa Gardens might call to mind the traditional layout of a Yoruba family compound as described by John Pemberton, who examined shrines at Ila-Orangun in Nigeria:

> At the entrance of almost every compound of Ila-Orangun there will be a small laterite rock protruding from the base of the wall on the right of the passageway. It may have a bit of yam flour on it or kola or have recently been moistened with palm oil. It is the entrance shrine for Èṣù. . . . Within the compound . . . there will be numerous *oriṣa* shrines. Some . . . are shrines of importance for the entire community, places where the annual festival is celebrated. Other shrines are tucked away in the recesses of an inner room, reflecting the sacred world of an individual worshiper. . . . a shrine for Osanyin, *oriṣa* of medicinal herbs, another for *oriṣa* Oko, god of the farm, and another in the open courtyard for Ogún.[14]

Similarly, Ola Olu is laid out with Èṣù at the front, while shrines for the other energies are placed here and there (fig. 21.2). When one turns off the rough limestone road into the property of the Ifa Foundation, a twisting, two-rutted drive leads into the woods. Once out of sight of the public road, the first evidence that this is not merely a forest home or a camp is a circular yellow sign carved in the shape of a divination tray proclaiming "Ola Olu." Further into the property the Phoenix bursts from the ground, acknowledging a new age (fig. 21.1).

As one approaches the house-on-stilts, to the right of the drive, tucked behind undergrowth and surrounded by trees, a small clearing contains the shrine to Èṣù (fig. 21.3). Rather than the piece of lateritic rock used in Yoruba compounds and marketplaces to receive offerings to Eṣu, the Èṣù at Ola Olu seems to be modeled more after the form used for Legba in Fon territory in the Republic of Benin. The large conical mound, made of concrete, is personified by large cowry shells for eyes and another large seashell for the mouth. A cow horn curls out of the top of the head. Scarification marks are incised into the surface of the cheeks. An oversize metallic key forms the bridge of the nose and nostrils. Spikes project from the face of Èṣù in all directions. Black pigment mixed with the surface coat of concrete gives Èṣù his signature black color. Remnants of cigars smoked in rituals remain in his seashell lips. A multitude of smaller Eṣu fashioned in conical forms of cement or from containers—small metal kettles, ceramic vessels, or seashells—their surfaces enlivened by cowry features, line the path to the shrine while others form a semicircle in front of the central figure. Standing in the forest behind the large Èṣù, three decorative metal roosters stand at attention and silently crow to announce his presence—messengers of the messenger. In rituals, objects from Nigeria such

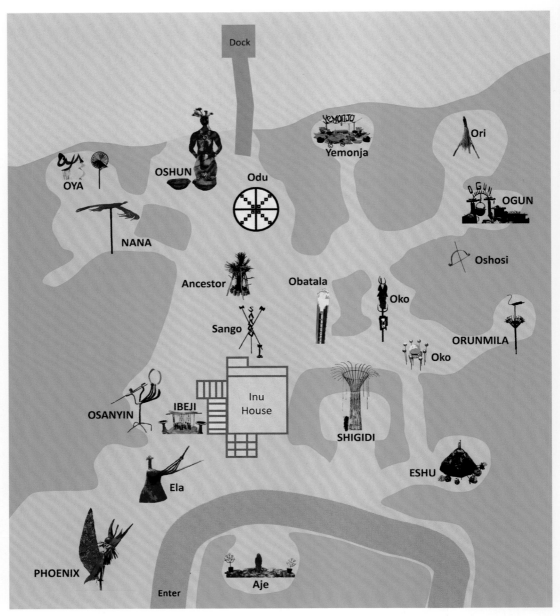

Figure 21.2. The layout of the Ola Olu retreat includes numerous "gardens" connected by paths through the lush forest growth. Diagram map by Chen Yin-Hsuen and Robin Poynor, based on a diagram by Iyanifa Vassa.

as Eṣu hooks and figures representing Eṣu are placed near the large concrete figure.

This garden/altar/shrine suggests in miniature what happens in the gardens in their entirety. The shrine is a locus of energy. It is the focus for initiates to interact with that energy. Objects—tools and images—have an assortment of origins. While the small wooden sculptures and hooks come from Nigeria

and are created by Yoruba artisans, the mound representing Eṣu is modeled af-
ter similar forms in the Republic of Benin and resembles the miniature figures
used in Santería in Miami. The range of forms of the smaller Eṣu figures relate
to forms found throughout the Yoruba diaspora. The roosters behind the altar
are purely "American gift shop" in origin, but they aptly reference the bird im-
agery so important in Yoruba thought, and perhaps the role of the rooster as
a herald or announcer can be stretched to suggest Èṣù's role as divine herald or
messenger. The cigar butts, remnants of ritual, reflect Cuban Yoruba practices.
Thus in the garden we see an eclectic blend of Yoruba, diaspora, and inventive
forms that allow the devotee to experience the energy of Èṣù. The means of
identifying and approaching the oriṣa may be flexible and interpretive, reflect-
ing the ideas emphasized by Neimark about the dynamic and fluid nature of
the Yoruba way.

Other gardens are defined for other energies. Locations are carefully chosen
based on the relationship of the oriṣa to each other or to the natural phe-
nomena. For example, Yamonja/Olokun and Oṣun, all associated with water,
are at the edge of the lake. Òṣóòsì and Ogún, closely related, are next to each
other in the depth of the forest. In some of the spaces Iya Vassa has created
name plates cut from steel to identify the shrine site with the occupying oriṣa.
Spaces are organized as well with appropriate forms and colors. For example,
the shrine of Yemonja/Olokun, near the water's edge, is embellished with blues

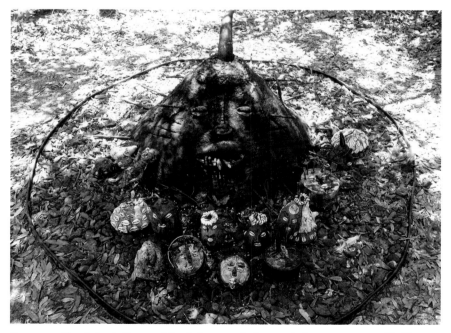

Figure 21.3. The shrine to Eṣu consists of a large conical mound of concrete, personified by a
face made of shells and other materials. Cigar butts remain in the mouth, left from recent ritu-
als. Smaller Eṣu figures nestle at the base of the large figure. Photo by Robin Poynor.

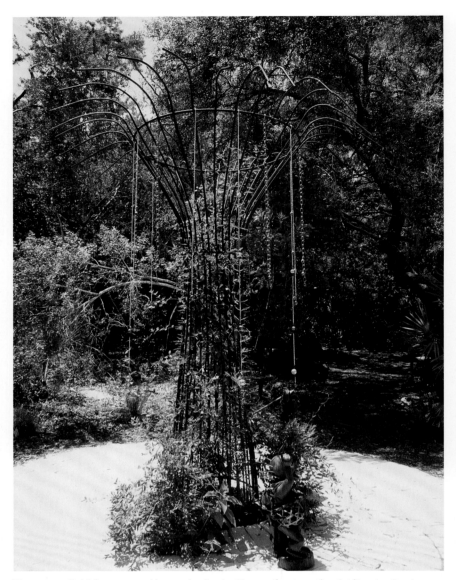

Figure 21.4. *Şigidi* figures stand beneath what Iya Vassa refers to as the *şigidi* protection tree. Wooden sculptures placed near the "tree" are imported from Ghana but are modeled on Kongo *minkisi* from Congo. Photo by Robin Poynor.

and whites and seashells. Oşun's space is adorned with yellows and bronzes and decorated with brass objects. Spiritual tools left in place from rituals vary depending on the occasion and the orişa for whom they were used.

Near the Èşù garden, a tall quasi-cylindrical form of iron rebar, its upper portion flaring out in a funnel shape, is covered in blooming coral honeysuckle vines (fig. 21.4). Chains with attached bells and decorative elements drop from the top of the form to dangle over the heads of carved wooden figures whose bodies are activated with metal blades. Iya Vassa refers to this as the *şigidi*

protection tree. The wooden sculptures below, in the form of Kongo *minkisi*, are imported from Ghana.

Among the Yoruba of Nigeria, *ṣigidi* are spirit presences made of substance, action, and word. In most Yoruba communities they were fashioned of earth or mud, thus the common saying in Nigeria, "When *ṣigidi* wants to die, he stands in the rain." The purpose of *ṣigidi* in Yoruba tradition is to embody a spirit in an object so that it may be called on by an individual for protection or for revenge. The idea of *ṣigidi* is not unlike that embodied in *bocio* among the Fon of the Republic of Benin or in *minkisi* among Kongo-related peoples in the Democratic Republic of Congo and Angola. All involve the creation of a container filled with meaningful materials and activated through word and action to entice a spirit presence into it. That the Ifa Foundation uses forms associated with Kongo *minkisi* is entirely fitting then.

The Ifa Foundation view is that the role of *ṣigidi* is entirely protective. Neimark cites *Odu Idigbe*,[15] which states that *ifa* was cast for Orunmila when death and disease threatened to enter his house. He was advised to prepare two *ṣigidi*, each brandishing a cutlass and holding kola in its mouth. These were placed at the front door and the back door to hold death and disease at bay. The description of the *ṣigidi* in the *odu*, each with two hundred herbs sticking from its body and cutlass in hand, is suggestive of the bristly form of the *minkisi* imported from Africa for use at Ola Olu.

To the left of the retreat house, the area for Osanyin (or Osain), the Yoruba god of herbal medicine, is marked off by a wooden frame. Hanging from the cubical structure, gourds filled with substances and decorated with feathers and beads swing in the breeze. On either side of the entrance, forged iron birds modeled after Yoruba Osanyin staffs from Nigeria stand guard (fig. 21.5). Created by Yaw Shangofemi, an African American blacksmith who practices Yoruba religion, the birds stand on four-footed forms rather than being stuck into the earth as Yoruba examples are. The Osanyin staffs here derive from a Yoruba object that Yaw Shangofemi saw illustrated in Drewal's *Nine Centuries of Yoruba Art*. He has used the model as a source for a variety of sculptural forms, most used in the context of Yoruba oriṣa veneration.

As the Yoruba god of medicine, Osanyin brings healing through the use of herbs—leaves, barks, and roots—combined with divination and ritual activity. In Ifa Foundation practice, Iya Vassa has remarked on the many different ways of giving physical form to the energy. She refers to the different representations of this energy in both word and visual representations as well as in the many ways it works in daily life in the many cultures that have adopted it. Osanyin, as the oriṣa who derives powers from the forest, was instrumental in the layout of the gardens at Ola Olu (fig. 21.2). He was called on through divination to designate where the different spaces should be allocated to the various powers.

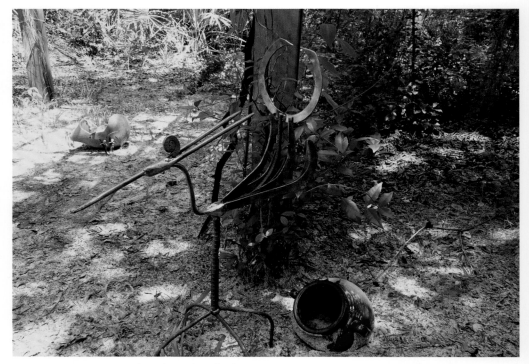

Figure 21.5. One of two forged iron birds that guard the shrine dedicated to Osanyin, the Yoruba oriṣa of healing and herbs. African American blacksmith Yaw Shangofemi modeled the forms after an image he saw in Drewal's *Nine Centuries of Yoruba Art*. Photo by Robin Poynor.

Across from Osanyin's structure, a small metal frame made of elements from wrought-iron gates supports palmetto fronds (fig. 21.6). In Nigeria, shredded palm fronds, called *màrìwò*, indicate a sacred space or sacred presence. Beneath the canopy of fronds, on a base made of concrete squares, *ibeji* figures stand at attention, facing outward. Imported from Nigeria, these carvings take on a variety of styles and degrees of finish. Some still show the light color of the wood from which they are carved. Others have been stained. A few have indigo applied to their hairdos or sandals. But none of them were used in ritual prior to their purchase by the Ifa Foundation. The Neimarks make a point of purchasing objects from Africa that have not been consecrated because they see it as their role to activate the objects in ritual at Ola Olu.

While the forms are produced by Yoruba carvers in Nigeria and are the same as those used in twin ritual in West Africa, the meaning varies. In Nigeria, *ere ibeji* represent dead twins. They are kept by the mother of the dead twin. Twin ritual in Nigeria is a family event that has to do with placating the soul of the dead twin for the good of the surviving twin and the family. In Nigeria, twins are often seen as somewhat contentious beings, demanding and hot-tempered.

In the Ifa Foundation, *ibeji* symbolize harmony, balance, and well-being. The Neimarks suggest that in Santería, children are associated with prosperity. And the Ifa Foundation idea of well-being derives perhaps from that. It is the Neimarks' contention that ritual in the past was intended to bring healing and balance after loss—to the spirit of the one that has passed but also to those who survive. The energy that was linked to a specific bereavement in traditional Yoruba culture has been generalized to bring healing and to restore balance after loss in general. The Ifa Foundation sees both *ibeji* ritual and ancestor veneration as rectification for loss. The energy of a dead child or that of an ancestor is still present and can connect to the living individual. The *ibeji* ritual is seen as especially pertinent to those who have lost a child through miscarriage, death, or abortion. Negative energies result from such loss, and the *ibeji* work to make the resulting pocket of negative energy dissipate.

The area designated for Nana Buuken activities is dominated by a mound over which a large forged-iron vulture crafted by Yaw Shangofemi seems to soar (fig. 21.7). During ritual in which women are initiated in Nana Buuken, a ring of fire surrounds the site. At that time, the mound is covered with an arrangement of tools created for each initiate (fig. 21.8). The crook-like *ileeshin* staff, made of iron and wrapped in raffia, is given to the initiate as a tool to protect her from negative energies that interfere with her clarity, keeping her from being thrown off balance and from succumbing to illness, connecting her to the power of her birthright as a woman. Nana Buuken has taken on

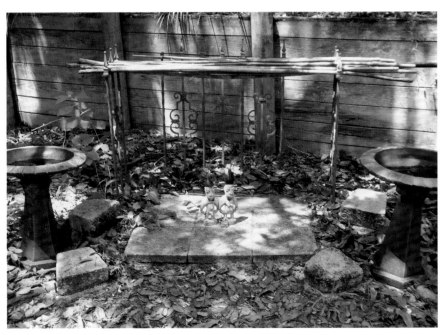

Figure 21.6. Twin figures imported from Nigeria stand in the shrine to the Ibeji. Photo by Robin Poynor.

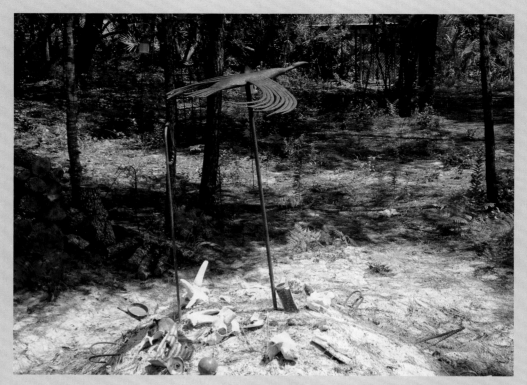

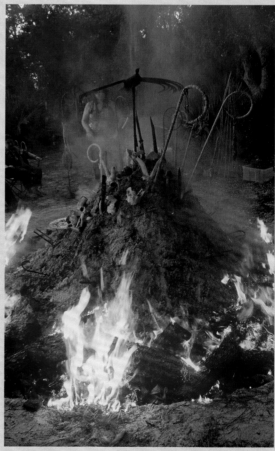

Above: Figure 21.7. A large forged iron vulture created by Yaw Shangofemi soars above the conical mound dedicated to Nana Buuken. Bird imagery in Yoruba is often associated with the powers of women. Photo by Robin Poynor.

Right: Figure 21.8. During Nana ritual a ring of fire surrounds the mound and it is covered with an arrangement of tools created for each initiate. Photo courtesy of IFA Foundation International.

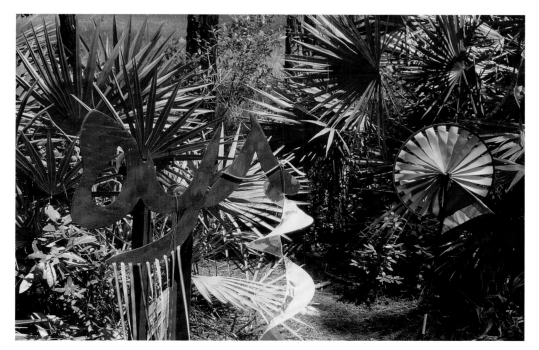

Figure 21.9. The shrine to Oya is identified with a steel nameplate. Numerous pinwheels, ribbons, and whirligigs announce the presence of the wind commanded by the deity Oya and her role as goddess of movement and sudden change. Photo by Robin Poynor.

particular meaning for Iyanifa Vassa, who has compared this energy to the collective powers of "the Mothers," a "reference and summation of the primal energies of being female."[16]

Oya is, according to the Ifa Foundation, "the matrix of the wind, the female hunter/warrior, the movement of sudden change as well as the marketplace." The shrine area at Ola Olu visually references the wind, each element intended to represent ideas of movement and change. Colorful pinwheels, ribbons, and whirligigs move with the breeze to announce the presence of the wind (fig. 21.9). While some transatlantic variations of the orişa tradition esteem Oya as the god of the cemetery, and she is a somewhat awesome being, here the rainbow colors on the playful tools express a certain joy and allude to concepts of movement and change.

The nearby zone established for Oşun is marked by a larger-than-life female figure cut from sheet metal (fig. 21.10). The sculpture stands boldly by the water's edge, broad-shouldered and wearing a warrior's necklace of curved forms suggesting claws or fangs. Heart-shaped breastplates adorn her chest, and an oval abdomen, created from the bladder from a discarded waterpump, alludes to some of the concepts associated with this water deity who is associated with both fertility and strength. The figure stands in a bed of rocks, suggesting a riverbed. A spray of peacock feathers forms her headdress. Oşun

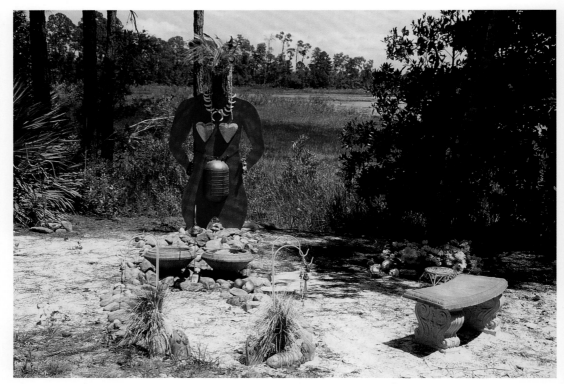

Figure 21.10. A large metal figure created by Iya Vassa symbolizes Òṣun, goddess of fertility and female energy. Since she is associated with the river Òṣun in Nigeria, the shrine in Ola Olu is set next to the water's edge. Stones beneath the figure allude to a streambed. Photo by Robin Poynor.

is usually associated with fertility and being female. She is a flirtatious deity. The Ifa Foundation sees Oṣun as a manifestation of joy. Her energy is not so much about pregnancy and motherhood as it is about the moment of orgasm that leads to conception and pregnancy.

The shrine site dedicated to Ogún, the god of iron and creativity, is visually striking with a large steel nameplate positioned over an assortment of metal forms (fig. 21.11). Functional objects from the nineteenth century and the recent past accumulate within an angular zone formed by concrete blocks. Positioned on either side of the gap between the low block walls, two large house-jacks support an arch from which a large iron crucible hangs. Several iron pots fill the space in front of the crucible. An assortment of iron tools and implements lie on the surfaces that top the walls. Throughout the Yoruba Atlantic world, altars to Ogún feature metal containers and metal objects. Here the collection of found metal objects expresses a number of the concepts associated with Ogún. The dominant material at the site, iron, references his being the god of iron and metal. His role as god of war is suggested by the fact that the large crucible was used in the nineteenth century for melting lead

to produce ammunition. His role as builder is alluded to by the large house-jacks that support the arch, and the concrete blocks suggest that role too. Iron objects such as spikes and other objects used on railroads associate him with transportation. Appropriately, Ogún is nestled in a heavily forested area near his companion, Òṣóòsì.

Vassa sees the shrine for Ogún, her patron oriṣa, as a powerful place, radiating strength, focus and creativity. In the Ifa Foundation, Ogún is the "muscle of how things are created," "the matrix needed for finding greater focus for the task at hand and the matrix that aids in more dynamic creativity in all one does." Ogún is deemed "the foundation required for moving forward."

To access the Orunmila site, one passes beneath an open pavilion on which a fringe of long white raffia strands wave in the breeze. A path leads from the pavilion to a small opening in which a single osun, created by Iya Vassa herself, stands. Recalling the form of the circle of birds topped by a larger bird seen in Nigeria, Vassa's are made of manufactured objects creatively arranged to make the recognizable form (fig. 21.12). Each bird head and body is made by bending and shaping an elongated metal bolt so that the top is the head of the bird and the rest of the threaded form becomes the body and legs. The wings, soldered to the body, are made of standard wire staples used for fencing. The sixteen

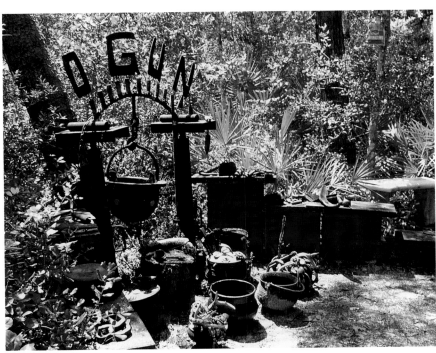

Figure 21.11. The shrine to Ogun, energy of iron and creativity, is identified by the large steel nameplate positioned over an assortment of metal implements and tools that reference Ògún's role as the oriṣa associated with metal, building, agriculture, transportation, and war. Photo by Robin Poynor.

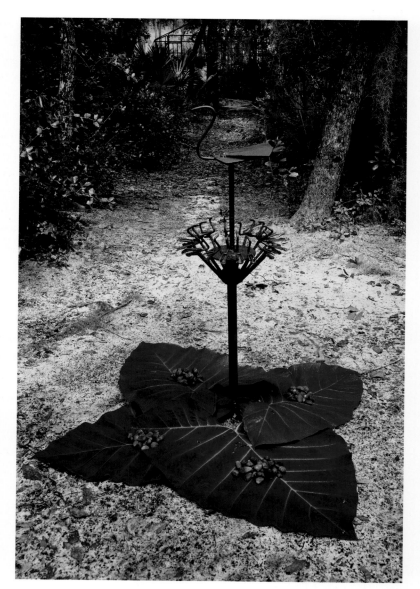

Figure 21.12. Iya Vassa created this sculptural form for the Orunmila garden from industrially made objects such as threaded bolts and steel staples. The object intentionally references the bird circles topped by a larger bird on staffs used by both healers and diviners in Nigeria. Photo courtesy of IFA Foundation International.

bird forms are attached to a metal circle suspended on a central rod of metal and are topped by a larger bird whose wings are shaped of sheet metal. Vassa interprets the larger bird above as symbolic of *odu* and sixteen birds below as the messengers, the *iyami*, the "mothers" of Yoruba lore.

Numerous visual forms are associated with the work of the Ifa Foundation—personal shrines, spiritual tools employed in rituals in that place, spiritual tools offered on the Ifa Foundation website, and the sculpture created by Iyanifa Vassa. All are used in personal devotion, in rituals of initiation

22 Igbo Masquerades in the Sunshine State

Amanda B. Carlson

Adighi ano ofu ebe ekili mmanwu.
(You can't stand in one spot to watch a masquerade.)
Igbo proverb

While ritual restrictions prevent certain African masquerades from traveling overseas, more and more communities have been allowing some masquerades to follow their members as they travel abroad. While masked performances have been adapted for the stage and performed for foreign audiences, the Igbo masquerades in Florida are a new type of cultural performance that is primarily for an African audience in the diaspora. They represent membership within a local community in Florida and a wider international "Igbo community," along with facilitating relationships with an individual's specific "hometown" in Nigeria. In Florida, masquerades are performed by Igbo organizations in Orlando, Miami, and Tampa that began forming well over a decade ago. These masquerades are the highlight of social events that celebrate Nigeria Day (October), New Yam Festival (August), and Christmas (December), among other occasions.

The meaning and importance of this tradition in Florida is in part tied to a broader Igbo consciousness that evolved from the social, political, and cultural atmosphere that characterized Nigeria in the 1970s—a critical time period when the prominent Igbo professionals in Florida began their diasporic journeys. It's not so much that individuals who support these traditions are "living in the past," as many of their American-born offspring might profess in moments of teenage angst fueled by a dilemma common to many first-generation Americans. Rather, members of Igbo organizations in Florida are using masquerades to feel Nigerian while living in America, to educate their children about their heritage, and to maintain a ritual system that allows for the advancement of social status in Florida as well as at home. These performances are more than nostalgic reminders of home.

For the most part, this is a story of prosperity and success among Igbos in contemporary Florida that diverges sharply from Florida's early history

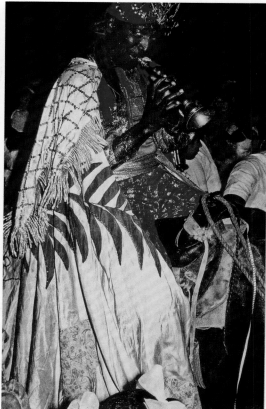

Figure 22.1. Masquerade and musician, Umunna Community Association of Florida, Orlando. New Yam Festival, Orlando Garden Club, 2003. The masquerade pictured here was accompanied by two bird masquerades. Photo by Amanda B. Carlson.

when the slave population included Igbos who encountered this land against their will. These two groups of Igbos are separated by time and circumstance; nonetheless, both are part of the story of Florida. Igbo masquerades in contemporary Florida offer a unique opportunity to study the development of a "diaspora masquerade" at the moment of its introduction. Studies that deal with "diasporic masquerades" are more typically about older traditions that are rooted in the history of slavery (thus mediated by circumstances of oppression and desire to overcome oppressive social systems) and that exhibit a spectrum of more or less recognizable characteristics attributed to Africa.

The historic influence of Igbo masquerade traditions in the diaspora is not as clearly identifiable as with Abakuá Íreme masquerades in Cuba (Efik/Ejagham) or Egungun masquerades in Brazil (Yoruba). Nonetheless, Robert Nicholls's research about the Igbo influences on masquerading and drum-dances in the Caribbean asserts that enslaved Igbos reinvigorated the masquerade traditions of the British Virgin Islands—originally introduced by slaves from other

regions of Africa—by infusing them with Igbo forms and concepts.[1] While African performance traditions were inevitably practiced in colonial Florida, they never manifested into lasting institutions such as Carnival in the Caribbean or Brazil.[2] Early Igbo influence upon Florida may not be identifiable, but that does not mean that it did not exist.

It is difficult to determine exactly what contemporary Igbos have in common with their ancestors who came to Florida before them. It may be the ability to utilize skills and knowledge rooted in a dynamic culture that adapts and transforms to meet new challenges. In general, Igbo masquerades, which are multimedia events that are notoriously open to wide-ranging interpretations, are highly adaptable and versatile in response to changing circumstances and political agendas. Contemporary Igbo masquerades in the diaspora are performed within prosperous immigrant communities that demonstrate political, social, and economic agency. These masquerades are rooted in the era of structural adjustment, characterized by the need to negotiate complex global relationships and identities, not in the eras of slavery or colonization/decolonization. The Igbo proverb "Adighi ano ofu ebe ekili mmanwu" (You can't stand in one spot to watch a masquerade)[3] speaks to the complexity of masquerades in the Sunshine State, which are impossible to view from one spot, either Africa or Florida. Therefore, my analysis begins with a discussion about Igbo identity and the development of Igbo Unions in Nigeria over the last fifty years and then situates the Igbo masquerades of Florida within this broader history of cultural practice and politics. After describing the vibrant social and political organizations that have evolved in Florida, I will discuss elements of masquerade performances in terms of continuity and change. My final reflection upon this new type of "diaspora masquerade" involves the role of video in terms of the production, distribution, and experience of cultural performances.

Nigeria: Igbo Unions and Masquerades

The Igbo, one of the largest ethnic groups in Nigeria, are actually made up several subgroups with distinct cultural and linguistic differences. An appreciation for the commonalities among Igbo peoples was not as strong in the past as it is today. A unified sense of Igbo ethnicity emerged in Nigeria during the colonial period in conjunction with the rise of Igbo Unions as a response to the political, social, and economic forces imposed by the British. Igbo Unions—mutual-aid organizations that provide financial assistance and other forms of support—are based on associations at the level of the village, clan, or town. The development of Igbo Unions was greatly affected by Igbos living in other parts of Nigeria or Africa where the Igbo diaspora nurtured associations to contest colonial power, support migrant communities, continue cultural traditions, and generate money to improve life at home.

Nigeria's Independence (1960) sparked intense reflection at all levels of society about the relationship between ethnic identity and an emergent national identity, whose conflicting objectives eventually lead to the Biafra Civil War (1967–70). Barth Chukwuezi explains that the war "spurred the outward-directedness of the Igbo. At the end of the war, many Igbo people were denied positions in the civil service and government parastatals [agencies]. Economic marginalization propelled them into the private sector where they specialized in trading."[4] This contributed to a large international migration of Igbos, many of whom were drawn to outward-focused opportunities as entrepreneurs of trade and business. This also included intellectuals and other professionals, which added to Nigeria's "brain drain." At the same time, a strong economy in the 1970s that was fueled by Nigeria's oil boom drew young Nigerians to universities in the United Kingdom and in the United States, where many became well established in their careers. This "tipping point" led to a sizable new diaspora and an "Igbo consciousness" that was carried by a generation of Igbo people who established Igbo organizations in the United States and continued to maintain ties to Nigeria. That "Igbo consciousness" was significantly informed by recuperations and reinventions of Igbo art and culture that spanned from the village to the studio and stage.

Igbo masquerade arts in Nigeria are rich and varied, differing from region to region. Igbo masquerades that are based in complex ritual systems have functioned as agents of law enforcement, as embodied images of ancestors or spirits, as educators, and as entertainment. Sylvester Ogbechie explains that "masquerades are the signifier par excellence of this Igbo idea that reality is inherently ambiguous and mutable. Masquerades exist in the interface between the worlds of human beings and spirits, and are imbued with a capacity for literal and metaphorical acts of transformation. They are metaphysical figures whose forms are endowed with divergent meanings depending on how they transform themselves in the context of ritual performance."[5] While most masquerades are performed for entertainment today, they continue to carry significant meaning for the community by expressing core cultural values and beliefs. Moreover, masquerades are often an identifying symbol for a village or town. Communities send their masquerades to burials or festivals in neighboring towns and to larger urban festivals in order to cement complex social and political relationships. Among the Igbo, masquerades and images of masquerades have been a prominent feature of indigenous responses to the political, social, and cultural shifts of the twentieth and twenty-first centuries.

In the twentieth century, the image of the masquerade became an important symbol of evolving pan-African philosophies that inspired artists and nations, well known as a central component of Negritude.[6] Masquerades signified the negotiation of traditional and modern identities and were used to

represent the idea of a quintessential African character. During the colonial era, artist Ben Enwonwu (1917–94) created some of the most famous images of masquerades and dancers that reflected a desire for an African renaissance that could challenge colonial power. He was a transnational African modernist whose work merged a search for personal meaning with envisioning a post-colonial identity. In an analysis of Enwonwu's art and professional practice, Sylvester Ogbechie explains how Igbo arts (and masquerades) informed the artist's aesthetic and conceptual approach to art making, which confirms that his masquerade images (paintings and sculptures) are far more than nostalgic depictions of Igbo traditional culture.[7]

In the 1970s a renaissance of Igbo art and culture emerged partially in response to the Biafra War, which heightened ethnic divisions and ultimately Igbo identity. A group of visual artists, associated with the University of Nsukka and led by Uche Okeke, drew upon traditional Igbo art forms (such as *uli* designs) and adapted them to contemporary art-making methods. The general term "ulism" has come to stand for the broad scope of artists who experimented with the linear forms of *uli* and its compositional logic. The genesis of this project drew from the theory of "natural synthesis" and the desire to merge international art-making techniques with traditional art forms. Similarly, in the realm of popular performance genres (masquerades), Nigerians focused on resurrecting tradition in a modern form. Masquerades became a symbol of sustained ethnic and cultural traditions within a rapidly changing society in which national and ethnic identities were being negotiated and leveraged for political and social gain. Moreover, the grand international event known as FESTAC '77, which brought people of color from around the world to convene in Nigeria for a celebration of a pan-African art and culture, also fueled a resurgence of masquerades among the Igbo and other groups in Nigeria. The FESTAC logo was based on the famous ivory mask from Benin—not an Igbo mask, but a mask nonetheless. In this context, masquerades became symbols of ethnic identity, regional affiliation, national citizenship, and pan-African identity, which were asserted and articulated in complex ways.[8]

In the current era, Igbo masquerades are responding to the evolution of a democratic-style government, new forms of religion, and Nigeria's place within a larger global landscape. Chika Okeke-Agulu explains that "masking is powerfully resonant to aspects of contemporary experience overlooked by secularism or the new faiths emerging at the crossroads of Christianity/Islam and traditional African religions. Thus a sort of nostalgia for 'the past' remains, even while belief in the cosmological order that informed the metaphysical/ritual basis of masking (i.e. masks as manifestations of the metaphysical) is in retreat."[9] Similarly, Igbo people living abroad find meaning in masquerades. In Florida, masquerades are the visual marker of communities that both replicate

and connect with social structures in Nigeria. Therefore, an understanding of the development of Igbo art and identity within the diaspora has the potential to enrich Igbo art studies by acknowledging its global dimension.

Florida: Igbo Unions

Since 1990, more Africans have come to the United States of their own freewill than during the times of slavery.[10] Igbos, like many other Africans, immigrate to the United States for a number of reasons ranging from personal to professional. Some have completed educational degrees here; others have joined family members or friends. Large communities have emerged in urban centers, partially due to networks of family and friends that formed a "chain migration."[11] Once a critical mass has been established, organizations take root that support community networks resembling the social structure at home, which depends upon kinship ties. Coming from one of the most densely populated regions in all of Africa, Igbos also live abroad in impressive numbers. The largest Igbo communities in the United States are in Houston, Chicago, Atlanta, New York City, Chicago, Washington, D.C., and Los Angeles. The attraction to Florida is the tropical climate, which is similar to that of Nigeria. Moreover, Florida's strong Caribbean component offers cuisines and spices that are "sweet" to the Nigerian palate.

In Florida, Nigerians congregate and develop personal relationships at informal gathering places such as Sam's, a Miami-based import business in a commercial space that resembles a warehouse. It is essentially a store that offers Nigerian food and beverages and that foments into a party on evenings and weekends. It is a notable Nigerian hangout where socializing can take place in a less structured environment, without the ceremonies and protocol of more formal organizations. While Nigerians also socialize at small family gatherings or engage in other activities characteristic of American life, these activities are no substitute for the Igbo social experience of an organization with a structure that allows individuals the opportunity to leverage personal standing by developing relationships within the community.

Nigerians in the United States have established social, political, and intellectual networks that have taken root and flourished with astonishing stamina. Such organizations support the community in the diaspora, but they also lead to philanthropic efforts to support development back home in Nigeria. Commenting on an Igbo organization in Chicago, Rachel Reynolds explains,

> Such socializing creates and maintains networks that allow this deterritorialized community to exist spatially outside, but still very connected to, the Nigerian nation-state and Igbo homeland. Although these

connections to the state and homeland are often purportedly about arts and language programming for children of families in the group, or sometimes about homeland investment and large-scale charity projects, the social opportunities afforded by these group meetings are ultimately the central *raison d'être* for the organization.[12]

In Florida, Igbos have a variety of diverse organizations that offer opportunities for bridging with local (American) communities, cultural continuity, mutual aid, and—most importantly—socializing. Pan-Nigerian groups include the Federal Council of Nigerians (Miami), the Nigerian Association of South Florida (Miami), and the Association for Nigerians for Unity and Progress (Boca Raton). The Council of Nigerian People and Organizations (Ft. Lauderdale) was a think-tank founded in 1989 that published scholarly articles in the *Journal of Nigerian Affairs*, which has become the *International Journal of Nigerian Studies and Development*.[13] Ft. Lauderdale is an unusual genesis for a scholarly project, as it is not an academic hub. The Akwa Ibom Association in Miami is composed of people from a specific Nigerian state mostly populated by Ibibios but adjacent to the Igbo region. In addition, there are numerous Igbo professional organizations and women's groups.[14] Thus, individuals are often members of more than one organization, each emphasizing a different aspect of their multifaceted identity.

In Florida there have been several organizations modeled after the Igbo Union concept: the Igbo Association of South Florida (founded in 1986, Miami),[15] the Anambra State Association, Inc. (founded in 2002, Miami), the Umunna Community Association of Florida, Inc. (incorporated in 1997, Orlando), the Igbo Union Tampa Bay, Inc. (founded in 1997, Tampa), and the Association of Ndi Igbo (incorporated in 2009, Tallahassee). As noted by Patterson and Kelley, "Today's African migrants are recreating the political as well as the associational life they shared in their countries of origin. Igbo migrants in the US, for example, have created village unions which participate in projects that are beneficial to their American communities, to the larger Nigerian society in America, as well as to their specific home village in Nigeria."[16] Thus, the Igbo Unions in Florida are part of a phenomenon that has occurred across the United States whereby Igbo immigrants have formed "village unions" in urban centers as a means of structuring community and a form of Igbo traditional governance. These American-based associations "help facilitate title-taking back home by providing a public place for Igbo men and women abroad to share their accomplishments and maintain ritual obligations."[17] While many of these organizations perform masquerades and cultural dances, this aspect has not yet been discussed within published scholarship. I hope that my discussion of the Igbo masquerades of Florida will inspire a broader dialogue about these "new diaspora" masquerades taking place across the country.

Florida: Igbo Masquerades

Igbo identity in Florida is not only expressed through group membership but also formulated performatively through masquerades. Each of the Igbo Unions in Florida has its own masquerade—except for the most recently formed group in Tallahassee. The masquerades perform at large events, which typically take place in rented ballrooms. Unlike the community centers of other immigrant communities, Igbo Unions in Florida do not have a specific building dedicated to the organization. With printed programs, the events are carefully organized to include a line-up of speeches, honored guests, a Nigerian meal served buffet style, cultural performances, masquerades, and dancing accompanied by music offered by a DJ. The entrance of a masquerade into the ballroom is an exciting moment within the event. The dancers move between the tables, often acknowledging important guests, and ultimately perform the high point of their dance in a central spot, typically the ballroom's dance floor. Members of one group frequently travel to the events of other groups, often bringing their masquerade with them.

The first Igbo masquerade in Florida was Okun ma, a Mbgedike masquerade that is extremely popular in Nigeria. It was brought to the United States by Chief Emmanuel Okpala and appeared in 1993 at a New Yam Festival in Miami.[18] Herbert Cole describes Mbgedike costumes as "unusually composite, with seedpods and porcupine quills and, more recently, pieces of metal sewn to enveloping cloth or fiber costumes, bulking the wearer to superhuman size. Medicinal charms are normally present, along with young palm leaves, *omu*, both being evidence of the spiritual power and potential danger of such characters."[19] In the past, the Okun ma masquerade acted as a messenger used in the process of going to war.

The first costume brought to Miami had aluminum painted shingles and did not meet the expectations of the group, so another was commissioned. While a preexisting costume may be sent from Nigeria to the United States, it is more typical to have a new costume commissioned as is the case with the formation of any new masquerade troupe in Nigeria. In lieu of the painted shingles, a dazzling layer of metal tablespoons cover the costume and create a shiny armor. In figure 22.2 (left), an attendant is fanning an Okun ma masquerade in order to control its "hot" aggressive behavior. The spoons create a kinetic element as they shift in unison in response to the dancer's movements. While these spoons are visually enticing, they would not have passed muster in Nigeria, where dancers would be far more particular. Ideally, the tablespoons should be teaspoons, which are not as heavy.

I first witnessed the Idu masquerade in 1999 at the inauguration of the Igbo Union of Tampa Bay (fig. 22.2, right). At the time this masquerade was associated with the Igbo Union of South Florida, who came to support the group in

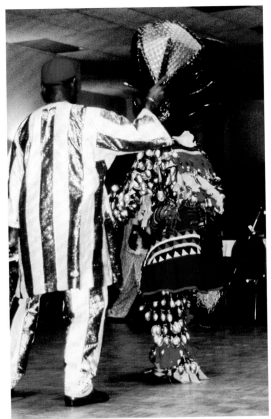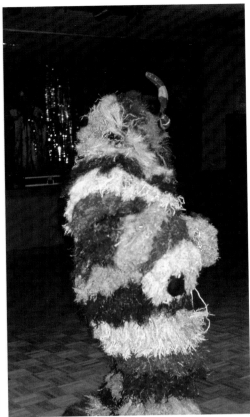

Figure 22.2. Masquerades, Igbo Association of South Florida, Miami, performing at Igbo Union of Tampa Bay Inaugural Celebration September 4, 1999. The Okun ma masquerade (*left*) can also be described as *mbgedike*-type masquerade. An attendant is fanning the masquerade in order to control its "hot" aggressive behavior. The Idu masquerade (*right*) continues to perform in conjunction with the Anambra State Association, which was founded in 2002 (Miami). Both masquerades were commissioned from Akwa village near the capital of Anambra State in Nigeria. Photos by Amanda B. Carlson, 1999.

Tampa. After a political rift within the Igbo Association of South Florida in 2001, the Anambra State Association (Miami branch) was officially founded in 2002, and this particular masquerade continues to perform in conjunction with that organization. Anambra State constitutes one of the largest Igbo areas in Nigeria, so it is not surprising that this would be a point of unification for parts of the Igbo community in Miami. However, an organization associated with a state in Nigeria shifts the goals of the group away from a more generalized, encompassing sense of Igbo identity and community.

The Anambra State Association has another Mbgedike type masquerade, Okwo Mma (fig. 22.3, top left), which is known for its aggressive behavior. Iga Ovuvu (fig. 22.3, top right) is a playful masquerade that clears the way for

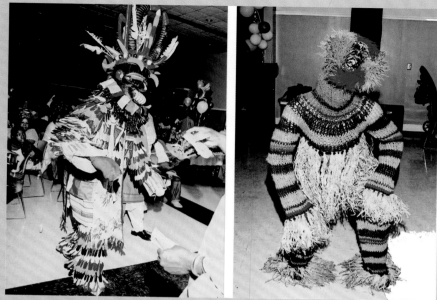

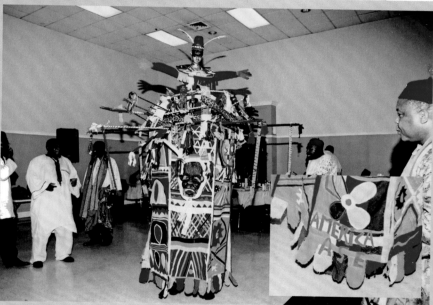

Figure 22.3. Masquerades, Anambra State Association, Miami. Okwo Mma (*top left*) is another *mbgedike*-type masquerade known for its aggressive behavior. Iga Ovuvu (*top right*) is a playful masquerade that clears the way for other masquerades. It wears a fiber knit body suit. Akwum Echenyi (*bottom*) is an *ijelle*-type masquerade, which resembles an anthill from which spirits and ancestors emerge. Its cloth appliqué costume includes the words "America Ase," borrowing the Yoruba term often used for igniting a ritual space with a spiritual presence. The masquerade is associated with the beauty and majesty of a community. Thus, an elderly titled man is depicted on the top with his arms extended in a welcoming gesture. Photos courtesy of the Anambra State Association (Miami).

other masquerades. It wears a fiber knit body suit. Akwum Echenyi (fig. 22.3, bottom) is an Ijele-type masquerade that resembles an anthill from which spirits and ancestors emerge. Its cloth appliqué costume includes the words "America Ase," borrowing the Yoruba term often used for igniting a ritual space with a spiritual presence. The masquerade is associated with the beauty and majesty of a community. Thus, an elderly titled man is depicted on the top with his arms extended in a welcoming gesture.

Igbo communities on both sides of the Atlantic are equally interested in the continuity of Igbo culture among its youth and see masquerades as an important component of this effort. For this reason, when a Tampa family took their son (born in America) back home for the holidays, his grandfather was delighted that the boy took an interest in masquerade. This event prompted community support for the masquerades' exportation to Tampa for use by the Igbo Union there. The Igbo Union of Tampa has a masquerade performance that is actually made up of two different masking traditions, from two separate regions within the larger Igbo area. It is not unusual for communities in Nigeria to acquire the masquerades of other groups, and masking styles can quickly spread resulting in a lot of complexity in terms of tracing origins and influences. In Florida, masquerades incorporate improvisational combinations of mask styles because the masquerade is no longer tied to a village, town, or region, but rather to an identity that is more universally "Igbo."

"Baby Face," as she is popularly known, is a maiden masquerade (Agbogho mma mwu) from Oguta Amaeshi, a riverine area in Imo State, Nigeria (fig. 22.4, left and right). This masquerade portrays a beautiful young woman who gracefully moves through the room with delicate steps as she peers into her hand mirror and waves to her admirers. Occasionally applying face powder through a pantomimed performance, her gestures highlight the importance of her good looks. She resembles other manifestations of water spirits that are broadly referred to as "Mami Wata" and that are associated with good fortune and travel. Ojiono (fig. 22.4, center) is a playful masquerade who clears the way for other masquerades. Its name refers to "someone who likes to talk a lot."

Adapting these masquerades to Tampa has resulted in several transformations. The meaning of each masquerade has become harder to pin down. Few people in Nigeria or in Tampa would have a "local" understanding of both parts of this syncretic performance. Therefore, the meaning of the masquerade shifts from a localized interpretation to a more generalized symbol of Igbo culture. And while mostly performed for entertainment, the masquerade does maintain some secretive elements that are known only to the initiates of the masquerade group. For instance, "Baby Face" will always walk backwards when entering and exiting a room, which originally had spiritual significance but has also become a tradition that is carried forward into the present and an expected part of the performance.

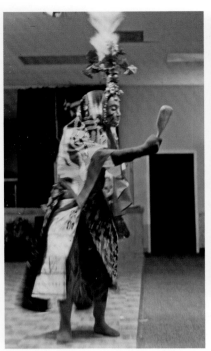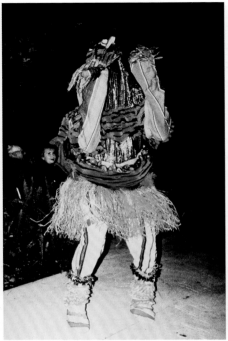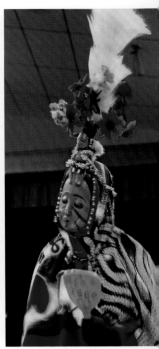

Figure 22.4. Masquerades, Igbo Union of Tampa Bay, Tampa. "Baby Face" (*left and right*), as she is popularly known, is a maiden masquerade (Agbogho mma mwu) from Oguta Amaeshi, a riverine area in Imo State, Nigeria. This masquerade portrays a beautiful young woman who gracefully moves through the room with delicate steps as she peers into her hand mirror and waves to her admirers. Occasionally applying face powder through a pantomimed performance, her gestures highlight the importance of her good looks. She resembles other manifestations of water spirits that are broadly referred to as "Mami Wata" and that are associated with good fortune and travel. Ojiono (*center*) is a playful masquerade who clears the way for other masquerades. Its name refers to "someone who likes to talk a lot." Photos by Amanda B. Carlson, 1999.

Igbo masquerades, like many African masquerades, are perceived as a male realm and involve complex gender performances. Men perform almost all Igbo masquerades, even if they depict female characters. In fact, women are typically forbidden to go near a masquerade in many African cultures. In the past this was enforced by reprimanding women who carelessly approached a masquerade or by popular beliefs that masquerades could cause infertility for women. Today, Nigerians frequently maintain respect for these time-honored gender boundaries, even if restrictions have been significantly relaxed. In Florida, gender restrictions are rarely enforced but not entirely ignored.

In Nigeria, members of the audience enthusiastically cheer dancers on, demonstrating their appreciation by "dashing" money to the masquerade, a tradition whereby currency (*naira*) is given to the masquerade while they perform. In the United States, audience members continue to shower excellent

performers, but with dollars. At a performance in Tampa in 2001, the announcer encouraged the audience to "shower them with love, shower them with love."[20] Then, a respected Igbo woman handed money to a masquerade instead of tossing it from a distance (what women traditionally do). Even the announcer prompted the woman to "drop the money on the floor, drop the money on the floor Mrs. . . ." The masquerade responded by turning down her offer and running away—a sign that the gender rules regarding masquerades in Tampa may not be as lenient as they sometimes appear. The rules of masking in Florida continue to be negotiated much as they have been throughout Igbo history. Now Florida is a part of that history of continuity and change.

Music is another dynamic component of masquerade traditions. In Florida, dancers are accompanied by recorded music played over a sound system, unlike the use of musicians in Nigeria. These rough sound recordings were clearly made from a live performance in Nigeria. Unlike other African groups in the United States, Igbo musicians are not a prominent feature in the Igbo diaspora community. While it may be easy to export a masquerade costume, it is rare to find a group of musicians who can master the complex rhythmic structure necessary for the musical component.[21] The use of prerecorded music for a masquerade would be unthinkable in Nigeria.

Expectations of the dance performance in Florida differ from expectations in Nigeria as well. Because life in Florida does not offer the same opportunities to generate highly skilled African dancers, the performance level may not be the same as back in Nigeria. However, they provide a commendable performance that is greatly appreciated by all. And with each new performance, noticeable improvements and innovations occur.

Nigeria and Florida: Video Remix

Video is a widely accessible technology that has radically changed the ways in which Nigerians visualize and engage the world around them. In fact, one could argue that the only narrative medium that can compete with masquerades in Nigeria is video. Videos of cultural events and video dramas allow Nigerians to fulfill their desires to hear and tell their own stories that frequently engage in dialogues about traditional culture and its relationship to modern society. Nigerians living in the United States use both video technology and masquerades as a means for developing similar narratives, which also help to visualize connections between local and global communities.

The impact of video on masquerade performance in Florida resonates in two ways. First, the performances are in part modeled after videos produced in Nigeria. In the process of acquiring a masquerade, videos of performances in Nigeria may be sent or acquired as a guide to direct the performers in Florida.[22] The dancers in Florida may not have had the opportunity to practice with a

preexisting masquerade troupe as is often the case in Nigeria. The videos often present elaborate festivals with many dancers, which cannot be replicated in the United States. Thus, it is simply a template upon which to develop a new interpretation of the performance in Florida. Second, similar to practice in Nigeria, Igbo masquerades in Florida are always recorded with video devices and distributed within a social network. Typically hiring a professional service, the organization will produce the official video, which is then sold to members and subsequently bootlegged and distributed in unexpected ways.

In Nigeria, videos of cultural performances (featuring masquerades and cultural dances) are frequently sold in Nigerian shops alongside the ever-popular Nollywood video dramas. Cultural performance videos, which feature cultural dances and masquerades, are significantly missing from the voluminous conversations about the role of video in Nigerian culture. Unlike the global themes and global distribution of Nollywood's video dramas, cultural-performance videos appeal to a local market.[23] Often created at an important ceremony (burial or title taking), the official video is then sold to people who attended the event or to persons related to that family. A larger but still local phenomenon occurs with the video coverage of urban festivals, such as Calabar Carnival,[24] whereby numerous DVDs enter the marketplace within days of the event taking place.

My sense is that a deeper investigation of cultural-performance videos would reveal that they are not only documents of an event but also opportunities to extend the ritual functions of the original performance. As noted by historian Paul Zeleza, "On the whole, the revolution in telecommunications and travel which has compressed the spatial and temporal distances between home and abroad, as well as the reflexivities of globalization, offer the contemporary diasporas unprecedented opportunities to be transnational and transcultural, to be people of multiple worlds and focalities perpetually translocated, physically and culturally, between several countries or several continents."[25] A study of the viewing habits of Nigerians who watch these cultural-performance videos would shed light on this widespread practice of video-recording events and performances.

Based on casual observational data, video viewing tends to happen in groups, at social gatherings, or on the occasion of a holiday (not unlike masquerade performances). Perhaps the repeated viewing of masquerade videos is another type of ritual performance. With video, the masquerade can be experienced repeatedly by watching the same performance again and again. Videos of masquerades mimic the patterns of communication inherent in masquerade (travel, identity, entertainment, ritual). Thus, the videotaped masquerade still cements community bonds and identities. In other words, watching the video is another type of community performance.

Conclusion

Masquerades have been a pervasive element in Igbo culture well beyond the reaches of human memory. Today, Igbo peoples live, work, and travel in many parts of the world, and they bring along masquerades that contribute to the evolution of Igbo identity in a global context. Diaspora masquerades operate in order to maintain links to home as well as to communities of Nigerians in America adapt to the realities of living a transcultural lifestyle. In Florida, where Igbo masquerades have existed for well over a decade, masquerades are not only re-creations of traditions from "back home" but also extensions of those traditions. Even if these organizations do not provide members with the opportunity for "real power" as it would be realized at home, it provides a sense of that system.

This new type of "diasporic masquerade" is one form of cultural expression that speaks to the space of Florida, which is shaped by a complex mix of people from Africa and the diaspora who have negotiated social relationships within transnational communities both in the past and in the present. Igbo masquerades in the Sunshine State provide an instance in which Florida and Africa are performing in collaboration. In this respect, the history of black presence in Florida is a lot like a masquerade—you can't watch it standing in one spot. Objects, ideas, and people have moved through this state over time, leaving in their wake a complex story that behaves like a vibrant, multifaceted dance with musicians, performers, spiritual entities, and audience members interacting in a choreographed but also improvisational ensemble. The dance of Africa and Florida is culturally exciting, historically powerful, politically engaged, as well as central to the dialogues about African history and world history—no matter where one stands.

Author's Note

I am grateful for the hospitality and assistance from the Igbo community in Florida, especially Celina Okpaleke, Rowland Obi, Columba Okpala, and Emmanuel Okpala. Special thanks to colleagues who read and commented on drafts of this essay: Eli Bentor, Robert Nicholls, Sylvester Ogbechie, Carol Magee, Shannen Hill, and Andrea Frohne.

Notes

1. Thanks to Robert Nicholls for sharing his forthcoming article, "Igbo Influences on Masquerading and Drum-Dances in the Caribbean." See also Nicholls, "The Mocko Jumbie of the U.S. Virgin Islands."

2. Landers briefly mentions Carnival, dances, and dress balls in St. Augustine (*Black Society in Spanish Florida*, 94), but very little has been published about these types of performances in Florida.

3. Cole and Aniakor, *Igbo Arts*, 111.

4. Chukwuezi, "Through Thick and Thin," 56.

5. Ogbechie, *Ben Enwonwu*, 35.

6. See Harney's *In Senghor's Shadow* for a description of Negritude in the context of Senegal.

7. Ogbechie, *Ben Enwonwu*, 35–36.

8. For discussions of masquerades and political symbolism see Apter, *The Pan-African Nation*; Bentor, "Masquerade Politics"; and Carlson, "Calabar Carnival."

9. Okeke-Agulu, Introduction, 6.

10. Roberts, "More Africans Enter U.S. Than in Days of Slavery."

11. See R. R. Reynolds, "An African Brain Drain," for a detailed analysis of how Igbo migratory orders developed in relation to the role of education and evolving family economic systems.

12. R. R. Reynolds, "Igbo Professional Migratory Orders," 211.

13. This journal is currently published biannually in the United States by the International Association of Nigerian Studies and Development (IANSD); see www.iansd.org.

14. In Tampa, for example, there is the Zest Club (a social investment group), Ivory Club (a social club dedicated to community involvement), Nigerian Forum of Tampa, Nigerian Pharmacists Association, Nigerian Women's Association, Nigerian Nurses Association, etc.

15. The Igbo Association of South Florida appears to have disbanded due to an internal controversy. Its members splintered into other groups such as the Anambra State Association's Miami branch.

16. Patterson and Kelley, "Unfinished Migrations," 6.

17. R. R. Reynolds, "Igbo Professional Migratory Orders," 211.

18. Interview with Emmanuel Okpala, July 16, 2003.

19. Cole and Aniakor, *Igbo Arts*, 132.

20. This was an event associated with the African Student Union at the University of South Florida.

21. Sylvester Ogbechie commented that the lack of Igbo drummers in the diaspora is a result of the amount of training it requires. He also noted that even secular songs at Igbo events in the diaspora are accompanied by prerecorded music. Personal communication, February 14, 2011. Robert Nicholls, in his research about how Igede children learn their traditional dance, explains that the majority of adult practitioners of music and dance (especially drummers) are farmers, who do not have the upward mobility (and the opportunity to travel). Personal communication, June 20, 2012. See also Nicholls, "Dance Pedagogy in a Traditional African Society."

22. For example, the masquerade in Tampa was modeled after a videotaped performance in 1995 of a masquerade in Ameshi (Imo State).

23. Personal communication with John McCall, January 31, 2011.

24. See Carlson "Calabar Carnival."

25. Zeleza, "Diaspora Dialogues," 44–45.

23

African Attractions

Florida Tourism Gone Wild

Amanda B. Carlson

Why Build Africa in Florida?

It's Africa in Florida
Busch Gardens brochure

The exotic appeal of "Africa" has fed the American tourism industry a steady diet of themed attractions that is plentiful in Florida, where African attractions have existed for over sixty years. African-themed hotels, resorts, miniature golf courses, zoos, and amusement parks have created experiences meant to resemble an encounter with Africa via safari tourism, a visit to a world's fair, or an adventure story. While there are certainly more animal exhibits and theme parks in Florida in general than in other parts of the United States, this alone does not explain the abundance of African lions, Maasai warriors, and safari guides who have taken up residence in the Sunshine State. This perplexing abundance of reconstructing Africa in Florida may be due in part to the fact that Africa and Florida have two things in common. First, they are both known as hot, humid, subtropical tourist destinations. Second, both have been places where fact and fiction are blended, packaged, and presented to fulfill desires for adventure and fantasy.

This chapter traces the progression of how Africa has been presented in tourist attractions in Florida over the course of six decades via theming devices, display techniques, and marketing materials. While similar tropes and representations of Africa appear time and time again, each tourist attraction is unique and presents a different interpretation of Africa. I provide a brief description of each park, its history, and how it *came to be* in Florida. For attractions that remain open, I provide scannable QR Codes that lead the reader to the venue's website, which is an extension of the experience. Some of the more interesting websites provide a history of the institution along with splendid

photographs that provide additional visual information; others focus more on ticket sales and visitor information. While many of the attractions I discuss remain open, remnants of those that no longer exist live on in photo albums and memories of bygone family vacations along with ashtrays, postcards, trinkets that linger like artifacts left behind by a now extinct civilization to be excavated from basements, tag sales, and eBay auctions. These "treasures" originated in gift shops in Florida and then traveled substantial distances in suitcases along interstate highways, further accentuating the idea of travel. Thus, I consider how Africa is presented, built, and imagined through experiences, memories, images, and objects.

Like most ethnographers whose careers have focused on studying other cultures (for me, cultures in Africa), I was enticed by the idea of turning the ethnographic gaze upon my own homeland (Florida) and drawn to the idea of doing fieldwork in some of the best playgrounds my state has to offer. Many of the largest attractions are theme parks that rely upon the conventions of botanical and zoological gardens mixed with amusement park thrills, where—in the role of participant observer—I ate french fries, rode roller coasters, enjoyed many a tram ride, conducted informal interviews with park staff and visitors, and came to know "Africa" in a new way. This research likewise changed the way in which I understand Florida, a place where fact and fiction endlessly merge.

Many people perceive Florida as a place without history, a place that is completely "constructed," the perfect environment to build fantasy. When tourists step into Florida their relationship to the world changes; they are far from home in a place where fantasy becomes reality. According to Umberto Eco, Florida is "an artificial region, an uninterrupted continuum of urban centers, great ramps of freeways that span vast bays, artificial cities devoted to entertainment."[1] This is the ideal environment for amusement parks that operate in a state of hyperreality, which leads to the conflation of the copy and the original.[2] Eco contends that theme parks present the "fake" in order to make the surrounding areas seem "real."

Theming, especially in the larger amusement parks, is characterized by multisensory experiences that produce "cognitive overload."[3] Many of the representations of Africa are familiar tropes, stemming from nineteenth- and twentieth-century narratives, which either celebrate or denigrate Africa, that continue to circulate in mass media and popular culture. However, it is doubtful that so many of these characterizations could have ever existed in such an elaborate multisensory experience anywhere else. There is clearly a "slippage" between the images of Africa that are built into tourist attractions and the ways in which the public is experiencing them that enables the visitor to overlook the offensiveness of certain stereotypical depictions of Africa or to be completely blinded by the content altogether. For an Africanist art historian,

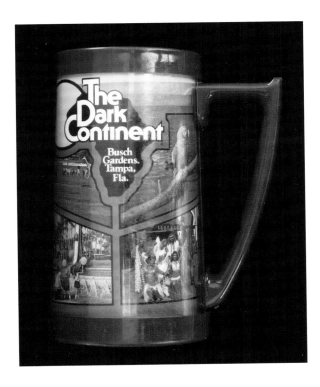

Figure 23.1. Souvenir from Busch Gardens: The Dark Continent, plastic beer stein (c. 1970s). Collection of the author. Photo by Susan Warner.

it was like slipping down Alice's rabbit hole into a wonderland that made me wonder, What exactly happens to the semiotic process as we absorb 5 Gs of freefall on a roller coaster or splash down a flume?

To understand how people absorb images of Africa in the context of an amusement park, I began talking to friendly tourists while passing the time in the ubiquitous queues that lead to every ride and commercial transaction. At Busch Gardens, in Tampa, I was surprised to discover that not everyone recognized the African theme, even though signs of Africa were everywhere. Originally a beer garden (the former site of the Anheuser-Busch brewery), the park introduced the African theme in the 1970s when the name was changed to "Busch Gardens the Dark Continent." In figure 23.1, images of "Africa" are layered upon a plastic beer stein, emblematic of how the two themes come together. It is curious that in the decade following African independence movements and the U.S. civil rights movement a name such as this would not arouse controversy—but it did not. "The Dark Continent" was eventually dropped sometime in the late 1980s, apparently not because of its offensive connotations but because people didn't really "get it" and therefore it wasn't an effective marketing tool. The Africa theme continued, though, and the name was changed to "Busch Gardens Africa," and then more recently back to "Busch Gardens, Tampa." As this example suggests, Africa is present—but it is not. When I took a group of students from my course "Exhibiting African Art and Culture" to Busch Gardens we had to perform a detailed analysis of

the park before the students began to understand the historical references and negative stereotypes that the park invokes. A deep understanding of the elaborate themes requires several visits; and most visitors are inclined to forego this type of analysis, since that isn't the point of the amusement park experience.

Because of Florida's tropical environment, which matches tourist expectations of how they think Africa should look, wildlife as a theme has prospered. However, tourists prefer to experience African wildlife over Florida's wildlife. Carl Hiaasen, an author and columnist for the *Miami Herald*, was quick to note the irony of this in his response to the initial proposal for Disney's Animal Kingdom.

> Well, Disney kicked us in the coconuts again. Maximum Mousketeer Michael Eisner has unveiled plans for . . . [Disney's Animal Kingdom]. . . . For once the animation will be performed by real animals. Consequently, the bears will not play banjos, the rodents will not whistle, and the lions will not break into song. Instead they'll do what real critters do, not all of which deserves videotaping. . . . Still, it doesn't seem right to employ African animals when Florida has so many interesting species of its own.[4]

In his column, Hiaasen suggests that as an act of protest, tourists should deliver native critters (Bufo toads, catfish, buzzard chicks, and fire ants) to the theme park. Taking into account Hiaasen's point, why do we need to replace Florida wildlife with African wildlife? Is Florida wildlife not exotic enough? Is it too *real* for this state of hyperreality?

Hiaasen's attention to Florida's quirkier side—where fact truly is stranger than fiction—is prevalent in his novels, which develop stories and themes drawn heavily from his nonfiction writing as a journalist and columnist. Hiaasen repeatedly writes about tourists and amusement parks in Florida and views corporate ventures, such as Disney, as inherently evil (see his nonfiction *Team Rodent: How Disney Devours the World*, 1998). In his novels, animal theme parks and safari parks are often the site whereby animals get back at man for his destruction of their natural environment. Unlike California, which has Hollywood and the western frontier to inspire themes, Florida's pre-Disney history is Seminoles and wildlife. Wildlife is the obvious choice, as the history of the Seminoles is not suitable for theme parks. How would you translate the Seminole Wars—when the United States attempted to remove or kill off Seminoles from their native lands—into a theme park narrative? In the novel Native Tongue (1991), Hiaasen provides a satirical description of a fictitious animal theme park in the everglades with a Disney-like parade featuring a Seminole Princess, which alludes to the commercial packaging of distasteful historical narratives.

Amanda B. Carlson

Every evening at nine sharp, visitors to the Amazing Kingdom of Thrills gathered . . . to await the rollicking pageant that was the climax of the day's festivities. . . . Ten brightly colored floats comprised the heart of the parade . . . These were organized in a story line based loosely on the settlement of Florida, going back to the days of the Spaniards. The plundering, genocide, defoliation and gang rape that typified the peninsula's past had been toned down. . . . even the most shameful episodes were reinterpreted with a positive commercial spin. A float titled "Migrants on a Mission" depicted a dozen cheery, healthful farm workers singing Jamaican folk songs and swinging their machetes in a precisely choreographed break-dance through cane fields. Tourists loved it. So did the Okeechobee Sugar Federation, which had bankrolled the production in order to improve its image.

One of the highlights of the pageant was the arrival of "the legendary Seminole maiden" known as Princess Golden Sun. . . . [invented basically] as an excuse to show tits and ass, and pass it off as ethnic culture.[5]

Considering Hiassen's point, Florida's natural environment is implicated in these complicated cultural and historical narratives which are not easily translated within the commercial tourist market. Thus, Florida and its wildlife are replaced by the narrative of Africa, which has already been scripted in popular culture in order to deal with the complicated histories of transatlantic slave trade, colonialism, and human suffering. Africa as a theme depicts the *idea* of Africa as it is imagined in Florida. While Africa could be represented through its success stories, these do not fulfill the touristic desire for travel, adventure, and the exotic.

African attractions in Florida are not *representations* of Africa but rather *simulations* of Africa. According to Baudrillard, "representation stems from the principle of the equivalence of the sign and of the real (even if this equivalence is utopian, it is a fundamental axiom). Simulation, on the contrary, stems from the utopia of the principle of equivalence, from the radical negation of the sign as value, from the sign as the reversion and death sentence of every reference."[6] To further complicate things, African attractions in Florida are not only the simulation of Africa but also the simulation of touristic experiences of Africa, which are themselves a construction of signs that simulate an "authentic" African experience. Like soul mates in the realm of hyperreality, Africa and Florida are both places where fact and fiction collapse in on each other and where tourists are seduced by a desire to travel to a different time and place. Getting lost in that distinction between reality and fantasy is part of the pleasure of the experience.

Gator Bait: Jungle Tourism and Race in the Ole South

Go Gators!

University of Florida slogan

While alligators are plentiful in Florida, they do not exist in Africa. Yet, every African-themed attraction mentioned in this chapter contains gators, who are quite simply stand-ins for African crocodiles. Living mostly in Florida's rivers and swamps, gators do appear from time to time in swimming pools and canals as development encroaches upon their natural environment. These pesky critters—which occasionally make a snack of someone's pet, or worse yet, a grandchild—have long held the fascination of tourists. While only air-boat rides allow tourists to see gators in their natural habitat, it requires a significant time commitment to a high-speed boat ride and a bad hair day. More convenient are the many attractions that keep live gators, which today range from mini-golf courses to mega-parks.

Figure 23.2. Alligators are integral to many Florida tourist attractions, then and now. In both images, tourists are safely gazing at these wild animals. *Left*: "BR.6—Feeding 'Jumping Alligator' on Jungle cruise at Africa, U.S.A." Curteich-Chicago "C.T." Art-Colortone postcard. (4C-H800). *Right*: Alligator exhibit at Congo River Golf Adventure Orlando. Photo by Amanda B. Carlson, August 2003.

Amanda B. Carlson

From the beginning of Florida tourism, gators have been very popular. Since the late nineteenth century, tourists have been traveling to Florida via train and steamship. These tourists encountered real adventure in a largely undeveloped state that offered a glimpse of untouched nature and beautiful waterways. At the turn of the twentieth century Florida was a poor, rural "primitive" place with only half a million inhabitants in the entire state. It was a place of racial segregation with old southern values. With raging humidity and annoying bugs, it would be hard to imagine Florida as a place to live or even vacation. The invention of pesticides and air-conditioning changed that. With expansion of the automotive industry, "tin can tourists" drove along roads that were lined with mom-and-pop shops and citrus stands that often included displays of exotic animals such as alligators. In the 1920s a strong national economy spurred Americans to invest heavily in Florida land, attracting significant populations for the first time who eventually suffered when the economy quickly went bust. Tourism, along with agriculture, helped to revive the failed Florida economy and continue to be the driving forces of this now more vibrant state.

The gator, derived from *alligator*, is symbolic of old Florida and its wild roots; thus the University of Florida rallying cry—Go Gators! Like the mascots of other sports teams, gators are associated with stereotypes of wild, primitive ferocity. Although in the early part of the twentieth century gators were not directly associated with African themes, they were embedded in narratives about race and ethnicity, which is relevant for understanding the roots of the tourist industry. Hence, the later conflation of gators with Africa is entangled in complicated references to race and man's relationship to nature.

The first recorded gator attraction was the St. Augustine Alligator Farm, which was established in 1893 and is still open today.[7] Moreover, baby alligators and alligator eggs were popular souvenirs at the turn of the twentieth century.[8] Alligator wrestling—a powerful symbol of man's control over beast—also developed during this period. Attributed to Henry Coppinger, who first appeared at Tropical Garden's Alligator Farm, alligator wrestling soon became associated with the Seminoles. As of 1919, young Seminole men began performing similar acts, which were widely publicized nationally through newsreels shown in movie theaters around the country.[9] In this way, gators became associated with the tourist experience in Florida and with the fantasy of Florida as a wild place.

Visit the website for the St. Augustine Alligator Farm to learn more about this zoological park, which was founded in 1893.

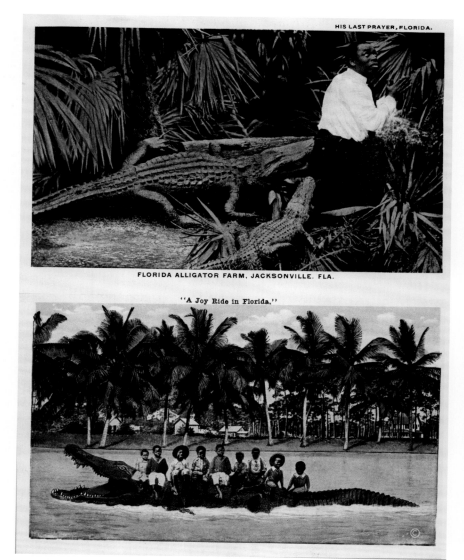

Figure 23.3. Postcards depicting alligators and people of color in Florida. *Top:* "His Last Prayer, Florida. Florida Alligator Farm, Jacksonville. Fla." Published by the H&B.W. Drew Co. Jacksonville Fla. (A-21329). *Bottom:* "A Joy Ride in Florida." E. C. Kropp C. Milwaukee (#17027).

Tourist postcards in the mid-twentieth century that depicted alligators did so in a way that sold racism as a quaint aspect of the "old south," where whites are in charge and blacks lived with the threat of violence. A postcard for a tourist attraction (fig. 23.2, left) includes the image of a white man in a pith helmet feeding a gator while white tourists leisurely look on. The caption reads, "Feeding 'Jumping Alligator' on Jungle Cruise at Africa, U.S.A." When black figures appear with gators they are not depicted as being in control of the animal, but rather as the victim of a violent, if not lethal, attack. A postcard from the

Amanda B. Carlson

Florida Alligator Farm (Jacksonville) shows a black man praying as two gators bite his leg and his bottom (fig. 23.3, top). The caption reads, "His Last Prayer, Florida." If not threatened by a gator, blacks are seen as living in unison with gators. In another postcard, nine black children sit on the back of a gator that is swimming past a tranquil neighborhood of old Florida homes (fig. 23.3, bottom). The caption reads, "A Joy Ride in Florida." In this image, the equation between blacks and gators suggests their inherent wild "naturalness."

What began as a symbol of "wild Florida" morphed into other, more complex symbols that had to do with control over nature as well as society in twentieth-century Florida, which was characterized by tense race relations. David Colburn notes that "in the aftermath of Reconstruction, they [Floridians] established a caste system, at first informally and then through law. That permeated the entire society, denying African Americans the rights promised to them during Reconstruction. This Jim Crow system imposed a subservient status on African Americans until well into the second half of the twentieth century."[10] This power dynamic is manifest in the tropes that regularly appeared on postcards that depicted gators and blacks, which were sent by tourists to friends and relatives back home, exchanged like dirty jokes.

In the 1930s, in response to the growing demand for tourist attractions, entrepreneurs built more elaborate attractions, which included "jungle tourism," in which gators began to play their roles as "African" animals. Propelled by the jungle adventure film genre, Florida's tropical environment was the initial stimulus for jungle tourism. The first among many was McKee Jungle Gardens (1932–76), which displayed tropical plants, exotic animals, and sexy broads in Tarzan-inspired costumes. The brochure reads, "Africa—in America. The thrills of a trip to the heart of darkest Africa may be had in safety and comfort, and in a matter of minutes, by the visitor to McKee Jungle Gardens" (fig. 23.4). This was perhaps the first African-themed gardens, but there were many other examples of jungle tourism, including Sunken Gardens, Sarasota Jungle Gardens, Monkey Jungle (recently renamed Jungle Island), and Parrot Jungle.[11] And gator exhibits have been a common feature at these tourist attractions.

From 1932 to 1942, many movies were filmed in Florida's "jungles," which provided the backdrop for scenes set in Africa.[12] Several Tarzan films were produced in Silver Springs, in north-central Florida. Animals from some of the African attractions, such as Africa U.S.A. (Boca Raton), had starring roles in these films. One newspaper article explains, "Since recent movies have thrown so much light on the dark continent even the small fry are familiar with the names like Tanganyika Territory, Mt. Kilimanjaro and Masai Land: magic names inspiring travel lust in the most sedentary soul."[13] Moreover, this film genre, which was popular in both U.S. and international markets, inspired a new breed of jungle attractions. As bigger investments in the 1950s–70s

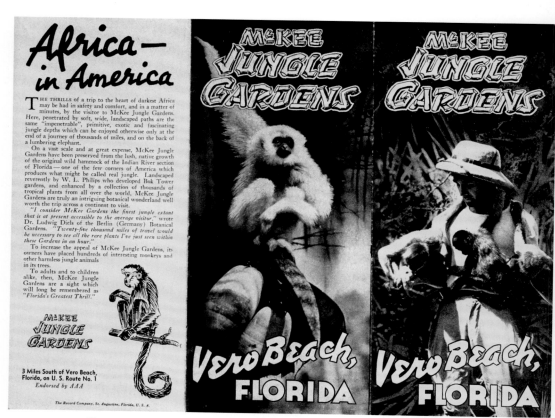

Figure 23.4. McKee Jungle Gardens, Vero Beach, brochure. From the Florida Ephemera Collection, Department of Special and Area Studies Collections, George A. Smathers Libraries, University of Florida.

required more precise themes, Africa became a pervasive subject for both family-owned and corporate theme parks. At this time, gators were joined by other exotic animals, many of which actually came from Africa.

Africa U.S.A. (1953–1961), Boca Raton, Florida

> A one-day safari. No passport is needed. They've moved Africa to Florida, which makes it much more convenient.
>
> *Miami Herald, December 4, 1955*

Africa U.S.A.—as the name makes clear—attempted to bring Africa to the States. With three hundred acres of zoological and botanical gardens, Africa U.S.A. was perhaps the most ambitious of the "mom and pop" parks. Tourists

Visit the website for Africa U.S.A. to learn more about this park, which closed in 1961.

went on "safari" in an open-air tram through Tanganyika Territory and in an electric boat around Lake Nanyuki. It was innovative in that tourists had close encounters with animals that roamed the park.

In step with a family-friendly tourist industry, the narrative of Africa U.S.A. involves a good family story. In 1931, John Pedersen's patent for curtain tie-backs and his related business brought him and his family out of poverty. After acquiring wealth through real estate in Wisconsin, he began to profit from the real estate boom in Florida. In the 1930s the Pedersen family drove from Tampa to Miami across Tamiami Trail, which passes through the Everglades (a subtropical wetland in southern Florida). The family felt that the landscape was comparable to what they imagined Africa looked like, but without the animals.[14] Invoking John Pedersen's own observations and a general sense of Florida in the American imagination, a newspaper article agrees that "in climate and plant life Southern Florida bears a marked resemblance to Africa." Inspired by jungle adventure novels and documentary films about Africa, John Pedersen began building Africa in Florida in 1951 in present-day Boca Raton.

John Pedersen's son, Jack, traveled to Kenya and brought back what was then the largest shipment of wild animals to enter the United States. But, the intrigue did not stop there; the public was fascinated by the efforts that Pedersen went through to import animals from Africa into the States. Pedersen was involved in many a court battle over the importation and quarantine of his animals. One giraffe ran up so many legal bills and food bills during her

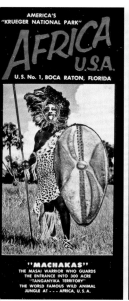 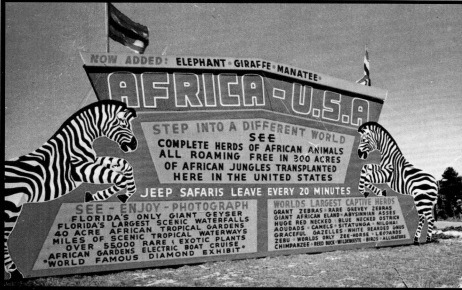

Figure 23.5. Africa U.S.A., Boca Raton. *Left*: Brochure, Florida Ephemera Collection, Department of Special and Area Studies Collections, George A. Smathers Libraries, University of Florida. *Right*: Entrance sign. Courtesy of Ginger Pedersen.

fifteen-month quarantine in New Jersey that the press nicknamed her "Money Bags." Thus, the adventure of capturing the animals and bringing them home alive gave additional meaning to these animals, "making the animals into living links to places, people, and experiences."[15]

Once the park opened in 1953, guests were greeted by a colorful sign flanked with two zebras (fig. 23.5, right). As one journalist explained, "Africa, USA was the real Florida at its best—a little tropical, a little kitschy, but a lot of fun." Along with restaurants and gift shops, there was also "diamond exhibit," which featured a 34.5-carat synthetic diamond. Aside from the association between Africa and diamonds, this exhibit may have attracted the interest of the fashion-conscious Palm Beach crowd. Admission to Africa U.S.A. was free, but you had to pay for the safari experience in order to see the animals. The boat tour cruised along alligator-infested waters in order to pass by Monkey Island[16] and to encounter Zambezi Falls and the man-made Watusi Geyser, which was modeled after Yellowstone's Old Faithful. Thus, it translated Africa through the lens of tourism in the United States and monumental American experiences of nature.

The main part of the park was modeled after a game preserve in Kenya. The tram drove past a sign for "Nairobi city limits" and passed into Tanganyika Territory,[17] a re-creation of the African veldt. In the middle of the tour the tram stopped in Jungle Town, where tourists encountered Maasai warriors performing a "lion dance"[18] along with an animal trainer (Phil Carrol) training gorillas, chimpanzees, and monkeys. One newspaper declared, "Local Negroes dressed as nearly like native Africans as the law will allow will dwell in the jungle village to add effect to this wild setting."[19] The Maasai warriors (see fig. 23.5, left) were African Americans from Pompano who wore costumes that Jack Pedersen had collected in Kenya. Like the Florida gator, African Americans performed their parts as "Africans." John Pedersen recalls that "one disbelieving patron . . . accused the 'native' at the concession building of being a phony. The worker, who had been a Japanese prisoner of war, rammed his spear into the ground between his feet, and angrily retorted in spitfire Japanese. The astonished visitor decided the warrior was authentic."[20] Thus, authenticity was gauged by a sense of foreignness. And, at this time few people had firsthand experience of foreign countries outside of the context of war.

Pedersen closed Africa U.S.A. after only eight years due to enormous pressure from local land developers, the city, and the U.S. Department of Agriculture (which apparently caused numerous animal deaths after fumigating the animals for red African ticks). From Pedersen's account there were numerous parties working against him.

"Perhaps you won't believe it but there have been fellows here trying to pull a shake-down on me." He went on to say that men of the hoodlum

Amanda B. Carlson

type had dropped by to say they would see that nothing unfortunate happened if he handed over a bundle of cash. "What can happen?" Pedersen asked them. They told him one never knows what can happen and they would see that nothing happened on his property.[21]

Carl Hiaasen couldn't have penned a more appropriate ending.

While the attraction is closed, it still exists in the virtual world with an extensive website that offers memorial publications and memorabilia. The park itself was sold to real estate developers and turned into the neighborhood known as Camino Gardens. The animals were sold to other attractions and zoos in the United States and Mexico. For instance, some descendants of the Africa U.S.A. animals are in Busch Gardens, Tampa.

Lion Country Safari African Adventure (1967–present), West Palm Beach, Florida

> Drive yourself wild. Experience the thrill of a real safari!
> *Brochure*

Unlike the peaceful safari experience at Africa U.S.A. (which had no carnivorous animals), Lion Country Safari plays up the danger involved in a safari. Lion Country Safari is a drive-through zoo that "was originally developed by a group of South African and British entrepreneurs who wanted to bring the experience of an African game park, then and now an expensive and time-consuming trip, to families who would otherwise not be able to experience an African safari."[22] You drive your own vehicle through four miles of road, which you share with other vehicles, including tour buses, while you listen to the audio tour on your car stereo[23] (fig. 23.6). This concept highlights the way in which American tourism aligns with the automobile.

Lion Country Safari is modeled after animal reserves in East Africa. There are seven different areas, five of which are places in Africa: Ruaha National Park (Tanzania), Kalahari Bushveldt (Southwest Africa), Gorongosa Reserve (Mozambique), Serengeti Plains (Tanzania/Kenya), and Hwange[24] National Park (Zimbabwe). The two additional sections are based on locations in South America and India. Thus, the prime safari locations are compressed into one manageable park. Lions that had become familiar with every make and model of car imaginable would at times come right up to the vehicle. It's important that guests are viewing "wild animals" even though they are probably much

Visit the website for Lion Country Safari African Adventure to learn more about the drive-through safari adventure.

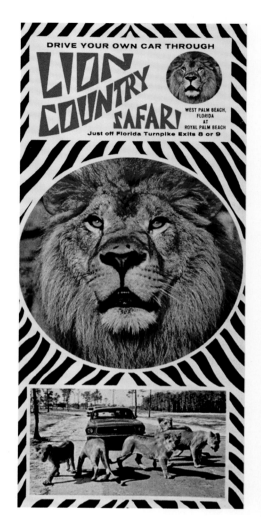

Figure 23.6. Lion Country Safari, West Palm Beach, brochure. From the Florida Ephemera Collection, Department of Special and Area Studies Collections, George A. Smathers Libraries, University of Florida.

more used to humans than animals in a zoo. And, "'wild' is often taken to mean 'dangerous.'"[25] Thus, there are many reminders posted on signs throughout the park and in the literature: warning lions, keep the doors and windows of your vehicle locked, and so forth. However, in 2005 a cage was installed around the roadway. Apparently, tourists couldn't be trusted not to wind down their windows. Thus, the lions roam freely while the tourists are in a cage.

Africa was further emphasized when the words "African Adventure" were added to the park's name over a decade ago. It includes an amusement park area called "Safari World" with live animals dispersed between small-scale amusement park rides. You can take a cruise on the *Safari Queen* or paddle boats around Lake Shanalee (formerly Lake Nakuru). It's so different from the safari portion of the park that it almost seems like two different attractions. However, it speaks to the expectations of visitors. In Florida, Africa requires a certain number of games and rides. Lion Country Safari attractions were

originally opened in five other cities around the country,[26] but only the one in Florida remains.

Jungle Larry's and Safari Jane's African Safari at Caribbean Gardens (1969–present), Naples, Florida

Enjoy all the thrills of a Safari.
Brochure

Jungle Larry's African Safari has been a family-owned zoo for the majority of its history. It was started by Lawrence Tetzlaff (Jungle Larry), whose career as an animal trainer started when he began wrestling alligators and training lions in St. Augustine, Florida. Jungle Larry and his wife, Nancy (aka Safari Jane) (fig. 23.7), trained animals for numerous TV shows and films about Africa. Thus, the brochure reads "Television's Jungle Larry." In fact, Larry Tetzlaff worked on several Tarzan films both as an animal handler and as a stand-in

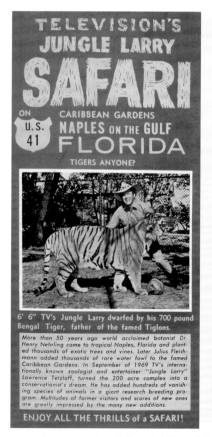

Figure 23.7. Jungle Larry's African Safari, Naples. *Left*: brochure from the Florida Ephemera Collection, Department of Special and Area Studies Collections, George A. Smathers Libraries, University of Florida. *Right*: Jungle Larry and Safari Jane (Lawrence and Nancy Tetzlaff), photo courtesy of Tim Tetzlaff.

Visit the website for Naples Zoo at Caribbean Gardens. See how "Jungle Larry's" family business has evolved into a modern zoo.

for Johnny Weissmuller.[27] The Tetzlaffs also performed an animal act in Cedar Point, Ohio, known as Jungle Larry's Safari.[28] The name "Circus Africa" was occasionally used to describe a show or a show area.[29] In the 1960s the family began to move their animals to Florida in the winter to provide them with a more temperate climate. On a piece of property that had been a private botanical garden (opened in 1919) and then opened to the public as Caribbean Gardens (in 1954), Larry and Nancy Tetzlaff opened Jungle Larry's and Safari Jane's African Safari in 1969.

Rooted in the tradition of circus acts mixed with a zoo, the focus had been on trained animal acts. Guests could also take a Safari Island Cruise around "Lake Victoria" where they visit eight islands each host to a different species. A book was written about the family, titled *Living with Big Cats: The Story of Jungle Larry, Safari Jane, and David Tetzlaff* (1995). It focuses less on the park experience and more on the family's safari adventures and animal training. It chronicles the evolution of public tastes, which shifted from trained animal acts to animal "experiences" that demonstrated "natural" behaviors. This suggests that audiences were increasingly concerned with a semblance of "authenticity" even though the experience of an animal in the wild cannot be replicated in captivity.

Jungle Larry's African Safari has evolved over the years and has had many different names. In 1994 it was named Caribbean Gardens: Home of Jungle Larry's Zoological Park. Today it is simply known as Naples Zoo at Caribbean Gardens, which continues to host numerous African themes. In the tradition of Jungle Larry and Safari Jane, who participated in numerous photographic and capture safaris, the zoo promotes safari tours to East Africa. Thus, the public's taste for safaris has not diminished.

Busch Gardens (1959–present), Tampa, Florida

After you get to Florida, get lost in Africa.
Brochure

Far too little has been written about this gem of a park, probably because scholars have been distracted by "The Mouse," which is just an hour away. Run by Anheuser-Busch Adventure Parks, this park originally opened in 1959 and began as a German beer garden combined with exotic birds and gardens. It was the "hospitality house" of the Anheuser-Busch brewery. In the 1970s it

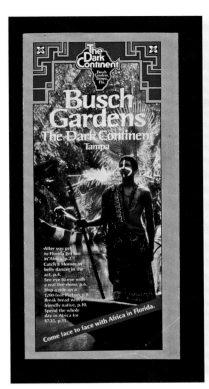

Figure 23.8. Busch Gardens: The Dark Continent, Tampa, brochures from the Florida Ephemera Collection, Department of Special and Area Studies Collections, George A. Smathers Libraries, University of Florida.

expanded to include a small zoo and became "Busch Gardens the Dark Continent," which later expanded to a full-blown theme park. To explain this leap between "beer" and "Africa" there is a small instructional exhibit in the Egypt section that explains how Ancient Egyptians developed brewing techniques. In addition to Egypt, sections of the park today include Morocco, Nairobi, Timbuktu, Congo, Jungala, Stanleyville, Nairobi, and Sesame Street Safari of Fun. They are constantly adding new adventures. In figure 23.8, the brochure on the left is styled after the popular magazine National Geographic, which is where most Americans in the twentieth century encountered Africa for the first time. Because a trip to Africa is often an unaffordable and complicated undertaking, many tourist attractions in Florida have provided "the experience of Africa," which at Busch Gardens includes hot dogs. Hot dogs are not an "African dish," but they are a common feature of amusement parks.

Visit the website for Busch Gardens Tampa to keep up with the evolving attractions at this large mega-park with an African theme.

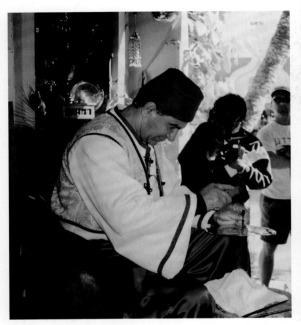

Figure 23.9. Busch Gardens, Tampa. *Left*: Artisan working in the Moroccan bazaar. *Right*: display of wares for sale. Photos by Amanda B. Carlson, 2001.

Audiences are so consumed with these stories of adventure that they barely recognize the African references, which are nothing but a backdrop to the colonial narratives that guide the visitor though the park. This park re-creates Africa at the turn of the twentieth century at the height of colonialism. The Crown Colony Lodge is the dining establishment that is positioned on top of a hill and looks out over the Serengeti plains. Built to resemble colonial architecture in Africa, the lodge comes to represent the colonial power that owns the park—Anheuser-Busch. Their stable of Clydesdale horses are off to the side of the building, resembling the stables of the colonizers who would use horses to traverse the territory.

Building upon the tradition of nineteenth-century ethnographic exhibitions and World's Fairs, there is a direct correlation between understanding the animals and the cultures of foreign lands. Africans only appear in the Morocco section and not in the other areas of the park. African characters appear in the show *KaTonga: Musical Tales from the Jungle* held in the Moroccan Palace Theater—Busch Garden's answer to Disney's *The Lion King*. There is also the Mystic Sheiks of Morocco, which is a marching band. Otherwise, African peoples are not present except for the artisans in Morocco who were displayed in gift-shop settings demonstrating craft production (fig. 23.9). It resembles the model of ethnographic exhibitions in which colonial subjects were exhibited in order to justify the need for colonialism.

Amanda B. Carlson

Timbuktu, a brand new re-creation of the legendary African trading center. Highlighted by our amazing Dolphins of the Deep show, the Festhaus (where you'll savor delicious German food), the Carousel Caravan, the Crazy Camel. And coming this summer, the Scorpion, a wicked vertical-loop roller coaster.

Figure 23.10. Busch Gardens, Tampa. *Bottom left*: Brochure (detail showing the dolphin show), Florida Ephemera Collection, Department of Special and Area Studies Collections, George A. Smathers Libraries, University of Florida. *Top and bottom right*: Islamic-style architecture associated with the country of Mali. Photos by Justin Smith.

Replicas of African architectural structures and gift-shop trinkets are stand-ins for African culture. Representations of Islamic architecture, deeply rooted in zoo culture from the turn of the last century, are a central theme in Timbuktu, which opened in 1980 (fig. 23.10). It was a "recreation of the legendary African trading center. Highlighted by our amazing Dolphins of the Deep show, the Festhaus (where you'll savor delicious German food), the Carousel Caravan, the Crazy Camel."[30] In 2003 a renovation removed the porpoise show from the structure that resembles a Malian mosque in order to make more space for Sesame Street Safari of Fun—not because of the international heightened awareness of representations of Islam. Islamic-inspired architecture appears in Festhaus—an eclectic mix of mosque architecture topped with the German flag. In 2004, this rowdy "beer garden" became the Desert Grill.

Once you step out of the "built architectural environment," you step into the other "built environment"—nature. Animal attractions include Bird Gardens, Jungala, Rhino Rally, Edge of Africa, Lorry Landing, Serengeti Plain, Jambo Junction, and Myombe Reserve. Jungala (in Congo section) re-creates an isolated, uninhabited village in the jungle, which features Bengal tigers. Even though tigers have never existed in Africa, "folk models of the tiger"[31] equate them with lions and thus with Africa. While the tigers at Busch Gardens were once kept in an Asian display setting, this part of the park was redone in 2008 in order to make tigers fit the African theme. Along with the animal experiences, the roller coasters are the main attraction, each with an African-inspired name: Gwanzi, Kumba, Montu, Scorpion, and SheiKra. This huge, commercial park is the most overpowering example of how animals and thrills are combined within an African attraction.

Congo River Golf Adventure (1987–present), Various Locations

It's not just a game, it's an adventure!
Brochure

Congo River Golf Adventure attests to the validity of the Africa theme in Florida's tourist market even beyond the power of the mega-parks. The Congo River Golf & Exploration Co. is a franchise with nine venues in Florida, which are each roughly two acres. It's essentially a miniature golf course with some arcade-like games. In its merchandising literature it's described as an "unforgettable African adventure"[32] (fig. 23.11). This is one of the few parks that is about exploration rather than colonialism—although the two are tied together.

Visit the website for Congo River Golf to learn about the numerous locations of this franchise and what they offer.

Amanda B. Carlson

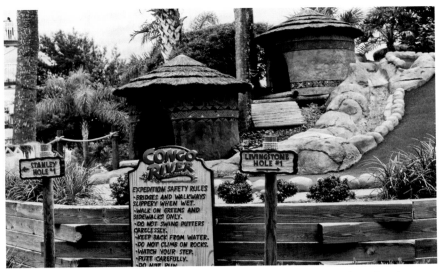

Figure 23.11. Congo River Golf Adventure, Orlando. A miniature golf course based on the theme of the Congo River and the story of Stanley and Livingstone. Photo by Amanda B. Carlson, 2003.

At the entrance in Orlando, guests are greeted by a pit of alligators (see fig. 23.2, right) and several wooden carvings that resemble Native American totem poles. Players are asked to follow the footsteps of Stanley and Livingstone as they explore the Congo River, a storyline that has also been used in zoos.[33] African masks function as signage marking each golf hole. The course takes you through artificially constructed mountains, rivers, and paths. Players eventually come across the explorers' plane, which has crashed into the side of the "mountain," and find the "corpse" of an explorer in the ground (or rather an imprint from his skeletal remains and pith helmet). Africa is both fun and dangerous.

Disney's Animal Kingdom, Orlando, Florida

It's Not a Zoo.
Brochure

In 1998, Disney really "put the mouse ears" on Africa with Disney's Animal Kingdom. Disney has represented Africa in other parks, such as in Adventure Land's Jungle Cruise and It's a Small World in the Magic Kingdom and the Morocco Pavilion in Epcot, but this tribute to Africa is far more grand and

Visit the website for Kilimanjaro Safaris to learn more about this Walt Disney World attraction.

complex. While sections of Disney's Animal Kingdom include Africa, Asia, Oasis, Discovery Island, Camp Minnie-Mickey, Rafiki's Planet Watch, and Dinoland, USA, I will only discuss the African section, which is a significant portion of the park. It includes Harambe Village, Kilimanjaro Safaris, Gorilla Falls Exploration Trail, and the Wildlife Express to Conservation Station.

This park strives to transport guests "to the realm of animals—real, extinct, and imaginary." However, "IT'S NOT A ZOO." This often-repeated marketing slogan buzzes over the loudspeaker of each tram that takes eager families from the parking lot to Disney's newest theme park—Animal Kingdom. It's not a zoo that relies upon scientific forms of classification/education. Rather, it presents animals as cultural symbols within a story that is in the most general sense about diversity and world order in the twenty-first century. In other words, the rest of the world matters to us if we consider how it might affect the world's ecosystem.

Imagineers (Disney's designers and engineers) took six trips to Africa, documenting the experience with photographs, sketches, and memories. While on safari in East Africa the team got caught in a traffic jam of tourists vying for the best view of a single leopard. "That's when we realized that the tourists' Africa is a theme park—just not a particularly well-run one," explained a project manager.[34] Moreover, the Imagineers had found their story—humans and animals are in conflict over land. For the most part, "wild animals" in Africa are kept on reserves because their natural habitat has been taken over by human development. Thus, the "wilderness" that tourists are experiencing is a contained and coordinated space. Therefore, Disney is constructing its own version of the African safari which is a constructed experience in and of itself. Disney strives to make the adventure experience of traveling to Africa as authentic as possible, not to create an authentic Africa.

The conflict between humans and animals informs all of the subthemes in the park, which likewise informs the very look of the park. Architectural structures are a bit gritty and grimy with lots of distressed surfaces and signs of wear and tear symbolizing the "frailty of human endeavor in the face of nature."[35] This aesthetic, which is based on a twenty-first-century vision of a decaying postcolonial Africa, is in sharp contrast to the glistening structures in Busch Gardens that reflect the image of colonialism in Africa in the nineteenth and twentieth centuries that sought to project the promise of modernity and prosperity. Similarly, transportation within Animal Kingdom differs greatly from Busch Gardens' sparkling railway and ultra-modern Skyride.

The giant baobab tree is the centerpiece of the park. Here, "in Harambe is the beginning of true-life adventure. Guests board a camouflage-painted 32 passenger truck, travel a twisting trail rutted with the tire tracks of many safaris before—through a lush green forest, across rivers and waterfalls to the Serengeti, grasslands rich with antelope, giraffes, zebras, baboons, rhinos,

elephants, crocodiles, lions, hippos, and much much more. But it's more than an over look experience—it's true storybook adventure as the safari joins in a hunt for dangerous game poachers."[36] As the safari truck cruises along over prefabricated ruts in the road, a British researcher (who is supposedly in a plane above) radios in and asks for our assistance in tracking some poachers. Poachers are individuals who illicitly hunt on animal preserves. In the nineteenth century, when safari culture developed as a white male hunting tradition, lands were allocated for these rituals of conquest. Even when photographic safaris became the vogue, notions of dominance were a large part of the adventure, so much so that photographic guns were invented (and still produced today). These practices denied traditional African hunters the use of land and labeled them as poachers. Poachers are the villains of this Disney story.

Back in Harambe Village, I interview Tabo, a cultural representative from Botswana in 2003. He is one of several people recruited annually in Africa to spend a year working in the park answering questions for guests about Africa. Tabo explained that he could wear traditional dress from home, but chooses the Disney costume because the traditional dress from Botswana is composed mostly of animal skins. Children coming from the Safari attraction and freshly informed of the evils of poachers have accused him of being "a very bad man." In this way, not just poachers, but black Africans inadvertently become the villains in this story. Our conversation was interrupted by a performer in an elegant, yellow Victorian-style dress, who wanted to talk about her husband, Tarzan. Jane is another inhabitant of Africa whose story is entwined with that of colonialism and a reminder that everyone had a part to play.

The reenactment of colonial order in Disney's depiction of Africa and its relationship with nature is obvious and everywhere. But, the cultural representatives (such as Tabo) are interesting mediators of this story. While they are trained to work from the Disney script, they do interject their own voices. In one interview, a representative admitted that he diffuses questions about wars in Africa but he will speak about AIDS, because his home country of Botswana can be seen as triumphant in this matter. Even with the opportunity of coming to America, most of the reps I interviewed exhibited a lukewarm enthusiasm for their jobs. With limited benefits and transportation, they have seen little of Florida (or the United States) outside of Disney. If this program was intended as a gesture to cross-cultural understanding, it fell short of its potential.

A Night in the Jungle: Beyond the Park

Florida vacations were often considered exotic for most North Americans who sought to escape their normal lives and the cold climates; and this experience

Figure 23.12. Sheraton Safari Hotel Lake Buena Vista, Orlando. Lobby and pool area. Photos by Amanda B. Carlson, 2003.

extends beyond the theme parks to restaurants and hotels. The Safari Beach Motel (Daytona Beach) is one of the earlier examples.[37] In a 1960s image produced by Jon G. Von, a postcard photographer,[38] the entranceway sign includes a large-scale shield with spears. In Orlando, the Sheraton Safari Hotel (Lake Buena Vista) was an African-themed hotel (fig. 23.12), until it was redeveloped by new owners in 2011 as Sheraton, Lake Buena Vista Resort. The brochure for

Visit the website for Disney's Animal Kingdom Lodge to learn more about this resort, which was inspired by a traditional African kraal (a rural village with an animal enclosure).

the Safari Hotel explains, "Our theme is African safari. A pair of fanciful zebras greet you at the front desk. Stylish, jungle artifacts decorate the lobby, and a python water slide twists into our pool. . . . The Sheraton Safari Hotel creates a mood of adventure, intrigue and African sophistication. The excitement of a safari permeates the hotel." Numerous pieces of African "tourist art" adorned the lobby, including an upside-down Bwa owl mask. This themed hotel had included restaurants such as Casablanca's and Outpost along with the Zanzibar Lounge, where they offered up Safari coolers.

The Sheraton may have had "stylish jungle artifacts" decorating the lobby, but Disney's Animal Kingdom Lodge, which opened in 2001, has that along with an actual collection of African art in the lobby with museum-style cases, text, and lighting. And, more importantly, they have real animals. A resort map guides guests to their rooms and to the animals. "With views of our 33-acre acre savanna that features free-roaming animals and birds, Disney's Animal Kingdom Lodge celebrates not only Africa's wildlife, but also its art, food and culture."[39] It's clearly an extension of the theme park. Notes from the management are signed "The Cast of Disney's Animal Kingdom Lodge."

Conclusion: Africa in Florida

The clichés that lead the tourist industry are slow to change and provide us with some of the most persistent, troubling images of Africa. If these attractions are meant to fulfill our desires for travel, adventure, and unexpected thrills, why must this be at the expense of re-creating colonial fantasies and interpreting them through the present? More importantly, we need to consider why visitors continue to desire these stories.

As described in this book, the histories of Africa and Florida overlap in interesting ways. Even when the histories of Africa and Florida do not overlap, they have been shaped by similar historical narratives framed by race, territory, travel, adventure, and conquest. Safari tourism is perhaps the clearest example of how this works in a state of hyperreality. And, perhaps it can also explain why African attractions have been so successful in Florida.

In Africa, safari culture at the turn of the twentieth century moved from an individualized sport of killing to organized group tours of photographers and naturalists. James Ryan explains that "this shift is inescapably linked to the broader colonial transformation of Africa itself, from an era of exploration and conquest to one of settlement and administration."[40] In the twenty-first

century in the postcolonial era, safari tourism has become part of a larger industry of ecotourism, which focuses on a respect for the environment and sustainability. How does this compare to Florida?

While hunting safaris in Africa were originally a demonstration of man's brute force over nature, to my knowledge safari attractions, where animals were physically hunted, never existed in Florida . . . except in Carl Hiaasen's novel *Sick Puppy* (1999), in which his lead character frequents safari parks that have been stocked with "wild" animals: "Palmer Stoat had more than enough money to go to Africa, but he didn't have the time. That's why he did his big-game hunting at local safari ranches, some legal and some not. This one located near Ocala, Florida, was called the Wilderness Veldt Plantation. Officially it was a 'private game preserve'; unofficially it was a place where rich people went to shoot exotic wild animals."[41] Hiaasen was likely inspired by the numerous theme parks that deploy the same language and imagery of hunting. Theme parks still involve "hunting," but with one's camera in a quest for adventure. Although the numerous safari experiences that operate in Florida today tell stories of Africa that resemble older models of the man-versus-nature story, they do so in an attempt to manage our anxiety about the disappearance or destruction of nature. Ironically, they do this through the erasure of Florida wildlife and Florida history.

Notes

1. Eco, *Travels in Hyperreality*, 26.
2. Baudrillard, *Simulacra and Simulation*; Eco, *Travels in Hyperreality*, and others.
3. Fjellman, *Vinyl Leaves*, 23.
4. Hiaasen, "Mickey and Minnie Need Some Fire Ants," 19–20.
5. Hiaasen, *Native Tongue*, 228–29.
6. Baudrillard, *Simulacra and Simulation*, 6.
7. http://www.lostparks.com/timeline.html.
8. West, *The Enduring Seminoles*, 43.
9. Ibid., 42.
10. Colburn, "Florida Politics in the Twentieth Century," 345.
11. For a description of the venues of early jungle tourism see Hollis, *Dixie before Disney*, 155–62.
12. While *The African Queen* (1951) was not filmed in Florida, the famous boat is currently kept in Key Largo and is listed on the U.S. Register of Historic Places.
13. "Safari in Safety," *Miami Herald*, December 4, 1955.
14. Hersh, "Africa U.S.A. Only a Memory for Boca Residents."
15. Hanson, *Animal Attractions*, 75.
16. Monkey islands became a popular feature in zoos in the 1920s and 1930s. Ibid., 4.
17. Tanganyika was the name of a British territory (1919–61) that later became the country of Tanzania.
18. The "lion dance" was re-created from documentary films that Jack Pedersen produced while he was in Kenya.
19. Mase, "Florida Wilds Being Transformed into African Jungle."

20. Hersh, "Africa U.S.A. Only a Memory for Boca Residents," 3.

21. "He'll Sell Africa for $2,000,000," publication and date unknown, newspaper article from the archives of Ginger Pedersen and Africa U.S.A. provided to the author in 2003.

22. http://www.lioncountrysafari.com/history.html (accessed May 24, 2010).

23. This is a memorable childhood experience for this author as well as for one of the writers for the series *The Simpsons*. In episode 30, "Old Money," the Simpsons visit Discount Lion Safari, which is a spoof on Lion Country Safari playing up the fact that this is not Disney.

24. This park in Zimbabwe was formerly known as Wankie National Park, but it changed to Hwange. Lion Country Safari likewise changed the name. The town of Wankie in Zimbabwe changed its name to Hwange in 1982.

25. Mullan and Marvin, *Zoo Culture*, 4.

26. Los Angeles, Dallas, Atlanta, Cincinnati, and Richmond.

27. Rendeall, *Living with the Big Cats*, 113.

28. According to Tim Tetzlaff, Jungle Larry's son, this attraction was once called "Jungle Larry's Safari Island," when there was an island. Personal communication, July 9, 2012.

29. "Circus Africa" was also the name of an attraction that Jungle Larry produced in Puritas Spring's theme park (near Cleveland, Ohio). Personal communication with Tim Tetzlaff, July 9, 2012.

30. Text from a brochure in P. K. Yonge Library of Florida History, reference #5245.

31. Mullan and Marvin, *Zoo Culture*, 3.

32. http://www.congoriver.com/ (accessed May 17, 2010).

33. The Blue Ridge Zoological Park, Virginia, developed a storyline based upon Livingstone's travels in Africa. See Mullan and Marvin, *Zoo Culture*, 59.

34. Malmberg, *The Making of Disney's Animal Kingdom Theme Park*, 18.

35. Ibid., 12.

36. Press packet.

37. This motel was located at 357 S. Atlantic Ave., Daytona Beach, FL 32018. It probably does not exist anymore, although Daytona does have a tour boat called *Jungle Jim*, which hosts Safari River Tours.

38. Greg W. McCollum maintains a website (http://chattoogaphotohistory.com/daytona.html) that documents the work of this German-born photographer.

39. Habari directory of Services (brochure), Disney's Animal Kingdom Lodge.

40. Ryan, *Picturing Empire*, 136.

41. Hiaasen, *Sick Puppy*, 5.

Bibliography

Abiodun, Rowland. "Hidden Power: Osun, the Seventeenth Odù." In *Osun across the Waters: A Yoruba Goddess in Africa and the Americas*, edited by Joseph M. Murphy and Mei-Mei Sanford, 10–13. Bloomington: Indiana University Press, 2001.

———. "Verbal and Visual Metaphors: Mythical Allusions in Yoruba Ritualistic Art of Orí." *Word and Image* 3, no. 3 (1987).

Abiodun, Rowland, Henry John Drewal, and John Pemberton III. *Yoruba Art and Aesthetics*. Zurich: Rietberg Museum, 1991.

Abraham, R. C. *Dictionary of Modern Yoruba*. 1946. London: University of London Press, 1958.

Adelman, Jeremy, and Stephen Aron. "From Borderlands to Borders: Empires, Nation-States, and the Peoples in Between in North American History." *American Historical Review* 104 (1999): 814–41.

Adepegba, C. O. "Oshun and Brass." In *Osun across the Waters: A Yoruba Goddess in Africa and the Americas*, edited by Joseph M. Murphy and Mei-Mei Sanford, 102–12. Bloomington: Indiana University Press, 2001.

———. *Yoruba Metal Sculpture*. Ibadan: Ibadan University Press, 1991.

Africa, African-American News. Brothers Corner, Sistas Corner. Press Release, African Liberation Day, May 19, 2010—1:11 pm.

Agee, James, and Walker Evans. *Let Us Now Praise Famous Men*. Boston: Houghton Mifflin, 1941.

Alegría, Ricardo E. "Indian America: Tainos." In *Christopher Columbus and the Age of Exploration: An Encyclopaedia*, edited by Silvio A. Bedini, 345–49. New York: Da Capo, 1998.

American State Papers, Class II: Indian Affairs. 2 volumes, 1832–34. Washington, D.C.: Gales & Seaton.

American State Papers, Class V: Military Affairs. 7 volumes, 1832–61. Washington, D.C.: Gales & Seaton.

American State Papers, Miscellaneous. 2 volumes, 1834. Washington, D.C.: Gales & Seaton.

Angel-Ajani, Angel. "Diasporic Conditions: Mapping the Discourses of Race and Criminality in Italy." *Transforming Anthropology* 11, no. 1 (2002): 36–46.

Angell, Stephen Ward. *Bishop Henry McNeal Turner and African-American Religion in the South*. Knoxville: University of Tennessee Press, 1992.

Anonymous. *La insurgencia en la Antigua Veracruz 1812*. Prólogo Leonardo Pasquel. México Editorial Citlaltépetl, 1960.

Appiah, Kwame Anthony, and Henry Louis Gates Jr., eds. *Africana: The Encyclopedia of the African and African-American Experience*. New York: Basic Civitas Books, 1999.

Apter, Andrew. "Herskovits' Heritage: Rethinking Syncretism in the African Diaspora." *Diaspora* 1, no. 3 (1991): 235–60.

————. *The Pan-African Nation: Oil and the Spectacle of Culture in Nigeria.* Chicago: University of Chicago Press, 2005.

Aptheker, H. "Maroons within the Present Limits of the United States." In Price, *Maroon Societies*, 151–67.

Arnade, Charles. "Raids, Sieges, and International Wars." In Gannon, *The New History of Florida*, 100–116.

Arnett, Paul, and William Arnett. *Souls Grown Deep: African American Vernacular Art of the South.* Vol. 1. Atlanta: Tinwood Books, 2000.

Aron, Stephen, and Jeremy Adelman. "From Borderlands to Borders: Empires, Nation-States, and the Peoples in Between in North American History." *American Historical Review* 104 (June 1999): 814–41.

Arthur, Jonathan D., Paulette Bond, Ed Lane, Frank R. Rupert, and Thomas M. Scott. "Florida's Global Wandering through the Geologic Eras." In *Florida's Geological History and Geological Resources*, edited by Ed Lane, 11–12. Tallahassee: Florida Geological Survey, 1994.

Asante, Molefi Kete. "African Elements in African-American English." In Holloway, *Africanisms in American Culture*, 19–34.

Ave, Melanie. "Famous or Infamous?" *St. Petersburg Times,* February 28, 2007.

Ayer Collection. Newberry Library, Chicago, Illinois.

Ayorinde, Christine. "Ékpè in Cuba: The Abakuá Secret Society, Race and Politics." In *Repercussions of the Atlantic Slave Trade: The Interior of the Bight of Biafra and the African Diaspora*, edited by C. Brown and P. Lovejoy, 135–54. Trenton, N.J.: Africa World Press, Inc., 2011.

Bailyn, Bernard. *Atlantic History: Concepts and Contours.* Cambridge: Harvard University Press, 2005.

Bair, Barbara. "Ethiopia Shall Stretch Forth Her Hands Unto God." In *A Mighty Baptism: Race, Gender, and the Creation of American Protestantism,* edited by Susan Juster and Lisa Macfarlane, 38–63. Ithaca: Cornell University Press, 1996.

Balandier, Georges. *Daily Life in the Kingdom of Kongo from the Sixteenth to the Eighteenth Century.* New York: Pantheon Books, 1965.

Baptist, Edward. *Creating an Old South: Middle Florida's Plantation Frontier before the Civil War.* Chapel Hill: University of North Carolina Press, 2002.

Baram, U. "A Haven from Slavery on Florida's Gulf Coast: Looking for Evidence of Angola on the Manatee River." *African Diaspora Archaeology Network Newsletter,* June 2008, http://www.diaspora.uiuc.edu/news0608/news0608.html.

Barrett, Leonard E. *Soul Force: African Heritage in Afro-American Religion.* New York: Doubleday, 1974.

Bartram, William. *Travels of William Bartram.* Edited by Mark Van Doren. 1791. Reprint, New York: Dover Publications, 1955.

Bascom, William R. "Two Forms of Afro-Cuban Divination." *Acculturation in the Americas.* Vol. 2, Proceedings and Selected Papers of the Twenty-ninth International Congress of Americanists. 3 vols. Edited by Sol Tax, 169–79. Chicago: University of Chicago Press, 1952.

————. "Yoruba Concepts of the Soul." In *Men and Cultures,* edited by A. F. C. Wallace, 401–10. Philadelphia: University of Pennsylvania Press, 1956.

Bassett, John Spencer, ed. *Correspondence of Andrew Jackson.* 7 vols. Washington, D.C.: Carnegie Institute of Washington, 1927.

Bastide, Roger. *African Civilizations in the New World.* Translated by Peter Green. New York: Harper & Row, 1971.

Batacumbele. *Afro Caribbean Jazz.* Montuno records, mcd-525 (audio recording), 1987.

Bateman, Rebecca. "Africans and Indians: A Comparative Study of the Black Carib and Black Seminole." *Ethnohistory* 37 (Winter 1990): 1–24.

Baudrillard, Jean. *Simulacra and Simulation.* Ann Arbor: University of Michigan Press, 1994.

Bedini, Silvio A. *Christopher Columbus and the Age of Exploration: An Encyclopaedia.* New York: Da Capo, 1998.

Beier, Ulli. *Yoruba Beaded Crowns: Sacred Regalia of the Olokuku of Okuku.* London: Ethnographica in Association with the National Museum, Lagos, 1982.

Beltrán, Elio F. *Back to Cuba (The Return of the Butterflies).* Philadelphia: Xlibris, 2009.

Benghiat, Norma. *Traditional Jamaican Cookery.* London: Penguin, 1985.

Bennett, Herman. *Africans in Colonial Mexico: Absolutism, Christianity, and Afro-Creole Consciousness, 1570–1640.* Bloomington: Indiana University Press, 2003.

Bentor, Eli. "Masquerade Politics in Contemporary Southeastern Nigeria." *African Arts* 41, no. 1 (Winter 2008): 32–43.

Berlin, Ira. "From Creole to African: Atlantic Creoles and the Origins of African-American Society in Mainland North America." *The William and Mary Quarterly*, 3rd ser., 53, no. 2 (April 1996): 251–88.

———. *Many Thousands Gone: The First Two Centuries of Slavery in North America.* Cambridge: Harvard University Press, 1998.

Beverley, Robert. *The History and Present State of Virginia.* Edited by Louis B. Wright. Charlottesville, Va.: Dominia, 1968.

Bice, David. *The Original Lone Star Republic: Scoundrels, Statesmen and Schemers of the 1810 West Florida Rebellion.* Clanton, Ala.: Heritage Publishing Consultants, 2004.

Bilby, Kenneth M. *True-Born Maroons.* Gainesville: University Press of Florida, 2006.

Black Art Ancestral Legacy. New York: Dallas Museum of Art and Harry N. Abrams, 1990.

Black Baptisms, Cathedral Parish Records, Diocese of St. Augustine Catholic Center, Jacksonville, Florida, on microfilm reel 284 F, P. K. Yonge Library.

Black Marriages, Cathedral Parish Records, Diocese of St. Augustine Catholic Center, Jacksonville, Florida, on microfilm reel 284 C, P. K. Young Library.

Blassingame, John W. *The Slave Community: Plantation Life in the Antebellum South.* New York: Oxford University Press, 1972.

Bleach, Gordon. "Visions of Access: Africa Bound and Staged, 1880–1940." Ph.D. diss., SUNY Binghamton, 2000.

Bockie, Simon. *Death and the Invisible Powers: The World of Kongo Belief.* Bloomington: Indiana University Press, 1983.

Bolton, H. Carrington. "Decoration of Graves of Negroes in South Carolina." *Journal of American Folk-Lore* 4 (1891): 214.

Bowen, T. J. *Central Africa: Adventures and Missionary Labors in Several Countries in the Interior of Africa, from 1849 to 1856.* Charleston, S.C.: Southern Baptist Publications Society, 1857.

Brah, Avtar. *Cartographies of Diaspora: Contesting Identities.* London: Routledge, 1996.

Brandon, George. "The Dead Sell Memories: An Anthropological Study of Santeria in New York City." Ph.D. diss., Rutgers University, State University of New Jersey, New Brunswick, 1983.

Braund, Kathryn Holland. "The Creek Indians, Blacks, and Slavery." *Journal of Southern History* 57 (1991): 601–37.

Bremer, Fredrika. *The Homes of the New World: Impressions of America.* Translated by Mary Howett. New York: Negro Universities Press, 1991.

Brewster, Paul G. "Beliefs and Customs." In *Frank C. Brown Collection of North Carolina Folklore*, vol. 1, edited by Newman Ivey White, 254–61. Durham, N.C.: Duke University Press, 1952.

"Brief History of the Orthodox Church in Ghana." http://www.orthodoxresearchinstitute
.org/articles/church_history/anderson_ghana.htm.

Britten, Thomas A. *A Brief History of the Seminole-Negro Indian Scouts*. Lewiston, N.Y.:
Edwin Mellon Press, 1999.

Brooks, James, ed. *Confounding the Color Line*. Lincoln: University of Nebraska Press, 2002.

Brown, Canter, Jr. "The Civil War, 1861–1865." In Gannon, *The New History of Florida*,
231–48.

———. *Florida's Black Public Officials, 1867–1924*. Tuscaloosa: University of Alabama Press,
1998.

———. *Florida's Peace River Frontier*. Gainesville: University Press of Florida, 1991.

———. "The 'Sarrazota, or Runaway Negro Plantations': Tampa Bay's First Black Com-
munity, 1812–1821." *Tampa Bay History* 12 (1990): 5–19.

———. "Tales of Angola: Free Blacks, Red Stick Creeks, and International Intrigue in
Spanish Southwest Florida, 1812–1821." In Brown and Jackson, *Go Sound the Trumpet*,
5–21.

Brown, Canter, and David Jackson, eds. *Go Sound the Trumpet: Selections of Florida's Afri-
can-American History*. Tampa: University of Tampa Press, 2005.

Brown, Canter, Jr., and Larry Eugene Rivers. *For a Great and Grand Purpose: The Begin-
nings of the AMEZ Church in Florida, 1864–1905*. Gainesville: University Press of Florida,
2004.

Brown, Christopher, and Philip Morgan, eds. *Arming Slaves: From Classical Times to the
Modern Age*. New Haven: Yale University Press, 2006.

Brown, David H. "Garden in the Machine: Afro-Cuban Sacred Art and Performance in
Urban New Jersey and New York." Ph.D. diss., Yale University, 1989.

———. *Santería Enthroned: Art, Ritual, and Innovation in an Afro-Cuban Religion*. Chicago:
University of Chicago Press, 2003.

Brown, Jacqueline Nassy. "Black Liverpool, Black-America, and the Gendering of Diaspor-
ic Space." *Cultural Anthropology* 13, no. 3 (1998): 291–325.

Burgess, Frederick. *English Churchyard Memorials*. London: Lutterworth Press, 1963.

Burlingham, A. H. *The Story of Baptist Missions in Foreign Lands: From the Time of Garey to
the Present Date*. St. Louis: Chancy R. Barns, 1884.

Button, James. *Blacks and Social Change: Impact of the Civil Rights Movement in Southern
Communities*. Princeton: Princeton University Press, 1989.

Cabrera, Lydia. *Anaforuana: Ritual y símbolos de la iniciación en la sociedad secreta Abakuá*.
Madrid: Ediciones Madrid, 1975.

———. *Anagó: Vocabulario lucumí*. Miami: Ediciones Universal, 1970.

———. "La Ceiba y la sociedad secreta Abakuá." *Orígenes* 7, no. 24 (1950): 16–47.

———. *Koeko Iyawó: Aprende Novicia*. Miami: Ediciones Universal, 1980.

———. *La Lengua Sagrada de los Ñañigos*. Miami: Colección del Chicherekú en el exilio,
1988.

———. *El Monte*. Miami: Ediciones Universal, 1975/1954.

———. *El Monte*. Miami: Colección del Chicherekú, 1992/1954.

———. "Refranes Abakuás." *Refranes de Negros Viejos: Recogidos por Lydia Cabrera*. Miami:
Colección del Chicherekú, 1970.

———. *La Regla Kimbisa del Santo Cristo del Buen Viaje*. Miami: Colección del Chicherekú
en el exilio, 1977.

———. *La Sociedad Secreta Abakuá: Narrada por viejos adeptos*. La Habana: Ediciones C.
R., 1958.

———. *Yemaya y Ochun: Kariocha, Iyalorichas, y Olorichas*. Miami: Ediciones Universal,
1980.

Cabrera, Raimundo. *Cartas a Govín: Impresiones de viaje*. La Habana: La Moderna, 1892/1992/1954.

Campbell, Edward D. C., Sheryl Kingery, and Kym S. Rice. *Before Freedom Came: African-American Life in the Antebellum South*. Richmond: Museum of the Confederacy, 1991.

Campbell, James T. *Songs of Zion: The African Methodist Episcopal Church in the United States and South Africa*. New York: Oxford University Press, 1995.

Campbell, M. C. *The Maroons of Jamaica, 1655–1796: A History of Resistance, Collaboration and Betrayal*. Trenton, N.J.: Africa World Press, 1990.

Canney, Donald L. *Africa Squadron: The U.S. Navy and the Slave Trade, 1842–1861*. Washington, D.C.: Potomac Books, 2006.

Canny, Nicholas, and Anthony Pagden, eds. *Colonial Identity in the Atlantic World, 1500–1800*. Princeton: Princeton University Press, 1987.

Carew, Jan. "United We Stand! Joint Struggles of Native Americans and African Americans in the Columbian Era." *Monthly Review* 44 (1992): 103–27.

Carlson, Amanda. "Calabar Carnival: A Trinidadian Tradition Returns to Africa." *African Arts* 43, no. 3 (2010): 14–31.

Carney, Judith A. *Black Rice: The African Origins of Rice Cultivation in the Americas*. Cambridge: Harvard University Press, 2001.

Carter, Clarence Edwin, ed. *The Territorial Papers of the United States*. 28 vols. Washington, D.C.: United States Printing Office, 1934–49.

Castro, Adrian. "Cross the Water." *Wise Fish: Tales in 6/8 Time*. Minneapolis: Coffee House Press, 2005.

César, Waldo. "From Babel to Pentecost: A Social-Historical-Theological Study of the Growth of Pentecostalism." In Corten and Marshall-Fratani, *Between Babel and Pentecost*, 22–40.

Child, L. Marie. *Letters from New York*. 2nd ed. New York: C.S. Francis and Company, 1844.

Chomsky, Noam. *Year 501: The Conquest Continues*. Cambridge, Mass.: South End Press, 1999.

Chukwuezi, Barth. "Through Thick and Thin: Igbo Rural-Urban Circularity, Identity and Investment." *Journal of Contemporary African Studies* 19, no. 1 (2001): 55–66.

Churchill, Winston Spencer. *Ian Hamilton's March*. London: Longman, Green, 1900.

Clark, Mary Ann. "Asho Orisha (Clothing of the Orisha): Material Culture as Religious Expression in Santería." Ph.D. diss., Rice University, 1999.

Clarke, Kamari. *Mapping Yorùbá Networks: Power and Agency in the Making of Transnational Communities*. Durham, N.C.: Duke University Press, 2004.

Cline, Howard. *Notes on Colonial Indians and Communities in Florida, 1700–1821*. New York: Garland, 1974.

Cohen, M. M. *Notices of Florida and the Campaigns*. A Facsimile Reproduction of the 1836 Edition. Gainesville: University of Florida Press, 1964.

Coker, William, and Douglas Ingles. *The Spanish Censuses of Pensacola, 1784–1820: A Genealogical Guide to Spanish Pensacola*. Pensacola: Perdido Bay Press, 1980.

Coker, William S., and Susan Parker. "The Second Spanish Period." In Gannon, *The New History of Florida*, 150–66.

Coker, William S., and Thomas D. Watson. *Indian Traders of the Southeastern Spanish Borderlands: Panton, Leslie & Company and John Forbes & Company, 1783–184*. Pensacola: University of West Florida Press, 1986.

Colburn, David R. "Florida Politics in the Twentieth Century." In Gannon, *The New History of Florida*, 344–72.

———. *Racial Change and Community Crisis: St. Augustine, Florida, 1877–1980*. Gainesville: University Press of Florida, 1991.

Colburn, David R., and Jane L. Landers, eds. *The African American Heritage of Florida*. Gainesville: University Press of Florida, 1995.

Cole, Herbert, and Chike Aniakor. *Igbo Arts: Community and Cosmos*. Los Angeles: University of California Press, 1982.

Combes, John D. "Ethnography, Archaeology and Burial Practices Among Coastal South Carolina Blacks." *Conference on Historic Site Archaeology Papers* 7 (1972): 52–61.

Combs, Diana Williams. *Early Gravestone Art in Georgia and South Carolina*. Athens: University of Georgia Press, 1986.

Conjunto Folklorico Nacional. "Canto de Wemba"; "Marcha De Salida De Efo"; "Marcha De Salida De Efi." 'Goyo' Hernández, lead voice. La Habana: Areito. LDA-3156. Released in Miami as: Grupo Folklorico de Cuba. *Toques y Cantos de Santos*. Vol. 2. Cubilandia. C-CD 513, 1964.

Corten, André, and Ruth Marshall-Fratani, eds. *Between Babel and Pentecost: Transnational Pentecostalism in Africa and Latin America*. Bloomington: Indiana University Press, 2001.

Covington, James. *The Seminoles of Florida*. Gainesville: University Press of Florida, 1993.

Cox, Isaac. *The West Florida Controversy, 1798–1813: A Study in American Diplomacy*. Baltimore: Johns Hopkins University Press, 1918.

Craton, M. "Forms of Resistance to Slavery." In *General History of the Caribbean*, vol. 3, *The Slave Societies of the Caribbean*, edited by Franklin W. Knight, 222–70. London: Macmillan, 1997.

"Crowns." *Encyclopedia Britannica*. 15th ed. Chicago, 2002.

Cruwell, G. A. *Liberian Coffee in Ceylon: The History of the Introduction and Progress of the Cultivation Up to April 1878*. Colombo, Ceylon: A. M. & J. Ferguson, 1878.

Cruz-Carretero, Sagrario. *The African Presence in México*. Chicago: Mexican Fine Arts Center Museum, 2006.

Curren, Erik D. "Should Their Eyes Have Been Watching God? Hurston's Use of Religious Experience and Gothic Horror." *African American Review* 29, no. 1 (Spring 1995): 17–25.

Curtin, Philip D. *The Atlantic Slave Trade: A Census*. Madison: University of Wisconsin Press, 1969.

———. *The Rise and Fall of the Plantation Complex: Essays in Atlantic History*. 2nd ed. Cambridge: Cambridge University Press, 1998.

———. *Two Jamaicas: The Role of Ideas in a Tropical Colony, 1830–1865*. Westport, Conn.: Greenwood, 1955.

Cusick, James. *The Other War of 1812: The Patriot War and the American Invasion of Spanish Florida*. Gainesville: University Press of Florida, 2003.

Dallas, R. C. *The History of the Maroons: From their Origin to the Establishment of their Chief Tribe at Sierra Leone, including the Expedition to Cuba for the Purpose of Procuring Spanish Chasseurs and the State of the Island of Jamaica for the Last Ten Years, with a Succinct History of the Island Previous to that Period*. London: Frank Cass, 1968.

Dampier, William. *A New Voyage round the World, describing particularly the Isthmus of America*. London: James Knapton, 1698.

Daniels, Christine, and Michael Kennedy, eds. *Negotiated Empires: Centers and Peripheries in the New World, 1500–1820*. New York: Routledge, 2002.

Davidson, James M. Interim Report of Investigations of the University of Florida Historical Archaeological Field School: Kingsley Plantation (8Du108), Timucuan Ecological and Historic Preserve, National Park Service, Duval County, Florida. Submitted to the National Park Service, Southeast Archaeological Center, Tallahassee, Florida, 2008.

Davis, Henry C. "Negro Folklore in South Carolina." *Journal of American Folklore* 27 (1914): 241–54.

Davis, T. Frederick. "United States Troops in Spanish East Florida 1812–1813, Part II." *Florida Historical Quarterly* 9 (October 1930): 96–116.

———. "United States Troops in Spanish East Florida 1812–1813 (Letters of Liet. Col. T. A. Smith)." *Florida Historical Quarterly* 9 (July 1930): 106–7.

Deagan, Kathleen, and Darcie MacMahon. *Fort Mose: Colonial America's Black Fortress of Freedom.* Gainesville: University Press of Florida, 1995.

de Castlenau, Francis. "Essay on Middle Florida, 1837, 1838." Translated by Arthur R. Seymour, *Florida Historical Quarterly* 26 (January 1948): 199–255.

Deetz, James. *In Small Things Forgotten.* New York: Doubleday, 1977.

Degler, Carl. *Neither Black nor White: Slavery and Race Relations in Brazil and the United States.* Madison: University of Wisconsin Press, 1971.

Delano, Oloye Isaac. *Atúmọ̀ ede Yoruba* [short dictionary and grammar of the Yoruba language]. London: Oxford University Press, 1958.

Department of Commerce, Bureau of the Census, *Negro Population, 1790–1915* (Washington, D.C.: Government Printing Office, 1918), 51.

De Reparaz, Carmen. *Yo solo: Bernardo de Gálvez y la toma de Panzacola en 1781: Una contribución española a la independencia de los E.U.* Barcelona: Ediciones Serbal, 1986.

Dewhurst, C. Kurt. "Afro-American Religion and Art." In *Religious Folk Art in America: Reflections of Faith,* 46–53. New York: Museum of Modern Folk Art, 1983.

Díaz, María Elena. *The Virgin, the King, and the Royal Slaves of El Cobre: Negotiating Freedom in Colonial Cuba, 1670–1780.* Stanford, Calif.: Stanford University Press, 2000.

Dictionary of Jamaican English. Edited by F .G. Cassidy and R. B. Le Page. Cambridge: Cambridge University Press, 1980.

"Dire Working and Living Conditions in Firestone Rubber Plantation Exposed." May 25, 2005. www.newsfromafrica.org/newsfromafrica/articles/art10283.

Douglas, Marjory Stoneman. *Florida: The Long Frontier.* New York: Harper and Row, 1967.

Dowd, Gregory. *A Spirited Resistance: The North American Indian Struggle for Unity, 1745–1815.* Baltimore: Johns Hopkins University Press, 1992.

Downs, Dorothy. *Art of the Florida Seminole and Miccosukee Indians.* Gainesville: University Press of Florida, 1995.

Drewal, Henry John. "Art or Accident: Yoruba Body Artists and their Deity Ogun." In *Africa's Ogun: Old World and New,* edited by Sandra T. Barnes, 235–60. Bloomington: Indiana University Press, 1989.

———, ed. *Sacred Waters: Arts for Mami Wata and Other Divinities in Africa and the Diaspora.* Bloomington: Indiana University Press, 2008.

Drewal, Henry John, and John Mason. *Beads, Body, and Soul: Art and Light in the Yoruba Universe.* Los Angeles: UCLA Fowler Museum of Cultural History, 1998.

Drewal, Henry John, John Pemberton III, and Rowland Abiodun. *Yoruba: Nine Centuries of African Art and Thought.* New York: Abrams/Center for African Art, 1989.

Drewal, Margaret Thompson. "Projections from the Top in Yoruba Art." *African Arts* 11, no. 1 (Fall 1977): 43–49, 91–92.

Du Bois, W. E. B. *Black Folk, Then and Now.* Millwood, N.Y.: Kraus-Thompson Organization, 1939.

———. *The Suppression of the African Slave-Trade to the United States of America, 1683–1870.* New York: Kraus-Thomson Organization Limited, 1896.

Dumbaya, Peter A. "Thomas de Saliere Tucker: Reconciling Industrial and Liberal Arts Education at Florida's Normal School for Colored Teachers, 1887–1901." *Florida Historical Quarterly* 89 (Summer 2010): 26–50.

Dunlop, J. G. "William Dunlop's Mission to St. Augustine in 1688." *South Carolina Historical and Genealogical Magazine* 34 (January 1933): 1–30.

Dunn, Marvin. *Black Miami in the Twentieth Century*. Gainesville: University Press of Florida, 1997.

Duque, Francisco M. "La criminalidad y el ñañiguismo en Regla." In *Historia de Regla: Descripción política, económica y social, desde su fundación hasta el día*, 125–27. Habana: Liberaría y Encuadernación "Martí.," 1925.

Dusheck, Jennie. "Africa-America Split: Back to the Suture—Evidence That Florida Was Once Part of Africa." *Science News*, August 10, 1985, n.p.

Duval, Francis Y., and Ivan B. Rigby. *Early American Gravestone Art in Photographs*. New York: Dover Publications, 1978.

East Florida Papers, P. K. Yonge Library, University of Florida, Gainesville.

Eco, Umberto. *Travels in Hyperreality*. Translated by William Weaver. 1973. San Diego, Calif.: Harcourt Brace Jovanovich, 1986.

Edilson, Max. *Plantation Enterprise in Colonial South Carolina*. Cambridge: Harvard University Press, 2006.

Elébùìbọn, Ifayẹmi. *Adventures of Obatala 1 & 2*. Lynwood, Calif.: Ara Ifa Publishing, 1998.

———. *Apetebii: The Wife of Orunmila*. Brooklyn: Atheila Henrietta Press, 1994.

———. *The Healing Powers of Sacrifice*. Brooklyn: Atheila Henrietta Press, 1991.

———. *Ifá, the Custodian of Destiny*. Ibadan: Penthouse Publications Nigeria, 2004.

———. *Invisible Power of Metaphysical World: A Peep into the World of Witches*. Ibadan, Nigeria: Creative Books, 2008.

———. *Poetry Voice of Ifá*. San Benedino, Calif.: Ile Orunmila Communication, 1999.

Eltis, David, Stephen D. Behrendt, David Richardson, and Herbert S. Klein, eds. *The Trans-Atlantic Slave Trade: A Database on CD-ROM*. Cambridge: Cambridge University Press, 1999.

Eltis, David, and David Richardson, eds. *Extending the Frontiers: Essays on the New Trans-atlantic Slave Trade Database*. New Haven: Yale University Press, 2008.

Enyenison Enkama Project. *Ecobio Enyenison*. Produced by Roman Díaz, Angel Guerrero, and Pedro Martínez. Habana | Harlem, 2009, compact disc.

Epega, Afolabi A., and Philip John Neimark. *The Sacred Ifa Oracle*. Brooklyn: Athelia Henrietta Press, 1995.

Fabel, Robin. "British Rule in the Floridas." In Gannon, *The New History of Florida*, 134–49.

Fagen, Richard R., Richard A. Brody, and Thomas J. O'Leary. *Cubans in Exile: Disaffection and the Revolution*. Stanford, Calif.: Stanford University Press, 1968.

Fagg, William. *Yoruba Beadwork: Art of Nigeria*. New York: Rizzoli, 1980.

Fairbanks, Charles H. "The Kingsley Slave Cabins in Duval County, Florida, 1968." In *The Conference on Historic Site Archaeology Papers*, 1972, vol. 7. Edited by Stanley South, 62–65. Columbia: The Institute of Archaeology and Anthropology, University of South Carolina, 1974.

Fenn, Elizabeth A. "Honoring the Ancestors: Kongo-American Graves in the American South." *Southern Exposure* 5 (September/October 1985): 42–47.

Ferguson, Leland G. "'The Cross is a Magic Sign': Marks on Eighteenth-Century Bowls from South Carolina." In *"I, Too, Am America": Archaeological Studies of African-American Life*, edited by Theresa A. Singleton, 116–31. Charlottesville: University of Virginia Press, 1991.

Ferris, William, ed. *Afro-American Folk Art and Crafts*. Jackson: University Press of Mississippi, 1983.

Fields, Dorothy. "Reflections of Black History: Fun and Games in Over-town." *Update Magazine* 4 (June 1976): 3–12.

Fjellman, Stephan M. *Vinyl Leaves: Walt Disney World and America*. Boulder, Colo.: Westview Press, 1992.

Flores-Peña, Ysamur. "'Fit for a Queen': An Analysis of a Consecration Outfit in the Cult of Yemayá." *Folklore Forum* 23 (1994): 47–56.

Flores-Peña, Ysamur, and Roberta J. Evanchuck. *Santeria Garments and Altars: Speaking without a Voice*. Jackson: University of Mississippi Press, 1994.

Florida: A Guide to the Southernmost State. Compiled and Written by the Federal Writers' Project of the Work Projects Administration for the State of Florida. Reprint of 1939 original. New York: Oxford University Press, 1940.

Florida Historical Records Survey, Works Projects Administration. 1940–41. *Spanish Land Grants in Florida: Briefed Translations from the Archives of the Board of Commissioners for Ascertaining Claims and Titles in the Territory of Florida*. Vol. 3, 141–45. Tallahassee: State Library Board, 1940–41.

Foner, Philip S. *Antonio Maceo: The "Bronze Titan" of Cuba's Struggle for Independence*. New York: Monthly Review Press, 1977.

Forbes, Jack. D. *Africans and Native Americans: The Language of Race and the Evolution of Red-Black Peoples*. Urbana: University of Illinois Press, 1993.

———. *Black Africans and Native Americans: Color, Race, and Caste in the Evolution of Red-Black Peoples*. Oxford: Oxford University Press, 1988.

Foreman, Grant. *The Five Civilized Tribes*. Norman: University of Oklahoma Press, 1934.

Foster, Helen Bradley. "African American Jewelry before the Civil War." In *Beads and Bead Makers: Gender, Material Culture and Meaning*, edited by Lidia D. Sciama and Joanne B. Eicher, 177–92. Oxford, U.K.: Berg, 1998.

Foster, Laurence. *Negro-Indian Relationships in the Southeast*. Philadelphia: University of Pennsylvania Press, 1935.

Frank, Andrew K. *Creeks and Southerners: Biculturalism on the Early American Frontier*. Lincoln: University of Nebraska Press, 2005.

———. "Family Ties: Indian Countrymen, George Stinson and Creek Sovereignty." In Friend and Jabour, *Family Values in the Old South*, 189–209.

———. "Red, Black, and Seminole: Community Convergence on the Florida Borderlands, 1780–1840." In *Comparative Perspectives on North American Borderlands, 1500–1850*, edited by A. Glenn Crothers and Andrew K. Frank. Athens: Ohio University Press, forthcoming.

Frank, Nance. *Mario Sánchez: Better Than Ever*. Sarasota, Fla.: Pineapple Press, 2010.

Fraser, Douglas, and Herbert Cole, eds. *African Art and Leadership*. Madison: University of Wisconsin Press, 1972.

Frazier, E. Franklin. *The Negro Church in America*. New York: Schocken Books, 1963.

Freyer, Bryna. *Asen: Iron Altars from Ouidah, Republic of Benin*. Washington, D.C.: National Museum of African Art, 1993.

Friend, Craig Thompson, and Anya Jabour, eds. *Family Values in the Old South*. Gainesville: University Press of Florida, 2010.

Fu-Fiau, Kimbwandende Kia Bunseki. *Tying the Spiritual Knot: African Cosmology of the Bântu-Kôngo*. 2nd ed. Brooklyn: Athelia Henrietta Press, 2001.

Gabriel, Ralph Henry. *The Lure of the Frontier: A Story of Race Conflict*. New Haven: Yale University Press, 1929.

Gallay, Alan. *The Indian Slave Trade: The Rise of the English Empire in the American South, 1670–1717*. New Haven: Yale University Press, 2002.

Gambrell, Alice. *Women Intellectuals, Modernism and Difference: Transatlantic Culture, 1919–1945*. Cambridge: Cambridge University Press, 1997.

Gannon, Michael. *Florida: A Short History*. Gainesville: University Press of Florida, 2003.

———, ed. *The New History of Florida*. Gainesville: University Press of Florida, 1996.

García, Maria Cristina. *Havana USA: Cuban Exiles and Cuban Americans in South Florida, 1959–1994*. Berkeley: University of California Press, 1996.

García de León, Antonio. "Indios de la Florida en la Antigua Veracruz, 1757–1770: Un episodio de la decadencia de España ante Inglaterra." *Estudios de historia novohispana* 16 (1996): 101–18.

García Martínez, Bernardo. "Pueblos indios, pueblos de castas: New Settlements and Traditional Corporate Organization in Eighteenth Century New Spain." In *The Indian Community of Colonial Mexico: Fifteen Essays on Land Tenure Corporate Organizations Ideology and Village Politics*, edited by Arij Ouweneel y Simon Miller, 103–16. Amsterdam: CEDLA, 1990.

Garnett, James Mercer. *Biographical Sketch of Hon. Charles Fenton Mercer, 1778–1858*. Richmond, Va.: Whittet and Shepperson, 1911.

Gehman, Mary. "The Louisiana Creole Connection." *Louisiana Cultural Vistas* 11, no. 4 (Winter 2000–2001): 68–75.

George, Paul, ed. *A Guide to the History of Florida*. New York: Greenwood Press, 1989.

Georgia, East Florida, West Florida and Yazoo Land Sales, 1764–1850. Georgia Department of Archives and History, Atlanta.

Georgia Writer's Project. *Drums and Shadows: Survival Studies Among Georgia Coastal Negroes*. Athens: University of Georgia Press, 1940.

Gibbs, George W. Videotaped interview with University of Florida Ethnographic Field Team, National Park Service–sponsored Kingsley Heritage Celebration and Family Reunion. Fort George Island, Florida, October 10–11, 1998.

Giddings, Joshua R. *The Exiles of Florida: or, The Crimes Committed By Our Government Against the Maroons, Who Fled From South Carolina and Other Slave States, Seeking Protection Under Spanish Laws*. Columbus, Ohio: Follett, Foster and Company, 1858.

Gidley, Mick. "Sam Fathers's Father: Indians and the Idea of Inheritance." In *Critical Essays on William Faulkner: The McCaslin Family*, edited by Arthur F. Kinney, 121–30. Boston: G. K. Hall, 1990.

Gilroy, Paul. *The Black Atlantic: Modernity and Double Consciousness*. Cambridge: Harvard University Press, 1993.

———. *There Ain't No Black in the Union Jack*. Chicago: University of Chicago Press, 1987.

Glave, E. J. "Fetishism in Congo Land." *The Century Magazine* 41 (1891): 825–36.

"God's Acre." *Chambers's Journal of Popular Literature* 11, no. 285 (Saturday, June 18, 1859): 385–87.

Goebs, Katja. "Crowns." In *The Oxford Encyclopedia of Ancient Egypt*. Edited by Donald B. Redford. Oxford: Oxford University Press, 2001.

Goggin, John M. "Style Areas in Historic Southeastern Art." In *Indian Tribes of Aboriginal America*, edited by Sol Tax, 172–76. New York: Cooper Square Publishers, 1967.

Gold, Robert L. *Borderland Empires in Transition: The Triple-Nation Transfer of Florida*, Carbondale: University of Southern Illinois Press, 1969.

———. "Conflict in San Carlos: Indian Immigrants in Eighteenth Century New Spain." *Ethnohistory* 17 (1970): 1–10.

Goldie, H. *Dictionary of the Efik Language in Two Parts*. Glasgow: Dunn and Wright, 1862.

Gómez-Barberas, José-Miguel "Batea." A three-paged manuscript, signed by Mr. Gómez, shared among his godchildren upon his death in 2003 (one page was signed and dated as 1992).

González Ortiz, Cristina. "Las Floridas y el expansionismo norteamericano en México." In *5 siglos de historia de México*, edited by Guedea Virginia y Jaime Rodríguez O., 387–410. Vol. 2. México: Instituto de Investigaciones Dr. José María Luis Mora, 1992.

Goodall, John A. "Regalia." *The Grove Encyclopedia of Art Online*. Oxford: Oxford University Press, 2003.

Gottlieb, K. *The Mother of Us All: A History of Queen Nanny, Leader of the Windward Jamaican Maroons*. Trenton, N.J.: Africa World Press, 2000.

Governors Letter Books. Georgia Department of Archives and History. Atlanta.

Grant, C. L. ed., *Letters, Journals and Writings of Benjamin Hawkins.* 2 vols. Savannah, Ga.: Beehive Press, 1980.

Gray, Louis C. *History of Agriculture in the Southern United States to 1860.* Washington, D.C.: Carnegie Institute, 1933.

Greenbaum, Susan. *More Than Black: Afro-Cubans in Tampa.* Gainesville: University Press of Florida, 2002.

Greene, Jack, and Philip Morgan, eds. *Atlantic History: A Critical Appraisal.* New York: Oxford University Press, 2009.

Grider, Sylvia Ann, and Sara Jarvis Jones. "The Cultural Legacy of Texas Cemeteries." *Texas Humanist* 6 (1984): 34–39.

Griffin, Patricia C., ed. *Sitiki: The Odyssey of an African Slave.* Gainesville: University Press of Florida, 2009.

Grismer, Karl H. *The Story of Fort Myers: The History of the Land of the Caloosahatchee and Southwest Florida.* 1949. Reprint, Fort Myers Beach: Island Press Publishers, 1982.

Guinn, Jeff. *Our Land before We Die: The Proud Story of the Seminole Negro.* New York: Penguin Putnam, 2002.

Gundaker, Grey, ed. *Keep Your Head to the Sky.* Charlottesville: University of Virginia Press, 1998.

———. *Signs of Diaspora, Diaspora of Signs.* Oxford: Oxford University Press, 1998.

Hadden, S. *Slave Patrols: Law and Violence in Virginia and the Carolinas.* Cambridge: Harvard University Press, 2001.

Hall, Gwendolyn Midlo. *Slavery and African Ethnicities in the Americas: Restoring the Links.* Chapel Hill: University of North Carolina Press, 2005.

Hall, N. A. T. "Maritime Maroons: 'Grand Marronage' from the Danish West Indies." *William and Mary Quarterly,* 3rd ser., 42 (October 1985): 476–98.

Hall, Robert L. "African Religious Retentions in Florida." In Holloway, *Africanisms in American Culture,* 98–118.

———. "African Religious Retentions in Florida." In Colburn and Landers, *The African American Heritage of Florida,* 42–70.

Hamnet, Brian R. *Política y comercio en el sur de México, 1750–1821.* México: Instituto Mexicano de Comercio Exterior, 1976.

Hancock, David. *Citizens of the World: London Merchants and the Integration of the British Atlantic Community, 1735–1785.* Cambridge: Cambridge University Press, 1995.

Hanson, Elizabeth. *Animal Attractions in American Zoos.* Princeton, N.J.: Princeton University Press, 2002.

Harney, Elizabeth. *In Senghor's Shadow: Art, Politics and the Avant Garde in Senegal, 1960–1995.* Durham, N.C.: Duke University Press, 2004.

Harold, Claudrena W. *Rise and Fall of Marcus Garvey.* New York: Rutledge Press, 2009.

Harris, Jessica B. *High on the Hog: A Culinary Journey from Africa to America.* New York: Bloomsbury USA, 2011.

———. *Iron Pots and Wooden Spoons: Africa's Gifts to New World Cooking.* New York: Fireside, 1989.

———. *A Kwanzaa Keepsake.* New York: Fireside, 1998.

Harris, Joseph E. "The Dynamics of the Global African Diaspora." In *The African Diaspora,* edited by Alusine Jalloh and Stephen E. Maizlish, 7–21. College Station: Texas A&M University Press, 1996.

Hartigan, Linda Roscoe, Judith McWillie, Roger Manley, and Robert Farris Thompson. *Unsigned, Unsung . . . Whereabouts Unknown: Make-Do Art of the American Outlands.* Tallahassee: Florida State University Gallery & Museum, 1993.

Hays, Louise Frederick, ed. "Creek Indian Letters, Talks and Treaties, 1705–1839." Typescript. Georgia Archives of History, Atlanta.

Hazard, Thomas R. *Miscellaneous Essays and Letters*. Philadelphia: Collins, Printer, 1883.

Helg, Aline. *Our Rightful Share: The Afro-Cuban Struggle for Equality, 1886–1912*. Chapel Hill: University of North Carolina Press, 1995.

Hemenway, Robert. *Zora Neale Hurston: A Literary Biography*. Urbana: University of Illinois Press, 1977.

Herron, J. T. "The Black Seminole Settlement Pattern: 1813–1842." Master's thesis, University of South Carolina, Columbia, 1994.

Hersh, Tina. "Africa U.S.A. Only a Memory for Boca Residents." *The Post*, December 13, 1981.

Herskovitz, Melville. *The Myth of the Negro Past*. Boston: Beacon Press, 1941.

Heywood, Linda M., and John K. Thornton. *Central Africans, Atlantic Creoles, and the Foundation of the Americas, 1585–1660*. Cambridge: Cambridge University Press, 2007.

Hiaasen, Carl. "At Courthouse, Even Chickens Need Bodyguards." *Miami Herald*, April 13, 1995.

———. "Mickey and Minnie Need Some Fire Ants, June 29, 1995." In *Paradise Screwed*, edited by Diane Stevenson, 19–20. New York: Berkley Books, 2001.

———. *Native Tongue*. New York: Fawcett Books, 1991.

———. *Sick Puppy*. New York: Knopf, 2000.

Hickeringill, Edmund. *Jamaica Viewed: with All the Ports, Harbours, and their Several Soundings, Towns, and Settlements*. London: John Williams, 1661.

Hine, Darlene Clark, and Jacqueline McLeod, eds. *Crossing Boundaries: Comparative History of Black People in Diaspora*. Bloomington: Indiana University Press, 1999.

Historical Museum of Southern Florida. Interview with Antonio Salas by Miguel W. Ramos, April 21, 1998. Transcribed and translated by Cristina Geada, Georgetown University, SFS '04.

Hochschild, Adam. *King Leopold's Ghost*. Boston: Houghton Mifflin, 1999.

Hoffman, Paul. *Florida's Frontiers*. Bloomington: Indiana University Press, 2001.

Hollis, Tim. *Dixie before Disney: 100 Years of Roadside Fun*. Jackson: University Press of Mississippi, 1999.

Holloway, Joseph E. "Africanisms in African American Names in the United States." In *Africanisms in American Culture*, edited by Joseph E. Holloway, 82–110. 2nd ed. Bloomington: Indiana University Press, 2005.

———, ed. *Africanisms in American Culture*. Bloomington: Indiana University Press, 1990.

———. "The Origins of African-American Culture." In Holloway, *Africanisms in American Culture*, 1–18.

Holmes, Jack D. L. "De México a Nueva Orleáns en 1801: El diario inédito de Fortier y St. Maxent." *Historia Mexicana* 16, no. 1 (July–September 1966): 48–70.

———. "West Florida, 1779–1821." In George, *A Guide to the History of Florida*, 3–76.

Housewright, L. Wiley. *A History of Music and Dance in Florida, 1565–1865*. Tuscaloosa: University of Alabama Press, 1991.

Howard, Philip A. *Changing History: Afro-Cuban Cabildos and Societies of Color in the Nineteenth Century*. Baton Rouge: Louisiana State University Press, 1998.

Howard, Rosalyn. "Black Seminole Diaspora: The Caribbean Connection." In *Caribbean and Southern: Transnational Perspectives on the U.S. South*, edited by Helen A. Regis, 73–88. Athens: University of Georgia Press, 2006.

———. *Black Seminoles in the Bahamas*. Gainesville: University Press of Florida, 2002.

———. "The Promised Is'Land: Reconstructing History and Identity among the Black Seminoles of Andros Island, Bahamas." Ph.D. diss., Department of Anthropology, University of Florida, Gainesville, 1999.

———. "The 'Wild Indians' of Andros Island: Black Seminole Legacy in The Bahamas." *Journal of Black Studies* 37 (2006): 275–98.

Hudson, Charles. *The Southeastern Indians.* Knoxville: University of Tennessee Press, 1976.

Hunt, Carl M. *Oyotunji African Village: The Yoruba Movement in America.* Washington, D.C.: University Press of America, 1979.

Hurbon, Laënnec. "Haitian Vodou in the Context of Globalization." Translated by Terry Rey. In Olupona and Rey, *Òrìsà Devotion as World Religion,* 263–77.

Hurston, Zora Neale. "Cudjo's Own Story of the Last African Slaver." *Journal of Negro History* 12, no. 4 (October 1927): 648–63.

———. *Go Gator and Muddy the Water: Writings by Zora Neale Hurston from the Federal Writers' Project.* Edited by Pamela Bordelon. New York: Norton, 1999.

———. *Jonah's Gourd Vine.* London: Virago, 1987.

———. *Mules and Men.* 1935. New York: Harper Perennial, 1990.

———. *Tell My Horse: Voodoo and Life in Haiti and Jamaica.* New York: Harper Perennial, 1990.

———. *Their Eyes Were Watching God.* London: Virago, 1986.

Ingersoll, Ernest. "Decoration of Negro Graves." *Journal of American Folklore* 5 (1892): 68–69.

Inscoe, John C. "Carolina Slave Names: An Index to Acculturation." *Journal of Southern History* 49 (November 1983): 27–54.

Ishemo, Shubi L. "From Africa to Cuba: An Historical Analysis of the Sociedad Secreta Abakuá (Ñañiguismo)." *Review of African Political Economy* no. 92 (2002): 253–72.

Jackson, Antoinette. "Africans at Snee Farm Plantation." In *Signifying Serpents and Mardi Gras Runners,* edited by Celeste Ray and Luke Eric Lassiter, 93–109. Athens: University of Georgia Press, 2003.

———. "The Kingsley Plantation Community in Jacksonville, Florida—Transition and Memory in a Southern American City." *CRM: The Journal of Heritage Stewardship* 6, no. 1 (2009): 23–33.

Jackson, Antoinette, with Allan Burns. *Ethnohistorical Study of the Kingsley Plantation Community.* Atlanta: National Park Service, Southeast Region, Cultural Resources Division, 2006.

James, Winston. *Holding Aloft the Banner of Ethiopia: Caribbean Radicalism in Early Twentieth-Century America.* Verso: London, 1998.

Jamieson, Ross W. "Material Culture and Social Death: African-American Burial Practices." *Historical Archaeology* 29, no. 4 (1995): 39–58.

Janzen, John M., and Wyatt MacGaffey. *An Anthology of Kongo Religion: Primary Texts from Lower Zaire.* Lawrence: University of Kansas Press, 1974.

Jeane, Gregory D. "Folk Art in Rural Southern Cemeteries." *Southern Folklore* 46, no. 2 (1989): 159–74.

———. "The Upland South Cemetery: An American Type." *Journal of Popular Culture* 11, no. 4 (1978): 895–903.

———. "The Upland South Folk Cemetery Complex: Some Suggestions of Origin." In Meyer, *Cemeteries and Gravemarkers,* 107–36.

Johns, John. *Florida during the Civil War.* Gainesville: University Press of Florida, 1963.

Johnson, Walter, ed. *The Chattel Principle: Internal Slave Trades in the Americas.* New Haven: Yale University Press, 2005.

Jones, Maxine, and Kevin McCarthy. *African Americans in Florida.* Sarasota: Pineapple Press, 1993.

Jordan, Terry G. "'The Roses So Red and the Lilies So Fair': Southern Folk Cemeteries in Texas." *Southwestern Historical Quarterly* 83 (1979–80): 227–58.

Jordan, Winthrop. *White Over Black: American Attitudes toward the Negro, 1550–1812*. Chapel Hill: University of North Carolina Press, 1968.

Joyner, Charles. *Down by the Riverside: A South Carolina Slave Community*. Urbana: University of Illinois Press, 1984.

Juster, Susan, and Lisa Macfarlane, eds. *A Mighty Baptism: Race, Gender, and the Creation of American Protestantism*. Ithaca: Cornell University Press, 1996.

Kanneh, Kadiatu. *African Identities: Race, Nation and Culture in Ethnography, Pan-Africanism and Black Literatures*. London: Routledge, 1998.

Kastor, Peter. *The Nation's Crucible: The Louisiana Purchase and the Creation of America*. New Haven: Yale University Press, 2004.

Keegan, William F. "The Caribbean, Including Northern South America and Lowland Central America: Early History." In Kiple and Coneè, *The Cambridge World History of Food*, 2:1260–78.

Kennedy, Stetson. Testimony of Enrique. "All He's Living For (Enrique and Amanda)." January 3, 1939. Adelpha Pollato (Cuban) 2315 12th Avenue Ybor City, Tampa Florida. (Cigar Maker). Stetson Kennedy, writer. Reel 1, folder 130. Federal Writers' Project Papers. University of North Carolina Library. Chapel Hill, North Carolina. Page 21.

———. "Ñáñigos in Florida." *Southern Folklore Quarterly* 4, no. 3 (September 1940): 153–56.

Kenny, Susan. "Exploring the Dynamics of Indian-Black Contact: A Review Essay." *American Indian Culture and Research Journal* 50 (1981): 149–57.

Kent, R. K. "Palmares: An African State in Brazil." *Journal of African History* 6, no. 2 (1965): 161–75.

Kingsley, Zephaniah. Address to the Legislative Council of the State of Florida. Bennett Collection. Washington, D.C.: Library of Congress, 1823.

Kinney, Arthur F., ed. *Critical Essays on William Faulkner: The McCaslin Family*. Boston: G. K. Hall, 1990.

Kiple, Kenneth F., and Kriemhild Coneè, eds. *The Cambridge World History of Food*. Cambridge: Cambridge University Press, 2000.

Klein, Herbert. *African Slavery in Latin America and the Caribbean*. Oxford: Oxford University Press, 1986.

———. *Slavery in the Americas: A Comparative Study of Virginia and Cuba*. Chicago: University of Chicago Press, 1967.

Klingberg, Frank J. *An Appraisal of the Negro in Colonial South Carolina*. Washington, D.C.: the Associated Publishers, 1941.

Klos, G. "Blacks and the Seminole Removal Debate, 1821–1835." *Florida Historical Quarterly* 68 (1989): 55–78.

Koerner, B. I. "Blood Feud." *Wired*, September 2005, http://www.wired.com/wired/archive/13.09/seminoles.html.

Kort, Wesley A. "Sacred/Profane and an Adequate Theory of Human Place-Relations." In *Constructions of Space I: Theory, Geography, and Narrative*, edited by Jon L. Berquist and Claudi V. Camp, 32–50. London: T&T Clark, 2007.

Lady Maria Nugent. *Lady Nugent's Journal of her residence in Jamaica from 1801 to 1805*. Edited by Philip Wright. Kingston: Institute of Jamaica, 1966.

Lammoglia, José A. "Botanicas: Absence in Cuba, Proliferation in the United States." Master's thesis, Latin American and Caribbean Studies, Florida International University, 2001.

Landaluze, Victor Patricio (illustrator). *Tipos y Costumbres de la Isla de Cuba*. Havana: Antonio Bachiller y Morales, 1881.

Landers, Jane. *Atlantic Creoles in the Age of Revolutions*. Cambridge: Harvard University Press, 2010.

———. *Black Society in Spanish Florida*. Champaign: University of Illinois Press, 1999.

———, ed. *Colonial Plantations and Economy in Florida*. Gainesville: University Press of Florida, 2000.

———. "Free and Slave." In Gannon, *The New History of Florida*, 167–82.

———. "Gracia Real de Santa Teresa de Mose: A Free Black Town in Spanish Florida." *American Historical Review* 95 (1990): 9–30.

———. "Slavery in the Spanish Caribbean and the Failure of Abolition." *Review* 31, no. 3 (2008): 343–71.

———. "Traditions of African American Freedom and Community in Spanish Colonial Florida." In Colburn and Landers, *The African American Heritage of Florida*, 17–41.

Larzelere, Alex. *The 1980 Cuban Boatlift*. Washington, D.C.: National Defense University Press, 1988.

Laura Kofi Papers. Research Collection, 1926–81. Schomburg Center, New York City Library.

Law, Robin. "Ethnicities of Enslaved Africans in the Diaspora: On the Meanings of 'Mina' (Again)." *History in Africa* 32 (2005): 247–67.

Lawal, Babatunde. "*À Yà Gbó, À Yà Tó*: New Perspectives on *Edan Ògbóni*." *African Arts* 28, no. 1 (Winter 1995): 36–49, 98–100.

———. *The Gelede Spectacle*. Seattle: University of Washington Press, 1997.

Leacock, Eleanor, and Nancy Lurie, eds. *North American Indians in Historical Perspective*, New York: Random House, 1971.

Lebrón, Manuel. Transcript of videotape interview conducted by University of Florida graduate students for the National Park Service Kingsley Heritage Festival and Family Reunion. Fort George Island, Florida, October 10–11, 1998. On file at NPS Timucuan Preserve Office, Jacksonville, Florida.

Lefebvre, Henri. *The Production of Space*. Paris: Anthropos, 1974.

Lelyveld, Joseph. "In Guantánamo." *New York Review of Books,* November 7, 2002, 62–66.

Lemos, William. "Voyages of Columbus." In *Christopher Columbus and the Age of Exploration: An Encyclopaedia*, edited by Silvio A. Bedini, 693–728. New York: Da Capo, 1998.

Leonard, Karen I., Alex Stepick, Manuel A. Vasquez, and Jennifer Holdaway, eds. *Immigrant Faiths: Transforming Religious Life in America*. Lanham, Md.: Altamira, 2006.

Le Roy y Gálvez, Luis Felipe. *A cien años del 71: El fusilamiento de los estudiantes*. La Habana: Editorial de ciencias sociales, 1971.

———. "El 27 de Noviembre cien años después." *Centenario del fusilamiento de los estudiantes de medicina*. Luis Le Roy, Rafael O. Pedraza, Julio Le Riverend. Serie historica no. 24. La Habana: Academia de Ciencias de Cuba, 1973. Pp. 4–8.

Lesko, Diane. "Mario Sánchez: Folk Artist of Key West and Tampa." In *Spanish Pathways in Florida/Caminos Españoles en La Florida*, edited by A. Henderson & G. Mormino, 280–301. Florida Humanities Council. Sarasota: Pineapple Press, 1991.

Lewis, M. G. *Journal of a West Indian Proprietor, 1815–1817*. Edited by Mona Wilson. London: Routledge, 1929.

"Liberia and the Negroes." *Illustrated American*, January 9, 1892, 339–40.

Little, Ruth M. "Afro-American Gravemarkers in North Carolina." *Markers* 6 (1989): 103–36.

Littlefield, D. F. *Africans and Creeks: From the Colonial Period to the Civil War*. Westport, Conn.: Greenwood Press, 1979.

———. *Africans and Seminoles from Removal to Emancipation*. Westport, Conn.: Greenwood Press, 1977.

———. *Rice and Slaves*. Baton Rouge: Louisiana State University Press, 1981.

Lockey Collection, P. K. Yonge Library, University of Florida, Gainesville.

Lovejoy, Paul E. "Ethnic Designations of the Slave Trade and the Reconstruction of the

History of Trans-Atlantic Slavery." In Lovejoy and Trotman, *Trans-Atlantic Dimensions of Ethnicity in the African Diaspora*, 9–42.

Lovejoy, Paul E., and David V. Trotman, eds. *Trans-Atlantic Dimensions of Ethnicity in the African Diaspora*. Cambridge: Cambridge University Press, 2003.

MacCauley, Clay. *The Seminole Indians of Florida*. 1887. Gainesville: University Press of Florida, 2000.

MacGaffey, Wyatt. *Custom and Government in the Lower Congo*. Berkeley: University of California Press, 1970.

———. "The West in Congolese Experience." In *Africa and the West*, edited by Philip D. Curtin, 49–74. Madison: University of Wisconsin Press, 1972.

Maesen, Albert. "Congo Art and Society." *Art of the Congo*, 15–16. Minneapolis: Walker Art Center, 1967.

Mahon, John. "The First Seminole War, November 21, 1817—May 24, 1818." *Florida Historical Quarterly* 77 (Summer 1998): 62–67.

———. *History of the Second Seminole War, 1835–1842*. Gainesville: University Press of Florida, 1967.

Mahon, John K., and Brent R. Weisman. "Florida's Seminole and Miccosukee Peoples." In Gannon, *The New History of Florida*, 183–206.

Malmberg, Melody. *The Making of Disney's Animal Kingdom Theme Park*. New York: Disney Enterprises, 1998.

Marshall-Fratani, Ruth. "Mediating the Global and Local in Nigerian Pentecostalism." In Corten and Marshall-Fratani, *Between Babel and Pentecost*, 80–105.

Martí, José. "Mi Raza." *Patria* (New York), April 16, 1883.

———. *Our America: Writings on Latin America and the Struggle for Cuban Independence*. Edited by Philip Foner. New York: Monthly Review Press, 1977.

———. "Una orden secreta de africanos." *Obras Completas*. 5:324–25. La Habana: Editorial de Ciencias Sociales. Originally published in *Patria*, 1 de abril de 1983. 1991/1893.

Martín, Juan Luis. *Ecué, changó y yemayá: Ensayos sobre la sub-religion de los Afro-Cubanos*. Habana: Cultural, 1930.

Martínez, Producers. New York City: Habana│Harlem™ (audio recording).

Mase, Sam. "Florida Wilds Being Transformed into African Jungle." *Tampa Sunday Tribune*. November 16, 1952.

Masud-Piloto, Felix Roberto. *From Welcomed Exiles to Illegal Immigrants: Cuban Migration to the U.S., 1959–1995*. Lanham, Md.: Rowman & Littlefield, 1996.

Matory, J. Lorand. *Black Atlantic Religion: Tradition, Transnationalism, and Matriarchy in the Afro-Brazilian Candomblé*. Princeton, N.J.: Princeton University Press, 2005.

Mattew, Gregory Lewis. *Journal of a West Indian Proprietor*. London: John Murray, 1834.

May, Katja. *African Americans and Native Americans in the Creek and Cherokee Nations, 1830s to 1920s: Collision and Collusion*. New York: Garland Publishing, 1996.

McAlister, L. N. "Pensacola during the Second Spanish Period." *Florida Historical Quarterly* 37 (1959): 281–327

McCoy, Clyde B., and Diana H. Gonzalez. *Cuban Immigration and Immigrants in Florida and the United States*. Gainesville: University of Florida Press, 1985.

McGovern, James, ed. *Colonial Pensacola*. Pensacola: Pensacola News Journal, 1974.

McReynolds, Edwin C. *The Seminoles*. Norman: University of Oklahoma Press, 1957

Meinig, D. W. *The Shaping of America: A Geographical Perspective on 500 Years of History*. Vol. 1, *Atlantic America, 1492–1800*. New Haven: Yale University Press, 1986.

Mencken, H. L. *The American Language: An Inquiry into the Development of English in the United States*. London: Routledge and Kegan Paul, 1947.

Mexico. National Archive of the Nation (Archivo General de la Nación). Files: Temporalidades, 1838. Vol. 77 Fojas 1–153.

Mexico. National Archive of the Nation (Archivo General de la Nación). Files: Indiferente de Guerra Exp. 47B 1778–1812.

Mexico. National Archive of the Nation (Archivo General de la Nación). Maps: Priego Santander Ángel and Eduardo Inzunza. Map of the Gulf of Mexico, 2010.

Meyer, Richard E., ed. *Cemeteries and Gravemarkers: Voices of American Culture*. Ann Arbor: UMI Research Center, 1989.

———, ed. *Ethnicity and the American Cemetery*. Bowling Green, Ohio: Bowling Green State University Popular Press, 1993.

Miguel De Castro vs Ninety-Five African Negroes, Admiralty Court, Georgia District, Savannah, 1819–20, Georgia Department of Archives and History, Atlanta.

Milbauer, John A. "Cemeteries of Mississippi's Yazoo Basin." *Mid-South Geographer* 5 (1989): 1–19.

———. "Folk Monuments of Afro-Americans: A Perspective on Black Culture." *Mid-America Folklore* 19, no. 2 (1991): 99–109.

Miles, Tiya. *Ties That Bind: The Story of an Afro-Cherokee Family in Slavery and Freedom*. Berkeley: University of California Press, 2005.

Miller, Ivor. "Abakuá: The Signs of Power." Program notes for a performance and exhibition of paintings by Leandro Soto. Interdisciplinary Arts and Performance Gallery. Arizona State University, Phoenix, February 2007.

———. "Obras de fundación: La Sociedad Abakuá en los años 90." *Caminos: Revista Cubana de Pensamiento Socioteológico* nos. 13–14 (2000): 24–25

———. *Voice of the Leopard: African Secret Societies and Cuba*. Jackson: University Press of Mississippi, 2009.

Miller, Joseph C. *Way of Death: Merchant Capitalism and the Angolan Slave Trade, 1730–1830*. Madison: University of Wisconsin Press, 1988.

Millett, Nathaniel. "Defining Freedom in the Atlantic Borderlands of the Revolutionary Southeast." *Early American Studies: An Interdisciplinary Journal* 5 (Fall 2007): 367–94.

Milspaw, Yvonne J. "Segregation in Life, Segregation Death: Landscape of an Ethnic Cemetery." *Pennsylvania Folklife* 30, no. 1 (1980): 36–40.

Missall, John, and Mary Lou Missall. *The Seminole Wars: America's Longest Indian Conflict*. Gainesville: University Press of Florida, 2004.

Mitchell, David B. *An Exposition on the Case of the Africans Taken to the Creek Agency by Captain William Bowen on or about the 1st December 1818*. N.p., 1822.

———. Papers. Newberry Library. Chicago, Illinois.

Mohl, Raymond. "Black Immigrant: Bahamians in Early Twentieth Century Miami." *Florida Historical Quarterly* 65 (January 1987): 171–97.

Monaco, C. S. *Moses Levy of Florida: Jewish Utopian and Antebellum Reformer*. Baton Rouge: Louisiana State University Press, 2005.

Montejo-Arrechea, Carmen V. *Andrés Quimbisa*. La Habana: Ediciones Union, 2001.

———. *Sociedades negras en Cuba: 1878–1960*. La Habana: Editorial de Ciencias Sociales/ Centro de investigación y desarrllo de la cultura cubana Juan Marinello, 2004.

Montemayor García, Felipe. *La población de Veracruz: Historia de las lenguas; culturas actuales; rasgos físicos de la población*. Gobierno de Veracruz, 1950–56, Xalapa, México. 1956.

Mooney, Margarita A. *Faith Makes Us Live: Surviving and Thriving in the Haitian Diaspora*. Berkeley: University of California Press, 2009.

Morgan, Philip. *Slave Counterpoint: Black Culture in the Eighteenth-Century Chesapeake and Lowcountry*. Chapel Hill: University of North Carolina Press, 1998 (Published for the Omohundro Institute of Early American History and Culture, Williamsburg, Virginia).

Morison, Samuel Eliot. *Admiral of the Ocean Sea: A Life of Christopher Columbus*. Boston: Little, Brown, 1942.

Mormino, Gary. "World War II." In Gannon, *The New History of Florida*, 334–35.

Morris, Margaret H. *A Praise-Meeting of the Birds*. Philadelphia: Edward S. Morris, 1878.

Morrow, Kara Ann. "Bakongo Afterlife and Cosmological Direction: Translation of African Culture into North Florida Cemeteries." *Athanor* 20 (2002): 105–15.

Mouser, Bruce L. "Landlords-Strangers: A Process of Accommodation and Assimilation." *International Journal of African Historical Studies* 8, no. 3 (1975): 425–40.

———. "Trade, Coasters, and Conflict in the Rio Pongo from 1790 to 1808." *Journal of African History* 14, no. 1 (1973): 45–64.

Mowat, Charles. *East Florida as a British Province, 1763–1784*. Berkeley: University of California Press, 1943.

Mudimbe, V. Y. *The Idea of Africa*. Bloomington: Indiana University Press, 1994.

———. *The Invention of Africa*. Bloomington: Indiana University Press, 1988.

Mullan, Bob, and Garry Marvin. *Zoo Culture: The Book about Watching People Watch Animals*. 2nd ed. Chicago: University of Illinois Press, 1999.

Mullin, Michael. *Africa in America: Slave Acculturation and Resistance in the American South and British Caribbean, 1736–1831*. Chicago: University of Illinois Press, 1992.

Mulroy, K. *Freedom on the Border: The Seminole Maroons in Florida, the Indian Territory, Coahuila, and Texas*. Lubbock: Texas Tech University Press, 1993.

Murphy, Joseph M. "Yéyé Cachita: Ochún in Cuban Mirror." In Murphy and Sanford, *Osun across the Waters*, 87–101.

Murphy, Joseph M., and Mei-Mei Sanford, eds. *Osun across the Waters: A Yoruba Goddess in Africa and the Americas*. Bloomington: Indiana University Press, 2001.

Muzio, María del Carmen. *Andrés Quimbisa*. Havana: Ediciones Union, 2001.

Myers, Aaron. "Food in African American Culture." In Appiah and Gates, *Africana*, 764–65.

Mykel, Nancy. The Seminole Towns—A Compilation prepared for Sociology 630, under Dr. John M. Goggin." Unpublished manuscript, 1962.

"Nature Trail Tree List." Rhoko Conservation, Education and Research Centre. Calabar, Nigeria: Cercopan, 2010. 10 pages.

"Negro Colonization." *Munsey's Magazine* 6 (January 1892): 498–99.

"Negro King Coming in Murder Inquiry." *New York Times,* March 21, 1928.

Neimark, Philip John. *The Way of the Orisa: Empowering Your Life through the Ancient African Religion of Ifa*. San Francisco: HarperOne, 1993.

Nelson, George H. "Contraband Trade under the Asiento, 1730–1739." *American Historical Review* 51 (October 1945): 57.

Newman, Richard. *Black Power and Black Religion: Essays and Reviews*. West Cornwall: Locust Hill Press, 1987.

Nicholls, Robert W. "Dance Pedagogy in a Traditional African Society." *International Journal of African Dance* 2, no. 1 (1995): 51–60.

———. "The Mocko Jumbie of the U.S. Virgin Islands: History and Antecedents." *African Arts* 32, no. 3 (1999): 49–61, 94–95.

Nichols, Elaine, ed. *The Last Miles of the Way: African-American Homegoing Traditions 1890–Present*. Columbia: Commissioners of the South Carolina State Museum, 1989.

Nigh, Robin Franklin. "Under Grave Conditions: African-American Signs of Life and Death in North Florida." *Markers* 14 (1997): 158–89.

Nkrumah, Kwame. *Ghana: The Autobiography of Kwame Nkrumah*. London: England International Publishers, 1989.

Northrup, David. *Africa's Discovery of Europe, 1450–1850*. 2nd ed. Oxford: Oxford University Press, 2008.

Nulty, William. *Confederate Florida: The Road to Olustee*. Tuscaloosa: University of Alabama Press, 1990.

Nyombolo, Eli B. *The African Messenger: Out of Africa, Called a God: Laura Adorkar, Sainted*

Martyr for African-American Relations. Jacksonville: Missionary African Universal Church, 1960.

———. *Mother's Sacred Teachings*. Jacksonville, Fla.: Missionary African Universal Church, 1960.

O'Brien, David M. *Animal Sacrifice and Religious Freedom: Church of the Lukumi Babalu Aye v. City of Hialeah*. Lawrence: University Press of Kansas, 2004.

Oduyoye, Modupe. *Yoruba Names: Their Structure and Meaning*. London: Caribbean Culture International, 1982.

Office of Indian Affairs. Creek Agency. Letters Received. National Archives. Washington, D.C. Record Group 75. Microcopy 234.

Ogbechie, Sylvester Okwunodu. *Ben Enwonwu: The Making of an African Modernist*. Rochester, N.Y.: University of Rochester Press, 2008.

Oguibe, Olu. *Crossing: Time.Space.Movement*. Tampa: USF Contemporary Art Museum, 1997.

———. "Gordon P. Bleach: From Zimbabwe to Xanadu." *NKA Journal of Contemporary African Art* 11/12 (2000): 28–33.

Ogunleye, Tolagbe M. "*Aroko* and *Ogede*: Yoruba Arts as Resistance to Enslavement Stratagems in Florida in the 18th and 19th Centuries." Paper presented at the Conference on Yoruba Culture and Ethics at the University of California, Los Angeles, February 1999.

———. "*AROKO, MMOMOMME TWE, NSIBIDI, OGEDE, AND TUSONA*: Africanisms in Florida's Self-Emancipated Africans' Resistance to Enslavement and War Stratagems." *Journal of Black Studies* 36 (January 2006): 396–414.

———. "The Self-Emancipated Africans of Florida: Pan-African Nationalists in the 'New World.'" *Journal of Black Studies* 27, no. 1 (1996): 1, 24–39.

Okedara, J. T. *Thomas Jefferson Bowen: Pioneer Baptist Missionary to Nigeria, 1850–1856*. Ibadan, Nigeria: John Archers, 2004.

Okeke-Agulu, Chika. Introduction. In *Phyllis Galembo: Maske*, by Phyllis Galembo, 4–9. London: Chris Boot Ltd., 2010.

Okpewho, Isidore, Carole Boyce Davies, and Ali A. Mazrui, eds. *The African Diaspora: African Origins and New World Identities*. Bloomington: Indiana University Press, 1999.

Okpewho, Isidore, and Nkiru Nzegwu, eds. *The New African Diaspora*. Bloomington: Indiana University Press, 2009.

Olupona, Jacob K., and Terry Rey, eds. *Òrìsà Devotion as World Religion: The Globalization of Yorùbá Religious Culture*. Madison: University of Wisconsin Press, 2008.

Omari, Mikelle Smith. "Completing the Circle: Notes on African Art, Society, and Religion in Oyotunji, South Carolina." *African Arts* 24, no. 3 (April 1991): 66–96.

Orovio, Helio. *El carnaval habanero: Ensayo*. La Habana: Ediciones Extramuros, 2005.

Ortiz, Fernando. *Los cabildos africanos*. Havana: La Universa, 1921.

———. *Los instrumentos de la música afrocubana*. Vol. 4. La Habana: Cárdenas y Cía, 1954.

———. *Los instrumentos de la música afrocubana*. Vol. 5. La Habana: Cárdenas y Cía, 1955.

———. *Hampa afrocubana: Los negros brujos*. Madrid: Librería de Fernando Fe, 1906.

Ortiz, Paul. *Emancipation Betrayed: The Hidden History of Black Organizing in Florida from Reconstruction to the Bloody Election of 1920*. Berkeley: University of California Press, 2005.

———. "Florida and the Modern Civil Rights Movement: Towards a New Civil Rights History in Florida." In Winsboro, *Old South, New South, or Down South?* 220–44.

O'Shaughnessy, Andrew Jackson. *An Empire Divided: The American Revolution and the British Caribbean*. Philadelphia: University of Pennsylvania Press, 2000.

Oxford English Dictionary. Oxford: Clarendon Press, 1989.

Page, Carol. "Conrad A. Rideout, Afro-American Advisor to the Chiefs of Lesotho and Pondoland, 1899–1903." In *Pan-African Biography*, edited by Robert A. Hill, 1–10. Los

Angeles: African Studies Center, University of California, Los Angeles, and Crossroads Press, 1987.

Painter, Nell Irvin. *Creating Black Americans: African-American History and Its Meanings, 1619 to the Present*. Oxford: Oxford University Press, 2006.

Palmer, Colin A. "Defining and Studying the Modern African Diaspora." *Journal of Negro History* 85, nos. 1/2 (2000): 27–32.

Palmié, Stephan. *Wizards and Scientists: Explorations in Afro-Cuban Modernity and Tradition*. Durham, N.C.: Duke University Press, 2002.

Panton, Leslie and Company Papers. University of West Florida, Pensacola.

Papers Relating to Foreign Affairs, Accompanying the Annual Message of the President to the Second Session, Fortieth Congress, Part II. Washington, D.C.: Government Printing Officer, 1868.

Parrington, Michael, and Janet Wideman. "Acculturation in an Urban Setting: The Archaeology of a Black Philadelphia Cemetery." *Expedition* 28, no. 1 (1986): 55–64.

Patrick, Rembert. *Florida Fiasco: Rampant Rebels*. Athens: University of Georgia Press, 1954.

Patriot War Claims of John Fraser, Manuscript Collection 31, claim no. 54, St. Augustine Historical Society.

Patterson, Tiffany Ruby, and Robin D. G. Kelley. "Unfinished Migrations: Reflections on the African Diaspora and the Making of the Modern World." *African Studies Review* 43, no. 1 (April 2000): 11–45.

Peel, J. D. Y. *Religious Encounter and the Making of the Yoruba*. Bloomington: Indiana University Press, 2000.

Pemberton, John, III. "A Cluster of Sacred Symbols: Orișa Worship among the Igbomina Yoruba of Ila-Orangun." *History of Religions* 17, no. 1 (August 1977): 1–28.

Perdue, Theda. *Slavery and the Evolution of Cherokee Society, 1540–1866*. Knoxville: University of Tennessee Press, 1977.

Pérez-Firmat, Gustavo. *Life on the Hyphen: The Cuban-American Way*. Austin: University of Texas Press, 1994.

Pérez-Martínez, Odalys, and Ramón Torres Zayas. *La sociedad Abakuá y el estigma de la criminalidad*. La Habana: Ediciones cubanas ARTex, 2011.

Phelts, Marsha Dean. *An American Beach for African Americans*. Gainesville: University Press of Florida, 1996.

Pitchford, Anita. "The Material Culture of the Traditional East Texas Graveyard." *Southern Folklore Quarterly* 43 (1979): 277–90.

Pollitzer, William S., and David Moltke-Hansen. *The Gullah People and Their African Heritage*. Athens: University of Georgia Press, 2005.

Porter, K. W. *The Black Seminoles: History of a Freedom-Seeking People*. Revised and edited by Alcione M. Amos and Thomas P. Senter. Gainesville: University Press of Florida, 1996.

———. "Negroes and the East Florida Annexation Plot, 1811–1813." *Journal of Negro History* 30 (January 1945): 17–18.

———. "Notes on Seminole Negroes in the Bahamas." *Florida Historical Quarterly* 24 (1945): 56–60.

Portes, Alejandro, and Alex Stepick. *City on the Edge: The Transformation of Miami*. Los Angeles: University of California Press, 1993.

Powdermaker, Hortense. *After Freedom*. New York: Atheneum, 1939.

Poynor, Robin. "The Many and Changing Faces of Ògún: Altars to the God of Iron in the State of Florida." *Nova Religio: The Journal of Alternative and Emergent Religions* 16, no. 1 (2012): 13–35.

Price, Richard. "Introduction: Maroons and Their Communities." In

Maroon Societies: Rebel Slave Communities in the Americas, edited by Richard Price, 1–30. 3rd ed. Baltimore: Johns Hopkins University Press, 1996.

———, ed. *Maroon Societies: Rebel Slave Communities in the Americas.* Baltimore: Johns Hopkins University Press, 1979.

Proby, Kathryn Hall. *Mario Sánchez: Painter of Key West Memories.* Key West, Fla.: Southernmost Press, 1981.

Proctor, Samuel, ed. *Eighteenth-Century Florida: The Impact of the American Revolution.* Gainesville: University Presses of Florida, 1978.

Project of the Work Projects Administration for the State of Florida. Reprint of 1939 original. New York: Oxford University Press.

Public Records data for the Division of Corporations for the Florida Department of State.

Puckett, Newbell. *Folk Beliefs of the Southern Negro.* New York: Negro Universities Press, 1926.

Ramos, Miguel W. "Ashé in Flux: The Transformation of Lukumí Religion in the United States." Unpublished paper presented at the Annual Conference of the Center for Latin American Studies, University of Florida, March 1998.

———. "The Empire Beats On: Oyo Batá Drums and Hegemony in Nineteenth-Century Cuba." Master's thesis, Florida International University, 2000.

Randolph, J. Ralph. *British Travelers among the Southern Indians, 1660–1763.* Norman: University of Oklahoma Press, 1973.

Rankin, William. "Incidents of Missions in Western Africa." *The Church at Home and Abroad* 7 (June 1890): 538–39.

Remini, Robert. *Andrew Jackson and His Indian Wars.* New York: Viking Penguin, 2001.

Rendeall, Sharon. *Living with the Big Cats: The Story of Jungle Larry, Safari Jane, and David Tetzlaff.* Naples, Fla.: IZS Books, 1995.

Rey, Terry, and Alex Stepick. *Crossing the Water and Keeping the Faith: Haitian Religion in Miami.* New York: New York University Press, 2013.

Reynolds, Jack. "Derrida Arche-writing," Internet Encyclopedia of Philosophy (IEP) accessed June 2012. Last updated January 12, 2010. Originally published November 17, 2002. http://www.iep.utm.edu/derrida/#SH3b.

Reynolds, Rachel R. "An African Brain Drain: Igbo Decisions to Immigrate to the US." *Review of African Political Economy* 29, no. 92 (2002): 273–84.

———. "Igbo Professional Migratory Orders, Hometown Associations and Ethnicity in the USA." *Global Networks* 9, no. 2 (2009): 209–26.

Richardson, Joe. *The Negro in the Reconstruction of Florida, 1865–1877.* Tallahassee: Florida State University Press, 1965.

Richman, Karen. "The Protestant Ethic and the Dis-Spirit of Vodou." In Leonard, Stepick, Vasquez, and Holdaway, *Immigrant Faiths,* 165–88.

Riordan, Patrick. "Seminole Genesis: Native Americans, African American, and Colonists on the Southern Frontier From Prehistory through the Colonial Era." Ph.D. diss., Florida State University, 1996.

Rivers, Larry E. "Louise Cecilia Fleming, 1862–1899: Medical Missionary." In Rivers and Brown, *The Varieties of Women's Experiences,* 122–50.

———. *Slavery in Florida: Territorial Days to Emancipation.* Gainesville: University Press of Florida, 2000.

———. "A Troublesome Property: Master-Slave Relations in Florida, 1821–1865." In Colburn and Landers, *The African American Heritage of Florida,* 104–27.

Rivers, Larry E., and Canter Brown Jr. "'The Art of Gathering a Crowd': Florida's Pat Chappelle and the Origins of Black-Owned Vaudeville." *Journal of African American History* 92 (Spring 2007): 169–90.

————. *Laborers in the Vineyard of the Lord: The Beginnings of the AME Church in Florida, 1865–1895.* Gainesville: University Press of Florida, 2001.

————. "'A Monument to the Progress of the Race': The Intellectual and Political Origins of the Florida Agricultural and Mechanical University, 1865–1887." *Florida Historical Quarterly* 85, no. 1 (Summer 2006): 1–41.

————. *The Varieties of Women's Experiences: Portraits of Southern Women in the Post–Civil War Century.* Gainesville: University Press of Florida, 2009.

Roberts, Sam. "More Africans Enter U.S. Than in Days of Slavery." *New York Times,* February 21, 2005.

Roche y Monteagudo, Rafael. *La policía y sus misterios en Cuba.* 3a Edición. La Habana: La Moderna Poesía, 1925/1908.

Rodríguez, Alejandro. *Reseña histórica de los ñáñigos de Cuba desde su creación a la fecha.* Unpublished manuscript. Archivo Nacional de Cuba, asuntos políticos, legajo 76, Exp. 56, 1881.

Roediger, David R. "And Die in Dixie: Funerals, Death, & Heaven in the Slave Community 1700–1865." *Massachusetts Review* 22 (1981): 163–83.

Rothman, Adam. *Slave Country: American Expansion and the Origins of the Deep South.* Cambridge: Harvard University Press, 2005.

Routon, Kenneth. "Unimaginable Homelands? 'Africa' and the Abakuá Historical Imagination." *Journal of Latin American Anthropology* 10, no. 2 (November 2005): 370–400.

Rowe, Anne E. *The Idea of Florida in the American Literary Imagination.* Gainesville: University Press of Florida, 1992.

Royal Decree, November 7, 1693, Santo Domingo 59–1–26, Stetson Collection, P. K. Yonge Library of Florida History University of Florida, Gainesville.

Rubin, Arnold. "Accumulation: Power and Display in African Sculpture." *Artforum* 13, no. 9 (1975): 35–47.

Ryan, James. *Picturing Empire: Photography and the Visualization of the British Empire.* London: Reaktion Books, 1997.

Rymer, Russ. *American Beach: A Saga of Race, Wealth, and Memory.* New York: Harper Collins, 1998.

Salillas, Rafael. "Los ñáñigos en Ceuta." *Revista General de Legislación y Jurisprudencia* 98 (1901): 337–60.

Sánchez-Boudy, José. *Ekué Abanakué Ekué: Ritos ñáñigos.* Miami: Ediciones Universal, 1977.

Sandoval, Mercedes Cros. "Afro-Cuban Religion in Perspective." In *Enigmatic Powers: Syncretism with African and Indigenous Peoples,* edited by Antonio M. Stevens Arroyo and Andrés Isidoro Pérez y Mena, 81–89. New York: Bildner Center for Western Hemisphere Studies, 1995.

Sanford, Mei-Mei. "Powerful Water, Living Wood: The Agency of Art and Nature in Yoruba Ritual." Ph.D. diss., Drew University, 1997.

Saunders, A. C. *A Social History of Black Slaves and Freedmen in Portugal, 1441–1555.* Cambridge: Cambridge University Press, 2010.

Saunt, Claudio. *A New Order of Things: Property, Power and the Transformation of the Creek Indians, 1733–1816.* Cambridge: Cambridge University Press, 1999.

Sawyer, Lena. "Routings: 'Race,' African Diasporas, and Swedish Belonging." *Transforming Anthropology* 11, no. 1 (2002): 36–46.

Schafer, Daniel L. *Anna Madgigine Jai Kingsley: African Princess, Florida Slave, Plantation Owner.* Gainesville: University Press of Florida, 2003.

————. "Family Ties That Bind: Anglo-African Slave Traders in Africa and Florida, John

Fraser and His Descendants." *Slavery and Abolition: A Journal of Slave and Post-Slave Studies* 20 (1999): 1–21.

———. "Shades of Freedom: Anna Kingsley in Senegal, Florida, and Haiti." In *Against the Odds: Free Blacks in the Slave Societies of the Americas*, edited by Jane G. Landers, 130–54. London: Frank Cass Publishers, 1996.

———. *St. Augustine's British Years, 1763–1784*. St. Augustine Historical Society, 2001.

———. "'A Swamp of an Investment'? Richard Oswald's British East Florida Plantation Experiment." In Landers, *Colonial Plantations and Economy in Florida*, 11–38.

———. "'Yellow Silk Ferret Tied Round Their Wrists': African Americans in British East Florida, 1763–1784." In Colburn and Landers, *The African American Heritage of Florida*, 71–103.

———. "Zephaniah Kingsley's Laurel Grove Plantation, 1803–1813." In Landers, *Colonial Plantations and Economy in Florida*, 98–120.

Scott, David. *Refashioning Futures: Criticism after Postcoloniality*. Princeton: Princeton University Press, 1999.

Seale, Bobby. *Barbeque'n with Bobby*. Berkeley, Calif.: Ten Speed, 1998.

Segal, Ronald. *The Black Diaspora*. London: Faber and Faber, 1995.

Shange, Ntozake. *If I Can Cook/You Know God Can*. Boston: Beacon, 1998.

Shaw, Thurstan. *Igbo-Ukwu: An Account of Archaeological Discoveries in Eastern Nigeria*. Vol. 1. Evanston, Ill.: Northwestern University Press, 1970.

Shepperson, George. "Africa Diaspora: Concept and Context." In *The Global Dimensions of the African Diaspora*, edited by Joseph E. Harris, 41–49. 2nd ed. Washington, D.C.: Howard University Press, 1993.

Shingleton, Roycee Gordon. "David Brydie Mitchell and the African Importation Case of 1820." *Journal of Negro History* 58 (July 1973): 327–40.

Shofner, Jerrell. *Nor Is It Over Yet: Florida in the Era of Reconstruction, 1863–1877*. Gainesville: University of Florida Press, 1974.

Simmons, W. H. *Notices of East Florida*. A Facsimile Reproduction of the 1822 Edition. Gainesville: University of Florida Press, 1973.

Simms Hamilton, Ruth. *Creating a Paradigm and Research Agenda for Compartive Studies of Worldwide Dispersion of African Peoples*. Monograph No. 1. East Lansing: Michigan University Publications, 1990.

Skinner, Elliot P. "The Dialectic between Diasporas and Homelands." In *Global Dimensions of the African Diaspora,* edited by Joseph E. Harris, 11–40. 2nd ed. Washington, D.C.: Howard University Press, 1993.

Smallwood, Stephanie E. *Saltwater Slavery: A Middle Passage from Africa to American Diaspora*. Cambridge: Harvard University Press, 2007.

Smith, Charles Spencer. *A History of the African Methodist Episcopal Church*. Philadelphia: AME Book Concern, 1922.

Smith, Julia H. "The Plantation Belt in Middle Florida, 1850–60." Ph.D. diss., Florida State University, 1964.

Smith, Mark. *Stono: Documenting and Interpreting a Southern Slave Revol*. Columbia: University of South Carolina Press, 2005.

Smith, Valerie [Valerie Boyd]. *Wrapped in Rainbows: The Life of Zora Neale Hurston*. London: Virago, 2003.

Soja, Edward. *Postmodern Geographies: The Reassertion of Space in Critical Social Theory*. London: Verso Press, 1989.

Sosa-Rodríguez, Enrique. *Los Ñañigos*. La Habana: Ediciones Casa de las Américas, 1982.

———. "Ñañigos en Key West (1880?–1923?)." *Catauro: Revista cubana de antropología* 2, no. 3 (2001): 159–71.

Spanish Land Grants. *Spanish Land Grants in Florida: Briefed Translations from the Archives of the Board of Commissioners. Confirmed Claims*, Vol. 4. Tallahassee, Fla.: State Library Board, 1941.

Stafford, Frances J. "Illegal Importations: Enforcement of the Slave Trade Laws along the Florida Coast, 1810–1824." *Florida Historical Quarterly* 46 (1967): 124–40.

Stagg, J. C. A. *Borderlines in Borderlands: James Madison and the Spanish-American Frontier, 1776–1821*. New Haven: Yale University Press, 2009.

Starr, J. Barton. *Tories, Dons and Rebels: The American Revolution in British West Florida*. Gainesville: University Presses of Florida, 1976.

Stepick, Alex, Terry Rey, and Sarah J. Mahler, eds. *Churches and Charity in the Immigrant City: Religion, Immigration, and Civic Engagement in Miami*. New Brunswick, N.J.: Rutgers University Press, 2009.

Stokes, Sherrie. "Gone But Not Forgotten: Wakulla County's Folk Graveyards." *Florida Historical Quarterly* 70 (October 1991): 177–91.

Stowell, Daniel W. *Timucuan Ecological and Historic Preserve Historic Resource Study*. Atlanta: National Park Service, Southeast Field Area, 1996.

Sturtevant, William. "Creek into Seminole." In Leacock and Lurie, *North American Indians in Historical Perspective*, 92–128.

Swanton, J. R. *Early History of the Creek Indians and Their Neighbors*. 1922. Gainesville: University Press of Florida, 1998.

Sweet, James. "The Iberian Roots of American Racist Thought." *William and Mary Quarterly* 54 (1997): 143–66.

Talbert, Horace. *The Sons of Allen*. Xenia, Ohio: Aldine Press, 1906.

Talbot, P. Amaury. *In the Shadow of the Bush*. New York: George H. Doren, 1912.

Tannenbaum, Frank. *Slave and Citizen: The Negro in the Americas*. New York: Knopf, 1947.

Taylor, Robert. *Rebel Storehouse: Florida in the Confederate Economy*. Tuscaloosa: University of Alabama Press, 1995.

Tebeau, Charlton. *A History of Florida*. Rev. ed. Coral Gables: University of Miami Press, 1987.

Telamon Cuyler Collection. Hargrett Library. University of Georgia. Athens.

Territorial Papers of the U.S. Senate, 1789–1873. National Archives, Washington, D.C.

Theodore Bissell to Harrison Reed, April 1, 1864, Florida Direct Tax Commission Records, Records of the Treasury Department, Internal Revenue, Record Group 59, National Archives, Washington, D.C.

Thompson, A. O. *Flight to Freedom: African Runaways and Maroons in the Americas*. Kingston, Jamaica: University of the West Indies Press, 2006.

Thompson, Robert Farris. *Black Gods and Kings*. Bloomington: Indiana University Press, 1976.

———. *Black Gods and Kings: Yoruba Art at UCLA*. Los Angeles: UCLA, 1971.

———. *Face of the Gods: Art and Altars of Africa and the African Americas*. New York: Museum of African Art, 1993.

———. *Flash of the Spirit: African and Afro-American Art and Philosophy*. Vintage Books: New York, 1984.

———. "Kongo Influences on African-American Artistic Culture." In Holloway, *Africanisms in American Culture*, 148–84.

———. "The Sign of the Divine King: Yoruba Bead-Embroidered Crowns with Veil and Bird Decorations." In Fraser and Cole, *African Art and Leadership*, 227–60.

Thompson, Robert Farris, and Joseph Cornet. *The Four Moments of the Sun: Kongo Art in Two Worlds*. Washington, D.C.: National Gallery of Art, 1981.

Thompson, Robert Farris, John Mason, and Judith McWillie. *Another Face of the Diamond:*

Pathways through the Black Atlantic South. New York: Intar Latin American Gallery, 1988.

Thompson, Sharyn. *Florida's Historic Cemeteries: A Preservation Handbook*. Tallahassee: Historic Tallahassee Preservation Board and Florida Department of State, 1987.

Thornton, John K. *Africa and Africans in the Making of the Atlantic World, 1400–1800*. 2nd ed. Cambridge: Cambridge University Press, 2005.

———. "African Dimensions of the Stono Rebellion." *American Historical Review* 96, no. 4 (October 1991): 1101–13.

———. "The African Experience of the '20 and Odd Negroes' Arriving in Virginia in 1619." *William and Mary Quarterly*, 3rd ser., 55, no. 3 (July 1998): 421–34.

———. *The Kingdom of Kongo: Civil War and Transition, 1641–1718*. Madison: University of Wisconsin Press, 1983.

Tierras, 2780. Expediente 11. Fojas 13

Tölölyan, Khachig. "Rethinking Diaspora(s): Stateless Power in the Transnational Moment." *Diaspora* 5, no. 1 (1996): 3–36.

Trujillo y Monagas, D. José. *Los criminales de Cuba y D. José Trujillo: Narración de los servicios prestados en el cuerpo de policía de La Habana*. Barcelona: Establecimiento Tipográfico de Fidel Giro, 1882.

Tsuji, Terry, Christine Ho, and Alex Stepick. "The Struggle for Civic Social Capital in West Indian Churches." In Stepick, Rey, and Mahler, *Churches and Charity in the Immigrant City*, 208–30.

Turner, Lorenzo Dow. *Africanisms in the Gullah Dialect.* Columbia: University of South Carolina Press, 1949.

Twining, Mary A., and Keith E. Baird, eds. *Sea Island Roots: African Presence in the Carolinas and Georgia*. Trenton, N.J.: Africa World Press, 1991.

Twyman, Bruce Edward. *The Black Seminole Legacy and North American Politics, 1693–1845*. Washington, D.C.: Howard University Press, 2000.

Ulmer, Gregory, Barbara Jo Revelle, Gordon Bleach, and John Craig Freeman. "Imaging Florida: A Research Initiative Conducted by the Florida Research Ensemble." *Exposure* 32, no. 1 (1999): 35–43.

United States Census Bureau. 2000. *United States Census 2000*. www.census.gov/cen2000.

United States Supreme Court. 1993. *Church of the Lukumi Babalu Aye, Inc. v. City of Hialeah*, 508 U.S. 520. June 11, 1993, Decided.

U.S. Bureau of the Census. 1860 Census rolls, Duval County and St. Johns County, Florida.

U.S. Bureau of the Census. 1870 Census roll, Duval County and St. Johns County, Florida.

U.S. Bureau of the Census. 1880 Census roll, Duval County, Florida.

U.S. Bureau of the Census. 1918 Negro Population, 1790–1915. Washington, D.C.: Washington Government Printing Press.

U.S. Bureau of the Census. 1920 Census roll, Duval County, Florida.

U.S. Bureau of the Census. 1935 Negroes in the United States, 1920–30. Washington, D.C: Washington Government Printing Press.

U.S. Census: http://factfinder.census.gov/bf/_lang=en_vt_name=DEC_2000_SF1_U_QTP3_geo_id=05000US12086.html.

Uya, Okon Edet. *African Diaspora and the Black Experience in New World Slavery*. Rev. ed. New York: Third Press Publishers, 1992.

Vass, Winifred. *The Bantu Speaking Heritage of the United States*. Los Angeles: Center for Afro-American Studies, University of California, 1979.

Verger, Pierre. "Trance States in Orisha Worship." *Odú* no. 9 (September 1963): 19.

Vlach, John Michael. *The Afro-American Tradition in Decorative Arts*. Cleveland: Cleveland Museum of Art, 1978.

————. *The Afro-American Tradition in Decorative Arts*. Athens: University of Georgia Press, 1990.

————. *Back of the Big House: The Architecture of Plantation Slavery*. Chapel Hill: University of North Carolina Press, 1993.

————. *By the Work of Their Hands: Studies in Afro-American Folklife*. Charlottesville: University Press of Virginia, 1991.

————. "Graveyards and Afro-American Art." *Southern Exposure* 5 (1977): 161–65.

————. "The Shotgun House: An African Architectural Legacy." In Ferris, *Afro-American Folk Art and Crafts*, 79–90.

————. "The Shotgun House: An African Architectural Legacy." *Pioneer America* 8 (1976): 47–70.

Voelz, Peter. *Slave and Soldier: The Military Impact of Blacks in the Colonial Americas*. New York: Garland Publishing, 1993.

Von Grafenstein Gareis, Johanna. "El abasto de la escuadra y las plazas militares del gran Caribe, con harinas y víveres novohispanos 1755–1779." In *Comercio exterior de México 1713–1850*, edited by Carmen Yuste and Matilde Souto Mantecón, 42–83. México: Instituto Mota-UNAM-UV, 1990.

Vought, Kip. "Racial Stirrings in Colored Town: The UNIA in Miami during the 1920s." *Tequesta* no. 60 (2000): 56–77.

Walker, Alice. *The Color Purple*. London: Virago, 1983.

————. *In Search of Our Mothers' Gardens*. London: The Women's Press, 1984.

————. "Zora Neale Hurston: A Cautionary Tale and a Partisan View." In Walker, *In Search of Our Mothers' Gardens*, 83–92.

Walker, Karen Jo. "Kingsley and His Slaves: Anthropological Interpretation and Evaluation." In *Volumes in Historical Archaeology V*, edited by Stanley South. Columbia: The Institute of Archaeology and Anthropology, University of South Carolina, 1988.

War Department. Letters Received. National Archives. Washington, D.C. Record Group 75. Microcopy 271.

War Department. Letters Sent, National Archives, Washington, D.C. Record Group 75. Microcopy 15.

Waring, Anthony J., Jr. "The Case of the Africans." Antonio J. Waring Jr. Papers. Georgia Historical Society. Savannah.

Waring, Mary A. "Mortuary Customs and Beliefs of South Carolina Negroes." *Journal of American Folk-Lore* 7 (1894): 318–19.

Warnes, Andrew. "Guantánamo, Eatonville, Accompong: Barbecue and the Diaspora in the Writings of Zora Neale Hurston." *Journal of American Studies* 40, no. 1 (2006): 367–89.

————. *Savage Barbecue: Race, Culture, and the Invention of America's First Food*. Athens: University of Georgia Press, 2008.

Weber, David. *The Spanish Frontier in North America*. New Haven: Yale University Press, 1992.

Weeks, John H. *Congo Life and Jungle Stories*. 2nd ed. London: The Religious Tract Society, 1924.

Weik, Terrence. "The Archaeology of Maroon Societies in the Americas: Resistance, Cultural Continuity and Transformation in the African Diaspora." *Historical Archaeology* 31, no. 2 (1997): 81–92.

————. "Freedom Fighters on the Florida Frontier." In *Unlocking the Past: Celebrating Historical Archaeology in North America*, edited by Lu Ann DeCunzo and John Jameson, 36–44. Gainesville: University Press of Florida, 2005.

Weisman, Brent Richards. *Like Beads on a String: A Culture History of the Seminole Indians in North Peninsular Florida*. Tuscaloosa: University of Alabama Press, 1989.

———. *Unconquered Peoples: Florida's Seminole and Miccosukee Indians*. Gainesville: University Press of Florida, 1999.

Wells, Sharon. *Forgotten Legacy: Blacks in Nineteenth Century Key West*. Key West, Fla.: Historical Key West Preservation Board, 1982.

West, Patsy. *The Enduring Seminoles: From Alligator Wrestling to Ecotourism*. Gainesville: University Press of Florida, 1998.

White, David Hart. "The Indian Policy of Juan Vincente Folch, Governor of Spanish Mobile, 1787–1792." *Alabama Review* 28 (1975): 261–75.

White, Vibert. *Inside the Nation of Islam: Historical Testimony of a Black Muslim*. Gainesville: University Press of Florida, 2002.

———. "The Pullman Porters and Black Train Workers of Winter Park, Florida." Unpublished manuscript, 2007.

Whitney, Ellie, D. Bruce Means, and Anne Rudloe. *Priceless Florida: Natural Ecosystems and Native Species*. Sarasota: Pineapple Press, 2004.

Williams, John Lee. *The Territory of Florida, or, Sketches of the topography, civil and natural history, of the country, the climate, and the Indian tribes: from the first discovery to the present time*. New York: A.T. Goodrich, 1837.

Willis, William S., Jr. "Divide and Rule: Red, White, and Black in the Southeast." In *Red, White, and Black: Symposium on Indians in the Old South*, edited by Charles M. Hudson, 99–115. Southern Anthropological Society Proceedings, No. 5. Athens: University of Georgia Press, 1971.

Wilson, Joseph M. *The Presbyterian Historical Almanac and Annual Remembrancer of the Church for 1867*. Philadelphia: Joseph M. Wilson, 1867.

Winsboro, Irvin D. S., ed. *Old South, New South, or Down South? Florida and the Modern Civil Rights Movement*. Morgantown: West Virginia University Press, 2009.

Wintz, Cary D. *Black Culture and the Harlem Renaissance*. Houston: Rice University Press, 1988.

Wittmer, Marcilene. "African Influence on Florida Indian Patchwork." *Southeastern College Art Conference Review* 11 (1989): 269–75.

Wolf, Eric R. *Europe and the People without History*. 1982. Berkeley: University of California Press, 1997.

Wood, Peter H. *Black Majority: Negroes in Colonial South Carolina from 1670 through the Stono Rebellion*. New York: Knopf Brown, 1973.

Woodson, Carter G. *The African Background Outlined*. New York: Negro Universities Press, 1936.

Woodward, David, and G. Malcolm Lewis, eds. *Cartography in the Traditional African, American, Arctic, Australian, and Pacific Societies*. Chicago: University of Chicago Press, 1998.

Woodward, Thomas Simpson. *Woodward's Reminiscences of the Creek, or Muscogee Indians, Contained in Letters to Friends in Georgia and Alabama*. Montgomery: Barrett and Wimbish, 1859.

Wright, J. Leich, Jr. *Creeks and Seminoles: The Destruction and Regeneration of the Muscogulge People*. Lincoln: University of Nebraska Press, 1990.

———. *Florida in the American Revolution*. Gainesville: University of Florida Press, 1975.

———. *The Only Land They Knew: The Tragic Story of the American Indians in the Old South*. Lincoln: University of Nebraska Press, 1981.

Wright, John K. "From 'Kubla Khan' to Florida." *American Quarterly* 8, no. 1 (1956): 76–80.

Yelvington, Kevin A. "The Anthropology of Afro-Latin America and the Caribbean: Diasporic Dimensions." *Annual Review of Anthropology* 30 (2001): 227–60.

Yetman, Norman. *Life Under the Peculiar Institution*. New York: Holt, Rinehart and Winston, 1970.

Zamora, Rigoberto. "La Letra del Año." Unpublished manuscript, International Union of the Yoruba Rights, Tampa Bay, 2003.

Zavala, Silvio. *El servicio personal de los indios en la Nueva España 1700–1821.* Tomo VII. México. El Colegio de México. El Colegio Nacional. 1995.

Zeleza, Paul Tiyambe. "Diaspora Dialogues: Engagements between Africa and Its Diasporas." In Okpewho and Nzegwu, *The New African Diaspora*, 31–58.

Zibart, Eve Muriel Stevens, and Terrell Vermont. *The Unofficial Guide to Ethnic Cuisine and Dining in America.* New York: Macmillan, 1995.

Contributors

Canter Brown Jr. is professor of history at Fort Valley State University. His many publications include the award-winning volumes *Florida's Peace River Frontier* and *Ossian Bingley Hart: Florida's Loyalist Reconstruction Governor*.

Amanda B. Carlson is assistant professor of art history at the University of Hartford. As a specialist in African art studies, Dr. Carlson has conducted research in the Cross River region of Nigeria on *nsibidi* (an indigenous writing system), masquerades, and women's ritual performances. Her other research interests include African photography and contemporary art. Publications include the essay "*Nsibidi*: Old and New Scripts" in *Inscribing Meaning: Writing and Graphic Systems in African Art* and "Calabar Carnival: A Trinidadian Tradition Returns to Africa" in *African Arts*.

Adrian Castro is a poet, performer, babaláwo, and herbalist. He was born in Miami, a place that has provided fertile ground for the rhythmic Afro-Latino style in which he writes and performs. He is the author of *Cantos to Blood & Honey*, *Wise Fish: Tales in 6/8 Time*, and *Handling Destiny*, and has been published in many literary anthologies.

Sagrario Cruz-Carretero is an anthropologist and historian who has studied cultural and historical aspects of African descendants in Mexico since 1987. She currently teaches "Ethnic Studies" and "Traditional Medicine in Mexico" at Universidad Veracruzana. She is co-curator of the exhibition "The African Presence in México: From Yanga to the Present" at the National Museum of Mexican Arts, Chicago.

Andrew K. Frank is Allen Morris Associate Professor of History at Florida State University. His recent publications include *Creeks and Southerners: Biculturalism on the Early American Frontier*; "The Return of the Native: Innovative

Traditions in the Southeast," in Frank Towers, Brian Schoen, and L. Diane Barnes, eds., *New Histories of the Old South: Slavery, Sectionalism and the Nineteenth-Century's Modern World*; and "Family Ties: Indian Countrymen, George Stinson and Creek Sovereignty," in Craig Thompson Friend and Anya Jabour, eds., *Family Values in the Old South*.

Michael V. Gannon, Distinguished Service Professor Emeritus of History at the University of Florida, earned graduate degrees from Catholic University, Washington, D.C., the Université de Louvain, Belgium, and the University of Florida. His research has focused on the Spanish colonial history of Florida. Among his many publications are those that address Florida: *Rebel Bishop*, *The Cross in the Sand*, *Florida: A Short History*, and *The New History of Florida*. Others include *Spanish Influence in the Caribbean, Florida and Louisiana, 1500–1800*, and *The Hispanic Experience in North America*. The Florida Historical Society awarded him the first Arthur W. Thompson Prize in Florida History. Juan Carlos I of Spain conferred on him the highest academic award of that country, "Knight Commander of the Order of Isabel la Católica." The St. Augustine Historical Society awarded him its Award for Excellence. Gannon has served on the Board of Directors of the Florida Humanities Council and as Chairman of the Board of Directors of the Historical St. Augustine Research Institute.

Rosalyn Howard is associate professor of anthropology and director of the North American Indian Studies Program at the University of Central Florida. Her research focus is ethnohistorial analyses of the relationships of African and Native American peoples in the Americas and the Caribbean. Among her publications is *Black Seminoles in the Bahamas*.

Antoinette T. Jackson is associate professor of anthropology at the University of South Florida. She is interested in issues of identity and representation at National Heritage sites. Her research focus is heritage tourism and the business of heritage resource management in the United States and the Caribbean. Antoinette directs the USF Heritage Research Lab, and her latest book is *Speaking for the Enslaved: Heritage Interpretation at Antebellum Plantation Sites*.

Jane Landers is Gertrude Conaway Vanderbilt Professor of History at Vanderbilt University. Her numerous publications include *Atlantic Creoles in the Age of Revolutions* and *Black Society in Spanish Florida*. Landers is director of the Ecclesiastical and Secular Sources for Slave Societies digital archive, which is preserving the oldest records for Africans in Cuba, Brazil, Colombia, and Florida (www.vanderbilt.edu/esss/index.php).

Thomas E. Larose is associate professor of art history and chair of the Department of Art and Design at Virginia State University. A specialist in African and Native American art, his current research focuses on Native American rock art in New England and the Mid-Atlantic States.

Ivor L. Miller is a cultural historian specializing in the African diaspora in the Caribbean and the Americas. He is the author of *Aerosol Kingdom: Subway Painters of New York City* and *Voice of the Leopard: African Secret Societies and Cuba*. He is currently teaching courses on African diaspora in the Department of History at the University of Calabar, in Calabar, Nigeria.

Nathaniel Millett is assistant professor of history at Saint Louis University. His research focuses on the Atlantic world and borderlands of colonial and revolutionary North America. Recent publications include "Defining Freedom in the Atlantic-Borderlands of the Revolutionary Southeast," *Early American Studies: An Interdisciplinary Journal*, and "An Analysis of the Role of the Study of the African Diaspora within the Field of Atlantic History," in *African and Black Diaspora: An International Journal*. He is also the author of *The Maroons of Prospect Bluff and Their Quest for Freedom in the Atlantic World*.

Kara Ann Morrow is assistant professor of art history at the College of Wooster in Ohio. Her publications include "Bakongo Afterlife and Cosmological Direction: Translation of African Culture into North Florida Cemeteries," in *Athanor*. Her current research explores aspects of public and private devotion in New Orleans's Holt Cemetery.

Joseph M. Murphy is the Paul and Chandler Tagliabue Professor of Interfaith Studies and Dialogue in the Theology Department at Georgetown University. He is the author of *Santería: An African Religion in America* and *Working the Spirit: Ceremonies of the African Diaspora*. With Mei-Mei Sanford he edited *Osun across the Waters: A Yoruba Goddess in Africa and the Americas*.

Ade Ofunniyin is an anthropologist. His academic work addresses the interaction of Yoruba Americans in the American Southeast and Yoruba in Nigeria, specifically in the city of Oṣogbo.

Robin Poynor is professor of art history at the University of Florida. He is the coauthor (with Monica Blackmun Visona and Herbert M. Cole) of *A History of Art in Africa*. Other books include *Nigerian Sculpture: Bridges to Power* and *African Art at the Harn Museum: Spirit Eyes, Human Hands*. A volume due out

in 2013 is an edited work (coeditors Susan Cooksey and Hein Vanhee), *Kongo across the Waters*, to accompany a collaboration by the Harn Museum of Art at the University of Florida and the Royal Museum for Central Africain Tervuren, Belgium.

Terry Rey is associate professor of African and African diasporic religions at Temple University. His recent publications include *Churches and Charity in the Immigrant City*, *Òrìsà Devotion as World Religion*, and *Bourdieu on Religion*.

Larry Eugene Rivers is professor of history at Valdosta State University in Valdosta, Georgia. He has authored, among other works, *Rebels and Runaways: Slave Resistance in Nineteenth-Century Florida* and the award-winning *Slavery in Florida: Territorial Days to Emancipation*. In collaboration with Canter Brown Jr., he has written *Laborers in the Vineyard of the Lord: The Beginnings of the AME Church in Florida, 1865–1895* and *For a Great and Grand Purpose: The Beginnings of the AMEZ Church in Florida, 1864–1905*. They also coedited *The Varieties of Women's Experiences: Portraits of Southern Women in the Post–Civil War Century* and, with Professor Richard Mathews of the University of Tampa, John Willis Menard's *Lays in Summer Lands*.

Andrew Warnes is reader in American studies in the School of English, University of Leeds (UK). He writes about transatlantic cultures of food and commodity consumption in addition to popular music. His recent publications include *Savage Barbecue: Race, Culture, and the Invention of America's First Food* and "Tricky's Maxinquaye: Rhizomes, Rap and the Resuscitation of the Blues," *Atlantic Studies*.

Vibert White Jr. is associate professor of history at University of Central Florida. His publications include *Inside the Nation: A Personal and Historical Testimony of a Black Muslim* and *Pullman Porters of Winter Park, Florida*. He has also published in several academic journals, such as the *Journal of Caribbean History*, the *Black Law Journal*, and *Cultura Vozes* (Brazil).

Visit the website "Africa in Florida: From Book to Blog" for updates and discussion related to this book.

Index

Page numbers in italics refer to illustrations.

"Behind the Mask: Africa in Tampa," 3, 5

Beier, Ulli, 296, 297, 298, 300n29

Belgium, 181

Beltrán, Elio, 269–70

Beltrán, Josefina, 299n10

Bely (slave), 80

Benedict College, 339

Benin, 290. *See also* Republic of Benin

Bennett, Herman, 80

Bennett College, 156

Berlin, Ira, 10–11, 19

Bermuda, 90

Bermuda Triangle, 30n12

Berrien County, Ga., 315

Besingi, Nasakó, 275n45

Bethel Baptist Institutional Church (Jacksonville, Fla.), *160, 161, 162, 163*

Bethune-Cookman College, 44

Betsch, Peri Frances, 155

Betsey (ship), 84n21

Betsy (ship), 78

Beverley, Robert, 230

Biafra Civil War, 368, 369

Biassou, Georges, 170–71

"Big Bend" region, Fla., 189

Big Hammock, 115

Bight of Benin, 94

Big Swamp (maroon community), *113*, 115

Billamia, Alex, 280

Bioko, 253

Biscayne Bay, 308

Bissett, Robert, 77

Black Atlantic, 7–9, 13, 164–65

Black Gods and Kings (Thompson), 321, 322

Blackhawk (former slave), 173

Black nationalist movement, 21

Black Renaissance, 218n15

Blacks: in Antebellum Florida, 40; and civil rights movement, 45–46; and class, 44; disenfranchisement of, 43; diversity among, 46, 47; during early 20th century, 44, 46; and education, 44; and elective office, 45–46; and frontier wars, 34, 38; and Great Depression, 44–45; late-19th-century, 43; in Mexico, 127, 132; and migration, 46–47; as percentage of Florida population, 45; and poverty, 43; during Reconstruction, 42–43; and religion, 46; scholarship on, 47n2; during Second Spanish Period, 38; and Seminole Indians, 36–37; violence against, 43; and WWII, 45. *See also* African Americans; Africans

Blacks, free: in Cuba, 94, 109, 120n11; in Iberia, 33; and religion, 33; during Second Spanish Period, 38; and Spanish exploration, 33; terms for, 120n21; in territorial Florida, 40. *See also* Fort Mose, Fla.; Garrido, Juan; Maroons and maroon communities; Slaves, escaped

Black Seminoles: and agriculture, 90, 111; in Bahamas, 18, 19, 118–20; and bandoleer bags, 98, *100*; clothing of, 18, 90; communities of, 111–12, 116; culture of, 18, 90–91, 111; descendants of, 118–20; emergence of, 90; illustrations of, *42, 100, 112*; as interpreters, 111, 112; lack of historical documentation on, 90, 91; in Mexico, 117, 119, 125; other terms for, 120n17; removal of, to Indian Territory, 117; as U.S. Army scouts, 19, 117–18, 119; as warriors, 111. *See also* Seminole Indians

Black Society in Spanish Florida (Landers), 113

Bleach, Gordon: as African, 10; as artist, 15, 16–17, 29, 65, 66, 68, 69n5; characteristics of, 16, 65; life of, 15; photo of, *59*; themes and places addressed by, *60–64*, 65, 68, 69n1

Bloomington, Ind., 348, 349

Blue Mote (Bleach). *See Xanadu, Florida* (Bleach)

Blue Ridge Zoological Park (Va.), 407n33

Boas, Franz, 241, 242

Boca Raton, Fla., 371, 389, 390

Boer War, 180

Boggy Kettle Island, *113*, 115

BoNasakó family, 275n45

Borderlines in Borderlands (Stagg), 48n25

Border Patrol, U.S., 27

Bosque Bello cemetery (Amelia Island, Fla.), 82

Botanica Halouba (Miami, Fla.), 303

Botanica Ifalola, 337

Botswana, 66, 403

Bowen, Thomas Jefferson, 181

Bowen, William, 144–45

Bowlegs, Billy: bandoleer bag owned by, 100, *102*; and delegation to Washington, D.C., *112*; family of, *103*, 176; as Seminole leader, 36; towns associated with, *113*, 115–16

Bowlegs, Scipio, 117

Boyd, Valerie, 238, 239, 242, 244, 245

Brackettville, Tex., 118

Braden River, 116, 121n34, 176

Bradley, Robert, 142

Brah, Avtar, 10, 11, 15

Brandon, George, 274n29

Brazil and Brazilians: and African language, 84n11; and Africans, 73; crowns in, 289, *291*, 297; masquerades in, 366; and migration to Florida, 46; religion in, 84n11; slavery in, 33; Yoruba influences in, 94

Bremer, Fredrika, 177, 278

Brewton-Parker Junior College, 316

Briones, Nicolás de, 83n10

British: and Asante Wars, 218n6; attacks on St. Augustine by, 36; cemeteries of, 200–202; and Gulf of Mexico, 123; and Indians, 39, 87, 88, 142; and maroons and maroon communities, 39, 90, 116; and Red Stick War, 145; and slavery, 20, 90. *See also* Florida: as British territory

British Royal Marines, 39
British Virgin Islands, 366
Brooklyn, N.Y., 236, 245, 262, 272n3
Brotherhood of Sleeping Car Porters, 43, 44
Brown, Canter, Jr., 116
Brown, Corrine, 45
Brown, David, 275n38, 275n39
Brown, J. N., 164
Brown v. Board of Education of Topeka, 45
Bucker (Buckra) Woman's Town, *113*, 115, 176
Buckra Woman (mother of Billy Bowlegs), 176
Bureau of Immigration, U.S., 219n25
Bureau of Investigation, U.S., 208
Bureau of Naturalization, 219n25
Burgess, Fredrick, 200, 201
Burning of the town Pilak-li-ka-ha by Gen. Eustis (Gray & James series), *114*
Busch Gardens (Tampa, Fla.), 12, 383–84, 396–400, 402
Bush, George, 175
Byrne, John, 239

Cabeza de Vaca, Álvar Núñez, 33
Cabrera, Lydia: in Cuba, 259; father of, 273n11; in Miami, 259; research of, 259, 267, 270, 271, 275n44, 275n48, 278, 300n36
Cabrera, Raimundo, 255, 273n11
Cádiz, Spain, 272n5
Cairo, Ga., 198
Calabar, Nigeria: Abakuá and, 251, 262; Adrian Castro and, 15, 50, 53, 58; Amanda Carlson in, 53; communities in, 249, 251, 254, 259; Ékpè terms from, 273n9; fauna in, 251; as homeland, 267; immigrants from, 272n3; leopard societies in, 50, 53, 55, 56, 57; on maps, *16*; peoples of, 275n50; travelers from, 262. *See also* Nigeria
Calabar Carnival, 378
California, 319, 322, 384
Cameroon: Cross River region of, 15, 53; Èfìk in, 267; Ékpè in, 272n4; immigrants from, 272n3; leopard societies in, 15, 23, 251, 252, 272n1
Campbell, Jabez P., 185
Campeche, Mex., 123
Campion, Jules, 307
Canada, 217n1
Candomblé, 330n2, 334, 347–48
Cantos to Blood and Honey (Castro), 56–57
Caribbean: Ade Rossman and, 245; and Africa, 15; African diaspora in, 9, 56; Africans in, 73; and barbeque, 21–22, 223; Dutch in, 107; and Florida, 38; Igbo in, 366; masquerades in, 366, 367; and migration, 18, 37–38, 46, 205; poetry in, 58; religions from, 302, 305, 306, 307; slaves in, 34, 231; trade with, 123; Yoruba influences in, 94; Zora Neale Hurston's depictions of, 222. *See also* Afro Caribbeans
Caribbean Gardens (Naples, Fla.), 395–96

Carlos III, king of Spain, 128, 129
Carlson, Amanda, 3
Carolinas: Africans in, 93; and escaped slaves, 139, 141; escaped slaves from, 87, 108; founding of, 34; Indians in, 47n9, 87; migration from, 77; and Revolutionary War, 90; scholarship on, 47n9; slavery in, 88; slaves in, 94; slave trade in, 47n9; Yoruba culture in, 319. *See also* North Carolina; South Carolina
Carretas, Mex., 131
Carrol, Phil, 392
Carroll, Kevin, 289
Cartographies of Diaspora (Brah), 11
Cashen, James, 79, 80, 85n28
Castelnau, comte de, 177–79
Castle of Figueras, 272n5
Castro, Adrian: "Cross the Water" by, 14–15, 51–52, 57; and Florida, 53, 56; photo of, *50*; as poet, 56–57, 58; on rituals performed in Miami, 312n17; travels of, 56, 57–58; as Yoruba priest, 54, 57–58
Catholic Archdiocese of Miami, 309
Catholicism: in Africa, 75; African descendants and, 171; Africans and, 17; and class, 306; in Cuba, 277, 298; Indians and, 124, 125; languages used for, 301, 309, 312n27; material culture of, 298; in Miami, 312n20; orders of, 87, 131; and Pentecostalism, 306, 307, 308; saints of, 285–87; and Santería, 334; slaves and, 35, 74, 76, 88; as unifying force, 126–27; Yoruba and, 277
Cavallo, Juan. *See* Horse, John
Cedar Point, Ohio, 396
Cemeteries: African-American, 189, 190–200, 202, 203; antecedents of, 200, 201; European American, 189, 198, 199–200, 201, 202, 203; folk, 189, 203n2, 204n29; grave goods in, 193–95, 196, 197, 203, 203n10; grave markers in, 177, 190–91, 194–96, 197, 203; images of, *190*, *191*, *192*, *194*, *196*, *198*, *199*; and Kongo beliefs, 191–93; locations of, 189–90; Neanderthal, 200; preservation of, 200; rural, 189; scholarship on, 189, 200; and segregation, 189; uses of shells in, 20–21, 82, 177, 189, *190*, 191, 193, 194, 195–203
Central Africa: Adventures and Missionary Labors in Several Countries in the Interior of Africa, from 1849 to 1856 (Bowen), 181
Ceremonia Secreta (Beltrán), 269, *270*
César, Waldo, 306
Ceuta, 253, 255, 272n5
Chachalacas River, 129
Chafarinas Islands, 253, 255
Chambers's Journal, 200, 201
Charles (slave), 81
Charles II, king of Spain, 88
Charleston/Charles Town, S.C., 74, 77, 79, 84n21, 108, 152

Sosa, Enrique, 256, 258, 259, 274n25, 274n26, 274n27
Soto, Hernando de, 33
Soto, Leandro, 53, 271, 275n50
Soul Force, 301–2, 305–6, 310, 311, 311n4
South Africa: 19th-century, 180; African Universal Church and Commercial League (AUC) and, 216, 217; and apartheid, 216; Conrad Rideout in, 183; Gordon Bleach on, 66; pan-Africa conferences in, 219n46; religion in, 306; Zulu Nation in, 216
South America, 123, 393
South American, 107
South Carolina: African Universal Church and Commercial League (AUC) in, 216, 217; barbeque in, 231; cemeteries in, 197, 202; creole languages in, 84n11; escaped slaves from, 74; Juan Bautista "Big Prince" Witten in, 171; migration from, 185; Oyotunji African Village in, 317, 329, 364n12; rice cultivation in, 34; slaves in, 47n10, 83n7, 231; and slave trade, 152; smugglers from, 143. *See also* Carolinas
Southern Christian Leadership Conference, 46, 331n10
Spain: Africans in, 32; and colonization, 33; and Congo peoples, 17; and escaped slaves, 140; and extradition, 143; and Florida, 19; and Indians, 139–40; Juan Garrido in, 73; and Portugal, 74; and slaves and slavery, 32, 33, 34
Spanish: and African ethnicity, 17; and British occupation of Florida, 122, 123; and Indians, 33, 34, 86–87, 89, 110, 124, 125, 142; and maroons, 116; and migration, 123, 124; and slaves, 35, 74, 88, 108–9, 141
Spanish Frontier, The (Weber), 47n3
Spatial theory, 11, 30n19, 150–52, 163
Spelman College, 156
Spunk, 240
Stanley, Henry Morton, 20, 179, 401
State Normal and Industrial College for Colored Students (formerly Normal and Industrial College for Colored Students for Colored Students), 174, 186
Status Sport, Oil Resistant (Bleach), 62
St. Augustine, Fla.: African culture in, 177, 379n2; Africans in, 5, 74, 83n9, 175; archaeology in, 82–83; British attacks on, 36; and Caribbean, 38; economy of, 38; founding of, 4, 33; Fredrika Bremer in, 177; Gordon Bleach's depictions of, 62; Jack Smith ("Sitiki") in, 171, 172; Kingsley Plantation community in, 164; Louise Cecilia Fleming in, 183, 184; map of, 36; Martin Luther King Jr. in, 46; minstrel shows in, 179; National Underground Railroad Conference in, 119; Nora Huston in, 83; religion in, 171, 172; significance of, 4, 34, 62; slaves in, 35, 73, 74, 83, 88, 94, 140, 141; wildlife at, 395

St. Augustine Alligator Farm, 387
St. Christopher, 75, 76
St. Cyprian's P.E. Church, Key West, Fla., 174
Stinson, George, 144, 146
St. Johns River, 37, 78, *151*, 159, 162, 172, 183
St. Lucie County, Fla., 22, 236, 246n1, 246n2
St. Marys River, 37, 78, 79
Stokes, Sherrie, 177
Stono (Smith), 48n11
Stono Rebellion of 1739, 35, 48n11
St. Petersburg, Fla., 210–11, 213
Straight University, 175
St. Simon Island, Ga., 140
St. Thomas, 79
Stuempfle, Stephen, 279
St. Vincent de Paul Catholic Parish (Miami, Fla.), 309, 310, 312n27
Sumter County, Fla., 113
Sunken Gardens, 389
Superior (ship), 152
Supreme Court, U.S., 45, 279, 304–5
Surí, Tomás, 258, 274n25
Suwannee River, 40, 89, 115, 116, 170, 175
Swanton, John Reed, 115
Sweetwater, Fla., 262

Tabo (Botswana cultural representative), 403
Talabi, *iyawo*, 339, 340, 342, 343
Talbot, P. Amaury, 197
Tallahassee, Fla.: cemeteries in, 193; Charles Fenton Mercer in, 180; Igbo associations in, 371, 372; religion in, 182; Normal and Industrial College for Colored Students at, 174; as territorial capital, 40
Tamiami Trail, 391
Tampa, Fla.: Abakuá in, 255, 257, 258, 273n19; Busch Gardens in, 383, 396; cigar manufacturing in, 174, 255, 273n13; Club Martí-Maceo in, 258; Cubans in, 22, 255, 273n13, 273n18, 273n19, 278; Igbo organizations and activities in, 26, 365, 371, 375, 377, 380n13, 380n21; Laura Adorkor Kofi in, 210, 213; migration from, 185; student exhibition in, 5
Tampa Bay, Fla., 116, 176
Tampa Cigar Workers (Pérez), 257
Tampa Florida Peninsular, 182
Tanganyika, 406n17
Tanzania, 393, 406n17
Tazi, Mbe, 272n4
Team Rodent: How Disney Devours the World (Hiaasen), 384
Tejumola (Yoruba initiate), 343
Tell My Horse (Hurston), 222, 225–26, 227, 228
Teran, Emma, 299n10
Tetzlaff, Lawrence, 395–96, 407n28
Tetzlaff, Nancy, 395
Tetzlaff, Tim, 407n28
Texas, 18, 19, 118, 119, 135n7, 181